Living with
# Shakespeare

# VENVS
# AND ADONIS

*Vilia miretur vulgus: mihi flauus Apollo
Pocula Castalia plena ministret aqua.*

LONDON
Imprinted by Richard Field, and are to be sold at
the signe of the white Greyhound in
Paules Church-yard.
1593.

# Living with Shakespeare

SAINT HELEN'S PARISH, LONDON, 1593–1598

GEOFFREY MARSH

EDINBURGH
University Press

For Vicky and James

Edinburgh University Press is one of the leading university presses in the UK. We publish academic books and journals in our selected subject areas across the humanities and social sciences, combining cutting-edge scholarship with high editorial and production values to produce academic works of lasting importance. For more information visit our website: edinburghuniversitypress.com

© Geoffrey Marsh, 2021

Edinburgh University Press Ltd
The Tun – Holyrood Road, 12(2f) Jackson's Entry, Edinburgh EH8 8PJ

Cover, design and typeset in Minion
by Biblichor Ltd, Edinburgh and
printed and bound in Malta at Melita Press.

A CIP record for this book is available from the British Library.

ISBN  978 1 4744 7972 1 (hardback)
ISBN  978 1 4744 7973 8 (webready PDF)
ISBN  978 1 4744 7974 5 (epub)

The right of Geoffrey Marsh to be identified as the author of this work has been asserted in accordance with the Copyright, Designs and Patents Act 1988, and the Copyright and Related Rights Regulations 2003 (SI No. 2498).

# Contents

*Acknowledgements*   vii
*Picture Credits*   ix

Introduction: 1593, the Theatre, Shakespeare, Saint Helen's, English and You   1

## PART I: 1576, LONDON, THE THEATRE AND HUNTING FOR CHINA

1. 1576: A Starting Point   29
2. James Burbage Plans His Theatre: The Theatre   46
3. Kick-Starting the British Empire   63

## PART II: THE THEATRE, 1576–1598

4. James Burbage Builds the Theatre   83
5. Trouble at the Theatre   101
6. The Early Years of the Theatre: 1576–1586   115
7. The 1594 Changes at the Theatre and Shakespeare's New Focus   130

## PART III: THE PARISH OF SAINT HELEN'S, BISHOPSGATE STREET

8. William Shakespeare and the Parish of Saint Helen's   145
9. Searching for Shakespeare's Lodgings in Saint Helen's   165
10. What Attracted Shakespeare to Saint Helen's?   180

## PART IV: LIFE, DEATH AND RELIGION IN SAINT HELEN'S

11. Saint Helen's Church: The Anchor of the Parish   203
12. A Walk Round the Interior of Saint Helen's Church   216
13. Dreaming of English Exploration, Trade, Wealth, Colonisation and Empire   230

## PART V: SHAKESPEARE'S NEIGHBOURS IN SAINT HELEN'S

14. The Radical Doctors of Saint Helen's   255

| | |
|---|---|
| 15. Dr Peter Turner Visits a Patient at the Sign of the Horse Head Inn | 276 |
| 16. Lawyers, Musicians, an Antiquary and More | 292 |
| 17. Saint Helen's as a Microcosmos: A Theatre of London | 306 |

## PART VI: BEWITCHMENT IN LONDON

| | |
|---|---|
| 18. Witchcraft in Thames Street | 333 |
| 19. Mary Glover is Bewitched in All-Hallows-the-Less, Thames Street | 349 |
| 20. An Exorcism in Shoreditch | 360 |

## PART VII: CODA: THE ADVANCEMENT OF ENGLISH

| | |
|---|---|
| 21. Honey or Cane Sugar? | 377 |

## APPENDIX

| | |
|---|---|
| 1. Introduction | 393 |
| 2. What Accommodation in Saint Helen's Would Have Appealed to Shakespeare? | 394 |
| 3. Identifying the Location of Shakespeare's Residence(s) | 404 |
| 4. When Did Shakespeare Leave Saint Helen's? | 432 |
| 5. Who Was John Pryn, Pryne, Prynne, Pryme, Prymme? | 444 |
| 6. Who Was John Hatton? | 452 |
| 7. Who Were Thomas Wrightson, John Harvey and Israel Jorden, Jordan, Jordaine, Jordayne, Jurden? | 457 |
| 8. Who Were John, Antonia and Katherine Jeffrey? | 466 |
| 9. Some Other Residents of Saint Helen's in the 1580s and 1590s | 470 |
| *Bibliography* | 475 |
| *Index* | 489 |

# Acknowledgements

This book is the result of research on both sides of the Atlantic.

In 2008, the remains of the Theatre, built in 1576 by James Burbage and John Brayne, were discovered on a redevelopment site in Shoreditch, London. In an act of great public-spiritedness, the Belvedere Trust supported a project which would allow visitors to view the foundations of the building that probably saw the première of *Romeo and Juliet* and many other famous plays. The Victoria & Albert Museum assisted with lending exhibits for the interpretive display which will open in 2021. As a result, I became intrigued by the question of where Shakespeare was living while he was working at the Theatre. This led me to Professor Alan H. Nelson in Berkeley and his website (https://ahnelson.berkeley.edu/) exploring the late sixteenth-century Lay Subsidy rolls for London. Anybody who has used Professor Nelson's transcriptions and who has experience of working on other rolls will know what a great debt of gratitude historians owe to his work of making these intractable documents available online. In doing so, he has brought back to light thousands of Elizabethan Londoners, including the neighbours of Shakespeare in St Helen's during the 1590s. His work was the fundamental starting point for this book.

Those who have read *1599: A Year in the Life of William Shakespeare* and *1606: The Year of Lear* by Jim Shapiro along with *The Lodger: Shakespeare on Silver Street* by Charles Nicholl will recognise the debt this book owes to them and their demonstration that, with careful excavation, one can discover much about Shakespeare's life in London. Chris Laoutaris, in his recent *Shakespeare and the Countess: The Battle that Gave Birth to the Globe*, has continued this approach and I am grateful for his advice.

The central arguments of this book were presented at the 2019 Annual Conference of the Shakespeare Association of America in Washington, DC. I am very grateful for comments made there by Alan H. Nelson, William Ingram, Sally-Beth MacLean, David Kathman, Natasha Korda and others. David Kathman's work on the parish of St Ethelburga was a vital parallel model for my examination of the records from St Helen's.

In terms of access to original materials, Jerome Farrell, archivist at the Leathersellers' Company, has been a huge help as well as a wise critic. The staff at the London Metropolitan Archive, the Guildhall Library, the National Archives and the British Library have all helped in their customary professional manner. Also, thanks are owed to Michael Witmore and Heather Wolfe at the Folger Library in Washington. Professor Vanessa Harding was of great assistance in improving my understanding of Elizabethan records; however, any errors in interpretation are my own. Peter Elmer, Richard Wilson,

Peter McCullough and John Schofield helped advise on specific points. Evelyn Welch and Elizabeth Kehoe commented on earlier drafts of the text. I am grateful to the estates of T.S. Eliot and George Orwell for permission to quote from *The Wasteland* and *Coming Up for Air*.

I am fortunate to work in the Department of Theatre and Performance at the V&A Museum. Nobody could hope to work with a more informed, hard-working group of specialists committed to enhancing the public's appreciation of the UK's extraordinary performance heritage. Flynn Allott, Ella Khalek, Carolyn Addelman, Peter Kellaway, Sophie Thomas and Sam Wassmer all helped in various ways. Sue Cawood and Cat Macdonald turned my scrawls into legible plans and diagrams.

I am grateful for the support of the Marc Fitch Fund, the Hiscox Foundation and the Worshipful Company of Leathersellers, whose financial support allowed this book to include illustrations that would otherwise have been unaffordable. I would also like to thank the team at Edinburgh University Press, especially Michelle Houston, James Dale, Ersev Ersoy, Bekah Dey, Gavin Peebles and Camilla Rockwood.

On a personal note, I would like to thank Harvey Sheldon, currently chairman of the Rose Theatre Trust, who introduced me to the archaeology of Bankside in 1971, where I had the good fortune to meet Sam Wanamaker. Both taught me, in different ways, that improving 'public good' almost always involves challenging or circumventing authority.

Finally, I would like to acknowledge a huge debt to the late, great Professor Ted Rabb of Princeton University (1937–2019), who challenged me to turn some casual thoughts into a book and guided me through the ups and downs that any publication involves.

As Charles Nicholl put it in *The Lodger: Shakespeare on Silver Street* (2007):

> with original spellings the demands of authenticity and readability pull in opposite directions. To modernise everything is to lose a certain richness – an orthographic brogue intrinsic to the period. On the other hand, quoting everything in archaic spelling can make things hard going for the reader. Inconsistency has seemed a lesser evil than either of these.

I have generally followed his approach. In terms of spelling, 's' and 'i' and 'u' and 'v' have been transposed as appropriate. In terms of dates, I have used 'new' style except where stated. All quotations of Shakespeare are from Stanley Wells and Gary Taylor (eds), *William Shakespeare: The Complete Works* (Oxford: Clarendon Press, 1986).

# Picture Credits

Alamy: 1.4, 1.5, 1.7, 1.11, 2.1, 3.3, 8.12, 21.8; Author: I.9, I.10, I.11, I.12, 5.1, 8.1, 8.7, 8.10, 8.11, 12.3, 14.3, 16.4, 17.3, 17.5, 17.6, A.12, A.13, A.14, A.15 & tables; Belvedere Trust: 4.11, 4.12; Bodleian Library, University of Oxford: 3.1, 18.7; British Library: I.3, 10.11, 20.2, 20.3; British Museum 3.4; Kind permission of Burden Collection: I.4; Kind Permission of the Governors of Dulwich College (© David Cooper): 6.5; Dulwich Picture Gallery: 4.1; Edinburgh University Library, Special Collections: I.1, 4.4, 10.6, 10.7, 10.8, 10.9, 18.5 and page corner details; London Metropolitan Archive: 2.2, 2.3, 2.4, 7.1, 8.3, 8.4, 8.6, 8.13, 10.1, 10.2, 10.4, 10.5, 11.1, 12.6, 14.1, 14.2, 18.3, 18.6, 21.4, 21.7, A.1, A.3, A.4, A.5, A.6, A.7, A.10; National Portrait Gallery: I.13, 3.5, 3.6, 6.8; Rochester Bridge Trust: 8.9; Victoria & Albert Museum: 1.8, 6.1, 6.2, 6.3, 6.4, 10.10, 14.7, 17.1, 17.2, 17.4, 17.7, 17.8, 17.9, 17.10; Wellcome Trust Library: 2.6; Worshipful Company of Leathersellers: 8.5, A.17.

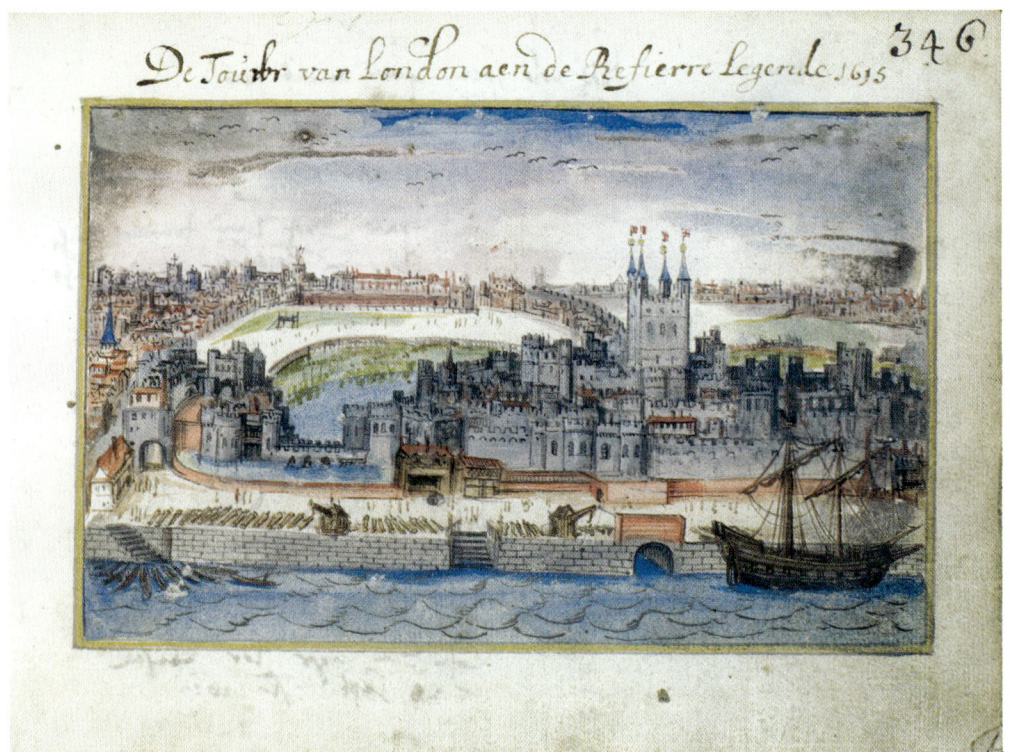

Figure I.1    Fortress, armoury, prison and brutal government interrogation centre, the Tower of London retained its brooding menace throughout Shakespeare's time in London. Francis Walsingham, Elizabeth I's 'spymaster', lived near the entrance in Seething Lane. Watercolour from Michael Van Meer's *Album Amicorum*, 1614–17 (f. 356r).

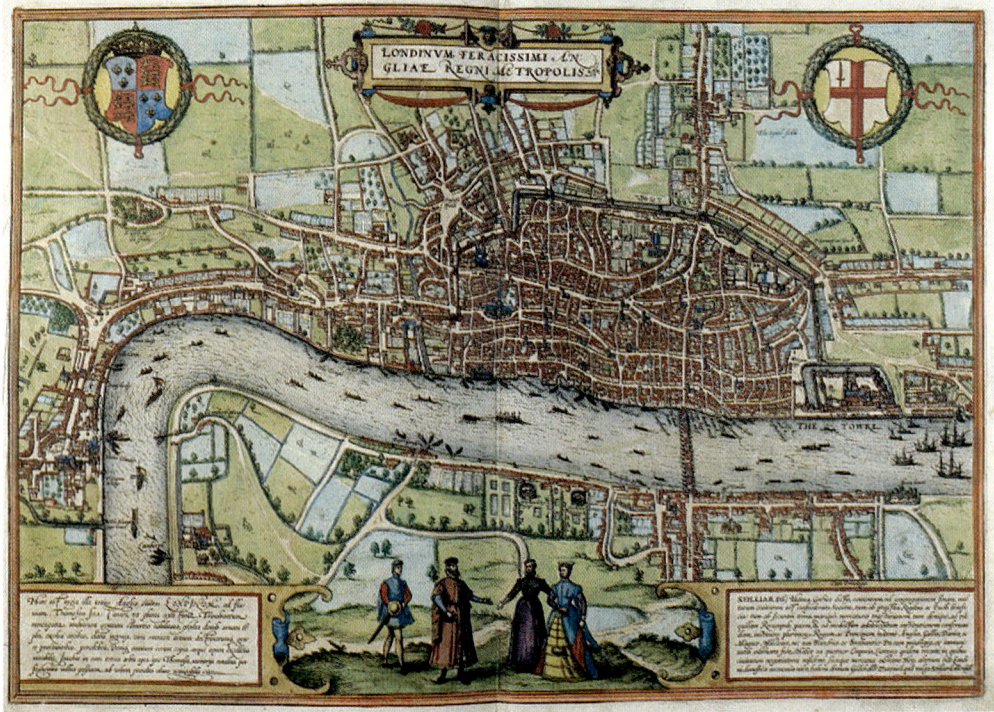

Figure I.2    London as recorded in the 1570s, when its population was rapidly growing beyond 150,000. The walled City (right) was linked to Westminster (left) by the Strand and the River Thames. Engraving from Georg Braun and Frans Hogenberg, *Civitates Orbis Terrarum*, vol. 1 (1572). On the eastern side, open fields still come up close to the City wall.

# Introduction

## 1593, the Theatre, Shakespeare, Saint Helen's, English and You

Seven o'clock in the evening, Tuesday 23 October 1593, thirty-five hours before the dawn of St Crispin's Day. In the heart of London, a young boy lies motionless on a straw mattress (Figures I.1 and I.2).[1] His sunken cheeks, greying face and feeble breath make it clear that he is dying. Alongside him, his brother Abraham, drenched in sweat, tosses and turns, hands clasping and unclasping with spikes of pain. Despite the autumn evening chill the room feels steaming hot, as if the boys' fevers can heat the fetid air. Across the room, their sister Sara tries to sleep. Upstairs, in the low garret under the roof tiles, two tearful servant girls lie wide awake, holding each other, trembling at the scene they know is just beneath them.

The boy's father Baldwin, sick himself, clutches his son's hand, whispering 'Pieter, Pieter, Pieter,' and tries to haul him back from death, but feels him slipping away. Kneeling beside him, Melchior Rate, a local Dutch preacher, prays fervently with his eyes closed: '*myne Heere ende God, myne Heere ende God . . .*', his Bible open beside him. His strong accent has never softened, despite his time in London. His face runs with sweat; he too is desperately ill, and will die within a day.

Baldwin feels his son's pulse flutter to nothing. It is all over. He glances at Melchior and sees that the mark of death is on him already.

Baldwin closes his son's staring eyes, then drags the body across the room to the narrow, twisting stairs. He has already carried Lucas, his wife, and another son down the same wooden steps. At the bottom, he wrestles the front door open, ignores the plague warning painted on the wall and lays his son's body out in the dark, rainy street for removal by the gatherers. Exhausted, he glances across to the former house of his friend John Ruttings, another 'stranger' or immigrant in London. John and his wife died of plague a month ago, and Baldwin and his family were well enough then to give them decent wood-coffined burials next to the font in the parish church of St Helen's. That all now seems like another time. Seven people out of the Ruttings' house have died already and only two children, Peter and Jacomin, now remain alive, shut up indoors, surviving on bread left by their neighbours. Within two weeks, they will be dead as well.

Tomorrow Baldwin will lug Melchior's heavy body down the same stairs, to be followed over the next ten days by his son Abraham, his daughter Sara and one of the servant girls.[2] Helen, his other servant, is tough; she fights and fights, but eventually the suppurating buboes on her joints are too much. She hunches up, fades into fever and

on 12 November her corpse too is left in the street. Finally, his household of seven who ate, worked and prayed together are all dead, and Baldwin is left utterly alone. He is sick, but by some quirk of fate or God's providence, he survives.[3]

Elsewhere, on that same evening, a man in his late twenties is sitting at an oak writing desk. Wrapped in his cloak, he is reading and rereading a heavily scrawled sheet of paper by the light of a tall wax candle. His finger follows the lines of verse:

> To fill with worm-holes stately monuments,
> To feed oblivion with decay of things,
> To blot old books and alter their contents,
> To pluck the quills from ancient ravens' wings,
> To dry the old oak's sap and blemish springs,
> To spoil antiquities of hammered steel,
> And turn the giddy round of fortune's wheel;
> (*The Rape of Lucrece*, ll. 946–52)

He dips his quill pen into the inkpot and puts a line through 'blemish springs', he can do better than that, but what? And 'the giddy round of fortune's wheel' indeed. He changes his mind and writes 'springs' back in. He likes the image of young trees, 'springs', contrasting with the heaviness of 'old oak's sap'. Then he writes in 'cherish springs'. The alterations are becoming a blotty mess and he is still unsure. Somewhere, close by, a baby screams and screams. He puts down his quill pen in frustration and stands up; how can he work in such conditions? He is torn between the apparent safety of Stratford-upon-Avon and his terror of plague-ridden London, which the royal court has abandoned for the comparative safety of Windsor Castle. He needs to be, has to be, around dynamic people, success and money to inspire him. Skulking in plague-free Stratford would be safer, but he gets nothing done there as family, friends and people he hardly knows disturb him with endless tittle-tattle, gossip this and gossip that and requests for loans. News of his success in London has filtered back, and people think he has money to spare. His growing fame is becoming a curse where his home town is concerned.

He must, he must get his new narrative poem *The Rape of Lucrece* finished. He is weeks behind. His first, *Venus and Adonis*, fortuitously published in May before the plague got started again, has been a critical success. It has been a route to a certain fame and some fortune. Already, he is spoken of with respect, the flirtatious eroticism appealing to the young men about town and the gentlemen studying law at the Inns of Court.[4]

> Now is she in the very lists of love,
> Her champion mounted for the hot encounter.
> All is imaginary she doth prove.

# Introduction

> He will not manage her, although he mount her,
> That worse than Tantalus' is her annoy,
> To clip Elysium, and to lack her joy.
> (*Venus and Adonis*, ll. 595–600)

The closure of the theatres since 1592, due to the outbreak of plague, has shown he cannot rely on acting for his livelihood. He needs to find a reliable and generous patron and for that he must be in London, whatever the risks. The winter frosts will soon chase the plague away. What he requires are living quarters where he can write without distraction. His new work needs to be a powerful success to show that *Venus and Adonis* was not a lucky one-off by a provincial with no university education to refine his raw talents. Also, there are darker and more disturbing threats at work than just the circling plague. Only five months ago, his colleague and fellow dramatist Christopher Marlowe was killed, stabbed with a dagger in his face, during a drunken brawl in Deptford. Knowing Kit's quick wit and quicker temper, anything is possible, but there are credible rumours that the authorities decided he knew too much and had him murdered. Thomas Kyd, another talented dramatist who once shared lodgings with Marlowe, was taken into custody. Now he has been discharged, but he is broken in mind, spirit and body. Kyd refuses to speak of his interrogation and has slunk away into some unknown alley to nurse his wounds.[5]

As for himself, he is careful about where he goes and what he says. All his papers are now locked in a chest in his lodgings, and he keeps the key to himself.

He sits down, picks up his quill pen again, wipes it clean and then dips it into the oak-gall ink. 'To slay . . .' – but to slay what?

> To slay the tiger that doth live by slaughter,
> To tame the unicorn and lion wild,
> (*The Rape of Lucrece*, ll. 955–6)

He feels his creative rhythm pick up. He continues writing far into the night.

This book links together three cultural drivers of mid–late Elizabethan London to explore the crucible of one of the greatest periods of English creativity. They are:

- A man who has moved the world;
- A theatre which, you will perhaps be surprised to discover, was physically uprooted and moved about a mile in 1598/9 to be recast, reopened and renamed; and
- A place, an ancient London parish,[6] particularly its church, which has never moved but, like its neighbours, witnessed a sixteenth century of cultural, economic and particularly religious upheaval.

It is, therefore, a book about movement, fluctuating stability, human migration and urban change, with the resulting shifts in people, sounds, words, language, ideas, identities and hence society. Plato wrote *c.* 275 BC: 'When the sound of the music changes, the walls of the City shake.'[7] Here, we will be looking at a time when the sound of English theatre changed.

The man is the poet, playwright and actor William Shakespeare (1564–1616) (Figure I.3). The theatre is in fact named 'The Theatre' (Figure I.4) and was originally constructed in Shoreditch, just north of the City of London, in 1576 before being 'stolen', if you can steal a building, in late December 1598.[8] For at least the last four years (1594–8) of its twenty-two-year life, the Theatre was the main workplace of Shakespeare as a member of the Lord Chamberlain's Men theatre company. He not only wrote and acted with this group but was also one of eight sharers in its profits. It is highly likely that ten or so of his plays, including *Romeo and Juliet*, *The Merchant of Venice* and *A Midsummer Night's Dream*, were premiered there. Shakespeare must also have been involved, at some level, in its 'theft'. In the following year, 1599, the Theatre reappeared phoenix-like on Bankside in Southwark, across the River Thames.[9] It had been given a new identity, the Globe, and it was to become one of the most famous buildings in the world.[10]

The place is the parish of St Helen's, Bishopsgate, nestling in the north-east corner of the City of London (Figure I.5). By modern standards the parish seems tiny, about seven acres or so, just 30,000m². Today, it is dominated by enormous office buildings like the Gherkin and the Cheesegrater, to be filled during the day with thousands of workers in financial, insurance and legal services, commuters who pour out of Liverpool Street and Bank stations. In the 1590s, it lay just inside the city walls by Bishopsgate, the main gateway to the north of England. Then, it was also a thriving, wealthy, bustling community of perhaps 550–650 people, with a distinctive identity. It was full of wealthy merchants, textile traders and leatherworkers with a scattering of MPs, gentry and artists. These individuals were not commuters but residents who lived, worked and usually died together in the parish. Among them, certainly in 1597/8, was William Shakespeare – the BBC's 'Man of the Millennium' in 2000. As we will uncover, it is likely

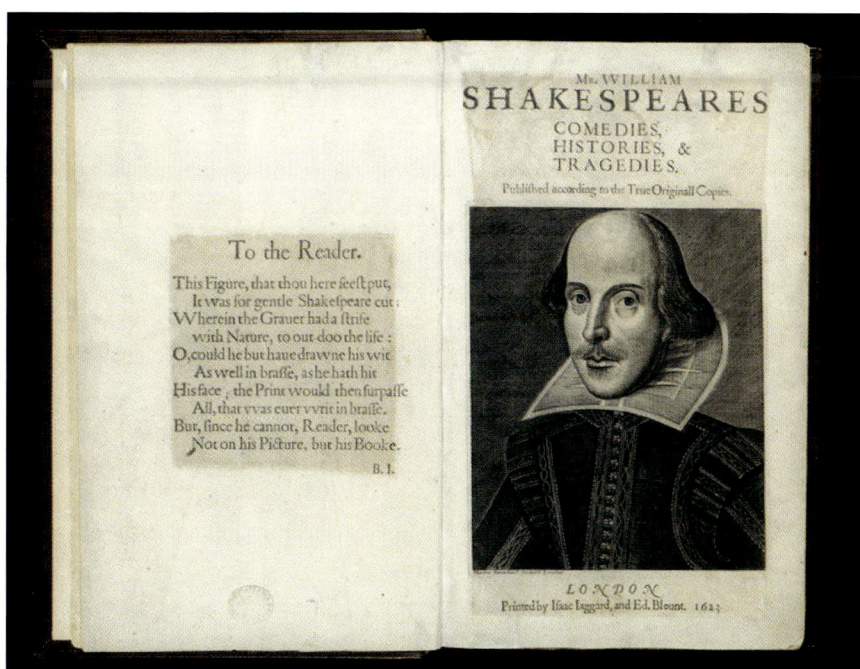

Figure I.3 The only definite image of Shakespeare: engraving by Martin Droeshout the Younger (1601–c. 1650) for the frontispiece of the First Folio of Shakespeare's collected plays (1623). This shows him in old age and is assumed to be a recognisable likeness, given the date of publication a few years after his death.

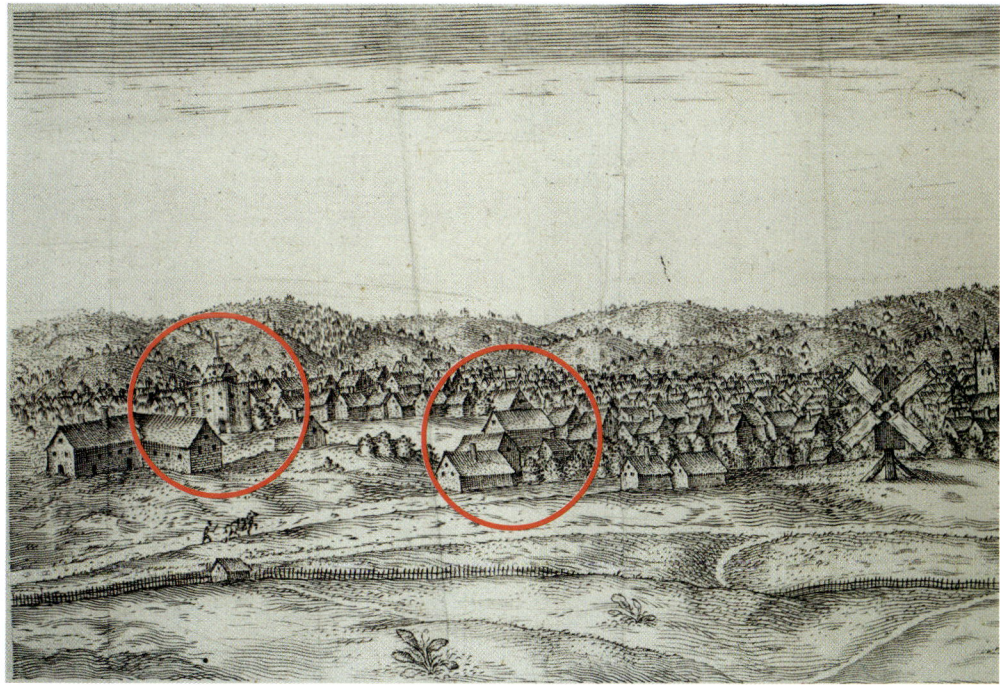

Figure I.4 The village of Shoreditch with the Theatre (circled left) and the Curtain playhouse (circled right) viewed from the south-west, close to London Wall. Section of the 'Utrecht Panorama', c. 1597. Shoreditch lay in the county of Middlesex, beyond the direct control of the City of London authorities.

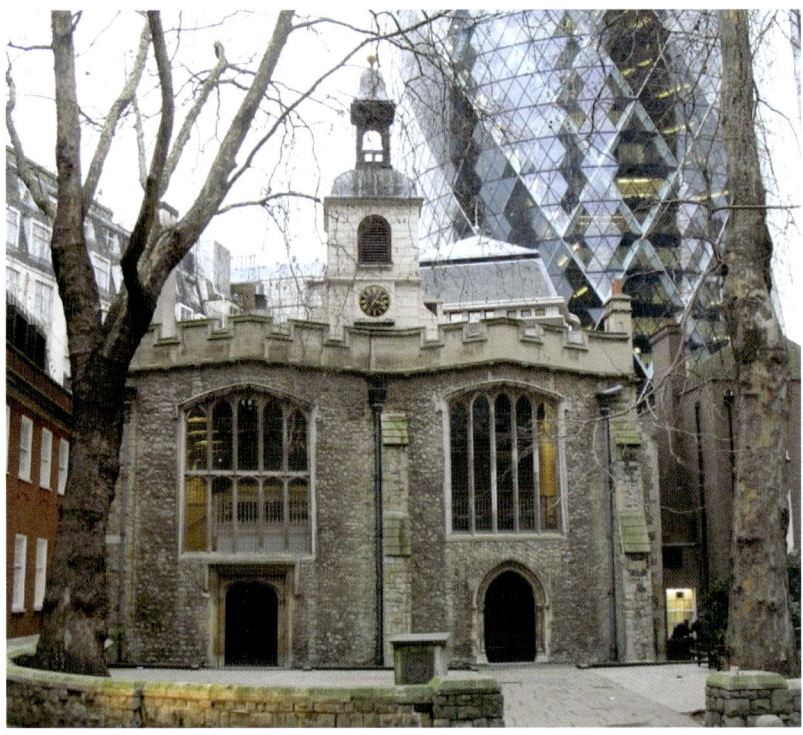

Figure I.5 The west front of St Helen's viewed across the churchyard, showing the doorways to the former nunnery (left) and the parish church (right), with the modern Gherkin office building (2004) behind. The clock turret is a later addition, and there was no bell tower attached to the church. The brick building on the extreme left is 33 Great St Helen's and marks the south end of 'The Cloister', the house carved out of the west wing of the nunnery and leased from the Leathersellers' Company, in succession, by Richard Clough, Anthony Stringer, Sir Thomas Gresham, Sir Humpfrey Gilbert, Sir John Pollard, Nicholas Gorges, Dr Peter Turner (from 1589–1614), Dr Patrick Saunders and eventually the sugar baker George Leech.

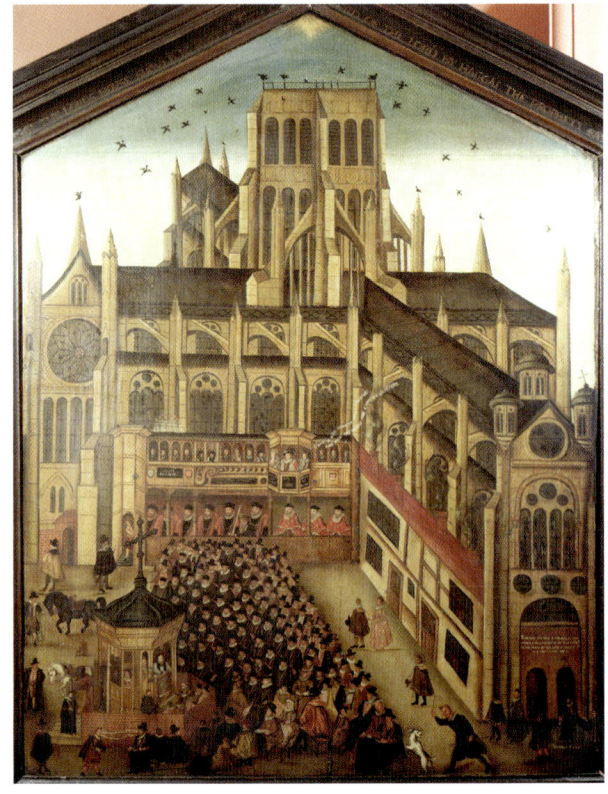

Figure I.6 Open-air preaching at St Paul's Cross took place after local parish services had finished. It was used as a platform for promoting official Church of England doctrine. Here Dr King gives a sermon in 1616. The churchyard was surrounded by bookshops. Detail from an oil painting on wood by John Gilpin, 1624.

that Shakespeare lived in St Helen's for four or five years, from late 1593/4 until 1598, when the Theatre was providing his main livelihood. It is possible that he moved there earlier, perhaps in 1592 or even before.

These five years, just either side of Shakespeare's thirtieth birthday in April 1594, formed a crucial stage in his career. It has long been recognised that the move to the newly constructed Globe Theatre in 1599 coincided with the start of the sequence of his great tragedies, beginning with *Hamlet*.[11] Did the roots of this new phase in his imagination lie in his life in St Helen's, or was it leaving the parish that helped liberate this new creativity? Did the inception of *Hamlet* date back to before 1599 and did the crucible of its moral questioning lie in the final seasons at the Theatre, in dinner-table deliberations with his neighbours and long evenings of introspection, staring out across the graveyard of St Helen's?

By law, everybody in Elizabethan England had to worship in their parish church on Sunday, and for Shakespeare this was St Helen's, even if he attended other services (Figure I.6).[12] Every church was part of the Church of England. To the state, religious and local civic authorities, Shakespeare was no different from any other parishioner. So, on most Sunday mornings, as the church minister John Oliver led his flock through the officially authorised Protestant service, somewhere among the high-backed wooden 'box pews' and low oak benches, Shakespeare would have been sitting, listening, standing, repeating the psalms, watching and thinking. Having almost certainly left his wife Anne and three children in Stratford-upon-Avon, Shakespeare would have been an independent man in his early thirties surrounded by a congregation largely made up of settled families, male apprentices and young female domestic servants.

The names of many people in the congregation are still known today. The middle chapters of this book aim to reconstruct, from the surviving records, something of these individuals and their daily life which surrounded Shakespeare. If one crept into the back of the service on Sunday morning, 23 October 1597,[13] there would probably have been Robert Hubbard near the front, presumably singing in tune as he was classed as a gentleman musician, and his fertile wife Katherine. She had given birth to at least eleven children over the last sixteen years and although a couple had fallen victim to the high infant mortality rate, she would still have had to shepherd a mini flock of five boys and three girls ranging in age from three to sixteen. Although Robert Hubbard was ranked socially as a gentleman, since he did not have to earn his living working with his hands, he was hard up – not surprising, with ten mouths to feed.[14] Even if they might have looked slightly old-fashioned, Robert Hubbard and his wife's clothes would have marked them out as people of rank. The gradations of Elizabethan society were revealed precisely by your apparel. The cost, feel and cut of the fabric were just the start. The quality of your buttons, jewellery, ruff and hat all advertised your status and aspirations.

Robert and Denise Spring would also have been there, maybe sitting a few pews further forward, denoting a slightly higher ranking in the parish social pecking order.[15] They had a family of six, five boys and a girl, aged from twenty down to six. Robert, a successful skinner who may also have traded in furs, had lived in the parish on and off for thirty years. The family lived in Little St Helen's, next to the church, in a house leased for thirty years from the Company of Leathersellers. They were close neighbours of Shakespeare. Robert had invested his profits in local property[16] and a country residence at Dagenham in rural Essex. Now, in his mid-fifties, he was part of the parish establishment, trusted with signing off the annual church accounts.[17] However, his self-confidence would soon take a major blow. Six months later, on 21 April 1598, he was back in St Helen's burying his wife, Denise. The burial register does not record the cause of her death, but she was probably aged around forty-five.

Another fertile local woman was Mary Bathurst, wife of prosperous grocer Timothy Bathurst.[18] She had given birth to six children in the last nine years, the most recent a son named Timothy after his father, born only a few weeks earlier. Timothy junior was baptised on 11 September, and Mary would have been 'churched' a month or so after. Churching is now a neglected Christian ceremony, but in the past, after childbirth, the mother would be the focus of a parish ritual to celebrate her survival and welcome her back into the community. The Bathursts were fairly wealthy[19] and as such would probably have had their own box pew towards the front of the church nave, close to the pulpit.[20]

Timothy was not Mary's first husband. In January 1582, she had married Thomas Saunders, a wealthy but older wool merchant.[21] They had a boy, Thomas, and a girl, Mary, in 1583/4. Then disaster struck: Thomas senior died in August 1584, leaving Mary with two children under two, and then Thomas junior died five weeks later. Within eighteen months, Mary married Timothy Bathurst, who thus acquired a wife, a stepdaughter and his new wife's comfortable house in Bishopsgate Street.[22] By 1597, the family would have included seven children ranging in age from thirteen down to the new baby. Wealthy or not, human life was precarious with London's poor sanitation and packed 'pestered' tenements, recognised as continual health hazards, even before the regular bouts of plague that flared up in the summer heat.[23] Only fourteen months later, on 20 December 1598, the flagstones and floor tiles of St Helen's were dug up again to receive Mary Bathurst's wooden coffin.[24] Had she died from complications from her last birth, or from some disease? We will probably never know. However, practicality generally outweighed sentiment in Elizabethan London. William Averell, the parish clerk of the neighbouring church of St Peter, Cornhill, was keen on moralistic versifying, and one of his poems compared the church's burial register to a:[25]

> Christall mirror and glas of mannes vaine glorie
> The virgin newlie married
> With pompe and wondrous pleasure:
> The next day heare is buried
> With sorrow passing measure:
> Shee meltes and mournes in dying
> Her spouse and frendes with crying[26]

Timothy Bathurst senior, with seven children under fourteen to be cared for, swiftly remarried.[27] Susan, his new wife, quickly produced three more sons, taking his family to around ten children.[28] Even if Shakespeare had been friendly with Mary Bathurst it is uncertain whether he would have attended her funeral, as the 20 December was a Wednesday and he may well have been rehearsing or performing.[29] And even if there was no performance, his mind was probably elsewhere, as just a week later he was part of an audacious and ultimately successful plan to steal the entire timber structure of the Theatre from under the nose of its landlord.

Attending divine service in church often meant walking past or over the decaying corpses of your relatives, friends and neighbours. Particularly in high summer, the smell inside St Helen's was probably a constant reminder of human mortality. During the 23 October 1597 service there may well have still been a slight whiff of Lawrence Kendrick, who had been buried near the pulpit on 17 August 'by his brother John Kendrick'; or particularly from Mrs Brown, whose coffin had just been placed alongside, 'under the stone where John Kendrick lieth' on the 6 October. John had only been buried four years earlier, so one hopes that the gravedigger's spade had not broken through his rotting wooden coffin lid.[30]

So just three families, with over twenty or so living children. In two cases, these were straightforward family units with two parents and their own children. However, with the Bathursts there was a tangle of relationships, creating a 'blended' family spread over a wide range of ages. One wonders what Shakespeare thought. Back in Stratford-upon-Avon there had been his three children – Susanna, born in 1582, and his twins Hamnet (his son and heir) and his second daughter Judith, born in 1585. However, the eleven-year-old Hamnet had died in August 1596, so Shakespeare knew that, with a wife aged forty-one, only her death and his remarriage might bring him a new male heir.[31] Perhaps, looking around the congregation, Shakespeare felt more affinity with Dr Edward Jorden and his wife Lucy, who still had no children. They had recently moved into the parish, probably as newlyweds. In May 1596 Lucy had given birth to twin girls, but they had been stillborn. The bleak and patriarchal record in the St Helen's parish register stated, 'Two women children of Doctor Jordens, still borne'.[32] A year later, in May 1597, Lucy had a boy, William, but he only survived a few days.

Living with Shakespeare

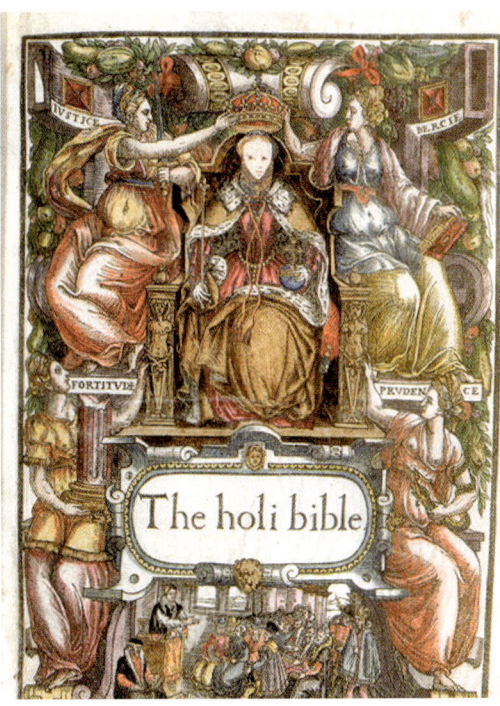

Figure I.7   Protestant religion: Title page of the officially authorised Bishops' Bible (1568). Elizabeth I is surrounded by female personifications of Justice, Mercy, Fortitude and Prudence (quarto version, 1569). The Bible, believed to be the absolute word of God, was fundamental to Protestant religion.

Dr Edward Jorden – then aged thirty-three, the same age as Shakespeare – was an ambitious medical doctor who had studied at the best universities in northern Italy that specialised in medicine and received his MD qualification from Padua University in 1591.[33] As we will uncover later, he had a particular interest in female physiology, trauma, hysteria and witchcraft. Indeed, in 1602, he was to be an important witness at one of the best-recorded London witch trials. Happily, Lucy did eventually give birth to a healthy son Edward, named after his father, and a daughter, Elizabeth. The latter married a future mayor of Bath, where Edward Jorden senior died in 1633, having played an important role in developing the local mineral springs as the English centre for medicinal spa treatments.[34]

Shakespeare's church has been our starting point because of the centrality of Protestant religion to his England. Central to that religion, the Bible provided the foundation for all theological debate (Figure I.7). Even Elizabethan specialists struggle to convey the all-encompassing influence of the Bible at this time to our modern secular society. Professor Hannibal Hamlin's recent study of the influence of the Bible summarises:

> Shakespeare's culture as a whole was profoundly and thoroughly biblical, a culture in which one could assume a degree of biblical knowledge that is difficult to imagine in today's mass-media global culture. One gropes for a modern analogy but there is none.

> Imagine a television programme that everyone in the country has been watching every week, sometimes more than once, for their entire lives, having seen some episodes dozens of times . . . Suppose that it was illegal not to watch this show and, moreover, that your eternal salvation was understood to depend on it.
>
> Suppose that this TV show was the basis for your country's literature and art, its political theory, its history, its philosophy, its understanding of the natural world . . . In sixteenth- and seventeenth-century England, the Bible was that show; *it was always in reruns, and it never went off the air.*[35] (emphasis added)

With divine service ended and the congregation dispersing or trading parish gossip, one wonders if Shakespeare slipped away quickly or waited to watch as the pews cleared. Shakespeare, for the more conservative or Puritan-inclined residents, would have been 'a player' [actor] and highly suspect both in terms of general morality and potential political disaffection. These parish elders included Sir John Spencer, the Lord Mayor of London in 1594/5, whose luxurious and sprawling mansion, Crosby Hall, dominated the southern half of the parish. However, to the more free-thinking and pleasure-minded parishioners, Shakespeare would have been a significant London celebrity whose new play *Romeo and Juliet* had been a major hit, 'hath been often (with great

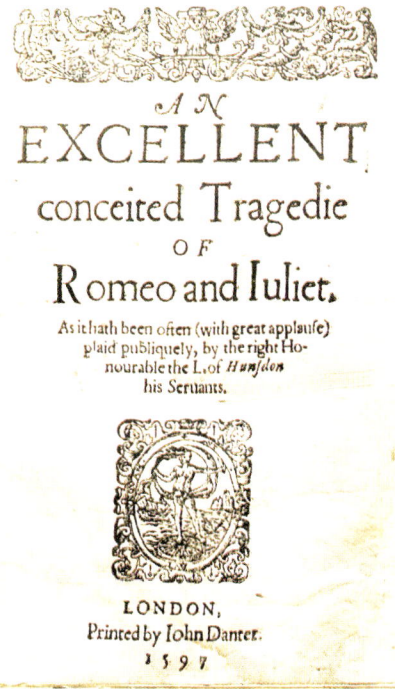

Figure I.8  Fame and success: The first edition of the 'Tragedie' of *Romeo and Juliet* was published as a 'quarto' in early 1597, 'as it hath often (with great applause) plaid publiquely'. This version was superseded by a longer second edition in 1599.

applause) plaid publiquely' and recently published in a cheap 'quarto' book version (Figure I.8).[36]

One thing is certain: among the strong London accents and regional dialects of recent immigrants, like Shakespeare's South Warwickshire speech, there would have been a significant number with distinctively exotic cross-Channel sounds and diction. Over the last thirty years, St Helen's and the neighbouring parishes had become home to a significant community of 'strangers'. These were mostly French-and Dutch-speaking Protestants who had fled the religious conflicts in northern France and the Spanish Netherlands,[37] today the area mostly comprising modern Belgium. Many were involved in textile production, including, for England, pioneering techniques of silk weaving. Their immigrant entrepreneurism often did not endear them to London natives, who accused them of unfair business practices and undercutting English workers.[38] Among Shakespeare's neighbours were de Beaulieus, Vegelmans and Van der Stilts, with a scattering of Italians, who would have known the latest news from Arras, Bruges, Brussels, Antwerp, Amsterdam and Venice. Alone in London, one wonders if these female 'strangers' appealed to Shakespeare's taste in women. Certainly, within a few years Shakespeare – in so many ways a product of the bosky West Midlands landscape – was lodging with the Mountjoys, an artistic but fractious French Protestant family.[39]

This book also aims to link two other factors of the time. Thinking of languages connects to you, unknown reader, since you are either a native English user or confident in English as a second language. In either case, you are heir to a remarkable linguistic success story. In 1576, probably fewer than four million people spoke English, and a far smaller number would have been able to read or write it. Almost all lived in the British Isles, with a tiny scattering abroad in ports such as Calais, cities of diplomacy like Madrid or religious centres, particularly Rome. A hundred years later, in 1676, the numbers had increased significantly, but there was another crucial difference. There was a thin streak of English speakers all along the eastern coast of America stretching down past Bermuda, then the Somers Islands, into the Caribbean. Across the East Indies, little pockets of English speakers were spreading from port to port, establishing trading bases including Bombay in 1668 and Calcutta in 1690. English maritime expansion had turned to colonisation and the British Empire was underway.

Today, English is probably the most spoken language in the world along with Mandarin and Spanish, and it is estimated that there are between 470 million and one billion speakers. Thousands start to learn every day. The popularity of English is, of course, an outcome of America's evolution into a world economic superpower, and of the extent of the British Empire. However, Shakespeare and his contemporaries played a crucial role in kick-starting this expansion. So, try rolling 'trippingly on the tongue' around in your mouth. Taste it, speak it, reshape it, and sense your direct connection to the writer who penned:

## Introduction

**Hamlet**
Speak the speech, I pray you, as I pronounced it to you –
trippingly on the tongue; but if you mouth it, as many of your
players do, I had as lief the town-crier had spoke my lines.
(*Hamlet*, III.ii.1–4)

On 5 August 1583, Sir Humpfrey Gilbert, MP (1539–83), half-brother of Sir Walter Raleigh, arrived off the coast of North America. There he claimed 'New Found Land' as the first overseas territory of England,[40] as a foothold towards his grand ambition of occupying nine million acres of what is now modern-day Canada. He cut a turf to symbolise English possession and thus started the chain of overseas interventions that became the British Empire.[41] Gilbert was a complex character, 'of complexion cholerike',[42] and his erratic personality and career matched his Latin motto, *Quid Non* – 'Why Not?' Five weeks later, he was drowned when his ship, the *Squirrel*, sank with all hands off the Azores. Despite the fact that Gilbert probably never knew of Shakespeare, there is an interesting connection. Gilbert lived in St Helen's for at least two years, 1572–3, in a house only a few yards from where Shakespeare was living in the 1590s – and, as we will discover, his activities there were to have a major impact on how the parish of St Helen's evolved.

Finally, this book aims to explore a little about why and how documents and other records of the period were created, and survived to be explored by modern historians. This facet of Elizabethan culture is complex, not least because documents of the period are difficult to read today. However, the explosion in the amount of written material produced at this time, much of it a by-product of the Elizabethans' frequent recourse to litigation, is fascinating. I have aimed to make the content as accessible as possible while still maintaining accuracy in a subject area where so much is speculation. Any failures in this respect are mine alone. However, for maximum clarity with this material, your critical and common-sense skills are crucial. It is often assumed by general readers that historical studies of this period and the resulting publications are 100 per cent fact, as if one can just jump back in time and carve out a text. But investigating history, especially Elizabethan history in the period 1560–1600, is just not like that. Instead, imagine you have been called for jury service in a murder trial at the Central Criminal Court at the Old Bailey. What are the true facts? For Shakespeare's period, much of the surviving evidence is unclear, conflicting or inconclusive. As in any criminal trial, you need to consider:

- motive
- opportunity
- likelihood – balance of probability
- character – status, social position
- timing

- overall milieu and nature of friends
- needs – especially money
- track record in the past
- most important – the 'witnesses' (who, how old, background, experience) and their motivation

As with all evidence, you should sift it, weigh it up and ask how it is biased. Also, you need to consider not only what is claimed to be known, but what has been destroyed, or is unknown or unrecorded. Elizabethan England was a patriarchal society where 50 per cent of the population did not get much of a look in at all, at least as far as official records were concerned, once they were married.[43]

The study of English literature, linguistics and history is not unchanging. Once it was considered sufficient just to read Shakespeare to appreciate his work. For many, that is still the much-preferred course to understanding. Others now argue that it is essential to study Shakespeare in the context of his time. Recently, Robert Bearman has written *Shakespeare's Money*,[44] looking at the trajectory of his career in terms of Shakespeare's 'earning power'. This highlights the fact that Elizabethan England was a society with no social security net, where there was the continual threat of imprisonment for debt and hence powerful economic drivers to succeed. None of this makes Shakespeare any less fascinating – quite the contrary – he continues to engage the thoughts of a wider and wider constituency across the globe. However, as in all things, you are the ultimate judge of your own view.

Above all, hopefully, this book helps to open up Shakespeare and his world to people who only have a passing knowledge of his life. At the same time, it may enhance the understanding of the many who already have a deep engagement with a man who died in 1616, aged fifty-two, in Stratford-upon-Avon, but who still speaks to the contemporary world every day.

To avoid interrupting the flow of the main text, the detailed documentary evidence relating to Shakespeare's time in St Helen's and some of his key neighbours is drawn together in the Appendix. This aims to provide rigorous documentation, without giving so much detail that it becomes burdensome. It should allow anyone who wants to interrogate the core research material to do so. It is not practical to publish a detailed analysis of the St Helen's families based on the parish registers of baptisms, marriages and burials surviving from 1575 onwards, and only specific details have been given from the Leathersellers' Company rent and lease records. However, I am happy to answer any detailed questions on these or other records.

Historians are trained to 'stick to the facts' and to avoid speculation. Given the often erratic development of Shakespearean studies over the years into complex conjectures (or worse), this is a wise policy to follow. However, in a number of places, I have deliberately used the present tense or, as one might put it in theatre parlance, 'broken

the fourth wall'. There are also a few sections, based on reasonably probable reconstructions, with some associated speculative thoughts. The reason for this approach is that this book is about the relationship between one individual and the micro-topography of a small area of the City of London around the parish of St Helen's, which many readers will never have the opportunity to visit. Although the church survives, most of the surrounding area has been completely rebuilt, although among the office blocks one can still define the streets and buildings Shakespeare would have known.

It is self-evident that Shakespeare undertook his normal daily activities within this *terroir* – sleeping, waking, getting dressed, eating, walking to work, sitting in church, writing. It would be tedious to enumerate all the hours that these took, but they are also fundamental to his life. Reconstruction allows the distillation of these activities into real physical locations to put some probable flesh on the bare bones of events largely based on fragmentary official records. They are also a reminder that the names of his neighbours preserved in archives and memorials are not ciphers but real people, who once loved, laughed, argued and cried just like you. Or, as T. S. Eliot wrote:

> Phlebas the Phoenician, a fortnight dead,
> Forgot the cry of the gulls, and the deep sea swell
> And the profit and the loss . . .
> . . . Gentile or Jew
> O you who turn the wheel and look to
> windward,
> Consider Phlebas, who was once handsome and
> tall as you.
> (*The Waste Land*, IV. Death by Water)

In the course of the five years from 1593 to 1598, which form the core focus of this book, Shakespeare's own situation altered significantly. The reconstructions aim to mark some of the changes in his personal circumstances. The associated speculations are intended as a tool to encourage further thinking about how materials can be researched in new ways.

As the great French philosopher Michel de Montaigne wrote, in a translation by John Florio which Shakespeare probably read:

> truth is of so great consequence that we ought not to disdain any induction that may bring us into it. *Reason hath so many shapes* that we know not which to take hold of. Experience hath as many. The consequence we seek to draw from the conference of events is unsure because they are ever dissemblable. No quality is so universal in this surface of things as variety and diversity.
> –John Florio's translation of Montaigne's Essay No. 71, '*Of Experience*' (1603)

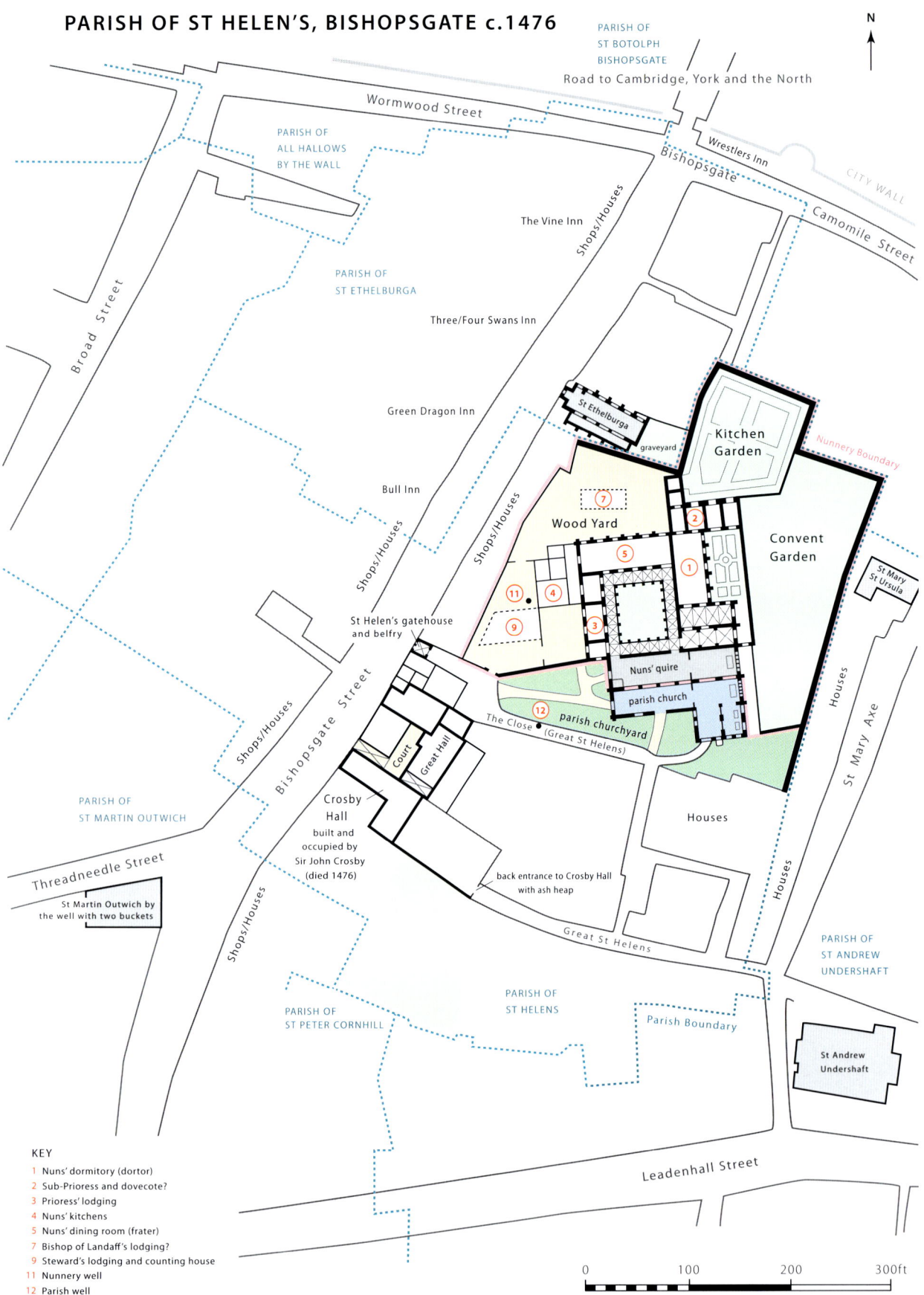

Figure I.9 Parish of St Helen's, c. 1466: The medieval nunnery, the church, Bishopsgate Street and the newly built Crosby Hall dominated the area. Much of the south-eastern part of the parish was probably undeveloped at this time.

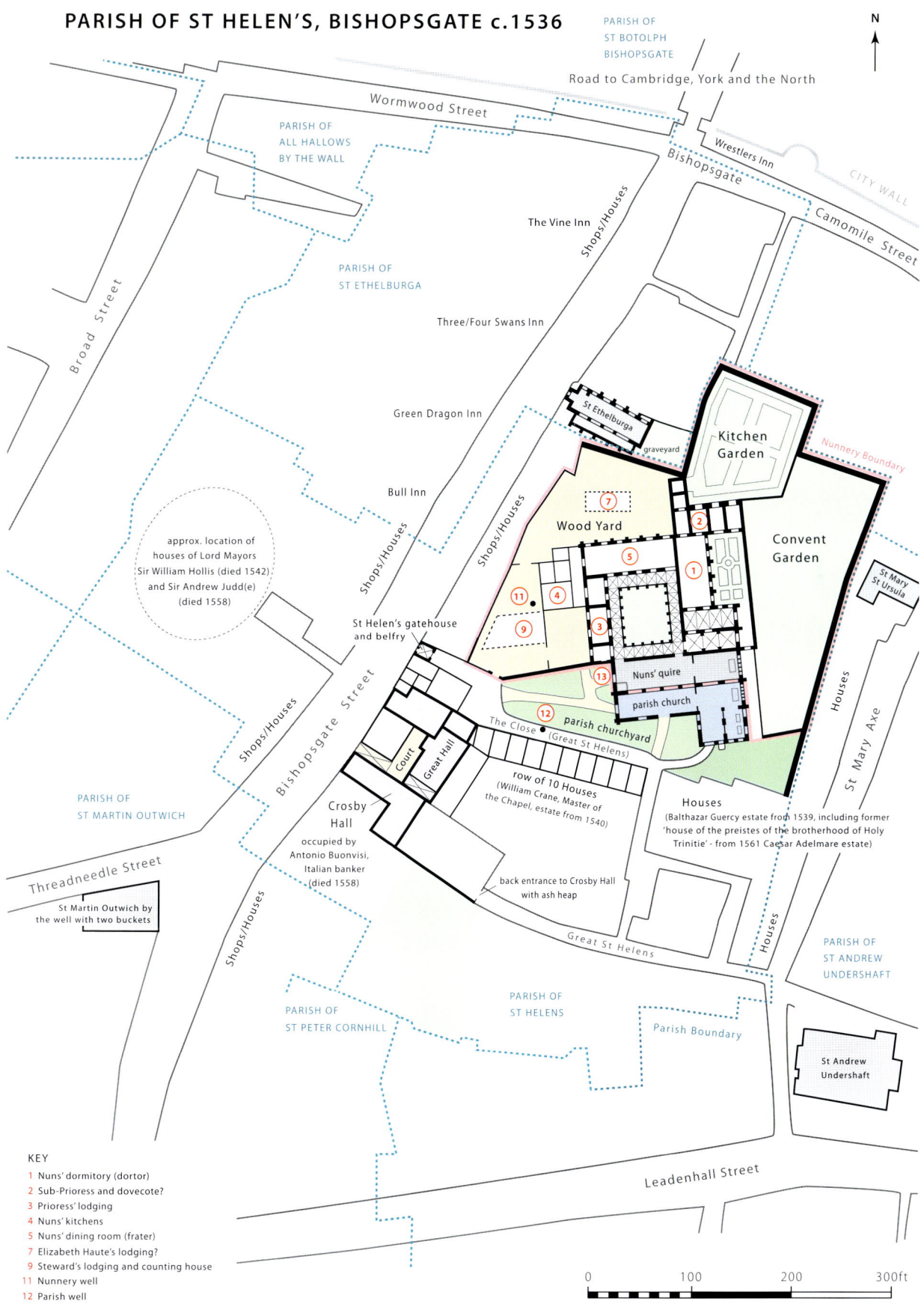

Figure I.10   Parish of St Helen's, *c.* 1536: On the eve of the nunnery's dissolution in 1538, a row of new houses created an upmarket residential enclave in Great St Helen's. Other new properties included a large house, worth £54, owned by the herald Thomas Benolt (d. 1534) and later by Guy Crafford (d. 1553).

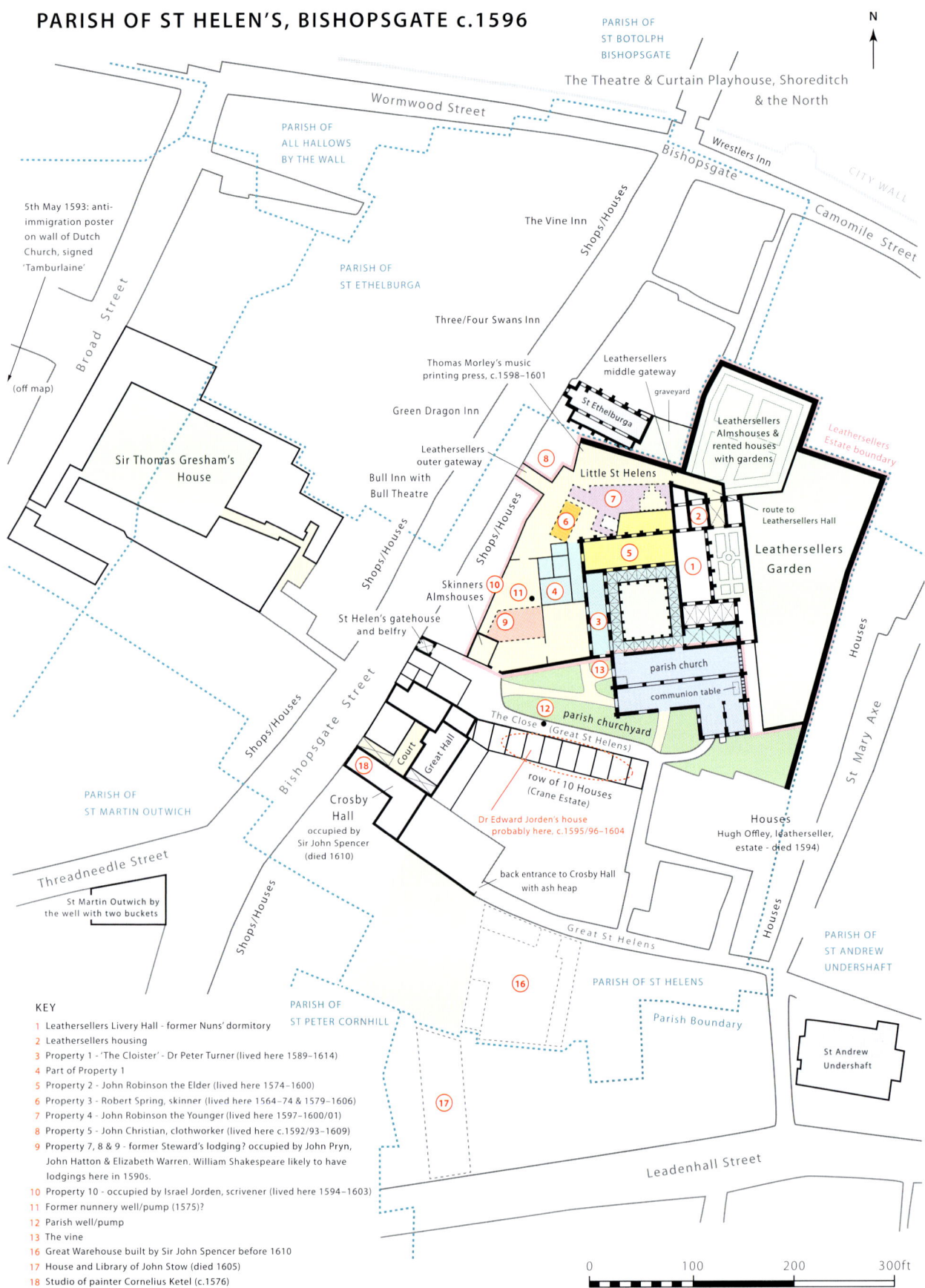

Figure I.11   Parish of St Helen's, *c.* 1596: In Shakespeare's time, the gated Little St Helen's, owned by the Leathersellers' Company, gave access to their grand Livery Hall, its attractive garden, their almshouses and a range of leased houses converted from former nunnery buildings.

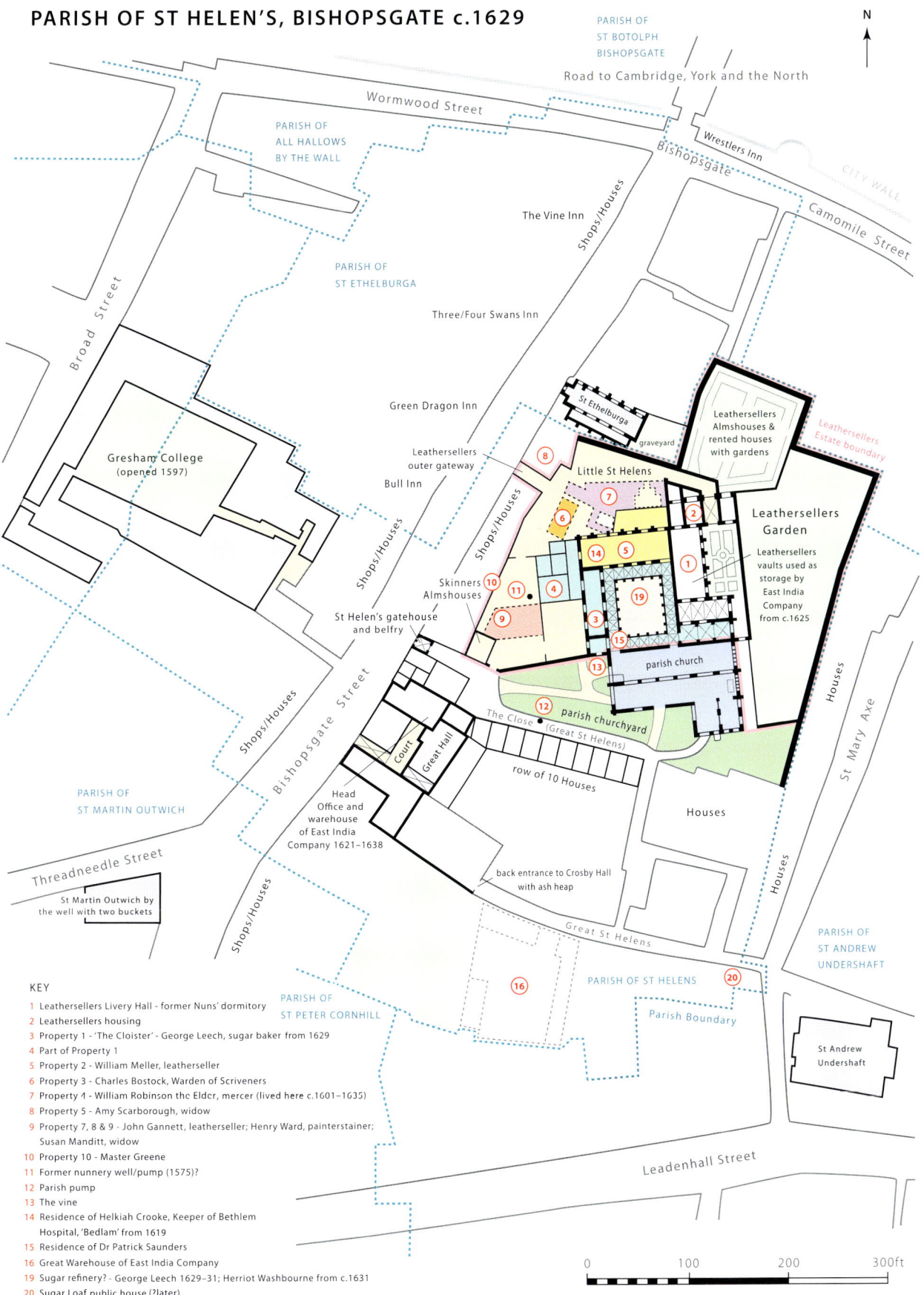

Figure I.12  Parish of St Helen's *c.* 1629: Dr Peter Turner's cloister garden, probably used for growing medicinal plants, was converted to a sugar refining works as the area shifted towards a London of proto-capitalism. Dr Patrick Saunders, inheritor of part of Dr John Dee's extraordinary library, lived in the southern part of the west wing.

The purpose of this book is to use the 'variety and diversity' of the lives of the residents of St Helen's, Bishopsgate, over a short period, to illuminate the life and work of our greatest playwright. There will be many views about whether these people can be connected directly to Shakespeare's doorstep or not, and about whether he participated in this *terroir* of lived experiences. The suggestions and uncertainties involved in sketching out this small world of St Helen's are, therefore, an indication of what both this book and Montaigne relish: the richness of Early Modern life. As multi-disciplinary approaches to Shakespeare increase, it is important to attract new types of specialists to the debate who otherwise might pass by with their potentially useful new insights and understandings. This effort at micro-history draws on the work of many different specialists, from architectural historians to specialists on plague morphology and experts on Elizabethan taxation. However, drawing these threads together has made me aware of how much remains to be examined.

This book is organised with Chapters 1 through 7 providing a background to the period starting from the creation of the Theatre in 1576, where Shakespeare worked from 1594. Readers who want to explore Shakespeare's life in St Helen's may wish to go straight to Chapter 8 and following, which explore the physical layout of the parish and some of the people who lived there. Figures I.9 through I.12 illustrate the physical development of St Helen's from 1476 until 1629. Chapters 18 to 20 look into how, in 1602, two of Shakespeare's neighbours were involved on opposite sides of one of the most dramatic witchcraft trials of the day. This raises interesting questions about how much Shakespeare was driven by the existing literary/theatrical establishment that he joined, and how much by more general contemporary events and personalities.

However, before exploring Shakespeare's links to the Theatre and the parish of St Helen's in the 1590s, we will step back fifteen years to the England and continental Europe of 1576. By examining the social, political and economic background to the creation of the Theatre, it is easier to understand the England that Shakespeare grew up in and the London to which he eventually migrated.

The year 1576 was not just a turning point in theatre, but a decisive point in England's engagement with the rest of the world. It is fortunate that, in the 1570s, a cleric named William Harrison (1534–93) was writing his *Description of England*, first published as part of *Holinshed's Chronicles* (1st edition 1577; 2nd edition 1587). This provides a remarkable overview of English life at this time and is well worth reading in full.[45]

At the time of writing, 1576 is nearly 450 years ago – or around twenty generations back for most families. How many generations can you trace your ancestors back – five generations? Ten generations? More? Queen Elizabeth II can trace her family back to at least Alfred the Great, born in Wantage in AD 849: roughly thirty-five generations ago. However, it is in the England of 1576, with the forty-three-year-old Elizabeth I having already reigned for eighteen years, that this account begins (Figure I.13).

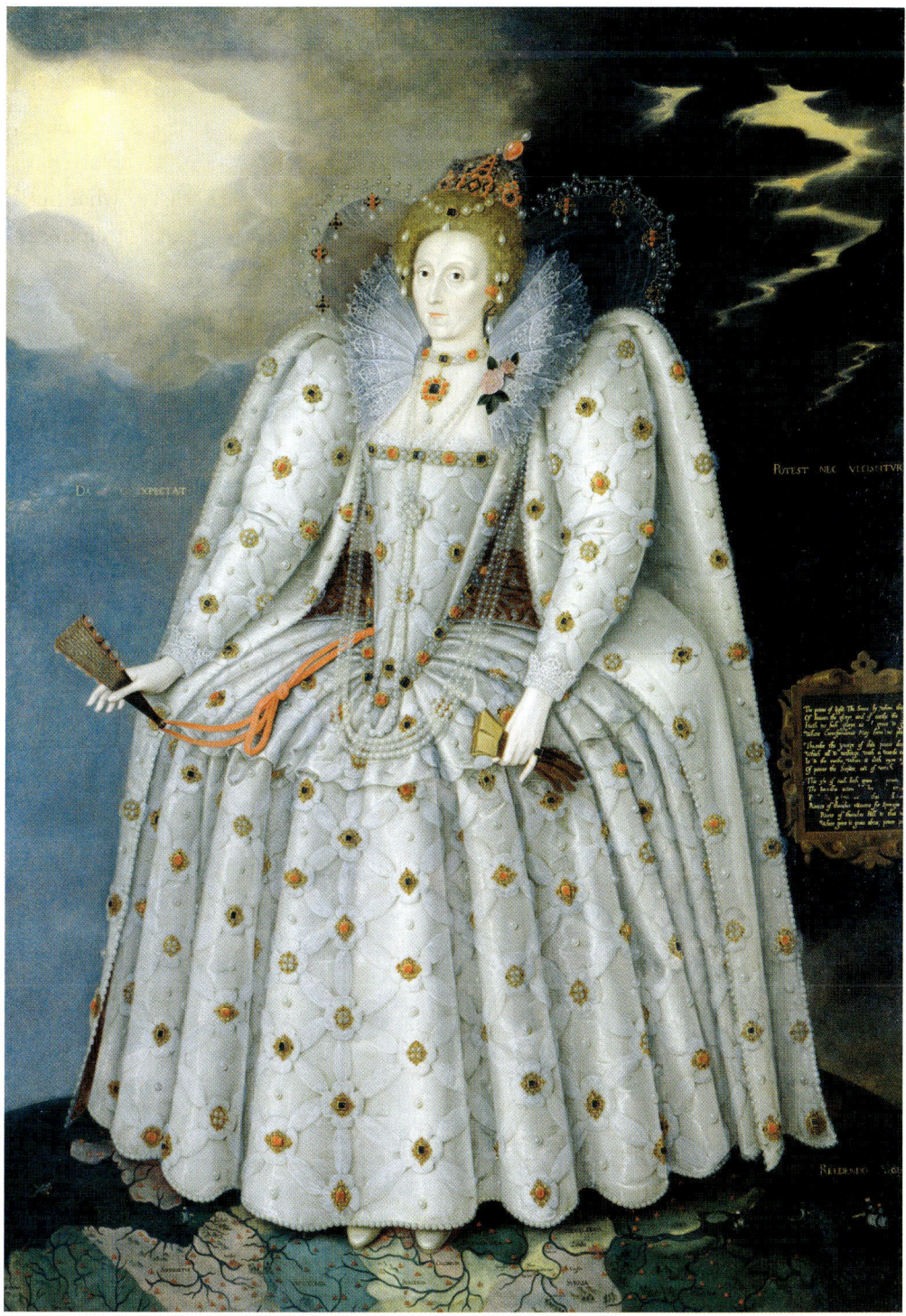

Figure I.13 Royal authority: The 'Ditchley Portrait' by Marcus Gheeraerts the Younger, c. 1592. An ageing Elizabeth I stands on a map of England located on top of the globe. The scenes of storm and sunshine behind her symbolise the Queen's power to shape the lives of her subjects.

Living with Shakespeare

## Notes

1. All the names, dates and relationships of individuals mentioned here and later in the book are based on real people recorded in specific documentation, particularly the parish registers of births, marriages and deaths for St Helen's surviving from 1575 – see Bannerman (1904), available online – but also related information in court cases, leases and wills. Details about buildings and their interiors are based on the known street layout of the parish in the 1590s. Generic information about buildings in the City is backed up by specific details from St Helen's included in the leases of the Company of Leathersellers' properties and other sources.

2. In October 1593, even Sir William Roe, the Lord Mayor of London, succumbed to the plague, three days before his year in office ended. 'In London is great desolation, the greatest part of the people fled or dead, and the Mayor is dead of the plague also' – see Colthorpe, 'The Elizabethan Court Day by Day', *Folgerpedia* (hereafter *FECDD*), 25 October 1593. This fascinating resource was compiled by Colthorpe over many years. It is now online and provides an easily accessible and searchable 'diary' of Elizabeth I's world. The following pages draw on her research. Baldwin Eightshilling was an immigrant (a 'stranger') from the Low Countries, and the fact that a Dutch minister died in his house suggests that he was Dutch-speaking. The 'Eightshilling' was probably an anglicisation or nickname given to him in England. Neither his family nor the Ruttings are recorded in St Helen's in the May 1593 'Return of Strangers', so they might have moved into the parish quite recently, perhaps taking over the houses of people who had already died of plague or left London.

3. Five years later, 'Baldwyne Eight Skyllinges' was recorded in the 1598 Lay Subsidy roll for Tower Ward (the three parishes of All Hallows Barking, St Dunstan in the East and St Olave's next to the Tower of London), assessed at ten shillings paying 2s-8d, and he also appears as 'Baldwine Eightshillinges' with a new wife in the 1599 Lay Subsidy roll together paying a 16d poll, alongside over a hundred other strangers, including Peter Flemminge and his wife, 'Lewse, a Negro', a 'blackemore' servant, and Maria, Mary and Clare, three black women ('Negra'). See Kirk and Kirk, *Returns of Aliens Dwelling in the City and Suburbs of London*, pp. 28 and 54.

4. The demand for *Venus and Adonis* meant the first reprint was done in summer 1594, and it went through five reprints before 1600 and fifteen before 1640. However, the financial benefit would have accrued to the printer/publisher. The only universities in England were Oxford and Cambridge. Young men looking for further education in London would often study at one of the four Inns of Court (Inner Temple, Middle Temple, Lincoln's Inn and Gray's Inn) in the distinct legal district around Temple/Chancery Lane, where they are still located. They were primarily for legal training but also provided a congenial atmosphere mixing study, dining, entertainment and networking with other men of similar age and social standing. Their great halls were used on occasion for theatre performances, notably Shakespeare's *Twelfth Night or What You Will* on 2 February 1602 (Candlemas night).

5. Kyd, writer of the popular play *The Spanish Tragedy*, died the following year in 1594 aged only thirty-five. He was arrested in May 1593 following the government's panic over the anti-immigrant 'Dutch Church libels' – 'divers lewd and malicious libells', according to a letter from the Privy Council to the Lord Mayor, 11 May 1593 (see Lloyd Edward Kermode, *Aliens and Englishness in Elizabethan Drama*, Cambridge University Press, 2009, p. 79) – attached to the churchyard wall of the Dutch church in Broad Street, only a few minutes' walk from St Helen's. The Privy Council gave the Lord Mayor authority to put suspects 'to the torture in Bridewel, and by th'extremitie thereof, to be used at such times and as often as you shal thinck fit, draw them to discover their knowledge concerning the said libels' (ibid.) Kyd was tortured to confess and implicated Marlowe. When Kyd was released from prison, he lost his job with the nobleman who had previously employed him for six years.

6. For readers unfamiliar with England, the whole country is divided into parishes, each based originally around a Roman Catholic, now Church of England, church. Most parishes date back to the Saxon period and the original conversion of the country in the sixth to eighth centuries AD. Today, there are 12,600 parishes in forty-four dioceses.

7. This is in fact a paraphrase of *The Republic*, Book IV: 'This is the point to which, above all, the attention of our rulers should be directed, – that music and gymnastics be preserved in their original form, and no innovation made. They must do their utmost to maintain them intact. And when any one says that mankind most regard, "The newest song which the singers have," they will be afraid that he may be praising, not new songs, but a new kind of song; and this ought not to be praised, or conceived to be the meaning of the poet; *for any musical innovation is full of danger to the whole State, and ought to be prohibited*. So Damon tells me, and I can quite believe him; he says that when modes of music change, of the State always change with them' (emphasis added).
8. The medieval walled city is now just 'the City' or 'the Square Mile' – the financial district of London.
9. In 1599, Southwark was a suburb of the City on the south bank of the River Thames. It was connected to the City proper on the north bank by Old London Bridge and hundreds of water taxis, known as wherries (see Figure 18.5).
10. Also, it is one of the most copied. There are currently over fifteen Globe theatres around the world, with more on the way. They are of varying degrees of physical accuracy and authentic materials, reflecting the periods of their creation.
11. For an excellent overview of this change, see Shapiro, *1599: A Year in the Life of William Shakespeare*.
12. People could and did attend other parish churches. Officially sanctioned sermons were also preached every Sunday at the open-air pulpit at St Paul's Cross in the north-east corner of the Cathedral churchyard. These were timed to begin after parish services were finished so that people could attend both. However, continued absence at one's parish church would be considered abnormal and eventually would be investigated.
13. The same morning after prayers, at Whitehall Palace, Queen Elizabeth created Charles Howard (1536–1624), hero of the defeat of the first Spanish Armada in 1588, Earl of Nottingham; see *FECDD* for 1597. The following day, Monday 24 October, was the state opening of parliament. On 26 October, news arrived from Plymouth that the third Spanish Armada was approaching England. In 1596, the second Spanish Armada had been dispersed by storms.
14. The Hubbards had lived in the parish for at least fifteen years, as Robert was listed in the 1582 Lay Subsidy roll at a valuation of £8. However, his wealth seems to have steadily declined over the years as, by 1598, he was below the £3 assessment level, meaning one did not contribute to the Subsidy.
15. In her will of 25 August 1608, Cecily Cioll, cousin of Sir Thomas Gresham, gives 'unto Robert Spring sonne of my cosen Rob(er)t Springe twentie poundes', suggesting he was a member of the extended Gresham family; see TNA PROB 11/115/130. In 1579, Spring took over the lease of a Leathersellers' property from John Gresham, probably Cecily's older brother, who was buried in St Helen's in December 1578.
16. This included, in 1598/1602, three houses with gardens about five hundred yards north on Bishopsgate Street, outside the city wall, located next to the charmingly named Katherine Wheel Inn. Sir Paul Pindar, a rich trader with the Ottoman Empire, was just about to build his magnificent mansion on the other side of the road. Perhaps Robert Spring planned his purchase as a shrewd investment with an income from renting the houses; or maybe he just wanted a different environment.
17. It is interesting to compare the various signatures of these auditors, which range from the 'marks' used by those unable to write, through shaky scrawls to the signatures of merchants, like Robert Spring, with clear and confident handwriting.
18. He was valued at £20 in the 1598 Lay Subsidy roll. Grocers were often wealthy, since they controlled the selling of expensive pepper and spices.
19. In 1598, they were ranked the ninth wealthiest household out of *c.* 110 families in the parish of St Helen's.
20. The closeness of one's box pew to the minister's pulpit was the source of much social one-upmanship.
21. She was the daughter of William Hagar, a wealthy salter who occupied the last house north on the west side of Bishopsgate Street in St Helen's, next to the entrance to the Bull Inn. William died in July 1580 and perhaps Mary had been helping her mother care for him but now took the opportunity to leave home, if only to move fifty yards away. A court case of 1576/7 shows that William dealt in malt

Living with Shakespeare

in bulk (see TNA C24/126A). He had a beam scale of sufficient size that on one occasion it was used to weigh a bell from the church of St Botolph, Aldgate before it was recast at the local Whitechapel foundry. He had a prestigious burial location under his own gravestone (now lost), close to Sir William Pickering's tomb. His widow continued to live in the house through the 1580s and 1590s, paying her Lay Subsidy tax, until she died at the height of the 1603 plague – one of fifteen burials during just four days in September.

22. They did not marry in St Helen's, perhaps for reasons of discretion. The location of their marriage in 1586/7 is not yet identified, but it may have been Timothy's home parish. Remarriage usually waited until probate was completed, which could take time; see Carlton, '"The Widow's Tale"', p. 120, which notes the proverb, 'A widow's sorrow for her husband is like a pain in the elbow – sharp and short'. Thomas Saunders owned at least two sizeable houses in St Helen's at the south end of Bishopsgate Street, which in his will of 1583 he left to Mary, but with a proviso for his future potential child, as she was pregnant at the time. In the 1582 Lay Subsidy he was assessed at £10. In the 1589 tithe survey, the payments on the Saunders–Bathurst house suggest a size equivalent to a rental value of at least £4 a year. The second property may have been the house immediately to the south, then rented to a mercer, James Elwicke, who was probably paying a rent of at least £6 a year.

23. There were major outbreaks of plague in 1563, 1578, 1592–4, 1603, 1625 and most seriously in 1665. The plague was not always fatal, and many Londoners must have built up some level of resistance. The medical practitioner Simon Forman provides a fascinating account of his own recovery in 1592, over five months: 'it was twenty-two weeks before I was well again'. In 1593, Forman stayed in London when other physicians fled the City. He subsequently wrote a fascinating pamphlet, 'A Discourse of the Plague written by Simon Forman, practising physician and astrologer 1593 and Notes for other Men to read and himself to Remember'; see Cook, *Dr Simon Forman*, pp. 57–62.

24. Richer parishioners would pay to be buried in a wooden coffin inside the church, where there was a hope that one's bones would lie undisturbed, often alongside other members of your family, until the Day of Judgement. This also offered the chance of a grave slab or other memorial. The poor were buried in the churchyard, where there was no fee for a grave but also, at this time, no gravestones. The result was that the positions of such graves would soon be forgotten. Sometimes, the burial register recorded locations in relationship to the parish well, pump or other features, such as the churchyard ash trees.

25. See Leveson Gower, *A Register of all the Christninges Burialles & Weddinges*.

26. The sixth of ten verses charting the seven, or perhaps eight, ages of men and women. William Averell (1556–1605) lived in the parish most of his life and wrote a variety of poetry and prose. The best-known today is *A Mervalious Combat of Contrarieties* (1588), published during the 1588 Armada scare, which was used by Shakespeare as the basis for the story of the battle of the parts of the body in *Coriolanus*. It was reprinted in 1590 as part of *Four Notable Histories* (1590), which was dedicated to Alderman Hugh Offley (c. 1528–94), an important leatherseller who owned property in St Helen's and the head leases of houses on the Leathersellers' estate. Shakespeare would have walked through Averell's parish every time he went to the Rose playhouse in Southwark or the Bell and the Cross Keys, the two City inns in Gracechurch Street used for theatre, a few minutes' walk from St Helen's. Averell lived in Corbet Court, between the Bell Inn and St Peter's church, with his large family. His wife Gillian died in February 1596 giving birth to their seventeenth child but he remarried within a year, and his eighteenth child arrived in November 1597.

27. For a discussion of remarriage at this time, see Todd, 'The remarrying widow', where she notes research suggesting that 'in the mid-sixteenth century 30 per cent of brides and grooms had already been married at least once before'. This would have made households of children from different parents relatively common.

28. Mary junior married Charles Bostock(e), a scrivener, in St Helen's in 1600, aged just sixteen – this was young for a woman from a well-off family, but Timothy was probably keen to reduce his household, particularly since Mary was a stepdaughter. A wife's property automatically became her husband's, unless there was some prior agreement to protect her interests. Timothy used Mary's marriage as the basis for arguing that her mother had brought the houses to him. This prompted a

major legal dispute, and Timothy later took Mary and his son-in-law to court in 1609; see TNA C 8 /10/11. Charles and Mary started their reply to Timothy Bathurst's Bill of Complaint by stating that it was 'devised framed and sett fourth of purpose only to putt theis defendants to wrongfull vexation coste and expenses in the Lawe without any juste cause or good ground of suite'. Then, as now, conflicts over inheritance provided good business for lawyers.

29. During the winter, performances must have been disrupted by poor weather, but records from the Rose show performances in the days running up to Christmas, e.g. Marlowe's *Dr Faustus* on 20 December 1594, and that they were often well attended.
30. Parish rules on burial inside St Helen's church required a wooden coffin. Only the super-rich could afford lead coffins. Hugh Kendrick, a gentleman and musician, followed his two brothers under the church floor on 31 December 1597.
31. Both daughters married but only Susanna had a child, a daughter called Elizabeth born in February 1608. Although Elizabeth married twice, she had no children of her own, so Shakespeare's direct line of succession died out with her death in 1670, aged sixty-one.
32. It was quite common, in the patriarchal society of the time, for only the father to be recorded – for both baptisms and burials.
33. Padua was then part of the land-based empire of Venice, an independent city state. It housed the Serenissima's university. Founded in 1222, Padua was the second oldest university in Italy and the fifth in the world. It was renowned for its medical teaching and still houses the world's oldest surviving anatomy theatre, built in 1595.
34. Edward Jorden's brother-in-law was, confusingly, an Edward Jordan, gentleman of Bath. He seems to have been unmarried, as in his will of May 1620 (TNA PROB 11/135/530) he left most of his possessions to his two nephews. He and Lucy were the children of Sir William Jordan, MP, of Chitterne St Mary in west Wiltshire, twenty-six miles from Bath.
35. See Hamlin, *The Bible in Shakespeare*, p. 1.
36. Rather like a paperback in size, format and quality. With no copyright law, most plays remained unpublished as, in manuscript, they remained valuable assets.
37. The main concentration in the Ward of Bishopsgate was in the parish of St Botolph, just outside Bishopsgate and the city wall, packed into crowded tenements with evocative names such as Three Squirrels Alley, Swan Yard, Half Moon Alley, Soaphouse Alley, Petty France, Houndsditch, Walnut Tree Alley and Net Makers Alley – all with poor, 'pestered' housing conditions.
38. The 'Dutch libel' included: 'Your Machiavellian Marchant spoyles the state, Your usery doth leave vs all for deade Your Artifex, & craftesman works our fate, And like the Jewes, you eate vs up as bread', followed by threats to 'cutt your throtes, in your temple praying, Not Paris massacre so much blood did spill'; see Bodleian Library MS. Don. D.152 f.4v, published in Freeman, 'Marlowe, Kyd, and the Dutch Church Libel'.
39. See Nicholl, *The Lodger*, which uses a surviving 1612 deposition by Shakespeare about a marriage and dowry in 1604 to explore his domestic arrangements, landlord, neighbours and life in Silver Street, St Olave's parish, in the following years.
40. Excluding the Norman/English occupation of Ireland.
41. The island was not a 'new found' land, since in the sixteenth century it was already a major base for many fishing fleets from western European countries taking the (then) abundant cod. In return, the locals presented Gilbert with a dog, which he named Stella.
42. According to John Hooker of Exeter (*c.* 1527–1601) the main source of information on Gilbert's early life, as quoted in Rory Rapple, 'Gilbert, Sir Humphrey', *Oxford Dictionary of National Biography*, <https://www.oxforddnb.com/view/10.1093/ref:odnb/9780198614128.001.0001/odnb-9780198614128-e-10690> (last accessed 20 July 2020).
43. As demonstrated clearly in Greer, *Shakespeare's Wife*, which reconstructs Anne Hathaway's side of the Shakespeare story.
44. See Bearman, *Shakespeare's Money*.
45. See Harrison, *England in Shakespeare's Day*.

# PART I

1576, London, the Theatre and Hunting for China

Figure 1.1 William Shakespeare's comfortable childhood home in Henley Street, Stratford-upon-Avon, photographed in 1863. His father John was of considerable local importance, becoming town bailiff (mayor). However, after 1576, when William was aged twelve, he became enmeshed in financial troubles.

Figure 1.2 Holy Trinity Church, Stratford-upon-Avon: the Shakespeare family's parish church, where, Sunday after Sunday, William would have imbued the doctrine of the Protestant Church of England as well as a deep grounding in the Bible.

# 1

## 1576: A Starting Point

*In which we take a swift bird's-eye journey over north-west Europe in 1576, passing across Antwerp, swooping over the North Sea to Canterbury, London and Hampton Court Palace while circling a young William Shakespeare in Stratford-upon-Avon. Christians are slaughtering Christians . . .*

It is ten o'clock in the morning on Sunday, 4 November 1576. William Shakespeare is twelve and a half years old, approaching puberty, and probably walking back to his home in Henley Street from Holy Trinity Church, Stratford-upon-Avon (Figure 1.1). There, Sunday after Sunday, he would have sat with his parents and siblings on a hard, high-backed oak pew somewhere towards the front of the church, close to the pulpit. Did he enjoy repeating the familiar words of the psalms, watching the gestures of the minister or listening to the readings from the Bible, those epic events from far distant lands, hundreds of years before? The word of God made manifest (Figure 1.2). During the week, almost certainly, he would have been sitting in the chilly classroom of the town's grammar school. Probably already marked as a talented boy among his classmates, his thorough but traditional classical education would have prepared him for trying to obtain a place at either Oxford or Cambridge Universities, then England's only two institutions of higher education.[1] For further education, the only alternative was the Inns of Court in London, which focused on providing legal training.

However, while Stratford-upon-Avon was a thriving market town serving the local needs of south-west Warwickshire, it was just one of dozens of similar communities across England. Its population has been estimated at around 1,500: a place where most people knew one another. Life was dominated by the cycle of the agricultural year. London was 100 miles or four to five days' journey away, and Edinburgh, the capital of an independent Scotland, was 325 miles distant. The great cities of continental Europe were much further away: Paris 400 miles, Venice and Vienna over 1,000 miles and Madrid even further – not to mention the need for a potentially dangerous cross-Channel passage by sailing boat. The risk was not just from storms: 'pirates' slipping out of Dunkirk were a constant threat.

Antwerp, northern Europe's richest city and leading trading hub, was 350 miles away. It was also, in 1576, the centre stage of a bitter power struggle as the majority free-thinking and Protestant Dutch population attempted to break away from the control of

Figure 1.3  The long conflict between the Dutch and their Spanish Catholic overlords led to thousands of Protestant refugees fleeing across the North Sea to England, particularly London. Over time, many returned home, but others settled permanently.

their Spanish Catholic masters.[2] The sixteenth century in north-western Europe was dominated by Christians fighting against Christians over whether the Pope in Rome or the freely accessible Bible should provide the basis of belief. At stake was nothing less than the eternal destiny of one's soul, family, community and country. The intensity of belief, on both sides, resulted in a continuous struggle with regular outbreaks of sectarian savagery.

In the Low Countries, warfare had fluctuated back and forth across the flat, watery landscape for a decade as control of towns changed back and forth (Figure 1.3). Waves of refugees had fled the fighting, many seeking refuge in England, particularly in the capital. Just one example from London must suffice of this flow of suffering. Margaret Fontaine's name suggests she came from the southern, French-speaking part of the Spanish Netherlands. She was probably born *c.* 1535/40, when this area was part of the Duchy of Burgundy, where the Protestant Reformation was making deep inroads into traditional Catholic belief. As a result, there was a fair degree of religious toleration until 1555. Then political control shifted to Spain, ruled by Philip II.[3] Catholic repression of Protestantism steadily increased.

Finally, rebellion against the Spanish broke out in 1566 and savage reprisals followed. In 1567 or 1568, Margaret fled to England with at least five children and two servants.[4] There is no mention of her husband; perhaps he had been killed or executed by the Spanish. She is first recorded in London in 1571 living in the parish of St Alban, Wood Street, five minutes north of St Paul's Cathedral and close to the major 'stranger' (foreigner) community around St Martin-le-Grand.[5] Interestingly, this area was only yards from where Shakespeare would be lodging with an immigrant French family in 1602/4.[6] Surrounded by other refugees, it was an obvious place for her to find security and safety for her children. However, by 1576 Margaret, now definitely a widow, was living in the section of Great St Helen's termed 'the Close',[7] next to St Helen's church, with four children and a female servant. Perhaps at first, she imagined in time the family returning to their home town. However, by 1576 as the Eighty Year War (1568–1648) dragged on and her children settled into local life, she had probably become inured to remaining in London. If not, the events in Antwerp would have convinced her to stay in England.

Indeed, 4 November 1576 marked a turning point not just in the fortunes of Antwerp but also the wider Dutch independence struggle. The city was located on the River Scheldt and the riverbank was lined, like the Thames in London, with wharves and warehouses (Figure 1.4). At the centre were the cathedral, city hall, market square and the famous merchants' exchange or bourse. As the Tower of London dominated the City, so Antwerp was controlled by a magnificent modern fortress/citadel completed by the Spanish in 1572.[8] It was designed by the leading Italian architect Francesco Paciotto (1521–91) as a pentagon and, most importantly, it allowed troops to pass through from

Figure 1.4   The Spanish garrison in their new fortress (lower left) controlled the port of Antwerp, the richest city in north-west Europe. The attacks on Antwerp in 1576 and 1585 led to a shift of economic power to Amsterdam and London.

Figure 1.5   During the 'Spanish Fury' looting of Antwerp in November 1576, the magnificent town hall, 'ein wunder der wellt' and only finished in 1565, was gutted by fire. In this illustration, Spanish soldiers fight with the Dutch in the Grote Markt while the buildings burn. Etching by Franz Hogenberg.

outside the city walls into the streets, thus holding Antwerp in its power. It was described as 'doubtlesse the most matchlesse piece of modern Fortification in the World'.[9]

Inside the citadel the Spanish troops, unpaid following Spain's third bankruptcy in 1575/6, were embittered and restless, and their limited patience was drawing to an end.[10] During the previous weeks, tension had been rising between the Spanish troops and the townspeople.[11] Both sides attempted to strengthen their forces to bolster their positions but events were moving too fast for a peaceful outcome. As the Spanish increasingly tightened control of the supply routes into the city, a force of nearly 4,000 footsoldiers and 1,000 cavalry, of uncertain loyalty, were sent by the Dutch States-General to protect the townspeople. On Saturday, 3 November these troops entered the town and immediately started excavating earthworks to protect it from the citadel. Inside the city walls was a wide cleared space to allow the cannons in the citadel a clear field of fire. The newly arrived soldiers, helped by the townspeople, constructed a ditch and bank along the edge of this open ground to split off the citadel from the city streets. Even bales of valuable (and probably English) wool were dragged from nearby warehouses to be piled up into the defences. Meanwhile, the Spanish had been gathering troops from nearby garrisons, and on Sunday about 4,000 soldiers arrived and gathered in the citadel. The English writer and soldier George Gascoigne (*c.* 1535–77) happened to be in Antwerp, staying in the 'English House',[12] and recorded that these troops:

> (as I have hearde credibly reported) would neyther stay to refresh themselves (having marched all night and the day before) nor yet to conferre of any thing, but only of the order how they should issue and assaile, protesting and vowing neyther to eat nor drinke untill they mighte eate and drinke at liberty and pleasure in ANTWERP.

A minute passed, two minutes, three minutes . . . then, with a blood-curdling roar, the Spanish forces stormed out of the citadel, across the bridge spanning the moat, and attacked the newly constructed defences. The Spanish soldiers had decided to get their back pay by other means. The struggle was intense, but over in an hour.[13] The townspeople and their mercenaries turned tail and the Spanish troops and their allies poured down the city streets into the heart of Antwerp. Within a short time all resistance had crumbled and the houses, churches and warehouses were systematically looted. The town hall was torched (Figure 1.5) and the bourse, one of the most famous buildings in Europe and a powerful symbol of the rising power of capitalism, was left gutted.[14] Gascoigne lamented:

> that within three daies Antwarpe, which was one of the rychest Townes in *Europe*, had now no money nor treasure to be found therein, but onely in the hands of murderers and strompets: for every *Dom Diego* must walk ietting up & downe the streetes with his harlotte by him in her cheine and bracelettes of golde. And the notable

> Bowrce [Bourse] which was wont to be a safe assemblie for Marchaunts, and men of all honest trades, had nowe none other marchaundize therein, but as many dycing tables as might be placed round about it al the day long.

But he was also keen to record his claimed heroic role as a cool Englishman abroad:

> gave adventure to passe through the sayde crossestreate, and (without vaunte be it spoken) passed through five hundred shotte, before I could recover the English house . . . but before I coulde well shut and barre the gates, the Spanyardes were nowe come forewards into the same streat: And passing by yᵉ doore, called to come in? bestowing fyve or six Musquette shotte at the grate where I aunswered them, whereof one came very neare my nose, and pearcing thorowe the gate, strake one of the Marchants on the head, without any greate or daungerous hurt.

While one needs to treat all figures cautiously, it was claimed that *c.* 8,000 civilians,[15] maybe 7 per cent of the population, had been slaughtered. Subsequently, lurid prints circulated through Europe showing men and women being tortured and mutilated (see Figures 1.6 and 1.7). Although Antwerp recovered, it was never to regain its dominant economic position, and much of its trade and skilled craftsmen drifted away to the new financial powerhouses, Amsterdam and London. Ironically, this appalling massacre drove the Dutch to unite more closely than ever before. A few days later, on 8 November, the 'Pacification of Ghent' was signed, creating an alliance of all the Dutch provinces to drive out the Spanish.

These traumatic events were closely monitored by the government in London. Gascoigne had arrived in Antwerp on 22 October, and thus was an eyewitness to the whole horror of the 'Spanish Fury'. He left the devastated city on 12 November and reached London nine days later. Within a few days, he had published his 'The Spoyle of Antwerpe', a fascinating record of his claimed role in the appalling events.[16]

The sack of Antwerp was such a dramatic event that news would have inevitably percolated across England, even to the Shakespeare family living in Henley Street, Stratford-upon-Avon. It gave the English authorities excellent propaganda to scare the population about the continual threat of treachery by Spain and, more generally, Catholics at home and abroad. While national sympathies would have been with the Protestant Dutch, everybody must also have known that the cost of any English military support would be met by an increase in their own taxation. In the late sixteenth century, national finances were still a fairly hand-to-mouth operation. What came in from custom duties, land sales and other charges usually went straight out again. The cost of any significant military activity was way beyond the nation's normal income: it had to be raised by special subsidies levied by individual Acts of Parliament. Indeed, the main

Figure 1.6 Cheap engravings carried sensationalised news across Europe of atrocities by Spanish soldiers against civilians in Antwerp.

Figure 1.7 The sacking of Antwerp gave the English authorities powerful propaganda about the threat to Protestant religion from the Pope and Catholic rulers. Oil painting on canvas, anonymous artist.

reason for Elizabeth I calling a parliament was usually the need to secure such additional finance. Subsidies were only paid by richer people and the records listing their names, the so-called Lay Subsidy rolls, form a vital record of the wealthier sections of England's population in the sixteenth century. As will be explained in Chapter 3, it is such listings which suggest that William Shakespeare was living in St Helen's *c.* 1597/8.[17]

In 1576, England along with Wales and parts of Ireland formed a relatively poor country, with a population of *c.* 4–5 million people living offshore from the richer countries of continental Europe: France, Spain, the Spanish Netherlands, the Italian States and the Holy Roman Empire. Most people still lived by subsistence agriculture and rarely, if ever, had the need to go beyond their neighbouring villages and market towns. The country's exports were dominated by the wool trade, which paid for luxuries: sophisticated fabrics, wine, specialist food, spices, musical instruments, weapons and so forth, traded across Europe and sourced as far away as Asia. London, with its busy port and around 5 per cent of the population, dominated the country's economy, finances and daily life. For anyone over forty and thus born before 1535, the first half of their life would have seen four monarchs and a sequence of violent religious upheavals; but for people under twenty, all they would have known was Elizabeth I's rule and nearly two decades of relative social stability. However, general calm did not mean stability for individuals or families.

Back in Stratford-upon-Avon in 1576, for the Shakespeare family money, as ever, was the priority. William's father, John Shakespeare, had developed a reasonably successful business in the town as a glove maker during the 1560s (Figure 1.8). He probably also made money as a 'brogger' or unlicensed wool dealer, money lender and landlord.[18] John had a sequence of increasingly important municipal roles and in 1568, when William was four, he was successful enough to be appointed High Bailiff, the equivalent of mayor, by his peers. William, the eldest of five surviving children, would have grown up used to his family being treated with a certain deference.[19] As late as 1576, John was sufficiently affluent to acquire two buildings to the west of his own house. However, soon after this, his business dealings seem to have become more troubled. From January 1577, he stopped attending Stratford Council meetings and many experts think he had significant debt problems. One wonders how much William would have noticed as he helped his father with jobs around the workshop. Were people in the town less respectful? Did his father's temper get worse? One is reminded of George Orwell's 1939 description of the decline of a small trader in an Edwardian market town:

> A small shopkeeper going down the hill is a dreadful thing to watch, but it isn't sudden and obvious like a working man that gets the sack. . . . It's just a gradual chipping away of trade, with little ups and downs. You can still keep going. You're still 'your own master', always a little more worried and a little shabbier, with your

Figure 1.8 In the 1590s, carrying or wearing highly decorated gloves was a mark of high status. They were usually made from doe or kid leather. Glove-making was a potential connection between the Shakespeares in Stratford-upon-Avon and the Leathersellers in St Helen's *c.* 1590–1610, although there was a separate Glovers' Company in London.

capital shrinking all the time. . . . I don't think I ever got further than realising that father 'wasn't doing well', trade was 'slack, there'd be a bit longer to wait before I had the money to 'set up'. . . . I wasn't capable of seeing, and neither was he nor anyone else, that he was being slowly ruined.[20]

But in an economy still driven by the success or failure of the annual agricultural cycle, people were used to the peaks and troughs of successive harvests. John Shakespeare probably expected to recover, but the surviving records suggest he never did.[21]

Parallel lives, parallel existences? One of the fascinating coincidences of Elizabethan drama is that Christopher Marlowe, Shakespeare's great rival, was born only eight weeks before him in Canterbury (Figures 1.9 and 1.10).[22] His background was prosaic: his father John was a shoemaker, but he had the opportunity of attending the King's School, refounded by Henry VIII, and part of the magnificent cathedral complex. Canterbury was not only four or five times larger than Stratford-upon-Avon but, as the seat of the Archbishop, was a major religious and administrative centre. As Marlowe walked through the city streets to school, he must have been aware of the buzz of power among the prelates, lawyers, scribes and messengers. Canterbury was also still – just about – a port,[23] and news from Antwerp would probably have arrived within a couple of days.

Figure 1.9   Portrait though to be Christopher Marlowe, who was born in Canterbury in February 1564, two months before Shakespeare. Marlowe enjoyed an education at the Cathedral School followed by Cambridge University – along with Oxford, the only higher education institutions in England.

There were already many Protestant refugees living in the city. They had been granted the cathedral crypt as a place to worship,[24] presumably as it provided the authorities with a place where they could keep a close eye on the new immigrants.

So, unlike the young Shakespeare, Marlowe would probably have been familiar with Dutch and Walloon (French-speaking) refugees when he was growing up. From his teens, he would have become acutely aware of the vicissitudes of international politics, civil war and the savagery that could be unleashed by religious conflict. Indeed, he was probably far more street-savvy and comfortable in strange surroundings than his peer in rural Warwickshire. Fifteen years later, in January 1592, Marlowe, then aged twenty-eight, was living in Flushing in Holland (the modern port of Vlissingen), where he was arrested and accused of counterfeiting coins. How was he affected by his upbringing in Canterbury? All we know is that around 1592, he wrote his play *The Massacre at Paris* about the St Bartholomew's Day Massacre of 23–4 August 1572, when the French authorities instigated the murder of thousands of French Protestants (Figure 1.11).[25] Many people could have recounted similar horror stories of the attacks on towns and cities like Antwerp.

While Spanish soldiers looted the accumulated riches of Antwerp, things remained calm but vigilant in London. Indeed, for Queen Elizabeth I, 1576 had started with the

Figure 1.10 Canterbury was an important city, as it was the seat of the Archbishop. However, its population was small compared to London's and much of the area inside the medieval walls was open space. Engraving from Georg Braun and Frans Hogenberg, *Civitates Orbis Terrarum,* vol. 4 (1588).

Figure 1.11 The St Bartholomew's Day Massacre of thousands of French Protestants in August 1572 became a byword for Catholic treachery. Oil painting by François Dubois (1529–84).

Dutch crisis to the fore. With her courtiers, she had arrived at Hampton Court Palace, next to the Thames upriver from London, on 20 December 1575, ready to enjoy the Christmas, New Year and Twelve Night festivities. She was already aware that an important message was being sent to her from the Dutch rebels. However, before international diplomacy, there was relaxation and pleasure. In 1576, January I was a Sunday and, by tradition, presents to the Queen from her courtiers were displayed on tables. This year she received 195 gifts, carefully listed, so that it is known they included the following:[26]

> Earl of Shrewsbury: 'In a blue purse in dimy [half] sovereigns, £20'
> Lady Burghley: 'A small coffer of mother-of-pearl garnished with woodwork gilt, with eight books in it'
> Lady Sheffield: 'A scarf of tawny silk wrought all over with silk of sundry colours . . . to be aired because it was made in a house infected'[27]
> Levina Teerlinc:[28] 'The Queen's picture upon a card [a miniature]'

The Earl of Warwick's Men also performed a play and George Gascoigne – he of the 'Spoil of Antwerp' eleven months later – dedicated 'The Tale of Hemetes the Hermit' to the Queen. The fluctuating status of each courtier was minutely dissected. The following day, Mrs Elizabeth Wingfield wrote to the Countess of Shrewsbury about her gifts:

> First her Majesty never liked anything you gave her so well. The colour and strange trimming of the garments with the ready and great cost bestowed upon it hath caused her to give out such good speeches of my Lord and your Ladyship as I never heard of better . . . If my Lord and your Ladyship had given five hundred pound, in my opinion it would not have been so well taken.[29]

However, much as she liked her presents, Elizabeth had to turn to the pressing diplomatic concerns. On Monday, 2 January, Dutch special ambassadors from Holland and Zeeland had arrived in London. William the Silent (1533–84), Prince of Orange, had sent a crack negotiating team to invite the Queen to become Countess of Holland.[30] William was the main leader of the Dutch rebels, until he was assassinated in 1584 in Delft by the Catholic Balthasar Gérard.[31]

By Tuesday 3 January, French special ambassadors had also arrived. The Sieur de la Porte, one of the Duke of Alençon's Chamberlains and Councillors, came with La Mothe Féneélon (ambassador to England 1568–75). Their secret mission was to reopen marriage negotiations and to request that Alençon might visit England for a meeting with the Queen. They stayed with the resident ambassador, Mauvissière. Finally, on Friday, 6 January, Sir Henry Cobham, England's special ambassador to King Philip II of Spain, returned to Hampton Court.

So, within a few days, the forty-one-year-old Queen Elizabeth, with eighteen years' rule to her credit, had been offered an additional country and a husband. Eventually, Elizabeth declined to become Countess of Holland and to provide assistance or a loan to the rebels in Holland and Zeeland. She sent her answer to the Dutch, still waiting in London, and Lord Burghley sent word of it to William Herle. On Friday, 23 March, Herle, then living in Red Cross Street, replied:[32]

> These poor Hollanders . . . were here betimes this morning. . . . The poor men were in a marvellous passion, for the answer that they had received in writing before they came to me from her Majesty, wherein, beside that she had expressly denied them either her aid or relief, she had threatened them further if they should join with any other.

During Elizabeth's reign, the day-to-day control of the country was managed by the Queen working with her Privy Council (a group of between fifteen and twenty aristocrats, courtiers and military commanders), along with the Archbishop of Canterbury. Unlike today, parliament was only called at long intervals and usually sat for a matter of only a few weeks.[33] There were no political parties and there was no prime minister. The composition of the MPs could vary quite widely from parliament to parliament. From Elizabeth I's perspective, parliament's main function was to give her enough income to run the country and provide exceptional finance to wage war if

necessary. During 1576, parliament was in session in February and March for the second session of Elizabeth's fourth parliament. It was prorogued on 15 March, when:

> This Afternoon also, her Majesty came in Person to the Upper House, where *Robert Bell* Esq; Speaker of the House of Commons, did amongst other things in his Speech move her Majesty, in the name of the House to Marry . . .; also the said Speaker did . . . present her Majesty with the Bill of the Subsidy, in the name of the Commons [the 1576 Lay Subsidy Bill] . . .

On Sunday, 25 March, Richard Curteys, Bishop of Chichester, preached to the Queen, who had now moved on with her court to Whitehall Palace. His sermon was based on St Paul's words recorded in Acts 20, verses 28–30. He used this to complain of church ministers who delivered populist sermons to impressionable congregations and who were:

> puffed up with vainglory to get themselves a name, and that the changeable people may flock to their sermons, and their lectures, and their churches, and their disciplines, drawn and fed with their fond novelties whereof the simple be too desirous.[34]

Meanwhile, a mile or so away outside the city wall, plans were underway to provide a novelty to attract Londoners and an alternative to weighty religious sermons. In 1576, all this would have been unknown to the young William Shakespeare, but eighteen years later the results would shape his writing and his entire working life.

## Notes

1. In the 1570/80s, there were two to three thousand students at Oxford and Cambridge. This meant that perhaps 600–900 students left each year, although a considerable percentage did not graduate. Few people went to university before the 1960s. As a comparison, in 1950, 17,337 full-time students (13,398 men and 3,939 women) were awarded a first degree in the UK, up from 4,357 (3,145 men and 1,212 women) in 1920. In 1950, only 30 per cent of fifteen-year-olds were still in full-time education. The total number of graduates in 2011 was 350,800. See Bolton (2012), which lists specific sources of data.
2. Allegiances were not just determined by religion. Location, economic status, language, family and business connections all played a part. In broad terms, the French- (and Walloon-) speaking areas to the south were more Catholic and the Dutch-speaking areas to the north (Flemish in modern Belgium) more Protestant and pro an independent Holland. However, many merchants in Amsterdam were pro-Spanish because of the commercial wealth generated by the crucial trade routes to Iberia.
3. Philip's father, Charles V, the Holy Roman Emperor, progressively abdicated parts of his empire during 1554–6. Although born and brought up in Spain and Spanish culture, Philip II was based from 1555 to 1559 in the Spanish Netherlands (the Seventeen Provinces). He also had experience of Protestant England as the consort of Queen Mary I, 1554–8.

4. They are recorded in the 1571 Survey of Strangers, listed as 'came into realm for religion'. De La Fontaines are recorded in Valenciennes in the sixteenth century, including the family of Jean De La Fontaine dit Wicart; see Junot, *Les Bourgeois de Valenciennes*, p. 165. However, Jean seems to have been a loyalist, and Fontaine is not a rare name in the region. The village of Lez-Fontaine lies twenty-eight miles south-east of Valenciennes.
5. In 1574, the area was described by the Privy Council as having 'strangers [foreigners], inmates and many lewd persons to the great noise [inconvenience] to the governors of the city'. See Nicholl, *The Lodger*, pp. 94–102, which explains the development of this immigrant community.
6. This date is set by Shakespeare's deposition on 11 May 1612, that 'hathe know[ne] them [his landlords, the Mountjoys] as he now remembrethe for the space of teene yeres or thereaboutes' (TNA PRO REQ 4/1/4/1). The 'or thereaboutes' is standard legal phraseology of the period. However, the marriage at the centre of the legal dispute was in 1604, so some experts take this year as the start of Shakespeare's residency in Silver Street. My own view is that the devastating 1603 plague and death of Elizabeth I in March, which would have been nine years earlier, would have been such a fundamental time datum that Shakespeare would have stated eight years earlier if he meant 1604. See Nicholl, *The Lodger*, pp. 17–18. Since there is no proof either way, 1602/4 is used here throughout.
7. Great St Helen's, the side street in which the parish church was located, had originated as the entranceway to the nunnery of St Helen's. It consisted of two sections. The area around the church and churchyard, which is here termed 'the Close', was wide and lined with impressive half-timbered houses. The street then turned into a narrow, twisting alley to the south-east, eventually exiting in St Mary Ax(e Street). St Mary Axe is used throughout.
8. The location of both fortresses meant that troops could be brought in directly without passing through the city, meaning that the city walls could be circumvented.
9. Evelyn, *The Diary of John Evelyn*, p. 40.
10. Despite the glamour of the gold, silver and precious stones brought back from Spain's conquests in Mexico and South America, the Netherlands was a far more valuable economic asset; hence the Spanish determination to maintain control of the rich tax revenues.
11. Especially after the looting of Maastricht, seventy miles to the east, when many civilians had been killed by the Spanish troops.
12. Many English merchants, like Sir Thomas Gresham, had houses in Antwerp. The 'English House' provided accommodation for ordinary traders passing through the city. See his account, George Gascoigne, *The sopyle of Antwepe. Faithfully reported, by a true Englishman, who was present at the time*. Novem. 1576. Seene and allowed. There is a copy online at <https://quod.lib.umich.edu/e/eebo/A01521.0001.001?view=toc> (last accessed 20 July 2020).
13. Gascoigne claimed 500–600 Spaniards were killed. Even allowing for exaggeration, it was clearly a bitter fight between well-trained and armoured soldiers.
14. The first bourse had been built in 1515 but proved too small for the rapid increase in business. In 1531, the New Bourse was built to the designs of Domien de Waghemakere. This building, the Handelbeurs, damaged by fire in 1583, survived until 1858 when it was destroyed by another fire. The present building is a Victorian recreation of the 1531 building, updated for contemporary needs and with the former open central courtyard glazed over. It only ceased functioning as a stock exchange in 1997. It is currently being restored for public use.
15. Gascoigne claimed 17,000 dead. It is thought that Antwerp's population in the 1560s was a little over 100,000, making it one of the ten largest cities in Europe. An unusual recent genetic study has failed to find DNA evidence of Spanish rapine in the region; see Larmuseau et al., 'The black legend on the Spanish presence in the low countries'.
16. Recent work has demonstrated that much of Gascoigne's account was actually lifted from a Dutch pamphlet; see Fagel, 'Gascoigne's *The Spoile of Antwerpe*', pp. 101–10. Such plagiarism is perhaps hardly surprising. When Gascoigne attempted to stand as MP for Bedford in 1572 the burgesses sent a petition to the Privy Council claiming: 'Then he is a common Rymer and a deviser of slanderous Pasquelles against divers personnes of greate callinge. Then he is a notorious ruffiane and especiallie noted to be bothe a Spie, an Athiest and a Godles personne.' On 21 November,

17. Unfortunately, the survival of such rolls is very patchy, both by date and geography. Many surviving rolls are also in poor condition. Such subsidies offered a good way of exploiting foreign immigrants, who all had to pay regardless of income. Ironically, this means that poor immigrants were better documented than their equivalent English residents, whose poverty resulted in historical obscurity.
18. For details of this period, see Bearman, *Shakespeare's Money*, pp. 10–23. In 1571, he was recorded as having 3,800 kg of wool (300 tods; 100 sacks).
19. Three siblings died in infancy, and in 1576 his youngest brother Edmund, baptised in 1580 when William was sixteen, had not yet arrived. At this time, the population of Stratford-upon-Avon is estimated at *c.* 1,500 living in *c.* 200 houses, or an average of 7.5 people per house.
20. Orwell, *Coming Up for Air*, p. 118.
21. Documents recently unearthed in the National Archives by Professor Glyn Parry suggest that John Shakespeare may have been blackmailed by professional informers and that these troubles continued until at least 1583, by which time Shakespeare would have been nineteen; see Flood, 'William Shakespeare: Father's Legal Skirmishes Shed Light on Bard's Early Years'. Shakespeare would have, therefore, passed his teens in a household that had seen a marked decline in its social status.
22. Marlowe's date of birth is unknown, but he was baptised on 26 February in the church of St George the Martyr.
23. In the medieval period, boats would have come up the River Stour to Fordwich, where the Caen stone from Normandy, used to construct the cathedral, was unloaded.
24. At their peak, the immigrants may have made up a quarter of Canterbury's population. A large percentage were weavers and the crypt was originally provided as a space to set up their looms.
25. Estimates of the numbers killed vary widely from less than 5,000 to over 30,000. Unfortunately, the play only survives as short version, which experts think may be a reconstruction by actors who performed it.
26. Lists only survive for some years. For examples, see *FECDD*.
27. This would seem a strange present to give one's monarch but shows the contemporary attitude to tackling disease. There was a major outbreak of plague in Venice, 1575–7. In London there was a major outbreak in 1578, but in most years there were some deaths, which were due to or might be attributed to plague. This may refer to smallpox, which Elizabeth had caught in 1562, when she was twenty-nine, and which had left her with unsightly pockmarks.
28. Levina Teerlinc (died 23 June 1576) was a female Flemish miniaturist who worked for Henry VIII, Edward VI, Mary I and Elizabeth I. She probably learnt her skills from her father, Simon Bening, who was a book illuminator and miniature painter. She was the most important miniaturist at the English court between Hans Holbein the Younger and Nicholas Hilliard. Six months later, she died in her house in Stepney.
29. *FECDD*, 2 January 1576.
30. Holland and Zeeland were the two of 'the Seventeen Provinces' making up the Spanish Netherlands where the rebels succeeded in maintaining control. The province of Holland was the western part of modern Holland. Zeeland was the area north-west of Antwerp. William could act as the rebel leader because he was also the ruler of Nassau in Germany, which lay outside Spanish territory.
31. In 1570, James Stewart, 1st Earl of Moray and Regent of Scotland, was shot in Linlithgow with a carbine. This was the first recorded high profile assassination with a firearm. In 1584, William the Silent was shot with a pistol and, in 1589, Henry III of France was assassinated with a dagger. Given these three well-publicised deaths, it is hardly surprising that the potential killing of Elizabeth was seen as a real and ever-present danger by the English government, particularly after Pope Pius V in 1570 issued a papal bull, *Regnans in Excelsis*, which excommunicated her and released her subjects from any allegiance.
32. *FECDD*, 23 March 1576.

33. Elizabeth called ten parliaments in thirteen sessions over forty-five years. Together, they sat for nearly 140 weeks or about 6 per cent of her reign. There were intervals of three or four years between some parliaments. They were:

    1. 23 January 1559 – 8 May 1559
    2. 12 January 1562 – 10 April 1563; 30 September 1566 – 2 January 1567
    3. 2 April 1571 – 29 May 1571
    4. 8 May 1572 – 30 June 1572; 8 February 1576 – 15 March 1576; 16 January 1581 – 18 March 1581
    5. 23 November 1584 – 14 September 1586
    6. 29 October 1586 –2 December 1586 (adjourned); 15 February 1586 – 23 March 1587
    7. 4 February 1588 – 29 March 1589
    8. 19 February 1593 – 10 April 1593
    9. 24 October 1597 –20 December (adjourned); 11 January – 9 February 1598
    10. 27 October – 19 December 1601

34. See *FECDD*, 25 March 1576.

# 2

## James Burbage Plans His Theatre: The Theatre

*In which, in a relatively peaceful England, Shoreditch is chosen for an innovation in popular entertainment, the construction of not just a theatre but the Theatre. However, will the local residents in City parishes like St Helen's make the twenty-minute walk along muddy roads to see their favourite players?*

On that same Sunday, 25 March 1576, across London in the village of Shoreditch, Middlesex, an apparently minor legal agreement had come into operation.[1] However, its impacts were to cascade down the centuries. Giles Allen, who owned a portion of the former Holywell Priory, had leased the site, including a run-down barn, to James Burbage, a joiner turned actor in his mid-forties. For an annual rent of £14, he could build a freestanding theatre: the Theatre. Burbage needed additional finance, so he had formed a partnership with John Brayne, his brother-in-law, a grocer in his mid-thirties. The pair had worked together before and both had a strong interest in theatre. A decade earlier, in 1567, Brayne had built a stage in the grounds of the Red Lion in Mile End.[2] By 1572, Burbage was involved with the Earl of Leicester's Men, the leading theatre company of the time. Now they erected a major structure, seating an audience of between perhaps eight and nine hundred, which was called the Theatre partly as an allusion to classical Roman theatre but also because it was the first permanent, purpose-designed theatre in England for over a thousand years.[3] In the 1590s, it was to stage the premieres of some of the greatest plays in the English language.

During the next few months, the polygonal oak frame rose among the tenements spreading across the fields and the former monastic precincts which once separated the City from the old village of Shoreditch (see Figure I.4). Burbage and his family lived close by in Holywell Lane, so he could keep an eagle eye on progress. The owners of the Theatre would need an average daily audience of at least 400, generating maybe £2-0s-0d or so to break even and to begin to pay back part of their capital investment. Around a third of London's population of over 150,000 lived within reasonable walking distance. So, each week, the Theatre needed to attract at least 3,000 people, 10 per cent of its local adult market.[4]

Who were these local people who would walk out a mile or so from the City to Shoreditch for entertainment? While contemporary detractors of the new theatres liked to portray their audiences as the idle rich and the feckless poor, the hard economic truth was that the Theatre, and later the Curtain and the Rose playhouses, needed to attract a broad and regularly returning audience if they were to turn a profit.

The nearest area of the City to the Theatre was the Ward of Bishopsgate, comprising six parishes,[5] named after the great towered gateway giving entry through the city wall. The extramural parish of St Botolph was distinctive due to its large, socially mixed population, with a significant proportion of immigrants.[6] Of the five parishes just inside Bishopsgate, we will look in detail at St Helen's as an example due to the clarity of its topographical layout and the excellent records of the Leathersellers' Company Estate, which accounted for about 20 per cent of the housing and the parish records starting in 1575.[7] The pattern of life there would have been similar to the surrounding parishes in the north-east corner of the City. It also happens that William Shakespeare was living there in the 1590s, meaning that one of the most studied of Elizabethan men was a one-time resident.

In 1576, there was a national Lay Subsidy assessment, and fortunately the record of the taxpayers survives for St Helen's (see Table 2.1). This listing provides an insight into the social structure of the parish about seventeen years before Shakespeare moved in. Positioned close to the top of the social pyramid was Thomas Coleshill (1517/18–1595), who was appointed as an assessor responsible for organising the collection of the subsidy.[8] Thomas Coleshill was a powerful figure in the City.[9] He was Inspector of the Great Customs for London, a highly responsible and lucrative job. He was also an MP in 1584–6, and his daughter Susan(na) married Edward Stanhope I, one of the five powerful Stanhope brothers, all of whom became MPs (despite their father having been beheaded on Tower Hill in 1552). By 1576, Thomas Coleshill had lived in the parish for thirty years, having moved in with his new wife Mary Crafford *c.* 1546. He had been a churchwarden no less than six times, most recently in 1574–6. He would, therefore, have had an extremely detailed knowledge of the parish and one can assume that the assessment process and enrolment for the Lay Subsidy tax would have been very accurate.[10] The listing shows that there were:

1. thirty-seven English households – only the male head of the household was recorded, or in six households the widow, where the husband had died;
2. one livery company – the Company of Leathersellers;
3. eleven immigrant ('stranger') households, where everybody was listed, as each had to pay at least the minimum 4d poll tax. Of these, six appear to be family households and five single men, who could have been lodging in other people's houses.

Therefore, in total perhaps forty-five individual houses, to which should be added the two almshouses and the rectory for the parish minister.

The Lay Subsidy, however, only records English households rated at £3 or above. Poorer households were excluded. The equivalent figures in 1598 were forty English households and nine immigrant households, making a total of forty-nine. This suggests

# Living with Shakespeare

**TABLE 2.1: PARISH OF SAINT HELEN'S: 1576 LAY SUBSIDY ROLL IN ORDER OF ASSESSMENT LEVEL**

The wealthier residents of the parish of St Helen's in 1576 recorded in the Lay Subsidy roll and listed here in order of assessment level. All adult foreigners, 'strangers', were included at the end.

|  | Name (as in listing) | Valuation other than goods | Trade/background | Burial | Assessment |
|---|---|---|---|---|---|
| 1. English | | | | | |
| 1 | Will[ia]m Birde | | merchant and financier | | [blank] |
| 2 | S[i]r Thomas Gresham k[nigh]t | | international financier | buried St Helen's 1579 | £500 |
| 3 | Margarett Bond | | widow, wife of Alderman William Bond died 1576, owner of Crosby Hall 1566–76 | buried St Helen's 1588 | £200 |
| 4 | Dame Katherin Pollard | | widow, wife of Sir John Pollard died 1575, leased 'The Cloister' 1575–85 | buried St Helen's 1585 | £100 |
| 5 | Edward Barrett | in land[es] | gentleman | | £100 |
| 6 | Daniell Bonde | | merchant, son of Alderman William Bond died 1576, owner Crosby Hall 1576–87 | buried St Helen's 1587 | £100 |
| 7 | Thomas Colsell | [As]Sessor [of the Lay Subsidy] | Inspector of Great Customs for London, daughter married Edward Stanhope MP | buried Chigwell, Essex, 1595 | £80 |
| 8 | Edward Skegg[es] | | Queen's Serjeant Poulterer | buried St Helen's 1578 | £80 |
| 9 | Will[ia]m Hagar | | salter | buried St Helen's 1580 | £50 |
| 10 | Iohn Robinson | | the Elder, alderman, leased north wing of nunnery 1574–1600 | buried St Helen's 1600 | £50 |
| 11 | Clement Kelke | | haberdasher, a governor of Bridewell Hospital and Bethlem 'Bedlam' Hospital | buried Bray, Berkshire, 1593 | £50 |
| 12 | Iohn Huffe | | worked for William Bond's son | | £50 |
| 13 | Wil[ia]m Bonde | | merchant, son of Alderman William Bond | | £50 |
| 14 | Richard Glascoke | | merchant | | £50 |
| 15 | Iohn Howe | in Land[es] | gentleman? | | £40 |
| 16 | Blase Saunders | in fees | grocer, international merchant and Marian exile | buried St Helen's 1581 | £20 |
| 17 | Iohn Gresham | in Land[es] | gentleman, cousin of Sir Thomas Gresham | buried St Helen's 1578 | £20 |
| 18 | Iohn Watson | in land[es] & fees | gentleman | buried St Helen's 1589 | £20 |
| 19 | Iamys Lomley | in Land[es] | gentleman, son of Dominic Lomeley | buried St Helen's 1593 | £15 |
| 20 | Will[ia]m Huckle | | Serjeant Poulterer to Queen | | £15 |
| 21 | Will[ia]m Kyrwin | | freemason | buried St Helen's 1594 | £10 |
| 22 | Georg Kightly | | leatherseller, son of Thomas Kightly leatherseller? | | £10 |
| 23 | Mris Drafforde | | widow, wife of Guy Crafford listed in 1541 LSR, died 1553 | buried St Helen's 1584 | £10 |
| 24 | Iohn Butcher | | ? | | £8 |
| 25 | Thomas Holmes | | blacksmith, described as 'Cousin Holmes' by Blase Saunders, living in an adjoining house | buried St Helen's 1595 | £7 |
| 26 | Will[ia]m Barbor | | ? | buried St Helen's 1586 | £5 |
| 27 | Raulf Skyres | | ? | | £5 |
| 28 | Widow Skyres | | widow of William Skerres | | £5 |
| 29 | Will[ia]m Basse | | ? | | £5 |
| 30 | Petter Dode | | grocer | buried St Helen's 1603 | £5 |
| 31 | Germyn Cyall | | merchant, owner Crosby Hall c. 1560–6, husband of Cecily Cioll, cousin of Thomas Gresham | | £5 |
| 32 | Widow Windesor | | widow, wife of Robert Windsor listed in 1541 and 1547 Lay Subsidy rolls | buried St Helen's 1587 | £3 |
| 33 | Thomas Horne | | ? | | £3 |
| 34 | Iohn Stocker Jekyll | | gentleman | buried Bocking, Essex, 1598 | £3 |
| 35 | Hughe Kenryk | | gentleman, musician, pronotary | buried St Helen's 1598 | £3 |
| 36 | Agnys Center wydow | | wife of Gregory Senter | | £3 |
| 37 | Simone Smythe | | merchant | buried St Helen's 1589 | £3 |
| | | | | | £1,683 |

| | Name (as in listing) | Valuation other than goods | Trade/background | Burial | Assessment |
|---|---|---|---|---|---|
| Livery Company | The company of Lether sell[e]rs | in Land[es] | | | £12 |

2. Strangers in St Ellyns p[ar]ishe

A. 'Within St Hellins Close'

| | Name (as in listing) | Valuation other than goods | Trade/background | Burial | Assessment |
|---|---|---|---|---|---|
| S.1 | Peter Bowltas | | | | £50 |
| | Lucy | wife | | | per poll 4d |
| | Sara | daughter | | | per poll 4d |
| S.2 | Jacob Saul | | surgeon | buried St Helen's 1585 | £30 |
| | Agatha | wife | | buried St Helen's 1590 | per poll 4d |
| | Mary | daughter | | | per poll 4d |
| | Anne [Browne?] | daughter | | | per poll 4d |
| | John Browne | son-in-law | | | per poll 4d |
| S.3 | Godrey Canion | | | buried St Helen's 1583? | £20 |
| | Mary | wife | | | per poll 4d |
| | Daniel | Mary's servant | | | per poll 4d |
| | Barbara | Mary's maid | | | per poll 4d |
| S.4 | Godrey Canionele | | | | £10 |
| | John Baldrye | Godfrey's servant | | | per poll 4d |
| | Michael | Godfrey's servant | | | per poll 4d |
| | Joseph | Godfrey's servant | | | per poll 4d |
| S.5 | Baptist Dongrone | | | | per poll 4d |
| S.6 | Frauncis Faulconeir | | | | per poll 4d |
| S.7 | Nicholas Shorotaill | | | | per poll 4d |
| S.8 | Anthony Russell | | | | per poll 4d |
| S.9 | Jeronimo Fulcius | | surgeon | | per poll 4d |
| S.8 | Margarett Fowntayne | | widow | | per poll 4d |
| | Philip | son | | | per poll 4d |
| | Paul | son | | | per poll 4d |
| | Jacob | son | | | per poll 4d |
| | Hester Selyn | daughter | | | per poll 4d |
| | Elizabeth Hawin | maid | | | per poll 4d |
| S.9 | Daniel Baptist | Giovanni Battista Agnello | distiller of waters/alchemist | buried St Helen's 1582 | per poll 4d |

B. 'In Brides Ally'

| | Name (as in listing) | Valuation other than goods | Trade/background | Burial | Assessment |
|---|---|---|---|---|---|
| S.10 | Hugon Wayne | | | | per poll 4d |
| | Joane | wife | | | per poll 4d |
| | John | son | | | per poll 4d |
| | Agnes | daughter | | | per poll 4d |

that there was relative stability in the built environment, certainly among the houses of the wealthier parishioners.

A detailed examination of the 1598 Lay Subsidy in St Helen's, when Shakespeare was resident, suggests that untaxed households may have made up 50 per cent or slightly more of the parish housing stock. It was probably a similar situation two decades earlier in 1576, so one might suggest there were *c.* 90–100 houses/households in total. Assuming an average household size of five or six would suggest a total parish population of 450–600, or perhaps a little more; certainly less than 800. At least a third of the population would have been children. Walking around the tiny area of the parish today, it is a challenge to imagine 150 or so children growing up and playing in the area.[11]

From the thirty-seven English households which were taxed, and excluding the six widows, one can identify the occupation of twenty-three male taxpayers. Nine are gentlemen, who would have had an income from land, loans and other investments. Of the remaining fourteen, seven, all among the richest, were dealing in textiles, wool and international trade. The balance consisted of: the Queen's Serjeant Poulterer (supplier of poultry and rabbits to the court), a salter, a mason, a leatherseller, a grocer, a blacksmith and an undefined merchant. So, all in all, St Helen's was an affluent area, focused on international trade with strong links to the city authorities, court and parliament.[12] At its heart sat Sir Thomas Gresham, Alderman William Bond and William Burd, three of the most influential members of London's merchant community. As will be shown later, this trio played a key role in the development of England's maritime empire. When Shakespeare arrived in St Helen's in the 1590s, around 25 per cent of these richer households were still living there[13] but, despite the changing families, the overall social mix seems to have remained fairly constant.

There is no way of knowing who from these ninety or so households would have taken the time to walk out of the City to the delights of the Theatre. Some of the wealthier residents would probably have considered it below their dignity. The haberdasher Clement Kelke was a governor of Bridewell, which had been established as a school, hospital and prison for reforming prostitutes in 1553/6. Kelke was a committed Puritan, and it is difficult to envisage him strolling out from Bishopsgate to an area that, as he knew from handing out frequent punishments at Bridewell, teemed with illicit activities.[14] On the other hand, the confrontational character of Edward Skegges, official supplier of poultry to Queen Elizabeth, suggests he at least would have enjoyed the rough and tumble of the Elizabethan stage.[15] In 1562 he had had an infamous run-in with Thomas Lodge, the Lord Mayor, over a dozen capons.[16]

Apart from Sir Thomas Gresham, the majority of the men listed in the 1576 Lay Subsidy roll served the parish as churchwardens and/or auditors of the churchwardens' (parish) annual accounts. A prime responsibility, of course, was recording of marriages,

baptisms and burials in St Helen's. These records open up a clear vista on the parish as its population evolved.

Starting with the excitement of new arrivals (Table 2.2), there were fourteen babies baptised in the font of St Helen's during 1576 and a possible two more births that waited for baptism on 2 January 1577.[17] This was a fairly typical year, as the annual birth level fluctuated between twelve and eighteen.[18] The babies were equally split between females and males. Most of them became part of what nowadays would be large families but then were medium-sized; there were eventually at least seven Risby and six Dod(d) children. In most cases, we know little about their lives, although Gideon was the son of Cornelius Ketel, a Dutch painter living in London, who eventually returned to Holland. Anne Kirke died just twenty-two months later during the 1578 plague; the

**TABLE 2.2: PARISH OF SAINT HELEN'S: BAPTISMS, 1576**

The fourteen baptisms in 1576. Only the father was normally listed in the St Helen's parish register at this time. Despite the threat to the mother of a difficult childbirth or a subsequent fatal infection, record-keeping reflected the patriarchal character of society.

|    | Date | First name | Sex | Father's name | | Father's trade or background listed | Trade or background known from other sources | Assessment in 1576 Lay Subsidy Roll | Contribution to 1576/7 parish lecturer's fee | Churchwarden? |
|----|------|-----------|-----|---------------|--|---|---|---|---|---|
| 1  | 22 January | William | son | Richard | Rysbe [Risby] | merchant taylor | | not listed (£3 in 1582 LSR) | 2s-0d | Yes – 1583/4 |
| 2  | 22 March | Elizabeth | daughter | Doctor | Fryer | medical doctor? | | not listed | | |
| 3  | 1 July | Marye | daughter | Richard | Staling | | ? | not listed | | |
| 4  | 28 July | Julyan | daughter | William | Knell | | ? | not listed | | |
| 5  | 2 August | John | son | John | Norgate | | [merchant?] taylor' | not listed | | |
| 6  | 24 August | Elizabeth | daughter | Gregory | Senter | | linen draper | died/widow Agnes £3 | 3s-4d | Yes – 1576/7 |
| 7  | 2 September | William | son | Willliam | Basse | | | £5 | 3s-4d | |
| 8  | 6 November | Gedeon | son | Cornelius | Kettle [Kettel] | | portrait painter | not listed | | |
| 9  | 17 November | Henrye | son | Willliam | Reade | gentleman | | not listed; presumably paid elsewhere? | | |
| 10 | 30 November | Judyth | daughter | John | Parke | pewterer | | not listed | 2s-0d | Yes – 1592/3 |
| 11 | 2 December | Thomas | son | Peter | Dod | | grocer | £5 | 6s-8d | Yes – 1570/1 |
| 12 | 5 December | Anthony | son | Anthony | Howse | | ? | not listed | | |
| 13 | 11 December | Anne ? | daughter | Richard | Kirke [the Younger] | | armorer' | not listed | 2s-0d | |
| 14 | 17 December | Dorothie | daughter | Edward | Holmes | | ? | Thomas Holmes £7 | Thomas Holmes 2s-0d | |
| 15 | 2 January 1577 | Anne ? | daughter | Edward | Stanhope | | courtier | not listed; presumably paid elsewhere? | | |
| 16 | 2 January 1577 | John | son | John | Deare [Deere] | | Farrior' | not listed | | |

same outbreak killed John Deare and four of his older children, four daughters of Richard Risby and an older daughter of John Parke.[19]

Remarkably, despite the usual high level of infant mortality and the plagues of 1578 and 1593, none of these new arrivals, apart from Anne Kirke, is recorded as being buried in St Helen's before they reached adulthood.

There were six weddings in St Helen's in 1576 (Table 2.3), compared to four in 1577 and 1578, ten in 1579 and twelve in 1580. In most cases, it has not been possible to trace any more information about the brides and grooms. Many of the brides were probably female servants marrying male servants and then moving elsewhere in the city. In a few cases, one can recognise the name of the son or daughter of a local tradesman. In 1576, Henry Skegg(e)s was almost certainly the son of the wealthy Edward Skegg(e)s, the Queen's Serjeant Poulterer. Presumably, chicken, rabbit or duck would have featured in the wedding celebrations.

TABLE 2.3: PARISH OF SAINT HELEN'S: WEDDINGS, 1576

The six weddings in 1576. Five took place during seven weeks in September/October. The bride would normally bring some form of dowry and a married woman's property belonged to her husband, unless a special trust was set up to protect it.

|   | Date | Bride's name | | Groom's name | | Trade or background of groom's father |
|---|---|---|---|---|---|---|
| 1 | 14 February | Katheryne | Greenehill | Godfrye | Swayne | ? |
| 2 | 10 September | Suzan | Barnardiston | Henry | Skeggs | Queen's Serjeant Poulterer |
| 3 | 13 September | Anne | Jennyngs | Henry | Cooke | ? |
| 4 | 17 September | Elynor | Lee | John | Leynthall | ? |
| 5 | 18 October | Daunyell | Morris | Thomas | Dale | ? |
| 6 | 18 October | Margaret | Clarke | Thomas | Preston | ? |

TABLE 2.4: PARISH OF SAINT HELEN'S: BURIALS, 1576

Parish of St Helen's: The eight burials in 1576. The burial of Alderman William Bond, owner of Crosby Hall, two weeks after his death was a major public event. He just missed the departure of Martin Frobisher's first voyage to Cathay, which he had backed as one of the four original funders.

|   | Date | Name | | Trade or background | Other information |
|---|---|---|---|---|---|
| 1 | 6 January | Elizabeth | Hearne | ? | |
| 2 | 22 January | John | Holmes | ? | |
| 3 | 6 March | Anne | Phillipps | ? | |
| 4 | 5 May | Bartholomewe | Barnadyne | ? | |
| 5 | 14 June | William | Bond | international merchant | alderman and sheriff, died 30 May; funerary monument in St Helen's |
| 6 | 25 July | Fraunces | | servant | of Mr Bowters |
| 7 | 29 September | Robert | Edrege | ? | |
| 8 | 15 November | Henry | Bryan | ? | |

In 1576, there were only eight burials (Table 2.4), compared to fifteen in 1577, when three deaths in Richard Risby's house were probably the beginnings of the 1578 plague. This outbreak killed about 7 per cent of the entire parish population, with forty burials in the twenty-two weeks from June to early December 1578. There were only seven in the rest of the year, resulting in an overall total of forty-seven burials. In 1579, burials dropped back to twelve.[20]

One burial stands out in 1576: that of Alderman and former Sheriff William Bond, the wealthy international merchant and owner of Crosby Hall. He was one of the four founder funders of Martin Frobisher's first attempt to discover the 'North-West Passage' in 1576. His investment of £100 demonstrates his overall wealth. His burial would have been a correspondingly impressive public event, and took place two weeks after his death so that representatives from the city government, the guilds and other organisations could pay appropriate respects.[21] Later, we will discover how Bond was eulogised in a magnificent memorial in St Helen's, which stated: 'Here lies a merchant far greater than the Grecian Jason.'

During this period, there were more deaths than births in most London parishes. The spectacular growth in London's population in the late sixteenth century was fuelled by immigration from the countryside and overseas. A substantial foreigner population had also grown up in St Helen's, and the 1567/8 Survey of Strangers recorded at least sixty-three foreigners (c. 10–12 per cent of the population), mostly refugees from the Low Countries.[22] By 1576, about half seem to have drifted away, as the Lay Subsidy tax, which all foreigners had to pay, lists only thirty-two. Interestingly, most of the names have changed, indicating a high turnover of families during the eight years.

While her subjects were born, married and died, Queen Elizabeth continued to control England with a wary eye. In early May, she decided to make a short royal progress through Middlesex and Surrey. It was a chance for a change of scenery, to enjoy some field sport and, importantly for the parsimonious queen, to shift the cost of feeding her court onto some of her noblemen.[23] It also provided an opportunity to assess how well the crops were progressing and the likely results of the harvest: crucial intelligence in a largely agrarian economy.

Her first destination, on Thursday, 10 May, was Osterley, an easy fourteen-mile ride westwards from the City.[24] Close into London, the villages scattered across the flat Middlesex countryside would have been surrounded by market gardens and orchards with occasional country estates. Today, Osterley Park, bisected by the M4 motorway, is known for its beautiful eighteenth-century Robert Adam house, much used as a backdrop for costume dramas. However, in 1576, Sir Thomas Gresham had just finished building the first 'faire and stately brick house'. As owner of the manor since 1562, he had also enclosed the local common land to create a magnificent park setting for his new residence. However, local agricultural labourers, who relied on access to the

common for grazing and other resources to augment their meagre livelihoods, were outraged.

While the Queen was staying, sections of the wooden fence or 'pale' of the deer-park were burnt in a violent protest, despite the severe penalties if the protesters were caught.[25] With their livelihood being destroyed, the protesters must have felt they had nothing to lose. Gresham's actions were part of a much wider enclosure movement, which saw arable land across England converted into sheep pasture, a process which provoked continuous social unrest. With a rising population, it also helped drive landless peasants to migrate to London and other cities.

As Elizabeth and Sir Thomas dined together, what might they have discussed? Probably old times, and almost certainly money, since Sir Thomas was the superstar financier of the 1550s and 1560s. He had spent many years successfully managing England's finances and arranging international loans. In the process, he had become one of the wealthiest men in England.[26] Much of that time had been spent travelling to and from Antwerp, which, with its famous 'bourse' (Figure 2.1), was the financial centre of northern Europe. Now aged fifty-six, Sir Thomas's golden years were behind him. His huge financial success was no solace for the death of Richard, his only son and heir, in 1563, or for his increasingly poor health, caused by a bad fall from his horse. Indeed, within three years he would be dead from apoplexy. However, in 1576, he was still immensely powerful, and a few months earlier had drawn up his elaborate wills.[27] Although he had already created London's Royal Exchange in imitation of Antwerp, with no male heir he had decided to immortalise the Gresham name in other ways. His restless ambition takes us back to St Helen's in the City of London.

In 1543, the Worshipful Company (Guild) of Leathersellers had acquired the former nunnery of St Helen's, seized five years earlier by Henry VIII. The nunnery lay at the heart of the parish and the church was expanded into the former nuns' quire to accommodate a growing population. The east wing, the former nuns' dormitory, became the Leathersellers' elegant Livery Hall. The rest of the nunnery complex was then broken up into a dozen or so houses. Four were upscale properties, which were let at high rents to generate a useful annual income to help support the Leathersellers' activities. The cheaper properties were leased to people connected to the company, including their Clerk and Beadle.

The west and north wings of the former nunnery were converted into two impressive stone houses. The first of these, called The Cloister, stretched down along the side of the former cloister to the parish church and the Close. The nuns' cloister became its garden, an appealing feature in the heart of the City. The house attracted a succession of upmarket residents. In 1562, the lease was taken over by Richard Clough, who worked closely with Gresham and who had also become very rich.[28] At the time, Gresham and his wife were living in Lombard Street, in an upmarket house which was

however hemmed in among other properties. As Gresham and Clough began planning their merchants' exchange for London (Figure 2.2), perhaps it was visiting Clough's property with its 'cloister' garden that suggested to Gresham the idea of building a spacious new mansion nearby for himself around a large square courtyard. By 1566, as the (soon to be Royal) Exchange neared completion,[29] Sir Thomas had moved into his sumptuous new residence, Gresham House, built on the section of St Helen's parish which lay on the west side of Bishopsgate Street.[30] His new home was unusual in having a large square central grassed court and eight almshouses on the west side, where the site spilled over into the parish of St Peter-le-Poore (Figure 2.3). From the courtyard, the building would have looked more like a Cambridge college than a house. Maybe Gresham's plan to create London's first higher education institution originated at this time (Figure 2.4).

If not, the idea had certainly occurred by the early 1570s, when several people were developing similar plans.[31] One of these was Sir Humpfrey Gilbert, who took over the lease on the Cloister in 1573 (Figure 2.5).[32] This was the same man who we have seen 'founding' the British Empire a decade later. He had returned to London in 1570 from a campaign of savage repression against Irish rebels, to marry and also to serve as an MP in 1571 and 1572. However, he was clearly missing action, and he soon led a force of 1,500 soldiers across the North Sea in support of the Dutch rebels in the Spanish Netherlands. Within a few months, he had another rapid shift of interest and returned to London to settle in St Helen's to write and promote schemes for colonisation. Among the first of a stream of ideas, he made a proposal, *The erection of an achademy in London* (Figure 2.6), to Queen Elizabeth for an academy to teach young gentlemen a modern curriculum of science, applied mathematics and languages. He focused on orphans who became wards of court, noting that they:[33]

> [for] the most parte brought up in idleness and lascivious pastimes, estranged from all serviceable vertues to their prince and countrey, obscurely drowned in education, of purpose to abase their mindes, leaste, being better qualified, they should disdaine to stoupe to the marriage of such purchasers daughters.

Instead, Gilbert proposed an Academy so that:

> there shall be hereafter no gentleman within this realme but is good for something; whereas now for the most parte of them are good for nothing.

He proposed teachers in a dozen subjects, including Latin, Greek, Hebrew, divinity, logic and rhetoric. The latter to help the 'choyse of wordes, the buyldinge of sentences, the garnishment of figures, and the other beauties of Oratorie'.

Figure 2.1 The famous Bourse in Antwerp was the first purpose-designed commodity exchange in Europe and a symbol of the city's wealth and commercial dominance. Engraving by Ludovico Guicciardini *c.* 1581, printed 1612.

Figure 2.2 The financier Thomas Gresham had lived in Antwerp and organised the planning and building of London's (later Royal) Exchange which opened in 1565. Traders could shelter under the arcades in poor weather. Engraving by Wenceslaus Hollar, *c.* 1660.

Figure 2.3  In the 1560s, Sir Thomas Gresham built a magnificent mansion in St Helen's constructed around an arcaded central courtyard. The building was behind the houses fronting onto Bishopsgate Street. Engraving showing the view from the west. Etching by G. Vertue, 1739.

Figure 2.4  Sir Thomas Gresham left his mansion to be used as the new Gresham College after he and his wife died. This illustration shows the central courtyard surrounded by arcades, similar to the Royal Exchange. Engraving by James Taylor after Samuel Wale, 1761.

Figure 2.5  Portrait of the adventurer Sir Humpfrey Gilbert, MP, half-brother of Sir Walter Raleigh. He drowned in 1583 off the Azores, shortly after his occupation of Newfoundland, arguably England's first imperial acquisition.

Figure 2.6  Sir Humpfrey Gilbert's 1573 proposal for an Academy to give young gentlemen in London a proper education. This was possibly drafted when he lived in St Helen's. The detail of his submission to Elizabeth I, itemised to the penny, gives an indication of his wide-ranging interests but also his mercurial personality.

There were also to be professors of moral philosophy, mathematics and geometry. These were to help with practical skills including navigation, the use of artillery and riding. A doctor of physic was to teach medicine and surgery, a lecturer civil law, and other professors music and dancing. There were also to be special teachers for French, Italian, Spanish and Dutch, an early attempt to overcome the English inability to speak other languages. Elizabeth was probably delighted with such an ambitious project, until it became clear that she was supposed to pay for it. Gilbert's meticulously calculated annual budget, including the professors' pay of £50 per year, came to £2,966-13s-4d precisely. The project was a non-starter, but Gilbert probably discussed his plan with Gresham and his assistant Anthony Stringer in St Helen's. In the early 1570s, Gresham had been considering founding a college in Cambridge, but his desire for immortality in London, if not Gilbert's ambitious ideas, persuaded him by 1575 to establish Gresham College in London. Indeed, its home was to be his palatial mansion once he and his wife had died.

His will set out his vision in great detail and, more importantly, provided the wherewithal to finance it. Without an heir, Gresham aimed to ensure his eternal fame through matching his Royal Exchange, the heart of the City's business life, with Gresham College, to be the centre of London's higher education. One wonders if Gresham saw the former nunnery buildings as a possible temporary home for his college. He seems to have recognised that he was in decline, describing himself in 1572 as 'blynde and lame', but, still in his early fifties, he might have anticipated another decade of life. If he did see the former nunnery as a step towards his college, he changed his mind.[34] The lease of The Cloister was taken over by Sir John Pollard, MP (1527/8–1574).[35]

Instead, Gresham focused on turning his mansion into a college after his wife had died. However, his carefully laid plans were to be frustrated for many years. Two decades later, when Shakespeare moved into the parish, Gresham was long dead – but in what he had planned to be Gresham College, his ageing and immovable widow lived on.

Notes

1. The lease was actually signed on 13 April 1576. Shoreditch was then in the County of Middlesex and the first village outside London, beyond the direct control of the Lord Mayor. The medieval parish church of St Leonard that Shakespeare would have known was rebuilt in 1740. This new church contains a modern memorial to the many people associated with Elizabethan theatre who were buried there, including James Burbage, Richard Burbage, Cuthbert Burbage, Richard Tarlton, William Sly, Richard Cowley and Gabriel Spencer, who was killed a duel with Ben Jonson in Hoxton fields.
2. The Red Lion was in Stepney. Sometime around 1567, a stage of forty feet by thirty feet was constructed for this short-lived project. For the description, recorded in a subsequent court case, see the Shakespearean London Theatres website: <http://shalt.dmu.ac.uk/> (last accessed 20 July 2020).
3. The Red Lion in 1567 and the Newington Butts playhouse near Elephant and Castle *c.* 1576 were conversions or adaptions of existing buildings. The remains of the theatre were discovered by archaeologists in 2019.

4. Presumably, residents in the south and west of the City and in the populous suburb in Southwark would tend to go to the Rose playhouse on Bankside after it opened in 1587. All population figures at this time are only estimates, so 10 per cent is an approximation. Today, the National Theatre attracts the equivalent of roughly 10 per cent of London's population in a year.

5. Dates are the start of the surviving parish records. Outside the city wall – St Botolph (1558); inside – All-Hallows-by-the-Wall (1559), St Ethelburga (1671), St Martin Outwich 'by the well with two buckets' (1670), St Peter (1561) and St Helen's (1575). Norton Folgate was a small 'liberty' immediately to the north of St Botolph. In Paul Slack's detailed study of the impact of the plague in London, he calculates that three of these parishes – All-Hallows-by-the-Wall, St Ethelburga and St Botolph, Bishopsgate – were, on average, among the ten poorest parishes in the City. This was based on about half the parishes where records survive. There is no comparable data for St Helen's, St Martin Outwich and St Peter; see Slack, *The Impact of Plague in Tudor and Stuart England*, Fig. 6.7 and Table 6.4.

6. During the medieval period, housing developed outside all the city gates creating extramural parishes. These typically had one church but could cover a large area. Following the dissolution of the monasteries, many of the monastic sites were broken up for housing.

7. On 5 September 1538, Thomas Cromwell ordered the keeping of parish records of all baptisms, burials and marriages. This was a result of the split of England away from the papacy. These records were meant to be kept in a wooden chest. However, early records are often lost.

8. His name is spelt Colshill, including in his will (TNA PROB 11/85/243), and Coleshill. Here it is spelt Coleshill throughout.

9. Thomas's brother Robert was also an MP and courtier (died 1580).

10. In 1561, he had also acquired the rectory rights of St Helen's with Dr Caesar Adelmare, so he would also have known the precise tithe payments for every household.

11. John Robinson the Elder and his wife Christian eventually had sixteen children, who you can still see today carefully carved on his wall memorial in St Helen's church (see Figure 13.1).

12. At least five of the ten wealthiest male residents listed in the 1576 roll eventually warranted an expensive funeral monument. Thomas Gresham (buried 1579), John Robinson the Elder (1600), Edward Skegges (1582 – now lost) and at nineteenth, William Kerwyn (1594 – a charming self-built structure, as he was a freemason) were all buried in St Helen's; Thomas Coleshill (1595) memorial at St Mary, Chigwell, then in Essex; Clement Kelke (1593), brass at St Michael, Bray, Berkshire; and William Burde (1591), brass plaque at St Nicholas, Denston, Suffolk were all buried in the churches where their country estates were located. James Lomeley, at seventeenth, had a brass plaque added to his father's grave slab in St Helen's. There is also the memorial to William Bond (1576) in St Helen's, although he had died just before the subsidy listing was made.

13. Five men and four widows, who had stayed on in their houses after the death of their husbands. Of the men, John Robinson the Elder and Robert Spring, who lived next door to each other in Little St Helen's on the Leathersellers' Estate, were very much the elder statesmen of the parish, along with William Kerwyn, a freemason. It is harder to track the poorer households, who did not pay the subsidy. However, at least five heads of households and two surviving widows recorded in 1576 were still living in the parish in 1596. These figures suggest that, on average, four English families disappeared from the parish every year over the twenty years from 1576 to 1596. In contrast, the only 'stranger' family to continue through from 1576 seems to have been Margaret Fontaine, who moved or died sometime between 1594 and 1598. The Jeffreys (see section 8 of the Appendix) seem to have left before 1576 and later received denization, moving back to St Helen's in the 1590s.

14. Clement Kelke (1523–93) was probably from Bristol. A freeman of the Haberdashers, he married the much younger Elizabeth Becher (1540–1612) at St Christopher-le-Stock in 1560, but they had no children. His wealth and status allowed him the time to be a governor of Bridewell, regularly being a member of the court that handed out harsh punishments to errant apprentices, prostitutes, pimps, coseners and vagrants. Along with a John Alsop, he was also one of three governors responsible for the separate Bethlem Hospital, 'Bedlam', outside Bishopsgate. By 1598, this was in an appalling state, but it is not clear whether these conditions dated back twenty years to when he was responsible in the late 1570s.

15. Several documents in the National Archives relating to Skegges record the use of violence; see also TNA STAC/A57/3 for when he had to face the Attorney General. He rose from being Serjeant of the Buttery at Court and was assessed at £80 in the 1576 Lay Subsidy roll. His will is TNA PROB 11/61/23.
16. He was the father of Thomas Lodge the writer. When the penitent Stephen Gosson had, in 1579, published his *Schoole of Abuse*, Lodge responded with his *Defence of Poetry, Music and Stage Plays* (1579 or 1580).
17. Due to high infant mortality, it was normal practice to baptise babies within a day or two of birth.
18. There was a low of only nine births in 1579, perhaps reflecting the impact of the 1578 plague.
19. Information from St Helen's burial register.
20. The average over the decade, excluding the 1578 plague year, was thirteen burials. By Shakespeare's time in the 1590s, the annual average in non-plague years had risen by 50 per cent to twenty-one, or nearly two burials every month. This rise is probably due to the increase in London's population during the last two decades of the sixteenth century, but may also reflect a population weakened by outbreaks of plague and rising prices of staple foods.
21. His death had at least one repellent consequence. His son, William Bond junior, seems to have used his large inheritance of £1,000 to widen his sexual experience with a young woman named Marie Griffen. She recounted two years later to the Court of Bridewell, on 5 April 1578, how she had been procured by the wife of John Ivett at Whitechapel. Away from nosey neighbours, Bond junior paid £3 for Marie, a large sum equivalent to nearly two months' wages for the minister of St Helen's (a more usual charge was 6d to 3 shillings). Marie stated in court that 'he went aboute to abuse her but he could not but hurte her. . . . Then Ivettes wife sent her to one Gillat a surgeon by Al[d]gate to heal her and paid viii s[hillings] for healing her' – see Bridewell Hospital Minute Book BCB-03, <https://archives.museumofthemind.org.uk/BCB.htm> (last accessed 20 July 2020).
22. On 1 December 1567, De Silva, the Spanish ambassador, wrote to Philip II: 'Five days since, by order of the Queen, all the houses in this city were visited and a memorandum taken of the people living therein, with the parish churches where they attend divine service, and what religion they profess, also in the case of foreigners how long they have been here. This has been done on previous occasions, but they say never with so much care. The Queen told me she was going to have this enquiry made in order to learn who had come to this country since the beginning of the disturbance in Flanders, the numbers, rank and religion of such people, and to make proper regulations with regard to them' (see <https://www.british-history.ac.uk/cal-state-papers/simancas/vol1/pp685-690>, last accessed 4 August 2020). The Bishop of London's Certificate of the Strangers in London gave the totals as: Dutch, 2,993; French, 512; Italians, 128; Spaniards, 54; Scots, 36; Portingals [Portuguese], 23; Venetians, 10; Grecians, 2; Blackamoors, 2; see Haynes, 'The Bishop of London's Certificate', pp. 455–61. In St Helen's, there were thirty-four adult men, twelve wives, eight children, one relative, a seamstress and seven servants listed in 1568.
23. In July 1576, proposals were drawn up and annotated by Lord Burghley for 'Reformations to be had and put in use for the diminution of the great expenses of her Majesty's house'; see *FECDD*, 1576, p. 27.
24. Elizabeth was an accomplished horsewoman and, if the day was warm, riding would probably have been preferable to a stuffy coach, with poor suspension on rutted roads.
25. The Acts of the Privy Council for their meeting on Tuesday, 22 May 1576 recorded that 'certaine persons are committed to the Marshalsey [prison], whose names are Johan Ayre, Mary Harris, George Lenton and George Bennet, for burning Sir Thomas Gresham's parke pale [fence] at the tyme when the Quenes Majestie was there, wherewith her Highness was very much offended, and commanded that the offendours should be searched out and punished . . .' However, by 19 July, the tone of the council had softened somewhat, having received a petition of support for the protesters. The investigators are asked to 'examine what detriment the pore men do receve by the meanes of this inclosure, what cattell they mought kepe afore, and what they may kepe now . . .'
26. See Blanchard, 'Sir Thomas and the House of Gresham', and Guy, *Gresham's Law*.
27. See Guy, *Gresham's Law*, pp. 205–8, TNA E 163/14/7 and PROB 11/61.

28. Born *c*. 1530, Richard Clough was a decade younger than Sir Thomas Gresham. His family came from Denbigh in Wales, where his father, like Shakespeare's, was a glover. He had a very close working relationship with Gresham, writing long reports on his activities in Antwerp, many of which still survive. He was central to the planning of the Royal Exchange, first proposed in 1500, and he probably moved to St Helen's to be close by for supervising the construction. The spectacular building relied on a Flemish architect and builders, and materials were also brought over from Flanders. Clough married his second wife, Katherine of Berain, in 1567 and, in the late 1560s, built two Flemish-inspired houses near Denbigh.
29. In 1571, Queen Elizabeth visited the (Gresham) Exchange and gave it her seal of approval by allowing it to be called the Royal Exchange, thus removing Gresham's name.
30. Gresham acquired almost an acre of land for his mansion. Today, the site is occupied by Tower 42.
31. Two recent publications were Roger Ascham's *Scholemaster,* 1570, and Sir Thomas Hoby's (1530–66) translation into English of Baldissare Castiglioni's *Il Cortigiano or The Book of the Courtier* (1561). These ideas stretched back four decades to the interests of Nicholas Bacon, MP (1510–79). He was appointed attorney of the Court of Wards and Liveries in 1546, and thus had an interest in the education of young men. Among various ideas was the suggestion of founding a new inn of court focusing on the ideals of a humanist academy, rather than just law. Bacon's ongoing interest led him to make a written proposal to Elizabeth I in 1561, shortly after her accession.
32. In 1570, Clough, aged forty, went to Hamburg and caught an unknown disease from which he died. Only his heart was brought back to Wales for burial. Anthony Stringer, who worked for Gresham, took over the lease. The following year it was leased to Sir Thomas Gresham, who sub-let it to Gilbert. Information for all these leases is in the Leathersellers' *Copies of Leases and Deeds, 1555–1660* – ref EST/8/1. In 1575 Gilbert seems to have moved back to his house in Limehouse, where Henry Gascoigne visited him.
33. In the Elizabethan period, wards fell under the control of the Court of Wards and Liveries, where wardships were a commodity which could be bought and sold. Ownership brought an enjoyment of the ward's estate until a male reached twenty-one or a female sixteen.
34. He took a twenty-one-year lease and paid a premium of £100, split into five £20 payments, which suggests Gresham considered he had some years ahead of him. Interestingly, several other ex-nunnery properties became available in 1572–4, so perhaps Gresham thought he could assemble a larger holding. The largest, probably the former north wing of the nunnery containing the nuns' dining room (frater) was occupied by 'Master Dereham' in 1572, probably Baldwin Dereham (*c.* 1531–1610), since his wife was Margaret Hethe and he took over the lease from a 'Master Heathe'. The Derehams were part of a group of closely interconnected gentry families in west Norfolk who had large wool operations. They left two years later and the property was then taken on a forty-year lease by Alderman John Robinson the Elder, Merchant of the Staple, who lived there for twenty-six years with his wife and sixteen children.
35. He died within a year, but his widow lived on there for another eight years. She was buried in St Helen's on 3 April 1585. In the 1540s and 1550s Sir John owned Forde Abbey in Somerset, which today is one of the best places to see the conversion of a monastery to domestic use. He, like Sir Humpfrey Gilbert, was involved in plans to colonise Munster in Ireland, which may account for why he took over the property. Other residents in the former nunnery included 'Mistress Seiliarde', possibly related to John Sulyard (1518–1575), MP from 1553 until 1558, and 'Mistress Garwey', who married John Povey.

# 3

## Kick-Starting the British Empire

*In which a voyage to China in 1576 ends up somewhere completely different; how a black stone found on a Canadian beach inspired gold fever in London; and how Queen Elizabeth I was persuaded to invest £1,000 in the money-making scheme.*

Meanwhile, the mercurial Humpfrey Gilbert had another pot on the boil. Until 1550, England's overseas focus was on retaining Calais and the surrounding area as its entrepôt to the Continent. Despite some earlier English voyages of exploration, the European 'New World' had largely been carved up between the Portuguese and the Spanish.[1] New shipping routes across the Atlantic increasingly undermined the old overland trade routes from Asia which had made Venice rich. Iberian expansion was rapid and in 1565 the Spanish began colonising the Philippines as their base for trading with China. In 1571, Manila was founded as the capital of the Spanish East Indies and the destination of the 'Manila Galleons' treasure ship route from Acapulco in Mexico, loaded with silver.

London's ambitious and canny merchants were aware of these developments but were constrained by their government's fluctuating relationship with Spain and Portugal, who claimed a monopoly on these trade routes. Despite ongoing tensions, Elizabeth was careful not to antagonise them too far. Above all, English merchants wanted to find a sea route to the fabulous riches of Cathay (China). Hardened shipowners and captains argued the possibilities of a northern route through the Artic seas, which were believed to be navigable during the summer months. While this idea may seem wildly ambitious today, such a route was much shorter than sailing around the Cape of Good Hope with all the perils of the African coast and Portuguese opposition.

Finally in 1551, Richard Chancellor and Sir Hugh Willoughby, advised by Sebastian Cabot (*c.* 1474–1557),[2] established the 'Company of Merchant Adventurers to New Lands' to look for the 'North-East Passage' to China by sailing north of Norway and Russia.[3] The first voyage in 1553, which survived great hardships, eventually made contact with the Tsar Ivan the Terrible in Moscow. The Company was then rechartered as the Muscovy Company in 1555 to progress the trading opportunities in Russia. It was the first major example of a chartered joint stock company, a structure which allowed the sharing of risk between investors and a critical development in the evolution of early capitalism.[4]

The opening up of the Russia trade did not stop the London mercantile community debating alternative ways to get to China without crossing Portuguese and Spanish

Figure 3.1 Sir Martin Frobisher was commander of three expeditions in 1576–8 to discover the 'Northwest Passage' to China (Cathay), which were organised in St Helen's. Oil painting by Cornelius Ketel, 1577. Ketel painted a set of five portraits of people involved in the expedition, as well as the Inuk man brought back to London in 1576.

interests. However, the ice and appalling weather in northern Russia persuaded many people that a North-East Passage was impossible and that a North-West Passage around America was more likely. Furthermore, such a route would only go past lands occupied by 'savages', which could be colonised, unlike Russia. Among this group was Humpfrey Gilbert. In late 1566, while back from fighting in Ireland, he presented Queen Elizabeth with a manuscript copy of his *A Discourse of a Discoverie for a New Passage to Cataia* (Cathay/China).[5] The level of detail Gilbert had assembled indicates his commitment, although the argument based on the location of unicorn horns shows how fact and fiction could get easily confused. Furthermore, the quality of English maps, such as Gilbert's in 1576 and George Best's in 1578, was poor at this time.[6]

Gilbert's published version ends with typical panache:

Desiring you hereafter, never to mislike with me, for the taking in hand of any laudable and honest enterprise, for if through pleasure or idlenes we purchase shame, y<sup>e</sup> pleasure vanisheth, but the shame remaineth for ever.

And therefore to give me leave without offence, always to live and die in this minde, *'That he is not vvorthie to live at all, that for feare, or daunger of death, shunneth his countrey service, and his ovvne honour'* seeing death is inevitable, and the fame of vertue immortall. Wherfore in this behalfe, *Mutare vel timere sperno* [I scorn to change or to fear].

FINIS.

However, Gilbert's petition to be allowed to explore for the North-West Passage was rejected by the government on the advice of the Muscovy Company. In 1567, Gilbert was sent back to Ireland as governor of Ulster, and he was distracted by plantation proposals there for several years. It was not until he was settled back in London in St Helen's in 1573 that he became mixed up in transatlantic exploration again. The tangled origins of the expedition, which eventually became Martin Frobisher's First Voyage in 1576 (hopefully to Cathay) have recently been examined in detail (Figure 3.1).[7] In 1574, Frobisher petitioned the Privy Council for permission and financial support to lead an expedition to find a North-West Passage to 'the Southern Sea' (the Pacific Ocean) and thence to Cathay. Although initially rebuffed by the Muscovy Company, which had the monopoly of exploring to the north, Frobisher was eventually granted permission, probably due to some arm-twisting by the Privy Council. By then it was too late to set off in 1575, so the expedition was prepared for 1576.

Of the six people who got the project underway, at least four lived within a few yards of one another in St Helen's. Sir Humpfrey Gilbert and William Bond lived opposite each other in the Close, in the Priory and Crosby Hall respectively. Thomas Gresham and William Burde both lived immediately outside the Close, in Bishopsgate Street. It is not

Figure 3.2 The Thames frontage of Greenwich Palace, where Elizabeth I said farewell to Martin Frobisher's first expedition to Cathay in 1576. Sketch by Anton van den Wyngearde, 1558–9.

clear where Michael Lok, who managed the practical organisation, was living at this time, but he may have had accommodation at the east end of the Close.[8] The records of the Frobisher voyage are remarkably well preserved and even record that the group met in Crosby Hall, Michael Lok later recalling: 'Mr. Alderman Bonde, now deceased, at whose house we had divers conferences of the maters'. Lok, Bonde, Gresham and Burde[9] each put up a £100 investment, contributing nearly half of the initial cost of £875. With their investment, Frobisher and Lok had secured the support of three key players within London's business community and major credibility for attracting other funders.[10]

By the 19th of May, Queen Elizabeth had finished her short tour through the countryside and was now at Greenwich Palace, which fronted directly onto the Thames (Figure 3.2). Eleven days later, on the 30th of May, Alderman William Bond, one of the key backers of Frobisher's attempt to discover the North-West Passage, died at Crosby Hall. The merchant, who had traded ivory from the African gold coast, would never know if his dream of a direct route to Cathay would be realised. He was given a prestigious funeral in St Helen's, while at Blackwall on the Thames the final preparations were being made on board the *Gabriel*, the *Michael* and a small pinnace, which would be used for exploring inshore. The total crew to cross the Atlantic was just thirty-five men. The ships would appear tiny to us today, only twenty to twenty-five tons apiece. On Thursday, 7 June 1576 the expedition weighed anchor and caught the tide downriver. The following day, Captain Martin Frobisher recorded: 'About 12 o'clock we weighed at Deptford, and set sail all three of us, and bore down by the court [Greenwich Palace], where we shot off our ordnance and made the best show we could. Her Majesty beholding the same commended it, and bade us farewell, with shaking her hand at us out of the

window. Afterward she sent a gentleman aboard of us, who declared that her Majesty had good liking of our doings, and thanked us for it, and also willed our Captain to come the next day to the court to take his leave of her.'

On Sunday, 10 June, in an independent Scotland, it was the tenth birthday of James VI. While his mother, Mary ex-Queen of Scots, was held prisoner in England by Elizabeth, a succession of regents had ruled the country. From 1572 until 1578/9, James Douglas, 4th Earl of Morton, was regent, and had Elizabeth's support as he tried to pacify the country. By 1576, it was increasingly clear that Elizabeth was unlikely to have children and that James, although still a child, had a good chance of eventually inheriting the English throne.[11] For the next three decades, struggles over Elizabeth's succession were increasingly to dominate politics.

Sometime around July 1576, the Theatre opened for business. The building was probably not properly finished, but with spiralling costs, Burbage and Brayne needed to generate some income to avoid financial disaster. As we will see, they were able to hold onto their development, but only just. The first months must have been tense, as they had to build a new audience from scratch. Unfortunately, there are no records of what plays were performed.

Meanwhile, with fine weather, at the court at Greenwich Palace plans were being made for Elizabeth's main summer progress across the Midlands. Perhaps surprisingly, spa water for medicinal purposes featured large. On Friday, 6 July, Gilbert Talbot wrote to his father, the 6th Earl of Shrewsbury:[12]

> Since my coming hither to the court there hath been sundry determinations
> of her Majesty's progress this summer. Yesterday it was set down that she would to Grafton, Northampton, Leicester and to Ashby, my Lord Huntingdon's house, and there to have remained 21 days, to the end the water of Buxton might have been daily brought thither for my Lord of Leicester or any other to have used . . .

The hot water springs at Bath were also becoming a spa destination:

> Mr Secretary Smith [presumably Sir Thomas Smith, Secretary to the Privy Council] lieth still in hard case at his house in Essex, and as I hear this day or tomorrow setteth towards the baths in Somersetshire [Bath]; the use of his tongue is clean taken from him that he cannot be understood . . .[13]

Late in August 1576, a small group of men trudge along a rocky beach. They are wearing thick cloaks against the cold and are heavily armed against possible attack by the local Inuks (Figure 3.3). They are hardened sailors and adventurers, but even they are awed by the scale of the Canadian Arctic. Memories of their royal farewell from Greenwich

Living with Shakespeare

Figure 3.3  When Frobisher's expeditions reached northern Canada they came into conflict with the local Inuks. In 1576, five of his men were captured and Frobisher seized an Inuk man, whom he brought back to London. Cornelius Ketel painted the Inuk in his St Helen's studio and also made a wax death mask. Illustration from second expedition in 1577.

only two months before have been scoured away by the bitter weather and the loss of two ships. A hundred yards offshore the survivor, the *Gabriel*, rocks at anchor, silhouetted like a tiny insect against the vast landscape. The ship has been their crowded, damp, dark, creaking home for eight weeks as they have battled through Atlantic storms and up the Canadian coast, seeking the fabled North-West Passage which would provide a sea route through to Cathay and the wealth of China. Eventually, blocked by ice and winds to the north, they have turned in to a huge strait which their commander, Martin Frobisher, believes is the route through to Asia.[14]

Ahead is the ship's boat, dragged up on the shingle beyond the reach of the huge tides. So far, the expedition, mounted at great cost, has been largely unproductive in financial terms. Although the main purpose is a route to China, discovering mineral deposits or other resources worth exploiting will help gain extra investors. Just as they get close to their boat, the ship's master, Robert Garrard, looks down and sees an interesting rock, later described as a black stone 'as great as a half-penny loaf'. Thinking it might be sea coal and hence of use for heating the ship's galley, the men carry their find to the boat and back to Frobisher.

Little did Garrard know what trouble that black stone would cause, and little would he care. A few days later, he and four other sailors were seized by Inuks on the beach and carried away beyond the expedition's reach. With further exploration disrupted by the search and with supplies running low, Frobisher abandoned them and turned for home. Inuk oral tradition recorded that Garrard and his colleagues lived with them for some time, and then drowned attempting to leave in a boat they had constructed.

Two and a half thousand miles away, in St Helen's, the black stone eventually ended up in the hands of Margaret Adelmare, or Lok. Little is known of Margaret, but she must have had a strong personality, as she became the wife of two remarkable but very

different men. Born Margaret Perient (or Perrin), probably in the 1530s, her family origins are uncertain. However, she made an excellent first marriage to a recently arrived immigrant, Dr Cesare Adelmare, brought up in the Venetian Republic and trained at the University of Padua. He came to London *c.* 1550 for unknown reasons, but he clearly had an excellent reputation. He was soon a medical advisor to Queen Mary, who gave him naturalisation in 1558, and then to Queen Elizabeth. Margaret probably married him *c.* 1556, as in 1557/8 she gave birth to the first of their eight children, whom they named Julius Caesar – a memorable name for a baby who would become a super-achieving lawyer, judge, civil servant, MP and Master of the Rolls. With a growing family and reputation, the Adelmares moved into the Close of St Helen's in 1561, where they acquired the former house of another Italian doctor, Bartholomew Guercy/Gwercy.[15] Since Dr Adelmare was supposedly paid £100 by Queen Mary for one consultation, they presumably lived in some style. In 1567, Adelmare, with a leading local citizen, Thomas Coleshill, acquired the rectory rights to the parish: a good example of a foreign immigrant becoming part of the local establishment.

Dr Cesare Adelmare died in 1569, leaving Margaret with eight children under twelve. She eventually remarried and became Mrs Lok. Michael Lok, her new husband, could not have been more different from Dr Adelmare, and brought her a roller-coaster life as well as another eight children from his first marriage.[16] His forty or so years had been filled with adventure, foreign travel, command at sea and a ruthless desire for success. When Frobisher docked the *Gabriel* back in London on 9 October, Lok was there to learn what Frobisher had achieved. Frobisher, with little to show apart from hopes for a second voyage, gave Lok the black stone – the first thing brought back from the newly christened 'Queen Elizabeth's Foreland' and a symbol of English possession.[17] Lok took the stone back to his house in St Helen's. What happened next is unclear. The best account, but it sounds rather like a fairy tale, is that Margaret threw the stone on the fire but then fished it out, washed it with vinegar and noticed that it 'glistered with a bright marquesset of golde'.[18] In an Elizabethan London, fascinated with alchemy, flecks of gold were the first step to solid gold and enormous wealth.

George Best (1555–84), who documented Frobisher's voyages, recorded:

Wherupon y^e matter being called in some question, it was brought to certain Goldfinders in *London*, to make assay therof, who indeed found it to hold gold, and that very ritchly for the quantity. Afterwards, the same Goldfinders promised great matters thereof, if there were anye store to be found, and offred themselves to adventure for the serching of those partes from whence the same was brought. Some that had great hope of the matter, fought secretly to have a lease at hir Maiesties hands of those places, wherby to enioy the Masse of so great a publike profit, unto their owne private gaines.

In an eight-page letter to Elizabeth I, dated 22 April 1577, Lok detailed what then happened over the next six months as gold fever spread through the court and the City. To understand this phenomenon, it is necessary to take a short detour into Elizabethan beliefs in alchemy, astrology and witchcraft. Today, in a relatively rational modern culture, the general acceptance of these beliefs by Elizabethans is perplexing – and the wide appeal of alchemy to, among others, the Queen and many of her advisors such as Sir William Cecil, Lord Burghley,[19] is especially challenging. Yet, in the context of the time, it was much less strange. Although prospecting, mining and smelting ores had been advancing, the activities of metallurgy were still primitive and surrounded by much mystery.[20] If coal could become ash, water could become steam and ore could turn into pure metal, the concept of transmutation did seem to have some credibility. Suffice it to say here that there were several alchemists in the north-east part of the City. Five are recorded in the parish of St Botolph Aldgate, and three in St Helen's itself.[21]

Lok first sent samples of his black stone to assaying specialists at the Royal Mint, located inside the Tower of London and elsewhere.[22] Their response was negative. Lok then got in contact with Giovanni Baptista Agnello (d. 1582).[23] Agnello was a fascinating but shadowy St Helen's resident. He grew up in Venice, and was recorded as an alchemist. He was the author of a book on alchemy, the second book in Italian printed in England: *Espositione di Giouanbatista Agnello Venetiano sopra vn libro intitolato Apocalypsis spiritus secreti*. In 1569, Jean de Ferrieres, a French Huguenot aristocrat and refugee, recommended him to Sir William Cecil as 'a man of honest and industry'.[24] Agnello knew Dr John Dee, England's most famous investigator of alchemy, and is thought to have given him a copy of Pantheus' *Voarchadumia contra alchimiam: ars distincta ab archimia, & sophia: cum additionibus: proportionibus: Numeris & Figuris* (Venice, 1530). Dee also had a copy of Agnello's book on alchemy.[25] His 1568 description as a 'distiller of waters' suggests he operated where the medical and scientific communities overlapped. Presumably, he would have been well known to Dr Cesare Adelmare as a fellow Venetian and neighbour in London; perhaps they worked together. Harkness says he operated a 'dangerous blast furnace' in St Helen's.[26]

Agnello, in contrast to the other assay specialists, claimed to have found a worthwhile amount of gold in his sample, asserting that this was as a result of his special expertise. There then followed a convoluted stage of technical analysis and negotiations in spring 1577,[27] which was inconclusive but persuaded many that there was a fortune to be made in the new lands. Investors now flocked to put their money into Frobisher's second (1577) and third (1578) voyages.[28] The two later expeditions focused on bringing large quantities of ore back to London, and the search for the North-West Passage was put on hold. A special furnace was constructed at Dartford, near Powder Mill Lane, where processing could take place well away from public gaze.

In the end, the huge investment in time and money, including £1,000 from the Queen, turned out to be completely wasted. There was no gold, and the 1,200 tons of Canadian rocks were used to build a wall around Dartford manor house and to metal the nearby roads. Perhaps they still exist today, somewhere under the A207.[29]

However, although the exploration flame lit in St Helen's may have flickered, it did not go out. As we have seen, within a few years Sir Humpfrey Gilbert had kicked off the British Empire by cutting a turf out of Newfoundland in 1583. More significantly, two months after Frobisher's second expedition made it back to Britain, Francis Drake weighed anchor with five ships at Plymouth on 17 November 1577 and set off west with the aim of forcing his way through into the Spanish-controlled Pacific. As it turned out, this led to Drake's epic voyage lasting thirty-four months. On 26 September 1580 he sailed into Plymouth Sound on the *Golden Hind*, his one remaining ship, with the fifty-nine surviving crew (Figures 3.5 and 3.6). They were the first Englishmen to circumnavigate the Earth. It was an extraordinary achievement. Moreover, inside the ship was a fantastic haul of captured Spanish treasure and valuable spices. Elizabeth's 50 per cent share of the booty was worth more than the crown's income for that entire year. So, just fifteen or so years before Shakespeare moved into the parish, St Helen's was a hotbed of intrigue and experimentation as gold fever and human cupidity combined to finance global exploration. When Shakespeare first walked into the Close of St Helen's, was this extraordinary frenzy all forgotten, or did the locals still point out the former houses of Gilbert, Bond, Lok, Burde, Agnello and Gresham?[30]

Figure 3.4   The Inuk Kalicho was brought back to Bristol by Frobisher's second expedition in 1577. Using his kayak, he demonstrated his duck-hunting skills on the River Avon, but within a month he was dead. Watercolour by the artist John White, who also accompanied the 1585 expedition to found the short-lived Roanoke colony.

Figure 3.5  Sir Francis Drake, MP's circumnavigation of the globe in 1577–80 transformed England's relationship with the world. This portrait shows the 'Drake jewel' given by Elizabeth I and now displayed in the V&A Museum. Oil on canvas by Marcus Gheeraerts the Younger, 1591.

Figure 3.6  Sir Walter Raleigh, MP, courtier, politician and explorer, was half-brother to Sir Humpfrey Gilbert. After the latter's death, Elizabeth I gave Raleigh a seven-year charter to colonise overseas, which led to the 1585 Roanoke colony in what is now North Carolina. Later, while imprisoned in the Tower, Raleigh was a patient of Dr Peter Turner of St Helen's.

In any case, back in the autumn of 1576, the financial disaster of Frobisher's voyages all lay in the future, and St Helen's was probably full of enthusiasm for the heroic adventurer. Furthermore, it was a project planned, funded and executed from London.[31] Locals could feel proud, particularly as they viewed the turbulent international situation across the Continent, Mediterranean and North Africa. Two events demonstrate that international turmoil.

Across the Mediterranean, the centuries-old struggle for dominance of the trade routes continued. The Christian success at the Siege of Malta in 1565 and the Battle of Lepanto in 1571 had halted the Ottoman military machine in the Mediterranean, but within a few years Turkish forces were advancing again on land through the Balkans, threatening Vienna. Indeed, the rule of Murad II in 1574–5 saw the Ottoman Empire reach its greatest extent. In retrospect, the seeds of its decay were already developing, but in the 1570s and 1580s the Turks still seemed like an all-powerful force that might sweep Christianity out of much of Europe.[32] Their influence also now stretched across North Africa, threatening to turn the southern flank of Christendom. In March 1576, Abu Marwan Abd al-Malik I Saadi captured Fez, the capital of Morocco, with Ottoman support.[33]

Meanwhile, news was filtering back to London of a terrible outbreak of plague in Venice.[34] This epidemic had started in 1575, died down in the cold months of early 1576 and then started to reappear again in the summer with special virulence. Experts estimate that *c.* 50,000 citizens died (25–30 per cent of the population). The victims included the painter Titian, who died on 27 August, shortly followed by his son and only heir. Hieronymus Mercurialis (1530–1606), professor of practical medicine at Padua University, recorded:

> from the middle of July [1576] all the symptoms [of plague] became more painful, many sick people appeared, deaths were more frequent. And all these things took on an increase throughout August and September, and also the beginning of October; in which months, if all factors be carefully assessed, it may be decided without difficulty that the sickness was at its full strength.[35]

Back in London, as noted above, recorded burials at St Helen's were at their lowest level in 1576. However, plague eventually caught up with London, with a severe outbreak in 1578, a milder attack in 1587 and then vicious outbreaks in 1592–4 and 1603. London was a city where one could achieve great fame and fortune, but it was also a city where lives could be struck down by a fatal infection in a day or two. Migrants, whether from rural England or the cities of Holland, with little inbuilt natural resistance, were particularly at risk.

On Saturday, 17 November 1576, Elizabeth I celebrated Accession Day, the eighteenth anniversary of her coming to the throne in 1558. The Queen's printer, Richard Jugge,

produced, 'A Form of Prayer with Thanksgiving to be used every year, the 17th of November, being the day of the Queen's Majesty's entry to her reign'. Parish churches all over England rang their bells and in some towns there were celebratory bonfires and banquets.[36] The sound from over a hundred church bell towers in the City of London must have been extraordinary.

Christmas 1576, like 1575, was spent by Elizabeth at Hampton Court Palace. The accounts record various entertainments: on Wednesday, 26 December, *The Painter's Daughter*, performed by the Earl of Warwick's Men; on Thursday, bear baiting by mastiff dogs, and the play *Tooley*, performed by Lord Howard's men; and on Sunday, 30 December, *The History of the Collier*, deferred from Friday, performed by the Earl of Leicester's Men. On Tuesday, 1 January, *The History of Error* was performed by the Children of Paul's. The Queen also received her traditional gifts from her courtiers – this year the 197 presents included £10 from the Earl of Shrewsbury and 'a gown of tawny satin . . . lined with yellow sarcenet' from the Countess. Lord North also gave £10, but recorded losing £70 gaming with the Queen.

1576 turned to 1577, to 1578, to 1579, to 1580. Back in Stratford-upon-Avon, Shakespeare, despite his father's financial problems, probably passed his early to mid-teens at the town's grammar school, still hopeful that his abilities might gain him a place at Oxford or Cambridge.[37] In spring 1581, the seventeen-year-old Christopher Marlowe's previously parallel life now diverged sharply. He finished at the King's School, Canterbury, and was awarded a scholarship to attend Corpus Christi College, Cambridge, where he graduated BA in 1584. It would have been unusual to stay at school after sixteen, so the fact that William was still in the town two years later has led experts to suggest that his father's financial problems prevented him taking up further education.[38] If university was not possible, there was always the opportunity of an interesting apprenticeship in a potentially lucrative trade. In 1579, Richard Field (1561–1624), a near contemporary and possible boyhood friend of William in Stratford, had secured an apprenticeship with the leading London printer Thomas Vautrollier, a French Huguenot refugee.[39]

However, as Shakespeare turned eighteen in 1582, events were to unfold in a very different way to the rapid progress of Marlowe and Field. Sometime during the summer, he formed a liaison with the unmarried Anne Hathaway, eight years his senior. Marriage to the pregnant Anne followed in November and their first child, Susanna, was christened on Sunday, 26 May 1583. Marriage at eighteen was extremely rare at this time – indeed, Shakespeare was one of only three teenage bridegrooms in Stratford-upon-Avon between 1570 and 1640.[40]

Whatever the details, at a stroke, Shakespeare had ruled out Oxbridge or an apprenticeship, since for both one needed to be unmarried. The fact that Shakespeare soon, still aged only twenty, had two more children suggests that by 1584 he had accepted

his future lay in rural market-town middle England. We hear no more of him until 1592. Although there is much speculation, there is no certainty about the next seven 'lost' years, except that at some point, as he aged from twenty-one to twenty-eight, some process took him to London. Perhaps he walked, perhaps he rode, perhaps it was a week on the back of a jolting carrier's cart, perhaps it came at the end of months of touring the provinces with a theatre company. He could have arrived drifting by barge down the Thames from Oxford or in a sailing ship in an easterly blow, rounding into Limehouse Reach and seeing the towers of the City's churches for the first time. He could have entered the City through one of its seven ancient gates or crossed over from Southwark by London Bridge, one of the sights of Europe. We do not know and probably never will. However, like every immigrant through time, after the emotion of arrival there was the nagging worry of finding a place to live and earning enough to survive. Perhaps his first time in London was just a visit, staying with contacts of friends in Stratford-upon-Avon. However, at some point – maybe in 1589, maybe in 1590, maybe a bit later – Shakespeare made a decision to separate from his family, friends and home town to settle in London. There he was to become the world's greatest writer, as well as a successful poet and, of course, a 'player'.

Notes

1. Following disputes between Portugal and Spain, the Treaty of Tordesillas, signed on 7 June 1494, divided the 'New World' beyond Europe in two between the Portuguese Empire and the Crown of Castile [Spain], along a meridian 370 leagues west of the Cape Verde islands.
2. Sebastian was son of the Venetian John Cabot, who had sailed in the *Matthew* from Bristol in 1497 and reached Newfoundland. In the 1520s, he worked for the king of Spain exploring the coast of South America. In old age he moved back to London, where he became a governor of the Muscovy Company.
3. Its full name was the 'Mystery and Company of marchants adventurers of England, for the discovery of lands, territories, iles, dominions, and seigniories unknowen, and not before that late adventure or enterprise by sea or navigation, commonly frequented'.
4. In 1577, the Company was given the monopoly of whaling, an important source of oil and baleen. This activity was focused in the North Atlantic.
5. This was eventually published in 1576 as *A discourse of a discouerie for a new passage to Cataia. VVritten by Sir Humfrey Gilbert, Knight. Imprinted at London : By Henry Middleton for Richarde Ihones, Anno. Domini. 1576. Aprilis. 12.*
6. See discussion in MacMillan, *Sovereignty and Possession in the English New World*, p. 151.
7. See Butman and Targett, *New World, Inc.*
8. Margaret Lok, Michael's second wife, certainly lived there with her first husband, Dr Caesar Adelmare. In 1576, Michael Lok appears in the Lay Subsidy roll as assessed in Tower Ward. Unfortunately, the four parishes in the ward are combined together, but this listing probably refers to his house in Seething Lane, which housed the Muscovy Company. The Company in turn sold the building to Sir Francis Walsingham in 1579/80. Unfortunately, it is not known when between 1571 and 1579 Michael Lok married Margaret or where they lived with their fifteen or sixteen children. The fact that Lok worked with Giovanni Baptista Agnello, who lived in St Helen's, suggests they may

have lived in Dr Caesar Adelmare's old house. However, Lok appears in neither the 1576 or 1582 Lay Subsidy rolls for St Helen's. In 1580, the St Helen's house was sold, perhaps because of Michael's debts, but Margaret was buried in St Helen's in 1586 so she still retained a strong attachment to the area, even if she had moved elsewhere in her last few years. Also, members of her family, most notably her oldest son Sir Julius Caesar, continued to be buried there.

9. For many years this William Burd(e), a mercer, was confused with William Byrd, the musician. They may have been related; see Harley, *The World of William Byrd*, which disentangles the members of the Burde family. William Burde was living in St Helen's by 1568 and is listed at the top of the 1576 Lay Subsidy roll, although without a valuation. In June 1574, he was leasing a house in Bishopsgate Street; see Harley, *The World of William Byrd*, p. 71. His apparent great wealth was fragile due to the endless attempts by Elizabeth I to reclaim money she claimed was owed from his time in charge of customs in London; see for example TNA E 355/16, from June 1582, when he surrendered fifteen tenements in the parish of St Martin Outwich to the Queen, which had originally belonged to the nunnery of St Helen's.

10. This investment brought in £475 from other important figures. Four investments of £50 came from the Lord High Treasurer of England; the Earl of Sussex, Lord Chamberlain; the Earl of Warwick and the Earl of Leicester.

11. There were several other claimants, but on 24 March, 1603, aged thirty-six, he became James I of England.

12. The fourth husband of 'Bess' of Hardwick. For fifteen years from 1569, they acted as 'prison hosts' of Mary Queen of Scots, an unwelcome duty especially as they had to meet the considerable costs. Bess's third husband, Sir William St Loe (1518–1565), was the victim of a poisoning, probably by his brother, and was buried in St Helen's.

13. He died on 27 August 1577 at Hill Hall, Essex, after a long illness.

14. They were on latitude 65 degrees north, the same as Iceland and mid-Alaska. The strait was only a huge inlet in Baffin Island.

15. On 21 May 1561, Dr Cesare Adelmare bought the property, described earlier as a 'neat house and gardens, late part of the dissolved priory of St Helen's situate within the close of said priory' from the son of Balthasar Guercy. It had been granted to his father by Henry VIII on 21 April 1539. Guercy was one of a group of Italians living in St Helen's which included Dominic Lomely and Antonio Buonivisi.

16. His first wife, Jane Wilkinson, was a cousin of Sir Thomas North, the translator of Plutarch's *Parallel Lives* in 1579. For a recent summary of Lok, see Alford, *London's Triumph*, Chapter 14.

17. Frobisher initially was not impressed by the black stone. Best, *A True Discourse of the Late Voyages of Discoverie*, records at p. 51, 'Some of his companye broughte floures, some greene grasse, and one brought a peece of a blacke stone, much lyke to a seacole in coloure, whiche by the weight seemed to be some kinde of mettal or Mynerall. This was a thing of no accompt, in the iudgement of the Captain at the first sight. And yet for novelty it was kept, in respect of the place from whence it came.'

18. See Best, *A True Discourse of the Late Voyages of Discoverie*.

19. See Campbell, *The Alchemical Patronage of Sir William Cecil*, pp. 120–6.

20. Mineral prospecting was divided between two joint stock companies created together on 28 May 1568. The Company of Mines Royal was focused on gold and silver, which were claimed by the crown. There were twenty-four shareholders, and William Burd was treasurer. The Company of Mineral and Battery [as in beaten metal] Works exploited other metals such as copper, iron and zinc.

21. See Harkness, *The Jewel House*, p. 9.

22. William Williams, Assay Master of the Mint; Wheeler, a gold refiner; and George Needham, Assay Master of the Society of the Mines Royal.

23. Giovanni Battista Agnello shows the difficulty of tracking people through Elizabethan documents. In the 1564 Lay Subsidy toll for St Helen's, he was recorded rated at £3. He appears in the 1568 Return of Strangers as Baptist Daniel, an Italian 'distiller of waters' and a tenant of Mr Huett (Hewitt), doctor of the Arches. Three years later, in the 1571 Return of Strangers, he was Baptist Angel, an Italian merchant and householder, who had been in England a year. In the 1576 Lay Subsidy roll, he was Daniel Baptist and recorded as living in St Helen's Close. He was buried in St Helen's on 20 July 1582.

Living with Shakespeare

24. In 1567, he had recommended Jean Carre to Cecil to establish glass kilns in London.
25. See Harkness, *John Dee's Conversations with Angels*, p. 204 and note 31.
26. However, there are other possibilities. The famous Venetian glass maker Giacomo Verzelini (1522–1606) had migrated to London *c.* 1571 from Antwerp and took over the glass furnace of the Fleming immigrant Jean Carre, originally built in the former friary buildings of the Crutched Friars. Following a major fire in 1575, he moved to Winchester House next to the Dutch Church, only a few minutes from St Helen's. It would be surprising if he did not know Agnello, and he would have had the furnaces necessary to work ore.
27. Detailed in Butman and Targett, *New World, Inc.*, pp. 115–28.
28. TNA E 164/35 lists the investors for the first voyage who contributed £875 out of the total cost of £1,418-17s-4d. Over £4,000 was raised for the second expedition in 1577.
29. The historian William Camden in *Britain: Or a Chorographicall Description of the Most Flourishing Kingdomes*, Book II, p. 216, recorded that 'which stones, when neither gold nor silver nor any other metal could be extracted from them, we have seen cast forth to mend the High-ways'.
30. By the 1580s, things had calmed down. Bond had been followed into the grave by Gresham (1579) and Agnello (1582), while Lok was pursued relentlessly by creditors. In 1581, although Margaret Lok was still alive, her son Julius Caesar seems to have disposed of her house in the Close to William Harrington. A William Harington invested £25 in the second Frobisher voyage, 1577 (£33-15s for the 1578 third voyage), which attracted £100 from William Bond junior (£135 for the 1578 third voyage). Julius Caesar Adelmare and three of his siblings each invested £25 in the expedition, while Dr John Dee invested £25 (all £33-15s for 1578 third voyage). Margaret Lok was buried in St Helen's on 11 August 1586. In 1590, William Bond junior acquired this property in 1590 as an alternative to living in Crosby Hall.
31. In a recent analysis of this period – Butman and Targett, *New World, Inc.* – eight out of their list of 'Seventy-Five Men and Women Who Helped Make America' (pp. ix–xxii) lived in St Helen's at one time or another, and several others were related to residents by marriage. Finally, the Flemish painter Cornelius Ketel (1548–1616) had his studio in Bishopsgate Street in front of Crosby Hall. It was here that he painted not only Martin Frobisher (Figure 3.1) and the other luminaries of the Muscovy Company, but also the first Inuk brought back to England from the 'New World' by Frobisher in 1576. By 1593, all these people had died or moved elsewhere.
32. The population of the Ottoman Empire at this time has been estimated at *c.* 30 million, a vast reserve of manpower.
33. The Portuguese, alarmed that their trade routes to west Africa might be attacked, planned an invasion of Morocco. King Sebastian, aged twenty-four, left Portugal on 24 June 1578 with much of the country's nobility. On the 4th August, the Portuguese invading force was destroyed at the battle of Alcácer Quibir by the Moroccan army. King Sebastian and much of the Portuguese nobility were killed, an outcome which resulted in Philip II of Spain taking over the kingdom of Portugal in 1580. The battle provided the plot for the popular English play *The Battle of Alcazar* by George Peele (1556–96), usually dated *c.* 1591 and printed in 1594. It was performed fourteen times by Lord Strange's Men in 1592–3.
34. See Weiner, 'The Demographic Effects of the Venetian Plagues', pp. 41–57.
35. See Mercurialis, *De Pestilentia*, pp. 4–5, discussed in Schupbach, 'A Venetian "plague miracle" in 1464 and 1576', pp. 312–16. Despite Mercurialis's great reputation, his refusal to use quarantine for plague victims in 1576 probably made the outbreak much worse than if the authorities had used their normal approach. He taught at Padua University until 1587, when he moved to Bologna. While at Padua, he published in 1582 *De morbis muliebribus* – 'On the diseases of women' – and one wonders if Edward Jorden met him while studying in Padua and Bologna. Today he is best known for his *De Arte Gymnastica*, published in Venice in 1569, arguably the first European book on sports medicine.
36. At St Helen's in 1574, 6d was spent to pay for the ringing of the four bells, and it was probably the same each year.
37. At this period, boys typically would start at Oxford and Cambridge at fifteen or sixteen, but entry at ages on either side were not uncommon.

38. See Bearman, *Shakespeare's Money*, pp. 23–5.
39. Technically, Richard Field was apprenticed to George Bishop. For a fascinating account of his life in London, which saw him eventually marrying Vautrollier's widow in 1589 and taking over the business, see Rutter, 'Schoolfriend, Publisher and Printer: Richard Field'. Vautrollier printed sophisticated books and, when Field started in the autumn of 1579, he was producing Sir Thomas North's translation of Plutarch's *Lives of the Noble Greeks and Romans*.
40. The average age of marriage for men was twenty-six, by which time they should have established themselves sufficiently to support a family. For details, see Bearman, *Shakespeare's Money*, pp. 26–7.

# PART II

The Theatre, 1576–1598

Figure 4.1   Portrait of Edward Alleyn (1566–1626), the great Elizabethan actor born in the parish of St Botolph, Bishopsgate. Christopher Marlowe probably wrote the lead roles in *Doctor Faustus*, *Tamburlaine* and *The Jew of Malta* for him. He married Philip Henslowe's daughter. Having acquired the Manor of Dulwich, he founded Dulwich College in 1619. Note his gloves held in his left hand like Elizabeth I in Figure I.13.

# 4

## James Burbage Builds the Theatre

*In which we discover that, in contrast to the devastation in Antwerp, 1576 is marked in Shoreditch, London by the appearance of a unique building – the Theatre. Its origins and construction reveal how economic drivers, theatrical ambitions and practical building techniques combined to create the first 'Wooden O', the source building of the Globe Theatre in 1599.*

Reed Hastings, Walt Disney, Sam Goldwyn, the Lumière brothers, Barnum and Bailey, Edward Alleyn (Figure 4.1) – a few successful entrepreneurs in the world of mass entertainment have secured enduring fame. However, their names hide the thousands of their rivals who failed and are now completely forgotten. Popular entertainment across the centuries, has been extremely profitable for the few, but it has also usually been high-risk. Rapidly changing fashions, aggressive competition and under-capitalisation take a huge toll. However, at the start of every innovation in the leisure sector there is always an individual who believes there is a gap in the market that only his or her own particular idea can fill.

It was thus that James Burbage, a trained joiner and woodworker who had turned professional actor in his early forties, came to be walking around the village of Shoreditch. It was probably summer 1575, and he was searching for an empty site on which to construct his dream, a new type of performance venue – not just *a theatre*, but the Theatre. Possibly his sons, ten-year-old Cuthbert and eight-year-old Richard, the future acting star, came along to enjoy the walk from their house in Coleman Street in the City. Perhaps he dreamt of leaving them a profitable and successful business. While medieval England had a rich and varied tradition of drama, it was typically performed in the streets or in buildings designed for other purposes, such as guildhalls, market halls or inns, which were temporarily fitted up for a day or two. The costs might be covered by a rich local landowner, the town council or a collection. Whatever the source of funding, the theatre company was always dependent for its space and income on the whim of others.

Burbage's vision was for an enclosed space that people had to pay to enter, before the performance. There was to be no refusal to pay, no sneaking in for free, no stealing a look from over a wall, no peering through a window. In Burbage's plan everyone would pay, if only a penny, on entry. He would be the owner and impresario, attracting the best talent from the various acting companies that toured the country. Although he would

have been unaware of its full ramifications, Burbage's idea was setting the course for the commercial popular entertainment industry, where hundreds, then thousands, then millions of small individual payments add up to a major income stream. Nobody had built or operated such a purpose-built theatre in England since the last Roman theatres and amphitheatres had fallen into decay twelve hundred years before.[1] More importantly, no one had developed this business model with ruthless determination. As we will see, Burbage was no shrinking violet; he had worked for years in the competitive London joinery/construction trade. Then, rather remarkably, having married and fathered four children, he decided to become a full-time actor.

However, James Burbage was not starting entirely from scratch. As an experienced joiner, he would have been familiar with the wide variety of temporary stages, 'scaffolds', built for viewing processions, mounting fencing displays and, of course, public executions. Moreover, commercial entertainment was beginning to expand as the population of London and its suburbs mushroomed from *c.* 100,000 in 1550 to nearly double by 1600.[2] As firearms increasingly replaced bows, the tradition of regular archery practice in the fields around the City declined. Moralistic social commentators decried these changes and the replacement of 'manly' activities with bowling alleys (particularly popular),[3] and the related vices of cock fighting, smoking and gambling.

The satirist, playwright and social commentator Stephen Gosson commented in his *Schoole of Abuse* (1579):[4]

> Oh what a woonderfull chaunge is this? Our wrestling at armes, is turned to wallowyng in Ladies laps, our courage to cowardice, our running to ryot, our Bowes into Bolles, and our Dartes to Dishes. We have robbed *Greece* of Gluttonie, *Italy* of wantonnesse, *Spaine* of pride, *Fraunce* of deceite, and *Dutchland* of quaffing.

Moreover, on the Southbank, where there was more open space, the years from the 1540s saw the construction of several 'rings' for baiting bears and bulls with dogs such as mastiffs (Figures 4.2 and 4.3).[5] Although, such entertainment seems repugnant to modern eyes, these blood sports were greatly enjoyed by Elizabethans, including Queen Elizabeth I herself. She had her own 'bearward', a prestigious and lucrative position.[6] In a world where many young aristocrats were trained in the complexities of siege warfare, bear baiting provided a useful parallel to the attacking sappers slowly closing in on the crumbling defences of a besieged city. In 1575, a spectator noted:

> It was a very pleasant sport, of these beasts, to see the bear with his pink eyes leering after his enemies approach, the nimbleness and wayt of the dog to take his advantage, and the force and experience of the bear again to avoid the assaults.[7]

Figure 4.2 From the Tudor period, a series of timber rings for baiting bulls and bears (circled) were built on the marshy land on Bankside, where they were easily accessible by wherry from the City. Detail from the 'Agas' map of *c.* 1553–9, this version published in 1633.

Figure 4.3 Cockpits were popular and provided cheap, intense, violent action with the opportunity to gamble on the fighting birds. The cockpit in Drury Lane was converted into a theatre in 1616. Watercolour from Michael Van Meer's *Album Amicorum*, 1614–17 (f. 388v).

What made Burbage's plan unique was his own background and events over the previous three to four years. When Burbage decided to become a professional actor, probably in the late 1560s, he joined Leicester's Men, the company whose patron was Robert Dudley, 1st Earl of Leicester, the Queen's favourite. Dudley was a year or so younger than Burbage and his patronage of the theatre company was a way of promoting his social status at little or no cost, while further ingratiating himself at court. However, in the aftermath of the Pope's excommunication of Elizabeth in 1570, the government's concern over wandering, 'masterless' men intensified. With the Pope, in effect, declaring open season on the Queen, the possibility of assassination was very real. On 20 June 1572, Elizabeth gave her assent to 'An Act for the punishment of Vagabonds and for the relief of the Poor and Impotent'. This specified that:

> All Fencers, Bearwards, Common Players in Interludes and Minstrels, not belonging to any Baron of this Realm or towards any other honorable personage of greater degree; all Jugglers, Pedlars, Tinkers and Petty Chapmen; . . . which shall wander abroad and have not licence of two Justices of the Peace . . . shall be taken, adjudged, and deemed Rogues, Vagabonds and Sturdy Beggars. 1st offence: to be whipped and burnt through the right ear with a hot iron; 2nd offence: to suffer [death] as a Felon, 'except some honest person . . . take him or her into his service for two whole years; 3rd: death.

By then, James Burbage as leader of Leicester's Men had already written to the Earl of Leicester saying that they did not require any more financial support, 'any further stipend or benefit', but requesting his legal protection as his 'household retainers'.[8] This resulted in a royal patent of 10 May 1574, permitting the company to:

> use, exercise, and occupy the art and faculty of playing comedies, tragedies, interludes, stage plays and other such like . . . as well within our city of London and liberties of the same, as also within the liberties and freedoms of any of our cities, towns, boroughs, etc. whatsoever . . . throughout our Realm of England.

This meant that the theatre company, as long as a play had been approved by the Lord Chamberlain and the Master of the Revels,[9] who worked for him, could perform anywhere without local interference. Burbage and his colleagues must have been delighted with the security and status provided by this powerful royal backing.

Burbage's ambitions were probably further fired by the Company performing before the Queen at Hampton Court Palace during Christmas 1574. Their company would probably also have been central to the magnificent celebrations put on for Elizabeth's extended stay at Leicester's estate at Kenilworth Castle from 9th to 27th July 1575.[10] Burbage, having seen what high-quality staging could deliver to the rich, was savvy

enough to imagine the potential in bringing a version to the mass market through an affordable 'pay as you view' approach, rather than by unpredictable aristocratic subsidy. His role as company manager meant that he, the actors, the plays and costumes were available; all he needed was the space to construct the Theatre.

However, Burbage's ambitious dream was far from the reality of the unprepossessing site where he was standing weighing up his options. It was a semi-derelict yard surrounded by run-down buildings,[11] with the pungent smell and detritus of animal butchery. To the south was a 'Great Barn', eighty feet long, which looked like the next gale might bring it to ruin. A legal deposition in 1600 stated that 'there was An ould longe decayed Barne upon parte of the premises . . . [which] was very ruinous'.[12]

The barn was partly used by a butcher as a slaughterhouse and partly as cheap tenements for those at the very bottom of the housing ladder. To the north and east were some buildings in better condition, but showing three decades of neglect. Only to the west was there an open aspect, over the brick boundary wall, stretching across the waterlogged ground of Moor Fields, towards Moorgate and the suburbs spreading out around the church of St Giles, just outside Cripplegate.[13]

Burbage's lease from Giles Allen, the (claimed) owner, dated 13 April 1576, gives a flavour of the area and his new neighbours:

> did demise unto the said James Burbage: all those two houses . . . then being in the several tenures . . . of Joan Harrison, widow, and John Dragon; and also all that house . . . then being in the occupation of William Garnett, gardener; and also all that house . . . called . . . the mill house, together with the garden ground lying behind, then being in the . . . occupation of Ewan Colfoxe, weaver; . . . to hold all the said houses . . . unto the full end and term of twenty and one years from thence . . . paying therefor yearly during the said term unto the said defendant [Giles Allen] and Sarah, his wife . . . £14 of lawful money of England.

The fact that Giles Allen was described as 'defendant' is significant. This lease was the starting point for a series of later epic legal battles that continued for decades, outlasting Burbage, Allen and many others dragged into the controversy. It would take a separate book to fully explain these conflicts, which are fascinating if one is interested in the detail of Elizabethan legal practice but are largely tangential to our story. It is ironic for Elizabethan theatre studies that Philip Henslowe, manager at the Rose playhouse, kept a detailed record of the plays performed there from 1592–7, while the theatre of Shakespeare is largely recorded through a mass of legal depositions about endless debts, real or claimed, but always in dispute.

However, it is necessary to highlight three clauses in the 13 April 1576 lease, as they were key to subsequent events:

1. [James Burbage] would, at his and their own costs and charges, within ten years . . . employ and bestow in and upon the building, altering and mending of the said houses and buildings for the bettering thereof, as is aforesaid . . . the sum of £200 . . .

. . . And furthermore, [Giles Allen] did covenant with the said James Burbage:

2. that [he – Giles Allen] would at any time within ten years next ensuing the date of the said indentures, at and upon the lawful request . . . of James Burbage . . . cause to be made to the said James Burbage . . . a new lease for the term of one and twenty years . . .

3. [that it would be lawful for] James Burbage . . . in consideration of the employing . . . foresaid sum of £200 in form aforesaid, at any time before the end of the said term of one and twenty years . . . to take down and carry away . . . all such buildings and other things as should be builded, erected or set up in or upon the gardens and void ground . . . either for a theatre or playing place.

In other words, James Burbage agreed to spend £200 on doing up the other buildings on the site to enhance the overall value of Giles Allen's property. In return Allen would, within the period 1576–86, agree to extend the lease for twenty-one years. Moreover, crucially, James Burbage, if he spent the £200 on improvements, could at any time during the next twenty-one years remove any other structures he built, particularly his proposed 'theatre or playing place'. This agreement probably did not sound so strange then as it does today. The Theatre would be a prefabricated building, test-assembled off site. If Burbage removed it, Giles Allen would have an improved property with space to build new tenements for London's burgeoning population. It was hardly 'gentrification', but Allen was getting someone else to pay for the improvement of his run-down property. Furthermore, if the project failed, he would probably be able to buy back the lease for a song.

Giles Allen was no lover of theatre but, overall, it must have seemed a pragmatic deal. Of course, much depended on whether Burbage could prove that he had in fact spent the £200 on improvements. Arguments over what had or had not been paid were one of the central disputes of the future legal battle. However, despite the bitterness of the court cases, underneath all the claims and counterclaims the litigants all recognised that Burbage had revealed something crucial: commercial drama could, in the right circumstances, make money. A lot of money.

However, in 1576, all this trouble, bitterness and legal expense lay in an unforeseen future. Moreover, the cramped site had a number of advantages. Giles Allen only wanted £14 a year rent, and the income from the existing buildings would bring in most, if not all, of this fixed outgoing. This was a crucial consideration, given that Burbage had little

money of his own and limited credit with potential lenders. Furthermore, as an experienced joiner, Burbage had a carefully thought out plan of his proposed building in his head. He had paced out the site and knew that his theatre, just twenty-two metres wide, would just fit on it. Most importantly, the location on the edge of the village of Shoreditch was beyond the legal boundary of the City of London. Here, the Lord Mayor and alderman in the Guildhall had no direct power to interfere with his plans. True, Shoreditch lay just over the boundary in the county of Middlesex, where life was controlled by local justices of the peace.[14] It was not a free-for-all, but Burbage was gambling that with their responsibilities stretching from Uxbridge to Enfield, including four of the main roads out of London, worrying about entertainment in Shoreditch would be low on their list of priorities.

Shoreditch, 450 years ago, was a community going through a rapid transformation. Originally it was just a small village nestling around the parish church of St Leonard. The main road to York and the north – the old Roman Ermine Street – went straight through. It was crossed by a more recent route from London's western suburbs around Smithfield. This road skirted the frequently sodden Moor Fields, passed north of St Leonard church (now Hackney Road), and headed for the wild and undrained marshlands of the Lea Valley. At this time, all of what is now East London was in the county of Essex. Essex, the butt of many modern jokes, was seen very differently in the sixteenth century. Its mixture of easily cultivated farmland, woodland, hunting forests, fishing and coastline made it one of England's most attractive counties. Its easy accessibility meant that many wealthy families had estates there, and the title of the Earl of Essex was 'created' no fewer than eight times. In 1572, Elizabeth I made Walter Devereux, the seventh 1st Earl. His son, the fiery Robert Devereux, born in 1565, was the queen's great favourite in her later years until, in 1601, political miscalculation led him to the execution block.

Many other Londoners had country houses a few miles out from the City, particularly near good hunting areas like Epping Forest. Thomas Coleshill, MP (Figure 4.4), who dominated the parish vestry of St Helen from the 1540s until the 1580s, had his country house at Chigwell, where he was eventually buried in 1595 (Figure 4.5). He could reach it with an easy ride of fourteen miles, and many other similar country houses lie buried under London's interwar suburban sprawl.

Shoreditch would have seen a steady stream of wagons, carts, riders and travellers on foot, passing though. It was also an easy twenty- to thirty-minute walk from the city gates at Moorgate, Bishopsgate and Aldgate. The village gained a reputation as an enjoyable place of entertainment for Londoners – a space to relax, drink, walk, flirt and perhaps more.

The 'Copperplate' map of *c.* 1553–9 (Figure 4.6), which ends just south of Shoreditch church, shows Bishopsgate Street lined with detached houses with pleasant back gardens at the rear.[15] This area was either in the parish of St Botolph, Bishopsgate – and hence

Figure 4.4  Possible portrait of Thomas Coleshill, MP, Inspector of the Great Customs for London (1517/18–1595), dated 1565. He was married for fifty years to Mary from the Kentish Crafford family. Their house was in Great St Helen's, where his wife's parents, Guy and Joan (née Bodley) Crafford, had lived since the 1530s.

Figure 4.5  Funerary memorial to Thomas Coleshill in St Mary, Chigwell, Essex. He was a dominant figure in St Helen's parish affairs for decades. Susan(na), his daughter, married Sir Edward Stanhope I, one of the five powerful Stanhope brothers, two of whom bought the rectory rights of St Helen's from Elizabeth I in 1599.

under City control, although outside the walls – or part of the curious eight-acre 'liberty' of Norton Folgate, which attracted all manner of residents, including Christopher Marlowe, keen on keeping authority at a distance. There are fascinating details in the map (Figures 4.7–4.10) including women hanging washing to dry and men practising archery, along with pigs, cows and horses.

However, this bucolic image from the 1550s had begun to change over the next two decades as the population of London shot up, creating an acute housing shortage. Despite plague and outbreaks of other fatal infectious diseases, net migration probably brought an extra 3,000 people every year to London. The government, alarmed by the ever-growing dominance of the capital, passed laws banning the building of new houses or the subdivision of existing properties.[16] However, it was a losing battle, particularly outside the city walls in the suburbs. Landlords, eager for a quick profit, built rows of cheaply constructed tenements, often just one or two small rooms, on some of the former back gardens. These were accessed by narrow passageways with names like Sopehouse and Netmakers Alleys. These colourful names could not hide the reality of their overcrowded, 'pestered' rooms, poor sanitation and lack of adequate ventilation.[17]

The situation was exacerbated from the 1560s by the arrival of thousands of French and Dutch Protestants fleeing the conflict in the Netherlands or the state-sponsored St Bartholomew's Day Massacre in France in 1572. Many arrived in London with little beyond their work skills and were attracted to the suburbs, where their communities were already established and there was less supervision and interference from the government, city authorities or the craft guilds. The latter sought to protect their members' monopolies from these ambitious, talented and hard-working arrivals. However, the area was no shanty town: there were large, luxurious houses such as Fisher's Folly (a Londoner's joke at the reckless spending by the goldsmith Jasper Fisher, which led in turn to its sale to Edward de Vere, 17th Earl of Oxford and then William Cornwallis the Elder, patron of the poet and playwright Thomas Watson).[18] In 1599, Sir Paul Pindar, a rich merchant and ambassador to the Ottoman Empire in 1611–20, built a new mansion on the west side of Bishopsgate – a site now occupied by the eastern platforms of Liverpool Street Station.[19]

However, with a viable and accessible site secured, Burbage faced a major problem: how to fund his development. Today, if one wants to start a business or buy a house, one can approach a bank for a loan, with the payback of the capital structured over many years. Banks may not be popular, but at least they are available. However, in the 1570s there were no banks in the modern sense. Burbage had only three options: save up the money himself, borrow it from relatives or friends, or go to a moneylender. Without banks for safekeeping, the rich had every incentive to lend out their money to avoid the risks of holding it themselves. Burbage was not rich; his adversary Robert Miles stated in 1592 that 'he never knew him but a po(o)r man & but of small Credit, being by

Figure 4.6 Detail of the 'Copperplate' map, *c.* 1553–9, showing Bishopsgate Street running north from the City to the village of Shoreditch. Shakespeare would have had a twenty-minute walk along this route every day when he worked at the Theatre.

occupacion A Joyner, and reaping but a small living by the same'.[20] So he chose the second route, enticing his brother-in-law, John Brayne, to become a partner in the project. In retrospect, both probably regretted this decision, but at the time it was probably the only route open to Burbage.

Furthermore, Brayne had already made one attempt to build a theatre when he constructed a stage at the Red Lion in Mile End in 1567. What little is known about this project is recorded, typically, in court documents recorded when John Brayne sued the carpenters for poor-quality work.[21] Burbage may have been a skilful joiner and actor, but would subsequent events show that he was also a good project manager? How did he plan his new project?[22]

The main costs Burbage and Brayne had to consider were the net rental for the site, the capital cost of building the new theatre, and then what proportion of the admission income they would have to pay out to attract the right quality of performers. In addition, they needed to take account of the amount they had to pay themselves until the theatre became established and generated a stable income. One would have thought, given that Burbage was an experienced joiner and ran the Earl of Leicester's Men, that he would have been able to work out accurate estimates of all these costs (Figures 4.11 and 4.12).

Figure 4.7   Detail of the 'Copperplate' map showing women drying laundry in the fields north of the City. An army of female servants spent their working lives endlessly cleaning houses, furnishings, utensils, bedding and clothes.

Figure 4.8   Detail of the 'Copperplate' map showing men practising archery. Firearms were replacing the longbow during the sixteenth century. Social commentators decried the loss of this manly and martial exercise.

Figure 4.9   Detail of the 'Copperplate' map showing tenter frames for stretching cloth. A great deal of general textiles were still produced in the home and then passed on to specialists for finishing.

Figure 4.10   Detail of the 'Copperplate' map showing the 'Dogge hous(e)', possibly a pound for strays. Dogs were thought to be plague carriers, and at the start of any outbreak London's canines faced a bleak future.

Figure 4.11  Plan of the Theatre, built in 1576 by James Burbage and John Brayne, based on recent archaeological excavations. The building was fourteen-sided and constructed using a timber framework, raised off the ground on low brick foundation walls.

Figure 4.12  Cross section of the Theatre. A full house was an audience of c. 800–900, with the cheapest admission for standing in the central pit; more expensive covered seating was located in the three tiers of galleries. The Theatre was dismantled at Christmas 1598 and the main timbers salvaged for the new Globe.

**1. Site improvements.** The rent agreed with Giles Allen was a fixed £14 a year for twenty-one years. Fourteen pounds was not a lot – it was about the same rent as seven moderately sized houses with a shop on the ground floor. However, the best part of the agreement was that they got some rental income from the existing structures. They had also agreed to spend £200 improving these other buildings, so a significant outlay of, say, £30 a year for the first seven years; but they may well have decided to defer this work until the new theatre was fully operational. Burbage divided the barn into eleven small tenements, which might each have commanded 10s a year, maybe alone generating about £6 a year of their rent. Allowance for some immediate upgrading = **£10.**

**2. The new theatre building.** Theatre historians have spent years trying to decipher exactly how the fourteen-sided, oak-framed polygonal structure was conceived. However, once decided, while a financing challenge for the partners, it was well within Burbage's expertise as a skilled joiner to commission from carpenters who built houses. In effect, it was simply a row of fourteen typical three-storey jettied houses, curled around into a tight circle. Such houses could be built for £15–£30 each, depending on overall quality and whether they were roofed with cheap straw or expensive tiles.[23] Although no one had seen his idea, Burbage could have costed his new theatre out roughly at, say, 14 by £15 = **£210.**

**3. Income in lieu of normal work.** Say £30 a year for each man = **£60.**

**4. Other.** Say for miscellaneous costs = **£20.**

**5. Theatre Companies.** Assuming thirty-five working weeks a year, with six performances a week with an average of £1 a performance = £210. This would equate to a company with eight main actors, each earning two shillings a performance or twelve shillings a week. However, they would only have to be paid for a couple of weeks up to opening to ensure their attendance. Thereafter, hopefully, their costs would be covered by receipts; so, say, **£20.**

Such a quick calculation might have suggested a capital investment in the order of £300. Such an expenditure is borne out by the surviving contract for building the Fortune Theatre in 1600. This agreement with Peter Street, a skilled builder, records that the construction (of a larger and probably higher-quality building) cost £520: £440 for the main building work, and £80 for painting and other finishes. This was also after twenty-five years of significant inflation in building costs. As Burbage and Brayne discussed the project, how would they have justified such a large investment? To put the £300 in context, Martin Frobisher's first expedition in the same year, 1576 – projected to reach China – was based on a capital spend of *c*. £1,400.

Elizabethan timber buildings were prefabricated off site, test assembled, the joints marked up, disassembled and then moved to site. Buying the timber, followed by cutting it to size and making all the joints, was the main task and cost. For a fourteen-sided polygonal theatre there would have been fourteen bays, all identical except for the stage/backstage structure, stairs and various entrances. This would have required felling, shaping, test assembling and bringing to Shoreditch:

1. fourteen major 30-foot uprights, probably a foot square, forming the outer wall of the Theatre. Each of these would be produced from the trunk of a single oak tree.
2. 750–850 smaller oak timbers, comprising:
    a. 42 verticals, typically 10 feet long, equivalent to four of the major 30-foot uprights, forming the jettied vertical uprights of the inner wall
    b. 168 horizontal timbers, including the base plates positioned on the brick dwarf foundation walls, typically 8 to 10 feet long, equivalent to twelve of the major 30-foot uprights
    c. *c.* 120 timbers, vertical and horizontal, possibly used to strengthen the outside wall on all three storeys
    d. 70 roof timbers, equivalent to four major 30-foot timbers
    e. 50 or 78 curved corner braces for the outside wall, number depending whether they were used on second storey
    f. 200+ floor joists for three floors
    g. roof structure to support a thatch or tile roof
3. three levels of timber floor boarding
4. rails and balustrades = 36 sets for three floors
5. seating = 36 sets for three floors, three or four benches for each floor of each bay
4. stage scaffold
5. back of house building and stage door
6. two main entry doors and frames
7. two staircases, with support structure and cladding
8. tiles for roof
9. lead guttering?
10. bricks and lime mortar for foundations and dwarf walls to raise the base plate timbers above ground level to avoid rot from damp earth
11. gravel for the central yard
12. wattle and daub infill to wall panels
13. glazing?
14. locks, bolts and keys
15. ironmongery
16. iron nails, all hand-made as needed; all the timbers were joined with wooden pegs
17. furniture, as necessary, in back of house (probably second-hand)
18. plastering as required
19. painting as necessary

It is difficult to estimate the exact cost of all these materials, but there was probably sufficient money left over to employ a foreman and around fifteen to twenty workmen, in various teams. It would take them between twenty and twenty-four weeks to complete

the main tasks, with around a four-month build on site. The building would have been built in a clear sequence, but some of the tasks could have overlapped. Good weather would have been crucial to speeding the construction.

1. design and order timber for main frame, probably in late 1575
2. fell trees, cut and (dis)assemble timber-frame offsite
3. transport to London (?raft down Thames) = 2 weeks April
4. dig foundations and build brick dwarf walls = 4 weeks April/May, after frosts
5. erect the main wooden frame = 4 weeks May/June
6. construct roof timbers = 4 weeks June/July
7. build back of house building and stage = 6 weeks June/July
8. stairs, floors, seating and balustrades = 6 weeks June/July
9. interior walls, plaster and painting = 4 weeks July/August

The calculation of potential income was just the same as that employed by a West End producer today. It was a function of the number of days with performance, the per cent occupancy rate of the *c.* 800–900 seats, the average price of admission and the profit from any sales of food and drink.

Theatrical performances were not allowed during the forty days of Lent. In addition, theatre companies often toured the provinces for a couple of months during the summer to escape the city heat and the threat of plague. So, Burbage might have estimated that there was the potential for around thirty-five weeks of performances at the Theatre. Playing on Sunday was repeatedly banned by the authorities, although it clearly took place at the Theatre.[24] However, for his initial estimates Burbage might have worked on the basis of six performances a week. This would have totalled *c.* 210 days of potential playing a year. Given that this included the winter months, he might also have assumed that ten days would be a total washout, leaving a realistic base of *c.* 200 days.[25]

The Theatre was designed to hold about 800–900 people: 300 or so standing in the central yard or pit, open to the skies, and *c.* 500 undercover in the three levels of galleries. The former, the groundlings, paid 1d, and the latter 2d or 3d according to position and comfort. Assuming a 50 per cent occupancy, there was a potential gross income of:

| | |
|---|---|
| 150 groundlings × 1d = 150d | or 12s-6d |
| 150 × 2d   = 300d | £1-5s-0d |
| 100 × 3d   = 300d | £1-5s-0d |
| **Total** | **£3-2s-6d** |

plus a few shillings net from food and drink sales – say £3-6s-0d in all.

There would be some costs, such as playbills and pay for the collectors of the entry charge, but it would have been realistic to assume an income of £400–£600 for the first year. Unfortunately, it is not known what agreement Burbage and Brayne made with the performers, but other evidence suggests it would have been some form of box-office split. If this was close to 50/50, it would have left them with a potential £200–£300 a year.

While nothing was certain, it seemed likely that the project could pay back its costs in one or two years. Thereafter, each partner might be earning a steady £100-£150 a year from their initiative. This was not a fortune, but definitely a route to significant wealth, if it could be sustained at a steady rate over the years. Certainly it was a lower-risk project than international trading, with the all the threats of shipwreck, seizure by foreign governments, pirates or dishonest crews. Also, it was largely founded on their own expertise.

The big uncertainty was whether they could attract an audience to walk out to Shoreditch to stand or sit in a partially unroofed building in all weathers. Of course, as always in the entertainment business, these figures were based on middling success. No doubt Burbage dreamed of a stream of successful productions with full houses when his potential income would double, making him a rich man within a decade and creating a valuable asset that could be sold to fund a comfortable retirement.[26] That is how he may have optimistically envisioned his future, but things did not turn out as planned – either during the construction of the Theatre, or in the early years of its operation.

## Notes

1. This was before Andrea Palladio designed the famous Theatro Olympico in Vicenza, Italy, built 1580–5, but after a number of theatres had been constructed in Italy.
2. There are no certain population figures for London until the start of the census in 1801. Before this, all figures are estimates based on various approaches to the data. However, it is certain that the late sixteenth century saw a rapid increase in population in percentage terms.
3. One was installed at the Leathersellers' Hall, *c.* 1587.
4. The full title was *Schoole of Abuse, containing a pleasant invective against Poets, Pipers, Plaiers, Jestters and such like Caterpillars of the Commonwealth* (1579). Gosson was also a church minister; he took over at St Botolph, Bishopsgate in 1600.
5. Occasionally there were other animals: horses, apes tied to horses or, very rarely, lions. See for a recent introduction Bowsher, *Shakespeare's London Theatreland*, pp. 150–9.
6. Philip Henslowe and his son-in-law Edward Alleyne were named by James I as joint 'Masters of the Royal Game of Bears, Bulls and Mastiff Dogs'. They also organised animal baiting at public venues.
7. Described in a letter dated 20 August 1575 by Robert Langham, or possibly William Patten, describing bear baiting at the revels organised at Kenilworth Castle by Robert Dudley, Earl of Leicester in 1575. See *A letter: whearin, part of the entertainment vntoo the Queenz Maiestyy, at Killingwoorth Castl . . .*, <https://babel.hathitrust.org/cgi/pt?id=uc2.ark:/13960/t8w952b0c&view=1up&seq=7> (last accessed 20 July 2020). Samuel Pepys' description of the Bear Garden in 1666 called the activity 'a rude and nasty pleasure'.

8. The letter was signed by James Burbage along with John Perkin, John Laneham, William Johnson, Robert Wilson and Thomas Clarke. The first royal patent of 1574 listed the first five of these men.
9. The Master of the Revels was a royal official, responsible to the Lord Chamberlain for all entertainments at the Royal Court. He was also responsible for censoring plays until 1624.
10. It is often suggested that John Shakespeare might have been invited to watch the outdoor festivities and might have taken the eleven-year-old William with him. Kenilworth Castle was twelve miles from Stratford-upon-Avon, so it would have been a two-hour ride or a four-hour walk.
11. Described in a court case in 1600 as 'A Slaughter hose and Brewe house and low paulterye buyldinges' and 'very symple buyldinges but of twoe storyes hye of the ould fashion and rotten . . . ould houses of office [toilets] and some of them open that Roges and beggars harbored in them'; see Wallace, *The First London Theatre*, pp. 3–4.
12. See Wallace, *The First London Theatre*, p. 227, deposition of Richard Hudson, carpenter, and subsequent five depositions which repeat the same information.
13. From 1600, the Lord Admiral's Men left their home at the Rose playhouse on the Southbank and moved to this area. Philip Henslowe, owner of the Rose and manager of the Admiral's Men, commissioned Peter Street to build them a new theatre, the Fortune, here. The remains, if any survive, lie under Fortune Street, where a plaque marks the approximate site.
14. However, at this time the two Sheriffs of the City of London also covered the county of Middlesex.
15. The 'Copperplate' map, so called because it is engraved on sheets of copper, is one of the most important visual records of Elizabethan London. Three of the original fifteen plates have been discovered, each with the reverse used for an oil painting at a later date. One hopes the remaining reused twelve copper plates remain lost in picture collections across Europe or in America and will be rediscovered one day. The map is not a literal representation. In the area of St Helen's, the total number of houses shown is about 50 per cent of the likely total and the houses themselves are diagrammatic in most cases. Despite these limitations, it provides a unique insight into London and is well worth studying in detail, area by area.
16. In 1580, a royal proclamation of Elizabeth I 'forbade building on new foundations, dividing existing housing and taking in lodgers'; see Hughes and Larkin, *Stuart Royal Proclamations*, and Hughes and Larkin, *Tudor Royal Proclamations*, discussed in Baer, 'Housing for the Lesser Sort in Stuart London', pp. 61–88.
17. The mixed reputation of the area is captured in a case from 12 May 1602 brought before the Court of Governors of the Bridewell; see *Minutes of the Courts of Governors of Bridewell 1559–1971*, BCB-04, <https://archives.museumofthemind.org.uk/BCB.htm> (last accessed 4 August 2020). An inebriated out-of-towner was caught in an Elizabethan scam: 'Thomas Perry dwelling at Hitchinge [Hitchin] in Hartffeshire sent in by Justice Langham saith that yesterday being some what in drinke & going through the long Alley in Moorefields, a woman whome then this Ex[amined] knew not but sure understood to be named Magarett Bell, standing at a garden Dore there tooke this Ex[amined] by the cloak and pulled him into the house and caused this Ex[amined] to give 2 s[hillings] to another Woman that was there to fetch a bottle of Ale which the said woman tooke & went forth of the house but came noe more. Also he saith that when the same woman was gone the said Mary pinneed the dore with a spit and there this Ex[amined] had the use of her bodye and further he saith that the said Magarett tooke five or six shillings out of this Ex[amined] pocket and a paire of gloves worth 2s-6d which this Ex[amined] had bought for his wife – Thereupon it is ordered that he shalbe pu[nished]. . . . Magarett Bell widdowe lienge in Nortonfolgate being examined whether Thomas Perry had not the use of her body denieth it but for that is sufficiently proved this Court that it is true, & that she is an [. . . ?] person It is therefore ordered she shal be punished & kept till she putting suerties for her good behaviour. . . . Eliz[abeth] Howe? sent in also by Justice Langham and is the woman whoe had the 2 s[hillings] to fetch the bottle of Ale, being ex[amine]d denieth it, but saith that she is owt of service and that one Henry Pullen servant to one Shivers (?) a Taylor at Nortonfolgate hath had the use of her body and that he should have married her but now is prest [forcibly enlisted] and gone for a Souldier. Ordered to be kept till the next court but not be delivered without good suerties.'

18. Thomas Watson (1555–92) was a poet and playwright, but none of his plays survive. William Cornwallis, his employer, stated that he created 'twenty fictions and knaveryes in a play'. For a detailed discussion of William Cornwallis's will, family and connections, see Nina Green's comprehensive review of his will, <http://www.oxford-shakespeare.com/Probate/PROB_11-118_ff_93-5.pdf> (last accessed 4 August 2020). William Covell, in *Polinmanteia* (1595), said that Shakespeare was 'Watson's heyre [heir]'. Francis Meres in his *Palladis Tamia, Wits Treasury* (1598) described him as among 'our best for Tragedie'. The house eventually passed to the Earl of Devonshire and Devonshire Square was built on the site. The site faced Bedlam on the west side of Bishopsgate Street. Although a stark reminder for Londoners because of its purpose and poor conditions, Bedlam at this time was a small institution with probably less than thirty inmates.

19. The frontage was saved in 1890 and is now on display in the Victoria & Albert Museum in London. The site was acquired by his brother Ralph Pindar in 1597; section 3 of the Appendix, n. 26. There is a double portrait engraving of the Pindars by W. T. Fry published in 1794.

20. As described by Robert Myles in 1592, who added, 'his Credit was such as ne(i)ther merchant nor Artificer (craftsman) would gyve him Credit for the value of £10 unless his brother Braynes wold Joyne wt him'. See Leinwand, *Theatre, Finance and Society in Early Modern England*, pp. 60–8.

21. The Red Lion may have only operated for 1567 and the only play recorded was *The Story of Sampson*. The location was probably too far of a walk from the City for long-term success. Since Burbage had married Brayne's sister, Ellen, in April 1559, he was probably also involved in some way.

22. For performance in this period, see the *Before Shakespeare* website, <https://beforeshakespeare.com/> (last accessed 20 July 2020).

23. Such a house in St Helen's would command a rent of £1 to £3 a year. With a payback period of seven to ten years, developers could afford to invest £15 to £30, depending on the cost of the land. Compared to today, the cost of labour was very low. Building materials would be the expensive element and the main cost would have been the fourteen main vertical timbers, each thirty feet long, forming the outer ring of the theatre structure. Each of these would have been cut from a single mature oak tree, grown straight in a wood rather than open countryside. Such large timbers were a very valuable resource, particularly with the increasing loss of woodland for building, ships and ironworking. However, compared to a house, each section of the Theatre was simpler because overall the structure was self-supporting and only twelve feet deep rather than the twenty-four-foot depth of a typical house.

24. See Wallace, *The First London Theatre*, pp. 7–8.

25. See Henslowe's diary/account book for a similar pattern at the Rose. Burbage had been an actor, so estimates of attendance and income would have been based on his considerable experience. Of course, the new operation was twenty minutes' walk from Bishopsgate, and for many people in the City would have been half an hour or more. However, again, living in Shoreditch, Burbage would have known the pattern of recreational use of the area. Walking out to the Theatre offered the perfect excuse for getting away from the watch of nosey neighbours, for whatever reason.

26. By 1576, the Burbages had moved to Hollywell/Halliwell Lane in Shoreditch so that James could keep a close eye on his project.

# 5

## Trouble at the Theatre

*In which we see an Elizabethan England where the authorities aimed to control every aspect of how people worked, spent their leisure and worshipped, with the Theatre a potentially disruptive new factor. However, many of the problems at the Theatre were self-inflicted, a consequence of the casual basis on which Burbage and Brayne had agreed to fund it. This was probably exacerbated by a cash-flow crisis, the bane of so many business start-ups.*

Eventually, the Theatre opened. It is not known exactly when (but probably in autumn 1576), or even what play was performed,[1] but it seems most likely that Burbage's own acting group, the Earl of Leicester's Men, was the first resident company in the early years. Even this, though, is a supposition. One may assume that simple curiosity brought bored Londoners in good numbers to the early performances. However, whatever pleasure Burbage and Brayne may have enjoyed as the first audiences filed in was undermined by a stark reality: the construction had cost far more than the £300 or so they had probably originally budgeted. Indeed, a resulting meeting in court claimed that the Theatre had cost £700 in total. With no written contract, the two partners were soon blaming each other for the mounting costs even before the building was finished.[2] Burbage and Brayne were desperate to get their new venture open to start earning back their investment. Tempers had flared as days passed and the carpenters, plasterers and painters were still at work. Family links, the bedrock of pre-banking Elizabethan business, had frayed as spring optimism had turned to summer heat. John Brayne and his wife, Margaret, even worked as unpaid labour to get the theatre finished.

Two later court depositions give a flavour of the family relationships, or perhaps one should say in-law relationships, on the project. Margaret Brayne was the wife of James Burbage's wife's brother, John Brayne.[3] These statements date from 1592, long after John Brayne's death in 1586, when the beneficiaries of his will, and subsequently beneficiaries of the 1593 will of Margaret Brayne, were trying to get hold of their (claimed) inheritance. Clearly, the Burbages were a family where physical violence and verbal intimidation were considered part and parcel of living in a society with no citywide police and where physical occupation was a crucial factor when legal action was lengthy and expensive. First, we hear James Burbage in full flow:

> And then the said Burbage called him rascal and knave and said before he would lose his possession he would make twenty contempts [of court]. And then the wife of the said James and their youngest son, called Richard Burbage, fell upon the said Miles and beat him and drove both him and the complainant [Margaret Brayne] away, saying that if they did tarry to hear the play as others did they should, but to gather any of the money that was given to go upon [the galleries?], they should not . . .[4]

Furthermore, Ellen Burbage was also a force to be reckoned with:

> the said James Burbage's wife charged them to go out of her ground or else she would make her son break their knaves' heads and so hotly railed at them. And then the said James Burbage, her husband, looking out at a window upon them, called the complainant [Margaret Brayne] 'murdering whore', and this deponent and the others 'villains, rascals, and knaves' . . . And then he cried unto her, 'go, go, a cart, a cart for you [prostitutes were punished by carting through the street]. I will obey no such order, nor care I not for any such orders, and, therefore, it were best for you and your companions to be packing betimes, for if my son come he will thump you hence.'

And her son, the intimidating Cuthbert Burbage, was used to backing up his ageing father:

> With that, in manner, his son [Cuthbert Burbage] came home . . . and then he in very hot sort bid them get them hence or else he would set them forwards, saying 'I care for no such order. The Chancery shall not give away what I have paid for. Neither shalt thou have anything to do here while I live, get what orders thou canst.' And so with great and horrible oaths uttered by both him and his father that they would do this and that, the complainant and her company went their ways.[5]

The family's financial disputes were, however, not the only problem. London's moral and civic guardians were quick to see the Theatre and its neighbour, the Curtain playhouse, as a threat to the godly lives of its citizens. Within a year, in a sermon preached at St Paul's in December 1577, John Northbrooke denounced the new theatres as:

> A spectacle and school for all wickedness and vice to be learned in . . . [are] those places . . . which are made up and builded for such plays and interludes, as the Theatre and Curtain is [sic]

On Sunday, 24 August 1578, the preacher John Stockwood commented as follows (quoted from his *A Sermon at Paul's Cross*):

> The Theatre, the Curtain and other places of plays in the City ... The gorgeous playing place erected in the [Finsbury] Fields ... as they please to have called it, a Theatre.

The preachers, especially those of a more Puritan orientation, believed the money paid out for the 'gorgeous playing place', rather than enhancing Protestant religion, was foolishly misspent. They were also obsessed by the lurking threat of sexual deviancy with, as usual down the centuries, siren women presented as the main culprits:

> In our assemblies at playes in *London*, you shall see suche heaving, and shooving, suche itching and shouldring, too sitte by women; Suche care for their garments, that they bee not trode on: Such eyes to their lappes, that no chippes light in them: Such pillowes to ther backes, that they take no hurte: Such masking in their eares, I knowe not what: Such giving the Pippins [apples] to passe the time: Suche playing at foot Saunt without Cardes: Such ticking, such toying, such smiling, such winking, and such manning them home, when the sportes are ended, that it is a right Comedie, to marke their behaviour, to watch their conceites, as the Catte for the Mouse ...

And behind the flirting and the teasing were the sex workers lurking in local taverns, back rooms and alleys. Stockwood, who seems singularly well informed, describes the opportunities to lead upright citizens astray:[6]

> If this were as well noted, as ill seene: or as openly punished, as secretly practiced: I haue no doubte but the cause would be feared to dry vp the effect, and these prettie Rabbets very cunningly ferretted from their borrowes. For they that lack Customers al the weeke, either because their haunte in unknowen, or the Constables and Officers of their Parishe, watch them so narrowly, that they dare not queatche;
> To celebrate the Sabboth, flock to Theaters, and there keepe a generall Market of Bawdrie: Not that any filthynesse in deede, is committed within the compasse of that grounde, as was doone in *Rome*, but that every wanton and his Parmour, every man and his Mistresse, every John and his Joan, every knaue and his queane, are there first acquainted ...
>
> If their houses bee searched, some instrumente of Musick is layde in sighte to dazell the eyes of every Officer, and all that are lodged in the house by night, or frequente it by day, come thither as pupilles to be well schoolde. Other ther are which beeing so knowen that they are the bywoorde of every mans mouth, and pointed at commonly as they passe the streetes, either couch themselves in Allyes, or blind Lanes, or take sanctuary in fryeries, or live a mile from the Cittie like Venus nunnes

in a Cloyster as *Newington*, *Ratliffe*, *Islington*, *Hogsdon* [Hoxton, Shoreditch] . . . And when they are weery of contemplation to comfort themselves . . . they visit Theaters . . .

James Burbage probably took little notice of such criticisms. If he has been concerned about religious opposition, he would never have started his project. However, he is likely to have kept a weather eye on the civic authorities who had the power to shut down his business overnight. The government saw the threat from the theatres as much as meeting places for potential troublemakers as for insidious ideas. With no organised citywide police force, one has some sympathy with their efforts to act on their responsibilities. The following records a 'brabble' or fight at the Theatre. William Fleetwood, Recorder of London, wrote on 5 October 1577 to the Lord Treasurer, Burghley:

> Yesterday . . . I was at London with the Master of the Rolls at my Lord Mayor's at dinner . . . After dinner we heard a brabble between John Wotton and the lieutenant's son of the one part and certain freeholders of Shoreditch for a matter at the Theatre. I mistrust [suspect] that Wotton will be found in the fault, although he complained.

In February 1580, Burbage and Brayne were accused of being a threat to social order:[7]

> The juries . . . present that John Brayne . . . and James Burbage . . . on 21 February [1580] . . . and divers other days and times before and after, congregated and maintained illicit assemblies of people to hear and see certain . . . plays or interludes put into effect and practised by the same John Brayne and James Burbage and divers other persons unknown at a certain place called the Theatre in Holywell . . . On account of which illicit assembly of people, great affrays, reviling, tumult and near insurrections, and divers other malefactions and enormities were then and there made and perpetrated by a great many ill-disposed people in a great disturbance of the peace of our lady the Queen, and also subversion of good order and government . . .[8]

Two months later, there was a riot at the Theatre reported on Sunday, 10 April 1580:[9]

> Where it happened on Sunday last that some great disorder was committed at the Theatre, I [the Lord Mayor of London writing to the Lord Chancellor] sent for the under sheriff of Middlesex to understand the circumstances, to the intent that by myself or by him I might have caused such redress to be had as in duty and discretion I might, and, therefore, did also send for the players to have appeared afore me, and the rather because those plays do make assemblies of citizens and their families of whom I have charge . . .

Two players, Robert Leveson and Laurence Dutton in the Earl of Oxford's new theatre company, were sent to the Marshalsea prison in Southwark 'for committing disorders and frays upon the gentlemen of the inns of Court'.[10] On 10 June 1584, the Recorder of London, William Fleetwood, wrote to Lord Burghley:

> Upon Wednesday, one Browne, a serving man . . . intending a spoil if he could have brought it to pass, did at [the] Theatre door quarrel with certain poor boys, handicraft apprentices, and struck some of them, and lastly he with his sword wounded and maimed one of the boys upon the left hand. Whereupon there assembled near . . . 1,050 people. This Browne did very cunningly convey himself away, but . . . he was taken after.[11]

This resulted in a dramatic demand by the city authorities on Sunday, 14 June 1584 for the demolition of the two Shoreditch playhouses and, in turn, a strong two fingers up to the city authorities from James Burbage:

> Upon Sunday my Lord [Mayor] sent two aldermen to the court [Whitehall Palace] for the suppressing and pulling down of the Theatre and Curtain. All the lords [of the privy council] agreed thereunto, saving my Lord Chamberlain and Mr Vice-Chamberlain, but we obtained a letter to suppress them all. Upon the same night I sent for the Queen's players and my Lord of Arundel his players, and they all willingly obeyed the lords' letters. The chiefest of her highness's players advised me to send for the owner of the Theatre [James Burbage], who was a stubborn fellow, and to bind him. I did so. He sent me word that he was my Lord Hunsdon's man and that he would not come at me, but he would in the morning ride to my Lord [Mayor].

This response led to Burbage being arrested:

> Then I sent the under-sheriff for him and he brought him to me. And at his coming he stouted [braved] me out very hasty. And in the end I showed him my Lord [Hunsdon's], his master's hand, and then he was more quiet. But to die for it, he would not be bound. And then I minding to send him to prison, he made suit that he might be bound to appear at the [sessions of] oyer and terminer [at Newgate], the which is tomorrow, where he said that he was sure the court would not bind him, being a [privy] councillor's man. And so I have granted his request, where he shall be sure to be bound or else is like to do worse.

Unfortunately, as so often with Elizabethan records, the story then goes cold, although it is clear that Burbage carried on. He knew, as an actor, builder and operator, that

despite all the quarrels, frustrations and shortage of capital, his basic hunch had been proved right unless the financial turnover, 'cash flow problems' in modern parlance, pulled his business under. That this was clear, even by Christmas 1576, when the Theatre had probably been open three or four months, is shown by one simple fact. This was the opening, in the following year 1577, of a second theatre in Shoreditch, the Curtain playhouse, only 200 yards away (Figure I.4).[12]

Significantly, the Curtain was built to the south, so it stood between the Theatre and its main audience in the City. Indeed, the buildings were so close that audiences at one could potentially hear shouting from the other venue if performances coincided. It seems unlikely that someone would have invested in a new theatre next door, unless the Theatre was recognised as a commercial success, or at least had the possibility of being one in short order. Indeed, given the speed with which the Curtain was developed, it must have been planned, with materials ordered, over the winter of 1576/7, indicating that the canny James Burbage had not only built the Theatre, but had inspired London's first theatre district. Unfortunately, we know even less about what was performed at the Curtain than the Theatre, although it lasted until 1624, at forty-seven years the longest-running of the early London playhouses.[13]

So, as 1577 turned to 1578, Burbage and Brayne might have begun to relax as slowly the surplus income from performances began to pay off their capital investment. They must have also established some sort of *modus operandi* with the authorities. However, by autumn 1579, their financial position had turned dire. What had happened to derail their project in less than a year? The evidence for a major problem comes in a document dated 26 September 1579, revealing that Burbage and Brayne had been forced to mortgage the Theatre to John Hyde, a grocer, for £125-8s-11d, a significant sum. However, Burbage and Brayne agreed to repay the mortgage in a year and a day, so they must have been confident that their future income would cover the cost:

> John Brayne . . . and one John Prynn, a broker, did take up, borow, and owe unto him, this deponent [John Hyde], about the 26 day of September 1579 the sum of £125 8s 11d or thereabouts, as this deponent remembreth, and he doth also well know and remember that the said James Burbage, the now defendant, did about the same time mortgage and convey unto him, this deponent, the lease and all his title therein of and in the Theatre and other buildings in Holywell in . . . Middlesex, the which he had of one Giles Allen and Sarah his wife, upon condition to this effect, that if the said some of £125 were repaid to him, this deponent, or to his assigns within twelve months and one day next ensuing after the said September 1579 by the said James Burbage, that then he, this deponent, should reconvey to him, the said James, the lease and Theatre and other the premises again.[14]

Hyde took possession of Burbage's lease as a guarantee:

> And, as he remembreth, the lease and other bonds made by Giles Allen for the enjoying thereof were delivered into his hands and possession at the time of the said conveyance sealed by the defendant, which was done with the consent and appointment of the said John Brayne . . . [James Burbage] for this deponent's better security, stood bound to him, this deponent, jointly with the said Brayne and Prynn in a bond of £200 (as this deponent remembreth) with condition endorsed as well for the repayment of the said money at the time appointed as for the performance of the covenants and performing the said mortgage.[15]

As events turned out, a year later Burbage and Brayne failed to repay the mortgage. They came to an agreement to pay it off in £5 weekly instalments, but these fizzled out after a few weeks. A document dated 8 December 1590 records Hyde's efforts to get his money back:

> After the said lease became forfeited to him, this deponent [Hyde], it was agreed on both sides that, if the said Burbage and Brayne, or either of them, did pay this deponent £5 a week till all the foresaid mortgage money were paid with some reasonable consideration for the forbearing of it, that then they should have their lease again, which they performed by the space of 4 or 5 weeks after. But they performed no more, and so suffered their lease to be once again forfeited to this deponent.[16]

Two years later, in June 1582, with the bulk of the mortgage still unpaid, Hyde began applying much more serious pressure. This delivered another £20 but, as always, Burbage ducked and dived, blaming his partner:

> He [Hyde] was offended that the said [James] Burbage and Brayne did not repay him the said sum of £125 8s 11d, and did thereupon threaten to put the said Burbage out of possession of the said Theatre and buildings . . . and thereupon did cause the said James Burbage to be arrested by process out of . . . [King's] Bench about June, as he remembreth, 1582. And the said Burbage did thereupon come to this deponent's [Hyde's] house with the officer or bailiff that had him arrested, and this deponent's wife in his absence did accept of £20 paid unto her to this deponent's use by the defendant [Burbage].[17]

Burbage was clearly skilled at shifting blame onto others:

> Burbage did complain unto him that the said Brayne had received and gotten into his hands a great portion of money levied in the said Theatre at the play times and that

> he would catch what he could and that he [Burbage] . . . could not enforce him to deliver any part thereof neither to him [Burbage] . . .[18]

Eventually, Hyde went back to trying to collect £5 a week from the Theatre:

> By reason the said Brayne would not depart [part] with the money he had received, he, this deponent, was constrained to appoint one of his servants and the said James Burbage . . . to gather up £5 weekly during the time of plays, thinking by that means to have paid himself with the profits of the Theatre, for that he saw the said Brayne to be so bad a fellow. And this deponent by that rate did receive in money to the sum of £20 or £30 as he remembreth.[19]

The case rumbled on, year after year, while Hyde wisely held onto the increasingly valuable lease. The debt was not settled until 1589, when Cuthbert Burbage finally regained the lease.

However, what had derailed Burbage's and Brayne's financial strategy in the first place, once the Theatre had become established? The cause of all these arguments was probably the major outbreak of plague in summer 1578. By then, memories of the last virulent plague outbreak, the 'sweating sickness' in 1563, were probably fading. There had, however, been an outbreak in 1572 that had led to the banning of theatre performances and this had been repeated the previous year when an order of 1 August 1577 banned performances for several months, including at the newly built Theatre:

> [The Privy Council ordered that:] A letter [be sent] to the Lord Wentworth, Master of the Rolls, and Mr Lieutenant of the Tower, signifying unto them that for the avoiding of the sickness likely to happen through the heat of the weather and assemblies of the people of London to plays, her highness's pleasure is that as the Lord Mayor hath taken order within the City, so they immediately . . . shall take order with such as are and do use to play . . . within that county [Middlesex] . . . as the Theatre and such like, shall forbear any more to play until Michaelmas [29 September] be past at the least . . .[20]

History lessons in British schools tend to focus on the 1665 plague in London, immediately prior to the Great Fire of London in 1666. However, there were regular major outbreaks every dozen or so years, and the plague was also probably endemic in most of London, flaring up locally due to varying circumstances and then dying down (Figures 5.1 and 5.2). The descriptions of families shut up in houses also tend to give the impression that whole streets were wiped out. Even in the worst years, the majority survived and people who caught the plague sometimes recovered. Indeed, some

Figure 5.1  Burials recorded in St Helen's, 1575–1613. This clearly shows the impact of four main outbreaks of plague in 1578, 1587, 1593 and 1603. The burial register also records ongoing deaths from plague in 1608–10.

Figure 5.2  Although this woodcut relates to the 1665 Great Plague, it captures the terror and social dislocation of outbreaks during Shakespeare's time in London. A woman covered with red buboes and her child die in a field ('Wee dye', left), whilst others abandon the City ('We fly') but are kept away by armed men ('Keepe out', right).

Londoners probably built up a natural resistance. During the next major outbreak, which killed 10,675 Londoners in 1593 alone, the astrologer/doctor Simon Forman caught the plague in late June 1592 and by 6 July was prostrate in bed with 'the plague in both my groins and some time after that I had red tokens on my feet as broad as halfpence'. Forman treated himself by lancing the buboes and survived, but he recorded that it took twenty-two weeks before he was fully well again. He then recorded his personal commitment to poor Londoners in a poem:[21]

> And in the time of Pestilent Plague
> When Doctors all did fly,
> And got them into places far
> From out the City
> The Lord appointed me to stay
> To cure the sick and sore,
> But not the rich and mighty ones
> But the distressed poor.

During the 1578 outbreak, there was nothing untoward in most of London until June. We will pick up events in just one family in the City, the Kirks, living in Bishopsgate Street in the parish of St Helen's. Head of the family was Richard Kirk the Younger, with his wife Katherine and their five children: Jane and George, perhaps three and four; Johane, aged two; Anne, aged one; and Richard Junior, about six months old. They had at least two servants and possibly an apprentice or two. Richard was an armourer and weapon-maker, trained by his father, with his shop and home in the row of commercial properties in front of Crosby Hall (see Figure 10.2).[22] This was a good location, particularly since during the mid-1570s Crosby Hall was the centre for planning Martin Frobisher's first voyage to Cathay in 1576. Richard's father, Richard Kirk the Elder, and his wife, Julia, lived a dozen or so doors further up Bishopsgate Street. Kirk the Elder was a regular attender at the parish vestry, suggesting he was a well-established local figure.[23]

Katherine kept a close eye on her five young children but, if they got sick, she only had household remedies and the advice of neighbours to help her. Generally, doctors were far too expensive for ordinary people. As May ended and the weather warmed all seemed well – so far, so good. The residents of St Helen's could enjoy a walk out of the packed City to the open fields around Shoreditch or, perhaps, enjoy a performance at the newly opened Theatre or the Curtain playhouse. Then, in early June, Edward Holmes, a neighbouring scrivener, fell seriously ill. Within a few days, he was dead; he was buried in St Helen's on Sunday, 9 June. People speculated about what might have killed him. Two weeks later, Margaret Saunders, his maid, and then three days later, his

daughter Katherine both died. Three people of different ages, from one house, in quick succession, suggested a virulent infection – maybe plague, maybe not – there were other fatal diseases, although they were rarely differentiated.

People began to worry, as sudden deaths were also being reported from nearby parishes. Then, at the end of June, another three people died in a St Helen's house belonging to Richard Ellis, a cutler. An outbreak of plague now seemed certain, but just as people began to pray for deliverance, things seemed to calm down, in St Helen's at least. For seven weeks, it looked like these six deaths might have been just a local occurrence.[24] However, the infection had not disappeared – it had just been waiting and spreading silently through the shops, alleys and back yards. Towards the end of August, in the summer heat, the whole Kirk family suddenly fell sick. It would probably have been the classic symptoms, as plague boils or buboes appeared around the groin. One can imagine Katherine going from child to child, trying to comfort them. They were too young to understand, but she would try to stop their crying so as to avoid disturbing her husband, who lay desperately ill downstairs. With their shop shuttered and closed, there was no income.

Over the next ten days, Katherine buried four of her children one after another, to be followed on the 9 September by Margaret Damper, her maid. Finally, two days later, she buried Richard, her husband and breadwinner, leaving her with no means of significant financial support. All she had to fall back on was help from her relatives.[25] In sixteen days, seven people apart from Katherine and baby Richard – almost the whole household – had died. Perhaps Katherine got sick as well, but pulled through; perhaps she had some natural immunity. A few doors along the street, two daughters of Richard Risby, a merchant taylor, died. In the house of John Deere, a farrier, three sons and a daughter died, followed by John himself. John Hatton, the newly arrived deputy clerk of the Leathersellers, lost his wife Mary and two young sons.[26] The Hattons lived on the Leathersellers' estate which, otherwise, seemed to be little affected, perhaps because general public access was restricted and the richer residents could escape to the country.[27]

Neighbouring parishes were equally affected. In the parish of All-Hallows-by-the-Wall, three children of Richard Smythe, one of the Queen's trumpeters, died in October. Officials at the court must have been terrified of anyone who might bring infection near the Queen. All in all, between thirty and thirty-five people died in St Helen's from the 1578 plague outbreak: this was perhaps 5 per cent of the parish population. Then, as the December cold set in, the plague stopped almost as suddenly as it had started. For four months, there was only one death: Alice Hart, a widow who probably died of old age.

Although the Covid-19 pandemic of 2020 has perhaps enhanced our understanding of how people experienced highly infectious disease in the past, it is still difficult to relate to the devastating impact of the regular upsurges in plague during the later sixteenth and seventeenth centuries. In a highly religious society, many would have seen the plague as an act of God, punishing people for their (not necessarily publicly obvious)

sins. Katherine Kirk was probably emotionally shattered, but there were dozens more ex-wives and ex-husbands in similar situations across London. What was she to do, in a society where women were mostly totally dependent on their husbands – and with the responsibility of a baby? On Sunday, 26 July, 1579, she walked up Bishopsgate Street to St Helen's to marry William Axton, a merchant taylor. This was just ten and a half months after she had buried her husband in the same church, and with her ex-father-in-law living a few houses away. The Axtons are of particular interest because George Axton, probably William's younger brother and also a merchant taylor, appears assessed at £3, immediately below Shakespeare's name in the 1598 Lay Subsidy listing.[28]

William Axton probably moved into the former Kirk family shop and home.[29] Within four months, Katherine Kirk, now Axton, was pregnant again. She had four children over the next six years, thus totalling nine children in the space of fourteen or so years. While she was pregnant with her last child, Simon, in 1586, Richard Kirk the Elder and his wife Julia both died within a couple of months of each other. George Axton took over their house, probably in the run up to his own marriage. His first child, also named George, was christened in St Helen's on 11 July 1588, just as all of England awaited the onslaught of the Spanish Armada. By then, domestic tragedy had struck yet again. On 7 August 1587, Katherine, probably still only in her late thirties, was buried in St Helen's, leaving William Axton with a stepson aged nine and his own four children, all under seven. He was still in the house in May 1589, presumably actively looking for a new wife who would take on five stepchildren. He then disappears from the records. Perhaps he was successful in establishing a new family elsewhere.[30] In the surrounding houses, life moved on. John Hatton remarried within a year and started a new family of four children; Mrs Deere remarried in 1581 and, by January 1579, Mrs Risby was pregnant again. However, fourteen years later, in 1592, the plague was to return to St Helen's with a much greater impact.

It is almost certain that the playhouses would have been closed during the 1578 plague outbreak, probably for up to six months from June until November.[31] This would have had a devastating impact on Burbage's and Brayne's predicted cash flow. There would have been no income, while they had to service any borrowings and probably pay off the builders. They may also have had to take on new borrowings to pay off existing debts. Whatever the detailed financial situation, it clearly made sense to them to consolidate their debts and move to a single mortgage. The very fact that John Prynn, the mortgage broker, could arrange a 'commercial' borrowing from John Hyde, an experienced grocer, suggests that the underlying profitability of the theatre enterprise was not in doubt. Moreover – although as we have seen, he only got his money back in irregular payments – Hyde seems to have been happy to keep holding the valuable lease, which still had many years to run.

A sum of £125 would have been sufficient to clear some outstanding debts, cover Burbage's and Brayne's own costs for another six months if the plague returned in 1580,

and provide some working capital. Although Burbage was now in greater debt, he may have felt that with a workable economic model there was a realistic chance that his gamble would now pay off – if only the plague would stay away.

Notes

1. The first recorded date for performance was 1 August 1577, when playing was banned because of the plague.
2. Burbage and Brayne ended up physically fighting each other, as recorded in a later deposition. William Nicoll, a public notary, stated that 'he well rembereth the said John Brayne did think himself much aggrieved . . . [and] did declare these words . . . how he had left his trade and sold his house by the means of the said James Burbage to join him in the building of the said Theatre . . . the sum disbursed by the said John Brayne was three times, at the least . . . the sum then disbursed by the said James Burbage and in the end declared so many words of ill-dealing . . . that Burbage did there strike him with his fist. And so they went together by the ears in so much that this deponent could hardly part them.' See Wallace, *The First London Theatre*, pp. 150–3.
3. Margaret (née Stowers) was born in the heart of the City in the parish of St Dionis Backchurch. She married John Brayne in January 1565. They were bankrupted by their investment in the Theatre project and a failed investment in the George Inn in Whitechapel, along with a friend and goldsmith Robert Miles, in the early 1580s. The shenanigans between John, Margaret and Robert Miles lie outside the scope of this book. Suffice it to say that Miles was accused of murdering John Brayne in 1586 and fathering an illegitimate daughter with Margaret. Whatever the truth, Margaret, now backed financially by Miles, pursued the Burbages for repayment throughout the 1580s until her death from the plague in April 1593. Robert Miles then continued a series of unsuccessful court actions until 1595, shortly before the Theatre itself was dismantled. For the full details of the case, see Wallace, *The First London Theatre*.
4. Deposition by Nicholas Byshop, 29 January and 6 April 1592; see Wallace, *The First London Theatre*, pp. 96–8 and 113–16.
5. Deposition by Ralph Miles, 10 February and 26 April 1592; see Wallace, *The First London Theatre*, pp. 102–3 and 119–22.
6. Perhaps Clement Kelke or one of the other governors of Bridewell filled him in with the details of the numerous men and women brought from the area for punishment for extramarital sexual activity.
7. This would have been during Lent, when playing was not meant to take place. In 1580, Shrove Tuesday fell on 16 February.
8. See LMA MJ/SR/0225/4.
9. This was a week after Easter Monday, which marked the point in the year when the theatres could reopen. There had been an earthquake four days earlier, recorded by Dr John Dee as taking place at 17.50 on Wednesday, 6 April. For the religious authorities: 'This was a token of the indignation of our God against our wicked living' and ' how justly God may be offended with all men for sin . . . which yet still warneth us by this terrible wonder what far more terrible punishments are like to light on us ere long, unless we amend our sinful conversations betimes'. However, John Aylmer, Bishop of London, noted with some resignation to Lord Burghley that 'the people is presently much moved with the present warning, and are of such nature as commonly they make it but a nine days wonder'. See *FECDD*, 6 April 1580 for coverage of the earthquake and the resulting outpouring of books, prayers and ballads.
10. Laurence Dutton was also operating as a pimp in 1577, taking 'little' Margaret Goldsmith from another pimp and setting her up at the Bell Inn, near St Leonards, Shoreditch church; see Ingram, 'Laurence Dutton, Stage Player', pp. 123–4.
11. See, BL, Lansdowne MS 41, folios 32–33, published in Wickham, Berry and Ingram (eds), *English Professional Theatre, 1530–1600*, no. 272, p. 345.

12. Without going into detail, one needs to be careful about terminology here. The Curtain was first recorded in 1577 and the assumption is that it was opened after the Theatre. Recent excavations have shown that the Curtain was square rather than a polygon. The remains are being preserved under the new building and will be opened to the public in due course.
13. For a year in the life of the Curtain in 1579, see the *Before Shakespeare* website: <https://beforeshakespeare.com/> (last accessed 20 July 2020).
14. See Wallace, *The First London Theatre*, p. 53.
15. See ibid. pp. 53–4; although Burbage and Brayne had jointly organised the project, Burbage had always held onto the valuable lease himself.
16. Ibid.
17. Ibid. p. 54.
18. Ibid.
19. Ibid. p. 55.
20. Historically, Michaelmas, the Feast of the Arkangel Michael, was 29 September (11 October in the old calendar). It was one of the four quarter days of the financial year, when rent was due, and marked the end of the annual agricultural cycle. As a result, in the Elizabethan period, many leases started at Michaelmas and it was also the day of the election of the Lord Mayor of London.
21. See Cook, *Dr Simon Forman*, pp. 61–2.
22. See Madge, *Abstracts of Inquisitions*, p. 200, post-mortem inquisition held for Alderman William Bond on 9 October 1576, reciting his will of 30 May 1576. His property was flanked by John Norgate, a (merchant) taylor, and John Parkes, a pewterer. He was not wealthy enough to make the £3 valuation in the 1576 Lay Subsidy roll but he contributed two shillings to the new Lecturer Fund in 1576, suggesting a solid but unspectacular business.
23. However, neither Kirk is recorded as a churchwarden or parish auditor once the records begin, *c.* 1565.
24. In the adjoining parish of St Peter, Cornhill, there were only three burials in the whole of June and July, then twenty in August to October; see Leveson Gower, *A Register of all the Christninges Burialles & Weddinges*, p. 126.
25. Children of a John Kirk, possibly her father-in-law, were baptised in St Peter Cornhill in the early 1540s, so there may have been relatives nearby.
26. In the middle of the plague, both Mrs Risby and Mrs Deere gave birth in August/September.
27. Or the wealthier residents simply left London. One notable death was that of John Gresham, cousin of Thomas Gresham and older brother of Cecily Cioll, who lived next to Crosby Hall. He would have been aged fifty and the cause of his death is not clear.
28. The Axtons (also spelt Axon and Axsson, hereafter spelt Axton throughout) seem to have been an established local family. In 1561, Lady Katherine Windsor, who lived in Bishopsgate Street in front of Gresham House, alienated a share of a property in the street to Peter Axton, possibly their father, along with Matthew Harrison, who ran the Bull with its theatre in the 1570s and 80s. The Axtons may, therefore, have had some later interest in the success of the Bull as a performance venue. A Lawrence Axon/Axsonne, possibly a brother and also a merchant taylor, lived in the neighbouring parish of St Peter Cornhill, where several children were baptised or buried in the 1560s/70s.
29. This is indicated by William Axton's location in the 1589 St Helen's tithe survey, which lists him among the names recorded in 1576 in the row of shops in front of Crosby Hall; see section 3 of the Appendix. Presumably, despite the terrible associations of the previous year, it was seen as a commercially advantageous address.
30. George Axton lived on in St Helen's and had three children. He was assessed at £3 in the 1598 Subsidy Roll and was sufficiently part of the parish establishment to be chosen as churchwarden in 1597 and 1598. He, therefore, almost certainly knew Shakespeare and must have observed him during church services, if nowhere else. He was buried in St Helen's in 1615. His son George continued to live in the parish.
31. Curiously, there is no direct documentation for a closure, as in other plague years. However, given the scale of the 1578 outbreak, a major closure seems inevitable.

# 6

## The Early Years of the Theatre: 1576–1586

*In which Burbage's theatre, although a new idea, can be seen to join a complex pre-existing performance ecology. In London, there are a variety of existing types of entertainment, performance spaces, theatre companies and playwrights. Unfortunately, the records for these early years are fragmentary, but it is possible to gauge something of what happened at the Theatre and how this compared to other venues.*

It is not known when Shakespeare first arrived in London. Most experts think it was sometime around the major social upheavals caused by military response to the Spanish Armada of 1588, as England prepared for this huge threat to its independence and Protestant religion. It certainly seems likely that he was in London by 1589, and enjoying the London playhouses was probably top of his agenda once he had secured lodgings and a source of income. It is not known whether his first experience of London theatre was at the Theatre, the Curtain or the newly opened Rose, but presumably within a few weeks he had visited them all and, of course, may have performed. The Theatre he was seeing was now twelve or thirteen years old and over that period would have developed a regular and knowledgeable audience.

It would be wonderful to know in detail what plays were performed at the Theatre during its first season in 1576 and the following decade. At the start, it seems likely that the Earl of Leicester's Men[1] was the resident company, since it was led by Burbage and was England's leading company until the creation of the Queen's Men in 1583. However, little is known of the programme, apart from a few contemporary comments. In 1579, Stephen Gosson's *The School of Abuse* discussed plays at the new Theatre:[2]

> And as some of the players are far from abuse, so some of their plays are without rebuke, which are easily remembered and as quickly reckoned: . . . *The Blacksmith's Daughter* and *Catiline's Conspiracies*, usually brought into the Theatre, the first containing the treachery of Turks, the honourable bounty of a noble mind, and the shining of virtue in distress. The last, because it is known to be a pig of mine own sow [i.e. written by Gosson], I will speak the less of it, only giving you to understand that the whole mark which I shot at in that work was to show the reward of traitors in Catiline and the necessary government of learned men in the person of Cicero, which foresees every danger that is likely to happen, forestalls it continually ere it take effect . . . These plays are good plays and sweet plays.

Figure 6.1  *The Triumph of Archduchess Isabella on 31 May 1615* recorded the great annual procession, or 'Ommergang', through the streets of Brussels, then the capital of the Spanish Netherlands. These illustrations are taken from the fifth of six long panels. Oil on canvas by Denys Van Alsloot, 1616.

Figure 6.2  At the centre of the parade was a pageant wagon representing the ruler, the Grand Duchess Isabella, daughter of Philip II of Spain. She is surrounded by her ladies-in-waiting and the scene is mirrored by the following shell-shaped wagon carrying Diana, the Roman goddess of the hunt and her female attendants.

Figure 6.3  The fifth panel is a rare depiction of medieval-style pageant wagons showing scenes from the Bible, such as the Annunciation and the birth of Jesus. In Protestant England, such 'mystery' plays had disappeared or been altered after the Reformation, as the imagery was considered idolatrous, but they continued in Catholic countries.

Figure 6.4  The procession contained several other types of 'street theatre', including giant wickerwork figures of camels and a unicorn. There were also real camels and mischievous 'green men' who chased the children.

The same year, plays at the Theatre were discussed by Gabriel Harvey in his *Letter Book*:[3]

> Leicester's, Warwick's, Vaux's or Rich's men or some other fresh start up comedians [may ask Harvey] for some malt-conceived comedy fit for the Theatre or some other painted stage.

So, it seems there was a mixed bag of types of play. Familiar favourites seem likely to have been staged in order to attract Londoners out of the City to Shoreditch, but equally, Burbage and Brayne would have needed new plays to differentiate their offering and to warrant charging their admission prices. The plays that were available in the late 1570s were the products of a tangled web of interlocking religious, cultural and social pressures of the previous decades. They would have ranged from productions close to slapstick through to high-minded versions of classical myths that would have appealed to the well educated, but might have had less appeal to the 'groundlings', standing for a couple of hours and expecting some dramatic action.[4] England had a rich theatrical heritage during the medieval period, including the 'cycles' of religious 'mystery' plays performed in the streets of Chester, Coventry, York and Wakefield, traditionally on the Feast of Corpus Christi. Other performances, along with music, displays of swordmanship and dancing, were arranged in the great halls of nobles, in market buildings, town halls and inn yards across the country (Figures 6.1–6.4). However, religious plays were progressively suppressed after the Reformation in England. Those in York disappeared in 1569, Chester after 1575, Coventry in 1579. In Wakefield in 1576, permission was given to perform an altered version, but only if:

> In the said play no pageant be used or set further wherein the Ma(jest) ye of God the Father, God the Sonne, or God the Holie Goste or the administration of either the Sacrementes of baptism or of the Lordes Supper be counterfeited or represented, or anything plaid which tend to the maintenance of superstition and idolatry or which be contrary to the laws of God or of the realm.
> (Order by the Diocesan Court of High Commission at York)[5]

With the decline in religious presentations, secular theatre developed to fill the gap through the 1550s and 1560s. In London, four inns were known for staging performances.[6] There was the Bel Savage in Ludgate and three others close together in the centre of the City along the main south to north route connecting London Bridge with Bishopsgate. These were the Cross Keys and the Bell in Gracechurch Street, and the Bull in Bishopsgate Street.

The dominance of Shakespeare in English literature and history means that the critical judgement on these earlier decades has usually been back-projected from a later

'golden age'. As a result, it is seen as a period of relatively low quality. However, in reality, cultural development moves forward in time, and this period needs to be viewed on its own merits rather than as a shadow of what was to come.[7] Furthermore, very few plays survive from this period, and it is difficult to know if these are a fair representation of all the ones which are now lost. What is certain is that for the decade from the opening of the Theatre and then the Curtain to the building of the Rose in 1587, there was a sufficient corpus of old and new plays to underpin the establishment of at least three commercial playhouses.

Moreover, the Theatre and the other playhouses did not sweep away the other existing venues. The years after 1576 probably saw a mixed ecology, with the Theatre and the Curtain competing but also possibly cooperating with the four City Inns that staged performances. There were also theatre companies of schoolboy actors, who performed without adults. The boy choristers of St Paul's Cathedral used the Almoner's Hall from 1575 until 1584, and in 1576 a rival group from the Chapel Royal was established in the old Blackfriars. These small indoor spaces allowed the boys to practise to a standard of acting and singing good enough to entertain the Queen at court. Stephen Gosson recorded in 1582 in his *Playes Confuted* that stagings included 'Cupid and Psyche played at Paul's and a great many comedies more at Blackfriars'.

Finally, there was the royal court itself, where the Master of the Revels ensured that there was a programme of masques, dances and other performances to entertain the Queen, courtiers and visiting ambassadors in suitably impressive style.

Over the Christmas/New Year festivities, the best theatre companies would attend and deliver their most appropriate productions. To give an idea of what could be available in the three decades after the accession of Elizabeth in 1558 and the opening of Henslowe's Rose playhouse in 1587, one play, *Gorboduc*, highlights several important elements. At Christmas 1561, the Inner Temple, one of London's four Inns of Court for legal training, saw the premiere of *The Tragedie of Gorboduc* in its great hall. A few weeks later, it was performed before the court at Westminster for Elizabeth I by 'the gentlemen of the Inner Temple'. Before considering the play itself, it is interesting to look at the broader context of its production. This illustrates how individual plays could be fitted into far more complex settings of allegorical stories exploring current events and political ambitions.

Winter 1561 saw the staging of elaborate revels at the Inner Temple to celebrate Lord Robert Dudley's success in defending the Inner Temple's rights.[8] He was made 'Christmas Prince', and the revels consisted of elaborate re-enactments of classical mythology, including the story of Pallas, Perseus and the Gorgon. Eventually, Pallaphilos appears to feast with the ambassadors of the other Inns of Court alongside members of Queen Elizabeth's Council. He also creates the Order of Pegasus, consisting of twenty-four knights, mirroring the real-life Order of the Garter. The entertainment stressed the

importance of loyalty and the dangers of the 'Serpent of Division'. Such allegories would have appealed to the sophisticated audience made up of the classically trained and Latin-speaking lawyers and students of the Inns of Court and their friends. Some experts consider the entire undertaking a clear but 'disguised' marriage proposal by Dudley to Elizabeth I.[9]

*Gorboduc* itself is a tragedy describing the fallout from the fateful decision by an ancient king of the Britons to divide his country between his two sons, Ferrex and Porrex, overturning the country's tradition of succession by the eldest son only. The result is murder, strife and civil war, which eventually destroys all the protagonists and leaves the country devastated. Despite its focus on the problems of succession, it was considered sufficiently respectful to be performed in front of Elizabeth, who had only gained her throne three years earlier.

> **Gorboduc**
> My purpose is to leave unto them twain
> The realm divided into two sundry parts:
> The one Ferrex, mine elder son, shall have;
> The other shall the younger, Porrex, rule.
> That both my purpose may more firmly stand,
> And eke that they may better rule their charge
> I mean forthwith to place them in the same,
> That in my life they may both learn to rule
> And I may joy to see them ruling well.
> (*Gorbuduc*, I.ii.128–36)

The play was written by two members of the Inner Temple, Thomas Sackville and Thomas Norton. Today it is best known as the first example of the use of blank verse in a play, rather than for its dramatic qualities.[10] Indeed, the play is very rarely performed, although there was a semi-staging in 2013 in the Hall of the Inner Temple. This highlighted the 'courtly, discursive and restrained' character of the play, where there was little action 'to please the groundlings'.[11] However, the play was popular enough to be published in September 1565, with a second edition in 1570 and a third in 1590. This suggests it would have been known to Burbage, Marlowe and Shakespeare, and the plot obviously presages *King Lear*.

Other evidence of plays at the Theatre included, from 22 February 1582:

> [Richard Madox] went to the Theatre to see a scurvy play set out all by one virgin, which there proved a freemartin ['fyemarten' – an imperfect female] without voice, so that we stayed not the matter.

Occasionally, there are mentions of specific performers, for example when the newly established Queen's Men appeared at the Theatre in 1583, when Harington's *Metamorphosis of Ajax* recorded:

> [Harington mentions a vulgar word,] 'prepuce', which word was after admitted into the Theatre with great applause by the mouth of Master Tarlton, the excellent comedian.

There is also evidence that an earlier version of *Hamlet* was staged at the Theatre, around 1595–6, since Lodge's *Wits Miserie* recorded:

> Pale as the vizard of the ghost which cried so miserably at the Theatre, like an oyster wife, 'Hamlet, revenge.'

There were also shows apart from straight drama. A document from 25 August 1578 records a fencing demonstration:

> Edward Harvie played his provost's prize the 25th . . . of August at the Theatre at three weapons, the two-hand sword, the back sword, and the sword and buckler [shield]. There played with him one provost, whose name is John Blinkinsop, and one free scholar, called by name Francis Calvert, who had a provost's licence for that time. And so the said Edward Harvie was made a provost under Richard Smyth, master, 1578.

These displays were organised by the Masters of Defence, which was the official organisation for teaching fencing in the London area. Demonstrations spread to a variety of venues across London in the late 1560s, including the inns in the City used for theatre performances. The Bull in Bishopsgate Street was the favourite location, hosting at least twenty-one shows.[12]

As the first decade of the Theatre came to a close, Burbage for reasons unknown teamed up with the adjacent Curtain playhouse, whose owner, Henry Lanman, recorded on 30 July 1592 their arrangement to profit-share:

> About seven years now shall be this next winter, they, the said Burbage and Brayne, having the profits of plays made at the Theatre and this deponent having the profits of the plays done at the house called the Curtain near to the same, the said Burbage and Brayne, taking the Curtain as an easer [meaning uncertain] to their playhouse, did of their own motion move this deponent that he would agree that the profits of the said two playhouses might for seven years' space be in divident between them. Whereunto this deponent, upon reasonable conditions and bonds, agreed and

Figure 6.5 Philip Henslowe, owner of the Rose, revived Marlowe's Jew of Malta (c. 1588) several times in May/June 1594, exploiting the controversy over whether Doctor Lopez was really guilty or a victim of political infighting at Court. Detail from Henslowe's account book for 14 May and 4 June 1594 (underlined). Alleyn-Henslowe MS 07-009 recto.

Figure 6.6 In early 1594, Londoners were shocked to learn that Dr Roderigo Lopez, physician-in-chief to Elizabeth I, had been arrested for plotting to poison her. Lopez was a Portuguese *converso* of Jewish ancestry. On 7 June, he was brutally executed at Tyburn. Engraving by Esaias van Hulsen.

consented and so continueth to this day. And [Lanman] saith that at the first motion of this agreement the said Brayne had his portion duly answered him of the said profits and until he died.

In 1587, this cosy operation of the Theatre and the Curtain in Shoreditch was disrupted by the arrival of the entrepreneurial Philip Henslowe, who built the Rose playhouse on Bankside.[13] Clearly, after a decade, London's regular theatre audience was established sufficiently enough to support a third major playhouse. Indeed, after five years the Rose was extended in 1592 to increase its capacity, just before the plague of 1592–4 shut all the playhouses.

In sharp contrast to the paucity of information about the Theatre, Philip Henslowe kept a diary/payment book in the 1590s which has survived and contains a mass of financial and other information about the day-to-day operation of his playhouse. In particular, for the three years 1594–6, there are complete listings of all the plays staged at the Rose with Henslowe's income, allowing an examination of the detailed programming of the Admiral's Men, the main rivals to Shakespeare's Company.[14] A few examples, as follows, indicate the level of public interest.

On Tuesday, 14 May 1594, a revival of Christopher Marlowe's *The Jew of Malta* reopened the Rose. It proved popular, with an income for Henslowe of 49 shillings or 588 pennies (Figure 6.5). It has been suggested that Henslowe was exploiting public interest generated by the trial of Roderigo Lopez, Queen Elizabeth's physician-in-chief and a Portuguese converso, who was convicted of high treason on 28 February 1594 (Figure 6.6).[15] The theatres were just getting back in business after the long closure 1592–4, so this old play did reasonably well. However, when it was repeated on 4 June at Newington Butts, just before Lopez was executed on 7 June, his share was down to a fifth at 10 shillings or 120 pennies. Henslowe tried again on 13 June, back at the Rose, when his income was a pathetic 4 shillings or 48 pennies. His income range at the Rose with the newly established Lord Admiral's Men ranged from 4 to 84 shillings.[16] Unfortunately, there are no records of the weather, which would have been an important factor and probably accounted for the occasional very poor attendances.[17]

In contrast, the premieres of two new plays, *Galiaso* and *Philipo and Hippolito,* both unfortunately now lost, were the most successful performances in 1594. His income from both was 84 shillings or 1,008 pennies, probably representing a close to full house. Over the seven months of 1594, Henslowe took in around £240 at an average of £1-10s-0d (30 shillings or 360 pennies) per performance. Over the seven months of 1594, the Lord Admiral's Men staged thirteen premieres of new plays, roughly one a fortnight, a punishing schedule when they also had to keep at least another twenty or so plays in repertory. The pace slowed somewhat in 1595 but there were still fourteen or fifteen new plays to be learnt that year. These typically generated 60–70 shillings (720–840 pennies)

# Living with Shakespeare

for their premieres. That year, Henslowe's income was close to £340 with the average per day slightly up at around £1-12s-0d.

While there is no certainty, it is likely that the Lord Chamberlain's Men at the Theatre were operating a similar pattern of performance with James Burbage as their landlord. If they premiered a similar number of new plays, with Shakespeare delivering two a year, they would have to have sourced at least a dozen more from other playwrights.

For anyone who would like to read some drama from this period, there follows a list of plays (in possible or 'best evidence' chronological order) of which the text survives and which might have been performed in the public playhouses from 1576 to *c.* 1591.[18] The plays of Marlowe and the early works of Shakespeare, some possibly written with Marlowe's help, have been studied and performed for centuries. Others on the list have only become easily available in recent years and productions are few and far between.

| | |
|---|---|
| George Wapull | *The Tide Tameth No Man* (published 1576) |
| Anonymous | *Common Conditions* (listed Stationers Company Register, 1576) |
| Thomas Lupton | *All for Money* |
| George Whetstone | I and II *Promos and Cassandra* |
| Francis Merbury | *A Marriage between Wit and Wisdom* |
| Robert Wilson | *The Three Ladies of London* |
| John Lyly | *Campaspe* |
| John Lyly | *Sappho and Phao* |
| John Lyly | *Galathea* |
| Anonymous | *The Famous Victories of Henry V* |
| Robert Greene | *Alphonsus, King of Aragon* |
| Thomas Kyd | *The Spanish Tragedy* |
| Christopher Marlowe | *I Tamburlaine* |
| Christopher Marlowe | *Dido, Queen of Carthage* |
| Christopher Marlowe | *II Tamburlaine* |
| John Lyly | *Endymion* |
| Henry Porter | *I The Two Angry Women of Abingdon* |
| Robert Wilson | *The Three Lords and Three Ladies of London* |
| John Lyly | *Mother Bombie* |
| John Lyly | *Midas* |
| Christopher Marlowe | *The Jew of Malta* |
| Christopher Marlowe | *The Massacre of Paris* |
| Anonymous | *I and II The Troublesome Reign of King John* |
| Robert Greene | *Friar Bacon and Friar Bungay* |
| Anthony Monday | *John a Kent and John a Cumber* |

| | |
|---|---|
| George Peele | *The Battle of Alcazar* |
| Anonymous | *The Taming of a Shrew* |
| Robert Greene | *The Scottish History of James IV* |
| Robert Greene | *George a Green, the Pinner of Wakefield* |
| Robert Greene and Thomas Lodge | *A Looking Glass for London and England* |
| John Lyly | *Love's Metamorphosis* |
| George Peele | *The Old Wives' Tale* |
| Robert Wilson | *The Cobbler's Prophecy* |
| Anonymous | *Fair Em, The Miller's Daughter* |
| Anonymous | *Edward III* |
| Anonymous | *King Leir* |
| Anonymous | *Mucedorus* |
| Robert Greene | *Orlando Furioso* |
| W.S. | *Locrine* |
| William Shakespeare | *II Henry VI* |
| William Shakespeare | *III Henry VI* |
| Christopher Marlowe | *Edward II* |
| Anonymous | *Arden of Faversham (published 1592)* |

In terms of output, John Lyly (1553–1606) heads the list:

John Lyly = 7 (although it is not certain which of these were performed)
Christopher Marlowe = 6
Robert Greene = 5
Robert Wilson = 3
George Peele = 2
William Shakespeare = 2
George Wapull, Thomas Lupton, George Whetstone, Francis Melbury, Thomas Kyd, Henry Porter, Anthony Monday, Robert Greene, Thomas Lodge, W.S. = 1 each, total = 10
Anonymous = 9

While in terms of subject matter, they fall into five main groupings:

- classical myths and heroes
- history (English, Scottish, overseas)
- recent events/politics
- revenge-tragedy
- local/love story

A selection of four plays written in the 1580s shows the range of drama that was being performed. *The Battle of Alcazar*, attributed to George Peele (1556–96), was a dramatised account of the events leading up to the epic real Battle of Alacácer Quibir in Morocco in August 1578. It was also known as the Battle of Three Kings, since all three commanders were killed. In contrast, *A Looking Glass for London* by Thomas Lodge (1558–1625) and Robert Greene (1559–92) is based on the biblical story of Jonah, highlighting the moral lessons that could be applied to London. In contrast, in *Campaspe* John Lyly took the story of Alexander the Great falling in love with the beautiful captive Campaspe in Athens, while *Arden of Faversham* describes the true story of the murder of Thomas Arden, the forty-two-year-old former mayor of a Kentish town, by his wife and her lover.[19] Domestic crime, international geopolitics, traditional moralising and retelling classical history: it was all there on the various London stages.

The London theatre world of 1587/8 was shaken up not just by the opening of the rival Rose playhouse on Bankside, but by the arrival of the twenty-three-year-old Christopher Marlowe as an *enfant terrible*. His first play on an adult stage was *Tamburlaine the Great*, and it was a major hit. The dramatic language and action-filled plot matched the mood of a country that had just been threatened by, and then defeated, the massive Spanish Armada of Philip II. The start sets the whole tone of the play:

> **Prologue**
> From jigging veins of rhyming mother-wits
> And such conceits as clownage keeps in pay
> We'll lead you to the stately tent of War,
> Where you shall hear the Scythian Tamburlaine
> Threat'ning the world with high astounding terms
> And scourging kingdoms with his conquering sword.
> View but his picture in this tragic glass,
> And then applaud his fortunes as you please
> [Exit]
> (*Tamburlaine the Great*, Part 1, Pro. 1–8)

Around the same time, probably in 1587, Thomas Kyd wrote *The Spanish Tragedy, or Hieronimo is Mad Again*. Another popular success, the plot focused on intrigue, corruption and revenge with violent murders. After Horatio, his son, is murdered, Hieronimo rages:

> **Hieronimo**
> Then sham'st thou not, Hieronimo, to neglect

Figure 6.7  Portrait of the young Mary, Queen of Scots (1542 – executed 1587). Mary abdicated in favour of her one-year-old son James VI in 1567 and fled to England the following year. Seen as a constant threat to Elizabeth I, she was kept under close house arrest until her implication in the 1586 Babington Plot led to her trial and beheading.

Figure 6.8  Portrait of James VI of Scotland and I of England (1566–1625). James never knew his mother or father, both of whom met violent deaths. As Elizabeth I was childless, he succeeeded to the English throne in 1603, since he was the great-great-grandson of Henry VII of England. Oil by John de Critz, *c.* 1605.

> The sweet revenge of thy Horatio?
> Though on this earth justice will not be found,
> I'll down to Hell and in this passion
> Knock at the dismal gates of Pluto's court.
> Getting by force, as once Alcides did,
> A troop of Furies and tormenting hags,
> To torture Don Lorenzo and the rest.
> (*The Spanish Tragedy*, III.xiii.1939–47)

Unfortunately, up to 1594, it is not certain what players, playing companies, dramatists, or plays appeared at the Theatre, although the works of Marlowe and Kyd's *The Spanish Tragedy* seem highly likely as potential plays.

On the larger political stage, the execution of Mary, Queen of Scots (Figure 6.7) in 1587 removed the most significant threat to Elizabeth I, now aged fifty-four and still childless. While there were various claims on the succession, increasingly Mary's son, James VI of Scotland (Figure 6.8) seemed to be a relatively safe future monarch, and the power brokers in England began to plan for a Jacobean future.

It was during this great burst of creative energy that William Shakespeare probably arrived in the capital, and some consider it possible that *Tamburlaine the Great* was the first play he saw in London. Certainly, Shakespeare was influenced by Marlowe, and recent editors consider that Marlowe may have made significant contributions to his early *Henry VI* trilogy.[20] The years 1589–92, in the aftermath of the 1588 Spanish Armada, must have been a fascinating time to be in London. England's confidence had soared, and the naval war was being taken to the Spanish coast or its colonial empire. English merchants were itching to exploit the victory to open up trade routes to the riches of the India, the Spice Islands and China or, as it was then known, Cathay.

Notes

1. Robert Dudley was made Earl of Leicester in 1564. His older brother Ambrose was made Earl of Warwick in 1561.
2. Stephen Gosson (1554–1624) was a playwright, described in 1598 as 'best for pastorall', although none of his works survive. However, he took holy orders and turned against theatre. In 1600 he became minister of St Botolph Bishopsgate, although with the demise of the Theatre in 1598, presumably the size of the crowds passing by his church on their way to the Curtain and Shoreditch had reduced.
3. See Scott, *Letter-Book of Gabriel Harvey*, edited from the original MS. Sloane 93 in the British Library.
4. See for example in the former category, *Gammer Gurton's Needle* (*c*. 1553), where the unknown author takes his characters through five acts of hunting for a lost needle, eventually located in the buttock of Hodge, Mrs Gurton's servant.

5. See 'Wakefield Mystery Plays', *Wikipedia*, <https://en.wikipedia.org/wiki/Wakefield_Mystery_Plays> (last accessed 4 August 2020).
6. Their names are recorded in a City licence of 1584. The Bel Savage was staging performances from at least the mid-1560s and was also used for fencing displays and bear baiting. The animal trainer William Bankes presented his horse 'Seignor Marocco', which could do various tricks and stunts.
7. For more information on this period, see the *Before Shakespeare* website – <https://beforeshakespeare.com/> (last accessed 20 July 2020) – which covers a multitude of fascinating events and personalities from this period, with the aim of showing them in their own time context rather than to connections later to Shakespeare. This includes a listing of plays from the period, the earliest of which is thought to be *The Three Ladies of London,* probably performed by the Earl of Leicester's Men and eventually published in 1584. For those who wish to delve deeper, see Richardson and Wiggins, *British Drama 1533–1642: A Catalogue*, which provides a vast amount of detail on plays, masques and related performances such as royal welcomes when Queen Elizabeth visited cities around England.
8. Dudley's wife had died a year earlier in September 1560 in mysterious circumstances, leaving him free to woo Elizabeth; see Axton, 'Robert Dudley and the Inner Temple Revels'.
9. From her accession, Robert Dudley was Elizabeth's favourite, but his wife had died in mysterious circumstances a year earlier. Rumours claimed Dudley had murdered her so that he could marry the Queen. Ironically, the resulting scandal ensured that she would never marry him. Dudley continued to use theatre as a means of self-promotion, most notably at the nineteen-day celebrations at Kenilworth Castle in 1575.
10. First used by Henry Howard, Earl of Surrey (1516/17 – executed 19 January 1547) in his translation of the second and fourth books of the *Aeneid*, written *c.* 1540 and published after his death in 1554–7.
11. See Evans, 'Review: Gorboduc', pp. 38–9. Other productions at the Inns of Court included *Jocasta* in 1566, written by George Gascoigne and Francis Kinwelmarsh, performed at Gray's Inn; and *Gismorde of Salene in Love*, written by five authors for the Inner Temple in 1567.
12. See Kathman, 'Hobson the Carrier and Playing at the Bull Inn'. For detailed information on the Masters of Defence, see Berry, *The Noble Science*, and see also for a short summary, Dylan, *A Study of the London Masters of Defence*, <http://iceweasel.org/lmod.html> (last accessed 20 July 2020).
13. The foundations of the Rose were discovered in 1989 and, after a public campaign to prevent their destruction, were preserved for public display in the basement of a new office building on the site.
14. The excellent Henslowe-Alleyn Digitisation Project now provides easy online access to these records, which are still owned by Dulwich College, founded by Edward Alleyn in 1619. See <https://henslowe-alleyn.org.uk/> (last accessed 20 July 2020).
15. A *converso* was a Jew who had 'converted' to Christianity, usually in Iberia.
16. The exact basis for income split is uncertain. Some argue that the playing company got the income from the pit plus half of the take from the galleries, with the balance going to the theatre owner. However, Henslowe had invested recently in expanding the Rose in 1592, so there may have been an agreement to allow him to recover the cost of the improvements.
17. For example, the premiere of a play about the thief Bellin Dunn, *Bellendon*, another lost play, on 8 June brought in 17 shillings at the Newington Butts playhouse, while the first repeat on 15 June at the Rose produced 64 shillings.
18. The list is provided in Berry, *The First Public Playhouse*, pp. 14–15.
19. There has been much expert debate over the author of *Arden of Faversham*. At various times it has been attributed to Thomas Kyd, Christopher Marlowe and William Shakespeare.
20. See Taylor et al., *The New Oxford Shakespeare.*

# 7

## The 1594 Changes at the Theatre and Shakespeare's New Focus

*In which we discover that from the early 1590s, the evidence for the pattern of playing in London becomes much clearer. From 1594 Shakespeare becomes a key part of the Theatre as he is a 'sharer' in its resident company, the Lord Chamberlain's Men. However, while we have his plays, most of our knowledge about the theatrical business comes from Philip Henslowe's account book relating to their rivals – the Admiral's Men, based at the Rose playhouse on Bankside.*

By 1592, the Theatre had been operating for sixteen years of its original twenty-one-year lease. James Burbage, having just turned sixty, was probably quietly satisfied with the success of his project. Despite all the problems, he was leaving his two sons, Cuthbert and Richard, with an established, popular and profitable legacy. The construction of the rival Rose playhouse on Bankside by the impresario Philip Henslowe in 1587 might have brought new competition, but the copying of his idea by other businessmen only demonstrated the soundness of his original gamble.

It had certainly brought him some personal wealth. In February 1596, Burbage bought the Blackfriars Hall in the City for £600, with probably another £200 more needed to fit it out as London's first permanent indoor theatre. It is noteworthy that he had been able to build up such a large financial reserve that he felt he could spend £800 on a new venture, particularly at a time when age might naturally have made him more risk-averse. The £600 purchase price alone suggests that he must have been generating an average annual surplus at the Theatre, over and above all his costs and living expenses, of at least £80–100 per annum – perhaps more. Given his experiences at the Theatre, it is doubtful that he would have put all his eggs into one basket. Indeed, as events turned out, he would have been right to be cautious. The new project was stopped in November 1596 by a petition against the potential disturbance from the upmarket residents of the Blackfriars enclave; in modern parlance, 'NIMBY' neighbours. James Burbage died three months later, bringing the whole project to an end for the moment. Despite this disastrous capital investment in a non-performing asset, Richard and Cuthbert flourished, suggesting that the Theatre continued to deliver financially.

However, just as it seemed James could begin to wind down, another crisis erupted across London's theatre community, again at least partly instigated by an outbreak of plague. Fourteen years had passed since the last major outbreak in 1578, and again, most people's memories of its virulence had faded. When the plague struck again in 1592, it

came late in the year, paused over winter and then struck hard from late summer 1593. During September 1592, Queen Elizabeth had been on a royal progress through Gloucestershire and then turned back east for a week in Oxford from 22 to 28 September.[1] On Monday, 9 October, she was back at Hampton Court Palace, but within days the Privy Council was writing to the sheriffs of the surrounding counties:

> by reason of the infection of sickness both in London and other places thereabouts. Her Majesty hath thought convenient that no access of strangers should be here to her court.[2]

Two days later, there was a proclamation prohibiting access to court because of the plague:

> To restrain access to the court of all such as not bound to ordinary attendance, or that shall not be otherwise licensed by her Majesty. No unauthorized persons to come within two miles of court; no one from court to go to and from London without special licence.[3]

Back in the City of London in St Helen's, four people in George Tedder's house in Bishopsgate Street died over four weeks in October/November 1592, almost certainly from the plague; and Richard Risby, after the tragedy of 1578, lost a third daughter. Then the plague seemed to disappear and deaths dropped back to normal. In early 1593, a scatter of deaths in a location recorded as 'Staveley's Alley' might have marked a reappearance,[4] but the plague really took hold again in the August heat, when there were seventeen burials followed by twenty-three in September, dropping back to thirteen in October. By the end of the year around sixty people had died in St Helen's from the plague, perhaps 10 per cent of all the parishioners.

In 1593, the plague swept alarmingly close to Queen Elizabeth, who was staying well out of London at Windsor Castle. On Tuesday, 20 November, John, a page to Lady Scrope, died of the plague and was buried the same day. Anthony Standen wrote to Anthony Bacon:

> The death of a page of the Lady Scrope (so near to her Majesty's person as of her bedchamber)[5] of the sickness this last night past, and that in the keep within the Castle, hath caused here a great alteration, so that it may not be doubted but that she [Queen Elizabeth] doth remove within a day or two the farthest. ... My Lord Treasurer [Burghley], for all his sore gout, upon the alarm of this Page, and a new one since by the death of one of the Scalding-house of the same disease, is preparing to be gone.[6]

The only effective response to plague, even for the most powerful people in England, was physical flight.

The overall effect of the plague was that London's playhouses were closed by the authorities for most of the period from June 1592 until April 1594. While theatre historians have tended in the past to see this as a sideways attack on their subject heroes, it was a perfectly logical response, and banning large meetings was used in many cities. Indeed, it was one of the very few actions that the authorities could order to show the severity of an outbreak of plague. However, it did cause huge disruption among the acting companies, since the only alternative to performing in London was touring in the provinces, with all the uncertainties of constantly moving on and an unpredictable income. By spring 1594, it was clear that there were serious impacts with theatre companies disintegrating and, for once, the government took action to ensure there was a sufficient theatrical resource left in the capital to continue to provide the court with entertainment when required.

Experts disagree about the precise reasons for the events of May/June 1594, the creation of the so-called theatre 'duopoly', but the broad outcomes seem clear.[7] Two new theatre companies were established in London, under the patronage of two leading aristocrats, from the companies left after the disruption of the previous two years. These were Lord Hunsdon, patron of the Lord Chamberlain's Men, managed by the Burbages,[8] and Charles Howard, his son-in-law, who became patron of the Lord Admiral's Men, managed by Philip Henslowe. Furthermore, from then on the Lord Chamberlain's Men were based at the Theatre in Shoreditch with Shakespeare as the lead writer, and the Lord Admiral's Men were based at the Rose playhouse in Southwark with performance rights to the plays of the recently deceased Christopher Marlowe. Both were located outside the City's jurisdiction and at the same time, it seems to have been agreed that playing would stop at the inns within the city walls and that all performances would start at two o'clock in the afternoon.[9]

From 1594/5 to 1598/9, these were the only theatre companies to play in winter at court, which strongly suggests that ensuring the supply of high-quality productions performed by the best actors to Queen Elizabeth was a key consideration in this new arrangement. The exact whys and wherefores can be left to the specialists.[10] It is not clear if this was a top-down decision from the authorities or more of a co-operative scheme among the leading actors to ensure stability and their future earnings. In practice, it may have been a mixture of both. Certainly, there were other theatres in operation – notably the existing Curtain, to be joined by the Swan on Bankside in 1595 and the Boar's Head, Aldgate, from *c.* 1598 onwards.

However, as far as the thirty-year-old Shakespeare was concerned, this change was crucial, as it brought recognition and membership of a stable company, working at the Theatre and possibly the Curtain, as it turned out for the next five years.

Furthermore, he was one of eight 'sharers' in the new company, bringing him a significantly improved income.[11] Robert Bearman has recently estimated that this would have brought him an annual income of £50, a path to a comfortable living although not great wealth. Given the election of Sir John Spencer, who was famously anti-theatre, as Lord Mayor a few months later, this reorganisation did not come a moment too soon.

The four-year period from May 1594 to 1598 was the golden age for the Theatre, and saw the transformation of English theatre more generally. Although experts disagree about precise dates, Shakespeare authored around ten plays during this period, including *Romeo and Juliet*, *A Midsummer Night's Dream*, *The Merchant of Venice* and *Richard II*. These must have premiered at the Theatre or the Curtain and in the absence of definitive proof, it seems likely that the Theatre was the lead venue of the two playhouses.[12] At the Rose playhouse it is known that a new play was staged every couple of weeks, so over this four-year period it is likely that another seventy to ninety plays were premiered alongside Shakespeare's masterpieces.

While Shakespeare's work improved the overall quality of the plays, the day-to-day operation of the Theatre from 1594 was probably similar to the period before its closure in 1592. The players would have gathered early in the morning inside the 'Wooden O' to rehearse. They would probably have started working on whatever new play was in production. Players would have had the previous evening to learn their lines, each role supplied individually on small scrolls. With a new play premiered every two to three weeks, there were probably fifteen morning rehearsals, maybe fifty to sixty hours in total, to master a play like *The Merchant of Venice*.

Given that actors would have done a different play each day from a repertory of more than twenty plays, late morning was probably taken up fine-tuning the performance for the afternoon. With a short break for some sustenance around one o'clock, the players would then have gone backstage into the tiring house to don their costumes as necessary, fix their hair, arrange accessories and props and go through their favourite ritual before the performance began. At a distance, a trumpet and drum would be literally drumming up an audience. Most of the audience would probably have downed their tools around one o'clock to allow sufficient time to walk out the mile or so to Shoreditch and arrive with enough time to queue through the narrow entrances to get a decent standing position or seat.

Gatherers by the entrance doors would take the penny admission charge, with others by the stairs to take additional payment for sitting in the galleries. Even in cold December weather, the hundreds of bodies would soon have helped warm the unheated, semi-roofed space. In summer heat, a full house must have been a sweaty and odoriferous experience. With any reasonable audience, the creaking floorboards, stamping feet, restless movement, gossip and backchat must have produced an extraordinary intensity

within the tightly enclosed space. Certainly, it would have been very different from sitting still on a hard pew in a cold stone church, watched over by churchwardens while listening to a long sermon. In the theatre, every new play was a chance to imagine a different world, and as the first player began to speak, the opportunity to catch 'Now fair Hippolyta, our nuptial hour'; 'Two households, both alike in dignity'; 'Old John of Gaunt, time-honoured Lancaster'; 'Now say Châtillon, what would France with us?'; 'In sooth, I know not why I am so sad'; 'Open your ears, for which of us will stop'; or perhaps from a revival, 'Now is the winter of our discontent'. The minutes fly by, the clock has passed four and is moving towards five as the play moves towards its finale: 'For never was a story of more woe/Than this of Juliet and her Romeo'; 'Naught shall make us rue/If England to itself do rest but true', 'To Master Brooke you yet shall hold your word/For he tonight shall lie with Mistress Ford'.

Whether the audience left happy or dissatisfied, Burbage knew that he always had their money in his pocket, the money to pay the best actors and to commission the best new plays. It was a win-win situation all round. There was financial stability not only for the theatre owners, but for the actors and playwrights too. In early 1596, James Burbage had felt sufficiently confident and rich enough with his accumulated earnings to pay £600 for the Great Hall of the Blackfriars to create a new type of theatre. His strategy is not totally clear. Some argue that this was intended to be an upmarket indoor replacement for the Theatre.[13] However, others contend that the shift to an unproven business model, with fewer seats than the Theatre or the Rose but much more expensive admission, was far too much of a risk. The Blackfriars might simply have been an opportunistic purchase, located closer to the Inns of Court, the Strand and the more affluent residents scattered across the parish of St-Martins-in-the-Fields and Westminster. Given Burbage's quixotic character, it would be a brave historian who would try to nail down his exact motives. The Blackfriars was also a 'liberty', outside the Lord Mayor's control. The opportunity to cock a snook at authority would have appealed to Burbage, especially in the months following on from the end of Sir John Spencer's mayoralty. Whatever his ambition, for once Burbage was stopped in his tracks; and it was only in 1608, twelve years later, that the by-then-renamed King's Men would enter into this inheritance.

The only shadow over the future, now that Brayne was dead and Cuthbert Burbage had recovered the lease of the Theatre in 1589 from John Hyde, was that the twenty-one-year contract had itself ended in March 1597. As the time remaining on the lease dropped to five years, then three, then two, James Burbage probably reflected how much England had change during his tenure. In 1576, it had been a 'little' England, before Drake's circumnavigation of the world, Sir Humpfrey Gilbert's occupation of the Newfoundland, the first 1588 Spanish Armada – and with a Queen aged forty-three, not an increasingly tetchy ruler approaching sixty-four.

By 1596, with the failure of his Blackfriars purchase, James Burbage must have been increasingly concerned about extending the lease on the Theatre after 1597. Richard Burbage, Shakespeare and the other actors may also have been anxious that the future of their theatre company was dependent on negotiations by this confident but truculent individual. James Burbage started negotiations with Giles Allen for a new lease, as the latter had promised in 1576. However, the constant disputes over the years had done little to endear Burbage or indeed theatre to the conservative Allen. Once again, we are dependent on court depositions to track events and to understand the key issues. Allen had a litany of complaints against James Burbage:

> And further, the defendant [Giles Allen] saith that such was the bad dealing of the said James Burbage towards the defendant from time to time before the time of the said new lease tendered, and the said James Burbage had been such a troublesome tenant unto the defendant, that there was no cause in conscience to make the defendant to yield to anything in favour of the said James Burbage, further than by the law he might be compelled to do . . .

Specifically:

> For first, whereas the said James Burbage was bound to pay unto the defendant the sum of £20 for a fine for the lease formerly made unto him, the said James Burbage neglected the payment thereof at the time appointed and long time after, and hardly could the defendant, after much delay and trouble by suit in law, obtain the same. . . . And at the time of the said new lease tendered by the said James Burbage, he, the said James, did then owe . . . £30 for the rent . . ., which as yet remaineth unpaid . . .[14]

While Burbage is the hero to theatre historians, one can also have a little sympathy for the position of Allen. Then, while all was still unresolved, James Burbage died and was buried in St Leonard, Shoreditch on 2 February 1597. By this point, there were only weeks left on the lease. Cuthbert Burbage took up the negotiations with vigour and despite James's death, or perhaps because of it, Allen did begin to discuss a new lease. A lawyer, Robert Vigerous, who helped both sides negotiate, stated that he knew the facts since 'he was of counsel with the said parties in the said agreement, and by all their mutual consents was appointed and especially named to draw, pen and write the said new lease'. His deposition shows a new agreement was almost reached:

> The said complainant [Cuthbert Burbage] together with James Burbage, his father, and the said defendant [Allen] were in communication about the making and taking of a new lease of the houses and grounds and Theatre mentioned in this interrogatory.

> And at the last it was concluded and agreed between all the said parties that the defendant should make a new lease of the same to the said complainant for the term of ten years for and under the yearly rent of £24 . . .[15]

Further detail about how close things got to a solution was provided by Henry Johnson, a silk weaver:

> About Michaelmas term last past was twelvemonth [September/October 1598], the complainant [Cuthbert Burbage] . . . and he, this deponent, met at the defendant's [Allen's] lodging, with the defendant, at the sign of the George in Shoreditch . . . at which time there passed between the complainant and the defendant divers speeches touching a new lease of the premises to be made by the defendant to the complainant for one and twenty years. . . . And the defendant was contented and did accept of the complainant's proffer in all, except . . .

for one clause which proved to be the deal breaker:

> . . . his demand for the Theatre to stand as a playhouse, which he misliked. . . . Whereupon the complainant requested the defendant that he would suffer it to stand for a playhouse but the five first years of the one and twenty years, and afterwards he would convert the same to some other, better use, viz., into tenements. . . . Whereupon he [the complainant] made proffer unto the defendant of his brother, Richard Burbage, with whom the defendant misliked, and so thereupon they left off and parted.[16]

This latter deposition shows that negotiations carried on for over a year after the lease ran out and, presumably, Giles Allen allowed the Lord Chamberlain's Men to continue performing at the Theatre as he seemed minded to extend the lease, if only for five years as a theatre. In the end the negotiations failed and the Burbage brothers along with the Lord Chamberlain's Men, including Shakespeare, decided on an alternative and audacious plan of action.

A few lines in the poet Everard Guilpin's satirical *Skialetheia, or A Shadowe of Truth, in Certaine Epigrams and Satyres* seems to indicate that performances had finally stopped at the Theatre by September 1598, after a remarkable run of twenty-two years.[17] The writer, after saying he would prefer to stay in his study than venture into the City streets, adds that he may go to the Rose or the Curtain playhouses:

> Or if my dispose
> Perswade me to a play, I'le to the *Rose*

> Or *Curtaine*, one of *Plautus Comedies,*
> Or the *Patheticke Spaniards* Tragedies:

but does not mention going to the Theatre, and adds a few lines later:

> but see yonder,
> One, like the unfrequented Theatre,
> Walks in dark silence and vast solitude.
> Suited to those blacke fancies which intrude,
> Vpon possession of his troubled breast:
> *Satyra Quinta, Skialetheia*

With no home, the Lord Chamberlain's Men may have moved into the Curtain playhouse as a temporary playing space. However, already they were planning a dramatic change: they were going to build an entirely new theatre on the Southbank. There, opposite the City waterfront, they could draw audiences from all of the City, the Inns of Court and Westminster to a grander and larger performance space.

Giles Allen probably assumed that all he had to do was wait until the Lord Chamberlain's Men accepted his deal. With Christmas approaching, he left London and travelled to his country estate at Hazeleigh, east of Chelmsford in Essex. He had not bargained with the determination of the Lord Chamberlain's Men and possibly their desperation, given the need to fund the new Globe, when £600 of the Burbages' money was sunk in the non-operative Blackfriars. To understand their subsequent actions, we need to return to the original 1576 lease, back in Cuthbert's hands since 1589. A clause clearly stated:

> [that it would be lawful for] James Burbage . . . in consideration of the employing . . . foresaid sum of £200 in form aforesaid, at any time before the end of the said term of one and twenty years . . . to take down and carry away . . . all such buildings and other things as should be builded, erected or set up in or upon the gardens and void ground . . . either for a theatre or playing place.

In other words, as long as James Burbage had spent £200 on improving Allen's buildings, Cuthbert Burbage was, as the current owner of the lease, perfectly within his rights 'to take down and carry away . . . all such buildings . . . as should be builded . . . for a theatre'. This removal Cuthbert now proceeded to plan with Peter Street, a master carpenter who built the Globe in 1599 (Figures 7.1 and 7.2) and the Fortune Theatre in 1600. Although taking the main structure apart was relatively simple in theory – it was just pegged together – in practice, the heavy timbers would probably have to be lowered

Figure 7.1 The second Globe Theatre (circled) on Bankside, rebuilt after the first, 'Shakespeare's' Globe, was destroyed by fire in 1613. The first theatre was built using timbers salvaged from the Theatre in Shoreditch. Section from the Panorama engraved by Claes Visccher (1616). Bear Garden to left.

Figure 7.2 Interior of the modern reconstruction of the Globe Theatre, London, which opened in 1997. It is 250 yards to the west of the original site, which lies buried under the approach to Southwark Bridge. The half-timbered structure provides a working laboratory for testing ideas about Jacobean theatre.

as separate frames to avoid damage. This meant taking the theatre apart in reverse order to how it had been built. Such a procedure would probably have required taking the roof off and removing the floors first. Keeping the plan secret must have been difficult, as trained teams of oxen would have been needed to drag or cart the major timbers to a place safely out of Allen's reach.

Despite their claimed legal right to the theatre, the fact that the dismantling was started in the middle of winter, on the 28th of December while Allen was out of London, suggests the Lord Chamberlain's Men were uncertain about their legal situation or their ability to face down a furious Allen and his servants. How much Shakespeare was directly involved in the events is unknown. The demolition needed to done as fast as possible before Allen found out. Much of the work was unskilled and simply needed as many people as possible. It is quite possible that Shakespeare exchanged his quill pen for a heavy mallet or drill to remove the pegs.

A series of legal documents reveal what happened next, and Giles Allen's own account has survived:

> The said Cuthbert Burbage . . . unlawfully combining and confederating himself with the said Richard Burbage and one Peter Street, William Smyth [a friend of the Burbages] and divers other persons to the number of twelve to your subject [Allen] unknown, did about the eight and twentieth day of December . . . [1598] riotously assemble themselves together and then and there armed themselves with divers and many unlawful and offensive weapons, as namely swords, daggers, bills, axes and such like. And so armed, [they] did then repair unto the said Theatre and then and there, armed as aforesaid, in very riotous, outrageous and forcible manner, and contrary to the laws of your highness's realm, attempted to pull down the said Theatre.[18]

Other records included an estimate, no doubt inflated, of Giles Allen's loss:

> And then and there he pulled apart, tore asunder, seized and took away a certain structure of the same Giles, framed and erected in the same place, called the Theatre, to the value of £700. And he caused other enormities against the peace of the said lady, the Queen, to the same Giles' damage of £800.

A later record specifically stated that the timber framing had been taken to Southwark to construct the new Globe Theatre:

> having so done [they] did then, also in most forcible and riotous manner, take and carry away from thence all the wood and timber thereof unto the Bankside . . . and there erected a new playhouse with the said timber and wood.

Back in Shoreditch, the furious Giles Allen began an epic legal battle to get compensation for his loss. One gets the sense it was not the theft of the troublesome Theatre which riled him; after all, he had wanted to turn it into tenements. Rather, he was enraged that he had been made to look a fool to the whole of London by a group of 'players' – as indeed he had. Giles Allen immediately sued the Burbages for trespass on 20 January 1599. In response, Cuthbert Burbage countersued Giles Allen in the Court of Requests the following year, on 26 January 1600. By then, the Globe was up and running. Allen's reply from 4 February 1600 in the Court of Requests has survived. Given Allen's procrastination over the new lease, his accusations of bad faith by Cuthbert Burbage have a hollow ring:

> But now by the dealing of the complainant [Cuthbert Burbage] it appeareth that he never in truth meant to take the lease as he pretended but only sought to take occasion when he might privily, and for best advantage, pull down the said Theatre, which about the feast of the nativity of our Lord God in the [one and] fortieth year of her majesty's reign [1598–9] he hath caused to be done without the privity or consent of the defendant, he being then in the country.

Allen's tenant, Henry Johnson, attempted to stop the demolition:

> This deponent [Johnson] saith he went to the Theatre when it was in pulling down to charge the workmen and the complainant [Cuthbert Burbage] not to pull the same down for that it was not according to any agreement or communication of agreement in his presence. And being there, he, this deponent, did perceive that the same Theatre was appointed to be so pulled down by the complainant, by his brother (Richard Burbage), and one Thomas [William] Smyth, and one [Peter] Street, who was head carpenter that gave assistance therein.

However, the demolition squad had a clever excuse. Johnson claimed that the Burbages deceived him by claiming they were repairing the building because parts were rotten:[19]

> And when he had so charged them not to pull the same Theatre down, they, the said complainant and Thomas Smyth and Street, the carpenter, told him, this deponent, that they took it down but to set it up upon the premises in another form, and that they had covenanted with the carpenter to that effect, and showed this deponent the decays about the same as it stood there, thereby colouring their deceit. And more he cannot depose, save only that, not withstanding all their speeches, they pulled it down and carried it away.

Although Allen was still fighting in the courts in late 1601, his claim was eventually dismissed. By then, the Globe was an established success. Within a few years, the site of the Theatre was built over. The Curtain playhouse probably continued on until the 1620s, but audiences seem to have been mostly attracted elsewhere, to the Globe on Bankside but also to the Blackfriars, the Fortune, the Red Bull and other new venues north of the Thames. For a while, the polygonal scar of where the base timbers had been dragged away would have indicated the site of the Theatre, but even most of the foundation walls seem to have been removed for reuse.[20] In the spring of 1599, as work on the Globe began, did Shakespeare ever walk out to Shoreditch to see a play at the Curtain and then stroll the two hundred yards to see the site of so many of his triumphs – including, probably, the premieres of *Romeo and Juliet*, *The Merchant of Venice*, *A Midsummer Night's Dream* and *Richard II* – remembering the applause and the stamping which shook the timbers? Personally, I do not think so. The moment the demolition of the Theatre started, it was finished: dead like Marlowe in May 1593. In 1598, Shakespeare was established and secure but still unfulfilled both artistically as well as financially. Part ownership of the Globe on Bankside not only offered him a wider stage and larger audiences, but the opportunity for real wealth, to re-establish not just his family name but also his personal reputation.

Today, as you read this, all the theatres that Shakespeare knew are no more. There may be many reconstructions, but the theatres he wrote for, acted in or sat within to watch his competitors survive only as carefully preserved foundations. However, his plays that were premiered at the Theatre are part of world culture. Somewhere, every day, a company is rehearsing *A Midsummer Night's Dream*; somewhere *Romeo and Juliet* is being performed, perhaps in English, perhaps in Spanish, possibly in Mandarin. A costume designer is thinking of the best way to present Falstaff in *The Merry Wives of Windsor*, and a set designer is creating a model for *Henry IV Part 2*. The plays spawned in the Theatre, Shoreditch between 1594 and 1598 live on around the globe today – to amuse, to entertain and to challenge us about what it is to be human.

## Notes

1. She started out from Nonesuch Palace, near Cheam, at the start of August and went via Newbury to Down Ampney. It is possible that the 'Ditchley' portrait of Elizabeth 1 (Figure I.13) was painted to commemorate this tour, since her feet are standing on the route of the progress.
2. See *FECDD,* October 1592.
3. The Privy Council took various steps to control the plague, including banning merchants travelling to Portsmouth and trying to prevent debtors being sent to prisons, which were recognised as spreaders of plague; see Dasent, *Acts of the Privy Council, 1592*, pp. 183–4.
4. If this was next to William Staveley's house. A lease of 1598 suggests that George Tedder's house was next door; see Leathersellers' Archive SHE/1/2/70.

5. Lady Scrope was a lady in waiting to Queen Elizabeth and the daughter of Henry Carey, 1st Baron Hunsdon, the patron of Shakespeare's Lord Chamberlain's Men and lover of Emilia Lanier.
6. See *FECDD*, November 1592.
7. See, for a detailed explanation of the proposed 'duopoly', Gurr, *The Shakespeare Company*, pp. 1–40; and for an alternative perspective, Syme, 'The New Norton Shakespeare and Theatre History' and the Introduction to the *New Norton Shakespeare*, summarised by Syme as: 'There is no duopoly narrative at all. Instead I present a portrait of a London as a city full of (in the inns) and surrounded by a large number of performance venues, populated by at least three, at many times five or more, resident companies and visited by touring groups of actors and other performers.' See also M. L. Stapleton's review of Roslyn Lander Knutson, *Playing Companies and Commerce in Shakespeare's Time* in *Shakespeare Quarterly*, vol. 54, no. 2 (Summer 2003), pp. 206–7; and 'Duopoly' on the Erenow website, <https://erenow.net/> (last accessed 20 July 2020).
8. Technically, Cuthbert Burbage held the lease of the Theatre from 1589, while his brother became the leading actor. Although James Burbage was in his sixties, it is difficult to imagine him, like any entrepreneur, giving up much real control.
9. However, almost immediately on 8 October 1594, Henry Carey, 1st Baron Hunsdon, requested that the Lord Chamberlain's Men could play the winter at the Cross Keys in Gracechurch Street; see Gurr, *The Shakespeare Company*, p. 2.
10. Several of the Lord Chamberlain's Men came from Lord Strange's Men, whose patron was Ferdinando Stanley, 5th Earl of Derby (Lord Strange until 25 September 1593), who died in highly mysterious circumstances in April 1594.
11. Bearman, *Shakespeare's Money*, pp. 44–7.
12. They are always listed as the Theatre first and the Curtain second, which suggests that the Theatre was pre-eminent. It is sometimes suggested that *Romeo and Juliet* was premiered at the Curtain since it was described as winning 'Curtain plaudits', but this could refer to later performances.
13. For alternative views, see note 7 above.
14. Giles Allen's response on 4 February 1600 to a Bill of Complaint by Cuthbert Burbage dated 26 January 1600; see Wallace, *The First London Theatre*, pp. 186–200. Sir Julius Caesar Adelmare, with his close links to St Helen's, was involved in this litigation; see Wallace, *The First London Theatre*, p. 254.
15. Deposition by Robert Vigerous, 14 August 1600; see Wallace, *The First London Theatre*, pp. 255–7.
16. Henry Johnson, silkweaver (26 April 1600), was a tenant of Giles Allen; see Wallace, *The First London Theatre*, pp. 218–23.
17. The book was entered at Stationer's Hall on 15 September 1598, so it must have been written before then.
18. Allen also stated the following in Star Chamber (23 November 1601); Wallace, *The First London Theatre*, pp. 276–83, especially p. 278.
19. Court of Requests, 26 April 1600; Wallace, *The First London Theatre*, p. 222. This has the ring of truth because most building specialists think that it would have taken a considerable time for the Theatre to be taken apart. The claim that it was being rebuilt would have allowed a considerable part to be taken down before Johnson, or others, smelt a rat and informed Allen three days' ride away in Essex.
20. The site of the Theatre was rediscovered by archaeologists in 2008. A public exhibition space explaining the discoveries is expected to open in 2021.

# PART III

The Parish of Saint Helen's, Bishopsgate Street

Figure 8.1 The wealthier residents of the parish of St Helen's in 1598 recorded in the Lay Subsidy roll, including William Shakespeare (underlined blue), assessed at £5 (underlined). 'Strangers' – foreigners (below green line) – were listed at the end. The dashed red line indicates the likely division between the original 'rich' and 'petty' listings.

# 8

## William Shakespeare and the Parish of Saint Helen's

*In which the evidence for Shakespeare living in the parish of St Helen's around 1598 is introduced. We explore the distinctive character and layout of his neighbourhood, shaped by the major transport artery of Bishopsgate Street and the site of a former medieval nunnery.*

What would Shakespeare have turned to when his work at the Theatre was finished? Let us suppose that it is five o'clock in the afternoon on Friday, 14 November 1595. It is not known what play the Lord Chamberlain's Men performed that afternoon at the Theatre in Shoreditch, but across the River Thames in Southwark, their rivals, the Lord Admiral's Men at Philip Henslowe's Rose playhouse, performed a new play entitled *A Toy to Please Chaste Ladies*. Henslowe received 51 shillings[1] (£2-11s-0d or 600 pennies), suggesting an audience of maybe 600–800.[2]

Back at the Theatre, the actors have taken their applause and gone backstage into the tiring house to change back into their ordinary clothes. The audience has drifted away and the main entrance doors will soon be shut and barred. The double-locked collecting 'box' holding all the entrance admission has been opened in front of the Theatre's owners and the day's takings in silver pennies (1d) and groats (4d) have been sorted on a baize cloth laid out on the counting table. A good audience of around 700–750 would have resulted in a take of say £4-7s-4d in total. The actors get about half – just over £2 – which, after paying for their costs, leaves something over £1 to share out among the eight main players and several assistants: say two shillings (24d) each, the sort of sum a grammar school teacher or a minister might earn. Not a lot, but not bad when for 6d you can buy a 1½lb wheat loaf (1d), 1lb beef (1d), ½lb butter (1½d), 1lb cheese (1½d) and four pints of cheap beer (1d). It might take a labourer three or four days of back-breaking work to earn this amount.

With work done, the day's pay slipped into the purses hanging from their leather belts, and the evening ahead, the players probably did what actors would do today: headed for a familiar local tavern to review their performance, reminisce about past triumphs and gossip about their colleagues and rivals at The Rose and elsewhere. Shakespeare was described by John Aubrey in his *Brief Lives* (1679/80) as 'very good company, and of a very readie and pleasant smooth Witt'.[3] As a successful actor, he probably shared a drink or two. However, after a while he would make his excuses and slip away into the gathering dusk. He had other things to do – writing his next

play – and with a twenty-minute walk back to his home he was keen, alone with money in his purse, to get back before moonlit darkness descended. Furthermore, the city gates would soon be barred for the night and the twin towers of Bishopsgate lay between him and his writing desk. However, where was 'home', with his family probably in Stratford-upon-Avon and the whole of the outstretched City to choose from?

Shakespeare almost certainly walked back into the City through Bishopsgate, based on the evidence that survives in a unique document preserved in the UK's National Archives at Kew in London (Figure 8.1).[4] This shines a bright but tantalisingly short burst of light on his domestic arrangements in London at this time. The document is a single sheet of vellum, 8 inches wide (20 cm) and 25 inches long (64 cm), bureaucratically identified by its modern reference number E 179/146/369. Vellum, made from animal skin, was robust but expensive, so the scribe (scrivener) has filled the page with tightly written lines. It is one of over a dozen such sheets sewn together at the bottom end and rolled up into a tight scroll to create, in this case, a 'Lay Subsidy' roll. Such rolls, suitably tagged on wooden shelves, made for convenient storage in a world before the invention of filing cabinets.[5] Unfortunately, their shape also made them perfect as homes for rodents, or firelighters for later generations, so those which survive are often damaged. E 179/146/369 is an extremely rare document, as it records William Shakespeare's name alongside those of his neighbours in 1598. Through careful analysis, it provides some clues to how he lived at the time.[6] In particular, when the subsidy collectors came knocking – probably on Sunday, 1 October 1598 – for some reason, the 13s-4d payment was not waiting for them. They left empty-handed, noting 'Affid.' (short for 'Affidavit') against Shakespeare's name.

The document is an official record made by the local tax collectors for the parish of St Helen's, one of six parishes making up the Ward of Bishopsgate,[7] for Shakespeare's contribution to a nationwide tax termed the '1597 Lay Subsidy'. It was approved by the English parliament in 1597 and it was 'Lay' in the sense that it was of the laity, the non-church population, since the Church of England was taxed separately. It was a subsidy in that it provided additional funds to the Queen, in this case largely for the expensive war in Ireland. It records a household by household listing of the first of three annual staged payments collected in 1598, 1599 and 1600, the first dated 1 October 1598. Viewed simply as a bureaucratic tax record, its purpose is clear. However, understanding the broader significance of these Lay Subsidy tax records is difficult even for professional historians. (For the general reader, section 3 of the Appendix provides more information.) It is sufficient to explain here that this tax demand was based on perceived wealth, and therefore supplies a financial and hence social ranking of Shakespeare compared to his immediate neighbours.[8]

In Shakespeare's case, a payment of 13s-4d was levied against an assessment of £5, representing a tax rate of 2s-8d in the £, or 13.3 per cent. The Elizabethan state used

this money mostly for paying for exceptional military needs. Much has been made of the fact that Shakespeare did not pay the 13s-4d demanded, nor indeed his 1597 charge from an earlier subsidy, since the 'Affid.', written against his name means that the tax was not collected. This could be because the person had died, moved, was a royal official or another reason. In Shakespeare's case, it is often taken to indicate that he was a tax evader. However, as Professor Alan H. Nelson has noted, a simpler explanation may be that he had recently purchased his mansion, New Place in Stratford-upon-Avon, in 1597 and chose to be taxed there. Unfortunately, the Stratford records for this period do not survive.[9]

Before looking at the St Helen's in which Shakespeare lived, this chapter will explore how the parish had evolved over the previous one hundred and fifty years. By modern standards, the parish of St Helen's seems tiny. In the 1590s, it lay just inside the city walls by Bishopsgate, the main gateway to the north of England. It was a thriving, wealthy, bustling community of perhaps around 600 people with a distinctive identity. It was full of wealthy merchants, financiers, textile traders and leatherworkers with a scattering of powerful politicians, gentry and artists. The English parish of today is largely an administrative division of the Church of England, with very limited public local governing functions through a parish council. However, during Queen Elizabeth I's reign and for centuries before and after, the parish was the basic administrative unit for managing, controlling, taxing and documenting England's population.[10] It was fundamental to most individuals' background and life. At a time when religion was central to identity, the Church of England's hierarchy and religious courts ran in parallel to the civil legal system and law courts. By controlling the minister and churchwardens in every parish, the church authorities could monitor and, if necessary, take action against perceived deviancy in everybody's life. Figure 8.2 explains the pattern of parishes – over a hundred in total – into which London was divided, while Figure 8.3 shows how only the north-east corner of the City survived the Great Fire of London in 1666.

The origins of London's parishes are complex and some, particularly those close to the riverside quays along the Thames, were tiny – only a short street or two – and densely populated. However, whatever their size and history, each was anchored by its parish church, which all parishioners had to attend for Sunday service. Comprehensive religious conformity was central to the Elizabethan state. Non-attendance would be noted and, if continued without good reason, would result in prosecution. The parish church was also usually the largest public building and so, additionally, functioned as a general meeting place, administrative office and records depository. It might also have a whole host of other functions, from schoolroom to store for weapons and firefighting equipment. The grass-covered churchyard would provide a rare open space among the crowded houses, and was used for anything from cheap burials to a convenient space

Figure 8.2   St Helen's, Bishopsgate (highlighted) in the north-west corner of the City, one of nearly a hundred parishes inside London's city wall.

Figure 8.3   Map of the City of London recording the extent of the Great Fire in 1666. It also shows how the north-east corner of the City, including all of the parish of St Helen's (circled), survived the fire. Engraving by Wenceslaus Hollar, 1666.

for drying washing.[11] The parish records of St Helen's list attempts to stop cloths drying in the churchyard, which probably indicates that the practice was widespread. Dirty streets and smoky back yards would have provided few alternatives.

The 350 acres (142 hectares) of land within the defensive city wall of London meant there was an average of three and a half acres per parish, an area slightly larger than modern Trafalgar Square.[12] The parish of St Helen's was in the north-east corner of the City and, at seven or so acres, was larger than average. It also had a different evolution from the waterfront parishes, having been shaped by the presence of a nunnery, the medieval priory of St Helen's. During the fifty years following the priory's forced closure, dissolution and royal seizure in 1538, its redundant buildings met a variety of fates. Unlike other monastic complexes in the City, the buildings were not demolished but adapted for new uses. The main complex was acquired by the Worshipful Company (Guild) of Leathersellers in 1543. The Leathersellers' Company had been founded by Royal Charter in 1444, and its first livery hall was near the city wall in Broad Street Ward. In modern terms, the Company was largely the trade association that governed quality, pricing and training across all aspects of leather manufacture and sale. However, it was also a kind of fraternal society helping out its members if they needed support, whether to set up in business, care in old age or other assistance.

The main priory buildings and the nuns' church were first acquired on 29 March 1542 by Sir Richard Williams, nephew of Thomas Cromwell, from Henry VIII. He then sold them on to the Leathersellers' Company on 28 April 1543 for a quick profit.[13] The Company's plan was to convert the large nuns' dormitory (dorter) into an impressive Livery Hall for diners (Figures 8.4–8.6), with a room for the meeting of the Company Court. The rest of the complex could be split up into houses for rent to generate a useful income, or to accommodate their own staff and pensioners (Figure 8.7). The term 'Livery Hall' was used, since each member would wear the Company's livery, or official dress, at meetings as well as at dinners, public parades and funerals. Where once the nuns had woken bleary-eyed before dawn to celebrate Matins, now hard-nosed businessmen met to discuss the problems of finding industrious apprentices, worry about competition from immigrant workers or feast together.

Leather was fundamental to Tudor life: from shoes and saddles to belts and bottles. In a world with no plastics, it could be stretched, cut, moulded and stitched into a myriad of shapes. This importance meant that the Guild of Leathersellers was ranked fifteenth in the order of precedence of London's livery companies, just outside the magic circle of the 'Great Twelve' from which the Lord Mayor was, and still is, selected.[14] There were separate guilds for specialised trades including the girdlers, curriers, saddlers, cordwainers (shoemakers) and glovers. Shakespeare's father built his livelihood in Stratford-upon-Avon as a glover,[15] and as a child William would have become steeped in all aspects of leatherworking. Indeed, it may have been the location of the Leathersellers'

Figure 8.4 Interior of the Livery Hall of the Leathersellers' Company, converted from the former dormitory of the medieval nunnery of St Helen's. Engraving by J. P. Malcolm in 1799, made just before its demolition.

Figure 8.5 Two wardens, George Hubberstee and Robert Dollar, of the Leathersellers' Company in their fur-trimmed livery gowns. Detail from the Leathersellers' second charter, issued by James I in 1604. These wardens issued John Hatton with his 1604 lease (see Figure A.16).

Figure 8.6 Exterior of the Livery Hall of the Leathersellers' Company with their impressive entrance added to the nunnery building. View from the former nunnery garden showing additional houses added to the north. Engraving *c.* 1750, reproduced in 1871.

Figure 8.7 Detail of the June 1606 Leathersellers' 21-year lease to Dr Peter Turner for his large house, 'The Cloister', the former Prioress's lodging, with an annual rent of £7-10s rising to £20 after three years. He paid a 'fine' of £200, a good indication of his wealth.

Figure 8.8 Parish of St Helen's *c.* 1553–9 (circled), as shown on the 'Copperplate' map. The buildings are shown schematically – compare the houses (circled) in the lower right corner with the detailed drawing in Figure 8.9.

Figure 8.9 Multi-storey tenements in Leadenhall Street, pre-dating the 1666 Great Fire of London. This estate was owned by the Rochester Bridge Trust. Property K was occupied by John White, a musical instrument importer. Drawing, 1719.

Hall and trade contacts which first drew him to this neighbourhood.[16] It is often claimed that his choice of accommodation in St Helen's was due to the proximity of the Theatre. However, examination of a map (Figures 8.8 and 8.9) shows that in the early 1590s the parish was equidistant between the three main playhouses and the concentration of bookshops next to St Paul's Cathedral. It was also adjacent to the Bull Inn and the two inns in Gracechurch Street, the Bell and the Cross Keys, used for performances up to 1594.[17]

While there were half a dozen major former monastic precincts in the City,[18] St Helen's had (and still has) some unique characteristics. The church was divided in half latitudinally by five arches, with the nuns and local parishioners using one nave each. The arches would have been filled with wooden partitions to prevent people peering at the nuns at worship.[19] Secondly, the church still survives today much as it would have looked in the 1590s; the major difference is that it would have been filled with high-backed wooden box pews with lockable doors, and most of the existing monuments and the first-floor gallery post-date 1650. Today, anyone can go inside and sit down where, Sunday after Sunday, Shakespeare would have joined with his neighbours to proclaim their apparent Protestant faith. Indeed, apart from Holy Trinity Church in Stratford-upon-Avon, St Helen's is the largest surviving 'artefact' which has a direct association with Shakespeare. Later on, we will examine what Shakespeare then, and you today, can see inside St Helen's, but why is a visit even possible? Today, the church huddles at the foot of enormous skyscrapers – the most elegant, the Gherkin, opened in 2000 and is now a global icon of the City of London. However, compared to its couple of decades of existence, St Helen's church has witnessed continuity of Christian service for 700 years or more. In the Elizabethan period, the church would have been the central reference point for everybody in the parish in terms of its architecture, its functions and as a place in people's thoughts. Its clock[20] and four bells in the gatehouse belfry marked the passing of the day and its minister provided all the rites of passage for life: christening, marriage, churching and finally burial.

Most of medieval and Elizabethan London was destroyed in the Great Fire of 1666, but a late shift in the wind's direction drove the fire westward and spared this corner of the City (Figure 8.3). Of the dozen or so medieval churches that survived, half were subsequently entirely rebuilt, demolished in the late nineteenth century for office buildings or gutted in the Blitz during the Second World War. St Helen's survived all these threats only to be severely damaged by the Baltic Exchange bombing in 1992 (which also caused massive damage to St Ethelburga church, whose small parish is immediately to the north).

The founder of the nuns' priory *c.* 1210 donated a property of about five acres, surrounded on all four sides by existing streets – Bishopsgate Street, Leadenhall Street, St Mary Axe (Street) and Camomile Street – which all still survive unaltered today

Living with Shakespeare

Figure 8.10　In the early 1590s, St Helen's was next to the Bull Inn with its theatre in Bishopsgate Street and equidistant from the Theatre/the Curtain playhouse in Shoreditch, the Rose playhouse on Bankside and the bookshops by St Paul's Cathedral, London's intellectual centre. Circle equals *c.* 20 minute walk in good weather.

Figure 8.11　From 1602/4, Shakespeare had lodgings with the Huguenot immigrant Christopher Mountjoy in Silver Street. This location was close to the newly built Fortune Theatre, which opened in 1600 and was used by the Lord Admiral's Men company. It was also easily accessible to the Globe Theatre by wherry. Circle equals *c.* 20 minute walk in good weather.

(Figure 8.10). The parish where Shakespeare lived was roughly 200 yards square, so you can still walk right around it in about ten minutes.[21] As the nunnery was founded relatively late, the valuable frontages on the surrounding streets had mostly been developed with shops and other buildings. In particular, Bishopsgate Street, as one of the main entrances and thoroughfares of the City, was always a prime commercial district. In the 1590s, records show that it was lined on both sides by shops selling richly decorated imported cloth and accessories, expensive armour and weapons, specialist foods and other luxuries (Figure 8.11).

At the northern end, close to Bishopsgate itself but beyond the parish boundary, were several narrow side turnings into inn yards which serviced the many travellers arriving in London. Among them, on the west side of the street, was one of the most famous – the extensive premises of the Bull Inn – which was also one of the four main venues inside the City for staging plays. Bull Yard ran along the northern boundary of St Helen's parish, on the western side of Bishopsgate Street.[22]

> Where shall we goe?
> To a playe at the Bull, or else to some other place.
> Doo comedies like you wel?
> Yea sir, on holy days
> They please me also wel, but the preachers wyll not allowe them.[23]

The satirist Stephen Gosson (1554–1624), in his *The School of Abuse* (1579), stated:

> The two prose books played at the Bell Savage, where you shall find never a word without wit, never a line without pith, never a letter placed in vain; the *Jew and Ptolome*, shown at the Bull, the one representing the greedinesse of worldly chusers, and bloody mindes of Usurers: The other very lively discrybing howe seditious estates, with their owne devises, false friendes, with thir owne swoordes, and rebellious commons in their owne snares are overthrowne: neither with amorous gesture wounding the eye, nor with slovenly talk hurting the ears of the chast hearers.

There may also have been one or two large houses in Bishopsgate Street, which were residences surviving from earlier decades. One, on the west side, was the house of Dominic Lomeley, a rich Italian immigrant, recorded in a lease from the St Helen's nunnery in 1512. Following his death *c.* 1560, it was taken over by 'Thomas Wotton, Gent.' – presumably Thomas Wotton (1521–87), the father of Sir John Wotton and Sir Henry Wotton, the diplomat and poet.[24] Given its status, one wonders if this was the house, near the Bull, which was occupied in 1594 by Anthony Bacon, the brother of Francis Bacon, to the consternation of his mother Anne. She was worried by the

unhealthiness of Bishopsgate Street and the moral threats from performances at the Bull, which staged plays and fencing demonstrations. In a letter dated *c.* 1 May 1594, she wrote:

> Having some speech with Mr Henshaw [a clergyman] after you went hence touching your house taken in Bishopsgate Street, he soberly said, 'God give him wit to be there, for this last plague [presumably meaning the outbreak in 1593] that street was much visited and so was Coleman Street, large and wide streets both.' And asking him what ministry there, he answered it was very mean, the minister there but ignorant and, as commonly withal, careless, and he thought you should find the people thereafter given to voluptuousness and the more to make them so having but mean or no edifying instruction. The Bull Inn there, with continual interludes, had even infected the inhabitants there with corrupt and lewd dispositions, and so accounted of, he was even sorry on your behalf. I promise you, son, it hath been in my mind since with grief and fear for you and yours to dwell so dangerously every way. I marvel you did not consider first of the ministry as most of all needful, considering that street, and them to have so near a place haunted with such pernicious and obscene plays and [a] theatre able to poison the very Godly, and do what you can, your servants shall be enticed and spoiled.[25]

Unfortunately, we do not know if the 'ignorant and careless' minister was John Oliver, the minister of St Helen's from 1590–1600 or, more likely, the minister of St Ethelburga, since this was the much poorer parish where the Bull Inn was situated.

Among the waggoneers and coachmen, or 'carriers', that Shakespeare might have seen pulling out of the yard of the Bull was Thomas Hobson. He died on 1 January 1631, aged eighty-six, having run a service from the Bull to Cambridge University and back for sixty years. He was eulogised in two poems by John Milton, which are a reminder of the economic as well as the human impact of the outbreaks of plague:[26]

> **On the University Carrier, who sickened in the time of the Vacancy, being forbid to go to London, by reason of the Plague**.
> Here lies old Hobson; Death hath broke his girt,
> And here, alas! hath laid him in the dirt;
> Or else, the ways being foul, twenty to one,
> He's here stuck in a slough, and overthrown.
> 'Twas such a shifter, that if truth were known,
> Death was half glad when he had got him down;
> For he had, any time these ten years full,
> Dodg'd with him, betwixt Cambridge and the 'Bull';

> And surely Death could never have prevail'd,
> Had not his weekly course of carriage fail'd;
> But lately finding him so long at home,
> And thinking now his journey's end was come,
> And that he had ta'en up his latest inn,
> In the kind office of a chamberlain,
> Show'd him his room, where he must lodge that night,
> Pull'd off his boots, and took away the light;
> If any ask for him, it shall be said,
> 'Hobson has supt, and's newly gone to bed.'

Most of the parish on the west side of Bishopsgate Street was taken up by the large mansion and grounds built by Sir Thomas Gresham, superstar international financier, founder of London's Royal Exchange and who appeared, to the public at least, to be one of the richest men in the City.[27] It was constructed in the early 1560s, and Sir Thomas lived there until his death in 1579.[28] A view from the west of *c.* 1739 (Figure 2.3) shows a domestic complex connected through to Bishopsgate Street by a narrow entranceway with a magnificent courtyard behind. The actual frontage on Bishopsgate Street was taken up with separate commercial premises, with living space on the upper floors. By the time of Shakespeare's arrival the premises were occupied by Gresham's ageing widow Anne and one of his two stepsons, Sir William Reade.[29]

On the south side was Leadenhall Street, which was a similarly grand street, linking Aldgate – the main route to Essex – with the centre of the City, particularly the newly built Royal Exchange, the financial heart of London.[30] Along the east side was a side street, St Mary Axe, named after its former parish church. It would have been lined with houses, some with shops, but smaller structures than on the major streets. Among them was the impressive townhouse of Sir William Pickering, buried in a magnificent tomb in St Helen's in 1575. Unusually for London, the church of St Mary had become redundant and the parish combined with the adjacent St Andrew Undershaft.[31] The name Undershaft referred to an ancient giant maypole which had been erected each year in the street for dancing until it was deemed 'idolatrous' by Protestant reformers and chopped up. Along the northern side was Camomile Street, part of the roadway which ran all along the inside of the two-mile city wall, providing rapid access to the battlements if London was threatened. In times of peace, this zone was colonised by all manner of activities ranging from games to market gardening. Although only a short distance from the hectic life of Bishopsgate, this area had been relatively undeveloped and the former herb and vegetable gardens of the nuns may still have been a green oasis at the time when Shakespeare lived nearby. The 1542 survey of the empty nunnery by Thomas Mildmay recorded:

Figure 8.12 The gateway into Bishopsgate Street from Great St Helen's, formerly the nunnery gatehouse in the medieval period, viewed from the east. The Skinners' almshouses to the right, willed by the Lord Mayor Sir Andrew Judd in 1558. Watercolour by Philip Norman, 1890.

Figure 8.13  A similar view from St Helen's churchyard, c. 1970, showing how the building layout survived until fifty years ago. Shakespeare's home was probably on the site of 35 Great St Helen's, the buildings to the right. The portico is the entrance to the St Helen Hotel which stands on the site of the Skinners' almshouses.

an entre leading to a little Garden, and out of the same littell garden to a faire garden called the Covent Garden, coteninge by estimacn half an acre. And, at the Northend of the said garden, a dore leading to another garden called the Kechin garden; and at the Westende of the same ther is a Dove-howsshe and in the same garden a dore to a faire Woodyerd.[32]

Even here though, large former mansions were being broken up to solve London's housing shortage. Stow writes of the decline in status of properties and their occupants:

On the south side of this [Camomile] streete stretching west from S. Mary streete towards Bishopsgate streete, there was of olde time one large messuage builded of stone and timber . . . *Richard de Vere* Earle of Oxeford possessed it in the 4. of Henry the fift, but in processe of time . . . sold to M. *Edward Cooke*, at this time the Queenes Atturney Generall. This house being greatly ruinated of late time for the most part bathy been letten out to Powlters, for stabling of horses and stowage of Poultrie, but now lately new builded into a number of small tenements, letten out to strangers [foreigners], and other meane people.[33]

St Helen's church, almost uniquely in the City, did not have a bell tower. Instead, the nunnery gatehouse on Bishopsgate Street was topped by a belfry with four bells.[34] This controlled access to 'the Close'[35] and the graveyard in front of the nunnery and parish church. At the closure of the nunnery in 1538, Roger Hall, with his wife Alice, was recorded as 'janitor of the west gate', but it is unclear if later there was the need or money to maintain this security. In 1566/7 there was a payment in the churchwardens' accounts for 'staples for the belfre gate', which suggests that there was still a gate then.[36] A detailed watercolour of 1890 (Figure 8.12; compare to Figure 8.13) shows the entranceway much as it would have been around 1595, when Shakespeare may have passed through it daily into what would have been, in effect, a 'semi-gated' community. Extraordinarily, this entry point still remains today, although much degraded by modern rebuilding. Even if the gates had been altered or locked open, the gateway would still have provided a psychological barrier to 'undesirables'. One is reminded of the porter in *Macbeth*:

> *Knocking within. Enter a Porter*
> **Porter**
> Here's a knocking indeed! If a
> man were porter of hell-gate, he should have
> old turning the key.
> (*Macbeth*, II.iii.1–2)

Indeed, this 'Close' area would have been a completely secure cul-de-sac had it not been for an ancient right of way that led out from its south-east corner and connected via a twisting lane, Great St Helen's, to an exit into St Mary Axe Street next to St Andrew Undershaft church.[37] However, the existence of the back exit did mean that for anybody who did not wish to be observed entering or exiting the gatehouse onto busy Bishopsgate Street, there was a short pedestrian route allowing one to come and go discreetly into the side streets. The layout was convenient if one wanted to visit a doctor with an embarrassing medical complaint or had other reasons to ensure one's visits went unnoticed. When Shakespeare arrived in St Helen's, part of its appeal may have been that the parish offered a central location combined with the possibility of a high degree of privacy.

Notes

1. In pre-decimal Britain, before the currency changes in 1971, there were twelve pennies in a shilling and twenty shillings, or 240 pennies, in one pound sterling (£ – or li[vre]).
2. Like most plays of the period, which are known from Philip Henslowe's account book, only the title and his share of the income are recorded. The author and the entire text are lost. The play was repeated the following week but Henslowe only got 21 shillings (252 pennies) and for the third performance he received 12 shillings (144 pennies). Experts suggest various divisions of the total income between the theatre company and the theatre owner based on scraps of evidence. However, there is no reason why the agreement could vary by theatre company and production over time. What is clear is that, if plays attracted a decent audience, the owner and the players who had shares in the acting company could make a good living. Henslowe's highest daily take in 1595 was 69 shillings (£3 -9s-0d or 828 pennies), received on three occasions. Since there are a cluster of twenty-six days when he received the maximum of 60–69 shillings, this level probably represents a 'full house'. As there were *c.* 215 days of playing, this level was reached for 12 per cent of performances. However, poor houses on other days meant his average daily income was £1-12s-1d, totalling just over £342 for the year. There was a significant drop of 33 per cent to an annual income of £226 in 1596.
3. Bodleian Library, MS. Aubrey 6, folio 109 recto; see online at shakespearedocumented.folger.edu.
4. First identified by the Rev. Joseph Hunter in Hunter, *New Illustrations of the Life, Studies, and Writings of Shakespeare*. The parish registers of St Helen's, Bishopsgate are published; see Bannerman, *The Registers of St Helen's Bishopsgate*. It is worth noting that the minister/churchwardens' names listed from 1575 through to *c.* 1600 are incorrect on all occasions. The details from a specific later year have been copied over onto every page.
5. Hence the title Master of the Rolls (and Records of the Chancery of England), now the President of the Court of Appeal of England and Wales, Civil Division and Head of Civil Justice. Until 1958, the Master of the Rolls was the nominal head of the Public Record Office, now the National Archives. St Helen's church contains the beautiful tomb of Sir Julius Caesar Adelmare, MP and Privy Councillor (1557/8–1636), who was Master of the Rolls from 1614–36.
6. An obvious question is whether the document or Shakespeare's name on it are genuine, given the considerable number of nineteenth-century Shakespeare forgeries. A visual examination gives no reason to think the document is not genuine, particularly as it is bound together with other sheets from the Bishopsgate Ward. The name itself also looks genuine, since the lines are evenly spaced with no evidence of it having been added later or been altered. A trickier question is whether this is *the* William Shakespeare, or another person with the same name. There is no other evidence of a second

Living with Shakespeare

William Shakespeare in London and, while one must be careful of circular arguments, the fact that he was living alongside other people connected to theatre is highly significant. This is particularly important as this information would not have been known to people in 1845.

7. The City of London was divided into twenty-five wards, plus from 1550 Southwark on the Southbank, each comprising a number of parishes. Each ward or aldermanbury was an ancient administrative and electoral unit of the City and elected an alderman, for life, as its most senior official. Each year the Lord Mayor was elected from one of the the Court of Aldermen.
8. See also the excellent Introduction in Lang, *Two Tudor Subsidy Rolls for the City of London*, pp. xv–lxxvii.
9. Other St Helen's residents in the 1590s, notably Dr Richard Taylor, chose to be taxed at their country residences rather than in London. Special certificates were issued to confirm payment elsewhere.
10. The medieval parishes, albeit in later years with a small growing administration, remained the basic administrative units for central London until the creation of the pan-capital London County Council in 1889 and the twenty-eight London Metropolitan Boroughs in 1900.
11. The churchwardens' accounts record that the grass was mowed twice a year with a scythe. There would have been no gravestones or other memorials outside. The parish well was located on the outside of the south churchyard wall and would have been the main supply of water to the parish. By 1598 at the latest, probably in the 1580s, a pump had been added. The parish accounts record payments for cleaning the well and repairing the (probably rather inefficient) leather pump, for example in 'new letheringe the pompe – 4s-6d'. One could either send a servant to collect water in a bucket or buy it from a water carrier.
12. Despite the development of powerful cannon and firearms in the sixteenth century, the medieval city wall of London was still maintained in the 1590s. Suburban growth was beginning to encroach on the defences and the name Houndsditch is a reminder that the moat was a convenient place to dump all manner of waste. However, walking through the city gates would still have given a strong sense of martial confidence and civic pride.
13. The buildings were actually purchased for £380 by Thomas Kendall (before 1520–1552), an Elder Master of the Leathersellers, who then rented it to the Company from 22 June 1543 for ninety years at a 'peppercorn' rent of one red rose, presented on Midsummer Day. This agreement was to cause major problems for the Company in the seventeenth century. Kendall kept the rental income until his death in 1552, when it passed to the Leathersellers. In the 1541 Lay Subsidy roll, the Livery Hall of Leathersellers is not recorded in either its old site or future location, so discussions about the acquisition may have already started. It is listed with seven other halls at the end of the Tower Ward listing, 'therefore written here in this warde bycause of most Rome [room] for the wryten of them' – a very practical approach to the efficient use of valuable vellum.
14. In order: 1. Mercers, 2. Grocers, 3. Drapers, 4. Fishmongers, 5. Goldsmiths, 6. & 7. Merchant Taylors and Skinners, 8. Haberdashers, 9. Salters, 10. Ironmongers, 11. Vintners, 12. Clothworkers, 13. Dyers, 14. Brewers. This order, which reflected their relative economic, financial and social power, was decided in 1515/16, when there were forty-eight companies embracing everything from wax chandlers (expensive wax candle makers) and tallow chandlers (cheap animal-fat candle makers) to fletchers (arrows), poulterers (chickens, ducks and fowl) and scriveners (writers).
15. Although Bearman, *Shakespeare's Money*, pp. 10–21, suggests it may have been his dealings in wool which led John Shakespeare into financial problems.
16. It is entirely possible that Shakespeare settled in this area when he arrived in London because of the location of the Leathersellers' Hall. However, there is no hard evidence.
17. At one time, the Priory of St Helen owned the Bull Inn.
18. Including Holy Trinity, Aldgate, the Grey Friars (followers of rule of St Francis), the Augustinian Friars (St Augustine) and, most importantly, the Black Friars (St Dominic). James Burbage had acquired the great hall of the Blackfriars as a potential indoor theatre in 1596, but it was not to be used by the Lord Chamberlain's Men until 1608. Unlike the Blackfriars, St Helen's was not a 'liberty' outside the control of the Lord Mayor.
19. See Reddan and Clapham, *Survey of London*.

20. A rare feature at this time which would only have had an hour hand. Harkness, *The Jewel House*, pp. 128–9 discusses the significance of London parish clocks and the associated costs. The St Helen's Vestry minutes for 27 June 1563 record 'Ric[hard]e Austen, clockmaker, to have 5 s[hillings] per year for mending and looking after the clock, and 15d for his pains already taken therein'.
21. The parish church is thought to have been established earlier, in the twelfth century. Only on the western side did the parish boundary cross the street frontage to include properties on the west side of Bishopsgate Street.
22. John Florio, an Italian linguist and tutor of James I's court, provides the earliest evidence of the Bull as a playhouse in 1578; see Bowsher, *Shakespeare's London Theatreland*, p. 45, and Gurr, *The Shakespeare Company*, p. 248, from John Florio, *Firste Fruites* (1578), which was an English–Italian conversation book.
23. John Florio, *Firste Fruites* (1578).
24. This sequence of owners is provided in the post-mortem inquisition on 17 June 1563 of Joan Tai(y)lor, widow; see Madge, *Abstracts of Inquisitions*, pp. 11–12.
25. See Wickham, Berry and Ingram, *English Professional Theatre, 1530–1600*, p. 303. Lambeth Palace, MS 650. Folio 187. Text transcribed and modernised by Berry.
26. Published in *Poems of Mr. John Milton, both English and Latin, Compos'd at several times* (1645/6), which also contained his poem 'On Shakespeare' (1630). Thomas Hobson was the source of 'Hobson's choice', meaning no choice, since anyone hiring a horse from his large livery stable in Cambridge had to take the one next to the door.
27. Six hundred yards to the south-east and officially opened on 23 January 1571 by Queen Elizabeth I. The site occupied by Gresham's house probably took in the land previously occupied by the large properties of two previous Lord Mayors, Sir William Hollis/Holles (1539) and Sir Andrew Judd (1550) – both buried in St Helen's. There were almshouses on the western side of the property.
28. Gresham spent much of his time at his country house at Osterley Park, now surrounded by the interwar suburbs of west London.
29. The latter's son, Sir Thomas Reade, was buried in Sir Thomas Gresham's vault in St Helen's on 14 July 1595. He was married to Mildred, daughter of Sir Thomas Cecil, 1st Earl of Exeter and MP for Peterborough.
30. The actual street frontage lay in the parish of St Andrew Undershaft.
31. By 1595, the church of St Mary Axe appears to have been demolished or divided up into housing, in the same way that many nineteenth-century churches in London have been converted into flats during the last forty years.
32. See Cox, *The Annals of St Helen's Bishopsgate, London*, p. 30.
33. See Stow, *Survey of London*, p. 163. Since he lived only a few minutes away, Stow's comments probably reflect his real experience. Edward Skeggs, Serjeant Poulterer, was buried in St Helen's in 1578. Strype/Stow also records the grave of a William Skeggs but it is unclear whether this is a mistake or a relative. William Huckle, Serjeant Poulterer, is also recorded in the parish in 1576, with his son John being buried on 10 March 1581. In the 1530s the priory owned fields outside Bishopsgate, used for raising ducks and chickens.
34. The bells remained until 1696 when the parish made an agreement with Thomas Armstrong that, in consideration of the sum of £100 and taking down the bells, wheels and ropes in the belfry (over St Helen's Gate in Bishopsgate Street), he would have the lease of the belfry for sixty-one years. On the 18 June following, it was decided to sell three of the four bells for the repair of the church and to keep the best one for the church.
35. A clarification of terminology. The sixteenth-century records usually refer to all of the street running from St Helen's Gate through to St Mary Axe (Street added to distinguish from the church which gave the street/area its name) simply as Great St Helen's, although it consisted of two distinct sections, the wide street around the church/graveyard and the narrow twisting alley connecting the church through to St Mary Axe Street. The term 'close' is used in various ways, including sometimes meaning all the land once owned by the nunnery. Here, 'the Close' is used to mean the section of Great St Helen's around the church and graveyard, unless otherwise stated.

Living with Shakespeare

36. It is not clear if there was some form of gate at the St Mary Axe [Street] entry to Great St Helen's in the 1590s. Around 1700, there is a sequence of references in the churchwardens' accounts to rehanging lockable gates at this entry point and installing a night watchman. Despite this presumably being for improving the security of the area, it was clearly not popular with some residents. There are references to the lock being torn off and the parish trying to reclaim payment for the damage.
37. This back route had always been an irritation to the nuns, who tried, unsuccessfully, to get it blocked off. However, it was probably difficult or impossible for carts to pass through, meaning that disturbance in the Close would have been much reduced.

# 9

## Searching for Shakespeare's Lodgings in Saint Helen's

*In which we discover more about the 1598 tax survey and how it lists Shakespeare's neighbours, or not, according to their perceived wealth. Shakespeare moved into a parish of a hundred or so households, a few very rich, others just getting by. However, all were at the mercy of plague when it struck.*

The 1598 Lay Subsidy roll for St Helen's (Figure 8.1) provides a guide to Shakespeare's domestic arrangements in London.[1] It preserves a taxpayer-by-taxpayer listing of the first of three annual payments required in 1598, 1599 and 1600.[2] The roll for 1599 is incomplete, so it is not possible to say if Shakespeare was included. He does not appear in the complete 1600 roll, but see section 3 of the Appendix below. Shakespeare was also recorded as not paying the five shillings owed for 1597 from the previous round of taxation in 1593–7. Details on these records and their significance has recently been discussed by Robert Bearman.[3] The rolls were clearly kept right up to date, as the surviving part of the 1599 roll includes new residents not listed in 1598. Richard Risby, a longtime resident and merchant taylor who was buried on 24 October 1599 – after the 1 October collection date – is listed on the 1599 roll but not on the 1600 roll.

Under each parish listing there are three pieces of information: first the tax payer's name, sometimes with a profession mentioned; second, an assessment of their assumed wealth;[4] and finally, the tax owed, based on a set rate. In 1598, this was 2s-8d in the £, a tax rate of 13.3 per cent. If the assessment was £5, as with Shakespeare, one had to pay 13s-4d, or two marks.[5] Englishmen are listed first, followed by foreigners ('strangers'), if present, at the end. The St Helen's roll lists forty English householders[6] considered wealthy enough to pay the tax and, after them, fifteen 'strangers' or foreigners. However, one should not imagine that the individual assessments represented people's exact worth. Such a household survey would have taken a great deal of time and was probably beyond the resources and expertise available. Rather, the sums (£3, £5, £10 – the commonest) are probably equivalent to the collectors thinking that Mr X's household was broadly, in our terms today, lower-middle-class, middle-middle-class, etc.[7] Shakespeare is positioned twenty-first out of the forty households, with a valuation of £5.

Table 9.1 shows all those listed, with Shakespeare halfway down the valuations. Below him were sixteen households assessed at £3. There were two others at £5: Thomas

# Living with Shakespeare

**TABLE 9.1: PARISH OF SAINT HELEN'S: 1598 LAY SUBSIDY ROLL, NAMES IN ORDER AS LISTED**
OCTOBER 1597 LAY SUBSIDY – REQUESTED 1st OCTOBER 1598

| Order of assessment level | Name | Trade or background | Assessment |
|---|---|---|---|
| **A. Taxed; definitely living in Saint Helen's parish 1597/8** | | | |
| 1 | Sir John Spencer | international merchant, financier and clothworker | £300 |
| 2 | William Reade | gentleman | £150 |
| 3 | John Robinson the Elder | alderman, Merchant of the Staple | £100 |
| 15 | Dr Richard Taylor | Doctor in Physic | £10 |
| 16 | Dr Peter Turner | Doctor in Physic | £10 |
| 6 | Peter Dallyla | ? | £30 |
| 5 | Robert Honeywood [II] | gentleman | £40 |
| 4 | John Allseppe | gentleman? | £50 |
| 7 | John Morris | haberdasher | £30 |
| 8 | Robert Springe | skinner | £30 |
| Likely boundary between the original rich 'high' list and general 'petty' list | | | |
| 17 | Edward Swayne | ? | £10 |
| 9 | James Scoles | merchant | £20 |
| 27 | Joane Lomley | widow #1 – wife of James Lomeley | £3 |
| 18 | Anthony Sno[a]de | grocer | £10 |
| 26 | John Roking | cook | £3 |
| 22 | Walter Briggen | merchant taylor | £5 |
| 14 | John Robinson the Younger | mercer | £10 |
| 25 | John Prynne | grocer and mortgage broker? | £3 |
| 20 | **William Shakespeare** | **poet, playwright and actor** | **£5** |
| 23 | George Ax[t]on | merchant taylor | £3 |
| 24 | Edward Jackson | merchant taylor | £3 |
| 19 | Edward Jorden | Doctor in Physic – but not listed as Doctor | £8 |
| 28 | John Jeffrey | embroiderer/milliner | £3 |
| 29 | Christopher Eland/Bland | merchant | £3 |
| 13 | Oswald Fetche | listed as yeoman, not attending church 1581 | £20 |
| 30 | John Stocker Jekyll | gentleman | £3 |
| 10 | John Suzan | haberdasher/Barbary [Morocco] merchant | £20 |

## Searching for Shakespeare's Lodgings

| Order of assessment level | Name | Trade or background | Assessment |
|---|---|---|---|
| 31 | Sisley Cioll | widow #2 – wife of German Cioll | £3 |
| 32 | William Winkefield | white baker | £3 |
| 33 | Childe | armourer | £3 |
| 34 | Richard Risby | merchant taylor | £3 |
| 11 | Timothy Bathurst | grocer | £20 |
| 12 | James Elwicke | mercer | £20 |
| 35 | William Cherle | ? | £3 |
| 36 | Francis Wells | ? | £3 |
| 37 | Henry Maunder | Messanger of Queen's Chamber' | £3 |
| 38 | Mrs. Poole? | ? | £3 |
| 39 | William Staveley | cordwainer | £3 |
| 21 | Thomas Morley | court musician, composer, music publisher | £5 |
| 40 | Henry Heatherband [Litherland] | plumber | £3 |
| 41 | Minister John Oliver |  | not listed |
| **B. 'Strangers' taxed; definitely living in Saint Helen's parish 1597/8** | | | |
| 42 | Levan Vandestilt (+4) | merchant | £50 |
| 43 | Augustine de Beaulieu (+2) | merchant of Antwerp | £25 |
| 44 | Peter Vegelman | ? factor | £20 |
| 45 | John de Clarke | merchant of Antwerp | £15 |
| 46 | Farrone Martyn | ? | £10 |
| 47 | John Varhagen (+2) | ? | £6 |
| 48 | Dr Cullymore | Doctor | £5 |
| 49 | LawrenceBassell (+2) | ? | £5 |
| 50 | Sherrett Bawkes (+2) | ? | £2 |
| 51 | Peter van Desker (+1) | ? | per poll 8d |
| 52 | Vincent Meringe (+1) | ? | per poll 8d |
| 53 | Barbara Lumbo | widow | per poll 8d |
| 54 | Mary de Boo | widow | per poll 8d |
| 55 | Michael Coosen (+2) | ? | per poll 8d |
| 56 | Abraham Grannere [Gramer] | silk weaver | per poll 8d |

TABLE 9.2: PARISH OF SAINT HELEN'S: RECONSTRUCTION OF ALL HOUSEHOLDS OF THE PARISH c. 1597/8, NAMES BY ORDER OF ASSESSMENT LEVEL BASED ON OCTOBER 1597 LAY SUBSIDY ROLL – REQUESTED 1st OCTOBER 1598 AND PARISH REGISTERS

| Household | | Name – head of household | Churchwarden? | Trade or background | Assessment | Affidavit? |
|---|---|---|---|---|---|---|
| **A. Taxed – definitely living in Saint Helen's parish 1597/8** | | | | | | |
| 1 | | Sir John Spencer | not CW | international merchant, clothworker | £300 | |
| 2 | | William Reade | not CW | gentleman | £150 | |
| 3 | | Alderman John Robinson the Elder | CW 1579 : auditor for four years 1576–82 | Merchant of the Staple [alderman] | £100 | |
| 4 | | John Allseppe | CW 1598 and 1599 | gentleman? | £50 | |
| 5 | Stranger | Lewan Vandestilt (+4) | | Dutch merchant, All Hallows Staining in 1582 | £50 | |
| 6 | | Robert Honeywood [II] | not CW | gentleman | £40 | Yes – moved to St. Leonard, Shoreditch June/July 1598 |
| 7 | | Peter Dallyla? | ???? | possibly Peter Delavale, merchant? | £30 | |
| 8 | | John Morris | CW 1603 and 1604 | haberdasher | £30 | |
| 9 | | Robert Springe | CW 1582 and 1583 | skinner | £30 | |
| 10 | Stranger | Augustine de Beaulieu (+2) | | merchant of Antwerp, LSR 1591 and 1592–3 | £25 | |
| 11 | | James Scoles | not CW | merchant | £20 | |
| 12 | | John Suzan | CW 1588 and 1589: auditor 1585–1605 | haberdasher, Barbary merchant | £20 | |
| 13 | | Timothy Bathurst | CW 1595 and 1596 | grocer | £20 | |
| 14 | | James Elwicke | CW 1593 and 1594 | mercer | £20 | |
| 15 | | Oswald Fetche | not CW | listed as Yeoman, not attending church 1581 | £20 | Yes – moved to Bocking, Essex? – where buried 1613 |
| 16 | Stranger | Peter Vegelman | | factor | £20 | |
| 17 | Stranger | John de Clarke | | merchant of Antwerp | £15 | |
| 18 | | John Robinson the Younger | not CW | mercer | £10 | |
| 19 | | Dr Richard Taylor | not CW | Doctor in Physic | £10 | |
| 20 | | Dr Peter Turner | not CW | Doctor in Physic | £10 | |
| 21 | | Edward Swayne | not CW: auditor 1601 | ? | £10 | |
| 22 | | Anthony Sno[a]de | CW 1596 and 1597 | grocer | £10 | |
| 23 | Stranger | Farrone Martyn | | ? | £10 | |
| 24 | | Mrs Poole? | n/a | ? wife of Robert Pollye/Poley? | £10 | Yes – reason uncertain |
| 25 | | Edward Jorden | not CW | Doctor in Physic (but not listed as Doctor) | £8 | |
| 26 | Stranger | John Varhagen (+2) | | ? | £6 | |
| 27 | | **William Shakespeare** | **not CW** | **poet, playwright and actor** | **£5** | **Yes – moved? or taxed in Stratford-upon-Avon?** |
| 28 | | Thomas Morley | not CW | court musician, composer, music publisher | £5 | Yes – royal official |
| 29 | | Walter Briggen | CW 1591 and 1592, 1613 | merchant taylor | £5 | |
| 30 | Stranger | Dr Cullymore | | Doctor | £5 | |
| 31 | Stranger | Lawrence Bassell (+2) | | ? | £5 | |
| 32 | | George Ax[t]on | CW 1597 and 1598 | merchant taylor | £3 | |
| 33 | | Edward Jackson | not CW | merchant taylor | £3 | |
| 34 | | John Prynne | CW 1565 and 1566, 1600 | grocer, mortgage broker? | £3 | |
| 35 | | John Roking | not CW | cook | £3 | |
| 36 | | Joane Lomley | husband was CW 1572 and 1573 | widow #1 | £3 | |
| 37 | | John Jeffrey | not CW | embroiderer, milliner | £3 | |
| 38 | | Christopher Eland | CW 1599 and 1600 | merchant | £3 | |
| 39 | | John Stocker Jekyll | not CW: collector 1/15th in 1595 | gentleman | £3 | Yes – moved to Bocking, Essex and buried 1598 |
| 40 | | Cicely Cioll | husband CW 1566 & 1567 | widow #2 | £3 | |
| 41 | | William Winkefield | CW 1605 and 1606 | white/brown baker | £3 | |
| 42 | | Thomas Childe | CW 1603 and 1603 | armourer | £3 | |
| 43 | | Richard Risby | CW 1583 and 1584 | merchant taylor | £3 | |
| 44 | | William Cherle | not CW | ? | £3 | Yes – destination uncertain |
| 45 | | Francis Wells | not CW | ? | £3 | |
| 46 | | Henry Maunder | not CW | Messanger of Queen's Chamber' | £3 | arrested Christopher Marlowe 1593 |
| 47 | | William Staveley | CW 1604 and 1605 | cordwainer | £3 | |
| 48 | | Henry Heatherband [Litherland] | not CW | plumber | £3 | |
| 49 | Stranger | Sherrett Bawkes (+2) | | ? | £2 | |
| 50 | | John Oliver | n/a | minister | not listed | |
| **B. Untaxed – definitely living in St Helen's parish 1597/8 – listed by trade/background** | | | | | | |
| 51 | | Robert Hubbard | not CW | gentleman, musician | £0 | |
| 52 | | Hugh Ken[d]rick | CW 1589 and 1590 | gentleman, musician, pronotary | £0 | |

| House-hold | | Name – head of household | Churchwarden? | Trade or background | Assess-ment | Affidavit? |
|---|---|---|---|---|---|---|
| 53 | | George Gray | CW 1581 and 1582 | merchant taylor | £0 | |
| 54 | | George Tedder | not CW | merchant taylor | £0 | |
| 55 | | Giles Mollett | CW 1609 and 1610 | merchant taylor | £0 | |
| 56 | | Peter Dod[d] | CW 1570 and 1571 | grocer | £0 | |
| 57 | | Benjamin Kerwyn | not CW | grocer | £0 | |
| 58 | | William Checkley | not CW | grocer | £0 | |
| 59 | | Francis Smith | not CW | skinner | £0 | |
| 60 | | Robert Ward[e] | not CW | haberdasher, perfumer | £0 | |
| 61 | | Robert Mewkwell | not CW | haberdasher | £0 | |
| 62 | | John Harvey | not CW | scrivener, grocer | £0 | |
| 63 | | Israel Jordan | not CW | scrivener, money lender | £0 | |
| 64 | | William Oliver | CW 1608 and 1609 | freemason | £0 | |
| 65 | | Richard Westney | not CW | freemason | £0 | |
| 66 | | John Park[e] | CW 1592 and 1593 | pewterer | £0 | |
| 67 | | William Prior | CW 1594 and 1595 | pewterer | £0 | |
| 68 | | John Hatton | CW 1606 and 1607 | Clerk of Leathersellers' Company | £0 | |
| 69 | | Thomas Thompson | not CW | Leathersellers' Beadle | £0 | |
| 70 | | Roger Burgis | CW 1601 and 1602 | leatherseller | £0 | |
| 71 | | John Curtis | not CW | leatherseller | £0 | |
| 72 | | Walter Tuckye | not CW | sadler | £0 | |
| 73 | | John Christian | not CW | clothworker | £0 | |
| 74 | | William Turner | not CW | [merchant?] taylor | £0 | |
| 75 | | George Thornes | not CW | [merchant?] taylor | £0 | |
| 76 | | Richard Atkinson | not CW | box maker | £0 | |
| 77 | | Thomas Millington | not CW | stationer | £0 | |
| 78 | | William Hilton | not CW | cooper | £0 | |
| 79 | | Edward Fenner | not CW | carpenter | £0 | |
| 80 | | Robert [A]man | not CW | plumber | £0 | |
| 81 | | Thomas Aman | not CW | cobler, also 'Thomas Man – waterbearer' | £0 | |
| 82 | | Roger Thompson | not CW | waterbearer | £0 | |
| 83 | | Matthew Ledill | not CW | labourer | £0 | |
| 84 | | Bevis Tod | not CW | ? (possibly gentleman) | £0 | |
| 85 | | Edward Duncombe | not CW | Leathersellers' tenant | £0 | |
| 86 | | Robert Hilliar | not CW | ? | £0 | |
| 87 | | Alice Mitten | not CW | unmarried? Leathersellers' tenant | £0 | |
| 88 | | widow of William Warren, tallow chandler | husband CW 1585 and 1586 | widow #3 | £0 | |
| 89 | | widow Stone | not CW | widow #4 | £0 | |
| 90 | | Margery, widow of Boniface Mitchell | husband not CW | widow #5 | £0 | |
| 91 | | widow of Edward Illage | husband not CW | widow #6 | £0 | |
| 92 | Stranger | Abraham Grannere [Gramer] | | silk weaver | per poll 8d | |
| 93 | Stranger | Peter van Desker (+1) | | ? | per poll 8d | |
| 94 | Stranger | Vincent Meringe (+1) | | ? | per poll 8d | |
| 95 | Stranger | Barbara Lumbo | | widow #7 | per poll 8d | |
| 96 | Stranger | Mary de Boo | | widow #8 | per poll 8d | |
| 97 | Stranger | Michael Coosen (+2) | | ? | per poll 8d | |
| 98 | | Skinners' Almshouses | | 6 women | £0 | |
| 99 | | Leathersellers' Almshouses | | 7 men/women | £0 | |
| **C. Untaxed – possibly living in Saint Helen's parish 1597/8** | | | | | - | - |
| 100 | | Henry Cyterne | | [parish?] clerk | £0 | |
| 101 | | Walter Daniel | | merchant taylor | £0 | |
| 102 | | Henry Collinson | | tallow chandler | £0 | |
| 103 | | Christopher Mathew[e] | | haberdasher | £0 | |
| 104 | | Barnard Thomson | | leatherseller | £0 | |
| 106 | | Thomas Sheppard | | hosier | £0 | |
| 107 | | Thomas Snelhawke | | woolcomber | £0 | |
| 108 | | John Willans | | [merchant?] taylor | £0 | |
| 109 | | Thomas Thornett | | cooper | £0 | |
| 110 | | Toby Ashby | | fishmonger | £0 | |
| 111 | Stranger? | Edward Pithion | | ? | £0 | |
| **D. Untaxed, no records – possibly living in Saint Helen's parish 1597/8** | | | | | - | - |
| 112–121 | | assumed at least ten households completely unrecorded | | | | |

Morley, a composer/musician at Queen Elizabeth I's court and music publisher; and Walter Briggen, a merchant taylor. Above him were one household at £8, seven at £10, five at £20, three at £30 and then five rich or very rich individuals – Robert Honeywood,[8] gentleman, at £40; John Allsop(pe), gentleman? at £50; Alderman John Robinson the Elder at £100; William Reade at £150; and finally 'Rich' Sir John Spencer, who had just been Lord Mayor of London in 1594/5, with a huge assessment of £300. This was more than the bottom thirty households put together – a powerful demonstration of the huge variations in wealth that existed cheek by jowl in the City.

What did a valuation of £5 mean? Since Shakespeare was halfway down the list, £5 is often taken to represent 'a man of fairly comfortable wealth', but 'on the other hand not a man possessed of great wealth'.[9] Detailed examination of the records shows that there were, in addition, fifteen foreigners ('strangers') assessed. Of these, two were rated at £5, then individuals at £6, £10, £15, £20, £25 and £50 respectively. There were also seven below £3 who simply paid a poll tax. If these fifteen are added in, then Shakespeare drops to twenty-seventh out of fifty-five households.[10]

However, an examination of just the listing of the names on the tax roll does not give a comprehensive picture of the parish, since it excludes all the households that would have been assessed at a value of less than £3.[11] The only way to get a full picture of all the inhabitants is to make a detailed trawl through the parish records of baptisms, marriages and burials (Table 9.2). Parish registers were introduced on 5 September 1538 as part of Henry VIII's split from papal control. Unfortunately, early registers have often disappeared. At St Helen's they only start from 1575, fortunately sufficiently early so that they can be used to look at the period when Shakespeare was living in the parish. By comparing the entries in meticulous detail, one can follow individual lives through records of their baptism, marriage, baptism of their children, and burial. One can then add together the individuals to construct records of whole families. Through this time-consuming process one can identify families with children born or known to have existed before, during and after the mid-1590s, where it can reasonably be inferred that the family was living in the parish throughout the period.

Looking at just two households, who must have been living in the parish when Shakespeare was resident there, illustrates vital differences. For example, Jo(h)an(e), the wife of Anthony Sno(a)de, a successful grocer (assessed at £10 in 1598 and a churchwarden in 1596/7), gave birth to ten children over fifteen years. The last child, a second Rebecca, was born three months after Anthony had died in 1606. Three died almost immediately, while three others died aged one, three and four. Only four survived into later childhood. In contrast, Elizabeth, the wife of Christopher Eland, a much poorer merchant (assessed at the minimum £3 in 1598 and churchwarden in 1599/1600), had seven children over eight or so years, of which only one died. Both families lived in St Helen's through the 1593 and 1603 plagues, but neither seems to have been affected directly.

However, this type of analysis can only pick up, in the main, households with children. Single people, childless couples and people with older children who had left home would be missed completely – so these listings should be seen as a minimum figure. This is demonstrated by an examination of the leases of the Leathersellers' Company for their St Helen's estate. Throughout the 1580s and 1590s, there are several leaseholders who neither occur in the parish births, deaths and marriages nor the Lay Subsidy rolls. Some are widows and others could well be older couples. Occasionally there are other listings, such as tithe surveys, which record all households. For St Helen's there is one surviving tithe survey carried out in 1589, which adds some more detail, explored further in section 3 of the Appendix. This lists seventy-four separate households, but excludes foreigners as well as some properties within the former St Helen's nunnery.

This examination suggests that there were probably about ninety-five or so separate native English families and another fifteen foreign households (see Table 9.2 – foreigners highlighted in blue). However, some of the English families might have shared a house, so overall a total of *c.* 100 houses (85 English; 15 foreign) seems the best estimate.[12] This means that, excluding the parsonage accommodation for the church minister and two almshouses managed by the Skinners' and Leathersellers' Companies,[13] there were probably at least sixty other households who were poorer than the £3 tax threshold limit.[14] The majority of these were families, but a small percentage must have been married couples where the children had grown up, widowers, widows or men living alone – probably Shakespeare's status in St Helen's, or at least as it has been assumed to be. There is, of course, no conclusive proof about whether he was living with his wife, children, servant or anybody else in London, except that it would be difficult to explain why he bought the spacious New Place in Stratford in 1597, if it was not for his family.

However, it is certain that *c.* 1602/4 he was lodging alone in London in the house of Christopher Mountjoy.[15] Interestingly, Mountjoy's household in the 1598 Lay Subsidy, consisting of seven or eight adults and a successful workshop for a luxury product, was assessed at £5 – the same amount as Shakespeare in St Helen's.

If these poorer households are added to the list, Shakespeare moves from halfway down the listing to being in the top quarter – and this was in a wealthy parish in the capital. This is a far more impressive position for the thirty-four-year-old, who had probably arrived in London less than a decade earlier with little or no financial backing. Furthermore, an examination of the types of people above Shakespeare in the listing and their relative valuations also underlines Shakespeare's status. Those over £30 are gentlemen, men whose income from land or other investments meant that they did not have to work in a conventional sense as merchants or craftsmen. However, those at the £10–£20 level all had a trade or profession showing that they worked. They are all members of the upper echelons of the business community – (international) merchants, skinners (furriers), haberdashers, grocers.[16] Among the foreigners, there are at least two

engaged in the textile trade and described as 'Antwerp merchants'. Conversely, among those under £3, one finds a whole range of more basic trades – leathersellers, a sadler, plumbers, a pewterer and a fishmonger.

Of the twenty-six people listed above Shakespeare, nearly a quarter were foreigners, almost all French or Dutch and probably largely in textile-related trades. In 1576, there were at least ten 'stranger' households, mostly recorded as Dutch-speaking. In the parish of St Helen's, they made up perhaps 10–15 per cent of the population. Five of the houses in the Close were specifically mentioned as being occupied by families of strangers. Six years later, in 1582, the main households are still there, although others have moved on. Among the former was the barber-surgeon Jacob Saul, who brought his family from the Spanish Netherlands and was buried in 1585. In 1571, he is recorded as 'came into England about 12 years past for religion'.[17] It is also particularly interesting to examine the eight English households assessed at £8 and £10, immediately above Shakespeare's assessment level. Three of these, Dr Richard Taylor, Dr Peter Turner and Dr Edward Jorden, were all doctors of 'physick', medical practitioners, an unusual concentration for one parish and discussed further below in Chapter 14.[18]

The three doctors were fully trained professionals, members of the (later Royal) College of Physicians, and would have occupied houses of sufficient quality to advertise their training, skills and success. The parish burial records show that they all had servants. They also had at least ten, eight and six children respectively, although due to high infant mortality, the actual number alive at any one time was smaller. In 1598, they probably had twelve or thirteen living children between them. Intriguingly, in 1597 the three wives all gave birth within twelve weeks of each other. Shakespeare, in contrast, may have occupied just one floor of lodgings in a larger house, probably without his family and possibly without even a dedicated servant. Yet, his valuation is still half that of two doctors at the peak of their profession and treating wealthy clients.[19] This suggests that by 1598 Shakespeare was not only considered a successful professional by his neighbours, but also recognised as a man on the way to much greater fame and fortune. By 1596 Shakespeare had secured a coat of arms, allowing him to be termed a gentleman, and in early 1597 he bought a spacious mansion, New Place, in Stratford-upon-Avon.[20]

Is it possible to say more about where Shakespeare lived, other than that his accommodation was somewhere in the parish of St Helen's? Shakespeare worked hard as a playwright when not acting, using his spare time in the evenings and when the theatres were shut to turn out at least two plays a year, together totalling at least 4,000 lines. He may also have helped on the revision of other plays and plotted new ideas which could be scripted by others. While no more epic poems were published after 1594, he may have worked on others which have not survived. With breaks, this meant he had to produce an average of twenty complete lines every day, year after year after year.

Assuming, in general, that he was rehearsing and acting on mornings and afternoons six days a week, his only free time for writing other than evenings would have been Sundays, when he would have had to attend church; the forty days of Lent, when the London theatres were closed; and potentially some time during the summer months, if the Lord Chamberlain's Men went on tour.

As a result, it is reasonable to suggest that Shakespeare's search for suitable accommodation was driven by a number of practical considerations. Probably, his prime driver was a combination of matching a sensible rent level with good security and a quiet location where he could work in peace. He did not need a whole house with all the associated costs and responsibilities, but he required a set of rooms, at least a bedroom and a second chamber, which he could lock up to secure his cash, manuscripts, books and clothes, all attractive to thieves in a period when there were no banks. Records of the period are full of accounts of stealing. For example, 'at Shoreditch, co[ounty] Midd[lesex] on the said day, Morgan Dollinge late of London y[e]oman' stole 'a footecloth of velvet' worth three pounds and ten shillings, four ells of the silk called 'Grene Taftayte' worth thirty shillings, 'a payer of pillowbers' worth eight shillings and three 'rotchett sleeves of Holland' worth five shillings. 'Pleaded guilty and hung.'[21]

Then, like most writers, Shakespeare would need quiet to work undisturbed, away from the noise of street hawkers, carts, beggars, babies, dogs, domestic disputes and the large number of local children. Everard Guilpin, a contemporary, highlights the noises outside:

> There squeaks a cart wheel
> Here a tumbrel rumbles
> Here scolds an old Bawd
> There a porter grumbles
> *Skialethia or a Shadow of the Truth*, 1598

In Ben Jonson's *Epicœne, or The Silent Women* (1609), the lead character, Morose, is mocked for his obsession about avoiding noise:

**Page**
Why, Sir he hath a chosen a street to lie in so narrow at both ends, that it will receive no coaches, nor carts nor any of these common noises

Two of the characters, True and Cler, also list the noises made by metal workers:

**True**
Methinks a smith should be ominous,

**Cler**
Or any hammer-man. A brasier is not suffer'd to dwell in the parish, nor an armourer. He would have hang'd a pewterer's prentice once on a Shrove-Tuesday riot, for being of that trade, when the rest were quit.

Although the play is set in another ex-monastic precinct, the former Whitefriars, one wonders if Jonson had a memory here of Shakespeare living in the Close of St Helen's a decade earlier, which was free of passing traffic. In 1576, an armourer and pewterer were located next door to each other in Bishopsgate Street, just to the south of the entrance gateway to the Close. The latter, at least, was still there during Shakespeare's residency.

He also needed looking after, since it seems doubtful that Shakespeare, married for many years, would have cooked his own food or washed and mended his clothes. Unless he had his own servant, with the associated cost and disturbance, he probably preferred lodging in a house where these services were provided. The house servants could also have done the dirty jobs of cleaning, making up the coal fires, sorting candles and supplying water for washing while he was out during the day. This would ensure that his precious time for thinking and writing at home would be undisturbed. Finally, he would have considered ensuring easy access to his workplaces and research resources – the Theatre, the Curtain playhouse out beyond Bishopsgate in Shoreditch, the Rose playhouse in Southwark and the booksellers mostly located around St Paul's Cathedral. In a period of woollen clothes, bitter weather, poor roadways, limited heating and no umbrellas, even a twenty-minute walk to work in the rain would have been an unappealing prospect.

These were his immediate practical needs, but Shakespeare's career trajectory brought other, more subtle pressures. The right social status of the area would have been increasingly important to him. Shakespeare was a provincial on the make in a society where everything – ancestry, title, name, accent, clothes and accessories, house, seating position in church, even the location of your grave – was taken as evidence of your status and value in society. However, these aspirations were also probably matched by a wish for some local anonymity. Shakespeare, as an actor, was public property who would want to avoid being doorstepped for help, ideas and, particularly, loans of money.[22]

A further factor, which is difficult to quantify, is the local impact of Sir Thomas Gresham's plan to turn his great mansion into London's first college after his death in 1579. This prestigious project would probably have attracted a variety of aspiring professionals and hangers-on into the area, hoping for some preferment to come their way.[23] However, the proviso that the college would only come into being after Gresham's widow died meant that for the seventeen years until 1596, this radical transformation hung in limbo.

The 1598 Lay Subsidy roll and other evidence not only helps us understand Shakespeare's position within the social mix of the parish, but gives some clues as to

where he may have lived. Unfortunately, in the Elizabethan period, there were no house numbers and there are no accurate maps. Properties were typically identified by their relationship to other properties or other obvious landmarks. While this clearly worked in around 1600, most of the Elizabethan City and such evidence has long disappeared, often even the roads. Fortunately, in St Helen's the church survives on its original site and provides a key reference point, as do the surrounding roads, particularly Bishopsgate Street.[24] However, the integration of the surviving evidence is still complicated and rather like trying to fill in a three-dimensional crossword puzzle where many of the clues are missing and where often, if clues survive, there is nowhere to place the answer. Furthermore, we know that other residents in St Helen's moved around within the parish and it is quite possible that Shakespeare lived at more than one address. Thomas Wrightson, a scrivener, who presumably wished to project an image of stability to attract clients, lived at four different addresses in Bishopsgate Street over seven or eight years.[25] In the interests of clarity, this information and the associated analysis has been set out, in detail, in section 3 of the Appendix for those who wish to cross-examine it. In summary, the following conclusion cannot be absolutely proven but seems the most reasonable solution, given what else we know currently about Shakespeare and St Helen's.

If one examines the layout and development of the parish, it is apparent that the housing stock breaks down into five distinct areas of housing, analysed in detail in section 2 of the Appendix. It seems most likely that Shakespeare would have sought accommodation away from the noise and distractions of Bishopsgate Street. This might have been in Great St Helen's, 'the Close', in one of the houses surrounding the graveyard of St Helen's, just to the west of the church itself. Alternatively, Little St Helen's, just to the north, was a private cul-de-sac owned and controlled by the Company of Leathersellers. Together, these two side streets contained about thirty houses which would have offered relative quiet, good security, significant status and engaging neighbours. Examination of detailed records about these houses (see section 2 of the Appendix) suggests it is most likely that Shakespeare lived in one of a small group of three or four properties running west–east, separating Great and Little St Helen's. In the days of the nunnery, this area was occupied by the Steward's Lodging and associated buildings, including a counting house. The Leathersellers probably divided and extended these buildings to provide a number of houses for rent. It is not known if they were half timbered or built of stone, like the rest of the nunnery. The counting house, the financial office of the nunnery estate, was likely to be stone for security reasons. Originally, the Steward's Lodging was accessed from Great St Helen's, but there is no way of knowing how things changed in the fifty years after the Dissolution. Elizabethan London was full of tiny passages and it was quite possible that there was a private way through for the residents of Little St Helen's to Great St Helen's, so they could access their church without having to step out into the dirt of Bishopsgate Street.

It is perhaps not surprising, but still intriguing, that among Shakespeare's immediate neighbours after 1593 were two men, John Pryn and Israel Jorden, with direct links to London's theatre world – but on the financing rather than the creative fronts. Then there was Thomas Morley, the composer and music publisher living nearby with his specialist press. Shakespeare was also living almost opposite the Bull, one of the City's four main theatre inns. In 1595, as Shakespeare probably began *Romeo and Juliet*, he was not living in some anonymous street among labourers and 'mechaniks' but in an area buzzing with new thinking from the Continent, creative debate and professional expertise.

Tonight, as Shakespeare walks back home towards Bishopsgate, we can pick up his trail. The spacious house plots around Shoreditch have changed to a few impressive frontages of large properties, increasingly mixed with neglected buildings subdivided into multiple occupancy for poor families. Dark alleys give access to packed tenements built over former gardens. He crosses the road to avoid passing close to the Bedlam hospital for people suffering from mental afflictions. He passes the church of St Botolph, patron saint of travellers, balanced on the northern edge of the City's defensive moat. The derisively named 'Houndsditch', just to his left, indicates just one of its current uses. He slips through Bishop's Gate into the City proper.

On his left, by the city wall, is an ancient half-timbered building, the Wrestlers. Once it was a popular inn and livery stables. Now it is in decay, with the interior broken up into small tenements rented to labourers, porters, water carriers and the like. The homeless sneak in at night to find shelter in the stables and hay lofts. He walks at a rapid pace past the shuttered shops. The streets are already empty as people seek the protection of home and fireside from the cold. On his right are turnings into newer inns, such as the Three Swans and the Green Dragon, brewing their own beers for Londoners who want to avoid drinking the potentially lethal water supply. As he approaches the turning into Bull Inn Yard, he crosses the road again towards the diminutive St Ethelburga church, to avoid the workless men begging by the entrance. An old woman sits by the church door, gripping a ragged shawl around her shoulders. She looks up but stays silent. Six paces more, and he crosses the invisible but very real parish boundary into St Helen's.

He is in his own parish now, his own ground, and his pace slows slightly as his eye takes in the familiar houses and the lives of his neighbours. The windows are all shuttered against the cold and there are only two or three where the faint gleam of tallowlight escapes to suggest an inhabitant is awake. Wax candles are too expensive for most people, who make do with the smelly lights made by tallow chandlers from animal fat. Where there are leatherworkers, there are always tallow merchants. He passes a few shops. At one, the door is still open and William Staveley, a cordwainer, stands in his doorway examining a pair of shoes with his last customer. He nods a greeting, but says nothing. Beyond, he passes the gateway into Little St Helen's, then more shops, and finally turns into the gatehouse at the entrance to Great St Helen's. He walks through,

past the Skinners' almshouses towards the brick-walled churchyard, with the west front of St Helen's looming up. (Today, the site of the almshouses is the St Helen Hotel. If you stand with the hotel to your left and narrow your eyes to cut out the modern offices, you will see a view little changed in 425 years.)

A man exits the church door and darts off into the dusk. Perhaps he has been settling his sins with God, or praying for better business. Shakespeare turns left and walks down the path beyond the churchyard wall, past a couple of shuttered houses to a heavy oak door. He unlocks it quietly and stands for a moment in the hallway. In the next room he can hear his landlord talking to his wife. The plastered mud walls offer little privacy in terms of sound. At the back, in the glow of the kitchen fire, he can see the maidservant preparing food. He gestures that he would like to eat soon, and then heads up two flights of creaking wooden stairs to his own rooms. He takes a small key from his purse and slips the expensive metal lock. Inside, a small fire is only just alight in the brick fireplace, but it has taken the edge off the cold. He pokes the smoky coals into flame but keeps his cloak on as he sinks down into his chair.

Unfortunately, unlike Shakespeare's birthplace in Stratford-upon-Avon, we can physically go no further. Nothing is known about his furniture, washing facilities or wall decorations. He probably had a bed, a writing desk, a chest for books and some sort of cupboard for clothes, but nothing is certain. Today, the site of this group of houses is largely covered by a prosaic early 1970s office building, 35 Great St Helen's, and the space immediately behind it. A glance at the entrance lobby shows that it is occupied by specialist lawyers and other businesses connected to global finance –perhaps not so far distant from the Elizabethan merchants and traders who lived, worked and slept in the houses around Shakespeare's home.

Notes

1. For those who wish to study these documents in detail online, the best starting place is *Shakespeare Documented*, <https://shakespearedocumented.folger.edu/> (last accessed 20 July 2020), with commentary by Professor Alan H. Nelson. This includes the 1598 Lay Subsidy roll and three subsequent documents from the Lord Treasurer's Remembrancer – Accounts of Subsidies, i. from 1598–9, ii. 6 October 1599 and iii. 6 October 1600 – which demonstrate the efforts to recover Shakespeare's unpaid tax of 13s-4d. It also includes a fifth document, a default roll dated 15 November 1597, which indicates the existence of a now lost 1597 Lay Subsidy roll. Shakespeare is listed as one of eight people (four English and four 'strangers') who had not paid. All five documents are preserved at the UK National Archives, Kew and can be requested on a visit should you wish to examine them. It should be noted that in the National Archives online publication (Education/Classroom Resources/William Shakespeare/Source 3) of the 1598 Lay Subsidy roll, John Pryn/Prymme's name is mistranscribed as 'John Scymme'; and the 'Affid', which is on the next line, relates to Shakespeare, not Pryn/Prymme. The document is the official record made by local tax collectors for the Parish of St Helen, one of six parishes making up the Ward of Bishopsgate. The first of the six parishes listed in the Ward was All-Hallows-by-the-[London]-Wall, then St Peter le Poore, St Martin Outwich, St Ethelburga, St Helen's

and finally St Botolph, Bishopsgate (the only one of these parishes outside the city wall). In Paul Slack's detailed study of the plague, he demonstrates that, in 1603, All-Hallows-by-the-Wall, St Ethelburga and St Botolph, Bishopsgate were among the ten poorest parishes in the City, based on surviving information from about half the parishes (Slack, *The Impact of Plague in Tudor and Stuart England*).

2. There is an excellent introduction to understanding these rolls in Lang, *Two Tudor Subsidy Rolls for the City of London*. See also Professor Alan H. Nelson's website, https://ahnelson.berkeley.edu/> (last accessed 20 July 2020). Lay subsidy rolls for the rest of the 1590s have not survived for St Helen's and the next previous surviving roll is for 1582, well before Shakespeare came to London. The Lay Subsidy rolls for 1601–10 are also missing. The next surviving roll is for 1611 but it is in poor condition.

3. See Bearman, *Shakespeare's Money*, pp. 61–6.

4. Usually in terms of possessions, sometimes in terms of income from land in the case of gentlemen and rarely earnings (fees) for professionals.

5. Subsidies were voted through by parliaments held at irregular intervals and, by modern standards, for brief periods of a few weeks. Lang, *Two Tudor Subsidy Rolls for the City of London*, pp. xv–xvi, notes: 'From 1512 to the death of Elizabeth parliament enacted twenty-six subsidy statutes providing for fifty-eight separate payments, each based on fresh valuations and assessments. The Stuart parliaments passed nine subsidy acts, the last in 1663. [. . .] The subsidy could be levied in a single payment or it could be spread over two payments. The notion of a subsidy was so firm by the 1580s that neither declining levels of valuation nor huge expenditures on defence could alter it. When bigger tax revenues were needed they were not achieved by higher rates or lower exemption levels (nor by tighter administration of the subsidy acts), but by voting multiple subsidies.' Due to the high cost of the war in Ireland, the 1597 parliament voted for three payments in October 1598, 1599 and 1600. A new parliament was summoned in 1601, largely to vote through a new series of subsidies. Lang also notes: 'It has been estimated that about 25 per cent of the heads of households in London were assessed in 1582, see Rappaport (1989), p. 166. His calculations are based on an estimated population for the city, excluding Southwark, of 102,600, and an average household size of four or five people.' The 1582 Lay Subsidy rolls lists 5,900 heads of households.

6. 'Householder' did not mean the person who owned the property. At this time, most homes would have been rented from rich landlords.

7. Modern concepts of class did not exist at this time, but it is difficult to suggest a better modern parallel.

8. His name is spelt Honywood, as in the subsidy roll, and Honeywood, which is also often the case with his relatives. Honeywood is used here throughout for all members of the family.

9. Bearman, *Shakespeare's Money*, p. 63.

10. This comparison is slightly misleading, as all foreigners were taxed, not just the wealthier ones. Poorer foreigners paid a poll tax, usually 4d or 8d. The names of their wives, children and servants are therefore listed, which does not happen with the English households, where only the male head of the household is usually listed.

11. Those who might be termed, in modern parlance, the working-class labouring population.

12. In the 1638 Tithe survey, there were *c.* 103 households listed. By this time, the foreign element seems to have largely moved out of the parish/married in, so this is comparable to the eighty-nine or so households forty years earlier in 1589. An increase of about 15 per cent seems reasonable given the rising population, the building on the former nuns' garden and possible subdivision of existing properties.

13. The Leathersellers built almshouses for seven men and women *c.* 1544 north of their livery hall, on part of the old kitchen garden of the nunnery. John Haselwood, Esquire, gave £200, 'appoyntinge that 7 Almsehouse should be therein erected and 7 poore folks there Receved which to this day are mantayned accordinglie'. The Skinners' almshouses for six women was established by Sir Andrew Judd and was eventually located on a site just inside the west gatehouse of St Helen's. It survived into the nineteenth century and a later rebuilding is now the St Helen Hotel. The money may have come from Sir William Hollis and his wife Lady Elizabeth, with Sir Andrew Judd acting as executor.

14. It is also assumed that there were a small number, perhaps about ten, of poor households where there were no births, marriages or deaths during this period and which are therefore completely unrecorded. This would have been the case with Shakespeare, if his assessment had been below the £3 tax threshold limit.
15. See Nicholl (2007), pp. 51–3. The number of all the people in the household, eight in total, is known because every foreign adult, including the servants, had to a pay 4d a head poll tax, so they were individually recorded.
16. To become the freeman of such a company, one had to take a formal apprenticeship with an existing member. Most people, once trained, would stay in that craft with tightly controlled products and wage levels for the rest of their working lives. However, more entrepreneurial people might branch out into other areas of trading or become international merchants.
17. Jacob Saul seems to have become well established; by 1576, he was described as householder/surgeon. He could subscribe twelve shillings to a student education fund. Two of his daughters had married, to Edward Collins and John Browne, presumably both Englishmen.
18. There was also a possible fourth, Doctor Cullymore, recorded among the listing of the foreigners in the parish and assessed at £5, although he could have been a lawyer. Prominent doctors had lived in the parish for fifty years. Queen Mary's and Queen Elizabeth's Italian physician Sir Caesar Adelmare (?–1569) acquired part of the former nunnery estate in St Helen's by *c.* 1561, buying a block of properties from another Italian doctor, Balthasar Guercy, who had been granted them by Henry VIII in 1539 (see section 2 of the Appendix, n. 18). About the same time, *c.* 1559, Jacob Saul, a Protestant immigrant barber surgeon from the Netherlands, settled with his family – see note 17, immediately above. His son James was also a doctor and both were buried in St Helen's. While medical knowledge at this period seems crude, the crowded suburban areas outside the city gates were recognised as the worst places for plague, to be avoided if possible. Shakespeare's health, indeed his very survival, might depend on the street he lived in and the health and hygiene of his neighbours. It is hard to identify cases of infectious disease, as usually only the plague is recorded in parish registers. However, there are examples. In 1584, in the adjoining parish of St Peter, Cornhill, six children of Hugh Gold, a grocer, died at intervals over a six-month period.
19. Most medical doctors in the City of London in the 1598 Lay Subsidy surveys are valued at £10, although there are a few at £20 or even more. However, a few are at £5.
20. See Bearman, *Shakespeare's Money*, pp. 67–76. In 1596, John Shakespeare, supported by his son, was awarded a coat of arms by the herald William Dethick, which brought the title of Gentleman. Most scholars believe it was William who was largely behind this renewed attempt to gain this coveted status; see Schuessler, 'Actor, Playwright, Social Climber' and Wolfe, 'Shakespeare's Coat of Arms'.
21. See Jeaffreson, *Middlesex County Records*.
22. Bearman, *Shakespeare's Money*, pp. 93–8 covers the surviving written request for a loan.
23. It was not a residential college like those in Oxford and Cambridge with a defined group of students. There were seven live-in professors who gave lectures to the public.
24. In contrast, the Leathersellers' Livery Hall has occupied six different buildings on four sites.
25. Scriveners held the monopoly on producing all legal documents, including wills, but often also acted as moneylenders. They therefore needed to be highly responsible, both in terms of the accuracy of their work and in ensuring proper documentation and enrolment of agreements.

# 10

## What Attracted Shakespeare to Saint Helen's?

*In which we meet 'Rich' Sir John Spencer, Lord Mayor of London and, in the 1590s, a resident of St Helen's. Would Shakespeare have chosen to live next to such a powerful man who was opposed to the theatre?*

Having identified the likely location of Shakespeare's house as accurately as the evidence currently allows, the question then arises how long he might have lived there. It is, of course, perfectly possible that Shakespeare lived at more than one address in the area. Studying the Lay Subsidy returns shows that there was quite a rapid turnover in inhabitants. One should not imagine a static population with families living for generation after generation in the same property. With leases constantly coming to an end, people could look for housing that matched growing or shrinking families or other needs. All we know for certain is that in 1597 and 1598, the Lay Subsidy assessors, who would have a highly detailed local knowledge, thought that he was living in the parish, but that the collectors did not receive the payments. The St Helen's Lay Subsidy roll for 1600 does not list Shakespeare, and by 1602/4 he was living in Silver Street, near Aldersgate.[1] In 1589, a survey was undertaken across St Helen's of all the tithe payers and Shakespeare was not listed, so he may have been living elsewhere then.[2] Therefore, it seems he was living in St Helen's some time between 1589 and 1600; but for how long?

Most specialists believe that Shakespeare moved to London *c.* 1587–9, around the time of the first Spanish Armada in 1588. It was a period of great upheaval, as the entire country mobilised against the massive invasion threat. It was also a time of rapid change in London theatre, as Philip Henslowe opened his Rose Theatre in Southwark in 1587, a new challenge to the two playhouses north of the City. Thomas Kyd's *The Spanish Tragedy* and Christopher Marlowe's *Tamburlaine the Great*, both probably first performed in 1587, created a new drama of high tension and violent action. While experts argue over the exact date and order of Shakespeare's first plays, the general view is that they were written and performed as follows:

    1590–1    *Two Gentlemen of Verona*
                     *The Taming of the Shrew*
    1591       *The First Part of the Contention* (*2 Henry VI*)
                     *Richard Duke of York* (*3 Henry VI*)

1592    *1 Henry VI*
        *Titus Andronicus*
1592–3  *Richard III*

Seven plays, even though some may have been written with others, in less than four years was some dramatic entry into the London theatre world.[3] This *tour de force* did not go unnoticed, nor was the reaction always positive towards this pushy provincial arrival. His contemporaries certainly had strong opinions, as witnessed by the vicious swipe taken at him by the satirist and playwright Robert Greene (1558–92) in his pamphlet *A Groats-worth of Witte, bought with a million of Repentance*, published in September 1592.[4] This was the first reference to Shakespeare in seven years, since his twins Hamnet and Judith were baptised in Stratford-upon-Avon parish church on 2 February 1585.

> Yes, trust them not, for there is an upstart crow, beautified with our feathers, that, with his Tygers hart wrapt in a Players hide, supposes he is as well able to bombast out a blanke verse as the best of you; and being an absolute Johannes fac totum [Jack-of-all-trades], is in his owne conceit the onely Shake-scene in a countrie.

In December 1592, Greene's publisher and printer, Henry Chettle, issued a public apology to the public and to the 'upstart crow' for any offence caused.

Experts rarely comment on how long Shakespeare lived in St Helen's, other than that he was there *c.* 1597/8. However, there is some evidence to suggest that he was living there from at least 1593/4 and possibly earlier. If this is correct, Shakespeare was resident for five years, possibly longer – perhaps the longest period he lived in one place, other than Stratford-upon-Avon. This possibility relates to the arrival of Sir John Spencer, Lord Mayor, in 1594/5 in St Helen's.

Apart from the church of St Helen's and the associated ex-nunnery buildings, the parish was dominated by the sprawling complex of Crosby Hall (Figures 10.1–10.5). The massive grey stone walls and tiled roof of the main wing would have loomed over the surrounding wooden houses. The historian John Stow, who lived just to the south of it, recorded it as being the tallest house in the City. Its main hall, which still survives, is 27 feet by 53 feet (roughly 8 by 16 metres) and 50 feet (roughly 15 metres) from the floor to the peak of the roof. It remains a stunning celebration of late medieval architecture.[5] However, despite its grandeur, it proved to be a problematic property to occupy as changing Tudor tastes in domestic living demanded increasing comfort and privacy. By 1576/7, it had passed into the ownership of Alderman William Bond's family, wealthy merchants, who lived there until the early 1590s.[6] In 1594, the property was sold to the hugely wealthy 'Rich' John Spencer (*c.* 1538–1610), then living in the adjacent parish of St Martin Outwich.

Figure 10.1 Crosby Hall: the north end, showing the fine timber roof. Shakespeare might have had a similar view from his home. The 'parlour' wing to the right faced onto Bishopsgate Street. Engraving by Wise after Nash, 1816.

Figure 10.2 Crosby Hall: view from Bishopsgate Steet. Five Elizabethan tenements originally occupied the demolition site, including the home of Richard Kirk the Younger's family, wiped out by the 1578 plague. Pen/ink drawing by Robert Randoll, 1899.

Figure 10.3 Crosby Hall: cross-section showing the magnificent scale of the building, home to the future Richard III. The 'parlour' wing with domestic rooms was to the right (north). The complex was briefly owned by Sir Thomas More and the rich Italian businessman Antonio Buonvisi.

Figure 10.4 Crosby Hall: detailed drawing of the great oriel window in the west wall. The late medieval grandeur appealed to Sir John Spencer as a backdrop for his mayoralty in 1594/5. Engraving by Rowle after Nash, 1816.

Figure 10.5 Crosby Hall, increasingly outdated as a home, became the headquarters of the East India Company from 1621–38. The main hall was eventually converted into a warehouse. Engraving by J. Storer after Nash, 1804.

Living with Shakespeare

Sir John Spencer should have been a character in a play by Shakespeare. Apart from his enormous wealth, he had three key characteristics. First, he was hugely ambitious. Having migrated to London from Waldringham, a village deep in rural Suffolk, he had become highly successful. He had been sheriff in 1583–4, elected alderman in 1587 and he was chosen as Lord Mayor in September 1594, taking office on 29 September and serving through to November 1595. Having secured what was the highest public position available to him, Sir John wanted to show off as much as possible. He therefore bought Crosby Hall from the Bond family as a suitably magnificent backdrop for his mayoralty (Figures 10.6–10.9). John Stow records that Spencer made substantial renovations to update Crosby Hall to a suitable standard. He had probably lobbied hard to secure the position of Lord Mayor, and may have gambled on his chances well before his election by his fellow aldermen. This, combined with the fact that the purchase of such a huge building probably involved significant negotiations, suggest that Spencer may have identified his new home in late 1593, perhaps as the major outbreak of plague was dying down.

By then, William Bond and his wife were both dead, as were two of his surviving four sons, Daniel (d. 1587) and Nicholas (d. 1590). The property may have been a burden for the other two brothers and, in 1591, William Bond junior acquired another and probably more practical property nearby in the Close.[7] At various times, the high status of the

Figure 10.6 Authority on display: Procession with the Lord Mayor of London followed by the two sheriffs and aldermen. Watercolour from Michael Van Meer's *Album Amicorum*, 1614–17 (f. 101r).

184

Figure 10.7 Clothes on display: i. Bishop, ii. Queen with attendants, iii. Carter and porter, iv. Watercarrier with dog. The materials, quality and cut of clothes and accessories revealed one's status and social aspirations. Watercolours from Michael Van Meer's *Album Amicorum*, 1614–17 (f. 373v, f. 221r, f. 500v, f. 478v).

mansion made it suitable to house foreign ambassadors. In 1592, the French ambassador appears to have been staying in the parish as his secretary, Nicholas Fylio, was buried in St Helen's on 23 September, just after the child of the 'French gardener'. He might have taken over all of Crosby Hall or, perhaps, just a set of rooms. When he left, perhaps alarmed by the rising death toll from the plague, the question would have arisen for the Bond family about whether it would be better to sell. Sir John Spencer, as a rich neighbour, would have been an obvious target as his mayoral ambitions became clear. One wonders if, when Shakespeare was drafting *Richard III*, in which Crosby Hall features, the mansion was largely empty and whether he might have been able to wander around inside.[8]

The second important characteristic about Spencer is that he was a bully – clearly a brave man in a crisis, but still a bully. He was clearly not particularly liked by his contemporaries. His influence stretched far and wide. His ability to make loans to a wide circle of cronies meant he could call in many favours, and his long arm could reach even to the far end of the Mediterranean. When, in 1592, Michael Lok was sent as consul of the Levant Company to Aleppo in Syria for four years, Spencer's connections followed. After two years, the appointment was summarily cancelled, by the intrigues – as Lok asserted – of one Dorrington, in the employment of Sir John Spencer, then alderman of London.[9]

Figure 10.8 Authority on display: Procession with King James I preceeded by his sword bearer. Watercolour from Michael Van Meer's *Album Amicorum*, 1614–17 (f. 58r).

Figure 10.9 Authority on display: King James I on his throne before the House of Lords with the Queen seated to his left. Watercolour from Michael Van Meer's *Album Amicorum*, 1614–17 (f. 164v).

Spencer famously tried to stop his daughter Elizabeth, his only child, from marrying her choice of husband, William Compton.[10] One is reminded here of the start of *A Midsummer Night's Dream* with the father Egeus complaining to Theseus, Duke of Athens, that his daughter Hermia refuses to marry Demetrius, his choice, but yearns instead for Lysander (Figure 10.10). This is a good example of the problems of suggesting that scenes in Shakespeare's plays reflect his actual life. First, the play:

*Act 1, Scene 1*
*Enter Egeus and his daughter Hermia, and Lysander and Demetrius*
**Egeus**
Happy be Theseus, our renownèd Duke.
**Theseus**
Thanks, good Egeus. What's the news with thee?
**Egeus**
Full of vexation come I, with complaint
Against my child, my daughter Hermia.–

Figure 10.10 Family disorder: *A Midsummer Night's Dream* (1595/6) starts with Hermia rejecting her father Egeus's choice of husband for her. Two daughters in St Helen's, Elizabeth Robinson and Elizabeth Spencer, married against the wishes of their wealthy fathers in the 1590s. Scene from Peter Brook's famous 1970 production. Photograph by Douglas Jeffrey.

> Stand forth Demetrius.– My noble lord,
> This man hath my consent to marry her.
> Stand forth Lysander.– And, my gracious Duke,
> This hath bewitched the bosom of my child.
> Thou, thou, Lysander, thou hast given her rhymes,
> And interchanged love tokens with my child.
> Thou hast by moonlight at her window sung
> With feigning voice verses of feigning love,
> And stol'n the impression of her fantasy
> With bracelets of thy hair, rings, gauds, conceits,
> Knacks, trifles, nosegays, sweetmeats – messengers
> Of strong prevailment in unhardened youth.
> With cunning hast thou filched my daughter's heart,
> Turned her obedience which is due to me
> To stubborn hardness. And, my gracious Duke,
> Be it so she will not here before your grace
> Consent to marry with Demetrius,
> I beg the ancient privilege of Athens:
> As she is mine, I may dispose of her,
> Which shall be either to this gentleman
> Or to her death, according to our law
> Immediately provided in that case.
> (*A Midsummer Night's Dream*, I.i.20–45)

Was the battle between Egeus and his daughter modelled on the recorded conflict between Sir John Spencer and his daughter, living within fifty yards of Shakespeare?

While it is tempting to make such connections, one must be very careful about pushing such possible associations without firm evidence. Disagreements between fathers and daughters over proposed marriage partners were probably a regular occurrence in Elizabethan London. Indeed, Alderman John Robinson the Elder, who lived on the other side of Shakespeare's likely residence (see section 3 of the Appendix) cut his daughter Elizabeth out of his 1599 will,[11] stating:

> my daughter Elizabeth Robinson, who of a wilfull minde, contrary as well to her dutie, as to the laudable customes of this honorable Citie of London, hathe bestowed herself in marriage without my consent and privitie, my full entente and minde is, that in regarde of her disobedience, she shall enjoy neither parte nor portion of anie parte of my goodes, onlie in rememberance of my love towards her, I give unto her the somme of tenne poundes . . .[12]

Elizabeth married the unsatisfactory Thomas Jefferies on 23 September 1596 at St Benet Fink, by special licence.[13] The church was next to the Royal Exchange and a few hundred yards from the presumably furious John Robinson. Clearly, this show of female independence still rankled three years later. Such a local scandal in the family of one of London's leading citizens could have provided the inspiration for the start of the play, in which case it must have been finished after autumn 1596. Indeed, one wonders if Shakespeare was making a sly connection when Theseus states Hermia's fate if she does not obey her father:

> Either to die the death, or to abjure
> For ever the society of men
> . . . , if you yield not to your father's choice,
> You can endure the livery of a nun,
> For aye to be **in shady cloister mewed**
> 	(*A Midsummer Night's Dream*, I.i.65–71; emphasis added)

since Alderman Robinson and his daughter Elizabeth lived in a house carved out of the dining hall of the former nunnery of St Helen's and which looked out over the former cloister of the nuns.

Many people are surprised to discover that no one actually knows for certain when a play as famous as *A Midsummer Night's Dream* was written or first performed. It was published in 1600, with the frontispiece stating: 'As it hath beene sundry times publickley acted, by the Right honourable, The Lord Chamberlaine his servants. Written by William Shakespeare', but it is unclear how many years earlier it was premiered. The play is praised in Francis Meres' *Palladis Tamia*, listed in the Stationers' Register on 7 September 1598, so it must have been first performed before then. Many experts connect it with the publication of Edmund Spencer's *Epithalamion* in 1595, an ode written to his bride covering the twenty-four hours of their wedding day, so a date of 1595/6 is often suggested.

In contrast, William Compton's interest in Elizabeth Spencer, at least his formal marriage proposal, is usually dated to 1598, two years later. John Chamberlain wrote on 31 January 1599:[14]

> It is given out that the Lord Compton shall marry our Sir Spencers daughter of London, on these conditions, that he geve him £10,000 redy money with her, and redeeme his land that lieth in mortgage for £18,000 more.

£28,000 was a vast sum of money and gives a clear guide to the huge wealth of Sir John 'Rich' Spencer. Five weeks later, events had clearly gone awry:[15]

> Our Sir John Spencer, of London, was the last weeke committed to the Fleet [Prison] for a contempt, and hiding away his daughter, who they say is contracted to the Lord Compton; but now he is out again, and by all means seekes to hinder the match, alledging a precontract to Sir Arthur Henninghams sonne.[16] But upon his beating and abusing her, she was sequested to one Barkers, a proctor, and from thence to Sir Henry Billingsleyes [Lord Mayor in 1596–7] a where she yet remains till the matter be tried. If the obstinate and self-willed fellow should persist in his doggedness (as he protests he will) and give her nothing, the poore lord shold have a warme catch.

In the event, William and Elizabeth married on 18 April 1599 at St Katherine Coleman church, not at St Helen's. There is no record of whether Sir John took his daughter to the wedding or, as seems more likely, boycotted the proceedings, since he was described as estranged.[17]

However, Elizabethan courtships could be protracted, especially among aristocratic families, so it is possible that the headstrong Elizabeth Spencer had already fallen out with her autocratic father by 1596, whether over William Compton or another suitor.[18] Elizabeth Spencer, therefore, might have provided a model for Hermia, but equally it might be an entirely different strong-willed young woman Shakespeare had in mind, such as Elizabeth Robinson, or possibly he simply imagined someone based on a common occurrence, which would have been appreciated by his audience. If you sit in St Helen's churchyard and read the passage aloud looking over to the site of Crosby Hall, you realise Shakespeare lived close enough to hear people shouting in Spencer's mansion, and probably also in Alderman Robinson's house as well. On location, a connection to one of these families seems very convincing, but that does not make it true. What Shakespeare did know was that such a scene would have been familiar to his audience, recognisable enough to provide the opening scene for one of his greatest works and a springboard for the plot for the rest of the play. With much of his audience coming from the northern part of the City and Sir John Spencer having finished his mayoralty in November 1595, he would have been an instantly identifiable figure. Unfortunately, we will probably never know the detail of his dealings with Elizabeth and William Compton. However, he does seem to appear as the 'villain' in other plays. Richard Rowland notes of Sir John Spencer that 'His popular reputation could not have been lower, his conspicuous failure to pity or relieve the poor being arguably being the worst of his offences.'[19] Charles Whitney has argued that Thomas Dekker's city comedy *The Shoemaker's Holiday* (1599, performed at court at Christmas 1600) had Sir John as its target.[20]

However, the position of Lord Mayor was not for the fainthearted. In June 1595, as poor trade and bad harvests resulted in acute economic hardship, rebellious apprentices

caused increasing trouble in the City. There had been ongoing tension since the anti-immigrant protests in spring 1593 and now these fractious groups almost burst into insurrection. Over 1,000 poor apprentices gathered on the evening of 29 June at Tower Hill and engaged in street battles when the authorities, led by Sir John Spencer, tried to clear them away.[21] According to accounts of the time, the public gallows were torn down and one was re-erected outside Sir John's house, presumably Crosby Hall. Such was the fear engendered by this rioting among the authorities that three weeks later, on 24 July, five apprentices were hung, drawn and quartered as a savage public warning (Figure 10.11).[22] A special Provost-Marshall, with horsemen armed with pistols, patrolled the streets.

Thirdly, and most importantly in this context, Sir John was strongly opposed to theatre in the City. The moment his mayoralty commenced, he was lobbying the Privy Council to close all the theatres in London, which would have included the Bull Inn on the opposite side of Bishopsgate to his new mansion.[23] On 3 November 1594, during his first week in office, he wrote to the Privy Council and set out the reasons why playhouses were a major threat to social stability and should be closed immediately. The letter is worth reading in full since it illustrates the drawn-out obsequiousness used by Spencer

Figure 10.11 Social disorder: In June 1595, there was increasing social unrest in London over rising prices, especially for food staples. Following a full pitched riot by apprentices on Tower Hill, the authorities executed five offenders as an example. Woodcut showing the heavily guarded gallows.

combined with heavy emphasis on the 'hot fear buttons' of the Elizabethan state – the undermining of Protestant religion, political subversion and threats to trade (and hence tax).[24]

> My humble duetie remembered to your good L. I understand that one Francis Lanley, one of the Alneagers for sealing of cloth, intendeth to erect a niew stage or Theater (as they call it) for thgexercising of playes upon the Banck side.

Francis Langley is planning a new theatre on Bankside, Southwark . . .

> And forasmuch as wee fynd by daily experience the great inconvenience that growth to this Citie & the government thearof by the sayed playes, I have emboulkened my self to bee an humble suiter to your good L. to bee a means for us rather to suppresse all such places built for that kind of exercise, then to erect any more of the same sort.

We do not want more theatres, in fact we should get rid of all of them . . .

> I am not ignorant (my very good L.) what is alleadged by soom for the defence of these playes, that the people must have soom kind of recreation, & that policie requireth to divert idle heads & other ill disposed from other worse practize by this kind of exercise. Whearto may bee answeared (which your good L. for your godly wisedom can far best judge of) that as honest recreation is a thing very meet for all sorts of men, so no kind of exercise, being of itself corrupt and prophane, can well stand with the good polocie of a Christian Common Wealth.

I know their supporters say theatres provide recreation and thus prevent worse activities, but plays are immoral . . .

> And the sayed playes (as they are handled) ar of that sort, and work that effect in such as ar present and frequent the same, may soon bee decerned by all thathave any godly understanding & that observe the fruites & effects of the same, conteining nothing ells but unchast fables, lascivious divises, shifts of cozenage, & matters of lyke sort, which ar so framed & represented by tghem, that such as resort tio see & hear the same, being of the base and refuse sort of people or such young gentlemen as haue small regard of credit or conscience, draue the same into example of imitation & not off avoiding the sayed lewd offences.

By presenting immoral actions and ideas, plays encourage the underclass to copy such activities . . .

> Which may better appear by the qualitie of such as frequent the sayed playes, being the ordinary places of meeting for all vagrant persons & maisterless men that hang about the Citie, theeues, horsestealers, whoremoongers, coozeners, connycatching persone, practizers of treason, and other such lyke, whear they consort and make their matches to the great displeasure of Almightie God & the hurt and the annoyance of hir Maiesties people, both in this Citie and other places about, which cannot be clensed of this ungodly sort (and by experience wee fynd to be the verysinck & contagion not only of this Citie but of this whole Realm), so long as these playes & places of resort ar by authoritie permitted.

Theatres attract criminals and the disaffected, who undermine a stable society . . .

> I omit to trouble your L. with any farther matter how our apprentices and servants ar by this means corrupted & induced hear by to defraud their Maisters, to maintain their vain & prodigall expenses occasioned by such evill and riotous companie, whearinto they fal by these kind of meetings, to the great hinderance of the trades & traders inhabiting this Citie . . .

Even bound apprentices waste their time and money at the theatres and this damages the economy . . .

> and how people of all sorts ar withdrawen thearby from their resort unto sermons & other Christian ewercise, to the great sclaunder of the ghospell & prophanation of the good & godly religion established within this Realm.

People go to the theatre when they should be going to worship God in Protestant churches . . .

> All which disorders having observed & found to bee true, I thought it my duetie, being now called to this publique place, to infoourm your good L., whome I know to beea patrone of religion & lover of virtue & an honourable a friend to the State of this Citie, humbly beeseaching you to voutchsafe mee your help for the stay & suppressing, not only of this which is now intended, by directing your letters to the Iustices of peace in Middlesex & Surrey, but all other places, if possibly it may bee, whear the sayed playes ar shewed and frequented. And thus craving pardon for this over much length I humbly take my leave. from London the 3 of November 1594.[25]

As Lord Mayor, responsible for the capital, I seek your help as the national bastion for maintaining social order, good moral behaviour and protestant orthodoxy in London to give support . . .

Ten months later, on 13 September 1595, as his mayoralty was coming to an end and in the aftermath of the apprentice riots in June, Mayor Spencer repeated his request in similar words, adding:

> which wee verily think to bee the cheef cause, aswell of many other disorders & lewd demeanours which appeer of late in young people of all degrees, as of the late stir & mutinous attempt of those fiew apprentices and other servants, who wee doubt not driew their infection from these and like places.[26]

Sir John would not have been interested in Shakespeare personally, for he was far beneath him socially, even if the Lord Mayor was aware of his work. However, his retinue of retainers at Crosby Hall might have felt it well within their role as loyal servants to at least make offensive comments to a 'player', if not to threaten worse. Given that Shakespeare could have lived virtually anywhere in London, it seems highly unlikely that he would have chosen, at a crucial point in his career, to move in next door to the residence of one of the most powerful people in London who was so opposed to his craft and source of income.[27]

Rather than his moving in within thirty yards or so of Sir John Spencer's mayoral residence, there is a far more obvious and probable scenario. This is that Shakespeare had moved into the parish, specifically 'the Close' section of Great St Helen's, before news got out that Sir John and his retainers were moving in next door. This would mean that he had arrived in St Helen's before the end of 1593 or early 1594 at the latest, and possibly earlier. This was a period of great upheaval for Shakespeare, with the closure of the London theatres due to the plague for much of the period from June 1592 through to spring 1594, his shift to writing poetry, potentially for a patron, and the establishment of the Lord Chamberlain's Men in May 1594. One could make arguments for virtually any date in this period as a possible moving-in time. It is interesting that Shakespeare appeared to move to Silver Street around the time of the terrible 1603 plague. The 1593 plague was roughly 50 per cent less severe, in terms of deaths at least, but it would undoubtedly have been traumatic and would have shaken up housing availability. It is, of course, possible that Shakespeare moved into St Helen's, or an adjacent parish, when he first settled in London.

This argument is crucial, for a move to St Helen's after Autumn 1594 means that Shakespeare was making the deliberate decision to live next to a (former) Lord Mayor who was totally opposed to his profession and who continued to lobby against the theatres to the Privy Council. Given Shakespeare's evidently cautious approach to life, compared to some of his contemporaries, and his wish to promote his family's reputation, this seems highly unlikely.

There is one other small piece of evidence. Shakespeare may have been amused by a St Helen's resident, a 'stranger', possibly French, with the unusual name of Andrew

Elbow, who appears as the word-mangling Constable Elbow in *Measure for Measure*.[28] Andrew Elbow was buried in St Helen's on 13 October 1596. If Shakespeare borrowed his name and possibly his character, it suggests he had arrived in St Helen's sometime prior to Elbow's death.

Therefore, I suggest that Shakespeare's residence in the parish of St Helen's was not a brief stay *c.* 1597–8, but a longer and far more profound engagement with this locale. He had probably moved there by late 1593/early 1594 at the latest and was possibly in residence by late 1592 or even earlier. He is likely to have spent at least four to five years there, when he was aged twenty-nine to thirty-four and drafting some of his greatest works for the Lord Chamberlain's Men Company. Furthermore, it seems most likely that he lived on the north side of the churchyard end of Great St Helen's (termed here 'the Close') in a property which backed onto Little St Helen's[29] among a community of highly gifted individuals embracing specialisms ranging from medicine to music, who are discussed further below. From there, across the graveyard, he would probably have had a fine view of the west end of St Helen's church with its double doors.

It is, of course, perfectly possible that Shakespeare moved into this area when he first came to London, perhaps around *c.* 1589/90. Andy Kesson has recently argued that Shakespeare may have had quite a mixed start to the beginning of his career and may have 'careered through multiple professional possibilities'.[30] It seems unlikely that Shakespeare would have brought much in the way of financial reserves with him to London. He may have planned to fall back on getting a basic income from working as a journeyman leatherworker if his theatrical employment was erratic.[31] Presumably, he would have learnt at least basic skills from his father as a boy in Stratford-upon-Avon, and he must have been working 1582–5, when his three children were born. What would be more natural, given the Leathersellers' Livery Hall was a two-minute walk from the Bull Inn/theatre, than for Shakespeare to have sought out John Hatton, the company clerk, to ask for guidance about who might need some extra help? In turn, Hatton, a trained scrivener looking for writing jobs on the side,[32] might have viewed Shakespeare as a possible future source of work and could have helped him to find accommodation in the area. In 1589, Shakespeare was as likely to work at the Rose in Southwark as the Theatre/Curtain in Shoreditch. The Bull Inn was almost exactly midway between the two (see Figure 8.10) and lodgings nearby would have offered a good compromise in terms of walking to work. Furthermore, although the Bull Inn and the other City theatre Inns are overshadowed by purpose-built theatres in the history books, at the time they all offered the potential of work. This does not necessarily mean Shakespeare immediately moved onto the Leathersellers' estate, since, as an unknown migrant and player, he might not have been considered suitable, even as a short-term sub-tenant. Hatton probably kept a weather eye on the local rental market, and Shakespeare acquired some knowledge of French sometime before *c.* 1598 when he wrote *Henry V.* There were many

'stranger' households in the Bishopsgate area where extra income from a lodger would have been welcome, just as occurred at Silver Street in 1602/4.

However, there are other potential routes for these connections. Thomas Wrightson was working as a scrivener for Philip Henslowe in January 1589, drawing up a deed of sale for theatrical properties and plays. This was around the time that Shakespeare probably first settled in London. Wrightson lived virtually next to the Bull Inn and was friendly with the Harrisons, who operated it.[33] Wrightson may also already have known Israel Jorden, who had become a freeman of the Scriveners' Company on the same day as John Hatton in 1577. Henslowe or the Harrisons might have introduced Shakespeare to Wrightson, who took on a Leathersellers' tenancy *c.* 1590 and might have connected Shakespeare to Hatton.[34] It is quite likely that Wrightson was unmarried, as Jorden immediately took over his house when he died, and there is no reason that Shakespeare could not have lodged with either for a while. Scriveners were usually well educated and would probably have appreciated a tenant who was interested in writing and the wider arts.

One thing is certain: all these people would have seen each other at Sunday service in St Helen's. And it is to the interior of Shakespeare's parish church that we will now turn.

## Notes

1. The 1599 Lay Subsidy roll for St Helen's is badly damaged and only the bottom half is readable. If Shakespeare was assessed in 1599, he would have been listed in the part which has been lost. By then, the authorities were chasing payment in Southwark, but see the discussion in the Appendix Section 4.
2. Although not absolutely certain, as some names of known occupants are missing in the 1582 and 1598 Lay Subsidy rolls. Records from this period are rarely 100 per cent consistent when cross-checked against other evidence. Also, if he was lodging in someone else's house for a short period, he would not have been responsible for the tithe payment.
3. Many specialists now believe that Shakespeare, following his arrival in London, may have worked with Marlowe on his first plays. The *New Oxford Shakespeare*, published in 2016, credits Marlowe as a contributor to *Henry VI Parts 1, 2* and *3*.
4. It was entered in the Stationers' Register 'upon the peril of Henry Chettle' on 20 September 1592, two and a half weeks after Robert Greene's death on 3 September.
5. In contrast, the medieval hall of the Blackfriars, purchased by James Burbage in 1596 for conversion to an indoor theatre, was *c.* 46 feet by 107 feet and 73 feet high. Crosby Hall was moved and rebuilt in Chelsea in 1909–10, where it can still be seen; see Norman and Caroe, *Survey of London* and Godfrey, 'Crosby Hall (re-erected)', pp. 15–17.
6. William's brother was Sir George Bond, Lord Mayor in 1587/8.
7. His other brother, Martin Bond, a successful merchant and MP in 1624/5, moved to Throckmorton House in the neighbouring parish of St Katherine Cree, just to the east. When Martin died aged eighty-five in 1643, he was buried in St Helen's, where his wall memorial, erected by his nephew William to his 'piety, prudence, courage and honesty', can still be seen, showing him in his tent at Tilbury in 1588, ready to defend London against the Spanish.

8. It is not clear how much time Spencer actually spent living in Crosby Hall. He had another favourite property, Canonbury House, a mile away in the countryside around the village of Islington. The scale of Crosby Hall is shown by the £200 per year rent recorded in 1615, when it was leased for twenty-one years to William Russell; see Norman and Caroe, *Survey of London*, pp. 15–32.

9. A George Dorrington, a gentleman assessed at £10, is recorded in the St Helen's 1611 Lay Subsidy roll. He was an early investor in the East India Company.

10. When she eventually married Compton in 1599 the Leathersellers decided to give her a present of ten shillings, which seems a strange gift, given her father's enormous wealth; see Leathersellers' Court Minutes. Spencer refused to give Elizabeth a marriage portion.

11. For his will, see TNA PROB/11/98/472, dated 12/15 July 1599. Robinson's threat to cut another daughter, Katherine, out of his bequests if she challenged his will indicate that there were broader tensions within the family. However, the main evidence lies in a suit brought in the Court of Chancery: Six Clerks Office by his eldest son John Robinson the Younger in June 1601 following the death of his father and his own wife, who had died in childbirth just before Christmas 1600. He took six of his siblings, two of his brothers-in-law and others to court claiming they had 'confederated' to defraud him of property bought by his father from John Aske, MP, in Yorkshire and a 'statute of £10,000'; see TNA C2/Eliz/R6/62/1–10, and also note 13 immediately below. The depositions by the defendants tell a story of high family drama. William Walthall states that as Robinson lay dying his son John came into his bedroom and demanded the proofs of his inheritance, adding he 'had never entermedling with the affaryes of John Robinson the elder . . . othere than that he beinge familiarlye acquainted with him as A neighboure in charitable manner both in his health and sickness often visited hym And sundrie tymes they met together beinge bothe merchants . . . remembreth that the saide complaynante [John Robinson the Younger] the day before the deathe of the saide complaynante father (this defft then sittinge by the complaynante fathers bed side) used some speech to his saide father concerning the statute of ten thousand poundes mentioned in the sayd bill wherewith all his said father was very much grieved and disquieted whereupon this defendante persuaded the sayd complaynante to consider of his fathers case (?) lyenge in extremitie of sickness and to forebeare to greeve his said father'. However, there had clearly been much indecision by the old patriarch as he sickened, Walthall adding, 'this defendant togeather with Anne Walthall Daughter of the said John Robinson the elder and Thomas Walthall husbande of the saide Anne [William's brother] by the speciall appointemente and request of the said John Robinson the Elder the Sunday before the decease of hym the said John Robinson did enter into the counting house of the said John Robinson the elder at which tyme by the especial direction and entreaty of the saide John Robinson this defft tooke out of a deske in the sayd counting house two boxes with writynge wherein was ye sd statute of ten thousand pounds men [. . . ?] in the bill & likewise the last will & testament of the sd John Robinson thelder . . .' Robert 'Sandy' Napier, brother of the astrologer Richard Napier, was blunter in his deposition, perhaps because he had only married into the family in 1594. There had been trouble between father and son for some years, Napier referring to the latter's 'stubbornes and disobedience' and that the father had said 'in his presence' that 'he [John, his son] should have none of his lands or goodes or words to that effect'. Napier also stated that John had 'in the lifetime of his saide father molestede hyme by sute in the chancery'. While major quarrels between siblings over inheritance were a regular occurrence in this period, one wonders if there are echoes of this bitter family dispute in some of Shakespeare's writings. Unfortunately, several of the depositions were badly creased and folded (now conserved) at the time of research so it was impossible to understand the whole case. Interestingly, Humpfrey, the youngest son, deposed that he had been in trading in 'Turkie' from 1596 and had only returned to England after his father's death. This again illustrates the international experience of people closely connected to St Helen's.

12. This Elizabeth Robinson, who married Thomas Jefferies 'of Ikenham', is different from the Elizabeth (née Rivers) Robinson who died in childbirth in 1600 and who was her sister-in-law (see Figure 13.2). At least five of Elizabeth's sisters married, probably in their birth order in 1582, 1586, 1588, 1589 and 1594 – all made excellent matches, including Mary to the future Sir Robert Napier of Luton Hoo and Anne to Alderman Thomas Walthall of St Peter, Cornhill (see TNA PROB 11/121/512 for his will

of 1613). Alderman John Robinson senior, like most of the heads of the leading London mercantile families, carefully planned his children's weddings to the offspring of other wealthy City dynasties. His third son, later Sir Arthur, married the daughter of Alderman William Walthall (see TNA PROB 11/112/269 for his will of 1608), whose brother Thomas was married to Arthur's sister Anne. With most of his children settled, John Robinson seems to have turned his attention to securing a large country landholding for the family. In 1595 he negotiated to purchase part of the major landholdings of John Aske MP, south of York. These properties may have appealed because of the ancient families associated with some of the manors. This proposed acquisition turned into a major fraud case; see section 7 of the Appendix, n. 20. However, by the time of his will in 1599 he had secured these estates and split them between his three oldest sons, John, Henry and Arthur.

13. See LMA P69/BEN1/A/001/MS04097.
14. John Chamberlain (1553–1628), the son of Alderman Richard Chamberlain, was a keen letter writer, especially to Dudley Carleton; see McClure (ed.), *The Letters of John Chamberlain*, vol. 1, p. 67, <https://catalog.hathitrust.org/Record/001632436> (last accessed 20 July 2020).
15. Ibid. p. 73.
16. Sir Arthur Heveningham/Henningam (*c*. 1540–*c*. 1630) was sheriff of Norfolk. His son John (1577–1633) eventually married Catherine, daughter of Lewis, Lord Morduant of Turvey. He ended up briefly in the Fleet Prison himself in 1627, but was elected MP for Norfolk in 1628.
17. Elizabeth had one son, Spencer Compton, christened on 28 May 1601 at St Michael Bassishaw. He was killed at the Battle of Hopton Heath in 1643 fighting for the Royalists.
18. William Compton, 2nd Baron Compton, was born *c*. 1572 and was a dashing courtier in the 1590s, which probably did not endear him to his future father-in-law. In 1590 he went to Edinburgh on a diplomatic mission with the Earl of Worcester to congratulate James VI on his marriage to Anne of Denmark. In 1618, James I created him 1st Earl of Northampton. A marvellous portrait miniature *c*. 1600 in the Royal Collection shows him in an exquisitely decorated and extremely expensive suit of armour with a 'lovelock' earring. From the late 1580s, he fought most years at the magnificent annual Accession Day Tilts in the tiltyard at Westminster. In 1595, he was paired with Henry Noel. George Peele celebrated the tilt in a poem, 'Compton of Compton came in shining arms, Well mounted and appointed for the field. A gallant lord, richly arrayed was he, He and his train . . .'; see *FECDD*, 17 November 1595. One can imagine how the young Elizabeth Spencer would have fallen for such a dashing, aristocratic young man and how her father could see his accumulated wealth being rapidly dissipated. In 1600, at the very public Accession Day Tilt, Compton alluded to his new father-in-law as a 'stone', see *FECDD*, 17 November 1600. Lord Compton's descendant, the 16th Earl of Northampton and 7th Marquess, still lives today at the family homes, Compton Wynyates and Canons Ashby. The design of Compton's armour surives in the Almain Armourer's Album now in the V&A Museum (D.611&A-1894).
19. Rowland, *Thomas Heywood's Theatre*, p. 54.
20. See Whitney, 'The Devil his Due', which lists all the correspondence between Spencer and the Privy Council.
21. The authorities were not helped by Sir Michael Blount, Lieutenant of the Tower of London, saying they were trespassing on the Liberty of Tower Hill and should back off.
22. This rioting is often linked to the description of street fighting between the Montagues and the Capulets at the start of *Romeo and Juliet*, possibly written the following year.
23. In theory, the City inns stopped staging performances as part of the May 1594 agreement about a 'duopoly' based at the Theatre and the Rose playhouse.
24. Various publications; for example, see Document 33 and following in Rutter, *Documents of the Rose Playhouse*, pp. 85–7. The wording followed that of previous demands; see Document 13, a letter from the Lord Mayor dated 25 February 1592. Document 40, a later letter to the Privy Council from the Lord Mayor, dated 13 September 1595, blamed the theatres for 'the late stirr & mutinous attempt of the fiew apprentices and other servants . . . the cause of the increase of crime within the City'.
25. See Gurr, 'Henry Carey's Peculiar Letter', p. 66. This provides a detailed analysis of Spencer's anti-theatre activities, which are recorded in 1597 well after his one-year mayoralty had finished. This is in contrast to the more relaxed attitude of other Lord Mayors.

26. See Chambers, *The Elizabethan Stage*, vol. 4, p. 318.
27. See Whitney, 'The Devil his Due'. Roland estimates that Spencer was the sixth richest man in London. Through his moneylending activities, he could manipulate a huge web of contacts.
28. Noted by Nicholl, *The Lodger*, pp. 41–2. Nicholl suggests this is Anthony Helbow, recorded earlier as a French silk-weaver from Leley (Lille); see Scouloudi, 'Returns of Strangers in the Metropolis', p. 182. This seems quite likely, as Elbow was buried 'out of Staveley's Alley', which in 1598 contained another 'stranger' silk weaver, Abraham Gramer; see section 3 of the Appendix.
29. The Steward's Lodging would originally have faced south-west, towards visitors coming from St Helen's 'belfry' gate. It is possible that over time, the layout of this row of buildings altered, with the main entrance moving to the north side.
30. See Keeson, 'His Fellow Dramatists and Early Collaborators'.
31. See section 7 of the Appendix for details of the player William Shepherd, who appears to have taken up tailoring when the 1603 plague prevented playing.
32. See section 6 of the Appendix for Hatton's 'moonlighting'.
33. See section 7 of the Appendix for details on Thomas Wrightson.
34. Wrightson was probably working in Southwark in 1580, close to the Liberty of the Clink, where Henslowe lived. He may therefore have known Henslowe before he developed the Rose, 1585–7. The deed of partnership for the Rose, dated 10 January 1586/7, was drawn up by another scrivener, Edward Pryce, but by this time Wrightson is known to have been living in Bishopsgate Street; see section 7 of the Appendix.

# PART IV

## Life, Death and Religion in Saint Helen's

1285.—Interior of St. Helen's.

Figure 11.1  St Helen's church: the north aisle (the former nuns' nave) viewed from the west, showing the high box pews that would have filled much of the church in Shakespeare's time. Wood engraving, 1840s.

# 11

## Saint Helen's Church: The Anchor of the Parish

*In which we enter St Helen's church and find a parish moving towards a more Puritan-influenced theology in the late sixteenth century. Shakespeare had decided to live in an area with a high-profile congregation, rather than lodge in a neighbourhood (like the adjacent parish of St Ethelburga) with a more humdrum social mix, where religious life might have been more traditional and low-key.*

On Monday, 25 March 1594, Shakespeare is perhaps waiting outside his lodgings in St Helen's. Nearby, in front of the fine row of half-timbered houses facing onto Great St Helen's, a small crowd is gathering. He watches, leaning on the mossy bricks of the churchyard wall, enjoying the spring sunlight that streams down between the houses. However, it is not a holiday.

In front of him, in the cemetery scarred by many muddy graves, the two ash trees, a plum tree, a gooseberry and a vine[1] are beginning to wake from the long winter. Theatre activity also seems to be on the rise. Following the almost complete closure of London's three main theatres throughout 1593, due to the severe outbreak of plague, there has been a brief respite with their reopening from the 30 December.[2] But just five weeks later, the actors received the grim news that the theatres are to be shut again – as it turns out, only until April – but at the time still deeply worrying. No playing means no income, with only the uncertainties of provincial touring as a realistic alternative for most.[3] Otherwise they wil have to fall back on temporary jobs to scrape a living until the ban is lifted. Already, other theatre companies have been forced to break up.

Fortunately for Shakespeare, his parallel career as a poet has provided a financial safety net. Upstairs, the manuscript of his new epyllion – the *Rape of Lucrece*, 266 seven-line stanzas – lies safely locked in his chest. A few more days of revising are needed and then it can go, like his long erotic poem *Venus and Adonis* the previous year, to the printer Richard Field.[4] Given that poem's success, he is optimistic about his new work in terms of its critical reception, public interest and his financial reward.[5] It has been suggested that Shakespeare would have needed £50–£80 to become a 'sharer' in the Lord Chamberlain's Men in May 1594 by 'buying in'.[6] It is hard to see how he could have saved such a sum from acting/playwriting during the previous four years, 1590–4, given there had been no playing in London for nearly half this period.

Both his long poems were dedicated to Henry Wriothesley, 3rd Earl of Southampton, presumably with the hope of receiving some financial patronage. Some experts argue

that the young earl was in no financial position to support a poet like Shakespeare. Others take the warmer dedication at the start of the *Rape of Lucrece*, 'The love I dedicate to your lordship is without end . . .', compared to the previous 'Right Honourable, I know not how I shall offend in dedicating my unpolished lines to your lordship . . .', as evidence that Shakespeare did receive some support in 1593.

One thing is clear: after May 1594, once the plague had cleared, Shakespeare did not attempt another long-form poem, or certainly not one which has survived. Instead, he turned back to a stage-related career. This suggests that sometime in the nine months between October 1593 and June 1594, Shakespeare made the strategic decision that despite his popularity as a poet, financial security was more likely to lie in working in public theatre. However, in the confusion and excitement of the reorganisation and reopening of the theatres in 1594, he would have needed to keep his options open. The quality and speed of his playwrighting in 1594–9 suggests a pent-up creative drive built on many hours of detailed thinking, character development and plotting. While he would be an actor, Shakespeare's exceptional abilities as creator of plays was his fundamental strength. To work at maximum efficiency, he needed what writers down the centuries have always sought: a quiet, warm, secure and stimulating environment where he could write undisturbed.

Above the gathering parishioners, the largest bell in the campanile above St Helen's Gate begins to toll the funeral knell to the surrounding streets.[7] The small crowd is collecting around the doorway of Margaret Fountain's house, whence a wooden coffin[8] covered by a black cloth will soon be carried across the street and to the churchyard for the funeral service. She will be buried outside in the graveyard, where there is no charge, unlike inside the church.[9] Quiet murmurs in French and Dutch interweave with the English conversations. Although for us today the corpse[10] is an unknown female Elizabethan Londoner, and we do not even know her name or age,[11] the burial register does record her origins and status: 'a French mayde out of Margaret Fowntaines house'.[12] She was one of the thousands of female household servants who undertook the laborious and continuous childcare, cooking, laundry and cleaning in houses across London. Margaret is recorded in 1576 as being a French widow, one of five immigrant ('stranger') households who are specifically detailed as living in the Close of St Helen's.[13] What did her French maid die of? There is no record.

In the cemetery, her grave has been neatly excavated down several feet by John Dunne, the parish sexton, with fragmented bones from previous burials scattered across the heap of raw earth piled up alongside.[14] The single hand on the church clock passes the hour, the tolling bell is stilled, heads are bowed.[15] John Oliver, the minister of St Helen's for the last four years,[16] begins intoning the familiar words of the burial service from the 1559 Book of Common Prayer, ordered for use in every parish to enforce Protestant conformity across the country: 'Earth to earth, ashes to ashes, dust

to dust'. The shrouded body is let down into the grave and in a few minutes it is all over. The sexton begins shovelling the clods of earth back onto the 'French mayde'.

For John Oliver, the occasional burial[17] is a welcome change from the previous year 1593, when, during a particularly vicious outbreak of the plague, he buried seventy-six parishioners – over one in ten of his flock.[18] These included at least six female French servants. For Margaret, the deceased is just one of many servants she has employed over the years. The mourners will probably be invited back to a short wake. Maybe Shakespeare prefers to keep the memory of this French maid, perhaps singing in the Close as she carried buckets of water back to her house, perhaps flashing a smile as she hung washing out to dry on the graveyard wall, locked inside his head. He nods his departure and walks off into the church to be alone with his thoughts (Figure 11.1).

If it is correct that Shakespeare resided in the parish for five years, then he could have potentially attended church on over 250 Sundays with additional special services and lectures as well as christenings, marriages and burials. However, there was no playing during the forty days of Lent, and most historians assume that Shakespeare would have used this period to return to Stratford-upon-Avon to catch up with his family and local affairs. Although there is some limited evidence of the Lord Chamberlain's Men touring – Marlborough in 1594, Cambridge and Ipswich in 1595 – the company seems to have preferred generally to stay in London with its greater financial returns.[19] Therefore, it seems there is a good chance he might have attended church services on 180 or so Sundays at St Helen's. His regular presence would have been absorbed into a distinct community, seeing the same people in the same pews in the same church week after week. Some might have been impressed that such a well-applauded figure was seen in their church. Others, particularly the more godly parishioners, may have taken offence at even seeing a 'player', whose work was perceived as encouraging lewd thoughts and living.[20]

The church of St Helen where Shakespeare worshipped had seen great changes since Henry VIII's Act of Supremacy in 1534 kicked off the Reformation in England. The older parishioners, like John Robinson the Elder, aged over sixty and hence born before 1535, would have witnessed a series of rapid shifts in religious authority, allegiance and practice. The first was the fundamental break King Henry VIII made with the papacy in Rome, which made him, rather than the Pope, head of the Church of England. This was followed swiftly by the dissolution of the monasteries from 1536–40, which brought an end to the priory of St Helen's.[21] The buildings, including the nuns' church, were not demolished but granted by the King on 29 March 1542 to Sir Richard Williams, alias Cromwell, in exchange for other land and a cash payment. The new owner immediately sold the church, the nuns' dormitory and probably the rest of the priory buildings to the Company of Leathersellers. Probably soon after 1543, the parish acquired the nuns' church and presumably the partition between the two aisles was removed immediately

afterwards. The extra space would have been useful for a parish with a growing population.[22]

It is not known when the fittings, artworks and decorations in the nuns' church were removed and destroyed. The will of Joanne Alfrey, who died in 1525, records that there was a statue or possibly a painting of St Helen on the nuns' altar. She also wanted an image to be created in three sections, possibly some form of triptych, with a kneeling woman (presumably representing her), praying to the Trinity flanked by St Katherine on the left and the Virgin Mary on the right. She desired to be buried in the:

> quere under a tumbe in the walle stonding before the image of Saint Helyn whereuppon the Sepulcre of our Lord hath ben yerely used to be sett . . . the said tumbe be newe made by myn executors . . . a stone to be laide upon the grave of my late husbonde William Ledys . . . a table conteyning thre ymages, that is to say the ymage of the Trinitie to be in the myddes of the same table and the ymage of our Lady to be on the right side of the same Trinitie and the ymage of saint Kateryn to be on the left side . . . and that in the same table be well and workmanly wrought and paynted an ymage of a gentilwoman kneling holding hir handes joyntly togiders and loking upon the said ymages with an oracion to be written in letters . . . [23]

Even if Joanne's commission survived the dissolution of the priory fifteen years later, it was probably destroyed a few years after that during the iconoclasm of Edward VI's reign (1547–53), when fervent Protestants destroyed such artworks as relics of popish idolatry. Some things did survive, however, from the nuns' church. Their choir was originally located in the middle section of their church[24] and would have consisted of twenty or so heavy wooden choir seats, set in rows facing each other. Some of these, probably of fifteenth-century origin, have survived in the church, albeit heavily restored over the years. Their weight and design meant that they were best placed against a wall, and over the centuries they have been moved around the interior as fashion and use have dictated. In the early eighteenth century they were, despite their origin, being used as seats for the parish poor. Located against the north wall, they may have had this function since 1543.

Prior to the Reformation, a main feature of the parish church would have been the rood screen, a wooden partition that divided off and protected the sanctity of the altar and choir at the east end from the nave. The nave would often have been used for all manner of secular purposes. Doors in the screen would have been kept locked except during services. The screen would have been latticed so that, during a Catholic service, the parishioners in the nave could see the priest elevate the host during communion. Above the screen would have been the rood itself, a large figure of Christ crucified, often flanked by figures of saints. Candles on top of the screen, on the rood loft, would have

created dramatic lighting of the carvings in the dark. Again, during the Protestant Reformation, such statues would have been seen as idols and destroyed, although the screen itself was to survive awhile. The years 1545–8 also saw the dissolution of nearly 2,400 chantries and other chapels across the country, medieval foundations endowed to celebrate masses for the dead. There were two chantry priests at St Helen's who were pensioned off.[25]

The state control of Protestant religious practice tightened over the following years. 1549 saw the first Act of Uniformity and the issuing of the first version of the Book of Common Prayer, which regulated all church services in England and ensured they were identical. However, it was not until 1552 that a new Act of Uniformity imposed penalties for unjustified absence from Sunday service.

All these changes went into a complete reverse during the five-year reign of Queen Mary I (1553–8), who re-established Catholicism and persecuted committed Protestants. Although her reign now seems brief, in 1553 Mary was aged thirty-seven, so it would have been reasonable to assume a reign of fifteen to twenty years and possibly children from a swift marriage. Blaise Sa(u)nders, a grocer and international merchant[26] who lived in St Helen's from c. 1560 until his death in 1581, was one of nearly a thousand Protestants who went into exile in Germany and Switzerland during Mary's reign.[27] His brother Lawrence (1519–55), rector at All Hallows church, Bread Street, remained and was arrested in 1554, convicted of heresy and burnt at the stake in Coventry on 8 February 1555.[28] He was the second 'Marian martyr' in England and the first to die in Coventry, where he was followed by Robert Glover on 20 September. Glover's granddaughter was to have a strange and ill-starred link with St Helen's some fifty years later, as is explained in Chapters 18–20 below. Having returned to London from exile, Saunders was one of the key men in the St Helen's vestry for the next two decades, with a web of family and commercial connections to other leading merchants and politicians in the City.[29] One wonders how he adjusted to his brother's hideous death.

However, the nunnery had gone forever and it is doubtful if the earlier statues, works of art, vestments, plate and other treasures were replaced.[30] When Elizabeth I succeeded her half-sister in 1558, Protestantism was restored and there was a new Act of Uniformity – 'An Acte for the Uniformitie of Common Prayoure and Dyvyne Service in the Churche, and the Administration of the Sacramentes' – which required everybody to go to church at least once a week, or be fined 12d. It was into this shifting religious environment that William Shakespeare was born in 1564, and his father had lived through it in Stratford-upon-Avon for the previous thirty years. Today, when attendance at Christian church services in the United Kingdom is a minority activity, it is hard for those used to a secular approach to the world to imagine an environment when religious belief impacted on every aspect of life – from how one said grace at mealtimes to how

one dressed. However, without some appreciation, it is difficult to understand the world that Shakespeare worked in and for which he wrote.

Given the continuous upheavals of the previous years, it is hardly surprising that people moved cautiously as they adjusted to each shift in religious practice. It was not until 1564/5 that another wave of reform impacted physically on St Helen's. Then, the churchwardens' accounts record: 'Rec[eived] 30s[hillings] of a marbler for an altar stone and a piece of another and 3 step stones' – this may be the final removal of the remains of the nuns' high altar.

This is followed by the Vestry minutes for 14 January 1565, recording:

It is ordered and agreade be the whole assent of the parishioners here present that the residue of oure roode lofte yet standinge at this daie shallbe taken downe according to the forme of a certain writing made and subscribed by Mr. Mollyns [Mullins], Archdeacon of London. . . . And further that the place where the same doeth stande shallbe comelie and devoutlie made and garnished [decorated] againe like to St Magnus Church or St Dunstone in the East.[31]

Clearly the parish had been ticked off by the religious authorities for lagging behind their neighbouring parishes in their enthusiasm for a plain church interior, where minds would only focus on God and his message to mankind as provided by the Bible. The year 1563 saw the publication of the refined version of the Thirty-Nine Articles – the central tenets of the Church of England – and the Vestry account for 1565 records: '2d pd for a book of articles set forth by my lord of Canterbury' [the Archbishop] alongside 4d for '2 books of prayers against the turk', who had just launched their massive assault against Malta and the beleaguered Order of the Knights of St John.[32]

As summarised in Chapter 1, the 1570s saw more changes. On 24 December 1570, 'by assent of the church', it was decided that 'a challic and a paten all gilt' were to be converted into a 'communion cuppe for the church' also of 'silver and gilt'[33] (Figures 11.2 and 11.3). The accounts for 1573/4 record the raising up of the pulpit on 'a long pillar stone', which cost 2s. In addition, '2 great stones to drive hooks into to hang the pulpit on' cost 6s, with 3s-4d for a 'ladder for pulpit with plank'.[34] The accounts for 1575/6 record 8d paid to four porters 'for removing the altar stone out of yhre choir'. The Vestry also 'agreed that the upper two steps where the altars did stand shall be taken away and made level with the third step immediately after Easter'.

Presumably by now, if not earlier, the elaborate elevated stone altar had been replaced with a plain, simple wooden communion table at the same level as the congregation. It was also 'agreed that there shall be convenient rails and benches with mats upon them in the chancel for them that shall receive communion to kneel and rest upon'. The

Figure 11.2  The 'Bishopston' communion cup, Holy Trinity church, Stratford-upon-Avon. It was made in 1571–2, during Shakespeare's childhood, as part of the push for greater simplicity in Protestant worship.

Figure 11.3  St Helen's church: parish communion cup, hallmarked 1570. A fine example of plain Protestant silverware probably made by melting down a Catholic 'chalice' left to the church by William Crane in his will, 1545.

Vestry on 25 February 1576 announced that 'there shall be kept on the first Sunday of each month one communion'. A sum of 4d was also spent on an hourglass to time the service, or perhaps the sermon.[35]

To improve the spiritual welfare of the parishioners, it was decided on 11 April 1576 that:

> Mr. Thomas Barbour or some other learned man shall every Wednesday and Friday for the whole year read a lecture in our church to begin at 5 o'clock and end at 6, from Lady Day to Michaelmas, and from 4 to 5 from Michaelmas to Our Lady. To have 20 marks p.a. for his pains paid quarterly. The sexton to knoll the biggest bell a quarter of an hour in advance.[36]

The Puritan minister Thomas Barber was employed as parish lecturer in 1576–8. He then moved to St Mary-le-Bow, where he preached four times a week. He was a well-known radical and was followed in subsequent years by others recognised for their Puritan views.[37] These included Richard Gard(i)ner in 1578–81, J. Thorpe in 1581, and Mr Curtis in 1585 for three months.[38] Payments for the lecturer appear annually in the churchwardens' accounts through to 1585, when the new minister, Richard Lewis (1585–90), appears to have taken on the role, probably as a way of augmenting his income.[39] Such sermons were part of a broader campaign by Puritan elements to improve the spiritual life of parishioners, who often had poorly educated ministers where the older ones, even in the 1570s, may have started as Catholic priests.[40] Every year, the two universities at Oxford and Cambridge turned out a new cohort of educated divines, but the numbers were small in relation to the number of English parishes. In 1581, there were complaints that many citizens were deserting their parish churches for the rigorous Protestant services at the Dutch and French churches, both located a few minutes' walk from St Helen's. By 1590, there was therefore an established Puritan tradition in the parish which was to result in high drama with the appointment of Lewis Hughes as minister in 1600 (see Chapters 18–20 below).

The new focus on lectures from 1576 prompted further physical changes to the layout of St Helen's. The pulpit was moved and 'Jeffes the joiner' paid 40s (or 45s) for a frame in the quire, with 17 yards of 'mats about the frame' purchased at 2d a yard for 2s 10d. Another 42d was spent on 42 'candle plates at 2d a pere', with 1d worth of nails to attach them to the walls – presumably the lectures were stretching into dusk.

The same year, the decision was also taken to remove the organs, although this clearly prompted some resistance and they were still there two years later. For many Puritan-inclined Protestants such artificial music smacked of Catholicism, since God would be best pleased by hearing the psalms sung directly and clearly by the human voice.[41] A few years later, in 1578/9, the 'choir partition', perhaps the last part of the rood screen,

was finally cleared away and the pulpit moved again – perhaps to its current position against the south wall.[42]

Hundreds of thousands of words have been written by experts about Shakespeare's religious beliefs, ranging from the view that he was a Catholic to the opposite, that he was an ardent Protestant. No more will be added here to this debate other than to note that as a parishioner in St Helen's, for whatever length of time, Shakespeare would have been expected to attend Sunday service, and any extended absence would have been noted and investigated. He could, of course, have gone to hear preachers at other parish churches or at the nearby Dutch and French churches, or the open-air sermons delivered at St Paul's Cross.[43] However, regular absence from the parish church would have been seen as suspicious by the churchwardens, particularly given his professional connections, and would probably have led to unwelcome investigation. Moreover, his behaviour during church services would have been observed, since it was an opportunity for the community not simply to be watched but to also to self-censor. Was he fervent in his singing of the psalms and attentive to the minister? Or did he seem disengaged and distant? It must have been strange for Shakespeare, so experienced in controlling his audiences' emotions from the stage, to be in an environment controlled by others in authority. However, if he was bored, there would have plenty of memorials surrounding him in the church to inspire thoughts about England's history, its burgeoning international trade and making money. Sadly, most of these have disappeared over the centuries, but a few remain – meaning that you can still look at some of the same monuments and inscriptions Shakespeare may have studied four hundred years ago. Let us go for a wander . . .

## Notes

1. All recorded in the parish burial registers. Seventy years later the trees were still there and one was now recorded as the 'great ashe'. The churchyard was surrounded by a brick wall to prevent encroachment and to keep out dogs and undesirable activities. A vine in an inner-city churchyard may seem a strange feature today. It appears to have been on the north side, where it would have got some light among the three-storey houses. Perhaps it had been planted by the nuns against the south wall of the Prioress's Lodging. It was still there in the 1660s, and distinctive enough to be used as a feature for recording the location of burials.
2. Detailed in Chambers, *The Elizabethan Stage*, vol. 4, pp. 310–15.
3. See Edward Alleyne's letters to his wife Joan, while forced to tour. He gave specific instructions for trying to avoid the plague, including hanging rue in the windows; see Rutter, Documents of the Rose Playhouse, pp. 72–7.
4. *The Rape of Lucrece* was entered into the Stationers' Register on 9 May 1594. It was printed in a quarto format for the bookseller John Harrison the Elder, whose shop was at the sign of the White Greyhound in St Paul's Churchyard. *Venus and Adonis* was written as 199 stanzas (verses) of six lines, *sesta rima*, where a four-line quatrain is followed by a couplet, totaling 1,194 lines. If Shakespeare wrote an average of two stanzas a day, he would have started *The Rape of Lucrece* about October/November

1593, when he may have been alarmed that there was no indication the theatres were going to reopen. If he was slower and wrote on average one stanza a day, he would have started almost immediately after *Venus and Adonis* was published. This is perhaps suggested by his first dedication, which includes the words 'and vow to take advantage of all idle hours till I have honoured you with some graver labour'.

5. For a discussion see Bearman, *Shakespeare's Money*, pp. 39–42. Bearman notes that there is no firm evidence of financial patronage and that most of the income from these poems would have gone to the printer/publisher rather than Shakespeare.
6. See ibid. pp. 43–7, which notes that Shakespeare could have come to some non-financial arrangement in return for his 'share', such as playwriting.
7. Later parish records show that there were four bells. The shortest knell seems to have been an hour, for which there was a charge of 6d. For the rich, the knell might continue for hours.
8. The Vestry minutes for 5 May 1563 record the decision that 'None to be bur[ied] in the church unless coffined in wood'. In the churchyard, most people were probably buried just in a woollen shroud.
9. The corollary was that outside, with no gravestones, burial locations would soon be forgotten. The small size of the graveyard meant eventually that many bodies would be disturbed, with the bones removed to the parish charnel house. Burials inside the church were meant to remain undisturbed, although over time even sunken vaults, for which there would have been special payment and agreement, were reclaimed for use by others.
10. The corpse would have been washed by some of the local women and then wrapped in a woollen burial shroud, which could range in price from 2d for the worst quality to 2 shillings for the best cloth.
11. However, by 1593, Margaret is described as a widow who had come to England twenty years before, with no trade, a householder with 2 [sic] from Antwerp and three foreign servants aged sixteen, twenty and fifty-four. As the burial is of a 'mayde', she may have been one of the two younger servants; see Scouloudi, 'Returns of Strangers in the Metropolis', no. 473.
12. Margaret Fountayne had lived in St Helen's since at least 1576 (see Lay Subsidy roll), when she is recorded as a French-speaking immigrant widow living with her two sons, a daughter and a maid. They were paying the poll tax at 4d per head, which all 'strangers' had to pay. Previously, in 1571, she was living as a widow with her five children, Philip, Palles, Hester Selyn, Daniel and James, and two servants in the parish of St Alban, Wood Street just north-east of the large 'stranger' community concentrated in the liberty of St Martin-le-Grand, just north of St Paul's. This is an interesting example of the links between these two immigrant concentrations and the movements between them. Shakespeare was to move in the other direction when he settled in Silver Street *c.* 1602/4, just a few yards from where Margaret must have been living thirty years earlier. For the significance of this community, see Nicholl, *The Lodger*, pp. 96–7. Six years later, by the time of the 1582 Lay Subsidy roll, her children all seem to have moved out and she is living with two servants, Marie Jones and Jane Whitebread, neither of whom sound foreign. In the 1589 St Helen's tithe survey, she is listed with the eighth highest tithe in the parish, paying 16s-6d. Her position in the list suggests she was living in the row of prestigious houses fronting the south side of Great St Helen's. The 1571 Return of Strangers says she migrated to England four years earlier, *c.* 1567/8, 'coming into realm for religion', probably a victim of the brutal crushing of Protestant dissent by Spanish forces under the Duke of Alba, who arrived in the Spanish Netherlands in 1567 and provoked the Eighty Year War. Perhaps Margaret's husband had been killed. Given that she had five children in 1571 and all her children seem to have left home by 1582, it seems likely that she was born *c.* 1540–5. The seventeen Dutch provinces had passed to the Spanish Philip II of Spain in 1555. His rule sparked resentment among the Calvinistic Dutch and provoked the 'Beeldenstorm' (statue[-smashing] storm), a mass outbreak of Protestant iconoclasm in August 1566. This burial is the last information of Margaret in the parish, when she was probably over fifty, and a later record of her death and burial elsewhere has not yet been located.
13. For the returns of strangers, see Kirk and Kirk, *Returns of Aliens Dwelling in the City and Suburbs of London*, and Scouloudi, 'Returns of Strangers in the Metropolis'.
14. The advantage of burial within the church was that the location would usually be recorded, while there were no markers in the graveyard. The St Helen's sexton always seems to have been an elderly

member of the Leathersellers, presumably as a way of providing a small income in old age. They did not last long: John Dunne was buried in August 1596 and his successor, John Curtis, in April 1600, to be followed by Ralph Marshall in February 1603.

15. The parish accounts contain regular payments for repairing the clock, which must have been an impressive feature of the parish church, but one that was expensive to maintain.

16. Bannerman, *The Registers of St Helen's Bishopsgate*, implies that Richard Oliver had begun his ministry in 1575. However, there is a mistake in the editing, as his name has become transposed several times prior to his first recorded appearance in 1590. This is demonstrated by the repetition of Christopher Eland and Roger Burgis as churchwardens, whose actual dates of service were only in 1599–1602.

17. In 1594, there were sixteen burials in the parish: six children and ten adults, about average. Four are from one family: James Jackson, a carpenter, and three of his children. This might have been due to a brief upsurge of the plague or some other infectious disease. Five adults were recorded as being buried inside the church, leaving the other eleven as probably buried outside in the churchyard. This level of activity meant that graves could be located in sequence around the small space so as not to disturb other recent interments. See Figure 5.1, which highlights that while 1593 was bad, mortality was far worse in 1603 – the year of Queen Elizabeth I's death.

18. Oliver's first child, a boy (name unknown), was christened on the 1 January 1594, so he may well have married in 1592 or early 1593.

19. See Gurr, *The Shakespeare Company*, pp. 54–63, for a detailed discussion of what is known about touring by the Lord Chamberlain's Men.

20. Players certainly sometimes earned their reputation. The parish register of St Botolph, Bishopsgate for 26 July 1596 recorded a 'stage player' who fathered a child with a woman, whose husband, John Allen, had gone to sea in August 1595 on Sir Francis Drake's expedition to the West Indies; see A. W. C. Hallen, *The Registers of St Botolph, Bishopsgate*, vol. 1 (London, 1889), p. 137.

21. Many people supported this process, seeing the monasteries as an unproductive drag on society and the economy.

22. The tomb of Sir William Hollis, who died in 1542, was recorded as being buried in the north aisle, the former nuns' church. Presumably his executors knew at that point that the nuns' church was not going to be demolished.

23. See Reddan and Clapham, *Survey of London*, Section VII – Monuments within the Church, 5. Johane Alfrey, 1525.

24. This is demonstrated by the position of the night stairs from the nuns' dorter (dormitory), which can still be seen.

25. For the background to the Chantries Acts of 1546 and 1548, see Kitching, *London and Middlesex Chantry Certificates*, 1548, pp. ix–xxxiv.

26. Sa(u)nders, hereafter Saunders, was a leading light in the Muscovy Company, founded in 1555, and was one of the governors who organised and paid for the translation of the Spaniard Martín Cortés's seminal navigation book *Breue compendio de la sphera y de la arte de nauegar* (1551) by Richard Eden – *The Arte of Navigation* (1561), which went through ten editions and became the model for English navigation manuals; see De Schepper, *Foreign Books for English Readers*, pp. 176–222, especially p. 195 and p. 213. Eden probably lived in St Helen's *c*. 1558/9, as he was recorded in Balthasar Guercy's post-mortem inquisition in 1557 as Richard Edon and Eeden; see Fry, *Abstracts of Inquisitiones Post Mortem for the City of London: Part I*, p. 144. Another governor was Thomas Lodge, Lord Mayor in 1562–3 and father of Thomas Lodge the writer. Saunders was elected a warden of the Grocers' Company in November 1564 and was churchwarden at St Helen's 1568–9, continuing as an auditor up until the time of his death in 1581. His will is TNA PROB 11/63/486. He was a first cousin of the rich merchant George Saunders, murdered on 25 March 1573 by George Browne. A pamphlet by the Puritan-inclined Arthur Golding (*c*. 1535/6–1606), *Brief Discourse of the Late Murther of Master George Saunders*, described the murder, as did the anonymous play *A Warning for Fair Women*, performed by the Lord Chamberlain's Men in the 1590s and published in 1599. Golding was a major translator, most significantly of the first English translation from the Latin of Ovid's *Metamorphoses* (1567), a key text used by Shakespeare.

27. Mostly in Strasbourg, Frankfurt and Geneva.
28. See Tom Betteridge, 'Saunders, Lawrence', *Oxford Dictionary of National Biography*, <https://www.oxforddnb.com/view/10.1093/ref:odnb/9780198614128.001.0001/odnb-9780198614128-e-24700> (last accessed 20 July 2020).
29. For example, Saunders' wife's mother was a first cousin of Sir Francis Walsingham (*c*. 1532–1590).
30. Unfortunately, there are no parish vestry records until 1565, well into the next decade.
31. St Helen's vestry records, LMA MS 6836.
32. In 1571/2, 4d was paid for the final version of the *Thirty-nine Articles* published in 1571.
33. The accounts record a payment in 1570–1 for making the change, requiring payment of a balance of 3s-4d. The cup, hallmarked 1570, is still owned by the church and will be displayed in 2021 in the exhibition on the site of the Theatre in Shoreditch. The same accounts record the sale for 6s-8d of 'ii parson Banners, two curtains' and various painted cloths, including an altar cloth, perhaps the last survivors of Catholic worship. These changes happened after the death of Dr Caesar Adelmare in 1569 and at the time when Lucas Clapham arrived as the new, young (at twenty-five) and ardent minister in 1570; see Guy, *Gresham's Law*, p. 165. Clapham was ordained by the former Marian exile Archbishop Edmund Grindal, who was keen to replace older ministers, 'dumb dogs', with 'godly' preachers of Calvinistic leanings. The chalice may be the 'chalice of silver and parcel gilt to St Helen's' donated to the church by William Crane in his will of 6 July 1545; see TNA PROB 11/31/103 – in which case, it only lasted twenty-five years.
34. The iron cost 7 s[hillings] and the solder to set them in 20d.
35. See also Sir John Spencer's tomb (Figure 13.12) which has an hourglass on the top, sitting on a skull as a *memento mori*.
36. Twenty marks was £13-6s-8d a year, two-thirds of the minister's salary. This worked out at about 2s-8d per one-hour lecture, and is an interesting comparison with a player's day wage. Finding money for lecturers was often problematic for parishes. At St Helen's, the money was collected from parishioners. In 1576–7, thirty or so people contributed £10-19s-8d but £7 came from five rich people, and the account was often in arrears. In 1580, the salary was dropped to £12 per year. See Owen, *The London Parish Clergy in the Reign of Elizabeth I*, p. 432.
37. Barber took his divinity degree at Cambridge, where he was a supporter of the Puritan theologian Thomas Cartwright (*c*. 1535–1603). His opinions led to the Bishop of London, Richard Aylmer, who described him as a 'depraver of the ministers', trying to get him removed. He was suspended from June 1584 until at least 1587. During this period, he was involved in house meetings with Richard Gard(i)ner.
38. Gard(i)ner was rector of St Mary Matfelon, Whitechapel, just outside Aldgate, from 1570–1617. Three of Richard Lewis's children – William, Richard and Harmanus – were baptised in St Helen's in 1587, 1588 and 1590. For these ministers, see Collinson, Craig and Usher, *Conferences and Combination Lectures*, pp. 131–2 and footnotes 377 and following. In 1604, Barber and Gard(i)ner were the first and third of twenty-two signatories to a Puritan petition to the new King James I. The second signatory was Stephen Egerton, the famous Puritan minister of St Anne, Blackfriars. The tenth signatory was Lewis Hewes, almost certainly the radical Puritan Lewis Hughes who was minister of St Helen's from 1600–1602/3. There his radical beliefs had led him into stormy waters. A good general outline of the Puritan movement in London at this time is provided by Laoutaris in *Shakespeare and the Countess*, his recent account of the Blackfriars precinct.
39. His pay in the 1590s was £20 per year at a time when the cleric William Harrison, in his *Description of England*, considered that £30 a year was necessary for a minister to live on in London. He was probably previously a lecturer in 1589 at the neighbouring church of St Andrew Undershaft. A J. Oliver is recorded as a lecturer at St Atholin in 1591–3.
40. In 1572, fewer than ten parishes had lecturers, but this increased rapidly to seventeen in 1577 and to at least thirty by 1583. These provided a wealth of views for Londoners prepared to visit different churches. The centre of this movement was at St Atholin.
41. Their removal was problematic, as the churchwardens' accounts for 1575/6 note: 'Pd to a carpenter when would have taken down the organs and was denied for taking of them down – 3d'. A note dated

5 October 1578 says the organs had still not been sold. The organs were regularly maintained in the 1560s by John Howe, who had a virtual monopoly of organ supply and maintenance in the City until his death in 1571. Under Edward VI, a complete ban on organs had been considered.

42. The current pulpit dates to the seventeenth century. Such partitions were also removed at this time at the neighbouring churches of St Ethelburga and St Christopher-le-Stock, although the change was debated at St Martin Ongar; see Owen, *The London Parish Clergy in the Reign of Elizabeth I*, p. 550.
43. These were timed on Sundays to happen after parish services.

# 12

## A Walk Round the Interior of Saint Helen's Church

*In which we look at the interior of St Helen's that Shakespeare would have known. Much has been destroyed, but here and there are graves and memorials that he could have seen, recording some of the personalities who shaped the parish and, in some cases, the history of England.*

You can still walk down the path that bisects the graveyard of St Helen's, just as Shakespeare would have done. It runs from the west entrance, near St Helen's Gate, to the west end of the church with its two entrance doors.[1] When you enter through the main west door, the immediate impression of St Helen's today is somewhat different from the interior that would have existed in the 1590s. With a bit of care, however, one can unpeel the layers of history and gain some insight into what Shakespeare would have seen (Figure 12.1).

Overall the double nave layout, the arches, the roof and the volume of the church remain the same as they were four hundred years ago – but one needs to 'edit out' several features and add in others, which have now disappeared. Step one: remove all the modern tables, chairs, microphones, bookshelves and other fittings of a modern working church. Step two: sweep away the balcony with the organ; it is a nineteenth-century addition. Step three: strip out the majority of the funerary memorials, since most of them were added in the seventeenth to nineteenth centuries, long after Shakespeare's lifetime. Furthermore, eighteen monuments, including the magnificent late fourteenth-century tomb of John Outeswich and his wife, were moved here in 1874, when the neighbouring church of St Martin Outwich was demolished for an office building.[2] Step four (hardest of all): imagine a slightly musty interior with peeling white limewash, probably with patches of vivid green mould, the smell of damp, the occasional bird flitting through a broken pane of glass and, if it is warm weather, perhaps the faint but pungent smell of mortal decay.[3]

One also needs to draw in the missing features that have been removed over the centuries. The most significant element absent today is that much of the church interior would have been filled with high-backed oak 'box pews'. Medieval churches would have been relatively empty of furniture, with most of the congregation standing. However, with the Protestant reformation and the increasing focus on Bible reading and the sermon, proper seating became necessary. While it seems strange today, as the use of pews spread during the sixteenth century they were usually privately rented or owned,

often with a key so that other parishioners could be locked out. Moreover, the location and price of pew rent reflected one's status in the parish. Rich people would occupy pews at the front near the communion table and pulpit, while the poor would sit towards the back.[4] As Christopher Marsh has put it:

> Sunday services in English parish churches were distinctive occasions upon which local society went on display in something like its entirety, presenting itself to itself. As congregational seating became more common under the late Tudors and early Stuarts, so the opportunities for collective self-definition grew more comprehensive. In a society that combined a hierarchical ideology with troubling doses of socioeconomic flux, such opportunities could not be missed. . . . The positioning of parishioners in pews according to hierarchical principles was an attempt to fix the confusing fluidity of social existence, to freeze the liquid of life, if only for a time.[5]

It would have fallen to the churchwardens to resolve disputes about who occupied which pew and the relative status of different families. In many churches men and women sat separately, either with men at the front and women at the back, or sometimes on separate sides of the aisle.

Churchwardens would often occupy the pews right at the back in order to keep a watch on everybody and to note people who failed to attend – or, if they did, did not seem to be paying attention.[6] Of course, over time as family fortunes fluctuated, the occupation of pews might reflect a decade or two back, and conflicts often arose as socially ambitious families sought to gain a position which they felt accurately reflected the good fortune that God had bestowed on them. In the Folger Shakespeare Library, there is a fascinating plan of the layout of the box pews in St Margaret's Church, Westminster. It is covered with rubbings-out, made as the churchwardens over the years attempted to keep an accurate record of the parish's evolving social mix.[7]

Unfortunately, no similar plan appears to have survived for St Helen's. However, there is a detailed plan of the church made in 1808. This is probably as close as one can get to the overall layout of the church where Shakespeare would have worshipped. Figure 12.3 shows the plan with features from after the 1590s removed, and some features which later disappeared restored. It is not known if this layout of box pews is the same as two hundred years earlier but, if not, it was likely to be similar, since the positions are largely determined by the pre-existing two aisles and the dividing columns.

It is not clear when the box pews were installed in the sixteenth century and they may have been added in stages.[8] The key drivers would have been the removal of the features associated with Catholic worship and refocusing away from the altar, now a simple wooden communion table, to God's word delivered directly from the pulpit. The removal of the rood screen loft in 1564/5 would have opened up the whole volume of the church.

Figure 12.1 St Helen's church: viewed from the north-west, showing the two naves divided by arches, originally for the nuns (left) and parish (right). Modern, functional layout following restoration after the 1992 Baltic Exchange bombing.

Figure 12.2 St Helen's church: section of nuns' wooden quire seats, later reused as seating 'for the poor of the Parish', repositioned against the north wall.

Certainly, by 5 November 1565, Sir Thomas Gresham, the richest man in the parish, had his own pew, strategically located in pole position immediately to the left of the communion table.

The plan of 1808 (Figure 12.3) shows that the box pews were located in the eastern two-thirds of the church, leaving a large open space at the west end in front of the two doors: the main door to the south, and the 'pardon' door (the original door into the nun's church) to the north.[9] This organisation by wealth and status was also reflected in how much one paid to be buried inside the church[10] – a decision not only to preserve one's status but also one's physical body, since it was recognised that burial in the small churchyard would usually lead to disturbance by later interments. The arrangements were as follows:

*Area A:* burial in the most sanctified area around the former altars at the east end, now the location of the communion table; cost 15s-0d.

*Area B:* the area of the former choir, where you would only generally be walked on during communion services; cost 10s-0d. Sometimes referred to as the 'ten-shilling ground'.

*Area C:* the main body of the church, where your former neighbours would step over you to access their pews, cost 6s-8d. This was termed the 'noble' ground in the burial records, not because of the status of the burials but because the gold noble coin was worth 6s-8d.

*Area D:* the church porch, at the west end, which was used for all manner of secular activities; cost 3s-4d.

The churchyard was free.

The churchwardens' accounts suggest that for a moderately well-off person, a burial in Area C balanced economy with status, with a typical funeral costing 11s-8d: 6s-8d for the grave and 5s-0d for tolling the knell for several hours.[11]

The 1808 plan shows just over fifty box pews, two of which were probably paid for by Skinners' and Leathersellers' companies, who managed the two almshouses.[12] Most pews were about eight feet wide, so could have held about five or at a push six adults. This seating would have held less than 300 people out of a population of probably closer to 600–700. Along the north wall the two runs of old nuns' choir seats are placed together and labelled 'for the poor of the parish' (Figure 12.2). This, and other evidence, indicates that much of the former nun's choir, and possibly the western porch area, would have been filled with simple form-style benches. There are two references to 'where the long formes stand' and 'under the formes'.[13] In 1575/6, the Vestry minutes record the acquisition of 'various forms, including two given by the Leathersellers'. These could have seated another 100–200 parishioners. At St Helen's we do not know who sat where, but three references to women's pews, 'under the women's pews in the Middle Aisle towards the north west corner'; 'between the piller and the women's pews close to her

Figure 12.3  St Helen's church: 1808 plan (adapted) showing layout of the box pews, probably mirroring the arrangement in the 1590s. Parish accounts also record benches in the north nave. The churchwardens' pews were probably in the same place in the Elizabethan period.

brother' and 'paid for nails for ye maydes pewes 3d', with one reference to men's pews – 'in North Aisle close to the mens pews and directly before the 3rd window eastward' – indicate there was some gender segregation.

Apart from the plan and the Vestry minutes a few more details can be gleaned from the parish burial records. For a period between 1589 and 1602, the parish clerk often recorded the location of burials by reference to various features in the church. Some of these are now gone, but their former location can be conjectured. The most obvious feature was the pulpit, although the existing one is seventeenth-century and it is not clear whether its predecessor was in the same location.

There are also seven references to the 'paraphrase', which was obviously of some size, since there is reference to its 'joists'. The paraphrase was a large reading desk or table which took its name from the paraphrases of the Bible created by Desiderius Erasmus (1466–1536), the theologian born in Rotterdam. Edward VI in his *Injunctions* of 1547 ordered that paraphrases were to be made available for reading, in English, 'in some convenient place' in all parish churches.[14] The most likely place would seem to be in the north aisle. There is a reference to a burial in 1597 'under the formes by the Paraphrase – in the middest of it', which may indicate that the paraphrase was positioned between rows of forms in the north aisle and box pews in the south aisle. Dr Peter Turner's son Henry, who died aged three weeks in 1599, is recorded as being buried 'directly under the paraphrase', perhaps because this location was considered particularly holy. Burials which refer to the paraphrase cost 11s-8d, indicating they were in Area C, in the middle of the church. One cannot be certain what books were available on the paraphrase when Shakespeare was living in the parish. The closest record dates from 1602/3, when the inventory of church plate and ornaments has a note added in the margin: 'Erasmi paraphrasis English (?) the Evangelists & the Epistles'.[15]

Of course, it would be fascinating to know where Shakespeare sat week after week. It is difficult to imagine him wanting to sit boxed up in a pew, under the close watch of the minister, churchwardens and the more inquisitive parishioners. However keen Shakespeare was on his status, it seems more likely that as in effect a single man, he would have carefully positioned himself in the north aisle on a male bench partly obscured by a column. There he could watch his fellow parishioners, dodge the eyeline of the minister and let his thoughts wander to whatever writing was on his mind.

Two other features of the church remain to be noted. The Protestant service reduced the sacraments from the seven of Catholicism to just two, communion and christening. For the latter, the font was the centre of the ritual and its position would have been a key feature within the church. Two burial records of 1599 and 1601 mention the font: 'between the font and the gravestone entitled out of earth', and 'in the middest of North Aisle between pillars by the font and the poor chest', but do no more than indicate it was in the north aisle where there would have been space for the family and friends to

Figure 12.4   Monuments in St Helen's Church: Tomb of Sir John Crosby (d. 1476) and his wife, builders of Crosby Hall, *c.* 1466. Despite having several children, they failed to establish an ongoing dynasty.

Figure 12.5   Monuments in St Helen's Church: Detail of the tomb of Sir John Crosby and his wife. Sir John's head rests on his helm, reflecting his important military role in the Wars of the Roses.

gather round.[16] Given the poor chest was probably positioned close to the main door, it is likely that the font was towards the west end of the church as well. The poor chest provided an important symbol of, and the practical means for, the responsibility of the better off to make charitable gifts to poor parishioners.

Today, perhaps the most interesting immediate insights into the period are provided by the funerary memorials. Given Shakespeare's interest in history and power politics, it would be surprising if he never studied these. Around thirty-five memorials are recorded that Shakespeare could have seen[17] but nearly thirty of these have disappeared over the subsequent four centuries. In the 1590s, these would have provided a swift canter through the last 200 years of English history. Indeed, the east end of the church would have displayed a gallery of fascinating characters recorded in inscriptions, incised in brass sheet, celebrated by bas reliefs and even full sculpture. It would have been a physical theatre of England's past and recent expansion onto a world stage, but one which only recorded high-status individuals, given their cost. The memorials included three Lord Mayors (one survives) and three Aldermen (one survives).[18] Most were wealthy merchants grown rich on trading overseas or, like Edward Skegg(e)s, Serjeant Poulterer, connected to the court. Despite the losses, you can still walk around the church and look at the memorials Shakespeare might have wandered past.

From the pre-Reformation period (before 1540) there are two surviving memorials of particular interest. First, there is Sir John Crosby (d. 1476), builder of Crosby Hall, who was buried alongside his first wife Anne (Figure 12.4). For many visitors today this is the most attractive of the tombs. The restrained recumbent alabaster figures probably appeal to most people's aesthetics far more than the brash polychromatic memorials of the sixteenth century. In Shakespeare's time it would already have looked old-fashioned. Figure 12.5 shows Lady Anne with her head on a pillow, while the martial Sir John, lying on her left, is shown in full 1470s plate armour resting on his helmet. The tomb is still in or close to its original position,[19] located between the high altar and what would have been two chapels to the south dedicated to the Holy Ghost and Our Lady. The Crosbys died when England was Catholic and the Reformation was still decades away. Most people then would have held the Catholic belief in the tormenting fires of purgatory as a necessary stage before entering heaven. Sir John's will left many grants for priests to say prayers and masses for the benefit of his soul, to speed it as quickly as possible through this ordeal. The tomb's location close to the high altar also offered the greatest spiritual benefit, while underlining the Crosbys' high social status to the living.

Much of the late medieval London Sir John knew would have been familiar to Shakespeare 120 years later. The city walls, gates and street pattern would have been largely identical. However, the greatest changes would have been in the huge increase in the population and the destruction of the monasteries. London in the 1470s would have only had a population of 50,000 or so. The amount of empty space within the city walls

*Living with Shakespeare*

allowed Sir John to lease a large area for his fabulous new mansion. Shakespeare's London would have been dominated by the continuous pressure to accommodate the 3–4,000 migrants who left the countryside every year to seek the opportunities offered in London for the ambitious. At the same time, the great monasteries and friaries that once dominated much of the City had been swept away two generations earlier, in 1538.[20] Most had been unroofed for their valuable lead and timber, or rapidly divided up into prestige houses or other secular uses.[21]

England's foreign trade in the fifteenth century was dominated by the export of wool to the Continent and Sir John Crosby made a fortune as a wool man and textile merchant. He was successively alderman, sheriff and mayor of Calais, a key English-owned entrepôt until it was finally lost to the French in 1558. However, he was also a man of martial action and provided a direct link back to the War of the Roses, the civil war dramatised by Shakespeare in *Henry VI – Parts, I, II and III* and *Richard III*. It was a bitter conflict that nearly engulfed St Helen's itself. Sir John was a Yorkist and a supporter of Edward IV against Henry VI; the fluctuating fortunes of the time are demonstrated by the four royal pardons that he received as Lancastrian power ebbed and flowed. He helped to defend London against the Lancastrian attack in 1471 led by Thomas Neville, whose troops got as close as attacking Bishopsgate and Aldgate. Although they forced Aldgate open, the Londoners fought back and the attack was driven off. Sir John was knighted by Edward IV for his part in saving the capital. If Shakespeare studied Sir John's effigy and his armour, he may have considered how close England lay again to civil upheaval with a childless queen now past sixty. However, Shakespeare might also have reflected that Sir John, for all his wordly success, only enjoyed his palatial mansion for less than ten years. Furthermore, although the tomb originally recorded six children, none appear to have survived long enough to continue the family line.[22] Sir John's widow eventually sold the lease of Crosby Hall to Edward IV's brother, Richard Duke of Gloucester – who would later become Richard III.

The construction of Crosby Hall and Sir John's elegant tomb helped secure the area's reputation as an upmarket part of the City. Other important residents in the area included Thomas Cromwell, a few streets away in Throgmorton Street. Even Sir Thomas More briefly owned Crosby Hall in 1523, although he may never have lived there. At other times, the complex was used to accommodate foreign embassies, further adding to the status of the area.[23]

If one moves around to the north wall of the church, there is another relic of pre-Reformation Catholicism that Shakespeare might have viewed. This is the tomb of Johane Alfrey, who died in 1525, and her husband William Ledys. Johane left precise instructions for the structure. It incorporated a stone grille which allowed nuns outside their church to look through slots to watch the celebration of mass before the high altar.[24] In Sonnet 73, as Shakespeare reflects on the process of ageing, he refers to:

> That time of year thou mayst in me behold
> When yellow leaves, or none, or few, do hang
> Upon those boughs which shake against the cold,
> Bare ruined choirs, where late the sweet birds sang.

'Bare ruined' is traditionally taken to refer to the physical ruins of the monasteries in the countryside. However, this is a nineteenth-century romantic image of 'ruins' which in the sixteenth century meant 'wrecked'. One wonders if this image came to Shakespeare sitting on a plain wooden bench in the heart of London in the former nuns' quire, with the parish poor sitting in the nuns' former choir seats? Could 'where late the sweet birds sang' be an allusion to the nuns of St Helen's?

Among other recorded memorials of Tudor date which have disappeared was the tomb of the rich Italian Dominic Lomley (before *c.* 1485–1560s?). His grave slab was later adapted to record his son James Lomley and his wife (Figure 12.6).[25] This gravestone was in the middle of the nuns' choir, in the open area just north of the pews.[26] The Lomleys are of particular interest as they demonstrate the potential for the oral transfer of history over long periods, stories which Shakespeare may have heard repeated but for which there is no written record. James died in January 1592/3, so Shakespeare may

Figure 12.6 Monuments in St Helen's Church: Brass memorial plaque (now lost) recording James Lomley and his wife Joan. James, son of a wealthy merchant from northern Italy, died aged eighty-eight in January 1593. Watercolour, *c.* 1800.

never have spoken to him. His memorial recorded that he died aged eighty-eight, meaning he was born *c.* 1504 and must have been thirty-four or so when the St Helen's priory was shut down. The inscription reads:

> And allso here lyeth buryed ye bodies
> of James Lomley the sonne of ould
> Dominick Lomley and Jone his wyfe
> the said James deceased the vith of
> January Anno domini 1592
> hee beinge of the age of lxxxviii
> yeares and the said Jone deceased
> the [25th] day of [September] Ano 1[613]
> Earth goeth upō earth as moulde upon moulde
> Earth goeth upon earth all glistring in golde
> As though earth to ye earth never turne should
> yet shall earth to the earth soner then he would.

This shows that Dominic, a Lombard immigrant from north Italy, must have been born before *c.* 1485 and he was recorded as leasing a large house from the nuns as far back as 1512.[27] He was later naturalised and was a very successful merchant, or gambler, as in the 1541 Lay Subsidy roll, he was assessed at the huge sum of £500.[28] While Shakespeare may not have met his son James, he could have met James's widow, Joan, who survived another nineteen years until 1613.[29] If Shakespeare spoke with her, he would have been talking to someone whose father-in-law was born around the time of the Battle of Bosworth and the death of Richard III in 1485, and had been a boon companion of Henry VIII.

Further to the west, in the porch area, there was another memorial brass which would have evoked the pageantry and chivalry of Henry VIII's reign. This was the grave of Thomas Benolt, Clarenceux Herald of Arms, who was buried in 1534, and of his two wives.[30] In the 1590s, Shakespeare was seeking a coat of arms from the College of Heralds, and the memorials in St Helen's would have shown a range of impressive examples. Among those recorded by John Stow in the 1590s but now disappeared were Adam Frances, mayor in 1354?; John Gower, steward of St Helen's nunnery, buried in 1512; the tomb of the mercer Sir William Hollis (*c.* 1471–1542), Lord Mayor in 1540,[31] who died 13 October 1542; Sir William St Loe (1518–65),[32] alongside his father; and Eleanor, daughter of Sir Thomas Butler, Lord Sudeley.[33]

Dominic Lomley was an early example of the successive movements of immigrants from an area that is now Italy, northern France and Belgium, the latter originally part of Burgundy until 1555 and then the Spanish Netherlands. Cities like Ghent, Tournai,

Valenciennes, Brussels and Antwerp were all important centres for textile manufacture ranging from silks to specialised lace. Some people migrated simply to better their prospects, but from the 1550s there was increasing conflict between Catholics and Protestants which led eventually to the horrific 1572 St Bartholomew's Day Massacre, when thousands of French Protestants were killed in Paris and elsewhere. From 1566, conflict broke out in the Netherlands, with the Protestants trying to eject their Spanish Catholic rulers. This was followed, as we have already seen, by the 'Spanish Fury' massacre in Antwerp in 1576, with many of the survivors fleeing to England.

In July 1550, the nave of the former Augustinian friary 250 yards to the west of St Helen's was handed over to the immigrants for church services in their own languages. With the rapid influx of Dutch speakers, the smaller French community split off and was given a separate church, created from the chapel of the medieval Hospital of St Anthony in Threadneedle Street. The authorities were anxious to keep a close eye on these ambitious, industrious but potentially fractious foreigners, and there were regular surveys of who was living where[34] and which of the two churches they were attached to.[35]

A significant proportion of the foreigners worked in some aspect of the textile trade and in 1576 there were at least ten 'stranger' households, mostly recorded as Dutch-speaking, in the parish of St Helen's – perhaps 10 to 15 per cent of the population. Five of the houses inside the Close were specifically mentioned as being occupied by families of strangers. Six years later, in 1582, although some had moved on, the main households were still there. Among these was the barber-surgeon Jacob Saul, who brought his family over and was buried in 1585. In 1571, he is recorded as 'came into England about 12 years past for religion'.

However, just as these immigrants were arriving in St Helen's, the parish was also a hotbed of discussion about England's opportunities to expand beyond its borders and open up new trade routes to Asia – notably to Cathay.

Notes

1. The churchwardens' accounts for 1594/5 record: 'P[ai]d for 20 yds of paving in the churchyard' – still the exact length of the path today. A few years later, there was: 'Paving before the ministers door in the churchyard, 54 yards'.
2. There is no reason why Shakespeare might not have seen some of these memorials if he went inside St Martins.
3. The St Helen's churchwardens' accounts for 1593/4 record 'P[ai]d for whiting the chancel 2s-0d' and 'P[ai]d for plastering the church walls with lime and hair', so the church may have had a refresh when Shakespeare worshipped there. There are also regular payments for window repairs, including the large sum of £2-13s-3d in 1594/5 for '42 foot of glass for ye windo'.
4. There are only a few churches with box pews left in London and most people have not sat through a service with this kind of seating. Fortunately, about ten minutes from St Helen's, you can still

experience them at the 1762 German Lutheran Church of St George the Martyr in Alie Street, which has retained its eighteenth-century seating. Although a foreign denomination chapel rather than an English parish church, it gives a fair approximation. Sitting towards the back, there is a powerful visual sense of a mass of disembodied heads and shoulders – in the 1590s, as far down as one's ruff – in the rows in front. The feeling is very much an evocation of the naked mind rather than of the clothed body.

5. Marsh, 'Order and Place in England, 1580–1640', p. 7.
6. Although the evidence is not conclusive, references to the churchwardens' pew(s) in the parish records suggest they were in this location in St Helen's. Box pews became seen in the nineteenth century as increasingly socially divisive and there were various campaigns in the Church of England to get them replaced with normal pews, which could be used by anyone. The result was that almost all were eventually removed.
7. See Wolfe, 'Pew-Hopping in St Margaret's Church'. Here the men sat at the front with women towards the rear of the church.
8. This appears to have been the case at St Martins-in-the-Fields where the churchwardens' accounts record payments for new pews. The St Helen's accounts have various bills for repairing pews. In 1591, a small sum of 1s was allowed for 'new pewes'. The arrival of new, rich residents also prompted work. In 1566–7, 10s was 'paid the joyner for making Alderman Bonde pewe'; in 1574–5, 2s 6d was spent, 'pew for Lady Pollar[d]'; and, more curiously, in 1591–2, 'Rec[eived] of Lady An[ne] Gresham toward the removal of her pew the sum of 20s'.
9. However, some other pews had disappeared by this date. When Dr Richard Taylor's daughter Sara was buried in April 1591, her grave was described as 'under the stone with her sister before the little pewe under the Clockhouse', which must have been at the west end of the church.
10. See the St Helen's Vestry minutes, 5 November 1565.
11. Quality burials at St Martins-in-the-Fields cost the same: 6 shillings for the grave, 6d for a coffin and 2d for a cheap shroud.
12. There are references to the Skinners' Pew(s), which seem to have been towards the north-west corner. One can identify about 20 per cent of the owners from references to them in burial records. Apart from the company pews, there are references to pews belonging to Lady Gresham; the Bond family; John Bowcher, Gentleman; Clement Kelke; [James] Lomley; Mrs Turner; Mrs Dobson; Mrs Risby; and Mr Baker.
13. See St Helen's burial register entry for Mr Bowles, 20 October 1597.
14. However, they have virtually entirely disappeared today.
15. See St Helen's churchwardens' accounts for 1602/3. There are further records of the Paraphrase in subsequent years.
16. The burials here also cost 11s-8d, indicating that the font was in Area C.
17. They were recorded in Strype's edition of John Stow's *Survey of London*.
18. At least two other Lord Mayors celebrated their mayoralty in the parish.
19. It was quite common to move tombs in churches. Sir John Spencer's memorial was moved in the nineteenth century. St Helen's is also full of memorials that were relocated from St Martin Outwich when it was demolished in 1874.
20. The great spire of St Paul's Cathedral was destroyed by lightning in 1561.
21. See, for example, the fate of Holy Trinity, Aldgate, in Schofield and Lea, Holy Trinity Priory, Aldgate; and the Blackfriars, in Laoutaris, *Shakespeare and the Countess*.
22. The children's names were originally on the tomb as specified in his will, but have disappeared over the years.
23. In 1504–5 the Lord Mayor, Sir Bartholomew Reade, a goldsmith, was based there.
24. See Reddan and Clapham, *Survey of London*, Section VII. – Monuments within the Church, 5. Johane Alfrey, 1525.
25. See description in Reddan and Clapham, *Survey of London*, VI. Fittings, lost brasses 5. 'Figure of a lady in pedimental head-dress and gown, *c.* 1540, standing on shield charged parted fesse-wise a crowned eagle displayed, with indents for a foot inscription and for a marginal inscription. Size of

slab 47 by 24 inches. Into this slab has been inserted a later inscription with four verses to James Lomley, 1592, and wife Joan, the date for whose death is left blank.' The Lomley family connections have yet to be sorted out in detail. However, Sir Martin Lumley (d. 1634), Lord Mayor in 1623, must have been related, as his grandfather is recorded as being from Genoa. In 1631, he gave the Black Boy Inn to the parish 'for establishing a Lecture, or Sermon for ever to be preached in this Parish Church on Thursday Evening Weekly'. His son was Sir Martin Lumley, MP, 1st Baronet (c. 1596 – c. 1651), who married twice in the neighbouring church of St Andrew Undershaft.

26. It is clearly marked on the plan of 1808 (see Figure 12.3). However, it may have been moved since James Lomeley, gent., was recorded as being buried 'under the stone next the pulpit'.
27. In 1538, the rent was £10-10s-0d.
28. See the 1541 Lay Subsidy roll. Henry VIII lost £620 to him in less than three years playing dice and cards; Nicolas, in *The Privy Purse Expences of King Henry the Eighth*, noted that he 'was, like Palmer and others, one of Henry's "diverting vagabonds" and seems to have accompanied His Majesty wherever he went, for we find he was with him at Calais in October, 1532'. This was the visit when Henry VIII went with Anne Boleyn to meet the French King Francis I, arguably one of the turning points in English history.
29. Possibly, although not necessarily, a second wife. James was buried in St Helen's on 6 January 1592/3, before the proposed arrival date of Shakespeare in the parish. He had been churchwarden in 1572 and 1573, so he must have been part of the parish 'establishment'.
30. The inscription read, 'Here und' lieth ye bodi of Thom's Benolt esquyer Somt'ye Saua't & Offycer of Armes by ye name of Wide'sore herault unto the right high & mighty Prince of . . . most drade sou'aye lord ky[n]g he'ry ye viii which Thom's benolt otherwyse namyd Clarenceux ky'g of armes decesid the viii daye of May in the yere of our lord God M° Vc xxxiiij [1534] in the xxvi yere of or said soueraȳe lord'. There is a drawing in the collections of the Society of Antiquaries; see Reddan and Clapham, *Survey of London*, VI. – Fittings, Lost brasses 2. Other memorials included several late fifteenth-century brasses.
31. His wife was buried with him in 1543 and left money for almshouses, which were probably then built by and attributed to Sir Andrew Judd. In the 1590s Hollis's tomb was a prominent feature, used to record the position of other burials; for example, 'within 2 yards of Sir William Hollis tomb' and 'between Sir William Hollyes tomb and Mr Kelke's pew door'.
32. Third husband of Elizabeth, 'Bess' of Hardwick. His appointments included Captain of the Yeomen of the Guard in 1558 on Elizabeth I's accession and Chief Butler of England in 1559.
33. See Strype's edition of John Stow's *Survey of London*.
34. For example, the churchwardens' accounts for St Helen's in 1593, at the height of anti-immigrant feeling, records 2s-6d 'paide for writing all ther strangers names'. Information from all surviving surveys was gathered together by Kirk and Kirk, *Returns of Aliens Dwelling in the City and Suburbs of London*, into a fascinating study of these immigrants.
35. Several other immigrant preachers are recorded in the parish, including Melchior Rate, a Dutchman who died of plague and was buried in St Helen's in 1593.

# 13

## Dreaming of English Exploration, Trade, Wealth, Colonisation and Empire

*In which we meet some of the parishioners from St Helen's and their families, who drove forward England's overseas exploration and the eventual colonisation of America. One can still see how they were commemorated in death – for example, 'the flower of the merchants – which the land of Britain has produced'.*

For the fifty or so years before Shakespeare's arrival in the parish, there are six important memorials in St Helen's, which vividly reflect the major economic shifts that were taking place in Elizabethan England. Although battered and mostly restored now, one has to imagine them virtually new and freshly painted as he would have seen them. A good place to start is the memorial to Alderman John Robinson the Elder (*c.* 1530–1600) and his family, tucked away upstairs in the gallery in the north-east corner of the former nuns' church (Figure 13.1).[1] Robinson died in 1600, just after Shakespeare may have left St Helen's, so he and his extensive family were probably known to Shakespeare and they must have at least seen each other in church. The Robinsons lived in a house carved out of the large nuns' dining hall (dorter) in the northern range of the former nunnery (see section 3 of the Appendix).[2] The memorial records his marriage in 1556 to Christian Anderson (*c.* 1540–92) and the sixteen children she produced over about twenty-three years.[3] John Robinson the Younger, their eldest son, also lived in the parish with his wife, Elizabeth. They had children in the 1580s, but a late pregnancy in 1600 resulted in Elizabeth's death in childbirth and her burial just eight months after her father-in-law (Figure 13.2).[4] The graves of this wealthy family,[5] connected business partners such as Sir Anthony Garrard and associates such as the scrivener Thomas Wrightson were clustered close to the former doorway from the nuns' church to the cloisters and away from the high status east end. This strongly suggests that they had access to the church through this door by a path across the former cloister, which was leased by Dr Peter Turner.

Both John Robinsons, father and son, were Merchants of the Staple, the organisation, incorporated by Royal Charter in 1319, which controlled England's export of wool, skins, lead and tin and levied the taxes which were a vital source of royal revenue in the late medieval period. Wool had been the mainstay of the country's external trade and the Merchants of the Staple had been the 'Merchant Princes of London', growing wealthy and powerful, with their children intermarrying. For two hundred years, until the loss of Calais in 1558, all wool had to pass through the port before distribution across continental

Europe. However, by the 1590s the power of the Staple was declining, and if Shakespeare had discussed business matters with John the Elder, then in his sixties, or his son, in his forties, he would probably have heard a litany of complaints. However, even in the 1590s wool still dominated England's exports and the associated trade routes to Europe, accounting for *c.* 80 per cent of exports by volume and *c.* 70 per cent by value.[6]

This new breed of international traders, the merchant adventurers, are also represented in St Helen's. If Shakespeare had walked up to the east end of the nuns' church he could have seen, just as you can today, the wall memorial to Sir Andrew Judd (*c.* 1492–1558), also a Stapler and Lord Mayor of London in 1550–1 (Figure 13.3).[7] The design consists of two panels with Sir Andrew, in armour, and his wife facing each other, flanked by their children: four sons and one daughter, Alice.[8] However, beyond the world of the Staple, the inscription records the growth of wider horizons with a record of his claimed travels to Russia, Muscovy,[9] Spain and Guinea, then meaning the whole coast of West Africa and the location of the nascent trans-Atlantic slave trade.[10] Sir Andrew's grandson, Sir Thomas Smythe (1558–1625), born the year Sir Andrew died, was to play a crucial role in building the foundations of the British Empire by helping to form, and then acting as first governor of, the 'Company of Merchants of London trading into the East Indies' – later the East India Company, which rose by 1800 to eventually dominate world trade. His epitaph in Kent says:[11]

> To the glory of God, and to the pious memory of . . . Sir Thomas Smith (late governor of the East Indian, Muscovia, French and Sommer Island Companies; treasurer for the Virginia plantation; prime undertaker in 1612 for that noble designe, the discoverie of the North-West passage; principall commissioner for the London expedition against the pirates, and for a voyage to the river Senega, upon the coast of Africa; one of the chief commissioners for the navie royal, and sometime ambassador from his majestie of Great Britian to the emperour and great duke of Russia and *Muscovia*.

Sir Andrew Judd's charitable acts included the founding of Tonbridge School, in his birthplace in 1563, and the Skinners' almshouses for 'six poor freeman of the company'.[12] These almshouses were eventually located just inside the gateway into Great St Helen's, where they were rebuilt as an elegant Georgian townhouse in 1729 (see on the right in Figure 8.12).[13]

In 1575, the memorial to Sir Andrew Judd was joined by a far more grandiose monument, the tomb of the enigmatic Sir William Pickering, MP (1516/17–1575), described by Strype as 'the finest gentleman of his age, for his worth in learning, arts and warfare'.[14] Pickering lived in a grand house in St Mary Axe. The elaborate tomb (Figures 13.4 and 13.5) has a single effigy, since he never married. He is shown in full military armour – the true warrior knight – and one, some gossiped, who might have

Figure 13.1 Monuments in St Helen's Church: Wall memorial to Alderman John Robinson the Elder, his wife Christian and their sixteen children. He was a dominant figure in the parish until his death in 1600. The family graves were clustered in the north-west corner of the church.

Figure 13.2  Monuments in St Helen's Church: Memorial brass (relocated) to Elizabeth, wife of John Robinson the Younger, who died giving birth in October 1600. John subsequently disappeared from the parish records.

Figure 13.3  Monuments in St Helen's Church: Wall memorial to Sir Andrew Judd, skinner and Lord Mayor in 1550/1. He died in 1558 and willed the creation of the Skinners' almshouses in Great St Helen's.

Figure 13.4  Monuments in St Helen's Church: The magnificent tomb of the courtier and diplomat Sir William Pickering (d. 1575). His executors included neighbours Thomas Wotton and Sir Thomas Heneage.

Figure 13.5  Monuments in St Helen's Church: The tombs of Sir John Crosby (1476) and Sir William Pickering (1575), both in full armour, would have flanked the simple Protestant wooden communion table, which replaced the Catholic stone high altar.

been a suitable match for Elizabeth I. Pickering always denied this, saying she 'would laugh at him and at all the rest of them as he knew she meant to die a maid'. A committed Protestant, he lived an eventful life, including being ambassador to France in 1551–3.

Pickering's tomb occupies and completely blocks the easternmost arch of the church, which in the medieval period would have separated the two high altars. It mirrors but outstrips the visual impact of Sir John Crosby's tomb to the south – two heavily armoured knights buried a century apart. In 1575, they would have created a powerful visual focus around the communion table, just as the new pulpit was creating a separate locus at the east end of the nave (Figure 13.5). To the north, the site of the former nuns' altar became the location for other high-status burials including several which developed into family vaults. The first of these was probably the tomb of the Italian-born royal physician Dr Caesar Adelmare, who died in 1569,[15] but this no longer survives. Over succeeding years, Paulina Adelmare, relationship uncertain (1575), his wife Margaret, who subsequently married Michael Lok (1586), son Charles (1586), unnamed daughter-in-law (1590), grand-daughter Dorcas (1608), son Sir Thomas (1610) and Dame Alice (1614) were added. Eventually, his eldest son Sir Julius Caesar, the famous lawyer, joined in 1636, buried in the beautiful table tomb (see Figure 14.1) that still survives in the south aisle.[16] What other Adelmare/Caesar family memorials existed in Shakespeare's time in the 1590s is now unknown.[17]

Other tombs in this part of the church probably included Edward Skegg(e)s, buried in December 1578 who was Serjeant Poulterer to Queen Elizabeth I.[18] Being in charge of the Queen's supply of chickens, ducks and rabbits may not sound much today, but his status at court gave him the authority for an infamous run-in with the Lord Mayor, Thomas Lodge (c. 1509–84), in 1562/3 when he seized twelve capons heading for the latter's dinner table.[19] This prompted a series of formal complaints, but Skeggs, despite being described as 'an unworthy citizen who got to be purveyor to the Queen', eventually won the case. There was clearly good money in poultry. Two years before Skeggs died, he was assessed at £80 in the 1576 Lay Subsidy roll, making him the seventh highest assessed man in the parish.

On 14 June 1576, Alderman William Bond (c. 1520–76), who had acquired Crosby Hall in 1566 from the financially embarrassed Cioll family, was buried. He was commemorated by a major wall memorial set up on the north wall (Figures 13.6–13.8) rather than an elaborate tomb, possibly because Sir Thomas Gresham had already bagged the north-east corner of the church for his own tomb. William is shown kneeling with his seven sons facing his wife and one daughter, with a desk on each side of the middle column. The inscription reads:

> Heere liethe the bodie of Will'm Bonde alderman somtime shreve of london a marchant adventvrer, moste famovs in his age for his greate adven tvres bothe by sea and lande obiit 30 may 1576.

Figure 13.6  Monuments in St Helen's Church: Wall memorial to the international trader Alderman William Bond (d. 1576). He was a founder-funder of Frobisher's voyage in 1576 to find the 'North-west Passage' to China (Cathay).

Figure 13.7  Monuments in St Helen's Church: Detail showing Alderman William Bond and his seven sons. Despite his wealth, his surviving children did not hold onto Crosby Hall, which he acquired in 1566/7.

Figure 13.8  Monuments in St Helen's Church: Detail of the inscription comparing 'The Flower of Merchants' Alderman William Bond's trading voyages to Jason's expedition to hunt for the golden fleece.

Flos mercatorvm, qvos terra Britana creavit, écce, svb hoc tvmvlo Gvlielmvs Bondvs hvmatvr. ille mari mvltvm passvs per saxa, per vndas ditavit patrias peregrinis mercibvs oras. Magnanimvm Græci mirantvr Iasona vates avrea de Gelido retvlit qvia vellera Phasi.

Graecia docta tace Graii concedite vates: hic jacet Argolico mercator Iasone maior. vellera mvlta tvlit magis avrea vellere Phryxi Et freta mvlta scidit magis ardva Phasidos vndis. hei mihi qvod nvllo mors est svperabilis avro flos mercatorvm, Gulielmvs Bondvs humatvr.

Behold, under this tomb William Bond,

the flower of the merchants which the land of Britain has produced, lies buried. He having suffered much amongst waves and rocks, enriched the shores of his country by means of foreign merchandise. Grecian poets admire the mighty Jason, for his having brought the golden fleece from the icy Phasia.

Learned Greece be silent! Grecian poets yield the palm! Here lies a merchant far greater than the Grecian Jason. He carried away many fleeces more golden than those of Phryxis, and passed over many seas more rough than the waves of Phusis.

Alas! that death cannot be bribed by gold!

The Flower of Merchants – William Bond – is buried.

Standing in front of this memorial with its classical allusions to the perils of international trade and the lure of wealth, one is reminded of how Bassanio at the start of the *Merchant of Venice* describes Portia to his friend Antonio:[20]

> **Bassanio**
> In Belmont is a lady richly left;
> And she is fair, and, fairer than that word,
> Of wondrous virtues: sometimes from her eyes
> I did receive fair speechless messages:
> Her name is Portia, nothing undervalued
> To Cato's daughter, Brutus' Portia:
> Nor is the wide world ignorant of her worth,
> **For the four winds blow in from every coast**
> **Renowned suitors, and her sunny locks**
> **Hang on her temples like a golden fleece;**
> **Which makes her seat of Belmont Colchos' strand,**
> **And many Jasons come in quest of her.**
> O my Antonio, had I but the means
> To hold a rival place with one of them,
> I have a mind presages me such thrift,

> That I should questionless be fortunate!
> **Antonio**
> Thou know'st that all my fortunes are at sea;
> Neither have I money nor commodity
> To raise a present sum: therefore go forth;
> Try what my credit can in Venice do:
> That shall be rack'd, even to the uttermost,
> To furnish thee to Belmont, to fair Portia.
> Go, presently inquire, and so will I,
> Where money is, and I no question make
> To have it of my trust or for my sake.
> (*The Merchant of Venice*, I.i.161–85; emphasis added)

and Gratiano claims later:

> Nerissa, cheer yond stranger. Bid her welcome.–
> Your hand, Salerio. What's the news from Venice?
> How doth that royal merchant, good Antonio?
> I know he will be glad of our success.
> **We are the Jasons, we have won the fleece**.
> (*The Merchant of Venice*, III.ii.235–9)

But, of course, the story of Jason and the Golden Fleece was well known to educated Elizabethans.

William's youngest son, Martin Bond (*c.* 1558–1643), was to be a war hero during the threatened Spanish Armada invasion of 1588. He was one of the leaders of the English land forces camped at Tilbury positioned to defend this vital strategic position on the lower Thames. Presumably while there he heard Queen Elizabeth's famous speech to the troops on 9 August, recorded in various versions:

> My loving people
>
> We have been persuaded by some that are careful of our safety, to take heed how we commit our selves to armed multitudes, for fear of treachery; but I assure you I do not desire to live to distrust my faithful and loving people. Let tyrants fear. I have always so behaved myself that, under God, I have placed my chiefest strength and safeguard in the loyal hearts and good-will of my subjects; and therefore I am come amongst you, as you see, at this time, not for my recreation and disport, but being resolved, in the midst and heat of the battle, to live and die amongst you all; to lay down for my God, and for my kingdom, and my people, my honour and my blood, even in the dust.

> I know I have the body of a weak, feeble woman; but I have the heart and stomach of a king, and of a king of England too, and think foul scorn that Parma or Spain, or any prince of Europe, should dare to invade the borders of my realm; to which rather than any dishonour shall grow by me, I myself will take up arms, I myself will be your general, judge, and rewarder of every one of your virtues in the field.

Martin Bond MP lived on at the suitably impressive Throckmorton House, nearby in Aldgate, dying aged eighty-five in 1643 during the English Civil War. His wall memorial, showing him in a tent at a military camp, is just to the left of his father's and records:[21]

> Neere this place resteth ye body of ye worthy Cittizen & Solder
> Martin Bond Esq son of Will' Bond Sherife & Alderman of London
> he was Captaine in ye yeare 1588 at ye campe at Tilbury & after remained
> cheife Captaine of ye trained Bandes of this Citty vntil his death
> He was a Marchant Adventver & free of ye Company of Haberdasher . . .

The ownership of Crosby Hall by the Bond family is of particular interest because of the mansion's associations with Richard III. It provided a dramatic backdrop to Shakespeare's residency in St Helen's, both in physical and historical terms. When Richard, still Duke of Gloucester and Regent, acquired the Hall in 1483, it was a newly built 'trophy' acquisition. When William Bond purchased it in 1566, it must still have seemed an impressive, if somewhat outdated, asset to promote the success of a West Country family which had transformed its fortunes. William's younger brother Sir George Bond, a haberdasher, was sheriff in 1579. He married the daughter of Sir Thomas Leigh, Lord Mayor in 1558, who had led Elizabeth I's coronation procession. Sir George, in turn, became Lord Mayor in 1587/8, just before Shakespeare probably moved to London and in the stressful months before the Spanish Armada.

However, within five years, things looked very different, an illustration of how family fortunes could fluctuate. Margaret Bond lived on at Crosby Hall after William Bond senior's death, with her surviving sons. However, the eldest, Sir Daniel Bond, died in March 1587, followed by Margaret a year later in May 1588 and a younger son, Nicholas, in February 1591. Sir George died in 1592. To the remaining sons, William junior and Martin, Crosby Hall must have seemed an increasing white elephant.

In 1590, William junior bought Dr Caesar Adelmare's old house. His widow, now married to Michael Lok, died in 1586, and it is not known who she left it to. Martin Bond had probably already moved out to his own house. Thereafter, Crosby Hall does not seem to have had a permanent occupant for several years until Sir John Spencer bought it in 1594. It is conceivable that at the time Shakespeare was writing *Richard III* he could have wandered around through the mansion, which is featured three times in the play:

> **Gloucester**
> Are you now going to dispatch this thing?
> **First Murderer**
> We are, my Lord; and come to have the warrant,
> that we may be admitted where he is.
> **Gloucester**
> Well thought upon; I have it here about me.
> (*He gives them the warrant.*)
> When you have done, repair to Crosby Place.
> (*Richard III*, I.iii.339–43)

and later:

> **Gloucester**
> Shall we hear from you, Catesby, ere we sleep?
> **Catesby**
> You shall, my lord.
> **Gloucester**
> At Crosby House, there shall you find us both.
> (*Richard III*, III.i.185–7)

There had been other dramatic events more recently at Crosby Hall, although perhaps not equaling regicide. As described above, in the early 1570s, the Close and the adjacent stretch of Bishopsgate Street were home to most of the key players behind Martin Frobisher's first proposed voyage to Cathay in 1576 and the subsequent outburst of 'gold fever' in London.[22] Two decades on, when Shakespeare arrived, one wonders what memories of those dramatic times were recalled in the parish. There were a number of important residents, including John Pryn, John Robinson the Elder and Robert Spring, who were still alive and had lived through these extraordinary events. However, they may have preferred to draw a discreet veil over the three expeditions that had caused such spectacular financial losses.

Furthermore, by the 1590s, there were new ambitions, particularly for trade with Asia. The defeat of the first Spanish Armada of 1588 led to the creation of the East India Company. Emboldened by the English success against the traditional Spanish enemy, London merchants petitioned Queen Elizabeth I to allow their ships to sail around the Cape of Good Hope with the aim of trading across the Indian Ocean, then controlled by Dutch and Portuguese companies. The spice islands of Indonesia, India and China offered the potential for enormous profits. The first expedition sailed from Torbay in 1591 and eventually reached the Malay Peninsula; the second, in 1596, was lost. This led

Figure 13.9 Monuments in St Helen's Church: Portrait of Sir Thomas Gresham (d. 1579), painted in 1544 when Gresham was twenty-six and marrying the rich widow Anne Ferneley. Despite his superstar status as an international financier, Gresham failed to establish a dynasty. Oil by unknown artist, possibly Flemish.

Figure 13.10 Monuments in St Helen's Church: The stark tomb of Sir Thomas Gresham. His wife, Lady Anne Gresham, was buried with him in 1596. Her death allowed the conversion of their mansion into Gresham College in 1597/8.

to the request for a Royal Charter and, following its granting, the first official East India Company expedition sailed in 1601, with further expeditions in 1603, 1607 and 1608. The company established a foothold in India and by 1613 had reached Japan. The anticipation of departure, the long silences of the voyages and the dramatic return of these pioneering expeditions must have been a constant source of hope and fear.[23]

Three years later, in November 1579, the greatest of the early Elizabethan merchant princes, the international financier Sir Thomas Gresham (*c.* 1519–1579) died and was buried in the north-east corner of St Helen's.[24] The spare design of the simple table-top tomb (Figures 13.9 and 13.10), especially compared to the elaborate adjacent tomb of Sir William Pickering installed only three or four years earlier, reflects the character of this cunning and calculating man. His only son had died aged about sixteen, on 2 May 1563. As a result, as Gresham aged, he sought personal commemoration in other ways. In January 1565 he proposed to the Court of Aldermen that an exchange, based on the famous Antwerp bourse, should be built in the City at his expense, if the City provided the site. It was completed in 1568 and honoured in 1571 by a visit from Elizabeth I, who named it the Royal Exchange. Its location, just 350 yards to the south-east of St Helen's, did much to consolidate the area's attractiveness to leading merchants. It was a crucial facility for the development of English trade and insurance and used as the backdrop to Thomas Heywood's play *If You Know Not Me, You Know Nobody, Part 2* (*c.* 1605):

> Not in my life; yet I have been in Venice . . . In the Rialto there, called Saint Mark's; 'tis but a bauble, if compared to this. The nearest, that which most resembles this, is the great Burse in Antwerp, yet no comparable either in height or wideness, the fair cellarage, or goodly shops above. Oh my Lord Mayor, this Gresham hath much graced your City of London; his fame will long outlive him.

The creation of the (Royal) Exchange was followed by a decision in the early 1570s to found a college of advanced learning, and initially Gresham's interest focused on his alma mater, Cambridge University, as the location. However, in 1575, he decided to establish it in the City, so adding a London college to the two ancient English universities of Oxford and Cambridge. His plan was to let his widow, Lady Anne Gresham (née Reade), with his stepsons Richard (?–d. by 1597) and (Sir) William Reade (1538–1621), live in his mansion until her death, and then to have the building converted for use as Gresham College.[25] The two Gresham-founded complexes, one celebrating and enhancing trade and the other higher learning, would be only 250 yards apart and would provide a fitting memorial to Sir Thomas. He decided the College would have seven unmarried professors lecturing in subjects based on the medieval curriculum of the seven liberal arts, but with some crucial changes. Gresham chose one subject,

rhetoric, from the Trivium (not grammar or logic); three subjects, geometry, music and astronomy, from the Quadrivium (not arithmetic); and three additional subjects: divinity, physic (medicine) and law. The exclusion of arithmetic seems surprising given Gresham's financial skills, but perhaps he had a low opinion of its academic study. Physic seems appropriate given his own health issues, while geometry and astronomy were fundamental to navigation.

Gresham wisely left his estate jointly to the City of London and the Mercers' Company. In 1579, Lady Gresham was aged close to sixty, so it would have seemed likely that the college would come to fruition during the next decade, given typical life expectancy. As news of Sir Thomas's plans spread, a professorship in London would have been an appealing prospect to many who wanted to combine living in the capital with a well-remunerated academic position at £50 a year, with accommodation provided in a comfortable and prestigious building. There would have been growing anticipation of the Bishopsgate area emerging as an intellectual hotspot from the 1580s and no doubt there was much lobbying of the relevant experts at Oxford and Cambridge Universities, who recommended the candidates for consideration. In the event, things did not turn out quite as Gresham had planned. Lady Anne survived another seventeen years, finally being buried in St Helen's on 14 December 1596, by then well into her seventies.

There is insufficient space to describe the complex legal and other manoeuvres that took place after Gresham's death. John Guy's recent biography of Gresham shows how his financial position had deteriorated in the 1570s, including losing his £470 investment in Frobisher's three expeditions. Gresham's lawyers eventually calculated that he had debts of £23,030, which his widow had to deal with. She attempted to sell her life interest in Gresham House and Osterley House and, when these efforts were unsuccessful, sold much of his land. In 1581 she attempted to overturn Gresham's will but failed, making her financial position even worse. For the next fifteen years there was a process of attrition between her and various creditors, which reached as far as the forging of document seals.[26] Suffice it to say that when the College finally started, John Bull, its first professor of music, concerned because Sir William Reade had not vacated his assigned rooms, employed a mason to break down a wall to gain access. Clearly, tempers were running high. This forced entry led to a legal action against Bull in the Star Chamber, the result of which is sadly unknown.[27]

When Shakespeare lived in St Helen's the situation on the west side of Bishopsgate Street must have been well known and the potential opening of such a prestigious college could hardly have put him off the area. Cecily Cioll, Gresham's cousin, lived opposite Gresham House, and from there she must have watched the shenanigans over the creation of Gresham College with some cynicism. This perhaps explains the underlying tone of her will, which starts:

Figure 13.11  Monuments in St Helen's Church: Self-built tomb and family vault of the freemason William Kerwyn, who died in December 1594. The sides are engraved with family members, including two swaddled babies. Kerwyn, with the Puritan Clement Kelke, owned the rectory rights in 1589.

> 1608, Aug, 25. Cicely Cyoll, Widow of German Cyoll, Merchant considering the fickle and uncertain state and condition
> of this present lyfe, and having observed what contentions and
> controversies doe many times arise amongst deere friends for the
> goods and possessions of such as leave their estates undisposed,
> being either prevented by suddaine death or by protracting tyme
> until such feebleness and debility of body and memory overtake
> them, that they cannot set any certaine course or order therein . . .[28]

Inheritance is, of course, fundamental to several of Shakespeare's plays, notably *Richard II*, *The Merchant of Venice* and *King Lear*. Richard II orders:

> Let's choose executors and talk of wills . . .

but then asks:

> And yet not so, for what can we bequeath save our deposed bodies to the ground?

In 1593, Shakespeare would have been living next to and walking past two huge mansions both in functional and legal limbo. At Crosby Hall, the surviving Bond family must have been looking to rid themselves of an increasingly outdated 'white elephant', while in Gresham House, Lady Anne and Sir William must have occupied only a corner of the large complex. Both mansions represented not just the problems of inheritance but the equal challenge of achieving an appropriate succession or lack thereof – a challenge the whole of England faced, as the childless Elizabeth I celebrated her sixtieth birthday.

The last significant tomb from this period is that of William Kerwyn, a freemason[29] buried on 26 December 1594. Shakespeare might have seen the funeral and his interment 'in the vault which he made'. You can still view the small, elegant table tomb (Figure 13.11) positioned in the second arch from the west, although the protective railings obscure the delightful incised figures of the family and swaddled babies on the sides.

Finally, there are the tombs of people that Shakespeare would have known while they were alive. Apart from the memorial to the Robinson family, there is the huge wall memorial to Sir John Spencer, his wife Alice and their single daughter, Elizabeth, who is depicted kneeling at their feet, but noticeably with her back to her parents[30] (Figures 13.12–13.14). All three were resident at the time Shakespeare was living in the parish, although they probably spent much time at Canonbury House in rural Islington. One wonders if Shakespeare went back to St Helen's for Sir John's magnificent funeral in 1610, to finally see the back of the power broker who had so opposed his profession.

Figure 13.12 Monuments in St Helen's Church: The magnificent tomb (relocated) of Sir John 'Rich' Spencer (d. 1610), Lord Mayor in 1594/5, his wife Alice, and Elizabeth, his troublesome only child.

Figure 13.13 Monuments in St Helen's Church: Detail showing Sir John, who was actively anti-theatre, and his wife. They acquired Crosby Hall in 1594 and lived there until March 1610, when they died within two weeks of each other.

Living with Shakespeare

Figure 13.14   Monuments in St Helen's Church: Detail showing Elizabeth, daughter of Sir John 'Rich' Spencer, who became estranged from him over her choice of husband. Sir John was briefly imprisoned in 1598 for 'abusing' her.

Sir John Spencer's memorial is the last of a resident connected directly to Shakespeare's time in the parish. There is also the beautiful tomb of Sir Julius Caesar from 1636, but it is not known whether he actually lived in St Helen's as opposed to feeling a strong family connection to it. Having walked among these evocations of past residents, it is time to turn to Shakespeare's living neighbours and their potential significance.

Notes

1. This rather battered memorial has been raised up the wall, presumably when the gallery was constructed, and one needs to go upstairs to view it. Originally, it would have been at ground floor level next to a door which gave access to the cloister garden leased by Dr Peter Turner from 1589 until 1614.
2. Leased from the Leathersellers from 1574 to 1613, it was formerly the house of Sir Francis Walsingham in the early 1560s.
3. The inscription reads: 'Vithin this Monument lye the earthly parts of Ihon Robinson marchant of ye Staple of England free of ye copany of Marchant Talors, and sometymes Alderman of Londo', and Christian his wife eldest davghter of Tho: Anderson grocer they spent together 36 yeares in holy wedlock and were happy besides other worldly blessings in nyne sonnes and seaven daughters. She changed her mortall habitation for a heavenly on the 24 of Aprill. 1592. her husband following her on the 19 of February 1599 [1600]. both much beloved in theire lives, and moare lamented at theire

deathes especially by the poore to whome theire good deedes (being alive) begott many prayers and now (being dead) many teares: The glasse of his life held threescore and ten yeares, and then ran out. To live long and happy is an honor, but to dye happy a greater glory, boeth theis aspird to boeth heaven (no doubt) hath theire soules, and this howse of stone theire bodyes where they sleepe in peace, till the som'ons of a gloriovs resurrection wakens them.' See Reddan and Clapham, *Survey of London*, Section VII. – Monuments within the Church, 26. John Robinson 1599/1600. John Robinson the Elder probably went into decline around 1597/8, as he had two consultations with Simon Forman, the well-known astrologer and doctor. The first time (Case 1242), he sent one of his daughters. Forman recorded a horary consultation (astrological chart): 'M[r] Ihon Robinson of Lyttle S[t] Ellins of 60 yeres 1597 the 17 feb. 4 pm' at j Diz [to discover about disease] the Daughter for the father.' The second (Case 1253), also a horary consultation, was three days later: 'm[r] \\[iohne]/ Robinson of 65 yeares 1597 19 \\[20]/ of feb . . . 20 p 9 [09.20]him self sente'. See the excellent online database of Forman's astrological/medical records at <https://casebooks.lib.cam.ac.uk/> (last accessed 20 July 2020). If John Robinson the Elder had been ill, this may account for why his eldest son, John Robinson the Younger, moved into the next-door house around this time. However, given later events, this may have been connected with him trying to control his father's division of his wealth, estimated at £20,000 to £25,000 (see p. 197 footnote 11). In January 1594, at St Helen's, John Robinson senior's daughter Mary had married Sir Robert 'Sandy' Napier, later 1st Baronet of Luton Hoo, the wealthy Turkey merchant. He was the brother of the Rev. Richard Napier, a physician/astrologer/vicar of Great Linford who was closely associated with Simon Forman. Other children of John Robinson had consultations with Richard Napier in later years. Sir Robert Napier had a house in Bishopsgate Street, nearby in the parish of St Martin Outwich, so his brother may have met the rest of the Robinson family there. Richard Napier first consulted with Simon Forman on 22 January 1597/8, five weeks before John Robinson's first casting, so the family may have provided the first connection for their friendship which lasted until Forman died in 1611. He left Richard Napier all his casebooks, which are now in the Bodleian Library.

4. John Robinson the Younger must have been born *c.* 1556/7, given the recorded length of his parents' marriage and his mother's fecundity. He may have lived after his marriage in his father's house or elsewhere until his forties. A daughter, Elizabeth, was his first child, christened in St Helen's in June 1581, suggesting he married in 1580. His wife, Elizabeth (née Rogers), was buried just inside the northern west door and the brass inscription from her grave still survives, although unfortunately now relocated in the south aisle, away from her father's memorial. Its inscription reads ' . . . daughter of Sr Richard Rogers of Brianstone in the countie of Dorscet Knight, who had issue . . . one sonne and a daughter'. Sir Richard Rogers (*c.* 1527–1605) was an MP and an irascible character who was mixed up in the Dorset piracy scandal of 1577 and fined £100. His stepdaughter married the parliamentarian George More (1553–1632) of Loseley; see *The History of Parliament* online for more information about the family's extensive activities and connections. John Robinson the Younger's brother William took over the lease on his house; see section 3 of the Appendix. John then disappears from St Helen's, and he is not buried in the church. Two and a half years later, on 7 March 1603, as Elizabeth I moved towards her end, John Robinson, in his mid-forties, married eighteen-year-old 'Susan Holmden', daughter of Sir Edward Holden in the nearby parish of St Mary Woolchurch Haw. Sir Edward (1544–1616), Master of the Grocers in 1596–7, became an alderman in 1597, sheriff in 1598–9 and was knighted in 1603. He was buried in St Mary, Leyton, where his memorial inscription still survives. The couple probably then moved to Yorkshire to the Ryther Estate, near York. His brother Arthur acquired the nearby manor of Deighton in 1596 from John Aske MP. There is no evidence that this John Robinson is connected to his namesake, who was a tenant in the Blackfriars Gatehouse when Shakespeare acquired it in 1613, or the witness to his will in 1616. John Robinson the Younger would have been around fifty-five in 1611, and it is a common name. However, given his age, previous habitation in an ex-monastic building and possible acquaintance with Shakespeare in St Helen's, a connection should not be ruled out. For John Robinsons generally, see Pogue, *Shakespeare's Friends*, pp. 42–3.

5. With an assessment of £100, the third richest person in the St Helen's 1598 Lay Subsidy roll.

6. See Stone, 'Elizabethan Overseas Trade'.
7. Given that Robinson is a common name, it is not certain who Alderman John Robinson the Elder's father was. Some records suggest his father came from Staffordshire. An Alderman William Robinson, a mercer and also a Merchant of the Staple, was buried in the church of All Hallows, Barking, near the Tower of London on 4 January 1553. For his burial see Nichols, *The Diary of Henry Machyn*, p. 28, and Henry Machyn, A *London Provisioner's Chronicle 1550–1563*, pp. 328–37, <https://quod.lib.umich.edu/m/machyn/> (last accessed 20 July 2020).
8. Alice (c. 1531/3–1593) married Thomas Smythe (1522–91) c. 1553/5 and had thirteen children, eleven of whom survived to adulthood. Her third son, Sir Thomas, was the first governor of the East India Company, granted a Royal Charter by Elizabeth I on 31 December 1600. He later became treasurer of the Virginia Company, founded in 1607, until the scandal of 1620 brought his resignation. She was painted by Cornelius Ketel in 1579–80.
9. Judd helped to finance the 1553 North-East Passage expedition which resulted in Richard Challoner eventually crossing the White Sea and reaching Tsar Ivan the Terrible in Moscow, with the start of commercial relations with Russia.
10. The Portuguese started the slave trade from West Africa in the 1440s, initially to Portugal, following on from the importation of slaves from North Africa. The start of English involvement came eighty years later. It is sometimes taken to be in 1562, when Thomas Lodge and others fitted out two ships, the *Mynon* and the *Prymrose*, to 'sail and traffic in the ports of Africa and Ethiopia'; see *Calendar State Papers*, Domestic Series 1547–1580, p. 215, but this may have been solely for gold and ivory. Certainly, a subsequent voyage in October 1562 by Sir John Hawkins with three ships was aimed at trading in slaves from Guinea – see Hakluyt, *The Principal Navigations*, iii, p. 500. Judd's interests included importing an elephant's head, which he kept in his house, located on the west side of Bishopsgate Street.
11. For his life see, *The History of Parliament* online. His magnificent tomb survives at St John the Baptist church, Sutton-at-Hone, Kent.
12. The money seems to have actually come from Lady Elizabeth Hollis, wife of Sir William, at her death in 1543.
13. Their original location is uncertain, but it would have been a suitably impressive site, perhaps immediately to the east of the later almshouses, which could have been constructed alongside.
14. For his life, see *The History of Parliament*, available online.
15. Since the burial registers only begin in 1575, previous burials are more uncertain. Sir William Hollis's tomb and Judd's wall monument were already here, and probably other medieval memorials, which have now disappeared.
16. This tomb was moved in the nineteenth century, but its original location is uncertain. Plans suggest it was to the north of Sir William Pickering's tomb. It has now been restored following damage by the 1992 bombing.
17. Dr Caesar Adelmare's daughter-in-law is recorded in 1590 as being buried 'under the stone where Sir John Caesar was byried by the Communion Table'. Dame Alice was 'buried under our Comunion Table about midnight'.
18. This location is suggested by his widow Johane being buried in 1598 'on the north side of Pickerings Toombe wthin iiii foote thereof'. Their son, the haberdasher Edward Skeggs, was added in 1608. Memorials now lost include a floor slab, inlaid with marble, to an Edward Skeggs, 1592, bearing his incised effigy, with an achievement and four shields of arms recorded in a drawing owned by The Merchant Taylors' Company and the grave of William Skegges, Serjeant Poulterer, undated; see Reddan and Clapham, *Survey of London*, plate 120.
19. Father of the physician, adventurer and writer Thomas Lodge (c. 1558–1625), author of *Defence of Poetry, Music and Stage Plays*, published in 1579–80.
20. It has been noted that the names Antonio and Bassanio, the latter unusual in England, could be an allusion to the court musician Mark Anthony Bassano (1546–99), one of the sprawling Bassano family of musicians and instrument makers who originated in Venice and played a key role in sixteenth-century London musical life. Although the family were scattered across the eastern part of

the City, Mark Anthony (assessed at 8s-3d, 23rd-richest out of seventy-three households) and his brother Jeronimo (1559–1635 – assessed at 13s-9d, 14th-richest) were both living in St Helen's in 1589 when a new tithe survey was undertaken (see section 2 of the Appendix). In the 1582 Lay Subsidy roll, they were living in Tower Ward, close to the Tower of London. They had both left St Helen's by the time of the 1598 Lay Subsidy: Jeronimo for the greener environment of St Leonard, Shoreditch. However, they could have been living in St Helen's during Shakespeare's residency and worshipping alongside him. Arguments about whether the Bassanos were originally Jewish have been extensively aired – see as a starting point Lasocki and Prior, *The Bassanos*, and more recently, Lasocki, 'The Bassano Family, the Recorder, and the Writer Known as Shakespeare', pp. 11–25, which provides an easily accessible family tree. Mark Anthony's much younger first cousin was the famous Emilia Bassano, baptised at the nearby church of St Botolph, Bishopsgate on 27 January 1567. Emilia, now recognised as arguably England's first professional female poet, is better known as the mistress of Henry Carey, 1st Baron Hunsdon, first cousin of Elizabeth I for five years from 1587–92. She then became pregnant and was rapidly married off to her first cousin once removed, the court musician Alfonso Lanier. Two years later, Carey became patron of the Lord Chamberlain's Men, Shakespeare's acting company, until his death in 1596. The question of whether Emilia was the 'Dark Lady' of Shakespeare's sonnets has generated an extensive dedicated literature; see as a starting point, Rowse, *Shakespeare's Sonnets*.

21. See Reddan and Clapham, *Survey of London*, VII. – Monuments with in Church, 8. Martin Bond, 1643.
22. Including three of the four initial investors at £100 each: Sir Thomas Gresham, William Byrd and William Bond, in whose mansion, Crosby Hall, the expedition was planned. The fourth, Michael Lok, later married the wealthy widow Margaret Adelmare, another resident and the mother of Sir Julius Caesar. Other people associated with the expedition included Sir Humphrey Gilbert and Giovanni Battista Agnello, the Italian alchemist, who lived in the parish. Indeed, in Butman and Targett, *New World, Inc.*, eight out of their list of 'Seventy-Five Men and Women Who Helped Make America' lived in St Helen's at one time or another, and several others were related to residents by marriage. Finally, the Flemish painter Cornelius Ketel (1548–1616) had his studio in Bishopsgate Street in front of Crosby Hall. It was here that he painted not only the full-length portrait of Martin Frobisher for a fee of £5 and four other luminaries of the expedition such as Michael Lok along with the ship *Gabriel*, but also the first Inuk, again for £5, brought back to England from the New World in 1576. Ketel also cast a wax death mask directly from the Inuk's face. See for a recent discussion of Ketel's work in St Helen's, Nicole Blackwood, 'Meta Incognita: Some hypotheses on Cornelis Ketel's lost English and Inuit portraits', *Netherlands Yearbook for History of Art*, 66.1 (2016), pp. 28–53. By 1593, all these people had died or moved elsewhere, but residents like John Robinson the Elder, who moved to St Helen's in 1574, must have remembered the excitement of those years.
23. The advice of doctor and astrologer Simon Forman was regularly sought by shipowners and wives of crew alike; see Cook, *Dr Simon Forman*, p. 126.
24. It is claimed that he offered to pay for a church steeple in return for the large space his tomb occupied.
25. She also enjoyed the huge income of £2,388-10s-6½d a year. The site of the complex is now occupied by Tower 42.
26. See Pelling, 'Failed Transmission', pp. 55–61 for a summary and, recently, Guy, *Gresham's Law*, pp. 204–26.
27. The first seven professors were appointed in 1596, although their first lectures were not given until the Michaelmas term, 1598. Shakespeare may have left St Helen's by then, but there must have been great excitement about the College in the preceding months after eighteen years of delay. The professors were a talented group – for example, Matthew Gwinne, professor of physic, had also taught music at Oxford University and wrote the comedy *Vertumnus* (lost?) to entertain James I when he visited Oxford in 1605. See also discussion of Richard Ball, professor of rhetoric, in Chapter 20, note 5 below.
28. See TNA PROB 11/115/130.
29. Kerwyn was a freemason. He played a significant part in parish affairs. Despite being unable to write his name, he signed documents with a mark; he was churchwarden in 1571 and 1572 and audited

accounts up to 1593 the year before his death. He also held the lease of the rectory rights with the Puritan Clement Kelke, around 1589.

30. Although now positioned on a west–east alignment on the south wall as a result of a relocation during the 1865–8 restoration, the tomb was originally south–north against the vestry wall in the south aisle of the church, with Sir John 'buried in a new vault by the Vestrye dore' on 22 March 1610 in a huge inscribed lead coffin. He was infamous for leaving no gifts to charity in his will. His wife died three weeks later, so presumably the memorial was commissioned by his daughter Elizabeth, by then married to William Compton, 1st Earl of Northampton.

# PART V

Shakespeare's Neighbours in Saint Helen's

Figure 14.1    Monuments in St Helen's Church: Table tomb of Sir Julius Caesar (1558–1636), the great jurist and son of the successful Italian immigrant Dr Caesar Adelmare (d. 1569), who acquired the rectory right for St Helen's. Engraving published by Robert Wilkinson, 1810.

Figure 14.2    Monuments in St Helen's Church: Detail of the inscription on the top of the tomb. Sir Julius' mother Magaret Adelmare later married Michael Lok, the organiser of Martin Frobisher's three voyages to Cathay 1576–8. Engraving published by Robert Wilkinson, 1810.

# 14

## The Radical Doctors of Saint Helen's

*In which it is explained that, in the 1590s, St Helen's was home to a noteworthy group of medical doctors with progressive Continental ideas, based on the thinking of 'Para-celsus', otherwise known as Theophrastus Philippus Aureolus Bombastus von Hohenheim. These ideas ushered in a revolution in methods of medical treatment.*

The Lord Chamberlain's Men theatre company, like any acting troupe, would have provided a 'family' of work colleagues for Shakespeare when he was lodging in London. These were the people with whom he spent hours every day, rehearsing, performing, arguing and celebrating. Apart from the fact that they were all male, there is no reason to think they were much different from any modern group of performers forced into a long-term and close proximity, with all the passions which acting excites. They would have fallen out, made up and ribbed each other, just like their counterparts today. They would also have shared their successes and failures and the ongoing competition with the Admiral's Men and other theatre companies. They would have celebrated weddings and christenings while mourning their children, work colleagues and friends that childbirth, disease, plague, and the occasional fatal argument took from them. Even the closest of colleagues sometimes sought freedom, as did the comedian Will Kemp, who in 1599 left the Company altogether for pastures new when his brand of ribald humour became less fashionable.

Shakespeare would also have known a host of other people in London. There were sometimes members of his family, such as his younger brothers Gilbert, a haberdasher, and Edmund, an actor.[1] Then there were connections with Stratford-upon-Avon and Stratfordians. The best known today was the printer Richard Field, with his hand press in the former Blackfriars, but there may have been other business connections through the Leathersellers' Company or lawyers acting in London for Stratford Council. It would also have been natural for him to make the acquaintance of a wide range of writers, printers, publishers and booksellers.

Prior to the establishment of the Lord Chamberlain's Men in 1594, Shakespeare's employment ambitions are unclear. The writing of his two long poems dedicated to the nineteen-year-old Henry Wriothesley, 3rd Earl of Southampton, in 1593 and 1594 indicates that, for a while, he toyed with the idea of being supported by aristocratic patronage. Experts think that the more familiar tone of the 1594 dedication indicates a positive response from Southampton, but whether this translated into financial support

## Social networks in the parish of Saint Helen's

**Robert Spring** lived in Saint Helen's c. 1564 – c. 1598/1606

- Family — wife & children; House(s) leased from Leathersellers Company
- Freeman, Worshipful Company of Skinners; also landlord
- Church and parish of Saint Helen's — Churchwarden 1583 & 1584; Auditor 1581–1597
- Citizen of London

Robert Spring, Citizen and Skinner of London (c. 1540 –1609)

---

**William Shakespeare** lived in Saint Helen's c. 1593? – 1598/later?

- Family — wife & children in Stratford-upon-Avon; Lodging in house leased by another from Leathersellers Company
- Aristocratic patronage? c. 1593 – 94
- 'Sharer' in Lord Chamberlain's Men Theatre Company from 1594; also landlord
- Court of Queen Elizabeth I from 1594
- Church and parish of Saint Helen's — no parish roles

William Shakespeare, Gentleman, poet, playright and actor (1564 –1616)

Figure 14.3  Comparison of the social relationships of Shakespeare and his neighbour, Robert Spring, a successful skinner. They probably lived almost next door to each other in the 1590s. Shakespeare's country house was in Stratford-upon-Avon, Robert Spring's in rural Dagenham, Essex.

is unknown. From 1594, and possibly earlier, Shakespeare would have begun making more contacts at court, and at least two officials – the court musician Thomas Morley and one of the Queen's messengers, Henry Maunder – also lived in the parish. From Christmas 1594, he was definitely at court, as the Lord Chamberlain's Men performed three times on 26 and 27 December and 26 January 1595.[2] It is entirely possible that while Shakespeare was living in St Helen's, his contacts with the other residents were limited to a few pleasantries, the occasional conversation in the street and meetings after Sunday worship. If he lodged in someone else's house, that would have been an additional barrier to casual meetings. However, Shakespeare's phenomenal interest in human character suggests that, to the contrary, he was deeply interested in observing people and probably enjoyed lively debate as well. Without further discoveries, there is no certainty, but it is worth considering the horizons of the parishioners among whom Shakespeare moved (Figures 14.1 and 14.2).

Shakespeare's status was fundamentally different from the majority of the English-born craftsmen who lived around him. Figure 14.3 compares Shakespeare's position with that of his near neighbour Robert Spring, a skinner. Spring's status, his very identity, was based on four foundations. Firstly, his family, where he was complete master. Then there was his parish, St Helen's, where he was resident for over thirty years. Thirdly, he was chosen by his neighbours to undertake the demanding role of churchwarden and also audited the parish's annual accounts. Finally, he was a freeman of the Skinners' Company, having served his apprenticeship, which also brought with it the proud boast 'citizen of London'.

In contrast, Shakespeare's family was almost certainly away in Stratford-upon-Avon and unseen by his neighbours. This, in itself, would have marked him as different to the mass of Londoners, where the family was the primary social anchor. Also, as he moved into different parishes in the City, Shakespeare would have had to attend services at the various churches. However, there is no evidence of him holding any parish office. In contrast, both Henry Condell and John Heminges, two of the other seven 'sharers' in the Lord Chamberlain's Men, stayed put in the parish of St Mary Aldermanbury, where they both became churchwardens in due course.[3] While Shakespeare was technically a servant of the Lord Chamberlain, in practice this was a legal protection and very different from being a freeman of a City guild. Most importantly, Shakespeare could not claim to be a 'citizen of London'. However, as a result, he was free of trade control and fixed rates of pay. This allowed him to exploit his talents in the most financially beneficial way possible. Conversely, Shakespeare was connected directly to the court through performance before Elizabeth I at her various palaces in and around London. This would have been something exceptional to most of his fellow parishioners, who might have only had occasional glimpses of the Queen and her courtiers during street processions or other public celebrations.

Shakespeare walked a singular pathway between the royal court/City establishment and 'the Other' – the foreign merchants, Huguenot refugees and 'masterless' English migrants who found a home in London despite the commercial restrictions, legal constraints and physical threats. Indeed, Shakespeare seems to have developed an unusual interest in 'the Other'. He knew a reasonable amount of French and St Helen's and its surrounding area had a large immigrant population. From 1602/4, he chose to take lodgings in the house of a French Huguenot specialist craftsman, a decision which might have seemed perverse to his more nationalistic colleagues. Mixed up in these choices, as a migrant himself, was also the desire for public recognition. This was demonstrated by his ultimately successful efforts in 1596 to be awarded a coat of arms, which brought with it the status of gentleman, including the right to carry a sword. These social nuances may seem arcane today, but in Elizabethan London they were vital parts of one's personal identity and how one was treated by society.

As in any community in the late sixteenth century, the majority of daily conversation would have been local and largely mundane news about family life, work, neighbours and the ups and downs of trying to survive in a tough economic environment. The results of the harvest across the country could make all the difference to an entire year. The years 1594–7 saw a particularly bad run of poor harvests that added to the problems of inflation. St Helen's was dominated by the textile trades and the supply of other upmarket goods. It was a world where the price of silk in Brussels, the rise of piracy in the Mediterranean and the weather in the Channel might all have an immediate impact on people's economic wellbeing. Religious discussion would also have played a much greater role than is normal today. London's printing presses produced a stream of religious commentaries, printed sermons and moralising texts, all offering guidance on the best way to secure salvation.

However, while he may have liked to keep his finger on the pulse of the community, it is hard to imagine Shakespeare sitting down for long discussions over dinner about the ups and downs of cloth prices or the availability of currants from Zante. For most of this period, Shakespeare seems to have been doing well financially, drawing on his range of talents – acting, scripting, writing and possibly rewriting plays by others. While theatre was a fickle profession, he was probably less anxious about his prospects than people who depended on a specific trade or who relied on the fixed but unpredictable cycle of the agricultural year.

This chapter, therefore, considers some of the individuals, the 'cast', that populated the streets of St Helen's and where it seems reasonable to assume that Shakespeare had some sort of acquaintance, even if only a passing recognition. In 1700, Richard Gough wrote a remarkable history of the village of Myddle in Shropshire.[4] He organised his account by moving through the local families and describing their connections in the order they sat in the parish church, pew by pew. Sadly, there is no equivalent seating

plan for St Helen's in 1595 setting out the network of families, businesses and other connections. In its absence, this section takes a different approach, looking at groups by their trade or profession. This inevitably focuses on the wealthier adult male inhabitants who were freemen of their respective livery companies and hence citizens of London, whether mercer, grocer or leatherseller. In practice, these were the people with whom Shakespeare was most likely to interact. However, it is vital to remember that he had to write plays for a very broad cross-section of society, from the Queen down to teenage apprentice boys wanting two hours of exciting action.

The reputation of St Helen's as an upmarket neighbourhood had risen in the late fifteenth century with the building of Crosby Hall in the 1460s. A reference to Nicholas, late Bishop of Llandaff, leasing a property suggests that other parts of the nunnery site were being developed to provide housing for outsiders.[5] The construction of a row of substantial houses in the Close, probably in the early sixteenth century, offered wealthy merchants, courtiers and gentry accommodation in the heart of the City, coupled with a substantial degree of privacy and security due to the location within the nunnery precinct.[6] The suppression of the nunnery in 1538 initially boosted this socio-economic profile by providing the space for the Leathersellers' Livery Hall and more high-status houses created from the conversion of the nunnery buildings.[7] For the next fifty years, through the 1540s to the 1590s, the central area of the parish was prime real estate, with the addition of a scattering of MPs and professionals alongside traders and financiers. Chief among the latter was Sir Thomas Gresham with his huge new mansion, but there were many others, including the Bond family of international traders, who took over Crosby Hall from 1566 until 1594. If there was a growth in poorer inhabitants, including foreign immigrants, from the late 1560s in the narrow alleys to the south of the Close, it does not seem to have deterred the richer occupants. When Shakespeare arrived *c.* 1593 it must have been a very appealing location, a fact underlined by Sir John Spencer's purchase of Crosby Hall from the Bond family in 1594.

In terms of an 'intelligentsia' that might have interested Shakespeare, there are some clues. Among the merchants, some stand out. The monument in St Helen's to Alderman John Robinson the Elder, his wife and their sixteen children gives the impression of a powerful family man with wide experience of foreign trade and places.[8] Nearby, in Great St Helen's, was Leven Vanderstilt, the richest of the Dutch 'stranger' community, probably an international textile merchant. The Leathersellers' Livery Hall would have brought members from across the City to St Helen's. Among them were some significant personalities, like Alderman Hugh Offley. The experiences of at least one liveryman caught Shakespeare's attention. In 1583, Ralph Fitch (1550–1611) sailed in the *Tyger* to Tripoli, the port of Aleppo, in the eastern Mediterranean and then completed an epic overland journey across Asia, ending in Burma and Thailand in 1586.[9] The first witch in *Macbeth* (Act 1, Scene 3, Line 7) makes reference to Fitch's voyage: 'Her husband's to

Aleppo gone, master of the *Tyger*'. While the connection is clear, it is less obvious why this reference was used and presumably thought to be recognisable by an audience. Perhaps it had become a term for 'disappearing', or simply going a long way away.

Like any parish, the church minister, a rector in the case of St Helen's, would have been a key figure in local life.[10] Unfortunately, we know almost nothing about John Oliver, who cared for the parish from 1590 until 1600, although the fact that he also delivered the parish lectures suggests he was a man of some intellect.[11] Although Ben Jonson's memorial to Shakespeare famously states: 'And though thou hadst small Latin and less Greek', Shakespeare may have had greater access to the classics than might be imagined. In 1592, the rectory of St Helen's was awarded to Dr Nicholas Felton (1563–1626). Felton today is best remembered as one of the translators of the King James Bible (1611), but twenty years earlier he was a highly talented scholar who in 1586, aged only twenty-three, was made lecturer in Greek at his Cambridge college.[12] The ownership of the rectory rights of St Helen's was followed by those of the important parishes of St-Mary-le-Bow, Cheapside, and St Antholin, Budge Row, and eventually the bishoprics of Bristol and then Ely. Since the vestry minutes of St Helen's do not survive for the years after 1578, unfortunately there is no information about whether he ever visited the parish or just used it as a source of income.

There is insufficient space here to examine all of the hundred or so households in the parish. Alongside the richer merchants were craftsmen including coopers, ironmongers and cobblers, producing and repairing the basic necessities of life. They lived fairly humdrum existences, where work changed little from week to week or year to year, but they at least had regular employment – unlike the day labourers who clustered in the suburbs. Examination of the parish population, as revealed in various sources, demonstrates that there was also a small elite of professionals who could have connected Shakespeare to the latest European thinking in the arts, sciences, medicine and religion. The Elizabethans were enthusiastic students of plants and natural curiosities. The neighbouring parish of St Andrew Undershaft, specifically Lime Street, running south out of Leadenhall Street, was a significant locale. This was less than a five-minute walk from Shakespeare's residence. Today, the view is dominated by Richard Rogers' extraordinary Lloyds Insurance Building. However, four hundred years ago, according to the historian John Stow:

> In Limestreete are diverse fayre houses for marchants and others

and living there was an extraordinary group of specialists termed the 'Lime Street naturalists'. These have recently been documented by Deborah Harkness, who points out that for a brief time 'Lime Street was the residence of both of Europe's most influential plant specialists', including Mattias L'Obel.[13]

Indeed, as Harkness has described:

> The Elizabethan City was riddled with neighbourhoods like Lime Street, where common interests shaped social and intellectual life and an urban sensibility emerged that blended cosmopolitanism with nascent nationalism, competition with collaboration, and theoretical learning with practical experience.[14]

In the same way that there was 'cluster' of natural history specialists in Lime Street, there was a long tradition of physicians living in St Helen's, particularly from the 1540s onwards. Shakespeare would not even have had to stroll across Leadenhall Street to enter this fascinating world as there were several, literally, on his doorstep.[15] Most medical doctors also had an interest in botany and zoology, since plants and animals provided many of the key ingredients in the medicines of the period.

It has been recognised since the nineteenth century that Shakespeare had an unusually broad knowledge of medical matters and terminology.[16] This is often attributed to the influence of his son-in-law, Dr John Hall. However, although presumably Hall had spent some time in Stratford-upon-Avon before marrying Susanna Shakespeare in 1607, Shakespeare may not have met him much before 1605. Now, through investigating the residents of St Helen's, one can see that earlier in the 1590s, Shakespeare was living alongside at least three doctors, two of whom were certainly recognised as 'Paracelsians'. To understand the origins of this grouping, one needs to step back fifty or so years to 1538 and the dissolution of St Helen's nunnery.

Doctors were probably initially attracted to St Helen's by the potential income from the wealthy individuals who lived at Crosby Hall and other mansions in the area. On 21 April 1539, Balthasar Guercy was granted a substantial house, formerly owned by the nunnery.[17] He was an Italian (de Guercis), born in Il Boscho in the duchy of Milan. His house was probably south of the church and at the east end of the Close. As a doctor, usually referred to as a surgeon, he had made good in London, having served Catherine of Aragon,[18] and was assessed at the huge sum of £200 in the 1541 Lay Subsidy roll. The Italian Caesar Adelmare (? –1569), doctor to Queen Mary and Queen Elizabeth, decided to settle in Great St Helen's in 1561, and acquired Balthasar Guercy's former house.[19] There he would have joined Jacob Saul, an émigré surgeon from Flanders, who probably came to England *c.* 1558/9.[20] Certainly, after Sir Thomas Gresham moved into his new mansion in the parish in 1566, he had need of such services, as his leg had been badly injured by a fall from a horse in 1560.[21] He subsequently described himself as lame, and in 1572 mentioned his unhealed leg with the wound throwing up pieces of bone.[22]

The mention of Gresham is also a reminder that throughout the 1580s and early 1590s, the parish's future status was dominated by the anticipation of it being the site for Gresham College, London's first college of higher education. This was a prestigious,

carefully planned and well-funded project, kept in limbo by the survival of Gresham's ageing widow Anne, which prevented the release of the building. Probably a number of people over the years, hoping for advancement through the new college, felt it worth moving near the proposed site.

By 1596, when Shakespeare is likely to have been living in the parish, there were at least three English doctors there,[23] to be joined in 1598 by Dr Matthew Gwinne, the first professor of physic at Gresham College.[24] These men and their families had strong links to Queen Elizabeth's court and direct experience of medical training in the northern Italian cities of Padua (the official university of the Venetian Republic), Bologna, Ferrara and Venice, along with major German cities.

The first of the physicians contemporary with Shakespeare was Richard Tayl(i)or, of whom relatively little is known.[25] He was probably born *c.* 1555 and he is first recorded in St Helen's in 1584, when his daughter Mary was christened.[26] He already had at least two children, and then another seven arrived by 1597. He seems to have been equally successful as a doctor, if judged by his house, which was almost certainly in the Close. In the 1589 tithe survey, it was assessed at 27s-6d – equivalent to a rent of £10, the third equal highest in the parish.[27] In his 1610 will he left the large sum of £1,000 to his four daughters.[28] He is recorded in the 1598 Lay Subsidy roll for St Helen's but, like Shakespeare, is missing from the 1600 listing. A few years later, he was paying the subsidy on his country property at West Ham, Essex, so he may have acquired that domicile *c.* 1599/1600, or at least transferred his subsidy payments to it then.[29]

In 1589, he was joined in St Helen's by Dr Peter Turner (1542–1614), a society figure who had married late in his mid-forties and was looking for an impressive address for his wife and growing family (Figure 14.4).[30] Much more is known about him. His move to St Helen's brought success on two fronts. He took over the lease on one of the most impressive houses in the Close, The Cloister, from Nicholas Gorges, MP, and fathered a girl, who was christened on Christmas Day 1591.[31] Dr Peter Turner was the son of William Turner (1509/10–1568), the 'Father of English Botany',[32] an important churchman and doctor who had studied medicine in Italy at Ferrara and Bologna.[33] In England, William Turner became chaplain and physician to the Duke of Somerset, developed a practice among the aristocracy and was also Dean of Wells Cathedral. In 1551, he started the publication of his famous illustrated herbal, *A new herball, wherin are conteyned the names of herbes . . .* This was the first generally available herbal in English, and it allowed the identification of most indigenous plants. In 1553, with the accession of the Catholic Queen Mary, he went into a five-year Continental exile with his family.

His son Dr Peter Turner senior, therefore, spent his early teens as a 'refugee' in Germany, before returning to England at the accession of Elizabeth in 1558 and going to Cambridge University, where he graduated MA. In 1571, aged twenty-nine, he became

Figure 14.4 Monument to Dr Peter Turner, MP, buried close to his father, William Turner, in St Olave, Hart Street. Dr Turner, who was strongly anti-Catholic, was a dominant personality in St Helen's from 1589 until 1614.

a medical doctor at the university town of Heidelberg, south of Frankfurt. By 1580, he had returned to England to take up the prestigious post of doctor at Saint Bartholomew's Hospital. At this point, confident in his training on the Continent, he came into conflict with the College of Physicians. He was called to account for not being a member of the College and their court records for November 1581 state that 'Turner openly confessed to having practised medicine for nearly a whole year in this city.'[34] Furthermore, 'he refused, insolently and stubbornly, to recognise the examination of the College'. The dispute ran for a year, but eventually Turner was admitted as a licentiate of the College, paying a one-off £30 and £2 a year.

This dispute may not have just been due to Turner's high opinion of his existing expertise, but because he considered the College's views increasingly outdated. While in Germany his contacts had included the physician Thomas Erastus and Sigismund Melanchthon, professor of medicine at Heidelberg. By English standards, revolutionary new medical thinking had been swirling across western Europe for several decades. For many thinkers, a full medical reformation was needed to match the religious reformation. As a result, Turner became known as a follower of the (for the time) radical medical practitioner and self-styled 'Para-celsus' (meaning surpassing Aulus Cornelius Celsus, the classical writer on medicine),[35] otherwise known as Theophrastus Philippus Aureolus Bombastus von Hohenheim (*c.* 1493–1541) (Figure 14.5).[36] Neither his names nor his extraordinary life are easy to forget, so some readers will probably know about his ideas, while for others this fascinating character may be a blank page. Also, for the purposes of this study, the important factor is less his remarkable life but how Paracelsus' complex ideas were transmitted to, interpreted and applied in England, fifty years after his death. Even experts on Paracelsus do not agree on exactly what he believed in. The following overview by Richard Stensgaard summarises the core debate, even if it avoids some of the intricacies which led to disagreements in interpretation:

> London shortly past the turn of the century was alive with talk of medicine, the result of the devastating visitation of the plague (ca. 1602–6), which exacerbated a long-standing controversy between the chief medical authorities of the day, the Galenists and the Paracelsians. Though complex in its ramifications, the debate centred on basic conceptions of disease and its cure. The Galenists, arguing that herbal medicines were the best remedies for all manner of sickness, based their thinking on the ancient belief that herbals best acted to maintain the humoral equilibrium (heat, cold, moisture, dryness) thought from antiquity to underlie the body's desired state of health. The more modern Paracelsians, on the other hand, rejecting the humoral theory, insisted on the use of 'specific' chemical medicines, simplified, distilled medicaments designed to restore health by acting on the special toxicity of the particular disease.[37]

Figure 14.5 The Swiss-born physician 'Paracelsus' (*c.* 1493–1541) pioneered new approaches to medical treatment. However, his ideas only began to influence doctors in England in the late sixteenth century.

Figure 14.6  Paracelsus' revolutionary and complex ideas combined medicine with astrology and philosophy – the inscription reads: 'All perfect gifts are from God'. Design after a 1540 portrait by Augustin Hirschvogel.

Figure 14.7  The oldest surviving English sampler was stitched far from London by Jane Bostocke of Langley, Shropshire in 1598, to commemorate the birth of her cousin. John and Charles Bostock, probably distant relatives, married in St Botolph's and St Helen's in 1598 and 1600 respectively.

The late Professor Roy Porter highlights how Paracelsus' approach combined practical chemistry with more esoteric ideas which merged into mysticism (Figure 14.6):

> Paracelsus's fundamental conviction was that nature was sovereign, and the healer's prime duty was to know and obey her. Nature was illegible to proud professors, but clear to pious adepts. . . . Paracelsus's significance lay in pioneering a natural philosophy based on chemical principles. Salt, sulphur and mercury were for him the primary substances. . . . His 'tria prima' are to be understood not as material substances but as principles. . . . Drawing on the occult, he associated diseases with the spirits of particular minerals and metals. . . . But he also boldly deployed [them] for therapeutic purposes, together with laudanum (tincture of opium).[38]

Paracelsus was nothing if not opinionated and delighted in his anti-establishment stance, writing:

> I cannot boast of any rhetoric or subtleties: I speak in the language of my birth and of my country, for I am from Einsiedeln, of Swiss nationality. . . . My writings must not be judged by my language, but by my art and experience, which I offer the whole world.

Our attention must focus on Paracelsus' impact in England. In London, the College of Physicians was wedded to classical medical doctrine and disapproved of Paracelsian views. However, it is difficult to tell what individual doctors thought and over time many probably combined elements of both philosophies. Interestingly, the first reference in an English publication to Paracelsus is in William Turner's treatise on medicinal baths.[39] Turner learnt of Paracelsus through his friendship, while in Continental exile, with the extraordinary Swiss polymath Conrad Gessner. From 1554 until his death in 1565 from plague, Gessner was city physician of Zurich and maintained a large personal library. William Turner's main interest was in Paracelsus' practical interest in spas and the benefits of mineral waters, but he did not give a view on the quality of Paracelsus' thinking. Presumably, he passed his interest onto his son and possibly early Continental publications of Paracelsus' works. Over the next twenty years, Paracelsus is mentioned in various English medical works but there is no general description of his work or philosophy. In 1583, John Hester:

> put the name of Paracelsus onto an English-language title page for the first time when he published *A hundred and fourtene experiments and cures of the famous phisition Philippus Aureolus Theophrastus Paracelsus* (1583) . . .[40]

This was followed in 1585 when a R. Bostock (author name proposed) wrote *Difference between the auncient Phisicke . . . and the latter Phisicke*, in order to distinguish the key

elements of this new thinking.[41] As Bostocke was not a doctor, it is uncertain what impact his book had.[42] It prompted an 'I.W.' to produce a defence of Paracelsian medicine the following year, so clearly by the mid-1580s there was sufficient interest and debate for publishers to see it as a worthwhile area of interest.

It is not clear how long Dr Peter Turner spent at Heidelberg in the 1570s, but it would have given him the opportunity to learn the latest thinking on the Continent. While there, he knew Thomas Penny, a doctor and etymologist who was part of a network connecting to Petrus Severinus, the Danish royal physician in Copenhagen, who was a leading follower of Paracelsus.[43] Peter Turner also knew Dr Thomas Moffett/Muffet, who studied at Basle in the late 1570s and became a supporter of Paracelsus' approach;[44] he was a member of the College of Physicians, demonstrating the range of views held by individual practitioners.[45]

Dr Turner's return to England came with the promise of the prestigious post of doctor at St Bartholomew's Hospital, as the holder, Dr Roderigo Lopez, a Portuguese *converso* had become physician-in-chief to Elizabeth I. This gives an indication of the circles that Dr Peter Turner moved in as he developed an upmarket practice in London with patients including the politician and courtier Roger North, 2nd Baron North (1530–1600)[46] and the peer Henry Brooke, 11th Baron Cobham.[47] In 1584, he gave up his post at St Bartholomew's Hospital and became MP for Bridport, Dorset in the parliaments of 1584 and 1586. At this time he married Pascha, daughter of Henry Parry senior, chancellor of Salisbury Cathedral, and sister of Henry Parry junior (1561–1616), later Bishop of Worcester. Parry junior was chaplain to Elizabeth I and present at her deathbed in 1603.

Peter and Pascha Turner's house was 'The Cloister', the former west wing of the nunnery, which had been the Prioress's lodgings.[48] The main section was described as three fair chambers on the first floor with the former buttery and larder below on the ground floor, probably enjoying part or all of the former nuns' cloister as its garden.[49] The south end of the wing overlooked the Close and a dedicated front entrance had been added. If Shakespeare's lodgings were at the west end of the Close, he would have looked directly out over the churchyard to Dr Peter Turner's house only seventy feet or so away. With the entry through the gatehouse in Bishopsgate and a position next to the west end of St Helen's, the house would have emphasised Dr Turner's status, and perhaps for his wife Pascha evoked memories of her childhood in the close of Salisbury Cathedral.[50] Two of the last three occupants of the house had been knighted (Sir Humpfrey Gilbert and Sir John Pollard), and perhaps Turner himself had aspirations in this direction.

Turner would probably have inherited his father's books and manuscripts covering a wide range of religious, medical and botanical titles and forming the basis of a significant library. It is likely that Turner owned books by Paracelsus, as when he wrote a pamphlet in 1603 about the effectiveness of plague amulets, he stated:[51]

> But if thou haddest rather heare what the learneder sorte that deale with such things holde of these matters. Then read what is written in a treatise of Arsenick by Theoprastus Paracelsus, **who was absolutely the most learned chimicall writer and worker that ever wrote**: And if thou hast any insight in this kind of Philosophie, whereby to understand him, he will satisfie thee of the natures of these things to the full. As for the authorities of such Phisitians or Philosophers which are not acquainted neither with the chymicall theory or practice, I holde their censures as insufficient, for want of knowledge of those things which they dislike: & therefore how many soever they be in number, so long as they understand not what they reprehend, it maketh no great matter: and yet if this controversie were to be debated by authorities, my opinion should not be lesse assisted then by others . . .
>
> Yet least it be thought That I have none but poore Paracelsus on my side, I will translate for them that understand no Latin, a fewe lines concerning these Amulets or Plague cakes, out of a little Treatise of the Plague of Johannis Pistorius a learned Phisition of Germanie . . . (emphasis added)

It is not known whether Dr Turner and his family fled London during the 1592–4 plague, as did many of his colleagues.[52] However, by summer 1594 he was presumably back in St Helen's and probably feeling pretty good about himself. The grandson of a Northumbrian tanner,[53] he would know that his new next-door neighbour was likely to be none other than the Lord Mayor of London.[54] Now fifty-two, Turner had four children – with, probably, more to come – and a wife with powerful social connections. He had arrived in every sense, and his commitment to Paracelsian medicine coupled with his Continental connections would have given him a powerful intellectual persona. He had an elegant house with a rare city centre garden and high-status neighbours. All he lacked was a knighthood. What would Dr Turner have made of the thirty-year-old writer and actor Shakespeare living nearby? The short answer is there is no evidence that they ever met or spoke to each other, let alone debated over a dinner table. Whether or not to believe these neighbours knew each other is entirely your choice. However, there are a few clues that Dr Turner's patients might have been of more than passing interest to Shakespeare. In particular, due to a case of Elizabethan fraud, there is a remarkable record of Dr Turner examining a mentally disturbed patient. Let us join him on his visit to Whitechapel in the autumn of 1596.

## Notes

1. They died aged forty-five and twenty-seven respectively in 1612 and 1607, both unmarried, although Edmund had a son who predeceased him.
2. From then on, they appeared between three and six times at Christmas during Elizabeth's reign, usually competing for attention with the Admiral's Men. See Gurr, *The Shakespeare Company*, Appendix 6 for a full listing.
3. Professor Alan H. Nelson has researched their parish roles in great detail. John Heminges was also a freeman of the Grocers' Company.
4. See Gough, *The History of Myddle*, p. v, and Hey, *An English Rural Community*, pp. 1–12, where it is described as 'the greatest insight into that group [that is, "the middle sort"] of people' in early modern England.
5. See Cox, *The Annals of St Helen's Bishopsgate*, p. 17. The only Bishop of Landaff named Nicholas was Nicholas Ashby (1441–58). This reference refers to the property being flanked by accommodation for John Russell, presumably the courtier 1st Earl of Bedford (*c.* 1485–1555) and Alan Haw(u)te, who worked for Sir Brian Tuke, Treasurer of the Household.
6. Including the herald and important diplomat Thomas Benolt, buried in St Helen's in 1534 with a fine brass memorial, now lost. He was present at the funeral of Henry VII in 1509 and the coronation of Anne Boleyn in 1533. In 1537, Sir Arthur Darcy took over Benolt's house. Darcy's sister-in-law Anne Carew married Nicholas Throckmorton, whose daughter, in turn, married Sir Walter Raleigh. Other major figures include Guy Crayford, first recorded in 1536, a significant landowner in Kent whose widow Johane survived until 1584. In 1540, William Crane, Master of the King's Chapel, was given a significant property holding; see section 2 of the Appendix, n. 14. There was also a group of prominent Italians holding important property, including the merchant Dominic Lomley from as early as 1512, the financier Anthony Buonvisi from 1523 and Balthasar Guercy, doctor to Catherine of Aragon, from 1539.
7. Explored further below, see pp. 394–425: *c.* 1545, Thomas Coleshill (1524–95) married Mary Crayford, daughter of the wealthy Guy Crafford (1541 Lay Subsidy roll) and moved into a house on the south side of the Close. He was a future MP, as was his brother Robert. Thomas Coleshill was a dominant figure in parish affairs for the next twenty-five years. His daughter Susan(ne), in turn, married the courtier Edward Stanhope I and secured the powerful Stanhope family's interest in the area. There was a similar pattern with the priory of Holy Trinity, Aldgate just 350 yards to the east, which became the home of the Duke of Norfolk and for a time John Foxe; see Schofield and Lea, *Holy Trinity Priory, Aldgate*. Ross and Clark's *London: The Illustrated History*, p. 87, includes a plan of St Bartholomew's Priory in Smithfield showing how the buildings were divided into six upmarket residences, including one built in the former lady chapel, which was occupied by Sir Percival Hart, son-in-law of Susan Coleshill. The parallel evolution of the Blackfriars precinct has been subject to very detailed study due to the various attempts to insert theatres within the former buildings; see Smith, *Shakespeare's Blackfriars Playhouse*.
8. Also shown in his detailed will written in July 1599, TNA PROB 11/98/, 'beinge thirteene sheetes of paper . . . sealed together upon the top with his owne marke in harde wax', with donations to the poor, prisoners and London's hospitals.
9. Fitch finally made it back to England in April 1591. He returned to Aleppo as Consul of the Levant Company in 1596–7.
10. The minister at St Helen's was technically a rector. Church of England parish priests were classified as rectors, vicars or perpetual curates, the differences being largely the origin of their salary. Although it seems strange today, the rights to the parish tithes could be bought and sold with the owner paying the rector's salary, here at St Helen's £20 per annum, covering other parish costs and keeping any remaining income. A note at the end of the 1589 tithe survey, which aimed to raise more money from the richer parishioners, states, 'So that the whole tithe of the parsonage amounts yearlt to £33 3s 8d', for which the said farmers [William Kerwyn and Clement Kelke] are to pay £8 16s 1d to HM [Queen

Elizabeth I]; and for the yearly stipend of the minister £20; and for the yearly charge of bread and wine by estimation £4; and so remains towards the repairs of the chancel the sum of 7s 7d., besides such losses as the farmers are like to sustain upon their collection yearly. And yet they are contented to stand this ceasement upon a proof.' At the bottom, on 24 May 1589, W. Burghley added, 'I do allow that the farmers shall continue the receipt of the tenths and duties above expresse.'

11. His predecessor, Richard Lewis, the minister from *c.* 1585–90, also combined both roles, certainly in 1589. Lewis was one of Archbishop Whitgift's panel of 'press correctors', a group of trusted clerics responsible for reading through proposed publications, checking them for any deviancy from official orthodoxy and providing the licence to allow publication, in effect the religious censors. He named his third son Melchisadecke (Melchizedek), indicating some serious interest in messianic connections. This again suggests a person of considerable ability; see Morrissey, 'Episcopal Chaplains and Control of the Media'. Richard Ball, the minster from 1603 until *c.* 1615, was highly educated and had come to the area as professor of rhetoric at Gresham College; see Chapter 20, note 5.

12. Two years later he married Elizabeth, the widow of Dr Robert Norgate, formerly master of Corpus Christi College, Cambridge and vice-chancellor of the university. Elizabeth was also distantly related to Matthew Parker, Archbishop of Canterbury from 1575 to 1599.

13. Mattias de L'Obel (1538–1616) was a Fleming originally from Lille after whom the plant lobelia is named. He came to England, possibly as a Protestant refugee, 1566–71. After returning to the Continent to marry in 1596, he came back to London, dying in Highgate in 1616, aged seventy-eight. While many people will not have heard of L'Obel, most will have heard of John Gerard and his famous book, *The Herball or General historie of plante,* published in 1597. The success of his herbal did guarantee that Gerard is remembered widely, although he plagiarised significant amounts of his book from L'Obel's and other botanists' work; see Harkness, *The Jewel House,* pp. 49–56.

14. Harkness, *The Jewel House,* p. 21.

15. Peter Turner had been on natural history expeditions, including a trip in the 1570s with Thomas Penny when he was studying in Heidelberg; see Harkness, *The Jewel House,* p. 34 and footnote 32.

16. See, for a general introduction, Iyengar, *Shakespeare's Medical Language.*

17. He is first recorded in England about 1515 when, paid in advance, he was accused of failing to cure a bishop's servant of syphilis. A surgeon to Queen Catherine of Aragon, he obtained denization as a native of Italy on 16 March 1521/1522. John Skelton's ribald poem *Why Come ye Nat to Courte?* alleged that 'Balthasar' had not cured Domingo Lomelyn's (Dominic Lomeley of St Helen's) nose and that his promised treatment of 'our Cardinals [Wolsey's] eye' would result in its loss, and render him lame:

> In Balthasar, which healed
> Domingo's nose that was whealed;
> That Lombard's nose mean I,
> That standeth yet awry;
> It was not healed alderbest,
> It standeth somewhat on the west;
> I mean Domy[n]go Lomelyn
> That was wont to win
> Much money from the king
> At the cards and hazarding:
> Balthasar, that healed Domingo's nose
> From the pustuled pocky [poxy] pose,
> Now with his gums of Araby
> Hath promised to heal our cardinal's eye
> Yet some surgeons put a doubt
> Lest he will put it clean out,
> And make him lame of his nether limbs,
> God send him sorrow for his sins!

About 1530, Guercy obtained a Cambridge MB. On 11 December 1543, Eustace Chapuys, the Holy Roman Emperor's ambassador in London, recorded that Guercy, 'a singularly clever surgeon and able physician', had been sent to the Tower of London for upholding papal authority. Henry VIII then had Guercy released, 'for the Emperor's sake'. Following '16 years of study and practice', Guercy was granted his MD degree by special grace at Cambridge in 1546. In April 1539, he was granted ten houses in the street of St Mary Axe by the King. Later, he and his wife, Joan, purchased a 'cottage' from Anthony Buonvisi. Subsequently, Guercy moved to a large house within the Close of St Helen's. Due to his Catholic sentiments, Guercy fled from England without permission in early 1551 to find sanctuary overseas. Excluded by name from Edward VI's general act of pardon in 1553, he was back in England by 14 January 1554, when he was pardoned by Queen Mary. He was made fellow of the College of Physicians in 1556. By his will dated 14 December 1556, Guercy left his residence in the Close and four other properties in St Helen's, Bishopsgate, the ten other messuages in the parishes of St Mary Axe and St Andrew, Undershaft, with other properties to his sons, Benedict and Richard. His daughter Frances was left two houses in St Helen's and small bequests were made to friends, including doctors John Fryer, who lived in Crosby Hall, and (John) Clement. The printer William Rastell and Ranulph Cholmley, Recorder of London, were named as the overseers, showing his close connections to the group around Sir Thomas More. Guercy is said to have been buried at St Helen's on 10 January 1557 but his tomb, if he had one, does not survive. His daughter Frances married the wealthy Thomas Polsted, a merchant taylor, and lived in the neighbouring parish of St Martin Outwich, where he was recorded in the 1541 Lay Subsidy roll. Both Polsted's cousins Henry and Thomas were MPs; see *The History of Parliament*, online. A Henry Polsted, possibly this cousin, was leasing a site for an early bearbaiting ring on Bankside in 1552. However, following Thomas's death in the 1550s, Frances seems to have moved back into St Helen's and was buried in the church in 1569/70.

18. This seems to have been a substantial property. It was sold to William Harrington in 1581, then William Bond Junior in 1590, when his family seems to have been vacating Crosby Hall. It was then purchased by William and Thomas Hewitt in 1595. It may eventually have become all or part of 29 Great St Helen's. In the St Helen's Hearth Tax return of 1666, it was registered with ten hearths compared to thirty hearths for Crosby Hall and fifty-nine for Gresham College.

19. The purchase on 21 May 1561 recorded that Dr Caesar Adelmare bought a 'neat house and gardens, late part of the dissolved priory of St Helen's situate within the close of said priory' from the son of Balthasar Guercy.

20. In 1571, the Return of Strangers lists another foreign surgeon, James Johnson, as a 'Burgundian', i.e. from Flanders, who had arrived in London four years earlier but had only moved to St Helen's six weeks previously; see Kirk and Kirk, *Returns of Aliens Dwelling in the City and Suburbs of London*, p. 427.

21. See Guy, *Gresham's Law*, p. 205.

22. See Pelling, 'Failed Transmission', pp. 38–61, especially p. 53.

23. In the 1582 Lay Subsidy roll there were nineteen doctors of physic assessed for payment in the whole of the City of London, an average of one per five parishes. There were at least twenty-three doctors of law. This compares to probably nine and six respectively in the 1541 Lay Subsidy roll. The single parish of St Helen's was, therefore, home in 1598 to the equivalent of 16 per cent of the medical doctors assessed sixteen years earlier. This is particularly noteworthy as there were only five physicians in the entire eastern half of the City in 1582. The College of Physicians was based at Stone House in Knightrider Street, south of St Paul's Cathedral. See Lang, 'Introduction', note 95. There were, in addition, many unlicensed doctors such as Simon Forman; see Cook, *Dr Simon Forman*, especially pp. 48–58, and Harkness, *The Jewel House*, pp. 57–96.

24. He was nominated by the University of Oxford in February 1597 and began in the Autumn term 1598. He was admitted a licentiate of the College of Physicians of London 30 September 1600, and a fellow 22 December 1605. In 1605 he was appointed physician to the Tower of London. In 1605 at Magdalen College, Oxford, a play by Gwinne entitled *Vertumnus sive annus recurrens* was acted by students for James I. He was a colleague of Richard Ball, professor of rhetoric and later minister of St Helen's from 1603.

25. Richard Tayl(i)or, MD – recorded as born a Londoner, BA Corpus Christi College, Cambridge, 1576, and a doctor of medicine of Basil [Basle, Switzerland] – was admitted a Licentiate of the College of Physicians, 9 April 1582; Candidate, 22 December 1585; and a Fellow, 8 March 1588. He had a troubled relationship with the College. On 27 November 1585 he appeared and was accused of using gum ammoniac and also of having an unjust attitude towards the College. He was handed over to the custody of the sergeant at arms, but was freed upon entreaty of full humility, and fined £5. He promised to pay more attention to the judgement of the College in future. For repeated acts of contumacy to the College he was, on 8 May 1590, declared by the president, Dr Baronsdale, expelled from his Fellowship: 'e societate Collegii expulsus, et non alio loco habendus, quàm ille qui omnibus Collegii privilegiis est penitus deprivatus.' On the 30 September 1591, having made his humble submission and apology, he was reinstated in his Fellowship; see his entry in Pelling and White, *Physicians and Irregular Medical Practitioners*.

26. In the 1582 Lay Subsidy roll, he is recorded as living nearby in the parish of St Gabriel Fenchurch Street, a few minutes walk away from St Helen's. He made his will there in 1610 and was buried in the church in 1615. Interestingly, the radical Paracelsian Robert Fludd moved into Fenchurch Street in 1607; see Guariento, *Life, Friends, and Associations of Robert Fludd*. Fludd was possibly taught at Oxford University in the 1590s by Matthew Gwinne, who became Gresham College professor of physic in 1597/8.

27. Another possibility is that he acquired the Guercy/Adelmare house. He was perhaps still living in St Helen's in January 1607, when his grown-up son Richard was buried there. However, by then, records of 1604 and 1611 (TNA E115/394/107 and 45) show that he was paying the Lay Subsidy on his country estate at Plaistow, West Ham, Essex, now in inner London but then a horse ride of an hour or so out through the countryside on the north side of the Thames. Interestingly, the renowned surgeon William Clowes (c. 1543/4–1604) also had a country property in Plaistow. Clowes worked at St Bartholomew's Hospital from 1575–85 and would, presumably, have met Dr Rodrigo Lopez and Dr Peter Turner there during the latter's tenure there from 1581–4.

28. See TNA PROB 11/126/609.

29. Shakespeare's absence from the 1600 St Helen's Lay Subsidy roll could be due to a similar shift in the location for payment, in his case to Stratford-upon-Avon; see section 4 of the Appendix.

30. From 1580–4, when Turner became an MP, his position at St Bartholomew's Hospital meant he would have been provided with accommodation. His residence from 1584 until his move to St Helen's is unknown. His son Peter (1586–1652), the famous mathematician, was born during this time. Peter junior was Gresham professor of geometry 1620–30 and then moved to Oxford University to hold the Savilian Chair of Geometry, 1631–49.

31. Owned by the Leathersellers – see Leathersellers' Company *Liber Curtes* (ACC/1/1) paying £7-10s-0d rent, the highest rate of the thirteen properties on their St Helen's estate. Gorges and Dr Turner both served in the 1584 parliament, so they probably knew each other. The daughter may have been Lydia, who married Edward Rogers, a lawyer of Middle Temple, in St Helen's on 28 May 1612.

32. See Addyman, *William Turner: Father of English Botany*, pp. 12–40.

33. At Bologna, he is thought to have studied under Luca Ghini (1490–1556), the Italian physician and botanist, and 'probably saw the first herbariums – collections of dried plants – being established'; see Addyman, *William Turner: Father of English Botany*, p. 26. Ghini created the first herbarium in Pisa in 1544. This does not survive, but material collected by his student Gherado Cibo (1512–1600) survives today in the Pontifical University Library in Rome.

34. See Dr Peter Turner's entry in Pelling and White, *Physicians and Irregular Medical Practitioners*.

35. Celsus (c. 25 BC – c. AD 50), the Roman author, wrote *De Medicina*, one section of a much larger encyclopaedia. It was the first medical book to be printed, in 1478.

36. This Swiss physician and alchemist named himself after Celsus; see for a general study, Ball, *The Devil's Doctor*.

37. See Stensgaard, 'All's Well that Ends Well and the Galenico-Paracelsian Controversy'.

38. See Porter, *The Greatest Benefit to Mankind*, pp. 201–11, especially p. 203.

39. Turner, *A Booke of the Natures and Properties*, folio iii.

Living with Shakespeare

40. See Harkness, *The Jewel House*, pp. 89–91.
41. The book was by R.B., and was attributed to R. Bostocke, Esq. by the draper Andrew Maunsell in *The Seconde parte of the Catalogue of English printed Bookes* (London, 1595). Richard Bostock (c. 1530–1605) lived at Tandridge in Surrey and was MP for Bletchingly four times between 1571 and 1589. He probably developed an interest in Paracelsianism during his time at Cambridge, where he was part of a group that included Dr John Dee. Dee visited him in Tandridge in 1582 and recorded lending him a book on the West Indies the following year. He was, therefore, writing the book around the time of the 1584 parliament when Dr Peter Turner was also an MP; see Harley, 'Rychard Bostok of Tandridge, Surrey'.
42. There is an interesting potential connection with St Helen's with Charles Bostock (c. 1569–1633). It is not possible to establish a clear relationship with Richard Bostock. However, both clearly come from the extensive Cheshire Bostock family. Charles was the fifth son and executor of John Bostock of Bostock; see TNA PROB 11/83/389. In June 1600, Charles Bostock, a scrivener, married Mary Saunders, daughter of Sir Thomas Saunders, in St Helen's. The Saunders were another extensive family with wide connections. Alice Saunders was the mother of Sir Christopher Hatton. Although Charles appears to have lived, and was buried, in the nearby parish of St Bartholomew by the Exchange from 1600, he may have been living in St Helen's by 1609, when he was taken to court by Timothy Bathurst, a local wealthy grocer, and his wife's stepfather in a nasty family dispute over the inheritance of a group of probably two or three houses in Bishopsgate Street (see TNA C8/10/11). In 1614, he took over the lease of the former house of Robert Spring, which backed onto the properties where Shakespeare probably had lived and Dr Peter Turner's house. In 1629, this property included 'a greate warehouse now in the occupacon of Charles Bostock'; see Leathersellers' lease to George Leech, in *Copies of Leases and Deeds, 1555–1660* (EST/8/1). There is no information about what Bostock was trading, but he was certainly doing more than working as a scrivener. Charles's son, the long-lived Charles junior (1606–1700), was a doctor. A John Bostock was married in St Botolph, Bishopsgate in 1598. The oldest surviving English sampler, preserved in the V&A Museum (T.190-1960) and dated 1598, was stitched by Jane Bostock(e), another member of this extended family (see Figure 14.7); see King, 'The Earliest Dated Sampler'.
43. In 1571, aged twenty-nine, Severinus published *Idea medicinæ philosophicæ*, explaining his interpretation of Paracelsus' ideas and his view that these were superior to those of Galen. Turner would have arrived in Heidelberg at a period of intense debate among academics and doctors.
44. For a detailed discussion of Dr Muffet's role, see Debus (1965), pp. 71–6. Dr Penn(e)y's will, dated 4 June 1588 (TNA PROB 11/73/215), highlights the interconnections between this group of doctors and radical Puritan ministers, the latter all spending periods in prison. Penny left money and/or books to three ministers, Nicholas Cra(i)ne 'now in the gatehouse [prison]', who died in Newgate in 1588, Giles Wigginton, and the future martyr John Penry ('Pennyre'). The latter was hanged at four p.m. on 29 May 1593, at St Thomas-a-Watering – curiously, as has been pointed out by conspiracy theorists, the day before the murder of Christopher Marlowe three miles away in Deptford. All three were connected to the printing of the anti-episcopacy 'Marprelate tracts' in 1588/9. The secret printing press used was housed in early 1589 at Whitefriars, Coventry, the house of John Hales, whose mother was the daughter of Sir William Lucy of Charlecote House, just outside Stratford-upon-Avon. It is not clear how this branch of the Hales family connected to the Kentish Hales; see below, pp. 315–20. The five medical men who received bequests were Dr Browne, William Brewer, John Banister, Dr Thomas Muffet/Moffett ('Muifett'), Mr Carter and Dr Peter Turner. Dr Browne, almost certainly Lancelot Browne (1545–1605) given his interest in Arabic culture, received travel books relating to the Middle East 'the *observations* in frenche of Bellonius [the naturalist and traveller Pierre Belon (1517–1564), who visited Egypt and Arabia] bounde with his booke *de coniferis arboribus* also *Periplus* Arians in greeke and latin [Arrian's *Periplus of the Euxine Sea*]'. Dr Mouffet received 'my written books of Isarke(?)' and ' . . . all my other books *de Alchimia* written or printed . . .' Mr Carter, probably the surgeon Henry Carter, was given '*Epitome Galene* and the twoe volumes of Paraselsiis in Latten *in sitano* . . .', while Dr Turner only got 'my hower glasse'. Perhaps Peter Turner already had an extensive medical library.

45. Dr Turner supported Valentine Russwurin, an itinerant 'Allmaigne [German] surgeon' medical practitioner who followed Paracelsian ideas and arrived in London in spring 1573. They visited patients together. For a full discussion, see Harkness, *The Jewel House*, pp. 57–96.
46. Dr Turner received a bequest in North's will, describing him as 'my physician'. Roger's brother was Sir Thomas North (1535–1604), who translated Plutarch's *Parallel Lives* into English in 1579. This was a significant source for several of Shakespeare's plays.
47. He owned a house built out of the remains of the Blackfriars, just to the south of the house of Elizabeth Russell. His famous ancestor Sir John Oldcastle was sent up by Shakespeare; Laoutaris, *Shakespeare and the Countess*, pp. 230–3. He was imprisoned in the Tower of London as a result of his involvement in the Main Plot of 1603 to depose James I in favour of Lady Arabella Stuart.
48. Dr Turner's and Alderman John Robinson's houses were in the west and north wings of the former nunnery respectively and commanded the highest rents of £7-10s-0d and £6-13s-4d. Turner's leases of 1606 and 1611 specifically stated where the property was located. Alderman John Robinson the Elder's lease of 1578 and his will of 1599 recorded that his house was in Little St Helen's, indicating it was the former frater on the north side of the cloister, 'I give and bequeathe unto John Robinson my oldest sone . . . And thone moyetie of the Lease of my dwelling house, in little Sainte Ellens in London, he payenge thone haulf of the rent . . .' The other half was left to his son Henry. John Robinson the Elder must have felt his own house was large enough to be divided into two family-sized homes. The Leathersellers' records show that another son, Robert, actually took over the whole lease until 1613, when a mercer, Robert Hungate, started leasing the property.
49. For further information about the property, see section 3 of the Appendix.
50. Dr Turner clearly liked the location, as he leased the property from the Leathersellers for twenty-five years until his death in 1614. In 1606, when he signed a new lease, the annual rent was increased threefold to £20 from 1609, suggesting that in 1589 he had paid a significant fine (premium) to acquire the original lease. Dr Peter Turner was buried near his father in an elaborate, highly coloured tomb in the nearby church of St Olave, Hart Street, London, which can still be seen.
51. Turner (1603), eight pages – on the copy in the British Library, handwritten in ink below title, 'beinge the yeare of the great plague' – signed Samuel Harrison. Harrison knew the family of Robert 'Sandy' Napier and there is a letter of 1632 in the Bodleian Library from him to Richard Napier junior, the grandson of Alderman John Robinson the Elder.
52. Or at least according to Simon Forman; see Cook, *Dr Simon Forman*, pp. 171–6. The plague killed Forman's only son, Joshua. The fact that Dr Turner published a plague-related pamphlet in 1603 suggests he was in London for some of this time.
53. See Addyman, *William Turner: Father of English Botany*, p. 4.
54. The Lord Mayor, due to his control of the capital, England's largest city and its associated wealth, was *de facto* the second most powerful person in the country.

# 15

## Dr Peter Turner Visits a Patient at the Sign of the Horse Head Inn

*In which we learn a little about the treatment of mental illness in Elizabethan London. Was Richard Whittingham tied down to a bed, or did he have his 'wits about him'? Was he going to be sent to Bedlam to protect his neighbours?*

Unfortunately, we will probably never know for certain if Dr Turner discussed his patients and medical ideas with Shakespeare or allowed him access to his books. However, there are one or two interesting suggestions. A particular insight is given by a legal deposition by Dr Turner relating to Richard Whittingham, a clerk of Sir John Smith,[1] who died at Christmas 1596. This means the events described took place in the preceding couple of months, when Dr Peter Turner and the newly arrived Dr Edward Jorden were both living in St Helen's and around the time Shakespeare may have been a close neighbour to them.[2]

The case is a typical investigation into a tortuous Elizabethan conspiracy to defraud Queen Elizabeth I of land in Crayford, Kent. It involved some of Whittingham's relatives forging his wills; the enquiry had to decide if he had made a will or was mad, 'distracted of his wits', and incapable of doing so. Nearly fifty witnesses made depositions, ranging from claims that Whittingham was entirely sane to claims that 'for his frenzy and lunacy' he had been tied down to a bed and they had seen the resulting chafing marks on his arms, wrists and ankles.[3] Roland Sleford, the seventy-year-old ex-keeper of Bedlam (the Bethlem Hospital for the mentally ill), was called to state whether Whittingham's friends had planned to place him there. Several witnesses claimed this was the case, but the canny Sleford said he could remember nothing.[4]

For a brief moment, it is possible to escape from a history based on burial records, house leases and tax demands and get down to street level to see real people going about their everyday business. Who should walk into our view, probably in October or November 1596, but Dr Peter Turner? He has left his house in St Helen's because he has been asked to come and examine this man, 'distracted of his wits'. Living so close to Bedlam, London's only facility for people with mental health problems, Dr Turner is probably used to being called to give his opinion and advise on treatments. Leaving St Helen's, he walks east along Fenchurch Street for five minutes and exits the walled City through Aldgate. The main road to Whitechapel, Colchester and Norwich is crowded with people, carts and animals being brought in 'on the hoof' for the butchers. The sprawling suburb is poor and crowded, smelling of horses, stale sweat and fresh

meat. He passes Aldgate bars, the legal limit of the City, and sees ahead the tower of St Mary Matfelon, the parish church of Whitechapel. In front of it is the sign of the Horse Head Inn. This is a popular drinking spot and also has rooms for rent. It is run by Mrs Chapel, Whittingham's mother-in-law, and her son. A barman, a 'tapster', says that Whittingham is upstairs; Dr Turner finds the room and knocks on the door. Perhaps it is opened by Joane Vere, one of Whittingham's carers, who will later be called as a witness.

Five years later, in September 1601, Dr Turner deposes to a clerk what he can remember:

Peter Turner of London, Doctor of Physic, of the age of 56 years[5] or thereabouts, sworne &c.

That he well remember that this deponent was sent for to a house against Whitechaple Church without Aldgate, London, that was an inn or some victualling house, but by whom he now remembereth not, for this end and purpose, that this deponent would deliver his opinion touching the state or disease of a man that then lay there, whom he thinketh to be the party who in this interrogatory is named, Richard Whittingham, and accordingly this deponent went, but how long ago, or what time of year it was, or how often he was there, he saith he doth not perfectly remember, but thinketh that he was there twice with the said diseased party, if not oftener, and he remembereth that once when this deponent was there that party was not in his bed, but was going in and out in some of the rooms of said house

That he this deponent had little talk or none at all with the said Whittingham, that he now remembereth, but he well remembereth that he had some talk with some of the house that had sent for the deponent, during which time the said Whittingham came in and out and passed from one place to another, and looked very wildly and as a man far over-gone with melancholy, but he used no speeches that this deposed can now call to remembrance . . .

Whittingham in this deponent's then judgement was very likely to fall into some great melancholy, if by means of physic it were not prevented, so as he might thereby be in hazard to lose his sense and understanding . . . but well remembereth that he [Whittingham] was very sullen and much given to melancholy . . . That he this deponent thinketh that at such a time as this deponent was with the said Whittingham, he was not so far past understanding and memory as that he was altogether disabled in his sense to make a will and to dispose of his estate, if he could have been by any means drawn or persuaded to do it, for that this deponent thinketh he might somewhat remember what he had to dispose of, and to tell whom he did most affect . . . he could not be persuaded to any such matter, for that (as it was said) no

physicians could draw him to yield to the taking of physic for the curing of his malady, because . . . he thought himself not sick.

And this deponent further saith that he did fear lest the said Whittingham would fall into the highest degree of melancholy, and lose his wits for want of sleep if it was not prevented by good course of physic, and so much that this deponent to the best of his remembrance did acquaint them of the house with: And he saith that he this deponent did afterwards hear some report that the said Whittingham died mad and bound in his bed, and he saith that it was likely to come to that case in this deponent's judgment when he was with him, but whether the same was prevented by some course of physic or not, he knoweth not, but besides such other things as this deponent did advise that he should have been let blood, besides such other things as this deponent then prescribed, which he now remembereth not, nor how far this deponent's direction in that behalf was observed. And more &c.

[signed] Peter Turner Doctor of Phisick

Anther deponent stated that Whittingham had his head shaved so it could be covered with a plaster. Others recorded that the patient ran about in the street in only his shirt, intimidating people and threatening to push one person into a fire. Dr Turner's language also captures Whittingham's state of mind: 'looked very wildly', 'man far over-gone with melancholy', 'sullen' and 'was very likely to fall into some greater melancholy'.

The 'lose his wits for lack of sleep' particularly brings to mind Macbeth, Act II:

> **Macbeth**
> Methought I heard a voice cry 'Sleep no more,
> Macbeth does murder sleep' – the innocent sleep,
> Sleep that knits up the raveled sleave of care,
> The death of each day's life, sore labour's bath,
> Balm of hurt minds, great nature's second course,
> Chief nourisher in life's feast–
> (*Macbeth*, II.ii.33–8)

and later in *Macbeth* Act V, Scene i as the Doctor and the Gentlewoman watch Lady Macbeth sleepwalking:

> **Doctor**
> This disease is beyond my practice. Yet I have known
> those which have walked in their sleep who have died
> holily in their beds.
> [. . .]

> infected minds
> To their deaf pillows will discharge their secrets.
> More needs she the divine than the physician
> (*Macbeth*, V.i.56–68; 69–71)

Shakespeare could have based his writings on accounts from medical books in the same way that he drew on Samuel Harsnett's descriptions for *King Lear*. However, in highlighting the fragile boundaries between sleeplessness, melancholia and madness, it is possible we are hearing the reworked recollections of doctors' dealings with real patients.

For Shakespeare, such eminent neighbours, including the Lord Mayor, must have fuelled his own aspirations. In 1595, Dr Peter Turner may have been a rich and successful doctor and an ex-MP but his grandfather had only been a tanner, albeit a successful one, in Morpeth in the wilds of Northumberland. It was a background not that far removed from John Shakespeare's gloving/wool business. His father, William Turner, had of course benefited from an excellent university education, but his fluctuating fortunes and two exiles on the Continent had not resulted in huge wealth. Dr Peter Turner was an object lesson in successful social promotion. His two eldest sons, Samuel (*c.* 1584–1647) and Peter (1586–1652), were of similar age to Hamnet Shakespeare and destined for St Mary Hall, Oxford. It is at this time that Shakespeare was focusing on the twin advertisements of social advancement, securing a coat of arms in 1596 and planning to acquire a suitable out-of-London residence, something he achieved with the purchase of New Place, Stratford early in 1597. There was no reason why Shakespeare might not have planned for Hamnet to attend Oxford or Cambridge in five or six years' time.

Perhaps his thoughts even began to turn to a suitable match for his son. The St Helen's marriage register contains a brief entry, 'Jan. 10 [1597] Michaell Stanhope and Anne Reade', which records what must have been one of the most brilliant marriages in the church's history. It was the union of the future Sir Michael Stanhope, MP (*c.* 1549 – *c.* 1621), one of Elizabeth I's Grooms of the Privy Chamber, and one of five brothers who all became MPs, with Anne the granddaughter of the recently deceased Anne Gresham. Two years later, in 1599, Michael Stanhope and his lawyer brother, Edward Stanhope II, acquired the rectory rights of the parish and clearly saw St Helen's as a good place for the Stanhope clan in London.[6] Two of Michael's daughters were christened in the church in 1601 and 1605. However, by 1597, Hamnet was dead, and William Shakespeare's direct line then descended through his two daughters to its final extinction in 1670.

Another interesting insight into Dr Turner's medical activities is provided by John Manningham, a barrister at Middle Temple, who knew his brother-in-law Henry Parry junior. In his diary for October 1602, he notes:[7]

> There is a kinde of compound called *Laudanum*, which may be had at Dr Turner's apothecary in Bishopgate Streete:⁰ the virtue of is very soveraigne to mitigate anie payne; it will for a tyme lay a man in a sweete trans, as Dr Parry told me he tried in a fever, and his sister Mrs Turner in hir childbirth[9]

Laudanum was one of Paracelsus' wonder drugs, although there has been much debate about what he actually created.[10] His assistant Oporinus claimed:

> [Paracelsus] had pills which he called laudanum and which had the form of mice excrements, but he used them only in cases of extreme emergency. He boasted that with these pills he could wake up the dead, and indeed he proved that patients who seemed dead suddenly arose.[11]

Paracelsus developed a tincture of opium for pain management and termed it laudanum, from the Latin *laudare*, to praise. His preparation was claimed to contain opium, crushed pearls, musk, amber, and other substances, while the *London Pharmacopoeia* (1618) listed opium, saffron, castor, ambergris, musk and nutmeg as ingredients of laudanum. No doubt the exotic mixture helped to justify a high price to desperate patients. Shakespeare was aware of the effects of opium and other drugs:

> Not poppy nor mandragora[12]
> Nor all the drowsy syrups of the world
> Shall ever medicine thee to that sweet sleep
> Which thou ow'dst yesterday.
> (*Othello*, III. Iii. 334–7)

Mandragora is mandrake, a known hallucinogenic mentioned several times by Shakespeare. Its oddly shaped roots were imported into London from the Mediterranean. Indeed, Peter Turner's father complained in his herbal about how the poor were tricked into buying fake 'male' and 'female' mandrake roots:[13]

> The rootes which are counterfited and made like little pupettes or mammettes which come to be sold in England in boxes with heir and such forme as a man hath are nothyng elles but foolishe trifles and not naturall. For they are so trymmed of crafty theves to mocke the poore people with all and to rob them both of theyr wit and theyr money.

while Shakespeare commented sardonically:

> . . . he was for all the world like a forked radish, with a head fantastically carved upon it with a knife. A was so forlorn that his dimensions, to any thick sight, were invisible; . . . yet lecherous as a monkey, and the whores called him mandrake.
> (*II Henry IV*, III.ii.305–9)

His plays also note its use as a sedative:

> Were such things here as we do speak about,
> Or have we eaten of the insane root
> That takes the reason prisoner?
> (*Macbeth*, I.iii.81–3)

as a lucky charm,

> Thou whoreson mandrake, thou art fitter to be worn in my cap than to wait at my heels.
> (*II Henry IV*, I.ii.14–16)

and as a cursing agent:

> what with loathsome smells,
> And shrieks like mandrakes torn out of the earth,
> That living mortals, hearing them, run mad . . .
> (*Romeo and Juliet*, IV.iii.45–7)

Dr Peter Turner was firmly committed to the Puritan movement in politics, as shown by his actions in Parliament during the struggles over further reform of the Church of England, particularly the replacement of bishops by a Presbyterian form of government:[14]

> On 14 Dec. 1584 . . . Turner – the representative of a more extreme wing of the party – called for a Bill and Book to be read, which he had previously deposited with the clerk of the House. The bill, which had been 'framed by certain godly and learned ministers', would have had the effect of replacing the prayer book then in use by the Genevan *Form of Prayers*, a new edition of which had only recently been issued in London, and would have set up a Presbyterian system of ministers and elders in the church. Turner's motion was 'received coldly . . . and it was agreed that the Bill and Book should not be read'.[15]

He was also strongly anti-Catholic, speaking against Mary Queen of Scots in the parliament of 1586:

Her Majesty's safety cannot be sufficiently provided for by the speedy cutting off of the Queen of Scots, unless some good means be had withal for the rooting out of Papistry, either by making some good new laws for that purpose, or else by the good and due execution of the laws already in force . . . so concluding in his own conscience that no Papist can be a good subject.[16]

Dr Turner's house also had an interesting connection to other areas of Elizabethan medicine and science. After Turner's death in 1614, the lease on his house was taken over by a mercer, John Grove, rather than by one of his children. It is not clear why. Peter Turner junior, the oldest son, maintained a local connection, as he was professor of geometry at Gresham College from 1620–30. By the late 1620s, the house was occupied by Sir William Ayloffe and Dr Patrick Saunders. This was the Patrick Saunders who *c*. 1604, then a young man aged about twenty-four, became the assistant of the famous Dr John Dee (1527–1609).[17] By this time, Dr Dee was nearly eighty and in relative poverty (Figures 15.1 and 15.2). It is now thought that he died in the house of John Pontois, who lived nearby in Bishopsgate Street, possibly just to the south in the parish of St Martin Outwich.[18] Elias Ashmole recorded that Dr Saunders

> practised Physick and dwelt in Bishopsgate Streete. He was a moderate Astrologer, & used the Christall, wherein he had instruction from a Fidleer in Moorefields who had a pure sight.[19]

Saunders 'played a pivotal role in in the dispersal of Dee's great library after his death, and owned himself a number of Dee's acquisitions (thirteen manuscripts and six printed books bearing Saunder's name survive from Dee's collection)'.[20] Saunders, in his will, left 'all my books and manuscripts' to his son Patrick, also a doctor.[21] So, for a while, some of the library of Dr John Dee, who has often been claimed as the model for Prospero in *The Tempest* (1613), was kept in the house next door to where Shakespeare had been living a decade earlier.

In 1595 and thus during Shakespeare's likely residency, Drs Taylor and Turner were joined by the young and recently married Dr Edward Jorden (1564–1633). Jorden, recently qualified, was not only a medical doctor but had also studied chemistry.[22] His progress was rapid and he was made a full fellow of the College of Physicians two years later.[23] The details of his education are disputed but he travelled on the Continent, where medical training was recognised as being far in advance of that in England. He is recorded as receiving his medical education in Italy, attending classes at the universities of Padua, Bologna and Ferrara. He received his MD from the University of Padua, recognised as the leading centre for anatomy, *c*. 1591. There he would have become familiar with the work of Gabriele Falloppio, or 'Fallopius' (1523–62), a specialist in

Figure 15.1　Dr John Dee's extraordinary life combined a fascination with mathematics, navigation and astronomy with astrology and alchemy. He died aged eighty-one in Bishopsgate Street in 1609.

Figure 15.2　A *volvella* of the moon, a rotating set of paper discs used to show the position of the sun and moon within the signs of the zodiac. Astrology and the lunar cycle were closely linked to health in Elizabethan England. English, late fifteenth century.

Figure 15.3  Dr Edward Jorden's research into spas during his studies in northern Italy led him to take a great interest in Bath. Map by John Speed (1610) with a detail of the King's Bath (lower left), where Jorden's son drowned in 1611.

Figure 15.4  Dr Jorden promoted the benefits of spa water as part of his broader interest in the effectiveness of 'chemical' medicines. He eventually moved to Bath and was buried in the Abbey in 1633.

anatomy, sexuality (he was the first person to describe a condom) and the benefits of mineral baths.[24] He is also known to have met the multi-talented Dr Andreas Libavius, who was a strong believer in alchemy, on his travels.

Jorden is most often mentioned today because of his interest in hysteria, which is discussed later in Chapters 18–20. However, Jorden's interests, which he had developed at the leading universities in northern Italy, extended to the effectiveness of medicinal springs and spas, a growing interest in the late sixteenth century. In the context of the group of doctors living in St Helen's, it is interesting as noted above that the first known book in English to discuss the benefits of mineral waters was written by William Turner, father of Dr Peter Turner.[25] One wonders if Dr Jorden deliberately chose to live near his son. Jorden was also a practical chemist and became involved in a loss-making enterprise to exploit alum[26] as well as the promotion of Bath as a spa (Figures 15.3 and 15.4).[27] Noel G. Coley notes:

> A more general account of the origins, chemical contents, and medicinal properties of English mineral waters was published in 1631 by Edward Jorden,[28] physician at Bath. A friend of Libavius, Jorden adopted the iatrochemical tradition of Paracelsus and Van Helmont and was amongst the earliest of the 'chymical physicians' in England. His book went out of print after two editions, but was later revived by Thomas Guidott in 1669, who summarized Jorden's classification of minerals in a table (see Fig. 1). Jorden was a pioneer of chemical analysis and his book became a standard for many later seventeenth-century physicians who followed his lead.[29]

The three doctors must have formed a distinctive trio for the eight or more years when they practised close to each other.[30] It is probable that Taylor and Jorden lived in the Close near to Turner, a highly suitable location for such professionals. If not, they must have lived only a few minutes away. They all had young families and in 1598 had about twelve living children between them, aged from approximately one to sixteen years old. In 1597, their three wives were all pregnant at the same time and gave birth within three months of each other.[31] Despite their difference in ages, they must surely have met together, whether to discuss problems with their patients or the latest medical ideas from Italy.[32] For example, Dr Taylor and Dr Turner would have been alarmed by the arrest of the Queen's physician, Dr Roderigo Lopez, for treason in January 1594 – which was followed by his conviction and horrific execution by hanging, drawing and quartering at Tyburn in June. Apart from a natural concern for the reputation of their own profession, Dr Peter Turner had succeeded Lopez as doctor in charge of St Bartholomew Hospital and must have known him and his work well.[33]

Dr Jorden was the closest in age to Shakespeare, being just four months younger but, in 1595, with a much broader knowledge of the world through his European travels and

university education in Padua. He probably had more in common with Shakespeare than the two older doctors, although the latter's daughters would have been closer in age to those of Dr Taylor.[34]

Shakespeare would have at least been on nodding acquaintance with Dr Jorden. However, the impression of Jorden as an inquisitive and caring man with a sympathetic interest in women's medical issues, including their mental conditions, indicates someone with whom Shakespeare would have been interested in discussing the matters of the day and wider philosophical questions.[35]

Jorden had a particular interest in spas and mineral waters all his life, which had started with his experiences in Italy. It was driven by the fact that spas were demonstrably beneficial and that, by distillation, he and chemists could clearly identify their different mineral content. Spas, therefore, provided an experimental template for how different applications of therapy using mixtures of chemical/mineral substances (as opposed to, for instance, theories of humours) could work as specific positive treatments. In 1571, the Danish royal physician Petrus Severinus produced his *Idea Medicinae Philosophicae*, which promoted Paracelsian thinking, and it clearly influenced Jorden.[36] Joel Shackleford explains:

> Jorden argued that the peculiar healing virtues of thermal baths arose from the generative properties specific to each spa's water and related to its particular heat. Therefore, the uniqueness of each spring hinges on the particular mixture of mineral salts dissolved in the water. Jorden identified these as 'Minerall iuyces concrete: called by the Alchemists, Salts.' Each of these salts has its own identity and its own specific virtue.' . . . Jorden [believed] Minerals (and their salts) are living beings, as plants and animals, and like them they occur in species that are distinguished by special characteristics – 'every kinde hath his owne fashion' . . . Jorden wrote that the reason for the differences in mineral species cannot be accounted for by the elements or their qualities . . . 'but only from the forme, anima, seed, &c. which frames every species to his owne figure, order, number, quantity, colour, taste, smell, &c . . .'

Jorden considered that minerals could spread as seeds (*semina*). Although this concept seems very strange today, it made sense in the context of Elizabethan knowledge and thought.

Jorden's particular interest in women's health may have developed because his wife's first pregnancy, in 1596, ended in stillborn twins. Twins were a rare occurrence among births in St Helen's; between 1590 and 1600, there were only two sets out of *c.* 200 recorded births.[37] Shakespeare had his own twins in 1585, which presumably prompted his curiosity about the phenomenon, and identical twins feature in two of his comedies. However, twins of any sort were often seen in a less than positive light at this time.[38]

Women were considered the weaker sex from both a theological and a physical perspective and, as a result, subject to a wider range of ailments then men. Doctors debated the causes of these problems and a generally held view was that the uterus, often termed 'the mother', moved around inside a woman's body, putting pressure on different organs and resulting in a variety of side-effects. In extreme cases, termed *hysterica passio*, the condition could cause suffocation in the throat or various types of fits. For many, the sight of such symptoms was sufficient evidence that someone had been bewitched.

In 1603, Dr Jorden published an extended pamphlet on this subject, *A Briefe discourse of a Disease called the Suffocation of the Mother*. This is famous for being one of the first attempts to explain how physical symptoms could be the result of mental upheaval – psychosomatic effects, in modern terms. However, as will be seen in the next section, this was no obscure medical publication but part of a wider struggle in England over religious orthodoxy. The scope of the pamphlet, which Jorden wrote in only three months, suggests this had been a long-term interest, alongside his work on spa waters. Since many mothers had six or more children, Jorden may also have recognised the benefit of spas as a therapeutic treatment for women. Given all these interests, it seems likely that he would have investigated the factors that shaped madness and melancholy. At the time, there was no clear distinction between physical and mental illness, so he must have been interested in whether the type of mineral- or chemical-based therapy he was writing about could change behaviour.

Therefore, one can suggest the possibility that in the 1590s, Shakespeare had access to the extensive experience, opinions and books of several doctors, who themselves probably met together. These were men with knowledge gained from studying at leading European universities in Italy and Germany, travelling across the Continent and meeting/corresponding with some of the leading thinkers of the time. It would be understandable if the grammar school boy from the provinces was fascinated and somewhat awed by this concentration of knowledge. They could have given Shakespeare an insight into the range of current opinions, particularly on the factors that shaped human personality. Dr Turner certainly, and probably both Drs Jorden and Taylor, had direct experience of treating mental illness and they probably discussed what caused humans to lose their mind.[39] This would not only have provided specific reference material for Shakespeare's plays, but a more general and broader understanding of the drivers of human psychology.

## Notes

1. This Sir John Smith (1534?–1607) was a diplomat and writer on military affairs. He sounds somewhat unstable himself. He was kept in the Tower of London from June 1596 until February 1598 for making a treasonous speech, and this fall was claimed by a witness to account for why his servant Whittingham had become unhinged.
2. I am indebted to Professor Alan H. Nelson for this reference; see TNA C24/297.
3. Such investigations were done with depositions by relevant witnesses. They would give verbal answers to a set of written questions, which would be written down by a clerk. Thousands of such Elizabethan depositions are preserved in the National Archives, most unstudied. It is from such a deposition of 1612 that it is known that Shakespeare was a lodger in Silver Street with Christopher Mountjoy *c.* 1602/04. The witnesses in this case included the wife and daughter of Dr John Martyn, who might be the 'stranger' Dr Martyn recorded in St Helen's in 1564 – see Kirk and Kirk, *Returns of Aliens Dwelling in the City and Suburbs of London* – when he was assessed at £150.
4. Roland Sleford, a clothmaker, was keeper of Bethlem from 1579 to 1598. It was during this period that the hospital fell into an appalling state resulting in a survey by the governors of Bridewell in November 1598; see *Minutes of the Courts of Governors of Bridewell 1559–1971*, BCB-04, <https://archives.museumofthemind.org.uk/BCB.htm> (last accessed 4 August 2020). At this time there were twenty-one inmates.
5. This would make Turner's date of birth 1544, which conflicts with his funerary monument, which states he died aged seventy-two, putting his birth in 1542.
6. In 1600, Sir Michael Stanhope acquired the manor of Sudbourne in Suffolk, where he erected a magnificent memorial to himself and his family in 1621. This survives in All Saints Church. For his will, see TNA PROB 11/139/119.
7. See Bruce, *Diary of John Manningham of the Middle Temple*, p. 46 (folio 34).
8. It is not certain who this was, particularly since, before the founding of the Society of Apothecaries of London in 1617, most belonged to the Grocers' Company. A possibility is the apothecary William Checkley (also Chetley), who lived in Bishopsgate. Four of his children were christened in St Helen's in the period 1596–1601, when he is recorded as a grocer. In his 1604 will (another) John Robinson, a merchant taylor, described him as his 'loving friend'; see TNA PROB 11/103/421. From *c.* 1617 he lived in St Ethelburga to the north. Despite being a charter member of the Apothecaries in 1617 and a member of their first Court, by 1623 he had become an innkeeper. In that year he was prosecuted by the College of Physicians for supplying anti-epileptic water and fined £2 and imprisoned 'as he joked'. Alternatively, there is also a John Chetley recorded as 'an apothecary of Bishopsgate Street' in 1595. This might be a relative or perhaps the same person, given that the date would fit with the christenings at St Helen's. Chetley was prosecuted because he 'had given Thomas Gwin a lenitive clyster, a pill of Cassia Rhabarbari & Terebinthia Tosta, a bolus of Succinus, Gum Tragacanth, and Mastiches. Chetley said he had given the pill and bolus on the advice of Dr Banister, the potion and clyster on the advice of Dr Jordan. Jordan said he had only suggested the clyster and had recommended a potion of Dia Scordium'; see Pelling and White, *Physicians and Irregular Medical Practitioners*.
9. Pascha Turner's last child was Margaret, christened in St Helen's on 25 October 1600 but buried less than a year later on 15 October 1601. Manningham also noted the following information: 'Dr Parry told howe his father was Deane [actually Chancellor] of Salisbury, kept a sumptuous house, spent above his revenewe, was carefull to prefer such as were men of hope, used to have shows at his house, wherein he would have his sonne an actor to embolden him'; see Bruce, *Diary of John Manningham of the Middle Temple*. These plays would presumably have been around the early 1570s, as by 1576 Parry junior was at Oxford University.
10. See Ball, *The Devil's Doctor*, pp. 186–90.
11. Ibid. p. 187.
12. Opium and mandrake are also joined together in Christopher Marlowe's *The Jew of Malta*. Barabas escapes by drinking a concoction of poppy and mandrake juice, which puts him into a deep sleep so

that his enemies will think he is dead: 'I drank of poppy and cold mandrake juice And being asleep, belike they thought me dead, And threw me over the walls' (Act V). Poppies and mandrake are often listed together in contemporary herbals.

13. Chapman, McCombie and Wesencraft, *William Turner: A New Herball*, p. 437.
14. See Collinson, *The Elizabethan Puritan Movement*, where he notes: 'The programme contained in the bill and book was so extreme, so manifestly unacceptable, not only to the queen but to all responsible opinion, that one marvels at the sanguinity of its sponsors . . .'
15. See Hasler, *The History of Parliament*.
16. See his entry in *The History of Parliament* online.
17. Following a warning in 1613, when he claimed ten years' study, Saunders was called before the College of Physicians in December 1617 for illicit practice and admitted he had done so for four years following Polish and German methods (i.e. iatrochemistry); see Pelling and White, *Physicians and Irregular Medical Practitioners*. He was prohibited from practising and then went to Franeker University, a Puritan centre in north-west Holland, where he obtained an MD in 1619. On his return to England, he was elected a member of the College of Physicians in 1620. He married Sara Smith on 27 December 1613 at St Saviours, Southwark and remarried after her death in 1632. Four of his children were baptised in St Helen's: Sara in 1621, Patrick in 1623 and, from his second marriage, Anne in 1634 and Underhill in 1637.
18. John Pontois was vice-admiral of the Colony of Virginia. He was left Dr Dee's library, but it was neglected after he sailed to America. He died in 1624, after returning to London, and left all his books to Dr Saunders and a Paracelsian surgeon, John Woodall. A major court case then ensued; see TNA C24/507.
19. Bodleian Library, Ashmole MS 419, vol. 2, f. 1.
20. Information kindly provided by Peter Elmer from his medical database. The editors of Dee's library catalogue speculate that Saunders may have been involved in the library in a number of ways: 1) recording the return of manuscripts, mainly alchemical between 1606-8; 2) in writing his own name in some of Dee's books before the latter's death (for deception, fraud or other motive) and 3) as someone who inherited some of Dee's books and manuscripts.
21. His will is TNA PROB 11/178/372, dated 3 September 1636 and proved 14 November 1638. Saunders was buried in the churchyard of St Helen's on 8 September 1636. He left his wife Anne 'my best lute and Orpherion [a stringed instrument]'.
22. Jorden's date of birth is often given as 1569, but Peter Elmer's medical database records it as 1564 with confirmation from the Cranbrook parish register. He was tested to become a licentiate of the College of Physicians on 4 July 1595 and was fully admitted on 7 November. His father, also Edward Jorden, died in 1593 and bequeathed his son an annuity of £25 a year with some short-term deductions; see TNA PROB 11/82/73. This income would have been sufficient to set Jorden junior up in practice and to support a family.
23. It is interesting that in the 1598 Lay Subsidy roll, Dr Edward Jorden was assessed at £8 after only three years of practising, while Dr Peter Turner with over twenty years of experience and 'society' patients was only slightly higher at £10. However, the uncertainty over the precise meaning of these assessments has already been noted. The relative valuations seem even stranger when one considers the size of Dr Turner's house.
24. Some information about Jorden is provided in the preface by Thomas Guidott to the fifth edition of his book on mineral waters. He was the son of Edward Jorden of Cranbrook, Kent, and was baptised there on 13 August 1564. He was admitted to Peterhouse, Cambridge in January 1579/80 and proceeded BA in 1582/3 and MA in 1586. He then studied on the Continent, enrolling to study medicine at the Protestant stronghold of Basle but receiving his MD from the University of Padua about 1591. Having completed his studies in Italy, he 'returned home, became an eminently solid and rational Philosopher and Physitian' and married the daughter of 'Mr. *Jordan*, a *Wiltshire* Gentleman' from Salisbury Plain. His wife, Lucy Jordan, was a daughter of William Jordan (Jordyn) of Chitterne, Wiltshire (before 1545–1602), MP for Shaftesbury in 1563. They had at least eight children, of which five died young. Elizabeth, his eldest daughter, married at Lacock in January 1625/6, 'Mr. *Thomas*

*Burford*, an Apothecary in *Bath*, and Mayor of the City', Jorden eventually moved to Bath between 1610 and 1617, where his ten-year-old son William drowned in the King's Bath, 'by lamentable mishap'. Immediately before moving to Bath he may have been living in Shoreditch, as his son Richard was buried in St Leonard on 31 August 1610. Dr Jorden was buried in Bath Abbey on 9 January 1632/3, followed by his widow, Lucy, on 28 July 1636. See Jorden (1631), 2nd ed. 1632 dedicated to Francis, Baron Cottington, 3rd ed. 1669 Thomas Guidott (1638–1706), with a preface by Thomas Guidott: *A century of observations containing further observations on the nature of the hot waters at Bathe* (London: for Thomas Salmon, 1669). At the start, he includes a number of poems praising Jorden, including by T. GUIDOT:

> *On the Sight of Dr. JORDEN'S Picture.*
> This faint resemblance shews the Seat
> Where once dwelt Art and Learning Great;
> But vail's with such a modest Meen,
> That 'twas not easie to be seen.
> . . . etc.

Hopefully, this portrait survives unrecognised somewhere in the West Country.

25. William Turner (Dean of Wells), *A booke of the natures and properties as well of the bathes in England as of other Bathes in Germanye and Italye etc.* (London, 1568). Turner's first essay on English baths was included in the second part of his *A new herball, wherin are conteyned the names of herbes . . .* published in 1562 by Arnold Birckman of Cologne. See Addyman, *William Turner: Father of English Botany*; also Webster, *The Great Instauration*, p. 298.

26. 'He had a great natural inclination to Mineral Works, and was at very great Charges about the ordering of Allum, which succeeding not according to expectation, he was thereby much prejudiced in his Estate; of which he complains in the 4 page of the following Discourse. He was much respected by King *James*, who committed the Queen to his Care, when she used to Bathe, and gave him a Grant of the Profit of his Allum Works, but upon the importunity of a Courtier, as I am informed, afterwards revoked it; whereupon the Doctor made his application to the King, but could not prevail, though the King seemed to be more then ordinarily sensible of his Condition' – Anthony Wood, *Athenæ Oxonienses. An Exact History of All the Writers and Bishops who Have Their Education in the University of Oxford*, vol. 2, 549 (1815).

27. It is interesting that Jorden's main run-in with the College of Physicians was about his casual approach to the beliefs of Galen, then still seen by the medical establishment as fundamental to understanding sickness. On 4 July 1595, Jorden was examined and was granted verbal authority to practise provided that he read Galen's *De Temperamentis, De Elementis* [ex Hippocrates.], *De [Naturalibus] Facultatibus, De [Causis] Morborum, De Symptomatum Causis, De Symptomatum Differentiis*, and *De Locis Affectis* before Michaelmas. On 7 November Jorden, MD of Padua, was examined on Galen, and his performance was exemplary. He was permitted to practise upon payment of 4 marks [£1-6s-8d] a year. This compares to £2 for Dr Turner. See Pelling and White, *Physicians and Irregular Medical Practitioners*. For Jorden's work as a chemist, see as an introduction Coley, '"Cures Without Care", pp. 191–214.

28. See Jorden, *A Discourse of Natural Bathes*.

29. Patrick Saunders was born and brought up in the village of Weston, which is just outside Bath. It is tempting to ask if Dr Jorden met him in Bath and introduced him to Dr Dee in London, *c.* 1603/4.

30. Jorden's position on the 1598 Lay Subsidy roll, three places below Shakespeare, suggests he may have occupied one of the large houses on the south side of Great St Helen's. The wealthy Sir Thomas Reade, who probably lived there, died in July 1595 and the Jordens could have taken over his house during the autumn. Dr Taylor is listed in the rich 'high' section of the 1598 Lay Subsidy roll, so one cannot estimate his location. However, his position in the 1589 Tithe Survey suggests a house on the south side of the churchyard as well. Interestingly, none of the doctors served as churchwarden. There are references to other doctors in the parish. On 1 July 1607, James Saule, doctor of physick, was buried

in St Helen's. He was the son of the Dutch immigrant barber surgeon James Saul, who had died in the parish in 1585. The younger James was accused in 1591 by the College of Physicians of practising without a licence. When examined, they claimed 'he knew no Latin; ignorant of Galen; claimed MD Leyden [University of Leiden]' but the College suspected he was a fraud. Although he promised to desist, he evidently continued. On 7 August 1604, the College wrote a letter of complaint to Lord Sidney because Saul had been taken into the Queen's service, as they suspected he was 'unlearned and a fraud'; see Pelling and White, *Physicians and Irregular Medical Practitioners.*

31. Mrs Taylor and Mrs Jorden gave birth within three weeks of each other on 1 and 22 May. In 1600, Lucy Jorden and Pascha Turner repeated their parallel pregnancies. One wonders if Pascha passed on some of her laudanum to Lucy.
32. By late 1598 or 1599, they were also joined by the elderly Italian doctor Matthew Gentili, who moved into the parish with his son, the famous lawyer Alberico Gentili (1552–1608). They had come to England in 1580, driven from Italy for their Protestant beliefs. Matthew was over seventy, and died in June 1602.
33. For the possible impact of the Lopez affair on the writing of *The Merchant of Venice* and the revival of Marlowe's *Jew of Malta*, see Green, *The Double Life of Dr Lopez*, pp. 242–6.
34. His wife gave birth at regular intervals throughout the 1580s and they had seven surviving children in 1597.
35. Thomas Guidott, writing thirty-seven years after Jorden's death, recorded his character as 'an eminently solid and rational Philosopher and Phystian', 'his Conversation was so sweet, his Carriage so obliging, & his Life so answerable to the port & dignity of the Faculty he professed that he had the Applause of the Learned, the Respect of the Rich, the Prayers of the Poor, and the Love of all' and 'leaving behind him the name of a judicious, honest, and sober Physitian, and the excellent example of a pious Christian' (see Thomas Guidott, 'A Preface to the Reader' (1669), n.p., in the third edition of Jorden, *A Discourse of Natural Bathes*. Guidott never knew Jorden, and this is a fairly conventional accolade. However, he lived in Bath and may have met older residents who remembered Jorden.
36. See Shackelford, *A Philosophical Path for Paracelsian Medicine*, especially Chapter 6, p. 251 onwards, which deals with the reception of Severinus' ideas in England; and specifically p. 268 onwards, which covers Dr Edward Jorden's work.
37. Based on christenings, 'still borne' and 'chrysome' children. The other twins, 'Twoo children dead borne of William Wells, Grocer', born just over a year later in 1597, did not survive either. From 1580 until 1610, there appear to be only two other sets of twins, in 1604 and 1608. All four children died within nine months, so having twins was not only strange but highly risky too.
38. Dr Helkiah Crooke, who moved into Alderman John Robinson the Elder's former house in 1619, defined twin conception as 'superfetation' in his *Microcosmographia* (1615). This was explained as a second conception, potentially adulterous, and often taken as evidence of excessive female desire. This fed into the broader belief that 'unnatural' births were due to some parental sin, mixing together moral and medical questions.
39. Viewing the patients at Bedlam was not recorded until 1610, when Lord Percy and his wife visited and paid 10s-0d.

# 16

Lawyers, Musicians, an Antiquary and More

*In which we meet some of the other residents of St Helen's.*

The medical doctors would have been the most distinctive group in St Helen's, but there were other significant professionals there in the 1590s. While lawyers were concentrated near St Paul's and the Inns of Court around Chancery Lane, the parish had links to two outstanding lawyers, although neither may have directly overlapped with Shakespeare's period of residency. The first was the magnificently named Sir Julius Caesar Adelmare (1557/8–1636), an English lawyer, judge and politician who sat in the House of Commons at various times between 1589 and 1622. He was the oldest son of the Italian doctor Caesar Adelmare, discussed above. Julius Caesar had an excellent education and, following Oxford University, went to Paris with the new English ambassador, where he gained an LLB and LLD from the University of Paris.[1]

After his mother's death in 1586, it is not clear what, if any, property Sir Julius retained in St Helen's over the following decades.[2] He became Judge of the High Court of Admiralty in 1584 and an MP in 1589, so he may have lived most of the time in London's legal district and his country house at Mitcham, Surrey. However, he felt close enough to St Helen's to be buried there in a magnificent table tomb (see Figure 14.1). This was probably originally on the site of his parents' grave close to or on the site of the nuns' high altar.[3] At some point, it was moved to its current location in the south transept, where it can still be seen today. Even if Sir Julius lived elsewhere, his powerful personality would have thrown a long shadow.

The second lawyer was the Italian Alberico Gentili (1552–1608), who had an international career. He emigrated to England in 1580 and probably settled in St Helen's with his physician father in late 1598 or early 1599.[4] He therefore arrived just after Shakespeare may have moved on, but he is worth mentioning because of his huge role in the development of international law. Even if Shakespeare never met him, he would have probably heard that Gentili had chosen St Helen's to be his London home. Gentili was a British–Italian jurist, who was the Regius Professor of Civil Law at Oxford University for twenty-one years. He is now recognised as the founder of the science of international law, and considered one of the most influential people in legal education to have ever lived. He was an 'older' father, having his first offspring aged forty-nine; his children, Hester and Mathew, were christened in St Helen's in February 1601 and December 1603. However, the young children were left fatherless in 1608 when, in sharp

## Lawyers, Musicians, an Antiquary and More

contrast to Sir Julius Caesar's elaborate tomb, Alberico followed his father into the graveyard for a cheap burial.[5]

While St Helen's had strong connections to medicine and law, it is noticeable that in the period Shakespeare may have lived there, it had no other obvious connections to the theatre world. However, scratching below the surface, some intriguing connections to London's theatre world do emerge. We last touched on John Pryne in Chapter 2 as a shadowy money broker, arranging the mortgaging of the lease of the Theatre by James Burbage and John Brayne to the grocer John Hyde for £125-8s-11d on 26 September 1579, only three years after it had opened. However, as we will discover later, by the 1590s there was at least one other moneylender living in St Helen's, funding theatre.

Shakespeare's neighbours in St Helen's not only had connections with the early years of the Theatre but also with its end in 1598 and rebuilding as the Globe Theatre. One person of interest is William Leveson (d. 1621). He and Thomas Savage were the two trustees used by the Lord Chamberlain's Men to oversee the allocation of shares in the ground lease of the Globe Theatre in 1599. William Leveson's grandmother was Dionyse (née Bodley) Leveson, who was born before 1530 and died in 1560 or 1561; she lived in the next parish to St Helen's, in Lime Street.[6] In 1548, Dionyse was left a gold ring by Ellis Bodley, parson of St Stephen's, Walbrook, situated next to the London residence of the Earls of Oxford. Ellis was the great-uncle of Sir John Bodley of Streatham, landlord of the Globe from 1601 until 1622.[7] Dionyse had eighteen children with her husband, Nicholas Leveson.[8] Her second son was Thomas Leveson (1532–76), who married Ursula Gresham (1534–74), one of the twelve children of Sir John Gresham, Lord Mayor of London. As a result, William's mother was a cousin of Sir Thomas Gresham, who owned the second largest property in St Helen's.

Ursula's sister Cecily married German Cioll on 20 February 1550. Cioll was possibly a Spanish merchant, and he had fluctuating fortunes. In 1560 they were riding high. In 1547, Anthony Buonvisi conveyed Crosby Hall to a number of people including Cioll. In 1558, he had been a witness of Sir Andrew Judd's will and in February 1560 he obtained Crosby Hall from Benedict Buonvisi,[9] taking possession in June 1561. Cioll's role in the transfer of power from Queen Mary to Queen Elizabeth is murky. He was part of a broadly pro-Catholic group which included Antonio Buonvisi, and in 1550 Cioll followed him into Continental exile. He later received a pardon from Elizabeth I,[10] and in 1566–7 he was churchwarden of St Helen's with John Pry(n)me and then with Thomas Coleshill. However, by this time his financial situation had deteriorated rapidly, and in 1566 he was forced to sell Crosby Hall to Alderman William Bond. German and Cecily were not destitute; they were able to hang on to four of the nine houses fronting onto Bishopsgate Street, and some rooms in Crosby Hall proper. German died *c.* 1587, but Cecily survived through a long widowhood, living in one of the houses in Bishopsgate Street until 1610.

Cecily would have been about thirty years older than Shakespeare. Did she entertain him at her house? William Leveson could well have got to know him by other routes, as he lived in the parish of St Mary Aldermanbury, where Shakespeare's colleagues from the Lord Chamberlain's Men, John Heminges and Henry Condell, also lived.[11] Still, it is an intriguing example of the close connections which existed between St Helen's and the wider world that Shakespeare moved in.

The St Helen's area had strong musical associations from the mid sixteenth century. William Crane, Master of the Chapel, had been given a valuable property holding in 1540 by Henry VIII, and probably lived in the parish until his death in 1545. In the 1570s/80s, two of London's most significant musical instrument importers and retailers, John White and Nicholas Sperynge, had their premises just around the corner from St Helen's in a row of shops on the north side of Leadenhall Street, in the parish of St Andrew Undershaft (Figure 8.9).[12]

A number of musicians are also recorded as living in St Helen's. The 1589 parish tithe survey records five musicians out of seventy-three households, a significant proportion. There were two members of the extended and highly successful Italian Bassano family of musicians and instrument makers, Jeronimo Bassano (assessed at 13s-9d)[13] and Mark Anthony Bassano (8s-3d); Robert Hubbard, gentleman/musician (5s-6d); and the two poorest, Hugh Ken(d)rick,[14] gentleman/musician/pronotary, and Giles Farnaby (both at 2s-9d). Of these, only Robert Hubbard and Hugh Kendrick were still living in the parish in the late 1590s.[15] Hubbard does not appear in the 1598 Lay Subsidy roll, but was buried in St Helen's in August 1606, indicating his continued residency. By then, he had fathered at least eleven children, which may account for his relative poverty. Hugh Kendrick was buried in St Helen's on 31 December 1597.[16]

However, the most influential musician to live in St Helen's was Thomas Morley (1557/8–1604), who had moved into the parish with his wife Susan by 1596, when his daughter Francis was christened.[17] He was a composer, singer and, from 1588, organist at St Paul's Cathedral. Morley, a Catholic, was a successful composer of madrigals and in 1597 published his *Plaine and Easie Introduction to Practicall Musicke* (Figure 16.1). The following year he obtained a monopoly on printing music[18] and in the 1598 St Helen's Lay Subsidy roll was assessed at £5, the same as Shakespeare.[19] In 1601 he published *The Triumphs of Oriana*, a collection of twenty-five madrigals by different composers, as a tribute to Elizabeth I.

Morley must have lived within a couple of minutes' walk of Shakespeare prior to the latter's departure from the parish, but it is not clear precisely where. In 1598 Morley set up, with William Barley, what has been termed the 'Little St Helen's Publications', and it is assumed that the printing press was either in his house or very close by.[20] Together, they produced eight music publications in St Helen's, the first in 1598 or 1599, five in 1599, and one in each in 1600 and 1601. The information on the title pages varies slightly. *The Whole*

Figure 16.1 The musician, composer and music publisher Thomas Morley (1557/8–1602) lived in St Helen's at the same time as Shakespeare. Title page of his famous and popular guide, *A Plaine And Easie Introduction to Practicale Musicke* (1597).

*Book of Psalms* (1599) states: 'Printed at London in little S. Hellens by William Barley affigne of T. Morley, and to be sold at his shop in Gratious street [Gracechurch Street]'; but Richard Carlton's *Madrigals to Five Voices* (1601) specifically says: 'Printed by Thomas Morley, dwelling in Little Saint Helens'. However, as noted above in Chapter 3, the pattern of property development in Little St Helen's in the late sixteenth century is unclear. By 1605 at the latest the Leathersellers' Company was allowing building on the former nunnery gardens, and other houses may have been erected next to the parish boundary with St Ethelburga.[21]

Morley composed the music for 'It was a lover and his lass' from *As You Like It*, probably written 1598–9:[22]

> It was a lover and his lass,
> With a hey, and a ho, and a hey-nonny-no,
> That o'er the green cornfield did pass,
> *In springtime, the only pretty ring time,*
> *When birds do sing, hey ding-a-ding, ding,*
> *Sweet lovers love the spring.*
> Between the acres of the rye,
> With a hey, and a ho, and a hey-nonny-no
> These pretty country folks would lie,
> *Repeat Chorus*
> This carol they began that hour,
> With a hey, and a ho, and a hey-nonny-no,
> How that a life was but a flower
> *Repeat Chorus*
> And therefore take the present time,
> With a hey, and a ho, and a hey-nonny-no,
> For love is crownèd with the prime
> *Repeat Chorus*
> (*As You Like It*, V.iv.15–38)

There is a further connection to the theatre world: Morley dedicated his *Cazonets to Five and Sixe Voices* (1597) to George Carey, 2nd Lord Hunsdon, who as Lord Chamberlain was patron to Shakespeare's theatre company. However, Carey was also dean of the Chapel Royal, and as such Morley's employer.[23] In 1598/9 prospects must have looked good for Thomas Morley, but his health had begun to decline:

Lastly, the solitarie life which I lead (being compelled to keepe at home) caused mee be glad to finde any thing wherein to keepe my selfe exercised for the benefite of my contie [country].[24]

Lawyers, Musicians, an Antiquary and More

One wonders if Morley ever sat in the graveyard of St Helen's to compose a piece of music or to practice the lute. Whatever his illness, it continued, and in 1602 he was dead, aged only forty-five.

Much has been written about what manuscripts and books Shakespeare may have read and owned. Apart from the publicly accessible *Paraphrases of Erasmus* made available in St Helen's church, possibly alongside other improving and officially approved religious texts, his neighbouring doctors, lawyers and musicians must have had a considerable number of important books. However, one of the most interesting questions is whether Shakespeare ever met or developed a friendship with the famous historian John Stow (1524/5–1605), who was renowned for his large library and collection of original documents.[25] By Shakespeare's time in St Helen's, Stow would have turned seventy and lived five minutes' walk away, in the adjoining parish of St Andrew Undershaft, where he was eventually buried and his impressive wall memorial still survives. Indeed, we know from the 1582 Lay Subsidy roll that Stow must have lived in the western part of the parish,[26] close to Leadenhall, a short stroll from Shakespeare's lodgings. While Stow does not seem to have been enamoured of the new theatres, writing rather dismissively:

> Of late time in place of these Stage playes, hathe been used Comedies, Tragedies, Enterludes, and Histories, both true and fayned: For the acting whereof certaine publike places as the Theater, the Curtine &c. have beene erected.[27]

However, he was acquainted with Ben Jonson.[28] During the 1590s, Stow was completing his great *Survey of London*, which was published in 1598 and provides an extraordinary ward-by-ward description of the cityscape in which Shakespeare lived and worked. It would seem strange that someone with such wide-ranging interests as Shakespeare would not have at least made the acquaintance of Stow. Although Stow would have been forty years older, he would have been a fascinating relic of the pre-Elizabethan age, with his nostalgia for the past and childhood memories of a Catholic London when Henry VIII was king and the monasteries were still in operation. If nothing else, scholars have remarked on the similarity of Stow's memorial erected *c.* 1605 by his widow and Shakespeare's wall memorial in Holy Trinity Church, Stratford-upon-Avon, erected by 1623 (Figures 16.2 and 16.3).[29] Stow is shown seated at a desk, writing in a book with the motto '*Aut scribenda agere, aut legenda scribere*' – '[Blessed is he to whom it is given] either to do things that are worth writing about, or to write things that are worth reading about' – based on a phrase of Pliny the Younger. As with Shakespeare's memorial, there is a real quill pen. While the general design was regularly used for memorials for academics and related professionals, it is an intriguing parallel.

Figure 16.2 The historian John Stow (1524/5–1605), owner of an extensive library, lived a few minutes from Shakespeare in the neighbouring parish of St Andrew Undershaft. His funerary monument survives in the church. In 1598, his great *Survey of London* was published.

Figure 16.3 Shakespeare's monument in Holy Trinity church, Stratford-upon-Avon. The similarity to Stow's memorial has been noted. Both hold real quill pens in their hands. The two monuments have been tentatively attributed to the brothers Gerard and Nicholas Johnson.

While we are passing around just outside the St Helen's parish boundary, it is worth noting that William Dethick (*c.* 1542–1612), Garter Principal King of Arms, lived in the adjoining parish of St Peter, Cornhill. He is recorded there in the 1582 Lay Subsidy roll, assessed at £25, although he is not listed in 1598. It was Dethicke who arranged the granting to the Shakespeares of their coat of arms in 1596.[30]

Returning back to St Helen's, and the hundred or so households certainly or likely to have been living there at the time of the 1597/8 Lay Subsidy survey (Table 9.2), there are several who would repay further investigation, such as John Allsop(pe).[31] There are also others, not listed, with close associations with the parish, such as the brothers Edward Stanhope II and Michael Stanhope, who purchased the rectory rights for St Helen's for £61-18s-1d from the cash-strapped Queen Elizabeth in 1599.[32] Such powerful associations not only contributed to the upmarket profile of the parish but provided a web of connections across high society and ultimately to the royal court.

When Shakespeare arrived in London in the late 1580s, the London stage was dominated by the new plays of Christopher Marlowe and Thomas Kyd. Marlowe lived in Norton Folgate, an 8.7-acre extra-parochial 'liberty', squeezed in between the north-eastern end of St Botolph, Bishopsgate and St Leonard, Shoreditch, the first parish in the County of Middlesex, to the north. Its unusual legal status would have made it attractive to free-thinking spirits like Marlowe and his friends, who included the poet Thomas Watson. In September 1589, a legal warrant stated:

> Thomas Watson of Norton Folgate in Middlesex County, gentleman, and Christopher Marlowe of the same, yeoman . . . were delivered to jail the 18th day of September by Stephen Wyld, Constable of the same on suspicion of murder.[33]

Shakespeare would have associated with Marlowe's circle following his arrival in London. Many specialists now believe that Marlowe may have worked with Shakespeare on some of his early plays.

The five years 1594–8 represent the third phase of Shakespeare's London career, after the initial years *c.* 1589–91 following his arrival, and then the upheaval of the plague years in 1592–4. From spring 1594, now aged thirty, he moved on from a focus on long poetry to concentrate on plays again. The creation of the duopoly in 1594 with the Lord Chamberlain's Men offered him the security to create as never before. During these five to six years, ten to twelve surviving plays were written and goodness knows how many (now lost) outline sketches, fragments of speeches and abandoned lines drafted. According to the generally accepted chronology, the sequence of plays follows ('FMPT98' means listed in Francis Meres' *Palladis Tamia, Wits Treasury*, published in autumn 1598):[34]

| | |
|---|---|
| 1592–3: *Edward III* | possibly a co-authored play. Not mentioned in FMPT98 |
| 1594: *Comedy of Errors* | FMPT98: 28 December 1594, Inns of Court |
| 1594–5: *Love's Labour's Lost* | FMPT98 |
| 1595–6: *Love's Labour's Won* (lost) | FMPT98 |
| 1595: *Richard II* | FMPT98 |
| 1595: *Romeo and Juliet* | FMPT98 |
| 1595: *A Midsummer Night's Dream* | FMPT98 |
| 1596: *King John* | FMPT98 |
| 1596–7: *The Merchant of Venice* | FMPT98 |
| 1596–7: *Henry IV Part 1* | FMPT98 |
| 1597: *The Merry Wives of Windsor* | |
| 1597–8: *Henry IV Part 2* | |
| 1598–9: *Much Ado about Nothing* | |

Shakespeare may also have started drafting plays that were only finished later, such as:

| | |
|---|---|
| 1599 | *Henry V* |
| 1599 | *Julius Caesar* |
| 1599–1600 | *As You Like It* |
| 1599–1601 | *Hamlet* |

This third period ends with the dramatic demolition and relocation of the Theatre, the opening of the Globe in 1599 and Shakespeare's move away from the security and familiarity of St Helen's. During the five years that Shakespeare may have lived in the parish, it provided an established and high-status address for supporting his writing and his ambitions to re-establish his family's reputation. What is certain is that by 1602/4 at the latest, and possibly earlier, Shakespeare had moved to Silver Street in the north-west corner of the City. This area was quiet and well-heeled but certainly had none of the immediate status of St Helen's or the Blackfriars. Certainly, in St Helen's and its surroundings, he would have been living in a more stimulating intellectual environment. However, Silver Street was much more anonymous and, with the surly Huguenot Christopher Mountjoy watching the front door, probably more private.[35] Whether one can back-project Shakespeare's living arrangements there, lodging with a 'stranger', to his time in St Helen's or elsewhere from 1598 to 1602 is unproveable – but the potential possibilities are suggestive (see the Appendix).

Clearly, Shakespeare could have returned to St Helen's at some point after his stay in Silver Street but, as far as we know, he decided not to. Maybe he was put off by the

Figure 16.4 The cultural, economic and social 'ecology', which surrounded Shakespeare when he was living in St Helen's c. 1597.

radical Puritan minister Lewis Hughes, who had been appointed in 1600 and was soon to bring the parish into disrepute. Or perhaps many of his friends had died in the devastating plague of 1603, so that the area would have seemed full of ghosts. St Helen's retained its social cachet in the early Jacobean period, particularly with Gresham College developing, and Dr Helkiah Crooke, the Royal Physician to James I, moved into the parish *c.* 1619. More prosaically, there may have been other advantages to Silver Street. The years 1598–1600 saw an overall shift of theatres westwards, which was to continue in subsequent years. Silver Street was about halfway between the Globe Theatre and Henslowe's new Fortune Theatre, which opened in 1600.[36] Living in Silver Street, Shakespeare was therefore well placed to go to work on Bankside or to walk northwards through Cripplegate to spy out the new productions of the Lord Admiral's Men.

While it is revealing to explore the micro-ecology of Shakespeare's living arrangements, the key question is whether his life in St Helen's impacted on his writing in any way; or would his plays have been the same whether he lived in Whitehall, Blackfriars or in the shadow of the Tower (Figure 16.4)? To what extent are writers shaped by their surroundings? Do they simply choose a place which matches their existing thinking? The public, of course, are fascinated by such questions, and this interest accounts for the powerful strand within the heritage industry of preserving birthplaces or workplaces of famous writers, artists and musicians. Indeed, Shakespeare's home in Stratford-upon-Avon was the first such birthplace to be 'saved' in the United Kingdom in 1847.

Does his birthplace tell us anything about Shakespeare's future creativity? Although the Shakespeare Birthplace Trust also owns the site of his last home, New Place, the mansion itself has been demolished. If it had survived and one could wander the real rooms where Shakespeare lived his last years, would it alter our fundamental understanding of the man? How would Shakespeare's plays have been different if he had been born and grown up in Canterbury, or Norwich, or Edinburgh? Clearly, they would have been different if Shakespeare was born in France or Holland – but at some point the impact of the *terroir* of birth and work, the move from small English market town to capital city and port, become indistinguishable from other factors such as the work of rivals, reading, personal relationships, economic pressures, political events and so forth.

Notes

1. On 6 September 1576, Sir Amias Paulet took leave of Elizabeth I at Windsor Castle to become the newly appointed ambassador to France. Francis Bacon, then aged fifteen, accompanied Paulet. Two days later, Paulet wrote to John Petre: 'My train hath been great by reason of divers gentlemen recommended unto me by the Queen's Majesty, as Mr Dr Caesar, Mr Throckmorton and Mr Hilliard, besides those of my own company.' The latter three were Julius Caesar, lawyer; Arthur Throckmorton,

# Lawyers, Musicians, an Antiquary and More

     brother-in-law of Sir Walter Raleigh; and Nicholas Hilliard, the recently married goldsmith, painter and miniaturist.

2. His mother, Margaret Adelmare, had remarried the unfortunate Michael Lok sometime in the 1570s. Like her first husband, she was buried in St Helen's, although any gravestone or memorial has disappeared.

3. Although other relatives were buried nearby. Dorcas, daughter of Sir Julius, was buried to the south, 'under the stone betweene the Communion Table and Sr John Crosbye's monument', on 2 April 1608.

4. He was listed in the 1599 and 1600 St Helen's Lay subsidy rolls, but not for 1598, demonstrating how these listings were regularly updated.

5. Inside St Helen's there is a modern memorial plaque to Gentili – just behind Gresham's tomb.

6. Sutton, 'Lady Joan Bradley', provides a great deal of information about how the family developed its wealth and influence. She was from the same family as Sir Thomas Bodley (1545–1613) who, in 1598, refounded the library in Oxford that became the Bodleian Library.

7. For Sir John Bodley's role as landlord of the Globe, see TNA C 54/1682, mm. 10–11.

8. For his will, see the National Archives PROB 11/27/552. In it he describes Guy Crafford, a lawyer, who lived in the Close at St Helen's, as his 'cousin', and leaves him £20. Crafford is listed in the 1541 Lay Subsidy roll with the huge valuation of £300. Guy died in 1553, but his widow Joan (née Bodley) survived until 1584, when she was buried in St Helen's on 31 August. Guy leased a house from the nunnery from as early as 1536. In 1539, following the dissolution, Henry VIII granted Guy and his wife a house with a garden and stable, formerly occupied by the Herald Thomas Benolt and then Sir Arthur Darcy, along with the house next door on the west. This may have been a different property in the Close.

9. When Antonio Buonvisi died in 1558 he left Crosby Hall to his nephew Benedict.

10. In 1550, under Edward VI, Buonvisi's properties were seized and in 1553 Crosby Hall was handed to Sir Thomas Darcy. With the ascension of Queen Mary in 1553, the properties were returned to Buonvisi.

11. For the will of William Leveson (d. 1621), see TNA PROB 11/137/600.

12. For a detailed discussion of their careers, see Page, *The Guitar in Tudor England*, pp. 64–9. In the surviving 1567/8 London port book, they are both recorded as significant importers of musical instruments, including 'gitterns' (guitars). For example, White imported a cargo in the *Sea Rider* of Antwerp, of '1 case with 6 slight citerns, 8 giterns and two *parv*. Lutes £5 3s 4d'.

13. Jeronimo and Mark Anthony were two of the five sons of Anthony Bassano, in turn one of six brothers who came to England as musicians for Henry VIII. Their sister, Lucretia Bassano, married Nicholas Lanier the Elder, grandfather of the artist–musician Nicholas Lanier. Their cousin was Emilia Bassano (1569–1645).

14. His son Thomas was christened at St Helen's on 14 July 1577, indicating he had lived in the parish for at least twelve years by 1589.

15. Hubbard and Kendrick both leased property from the wealthy leatherseller Alderman Hugh Offley (*c.* 1525–94). The fact that they are listed together in his post-mortem inquisition of 1595 suggests they may have been living next door to each other; see Fry, *Abstracts of Inquisitiones Post Mortem for the City of London: Part 3*. Giles Farnaby (*c.* 1563–1640) married Katherine Roane in St Helen's on 28 May 1587 but had moved to the parish of St Peter, Westcheap by 1591, where their first daughter, Philadelphia, was christened. His cousin Nicholas was a virginal maker, and fifty-one of Giles's works for the virginal are preserved in the *Fitzwilliam Virginal Book* – a key source of Elizabethan/early Jacobean music for keyboard instruments.

16. The burial register records: 'gent, wthin twoo yards of Sr William Hollis his tombe next the pewes on the right side of the toombe', a prestigious location close to his two brothers John and Lawrence, buried under the same stone in 1593 and 1597 respectively. His will – TNA PROB 11/91/9 – records how he had devoted his money to educating his son, 'brought up at learning at Cambridge . . . to my greatte costs and infinite charges . . . now a Master of Arts'.

17. Francis died aged two in 1599 but two further children followed: Christopher in 1599 and Anne in 1600. An earlier son died in 1589.

## Living with Shakespeare

18. There was a separate monopoly on church music, which had been given to Thomas Tallis in 1575. He worked with the French Huguenot printer Thomas Vautrolier (d. 1587). Two years later, in 1589, Vautrolier's widow, Jaqueline, married his apprentice, Richard Field, a schoolfriend of Shakespeare's from Stratford who published his *Venus and Adonis* in 1593. Thomas East (c. 1540–1609) acquired Vautrolier's music type and worked with Morley. In 1588, East printed the highly influential collection of fifty-seven Italian madrigals with English words *Musica Transalpina*. This was followed in 1590 by *The First Set of Italian Madrigals*, with English words by the poet Thomas Watson (1555–92).
19. He was probably excused payment as a royal employee.
20. See Murray, *Thomas Morley*, especially pp. 110–23 and Appendix 4, pp. 196–202. This is a fascinating biography of a St Helen's parishioner, a contemporary of Shakespeare, with a detailed analysis of the music publishing business. Murray estimates that Morley's income from 1596 to 1602 fluctuated between *c*. £64 and £100 a year; see table 3, p. 109.
21. Morley's music monopoly was negotiated by the lawyer Sir Julius Caesar, who, as noted above, had strong links with St Helen's and owned property there. Murray raises the possibility that Morley may have been his tenant; see Murray, *Thomas Morley*, p. 85. However, all the property in Little St Helen's was owned by the Leathersellers; Julius Caesar would have been an unlikely tenant, and does not appear in any of the rental listings.
22. The text first appears in the First Folio edition (1623) of *As You Like It*. Murray, *Thomas Morley*, p. 147, notes that 'Neither the authorship of the text nor the relationship between Morley's setting and Shakespeare's play is known.' It appears as Ayre No. 6 of twenty-three in Morley's *The First Book of Ayres* (1600); see Murray, *Thomas Morley*, p. 227.
23. See Murray, *Thomas Morley*, p. 190.
24. From the preface to Morley's *A Plaine and Easie Introduction to Practicall Musicke* (1597), see Murray, *Thomas Morley*, p. 46. At some point just before his death, Morley left St Helen's, probably to live in the parish of St Andrew, Holborn.
25. Stow's collection had attracted the attention of the ecclesiastical authorities, who searched his house in 1569 and 1570 claiming there were 'many dangerous and superstitious books in his possession', some 'in defence of papistry'. Stow was, however, able to convince them that these were for his historical research and that he had orthodox religious beliefs. The 1908 Kingsford edition of Stow's *A Survey of London*, pp. lxxxvii–xciii, contains a listing of manuscripts once owned by Stow.
26. The parish of St Andrew Undershaft fell into two wards and John Stow is recorded as living in Lime Street Ward, which was the western part, rather than in Aldgate Ward, which covered the eastern part of the parish; see his listing in the 1598 Lay Subsidy roll. Lime Street was a small ward, largely taken up with the large Leadenhall complex. Most of the housing was along Cornhill or the west side of St Mary Axe. Letters to Stow, including one from his daughter Joan, show that he lived near Leadenhall, thus the address on one: 'To my loving ffather Mr. Iohn Stowe benethe Leadon hall neare unto the Thrye Towenes [Three Tuns] in London, gyve this.' – see Kingsford, 'Introduction: Letters to Stow', pp. lxviii–lxxiv. A later legal inquisition of 1624 records a property 'next the tenement of John Stowe on the east side, and abutting north on a garden of the late priory of St Helen and south on the highway from Leadenhall to Aldgate', suggesting Stowe lived on the north side of Leadenhall Street; see *Inquisition post mortem*, Court of Wards 75/88.
27. In the 1603 edition of *A Survey of London*, the Theatre and the Curtain have both been removed, presumably at least partly because the former had been demolished.
28. Jonson related walking with Stow, who jokingly asked two mendicant cripples if he could join their order.
29. See Duncan-Jones, 'Afterword: Stow's Remains', pp. 157–63. Shakespeare's memorial is claimed to be by Gerard Johnson, son of the émigré Dutch sculptor Gerard Johnson the Elder, who came to London in 1567. The Johnsons' workshop was in Southwark, close to the Globe theatre.
30. He was definitely still there in 1585, when his last child was baptised; see Leveson Gower, *A Register of all the Christninges Burialles & Weddinges*.
31. Churchwarden in 1598 and 1599. A John Alsop, haberdasher, was a governor of Bridewell at the same

time as Clement Kelke in the late 1570s and also one of the three governors responsible for the Bethlem Hospital, but it is not clear if it is the same person.
32. Their brother Sir John Stanhope was appointed vice-chamberlain when George Carey, 2nd Baron Hunsdon (1547–1603), the Lord Chamberlain from 1597 and patron of Shakespeare's company, became ill.
33. Marlowe had been attacked in Hog Lane, the modern Worship Street, by William Bradley, an innkeeper's son, over a debt. Thomas Watson intervened to protect Marlowe and killed Bradley with his sword. Marlowe and Watson were arrested and the former kept in Newgate Prison for a fortnight. At the trial on 3 December, Watson claimed he had acted in self-defence. Both were discharged by the court. Five years later, in May 1592, Marlowe was summoned to the Middlesex sessions for attacking two constables in Holywell Lane, in nearby Shoreditch.
34. To the nine plays noted here, Francis Meres also added *Two Gentlemen of Verona*, *Titus Andronicus* and *Richard III*, which are usually thought to have been written before 1593.
35. While his lodgings overlooked the church and graveyard of St Olave's, there was none of the sense of privacy and security provided by Great or Little St Helen's that existed at St Helen's. Silver Street was a public street, open to all. There may have been other factors at work. The purchase of New Place, Stratford-upon-Avon in early 1597 would have provided Shakespeare with a secure location in which to store his books and papers. He may have felt he no longer needed a prestigious address in London.
36. The battle over renewing the lease of the Theatre probably generated much debate about the future direction of the Lord Chamberlain's Men. One wonders if Henslowe's decision to abandon the Rose in Southwark and build the Fortune Theatre in 1600, north of the City, was solely his idea, or whether he took on a location already identified by his rivals a few years earlier.

# 17

## Saint Helen's as a Microcosmos: A Theatre of London

*In which we look in detail at the people who lived around Great St Helen's and, while digging into the records, unearth some interesting connections. Appropriately for a graveyard, the source of the two gravediggers in* Hamlet *may be closer to St Helen's than might be expected.*

So far, this exploration of Shakespeare's parish has highlighted an interesting cast of neighbours, but there is no certain evidence that Shakespeare interacted with any of them. Common sense would suggest he did, but there is no conclusive proof. However, there are a few cases where the evidence is more suggestive. This chapter will drill down into just one example which relates to Shakespeare's creation of the gravediggers' scene in *Hamlet*, arguably his greatest play. However, before visiting the graveyard, a swift review of the evidence presented so far will provide the context.

This investigation started with a single, central fact – that the well-informed local assessors responsible for listing the appropriate payees and then collecting the Lay Subsidy payments in St Helen's believed the thirty-four-year-old William Shakespeare lived in the parish *c.* 1597/8. At this time, they considered him wealthy enough to be taxed for the request of 1 October 1598 at an assessment of £5, well above the bottom rate of £3.[1] This positioned him in the top quarter of residents in terms of wealth, in what was a well-off parish. This list of subsidy payees does not reveal how long Shakespeare had lived in the parish. Furthermore, the 'Affid' noted against his name indicates the tax collectors did not receive payment.

By comparing this listing with other records, it has been proposed that there is a strong likelihood that:

- Shakespeare lodged, probably as a sub-tenant, in one of the houses on the north side of the Close, the section of Great St Helen's which faced the northern side of the churchyard. These buildings may have been created by dividing up the Steward's Lodging and associated buildings of the former nunnery after 1538. By the 1590s, as the Leathersellers' Estate evolved, these properties may have been incorporated into the development of Little St Helen's. If this location is correct, his lodgings might have been accessed from Little St Helen's or Great St Helen's or potentially both.
- Whatever the access route to his home, the location would have provided him with a relatively quiet, secure, discreet and high-status address.

- Given his position in the listing in the 1598 Lay Subsidy roll, the people most likely to be his landlord were either John Pryn, an ageing grocer with links to the theatre world, or John Hatton, the aspiring clerk of the Leathersellers' Company. In 1593, Pryn had lived in his house since 1558 (so over thirty-five years) and Hatton had lived in the area for fifteen years. So, if either was Shakespeare's landlord, they were well-established figures in the parish. However, there are other possibilities, and Shakespeare could have lived in several properties over the years.
- Shakespeare is likely to have moved into the parish by early 1594, and possibly earlier in late 1592/3, during the 1593 plague outbreak that shut the London theatres from June 1592 to April 1594. It is possible that he came to the area when he first moved to London permanently, in the late 1580s. At this time, the Bull Inn directly across Bishopsgate Street was a significant theatre and entertainment venue.

The issues of the location of his residence and the date of his occupation are not interdependent. Shakespeare could have lived in St Helen's for a longer or shorter period and, at other times, he could have lived anywhere in the small parish. However, even if at a minimum he lived in the parish only in 1597/8, he would still have had to attend many church services in St Helen's. There he would have seen and been seen by the other residents of the parish. In contrast to the world-famous William Shakespeare, these hundred or so families have been largely forgotten. However, by reconstructing their lives and their connections, it is possible to understand something of the parish life in which Shakespeare chose to live. 'Chose' is the key word: he could have resided in any one of London's parishes, and indeed he definitely lived in Silver Street, St Olave's when he was older. However, around his thirtieth birthday, St Helen's offered him the location, environment and neighbours that he either required or desired. The determining factors could have ranged from the specific beliefs of the parish minister, the attitude of the parish vestry, the availability of specific services, connections with the Company of Leathersellers or personal friendships. It may just have been its convenience for easy access to all of the London playing venues: we simply do not know.

Tracking these residents four hundred years later is not easy. The profile of the doctors, due to their professional connections, can be sketched in a little. For many others, there is little more that can be discovered than their trade and their passage through the cycle of baptism, marriage and burial which was recorded in the parish registers. In reality, an acquaintance with the humblest cobbler to mend his boots or an interesting widow to pass the time with may have been just as important for Shakespeare as a highly opinionated international trader. It has been possible to estimate the overall size of the parish community and something of the mix of employment and relative wealth. One can see families arrive, intermarry, breed and disappear. Mostly, the process is a slow evolution but it is punctuated by the major dislocations of the plague outbreaks

in 1578, 1592–4, 1603 and later. Immigrants were present in noticeable numbers and, at some point, Shakespeare picked up enough French to make use of the language in writing *Henry V*, probably around late 1598 or early 1599. There were also some locals, where it is harder to judge Shakespeare's likely interest. Among them was Henry Maunder, the Queen's messenger, who had taken Christopher Marlowe into custody in May 1593 and must have known something of his subsequent murder. For Shakespeare, Maunder could have been a useful connection to gossip from the court – or, alternatively, someone he avoided, given his connection to a colleague's violent death.

Given Shakespeare's residence in the parish, it is unsurprising that there are theatre connections, particularly with the Bull Inn almost next door, where theatre performances were held until at least 1594. However, owing to the limited records, it is intriguing to find pre-existing personal links to several play venues. The scrivener Thomas Wrightson had strong connections to the Bull, but also knew Edward Alleyn, who later led the Admiral's Men at the Rose, and the actor Robert Browne. John Pryn had financial connections to the Theatre, and the scrivener Israel Jorden was involved later with the Boar's Head Theatre and, again, Robert Browne.

What might these connections suggest about the Shakespeare's life and his decision to live in St Helen's? With the end of playing at the City inns after 1594, he clearly decided to stay away from the vicinity of the playhouses, where he worked, whether from the Theatre out at Shoreditch or Burbage's later proposed project at the Blackfriars. This suggests his main focus was to find somewhere he could get on with his writing without disturbances.

Let us assume that Shakespeare is standing by the west entrance to St Helen's churchyard in October 1595. It would have been a pleasant green oasis, despite its small size and being hemmed in by the surrounding buildings. The ash trees have dropped their leaves, giving him a clear view across the Close area.[2] He is surrounded by about fifteen houses and St Helen's church. Looking south, a row of ten impressive three-storey houses are flanked to the west by the towering north end of Crosby Hall, probably with a large window lighting the main hall. Below, a back entrance services the main domestic apartments located in the north wing, linking the main hall through to Bishopsgate Street. He knows every resident by sight, at least; but what, together, do they represent to him?

For Shakespeare, life overall probably seemed good in autumn 1595. He was thirty-one and a recognised success. The Lord Chamberlain's Men had settled down to a stable and profitable residency at the Theatre. His play-writing was in full flow, with *Romeo and Juliet* and *The Merchant of Venice* either nearing completion or in performance. The Company had probably already been informed that they should prepare for the lucrative honour of performing several plays before the Queen at court during the Christmas and New Year festivities.[3] His sonnets were circulating to acclaim among his friends and acquaintances, while *Venus and Adonis* and *The Rape of Lucrece* were well received. Like

most London residents, he had probably been shocked by the violence of the recent apprentice riots in June, but the Lord Mayor Sir John Spencer and the city authorities now seemed to have the situation under control. Crucially for his financial wellbeing, there had been no sign of the plague for eighteen months. With the approach of winter, it was not going to blight this year; and as for the future, who but God knew?[4]

His relatively steady income meant that Shakespeare could probably plan ahead and save significant sums of money. Indeed, with strict control of his expenditure in London, he was able, eighteen months later in May 1597, to make a down payment of £60 to purchase New Place, one of the most impressive houses in Stratford-upon-Avon. Also in 1595 his son and heir, Hamnet, was ten years old and growing up fast. An obvious question is why he decided against bringing his family to London, to settle down in the capital. The rent level on the better houses in the Close was *c.* £4 to £6 a year, which he could have afforded. Here one touches on the complexities of Shakespeare's relationships with his father, Stratford-upon-Avon and his wife Anne Hathaway, as well as his social aspirations for himself and, most importantly, for Hamnet. Despite the rise of the mercantile economy in London, social status was still largely determined by the ownership of land. A country estate, whether held by the family for centuries or recently purchased, was a key requirement for social advancement. It is noticeable among the residents of St Helen's how the craftsmen and merchants were buried in the parish church but many of the richer parishioners decided to be buried in the village churches next to their country houses and estates. Shakespeare decided on a middle course: a prime residence outside London, but in the centre of Stratford-upon-Avon, rather than in the countryside with all the associated expense of maintaining an estate. He would buy land as well, but these were cultivated acres for income, not gardens for pleasure or parkland for hunting. There were also serious fires in Stratford-upon-Avon in 1594 and 1595. Shakespeare could have felt this was a way to help his home town, or an opportunity to exploit a depressed market, or possibly a mixture of both.

Turning back to St Helen's, is it possible to discover anything about the interests of his neighbours? The first step is to identify the people who might have been his near neighbours in the Close, whose attitudes and experience could have helped influence his thinking. Taking the suggested total of a hundred or so households in the parish in the 1590s, around sixty families, those not paying the Lay Subsidy, would have been too poor to afford the high rents here. That leaves fifty or so possible wealthier households who were potential residents.[5] However, from this number a further ten names can be removed because their houses were definitely located elsewhere.[6] Of the remaining forty or so households, the most likely to have lived around the Close were the four gentlemen, two doctors, the seven richer foreigners and perhaps four other long-standing residents. To this total of seventeen, one might add three other foreigners known from the 1598 Lay Subsidy roll, but whose presence in 1595 is uncertain.[7]

Living with Shakespeare

This leaves around twenty other households. Of these, twelve were mainstream, prosperous merchants (eight) or established craftsmen (four), who were most likely to have needed premises in Bishopsgate Street.[8] This leaves seven names, all rated at the lowest £3 level in the 1598 Lay Subsidy, where there is no strong indication of where they might have lived.[9] Most had a trade which could either be undertaken in Bishopsgate Street or in a back street.

Finally, there was William Shakespeare himself. If we follow his gaze around the Close, it is possible to make a reasonable guess at many of his immediate neighbours:

**Confirmed residents around the Close, Great St Helen's**
**1. Crosby Hall – facing onto Bishopsgate Street/Great St Helen's**

| | |
|---|---|
| Sir John Spencer | Former Lord Mayor (£300, 1598 LSR), moved from adjacent parish of St Martin Outwich to St Helen's in 1594. Resident in parish 1594–1610. Buried St Helen's alongside his wife Dame Alice with a large memorial in 1610. |
| Cecily Cioll | Widow, Sir Thomas Gresham's cousin (£3, 1598 LSR), living St Helen's 1566–1610. Buried in St Michael Bassishaw, near her father, in 1610. |

**2. Skinners' Almshouses, Great St Helen's (north side inside gatehouse)**
Six elderly women residents; usually stayed until they died and were buried in the graveyard of St Helen's.[10]

**3. Leathersellers' Estate (former nunnery) – facing onto Great St Helen's**
*3.1 The Cloister – west wing of former nunnery*

| | |
|---|---|
| Dr Peter Turner | Doctor of physic, former MP (£10, 1598 LSR), living in St Helen's 1589–1614 with his wife Pasha and family. Buried in Hart Street, St Olave's near his father in 1614. |

*3.2 Houses on north side of the Close, possibly carved out of the former nunnery Steward's Lodging and counting house. Leased from the Leathersellers' Company*

| | |
|---|---|
| i. John Pryn(ne) | Grocer (£3, 1598 LSR), lived in St Helen's for over fifty years, 1558–1609. Buried in St Helen's in 1609. |
| ii. John Hatton | Clerk to the Leathersellers (not in 1598 LSR), lived in St Helen's 1578–1608. Buried in St Helen's in 1608. |

| | |
|---|---|
| iii. Elizabeth Warren | Widow of William Warren, a tallow chandler who lived in St Helen's from 1561–1590. She probably continued the business (not listed in 1598 LSR). Eventually, Leathersellers' almswoman. Buried in St Helen's in 1625. |
| iv. Israel Jorden | Scrivener (not listed in 1598 LSR), lived in St Helen's 1594–1603. House, definitely leased from the Leathersellers, probably that formerly occupied by the Stone family and possibly located in Bishopsgate Street.[11] Plague victim? Buried in St Helen's in 1603. |
| *3.3 St Helen's Gatehouse* | *Occupied?*[12] |

## Likely residents around the Close, Great St Helen's, *c.* 1595
### 4. Nos. 1–10 on south side of Close
*4.1 English (listed by status of social rank and assessed wealth)*

| | |
|---|---|
| i. Sir Thomas Reade, MP | Gentleman, lived St Helen's ?–1595. Grandmother and father lived in Gresham House. Buried in St Helen's in 1596. His mother, Lady Gertrude, buried on top of Sir Thomas Gresham's 'leaden coffin' in 1605. |
| ii. John Allsop(pe) | Gentleman (£50, 1598 LSR), recorded in St Helen's by 1595. Place and date of death currently unidentified. |
| iii. Robert Honeywood II[13] | Gentleman (£40, 1598 LSR – 'Affid'), future MP 1604/14, recorded in St Helen's by January 1592 when daughter baptised. Moved to St Leonard, Shoreditch in June/July 1598. Country estate acquired in 1605 at Marks Hall, near Coggeshall, Essex. Buried in St Margaret's church, Markshall, Essex, 13 June 1627; church demolished 1933. |
| iv. Oswald Fetch[14] | Gentleman (£20, 1598 LSR – 'Affid'), recorded in St Helen's by 1581, when listed as not attending church. However, |

| | |
|---|---|
| | not listed in 1582 LSR or 1589 tithe. Place and date of burial probably St Mary's, Bocking, Essex, in 1613. |
| v. John Stoker Jekyll[15] | Gentleman (£3, 1598 LSR – 'Affid'). The family was originally from Stoke Newington. Recorded in St Helen's by January 1570, when his third son Thomas Barnhouse Jekyll, a future attorney, was baptised. Another son was baptised in March 1580. Not in 1582 LSR but in 1589 tithe. Buried in St Mary's, Bocking, Essex, 28 December 1598. |
| vi. Robert Hubbard | Gentleman/musician (did not pay 1598 LSR but did pay the 1582 LSR and 1589 tithe), recorded in St Helen's by 1580. Buried in St Helen's in 1606, followed by his wife, Katherine, in 1612. |
| vii. Dr Richard Taylor | Doctor of physic (£10, 1598 LSR; £5 in 1600 LSR), recorded in St Helen's by 1584 and lived locally until at least 1607 when his son was buried in the church. Place of death uncertain; possibly Plaistow, West Ham, Essex where he had his country house. Buried in St Gabriel, Fenchurch Street in 1615. |
| viii. Dr Edward Jorden | Doctor of physic (£8, 1598 LSR; £5 in 1600 LSR), recorded in St Helen's by 1595/6 and left *c.* 1604, when recorded in the parish of St Michael, Wood Street. Buried in Bath Abbey in 1633. |
| ix. Mrs Poole(y?) | Wife of Robert Pooley? (£10, 1598 LSR – 'Affid'), ?, possibly St Helen's by 1583 when Anne, daughter of 'Roberte Pollye', baptised. If his wife, possibly 'Affid' because her husband was working on government business. Place and date of burial currently unidentified. |
| x. John and Katherine Jeffrey | Naturalised immigrant embroiderer/milliner (£3, 1598 LSR), recorded in St |

Helen's by *c.* 1566 with first wife Antonia and family. By 1576, recorded with second wife, Katherine, in Lambeth Hill. Moved again by 1582 when recorded in LSR for nearby parish of St Botolph, Bishopsgate. Still recorded there in 1589. Subsequently, returned to St Helen's in 1590s. John buried in St Helen's in 1601 followed by the 'aged' Katherine in 1607. See section 8 of the Appendix.

*4.2 Immigrants (northern French/Dutch Protestants) – by order of assessed wealth*

xi. Lewen Vanderstilt — Rich Dutch merchant (£50, 1598 LSR), recorded London by 1582 and in St Helen's by 1589. Lived in parish 1589–1608. Buried in All Hallows, Staining 1608.

xii. Augustine de Beaulieu — Rich 'Antwerp merchant' (£25, 1598 LSR), recorded London by 1591. Living in St Helen's ?–1601. Buried in St Helen's 1601 followed by his wife, Mary, in 1612.

xiii. John de Clerk — 'Antwerp merchant' (£15, 1598 LSR), recorded London by 1591. Place and date of death unknown.

xiv. Margaret Fountayne — Widow (1589 tithe, so naturalised?), recorded London by *c.* 1568, St Helen's by 1576–94. Place and date of death currently unidentified.

xv. Peter Vegelman — Factor from Bruges (£20, 1598 LSR), recorded London by 1549. Living St Helen's ?–1601. Buried in St Helen's in 1601.

xvi. Lawrence Bassell — Foreigner (£5, 1598 LSR), trade?, recorded St Helen's by 1593, moved away *c.* 1599–1600. Place and date of death currently unidentified.

xvii. Garret Bawke — Foreigner (£2, 1598 LSR), trade?, recorded St Helen's by 1593–9. Buried in St Helen's in 1599, followed by his wife, Joyce, in 1604.

| | |
|---|---|
| xviii. Farrone Martyn | Foreigner (£10, 1598 LSR), trade?, date of arrival St Helen's after 1593. Place and date of death unknown. |
| xix. John Varhagen | Foreigner (£6, 1598 LSR), trade?, date of arrival St Helen's after 1593. Place and date of death unknown. |
| xx. Dr Cullymore | Foreigner (£5, 1598 LSR), medical doctor?, date of arrival St Helen's after 1593. Place and date of death unknown. |

Since there were probably ten to twelve significant houses in the Close, where no record has yet been identified of their residents, and twenty potential occupants, half of these people must have lived elsewhere. There is no certainty, but the ordering of payees on the 1598 Lay Subsidy roll suggests the occupants of these ten houses were most likely to have been:

| | |
|---|---|
| Robert Honeywood II | gentleman |
| John Allsop(pe) | gentleman |
| Oswald Fetche | gentleman, probably Oswald Fitch |
| John Stoker Jekyll | gentleman |
| Dr Richard Taylor | doctor |
| Dr Edward Jorden | doctor |
| John Suzan | international merchant with Barbary (Morocco) |

with the balance occupied by some of the richer immigrants and, possibly, John and Katherine Jeffrey.

Assuming that Shakespeare was living in the parish from 1593, the overall feeling must have been of being at the nexus of civic/mercantile power, with the mansion of the current Lord Mayor in front and the house of Alderman John Robinson, an international merchant, to the north. Robinson, aged sixty-three in 1595, could still potentially have been elected Lord Mayor in the future. The cluster of doctors, with their experience of high-level intellectual life on the Continent, would have made for interesting neighbours, while around him were gentlemen from significant country families, each with a web of connections to other influential people. True, there were no blue-blooded aristocrats, but there were several past and future members of parliament.

Fast forward two years to Shakespeare's situation in October 1597, when his certain presence in the parish is testified by the Lay Subsidy roll. There is a fine house in Stratford-upon-Avon, but his son and heir is dead. He has written more successful plays, but the Lord Chamberlain's Men are teetering on the brink of eviction from their home at the Theatre.

Sir Thomas Reade has been buried in St Helen's but most of the other residents in the Close are still there. Let us look a little closer at a few of the swirling undercurrents and the intriguing connections between some of these professionals and gentlemen.

A few houses away from Shakespeare is the home of Israel Jorden, scrivener and moneylender.[16] Opposite, across the Close, Robert Honeywood II, gentleman (1545–1627) is probably worried. His younger sister Elizabeth Honeywood (1561–1631) is the wife of George Woodward, MP (1549–98).[17] Thirteen years older than Elizabeth (his second wife), George is sick and will die within a few months. Like their neighbour Dr Peter Turner, Woodward was a member of the 1586 parliament and one of the seven MPs to demand the execution of Mary, Queen of Scots. Another sister, Grace Honeywood (1556–1620) is married to Michael Heneage, MP (1540–1600). Michael is George Woodward's executor and Robert wants to ensure that all the financial affairs are in order.[18] The Heneages live nearby in the parish of St Katherine Coleman but are planning to move out to a house in the still rural parish of St Leonard, Shoreditch, closer to the countryside.[19] Robert and his wife are tempted to move as well.[20] Robert's formidable mother, Mary Atwater Honeywood, a widow for twenty-one years, is now seventy and the fresh air of Shoreditch would probably do her good.[21] Yet another sister, Anna (1547–1617), is married to Sir Charles Christopher Hayles (1545–1623), owner of Thanington outside Canterbury. There is a second connection to a parallel line of the Hayles family: Robert Honeywood II's aunt Joyce Atwater (1525–?) was married to Humpfrey Hales (d. 1571). How do theatre and Shakespeare fit in to all these family connections?

Well, to start, fast forward another three years to May 1601 and a William Woodward, gentleman (1574–?), is in court chasing payment from a Robert Browne.[22] This Robert Browne is an actor and the manager of the Earl of Derby's Men. In 1599, he acquired a share of the newly developed Boar's Head Theatre, just outside Aldgate, and installed his company there.[23] The shadowy moneylender behind Robert Browne, called as a witness, is none other than Israel Jorden, scrivener, described caustically as being responsible for all Browne's 'indirect dealeings & unlawfull Courses' – the same Israel Jorden who is a neighbour of Shakespeare (see section 7 of the Appendix).

Furthermore, in May 1594, Michael Heneage's brother, Sir Thomas Heneage (1532–95), married as his second wife Mary Browne/Wriothesley, Countess of Southampton, mother of Henry Wriothesley, 3rd Earl of Southampton (Figures 17.1 and 17.2). As a result, for the sixteen months from 1594 until his death the following year, the brother of Robert Honeywood's brother-in-law was stepfather to the dedicatee of Shakespeare's *Venus and Adonis* and *The Rape of Lucrece*.

Robert Honeywood II had other interesting connections.[24] In 1594, he was one of group of eight gentlemen bringing a chancery suit protecting the interests of a relative, Cheyney Hayles (d. 1596) against Sir Richard Lee, his stepfather.[25] Cheyney Hales's grandfather was Humpfrey Hales, and Cheyney's great-grandfather – and Robert

Figure 17.1   The 'Heneage Jewel', with a miniature of Elizabeth I by Nicholas Hilliard, *c.* 1595: 'Alas, that so much virtue suffused with beauty should not last forever inviolate.' Tradition has it that this locket was given by the Queen to Sir Thomas Heneage. The exceptional quality gives an indication of the luxury enjoyed by London's rich elite.

Figure 17.2   The ark on the stormy sea (reverse) represents the Church of England safe amid religious turmoil, 'peaceful through the fierce waves'. Sir Thomas Heneage was a member of the Privy Council, vice-chamberlain of the Royal Household and responsible for Sir William Pickering's tomb in St Helen's in 1575.

Honeywood's aunt's father-in-law – was the judge Sir James Hales (*c.* 1500–54), a name that will ring bells with any *Hamlet* specialist. For a diagram of the key relationships, see Figure 17.3.[26] Sir James Hales committed suicide by drowning himself in a stream on a relative's estate at Thanington, near Canterbury, the same property owned in 1598 by Robert Honeywood's brother-in-law, Sir Charles Christopher Hayles. The suicide resulted in the famous legal case of *Hales v. Petit*, a classic case of abstract legal argument. It is generally accepted by editors that this case is the source of the gravediggers'/clowns' debate in *Hamlet*, following Ophelia's suicide in a stream (Figure 17.4).

**First Gravedigger/Clown**
Give me leave. Here lies the water– good: here stands the man – good. If the man go to this water and drown himself, it is, will he nill he, he goes. Mark you that. But if the water come to him and drown him, he drowns not himself; argal he that is not guilty of his own death shortens not his own life.
**Second Gravedigger/Clown**
But is this law?
**First Gravedigger/Clown**
Ay, marry, is't; coroner's quest law.
(*Hamlet*, V.i.15–22)

Figure 17.4  The gravediggers' scene continues with Hamlet addressing the skull of 'poor Yorick', thrown up by the digging of Ophelia's grave. Damian Lewis, straight from drama college, as Hamlet in a 1994 production at Regent's Park Open Air Theatre. Photograph by Douglas Jeffery.

# Robert Honeywood II, William Shakespeare, Sir James Hayles' suicide, *Hayles v. Petit* 1558 and *Hamlet*

```
                          John Hales
                          Baron of the
                          Exchequer         mar.         Isabel Harry
                          (by 1470–1540)
```

- John Hales — mar. — Isabel Harry
  - Sir Thomas Hales (c.1500–1583) — *owner of Thanington, Kent where Sir James Hayles drowned himself in stream*
  - Sir John Honeywood MP (1500–1557) — mar. 1543 — Mary Atwater (1527–1620)
    - 2 children
    - Robert Honeywood I (1525–1575)
    - 16 children
    - *moved to Shoreditch 1598*
  - Thomas Honywood MP
  - Mildred Hales
  - Christopher Honywood, MP

Children/associated:
- Sir Charles Hales (1545–1623) — mar. 1570 — Anne/Anna Honeywood (c.1545–1617)
  - *owner of Thanington, Kent where Sir James Hayles drowned himself in the stream in 1554*
- Sir John Croke MP (1530–1609) — mar. 1533 — Elizabeth Unton (1538–1611)
- Henry Crooke (c.1563–?) — mar. — Bennet(t) Honeywood (c.1565–1638)
  - *Barrister and brother (?) of Sir John Cro(o)ke MP (1553–1620), Recorder of London, and Speaker in 1601. Judge in Mary Glover trial 1602.*
- Sir Thomas Browne MP (?–1597)
- Sir Matthew Browne MP (1563–1603) — Elizabeth Browne
  - *freeholder of Globe Theatre from 1601–1603 when killed in a duel*
- mar. (2) 1584 — Robert Honeywood II (1545–1627) — mar. (1) 1569 — Dorothy Crooke (c.1547–c.1583)
  - *in 1584 owed a bond of £3,000 by the 17th Earl of Oxford*
  - *neighbour of William Shakespeare in St. Helen's until 1598, then moved to Shoreditch*
  - *helped Cheyney Hales in 1594 court case against his step-father Sir Richard Lee*
  - *Executor of Mic Heneage MP in*
- Grace Honeywo (1556–1620)

17 children by his two wives:
- Sir Robert Honeywood III (1574–c.1654) — mar. 1598 — Alice Barnha (1581–1638)
  - *lived in St. Helen's on Leathersellers Estate c. 1631*
  - 16 children
    - Sir Robert Honeywood IV MP (c.1601–1686)

IMPORTANT NOTE: There are conflicting birth/death dates for several people in this diagram. Caution advised.

Figure 17.3 Family tree showing the relationship of Robert Honeywood II to both branches of the Hayles family. The suicide of Sir James Hayles at Thanington in the River Stour (1554) prompted the 1558 *Hales v. Petit* court case, considered to be the basis for the gravediggers' discussion about Ophelia's death in *Hamlet*.

```
                                                                                    Sir James Hales    mar.   Margaret    mar.   Sir William
John Honywood of Sene                                                               (1500–1552)        (3)    Wood        (2)    Haute
                                                                                                                                 (d.1539)
Margaret Honywood    mar.    Edward Hales of
                             Tenterden
                                                                                    committed suicide         instigated        lived at the
                                                                                    1554 in stream at         case of           manor of
                                                                                    Thanington, Kent          Hales v. Petit    Bishopsbourne,
         Robert Atwater      mar.    Katherine Briget                                                         1558–62           five miles from
         (1500–c.1565)               c.1505–c.1565                                                                              Thanington

    Sir Robert Heneage                                              Joyce Atwater    mar.   Humfrey Hales
    (1500–1556)                                                     (?–1594)                (?–1571)

                                                                                         at least seven
                                                                                         children

Michael Heneage MP   brothers   Sir Thomas Heneage  mar. (2)  Mary Browne   Elizabeth        mar. (2).   George Woodward MP   Sir James Hayles   mar.   Alice Kempe   mar.   Sir Richard Lee
(1540–1600)                     MP                  1595      (1552–1607)   Honeywood        c. 1579     (1549–1598)          (?–1589)           (1)    (?–1592)      (2)    (?–1608)
                                (1532–1595)                                 (1561–1631)

Executor of George              friend of Thomas              mother of Henry              one of the seven MPs who
Woodward MP in                  Coleshill MP.                 Wriothesley, 3rd Earl        urged execution of Mary
1598 - moved to                 Reponsible for                of Southampton               Queen of Scots in Nov.
Hoxton in 1598                  Sir William                   (1573–1624)                  1586. Appointed by the
                                Pickering's tomb in                                        House of Commons to
                                St. Helen's in 1575                                        confer with the Lords on
                                                                                           the 'great cause'.

10 children

Thomas Heneage MP                                  mar.(3?) 1630                Bridget Woodward                  Cheyney Hayles
(1581–1641)                                                                     (1590–?)                          (– 1596)
```

It could be argued that the *Hales v. Petit* case was common knowledge among educated Londoners, particularly since an account of it was published in 1571.[27] However, it is intriguing that Robert Honeywood II, a relative of the suicide (brother-in-law to his grandson), who was helping his great-grandson in a 1594 court case, lived less than a hundred yards, possibly just fifty yards, from Shakespeare, across the graveyard of St Helen's.

When Shakespeare came to write one of the most famous scenes in arguably the world's greatest play, he could have heard talk about the *Hales v. Petit* case from others, or he could have read about it in a legal textbook, or Robert Honeywood II could have told him the story and perhaps lent him a copy of Sir Edmund Plowden's 1571 account. There is no certain evidence, but the balance of probability in this case leans towards Shakespeare learning of the case through a personal connection with Robert Honeywood II. Given that both Shakespeare (possibly) and Robert Honeywood II (definitely) seem to have left St Helen's by October 1598, if this route for the source is correct, it would suggest that at least this part of *Hamlet* might have been under development prior to the end of 1598.

Drawing back from this specific detail to a broader overview of the Close, St Helen's gives the strong impression of an area which smelt of success, with most residents on the rise in society; in the case of Sir John Spencer, entirely self-made.[28] Even the immigrants, driven out of their own countries by war or attracted to London by business opportunities, were generally making good in their new city. For Shakespeare, it would have been a suitable address but perhaps not an altogether restful one.[29] Each evening, as he walked past his neighbours' houses, he may have reflected on how far he had come but also how far he had yet to go, artistically, financially and socially. St Helen's may have been a powerful driver of social climbing, but it could also have been a practical 'workshop'. The physical layout of the Close could have stirred up deeper emotions and thoughts. If one compares the footprint of the Theatre to the area of the Close, it fits neatly inside (Figure 17.5). The west end of St Helen's, with its unique pair of doors, was forty-eight feet across. The stage of the Globe, with its two entrance doors, is thought to have been about forty-eight feet across and around thirty feet deep. The stage of the Theatre would have been smaller, but even so, Shakespeare could stand in the graveyard of St Helen's with a physical evocation of his daily workplace all around him. The row of ten three-storey houses, with their jettied upper stories, would have been very similar in construction to the separate bays of the fourteen-sided Theatre uncurled. Each window overlooking the churchyard would have mirrored a separate section of his audience at the Theatre. The graveyard and its surrounds would have been a 'yard' of London's daily life, probably with children playing, servants collecting water at the parish well, hawkers, peddlers and small tradesmen in conversation, all making their entrances and their exits. By St Helen's Gate, the six women in the Skinners' almshouses would have kept a watchful eye on any potential troublemakers. The Close next to the

church of St Helen's would have provided Shakespeare with a simulacrum to his theatre space, a microcosmos of his imagined worlds.

With nearly one hundred parish churches within the city walls, there were plenty of places where Shakespeare could have looked over a graveyard to a church. However, there were only a few where the graveyard was positioned across the west end of the church, and only at St Helen's were there two entrance doors, a relic of its former use as two churches, creating a broad entrance. There was also another distinctive feature. Looking at St Helen's on the 'Agas' Map,[30] one can see the parish well clearly drawn positioned up against the south wall of the churchyard. It is tempting to think that Shakespeare recalled this arrangement of two doors, churchyard and well in *Romeo and Juliet*:

**Benvolio**
What, art thou hurt?
[. . .]
**Mercutio**
No, 'tis not so deep as a **well** nor so wide as a **church-door**, but 'tis enough, 'twill serve. Ask for me tomorrow, and you shall find me **a grave** man.
(*Romeo and Juliet*, III.i.93; 96–8; emphasis added)

Close inspection suggests the well may have been of the double bucket type, where one rose as the other fell, evoking *Richard II*'s:[31]

Now is this golden crown like a deep well
That owes **two buckets** filling one another,
The emptier ever dancing in the air,
The other down, unseen, and full of water.
That bucket down and full of tears am I,
Drinking my griefs, whilst you mount up on high.
(*Richard II*, IV.i.174–9; emphasis added)

However, such connections need to be made with caution. By 1586/7, there are references to 'the pumpe' at St Helen's, so whether the original parish well continued into Shakespeare's time is uncertain.[32]

Moreover, beyond the immediate atmosphere of success and social advancement around the Close, there may have been darker associations at work. In 1597, Shakespeare's only son and heir was dead. In terms of his family, this tragedy would probably have prompted thoughts about his own succession and inheritance itself. Around him, the remains of the former Catholic nunnery might have triggered thoughts about 'failed

Figure 17.5   Footprint of the Theatre (1576) superimposed on the graveyard of St Helen's. Great St Helen's could have provided a theatrical microcosmos, with the two church doors mirroring the entrances onto the stage at the Theatre.

Figure 17.6   Despite the wealth of Sir Thomas Gresham and the owners of Crosby Hall, both of the large mansions in St Helen's saw a 'failed transmission' to create ongoing dynastic succession.

Figure 17.7 Miniatures of two young girls, aged five (holding a carnation) and four (an apple). Miniatures were commissioned for various purposes, ranging from family mementos to love tokens. However, they were expensive, and most Londoners died without any visual record. Watercolour on vellum by Isaac Oliver, dated 1590.

Figure 17.8 Miniature of a young man among roses. This courtier, with his hand on his heart, is possibly Robert Devereux, 2nd Earl of Essex and Elizabeth I's great favourite in the 1590s. Watercolour on vellum by Nicholas Hilliard, c. 1587.

Figure 17.9 Miniature of an unknown young man against flames. He is holding a jewel to his heart and the fire is probably meant to symbolise his intense passion. Despite their small size, Elizabethan miniatures could convey a great deal of character. Watercolour on vellum by Nicholas Hilliard, 1590–5.

Figure 17.10 Miniature of an unknown woman, possibly Mistress Holland, maid of honour to Elizabeth I. Painted the year Shakespeare may have moved into St Helen's. Watercolour on vellum by Nicholas Hilliard, dated 1593.

transmission' by both religious and secular powers. The wealth of the nunnery and all of England's monastic foundations was now scattered among ambitious secular beneficiaries. Despite the fortunes made by merchant princes and financiers like Sir John Crosby and Sir Thomas Gresham, they had not been able to create or to ensure the survival of their own family lines (Figure 17.6). Just like Shakespeare, there were no surviving direct male heirs to ensure the succession, crucial in a patriarchal society. Even the wealthy Bond family, new arrivals themselves in 1566, which had continued into the next generation, had moved out of Crosby Hall in 1593/4 in exchange for the new money represented by Sir John Spencer. Between their former mansions, the Close provided an echo chamber to historical change, lost power and unrealised dynastic ambitions.

Although Shakespeare, or a contemporary, might write:[33]

> To the Queen
> As the dial hand tells o'er[34]
> The same hours it had before,
> Still beginning in the ending.
> Circular account still lending,
> So, most mighty Queen we pray,
> Like the dial day by day
> You may lead the seasons on,
> Making new where old are gone.

– everybody recognised that, with the childless Queen Elizabeth now in her sixties, a succession crisis was looming. As her subjects, young and old, female and male, rich or poor, urban or rural, lived through the 1590s (Figures 17.7–17.10), the threat of civil conflict remained a constant.

The contrast between historical glory and current reality must have been sharp. The wealth and piety of the priory was now transformed into the business-focused Leathersellers' Livery Hall and housing – 'a bare ruined choir' indeed – some now occupied by the upper echelons of the parish: a successful skinner, a wealthy wool merchant and a society doctor. Where once the high altar of St Helen had stood for three hundred years, tombs of the rising merchant classes now jostled each other for space. Shakespeare recognised, in Sonnet 55, the temporality of even these brash memorials:

> Not marble, nor gilded monuments
> Of Princes, shall outlive this powerful rhyme:
> But you shall shine more bright in these contents
> Than unswept stone, besmear'd with sluttish time

> When wasteful war shall statues overturn,
> And broils root out the work of masonry.
> Nor Mars his sword nor war's quick fire shall burn
> The living record of your memory.
> 'Gainst death and all-oblivious enmity
> Shall you pace forth; your praise shall still find room
> Even in the eyes of all posterity
> That wear this world out to the ending doom.
> So, till the judgement that yourself arise,
> You live in this, and dwell in lovers' eyes.
> (*Sonnet 55*, ll.1–14)

The presence of the looming Crosby Hall off to his right was also a constant reminder of the uncertainty and transience of secular power. Sir John Crosby had enjoyed his mansion for only nine years. Despite, or perhaps because of, its grandeur, no family – most notably even Richard, Duke of Gloucester – had been able to maintain the property in long-term ownership. The result of a battle or the fate of a trading expedition could equally doom the powerful. After Richard III, other owners had fared little better – Sir Thomas More executed; the Italian banker Antonio Buonvisi driven abroad; Cecily Cioll, Gresham's cousin, and her husband forced to give up it up after six years because of straitened finances. Even the new occupant, the great, powerful 'rich' Sir John Spencer had only one free-spirited daughter, who refused to obey him. There was no son to carry on his line despite his enormous wealth.

The Close could have served as an analogue of a physical theatre, but it could also conjure up a more complex mix of power dynamics. There was the shift from the religious power of the nunnery to the secular power of Crosby Hall. There was Gresham House, held in limbo between dynastic failure and its future as a college. There were the doctors arguing for a more proactive approach to healing the human body, while the ageing John Robinson represented the declining power of the wool staple, which had dominated medieval England. Overall, there was the growing power of a monetary economy, reaching out across the oceans. At the centre of this turmoil was the finality of human existence, manifested by the graveyard of St Helen's with the eternal movement of the planets and stars overhead. No wonder Shakespeare's next workplace was named the Globe.

Notes

1. At this time, Richard Quiney was also trying to borrow £30 from Shakespeare, a substantial sum.
2. The Close and churchyard provided the only public open space in the parish, shaded by the surrounding houses. While the Leathersellers' Company, Lady Gresham, Sir John Spencer and Dr Turner enjoyed

private gardens, the other hundred or so households only had their back yards or this space. The irregular area measured only forty yards east to west and about sixteen yards across at its maximum – in total an area of less than 650 square yards (540m$^2$). The churchyard itself was smaller still – less than 500m$^2$, as it was bounded on each side, apart from the east, by access roads separated by a simple brick wall and gated to keep out dogs. Without gravestones, the churchyard was left to grass, which was mown twice a year. A path ran across the grass from the west end to the main church door. Assuming 300m$^2$ was available for burials, the churchyard could have taken about 150–200 adult burials before there would have been a need to disturb an earlier grave. Given that many burials were babies or young children, the capacity would have been greater. However, during plague years, such as 1578, 1593, 1603, 1625, 1665, the space would have been quickly overwhelmed, probably resulting in fragments of former parishioners appearing on the surface; 'poor Yorick', indeed. A narrow strip of ground continued the churchyard along the south side of the church to the east end. This may have been the location of the 'new churchyard' mentioned in 1595, possibly laid out because of pressure of space for the 1593 plague victims. If so, it did not last, as the area was built over by 1700. The Leathersellers' records include regular payments for maintaining their garden, e.g. in 1570 'payment John Riche for keeping the garden quarter 15s', in 1586 'Paid for new tryminge of the garden this yeare beinge gretlie decayed by reson of the harde wynter and for plantes to sett it 15s-0d' and in 1599, 'payd for [h]Isope plantes lavender Rosemary and to two women for their paynes 20s' and the orchard 'palled in'.

3. They performed five times on 26, 27, 28 December, 6 January and 22 February, and six times at Christmas 1596.
4. The winter of 1595 was so cold that the Thames froze over.
5. With the exception of Robert Hubbard, gentleman/musician, who is known to have been in this area from other information and had declined in wealth over the years.
6. Sir John Spencer (Crosby Hall), Lady Anne Gresham (Reade)/William Reade (Gresham House), John Robinson the Elder, John Robinson the Younger, John Pryn(ne), Robert Spring (all main Leathersellers' Estate), Dr Peter Turner (nunnery west wing – Leathersellers' Estate), Thomas Morley (possibly Little St Helen's), Cicely Cioll (Bishopsgate Street/Crosby Hall). There was also Walter Briggen, who may have been living on the Leathersellers' Estate.
7. Farrone Martyn, John Varhagen and Dr Cullymore.
8. Assessed at £5–£30 in the 1598 Lay Subsidy roll: Peter Dallyla (?), John Morris, James Scoles, John Suzan, Timothy Bathurst, James Elwicke, Anthony Sno(a)de and Edward Swayne. The 1589 tithe survey and other records indicates that Bathurst and Elwicke were living at the south end of Bishopsgate Street. The tithe survey also suggests the following three, rated at £3 in the 1598 Lay Subsidy roll – William Staveley, George Ax(s/t)on, Richard Risby – also lived in Bishopsgate Street. James Rowkyll, cook, also assessed at £3, lived in Little St Helen's.
9. Rated at £3 in the 1598 Lay Subsidy roll: Edward Jackson, Christopher Eland, William Winkfield, Thomas Childe, Francis Wells, Henry Maunder, Henry Litherland.
10. There were regular burials of the inhabitants and also from the Leathersellers' almshouses, as on 20 June 1597, Widow Bredon, 'one of the Skinners almeswomen', 3 March 1598, Katherine Baker, 'one of the Leathersellers almswomen'.
11. Israel Jorden's house was probably that leased by Edmund Stone, a sadler, from the Leathersellers c. 1554–77. His widow, Agnes Stone, may have continued the business after his death, 1577–87. William Stone, their son, was a draper and, for a short period in the 1590s, parish clerk. He is not in 1598 Lay Subsidy roll, as he died in 1597 and was buried in the church. He lived in St Helen's but may have moved out of this property in 1587 as the lease was taken over by Richard Hey, followed by Thomas Wrightson before Israel Jorden.
12. At the dissolution of the nunnery, the janitor and his wife were paying 10s-0d rent, suggesting a basic one- or two-room accommodation, unless a larger house was provided in lieu of wages.
13. In the Elizabethan period there were no house numbers. Locations would be given by reference to major buildings or other topographical features.
14. A Robert Honeywood paid his Lay Subsidy in the parish of St Leonard, Shoreditch in October 1598 (assessment £20) and 1600 (£25). This seems likely to be Robert Honeywood II, particularly since

Michael Heneage, his brother-in-law, is listed two names below him and 'Mary Honnywood wid[owe]' (£5) is six lines further down – probably his mother, the famous Mary Atwater Honnywood (see below). Robert Honeywood seems to have moved to Hoxton, Shoreditch in June /July, since Thomas Brand was hauled before the governors of Bridewell on 9 August 1598 for having 'carnall knowledge' of Marye Games in Honeywood's house for which he gave her a 'Livereye cloke'; see BCB-04, p. 66, available online. Six weeks later, Ben Jonson killed the actor Gabriel Spencer in a duel nearby in 'Hogsden [Hoxton] Fields'. Edward and Jeronimo Bassano, both queen's musicians, were also both listed in Shoreditch in 1600. Only Jeronimo is in the 1598 Lay Subsidy roll (£20). Since he was listed in the 1589 St Helen's tithe, he must have moved to Shoreditch between 1589 and 1598. On 28 October 1598, burglars broke into his house and stole nearly £100 of jewellery and money, perhaps suggesting he had moved there recently. If this was the case, he would have been a neighbour during Shakespeare's time in St Helen's; see Jeaffreson, *Middlesex County Records*. The Honeywoods were a large family, originating from Charing near Canterbury, Kent. Robert Honeywood II was born at Charing but eventually established his branch of the enormous family at Marks Hall, Essex. It is interesting that, given the next two entries, Marks Hall is only seven miles from Bocking/Braintree. In the 1598 Lay Subsidy roll, Honeywood is recorded as 'Affid'. There are seven names recorded as 'Affid' in the 1598 Lay subsidy roll, including Shakespeare, where payment in St Helen's could not be obtained. Of the other six, it is intriguing that three, John Stoker Jeckett (d. 1598), Oswald Fetche and Robert Honeywood, all ended up living and being buried within a few miles of each other in north-west Essex. The remaining three are the composer Thomas Morley, excluded as a royal official, Mrs Poole and William Cherle, trade and background unidentified. Sir Robert's mother, Mary Atwater Honeywood (1527–1620), was a remarkable woman whose entry in the nineteenth-century *Dictionary of National Biography* states: 'Mrs. Honywood was chiefly celebrated for her longevity, and for the unprecedentedly large number of lineal descendants whom she lived to see. By her sixteen children she had 114 grandchildren, 228 great-grandchildren, and nine great-great-grandchildren, 367 in all. Her grandson, Dr Michael Honywood (1597–1681), Dean of Lincoln Cathedral, was accustomed to tell of his having been present at a banquet given by her to her descendants, two hundred of whom sat down to table. She was also noted for her piety, but in her declining years fell into deep despondency. It is recorded that Foxe, the martyrologist, having visited her with the view of consoling her, she dashed a Venice glass to the ground, saying, "Sir, I am as sure to be damned as this glass is to be broke," when by God's wonderful providence the glass was taken up uninjured.' She died aged ninety-three. Robert Honeywood II's son Dr Michael Honywood built the magnificent Wren library at Lincoln Cathedral to house his donation of 5,000 books.

15. An Oswald Fitch, born *c.* 1543, was buried in St Marys, Bocking, Essex, where his fine memorial brass survives, showing a standing gentleman in a ruff. It states his death as 28 February 1612/13. Oswald Fitch was part of the extensive Fitch family. Various branches of the family had landholdings across north-west Essex at a time when the Bocking/Braintree area was a major centre for wool production and weaving. Oswald is not a common Elizabethan name, and it seems that this is the same person, particularly given that John Stoker Jekyll (see next entry) was memorialised in the same church in 1598. Edward Jekyll, one of John Stoker Jekyll's sons, is recorded in the inscription as being Oswald's executor and erecting the memorial. That this is the St Helen's Oswald Fetch is also strongly suggested by the fact that Edward Jekyll married Martha Fitch at St Helen's on 14 February 1613, just two weeks before Oswald's death. Martha was the daughter of the Rev. James Fitch and possibly Oswald's niece. Oswald Fetch and John Stoker Jekyll are listed next to each other in the 1598 St Helen's Lay Subsidy roll, suggesting that they lived in neighbouring properties or, conceivably, in the same house. If the latter was the case, Jekyll's illness and death may have led to Fetch giving up the house as well, and hence his 'Affid' status. Oswald's assessment in the 1598 Lay Subsidy roll was £20, a substantial sum which placed him eleventh in terms of wealth. The Bocking Fitches were strongly Puritan, and several were early emigrants to New England. Oswald Fetch was never made a churchwarden or auditor in St Helen's, which most other residents of his status were; perhaps he was considered religiously suspect.

Living with Shakespeare

16. There is some evidence to support John Stoker Jekyll living in this row of houses. His sister Cecily (c. 1530 – before 3 July 1590, buried Braintree, Essex) was married to Thomas Heron. His brother was John Heron and they were grandsons of Sir Thomas More, as their mother was his daughter Cecily More, who married Giles Heron (1504 – executed 1540) in September 1525. A John Heron was recorded in October 1546 as living in the row of ten houses then owned by the Crane family; see the post-mortem inquisition of William Crane, in Fry, *Abstracts of Inquisitiones Post Mortem for the City of London: Part I*, p. 57. Cecily and Thomas had no children, so she may have passed the house to her brother at some point. Sir Thomas More had briefly owned Crosby Hall *c.* 1523.

17. See section 7 of the Appendix for details about Israel Jorden.

18. They were married in St Helen's on 27 December 1579.

19. In 1578, Michael Heneage, with his brother, the politician and privy councillor Sir Thomas, were made keepers of the records in the Tower of London. Robert Honeywood II was Michael Heneage's executor when he died in 1600. There are other connections; Thomas Coleshill mentions Sir Thomas Heneage in his will in a way which suggests familiarity – hardly surprising, given his crucial role in running the London customs service. Thomas Coleshill MP is a key figure in parish affairs in the 1560s/early 1570s but seems to disappear after 1576, apart from a listing in the 1582 Lay Subsidy roll. He may have progressively moved out to his country estate at Chigwell in Essex, with his daughter Susan(na) and her husband Edward Stanhope I taking over the St Helen's house, as four of their children were baptised in St Helen's in the period 1577–81. Bennet, a half-sister of Robert Honeywood, was married to the lawyer Michael Croke, brother of Sir John Croke MP, Speaker in 1601, Recorder of London and a judge in the Mary Glover trial in 1602 (see Chapters 18 to 20).

20. Michael Heneage's (1540–1600) brother was Sir Thomas Heneage, courtier, politician and 'treasurer of the chamber', a post which he retained after becoming vice-chamberlain. There are numerous references to payments made by him for such diverse purposes as bringing messages from ambassadors, decorating the council chamber with 'boughs and flowers' and providing post horses. The wages of the companies of players who acted before the Queen, and of the bearwards and keepers of wild beasts, also came within his department. He was one of four men responsible for the tomb of Sir William Pickering in St Helen's in 1575.

21. Michael Heneage and Robert Honeywood were close friends, as is made clear in the former's will (TNA PROB 11/97/22), where Heneage appoints him as executor. Heneage's will is a rare example of specific bequests of books to different people: Foxe's *Book of Martyrs* to his sister; 'my two greate volumes of Englishe *Cronicles* [probably Holinshed's]' to his son Thomas; and 'my three great volumes of Gesner *de animalibus* . . . [presumably the *Historia animalium* of the Swiss physician and naturalist Conrad Gessner, 1516–1565]' to 'my close and dearest friend Doctor Gilbert (Gilberd). He let his son chose up to twelve books, suggesting a library of perhaps thirty to fifty books. If this was Holinshed's *Chronicles*, could it have been the one used by Shakespeare?

22. By the 1 October 1598 Lay Subsidy collection, Robert Honeywood II, the Heneages and probably Mary Atwater Honeywood were all recorded as living in St Leonard, Shoreditch, just as the Lord Chamberlain's Men were planning to remove the Theatre to Southwark.

23. The 1598 Lay Subsidy roll for Holborn End (towards St Giles-in-the-Fields church) records a William Woodward, gentleman, assessed at £6. A William Woodward was a cousin of George Woodward, MP, but it is not certain that it is the same person.

24. It is generally considered likely that Lord Strange's Men formed the core of the Lord Chamberlain's Men in 1594. However, despite the mysterious death of the 5th Earl in April 1594, his successor the 6th Earl continued to patronise a theatre company; see Manley and MacLean, *Lord Strange's Men and Their Plays*, pp. 321–5.

25. Nina Green's analysis of the will of Sir James Hayles, junior, TNA PROB 11/75/265, also records that on 23 May 1584, Edward de Vere, 17th Earl of Oxford, acknowledged a bond of £3,000 to 'Honeywood' – see TNA PRO 30/34/14 – who, she considers, was probably Robert Honeywood II.

26. Sir Richard Lee was half-brother of Sir Henry Lee, MP (1533–1611), from 1570 the Queen's champion.

27. Since Robert Honeywood II was brother-in-law of the then-current owner of the property, Thanington outside Canterbury, where the suicide had taken place, he conceivably might have seen the site itself.

28. Plowden, *Les Commentaries ou les reports de Edmunde*.
29. Sir John Spencer came from Waldingfield, a village in the rich wool-producing area of Suffolk, around Long Melford. In 1599, Elizabeth I gave him the manor of Bocking, Essex, eighteen miles to the south. This was where John Stoker Jekyll and Oswald Fitch were buried in 1598 and 1613 respectively, highlighting the web of commercial and other connections, now unrecorded, between the major families involved in the wool trade.
30. William Dethick, from 1586 the Garter Principal King of Arms, the senior officer of the College of Arms who arranged John Shakespeare's grant of arms in 1596, lived in the adjoining parish of St Peter, Cornhill.
31. A somewhat later and woodcut version of the Copperplate Map, which survives complete, albeit in a later 1633 printing.
32. However, the neighbouring church of St Martin Outwich in Bishopsgate Street was next to a well and was specifically known as St Martin 'with the well with two buckets'.
33. The parish accounts for 1586/7 record for 'two labourers cleaning the welles 3s[hillings]' and repairing the paving 'around the poumpe 3s-6d'.
34. Experts disagree about whether this poem, possibly an epilogue to a play, was written by Shakespeare; other possibilities include Ben Jonson and Thomas Dekker.
35. St Helen's church was unique in that it lacked its own attached tower. Virtually every other parish church in the City had one. Apart from pointing to heaven, a church tower had another fundamental role as the housing for the parish bell or bells. In a world with few watches or domestic clocks and cloud-censored sundials, the course of the day and the cycle of life were proclaimed by the church bells. With a hundred churches spread across the City, Londoners' hearing would have been attuned to picking out the distinct sound of their own parish from the others around them. St Helen's unique evolution meant that its four bells hung in the former priory campanile over St Helen's Gate. The church itself only had a meagre clock turret built on the west end, and even this was moved in 1569 because of concerns about its structural stability. Indeed, the overall impression of the west end of St Helen's was probably more akin to a medieval city wall or the great hall of a castle than a typical parish church. Church clocks were complex and maintenance-heavy instruments, where the benefit of their status was often outweighed by the continuous costs of keeping them wound up and running to time. It is not known if the St Helen's clock mechanism triggered a hammer to strike a linked bell. If so, it would have been small and sharp. The Close, therefore, had a sonic canvas stretched across it, with the clock at one end and the four larger bells at the west end. As Shakespeare struggled with *Richard II* or *Romeo and Juliet*, did the echoes of the bells remind him of the former nuns, celebrations of past coronations and great victories?

# PART VI

Bewitchment in London

Figure 18.1 Conviction of the reality of witchcraft fitted into a broader pattern of belief in magic, fabulous creatures and the supernatural. Lucas Cranach the Elder's woodcut *The Werewolf or the Cannibal* (*c.* 1512) conjures up the terror of a bestial man stealing a child from a distraught mother.

# 18

## Witchcraft in Thames Street

*In which the account of Mary Glover's extraordinary symptoms of bewitchment in 1602 connects to two prominent residents of St Helen's. They take opposite sides in the debate over whether she is a fraud or not.*

During the early summer of 1602, rumours began to spread along the waterfront of London about an extraordinary happening. Besides the usual gossip that the ageing Queen was finally dying, people spoke in fearful whispers of a fourteen-year-old girl, Mary Glover, who had been bewitched. As wherrymen rowed across the Thames to the new Globe Theatre on Bankside, they probably enjoyed scaring their passengers with increasingly dramatic stories about demonic possession, right there in the heart of the City. For many Londoners, witchcraft was not some fantasy hidden away in dark forests or on distant moors, but a very real presence all around (Figures 18.1 and 18.2). The Devil was constantly trying to snare the unwary in his webs of deceit.

Sometime between 1603 and 1606 – most likely 1605–6 – Shakespeare wrote his masterpiece *Macbeth*, starting with one of his most famous scenes:

> *A desert place*
> Thunder and lightning. Enter three Witches
> **First Witch**
> When shall we three meet again
> In thunder, lightning, or in rain?
> **Second Witch**
> When the hurlyburly's done,
> When the battle's lost and won.
> **Third Witch**
> That will be ere the set of sun.
> **First Witch**
> Where the place?
> **Second Witch**
> Upon the heath.
> **Third Witch**
> There to meet with Macbeth.
> (*Macbeth*, I.i.1–7)

Figure 18.2 The romantic imagery given to Macbeth's witches in the nineteenth century obscures the reality of bewitchment to ordinary people two hundred years earlier. *The Three Witches from Macbeth* by Alexandre Colin, oil painting, 1827.

Figure 18.3 Parish of All-Hallows-the-Less (circled), where Mary Glover accused Elizabeth Jackson of bewitching her in 1602. Note the traitors' heads mounted on spikes on London Bridge. Section from the Panorama engraved by Claes Visscher (1616).

Figure 18.4 Portrait of the Chief Justice of Common Pleas, Sir Edmund Anderson, who presided over the Mary Glover trial. He considered himself an expert in identifying witches and was also involved with Anne Kirk. Anonymous oil painting, 1590s.

Figure 18.5 A wherry or water taxi crossing the Thames to Southwark. Wherrymen were often raconteurs or, like John Taylor, self-styled 'water poets'. Watercolour from Michael Van Meer's *Album Amicorum*, 1614–17 (f. 408v).

## Living with Shakespeare

Even if Shakespeare had never lived in St Helen's, it is likely that he would have soon learnt about Mary Glover. As it was, Shakespeare probably knew two of the key players in the unfolding drama, Dr Edward Jorden and Lewis Hughes, the Puritan minister of St Helen's who took over the parish in Autumn 1600.[1]

Events started some 700 yards to the south of St Helen's, in Thames Street in the parish of All-Hallows-the-Less. This was a small riverside neighbourhood just 200 yards west of Old London Bridge (Figure 18.3).[2] The situation involved a prepubescent girl, Mary Glover, and her entanglement with a 'lewd' old woman, Elizabeth Jackson, who lived in the same tiny parish.[3] Jackson was later described unflatteringly as 'aged, homely, gross bodied, and of low stature'.[4] She seems to have been an old woman on the fringes of society. So far, so familiar – different generations and backgrounds clashing over some real or imagined slight – tempers flaring among the sweating sailors, porters and carters unloading along the quays. Mary's father, Timothy Glover, was a wealthy merchant,[5] but more importantly she was related to a future alderman and knight, William Glover (c. 1545–1603), a dyer and recent sheriff – one of the most powerful figures in the City government.[6] As a result of his status, a whole series of physicians, ministers and judges (and hence the professions of medicine, religion and law) got dragged into the Glover affair, providing one of the best-documented Elizabethan cases of potential bewitchment and the claimed working methods of witches.[7] Suddenly, one is down at ground level, watching the day-to-day interactions of Londoners as they struggled to explain events and actions completely outside their normal experience.

The Mary Glover affair was not an isolated case of witchcraft in London. Just three years earlier, in 1599, there had been another claimed bewitchment – in this case of two girls, by Anne Kirk(e)[8] at Castle Alley, near Broken Wharf, about 300 yards along Thames Street to the west of Mary Glover's house. The girls' mother had a falling-out with Kirk in the street:

> Whereupon the woman going home and sitting with her child by the fire in her lap, it gave a great shreeke, and was suddenly changed; and after that continually pinned away till it dyed.[9]

Then her other daughter met Kirk in the street, and began to suffer fits, with her appearance being described as:

> stricken downe in a very strange maner; her mouth beeing drawne aside like a purse, her teeth gnashing togeather, her mouth foming, and her eyes staring the rest of her body being strangely disfigured.

When Kirk left her, the girl recovered, but she continued to suffer fits. The girl appears to have been interrogated by 'Lord Anderson' – this was Sir Edmund Anderson

(1530–1605), Chief Justice of the Common Pleas, who was later to be the main judge in the Glover case (Figure 18.4). Anderson considered himself an authority on witchcraft. With limited understanding of the causes of illness and high childhood mortality rates, one can appreciate how distraught parents would find bewitchment a convincing reason for their tragedies. Families lived cheek by jowl, packed together in crowded tenements, and it is easy to imagine how years of friction and quarrels about minor grievances could boil over into potentially fatal accusations. Kirk was also accused of interfering with three other families – a common pattern of a local community turning its group disapproval onto an unpopular individual, often, but not always, an elderly woman. In the first case, it was claimed that Kirk was making a child suffer because the parents had not invited her to the christening. The father and some friends crossed the Thames, presumably on a wherry (Figure 18.5), to consult with 'Mother Gillams, dwelling on Bankside', perhaps a 'wise woman' who advised:

> for the childes recovery they should cut of a piece of the witches coate with a payre of sheeres, & burne it togeather with the childs under cloth: which they did and the childe accordingly was healed.

The use of this sort of sympathetic magic at the heart of the hard-nosed Elizabethan mercantile City reveals the way ancient folk beliefs were mixed up in many peoples' minds with official religious dogma. Kirk also bewitched the child of a local unnamed innkeeper. He consulted a 'cunning-man (as they are called)', who:

> told him, that the causer of his childes torments was conversant in his house: and (after promise made of not revealing the partie) he showed him in a glasse [mirror] this witch Anne Kerke.

The innkeeper denounced Kirk to a neighbour, but the child still died, and then the innkeeper expired in turn. Presumably by now Kirk's apparent powers would have made her feared and hated by her neighbours in equal measure. It was then claimed that she had bewitched three children of the local Nai(y)ler family, who also lived in Thames Street (Figure 18.6).[10] First, George Nailer was tormented and died, then his sister Anne. Before Anne's death, it was claimed a devil in her said to George, 'one would come after who should discover the causer, and the truth of all'.[11] The family distributed money to the poor at Anne's burial but failed to give Kirk any of the alms. As a result, Kirk was accused of bewitching another sister, Joan, who began to have serious fits and visits by an evil spirit, which said:

> Give me thy liver, thy lights [lungs], thy heart, thy soule, &c; then thou shalt be released, then I will depart fro[m] thee: also, Goe, take thy lace & hang thy selfe:

Figure 18.6   Parish of St Mary Somerset (circled), where Anne Kirk was accused of bewitchment in 1599. Shakespeare might have walked through the area for a wherry to the Globe (dashed line). Section from the Panorama engraved by Claes Visscher (1616).

> Go into the next roome and hang thy selfe in the sack rope, and so thou shalt be released.

One wonders if the innkeeper had consulted the astrologer and doctor Simon Forman, who lived about fifteen minutes' walk to the east. An examination of his casebooks for 1598/9 does not reveal a clear match, although he had many clients claiming to be victims of witchcraft.[12] However, two of the Nailor sisters definitely did seek Forman's guidance in June 1599, which provides a precise timing for the central events.[13]

Twelve days after her sister Anne had been buried in St Mary Somerset church,[14] at 14.45 on Sunday, 10 June, Christian Nailor, 'of 14 yers',[15] had her astrological chart cast. Forman's notes (Figure 18.7) recorded:

> Christian Nailor[16] – 10 June 1599
>     Christian Nailor of 14 yers 1599 the 10 of Iune ☉ p m At 45 p 2 Diz
>     Left margin: good wif(e) Kirke
>     Yt is of [Mars] in [Taurus], [Moon] separating from [Venus] in [Cancer].

Figure 18.7 Simon Forman's astrological casting for the thirteen/fourteen-year-old on 10 June 1599, which notes 'she is bewytched'. In the left-hand margin is written 'good wif kirke', the presumed witch. Detail from his casebook

> Of moch cold humors. She is bewytched. The rising of the lungs like to stop her wind & full of fansyes.

The question is 'diz', meaning the querent asked, 'What is the disease?' When witchcraft and the other symptoms appear in the judgement, it is often unclear whether these are things the astrologer has heard from the querent/patient, or read in the stars. If the querent mentioned witchcraft, it was typical for Forman and his associate Napier to write the name of the suspected witch in the margin, here 'good wif(e) Kirke'. This did not necessarily mean that he thought the cause was witchcraft.[17]

Two weeks later, one of Christian's parents came for a consultation with Forman about their daughter, although they did not bring her with them. Curiously, part of the page was removed later.

> Parent? of Christian Nailor[18] – 25 June 1599
> Christian N[illeg.] [of] 13 yers 1599 the [25 of Iune] ☾ an' m' at xj Diz [illeg.] for the daughter w'ou[t her consent]
> [Page damaged – deliberately to remove name or other detail?]
> Yt is of [Saturn] in [Libra]. [Moon] separating from [Jupiter]. By[?] ther wilbe some alteration shortly. Let her blod.

This means Forman thought there would be a change, for better or worse, to her illness soon – usually predicted on the stars. 'Let her blod' is probably a prescription, but possibly a record of a treatment.

Two weeks later, a scared and agitated Joan, the sister of Christian, came by herself to seek Forman's advice.

Jo(a)n Nailor[19] – 26 June 1599
   Ion Nailor of 16 yers 1599 the 26 of Iun' ♂ An m' at 15 p 10 diz
   Yt is of [Venus] in [Cancer]. [Moon] separating from [Venus]. [Not clear what letter/symbol at end of line is.] The green sicknes. Pain stomak & stuffing. Pain head & backe. Fearfull.
   Prepare 2 daies & purg & bring down her courses.

The green sickness was typically understood as a disease of virgins, although the use of the term was more complicated than that. The prescription was standard for Simon Forman and designed to encourage her to menstruate.

This time, decisive action was taken. Joan Nailor accused Ann Kirk of bewitching her and a warrant was procured from Sir Richard Martin, a former Lord Mayor, for Kirk's arrest.[20] Joan went with Martin to Kirk's house and when she opened the door Joan fell into a trance. Joan was also examined in the houses of Sir John Harte MP, Lord Mayor in 1589/90,[21] and Sir Stephen Slaney, Lord Mayor in 1595/6. During both interviews, she entered a trance as soon as Anne Kirk was brought into the same room:

Into the like trance the maide did also fal[l] ... so soone as the Witch (being by the[m] sent for,) was entered into their doors ...

The involvement of at least three recent Lord Mayors, some of the most important people in England, gives an indication of the enormous interest generated by this apparent demonic possession.[22] For once, apparent bewitchment could be observed directly in the City of London, rather than just read about in reports from distant counties. For the pious, it provided a rare direct example of the work of God and the Devil in action and the reality of the battle for salvation. Kirk was imprisoned to await trial and Martin tested her further by ordering the serjeant gaoler to cut off ten or twelve of her hairs. By tradition, it was claimed that a witch's hair could not be cut. It was recorded that Kirk's gaoler:

offering to cut the[m] with a paire of Barbers sissors, they turned around in his hand: and the edges were so battered, turned, & quite spoiled, as they would not cut any thing.

proving, at least to some, that she was a witch, particularly since:

> Then the Serjant took the haire, and did put it into the fire to burne it; but the fire flew from it.

Joan had further fits when Kirk was eventually bailed and during the trial itself held at the City of London Session House, next to Newgate Prison, on 30 November 1599. The legal process was very different from today:

> trials in this period contained few of the protections against wrongful convictions which exist today. Trials were quick, with lawyers rarely present (until the early nineteenth century), and, since there was not a fully developed law of evidence, prosecutors, judges, and jurors had more power and flexibility than they do today. Basically the trial involved a confrontation between the prosecutor, normally the victim of the crime, and the defendant, in which the defendant was expected to explain away the evidence presented against them (witnesses also testified on both

Figure 18.8  Illustration from John Foxe's *Actes and Monuments* (1568), showing the Protestant martyrs Hugh Latimer and Nicholas Ridley being burnt alive at the stake at Oxford in October 1555 during the persecutions of Queen Mary. Robert Glover, Mary Glover's grandfather, suffered such a fate a month earlier at Coventry.

sides). Although contemporaries thought these procedures provided reasonable means of determining guilt and innocence, from a modern point of view they appear to substantially disadvantage the defence.[23]

Kirk was convicted and hung at Tyburn a few days later on 4 December. Under the 1563 Witchcraft Act,[24] witches could only be executed if it was proved they had killed someone; otherwise they were sentenced to prison.[25]

The story of Anne Kirk, the possession of the local Nailor girls and her eventual hanging would have been well remembered along Thames Street and repeated in the neighbourhood.[26] Perhaps Mary Glover, who would have been about eleven at the time, might have known some of the girls or heard her mother recount the events. We do know that Mary grew up in a highly religious and Puritan-orientated household. In particular she must have been told about the religious faith of her grandfather, Robert Glover, who was the sixty-fifth Protestant martyr during the reign of the Catholic Mary I.[27] He was burnt at the stake at Coventry on 14 September 1555 and the bodies of his two dead brothers, John and William, were desecrated. All this was recorded in John Foxe's *Actes and Monuments of these Latter and Perillous Days, Touching Matters of the Church*, usually referred to as *Foxe's Book of Martyrs*, which was first published in 1563 with a much expanded second edition in 1570 (Figure 18.8).[28] Mary Glover could have read in detail about the testing of her grandfather's faith forty-seven years before, particularly as it was recorded in a letter sent to his wife, also named Mary Glover:

To my entirely beloved wife, Mary Glover,
The peace of conscience which passeth all understanding, the sweet consolation, comfort, strength, and boldness of the Holy Ghost, be continually increased in your heart, through a fervent, earnest, and stedfast faith in our most dear and only Saviour Jesus Christ, Amen.

    I thank you heartily, most loving wife, for your letters sent unto me in my imprisonment. I read them with tears more than once or twice (with tears, I say,) for joy and gladness, that God had wrought in you so merciful a work; first, an unfeigned repentance; secondly, a humble and hearty reconciliation; thirdly, a willing submission and obedience to the will of God in all things; . . .

    . . . manfully to persist in the defence of the same, not with sword and violence, but with suffering and loss of life, rather than to defile themselves again with the whorish abomination of the Romish antichrist; so, the hour being come, with my fact and example to ratify, confirm, and protest the same to the hearts of all true believers: and to this end, by the mighty assistance of God's Holy Spirit, I resolved myself, with much peace of conscience, willingly to sustain whatsoever the Romish antichrist should do against me.

John Foxe, who knew Glover slightly, then recounted his final words, as he approached his martyrdom:

> The next day, when the time came of his martyrdom, as he was going to the place, and was now come to the sight of the stake, although all the night before praying for strength and courage he could feel none, suddenly he was so mightily replenished with God's holy comfort and heavenly joys, that he cried out, clapping his hands to Austen [Bernher, a minister and friend], and saying in these words, 'Austen, he is come, he is come,' &c., and that with such joy and alacrity, as one seeming rather to be risen from some deadly danger to liberty of life, than as one passing out of the world by any pains of death.[29]

One can imagine the impact that this intense religious inheritance might have had on a fourteen-year-old girl, a girl who shared her name with the mother of Christ and the persecutor of her grandfather. Furthermore, Mary must have been born around 1588. This suggests her father, Timothy, was born in the late 1540s or early 1550s, so his father Robert was probably martyred while he was still a child. As Mary sewed with her mother by the fireplace during the winter of 1601, in preparation for adulthood and future marriage, did she see her grandfather's flesh crackling in the flames?[30] Did her father read passages from *Foxe's Book of Martyrs* aloud to his wife, to Mary and her sister Anne? He was certainly wealthy enough to own a copy, and if not, it was required that there was a copy in many parish churches.

April 1602 was certainly a period of acute stress across all sectors of society in the capital. Elizabeth I, now sixty-eight, was fading fast, distressed by the execution of the Earl of Essex the previous year. At the court, the powerful magnates jockeyed for future positions and influence as they plotted who would succeed her. War continued against Spain and in Ireland. The constant need for money to fund these wars had resulted in increasing financial abuses and public anger.

Easter 1602 itself, with the passion of Christ, was probably also a particularly emotionally intense time in the Glover household. It is hardly surprising in this toxic atmosphere that a few cross words blew up into a major affair. We know a mass of detail about Mary Glover in 1602 because of two accounts which were published in 1603, notably Stephen Bradwell, *Mary Glover's Late Woeful Case*, and John Swan, *A True and Breife Report, of Mary Glover's Vexation and Her Deliverance*.[31] These accounts were part of a wider religious battle as the Church of England struggled to contain and marginalise Catholics and Puritans alike in the years prior to the Queen's death and succession.

There is only space here to provide a brief summary of the key events of the Mary Glover affair, which were by turns sinister, weird and perplexing, and it is well worth

reading the full contemporary accounts.[32] However, the case was not simply a conflict between the 'bewitched' and the 'witch'. Two other individuals are crucial to the story, and need to be mentioned to fully appreciate the consequences of the case. The first was John Whitgift (c. 1530–1604), Archbishop of Canterbury from 1583 until 1604, based across the River Thames in Lambeth Palace. The elderly Whitgift was supported by his successor, Richard Bancroft (1544–1610), who was Bishop of London from June 1597, but who wielded much greater authority due to Whitgift's age. Both were not only the power base of the Church of England but were fervently opposed to Puritanism.[33] From his appointment in 1583, Whitgift launched a campaign against any deviancy from official Church of England theology and in 1586, in an atmosphere of increasing government censorship, he was given control over all printing presses. Indeed, following the execution of Mary Queen of Scots in February 1587, extreme Puritans were seen as almost a greater threat to the State than Catholics. In 1588, as the Spanish Armada threatened, and in 1589, a pamphlet war termed 'the Marprelate controversy' was waged between Puritans and the Church of England. While the arguments may seem arcane today, at the time they were believed to be crucial to one's eternal destiny. Although the radical Puritans were eventually silenced, leading ministers like Stephen Egerton (1555?–1621?) at the parish of St Anne, Blackfriars, continued to demand reform of the church.

Perhaps strangely for us today, one key focus of this theological battle was the issue of exorcism. In 1984, Stephen Greenblatt published his essay 'Shakespeare and the Exorcists', connecting this particular religious debate to the heart of Shakespeare's writing.[34] Greenblatt demonstrated how Shakespeare drew on the contemporary religious controversy about whether humans could be possessed, and hence whether the potential need for exorcism existed. In 1603, Samuel Harsnett, chaplain to Bishop Richard Bancroft, published 'A Declaration of Egregious Popish Impostures'.[35] This was an account of a series of exorcisms carried out in 1585 and 1586 by outlawed Catholic priests in the village of Denham, just twenty-two miles to the west of the City of London. Despite the huge risks,[36]

> the exorcisms, though clandestine, drew large crowds, almost certainly in their hundreds, and must have been common knowledge to hundreds more.[37]

However, it has been long recognised that in 1606, as Shakespeare wrote *King Lear*, he had been reading Harsnett's book and included elements from it in his description of Edgar's transformation into the possessed 'Poor Tom'.[38] Tom was a shorthand slang for the inmates of Bedlam, London's hospital for the insane and mentally troubled, located just outside Bishopsgate.[39] Shakespeare would have walked past Bedlam most days on his way to work at the Theatre. In the 1590s, Bedlam was in a terrible state of

maladministration which led to an official investigation in 1598.[40] Although the seriously ill inmates were chained up, harmless patients were free to wander. Shakespeare may well have seen some of them in Bishopsgate Street.

For Harsnett and, more generally, the Church of England, exorcism was a fraud, a piece of theatre, carried out on the credulous as a way of promoting the power of Catholicism. In the mid-1590s, the Church of England was equally concerned about such activities by the Puritans[41] and picked on a Puritan-inclined minister, John Darrell, as a scapegoat. Darrell had carried out exorcisms for many years, but his casting out of devils from children was promoted in various pamphlets. In 1599, Darrell was put on trial, accused of carrying out fraudulent practices. The case meant that debate about witchcraft and exorcism were much to the fore, particularly because James VI of Scotland, the likely successor to the English throne, had produced his own book on the subject (Figure 18.9).

In 1602, as the royal succession loomed, this power struggle continued – and Mary Glover was soon to be dragged into the wider conflict. Her story, as recorded, unfolds through several distinct stages, almost like the acts of a play. It follows a twisting path, beginning with a family trying to keep a terrifying experience secret, then spiralling through increasing outside interest to full-blown public exposure – and finally, back to semi-secrecy.

Figure 18.9   King, writer, witch-finder? Before James VI of Scotland became king of England in 1603, he wrote *Daemonologie,* published in 1597, a manual on the detection of witches and a source used by Shakespeare for *Macbeth*. The illustration shows suspected witches kneeling in front of James.

Living with Shakespeare

## Notes

1. Frustratingly little is known about the early life of Puritan minister Lewis Hughes (*c.* 1570 – *c.* 1646); see recently Bremer and Webster, *Puritans and Puritanism in Europe and America*, pp. 136–7. Lewis, who married in 1594, had taken over the ministry of St Helen's from John Oliver. By then, Oliver probably had at least three children, so he may well have left for a better-paying parish. Two of the Stanhope brothers had acquired the rights to the parish in 1599 and they may have been behind the change of minister. Hughes was probably involved in Puritan 'networks' in the City before his appointment. Shakespeare may well have left the parish before Hughes arrived; the events of 1602 must have been common knowledge in the City.
2. The church was destroyed in the Great Fire of London in 1666 and not rebuilt.
3. For the relationship between 'lewd' and 'bitch', see Stamper, *Word by Word: The Secret Life of Dictionaries*, pp. 149–53.
4. This and the following quotations are from Stephen Bradwell's *Mary Glovers Late Woeful Case, Together With Her Joyful Deliverance,* British Library MS Sloane 831, transcribed by Michael MacDonald. See MacDonald, *Witchcraft and Hysteria in Elizabethan London*, pp. 1–149.
5. He was assessed at £80 in the 1598 Lay Subsidy roll.
6. See Beaven, 'Chronological List of Aldermen: 1601–1650', pp. 47–75. He was knighted in 1603, a few months before he died. His will TNA PROB 11/103/522 is very detailed, extending to over 'twelve and a half sheets'. In October 1603, he referred to Timothy as a 'cozen', and he is clearly not a brother, since they are carefully listed. He left him £50 and forgave him any debts owed. Two months later, in an addition to the will, he also refers to giving £40 to William, 'the sonne of Timothy Glover my kinsman late deceased', when he came of age, who does not appear anywhere else in the account. He does not appear to have left anything to Anne or Mary, although he left £800 to the four children of his brother. There is a somewhat strange bequest of £200 to be 'distributed to such of my poor kin(d) red . . .' However, the families were clearly closely connected, since he left £10 to the poor of All-Hallows-the-Less, where he 'used to live', and to the Company of Dyers. In 1602, the company hall of the Dyers was located close by in Thames Street, so it was an obvious place for the family to be based. Sir William's son Sir Thomas Glover was ambassador at Constantinople from 1606–11, prior to the arrival of Sir Paul Pindar, who was there 1611–20.
7. For a detailed analysis of the events and trial see the website *Witches in Early Modern England*, <http://witching.org/> (last accessed 20 July 2020).
8. Her name is spelt Kirk, Kirke and Kerke. Kirk is used here throughout.
9. For this and following quotes in the Kirk case, see Anonymous, *The Trial of Maist. Dorrell* (1599), pp. 99–103. The description suggests she could have suffered from some form of epilepsy. See also *Witches in Early Modern England*, <http://witching.org/>, for a detailed analysis.
10. Spelt Naylor, Nayler, Nailer and Nailor. Here spelt Nailor throughout, as in Forman's records. By 1599, George Nailor (d. 1601) had a family of about a dozen surviving children ranging from the twenty-two-year-old Anne, born in 1577, to one-year-old George III. They were all baptised in the church of St Mary Somerset, a waterfront parish.
11. 'For as yet they did not suspect this Anne Kerk.' 'George Nayler' was listed in the 1598 Lay Subsidy roll at £5, the same rate as Shakespeare, under the parishes of St Nicholas, St Mary Somerset and St Peters parishes in Queenhithe Ward, which frustratingly are combined together. The listing also records 'Thomas Nayler & Roger Royden p[ar]tn[er]s' at £8. These parishes were immediately north of Castle Alley.
12. A Mr Vaughan enquired about his baby boy, William Vaughan, being bewitched on 20 January 1599, Case 18808, MS Ashmole 4041, f.12r.
13. A Robert Nailor visted Forman on 5 November 1598, who might possibly be an uncle or other relative of the girls. Forman's record reads:

    Robart nailer of 36 yers the 5 of Nouemb ☉ An' m' at 36 p 8 diz

> A relaxation of the ligaments that tyeth the stones from ye back & yt is swollen hard withall.

'Stones' were testicles and the 'yt' might be the scrotum.

14. Anne was buried on 29 May 1599.
15. Christian was baptised on 3 June 1586, so she would have just turned thirteen, as recorded by her parent at the next casting.
16. Person 5215 – Case 5479; see Kassell et al. (eds), *The Casebooks of Simon Forman and Richard Napier, 1556–1634*. For a broader introduction, see Kassell, *Medicine and Magic in Elizabethan London*.
17. Information and transcriptions kindly supplied by Professor Lauren Kassell and the Forman Project research team.
18. Person 5217/5215 – Case 5559.
19. Case 5568. Joan was baptised on 12 August 1582, so she would have been nearly seventeen.
20. Sir Richard Martin (?–1617) was a very powerful figure in the City. A goldsmith, he had served twice as Lord Mayor in 1589 and 1593/4. The Naylers probably approached him because he was the alderman for the adjoining Bread Street Ward and had a reputation for action. He and his wife, Dorcas (1537–99), were leading members of London's Puritan community. His daughter Dorcas (1561–95) married the lawyer and MP, Sir Julius Caesar. One can still visit Martin's country mansion, now Lauderdale House, built in Highgate in 1582; it provides a superb view over the City of London.
21. At the time, Harte (d. 1604) was president of St Bartholomew's Hospital (1593–1604) and surveyor general of London hospitals (1594–1602). A freeman of the Grocers, he became a successful international merchant and one of the founders of the East India Company in 1600. He served on the 1593 parliamentary subsidy committee (see *The History of Parliament* online). He appears to have been of the Puritan tendency.
22. The raises the question of how Shakespeare might have learnt about this bewitchment. It could have just been through general gossip in the street, but there is a clear line of connection to at least St Helen's. Simon Forman's protégé from 1597 was Richard Napier, who was the brother-in-law of Mary Robinson, daughter of Alderman Robinson, who had been treated by Forman in 1597. It is not certain whether Shakespeare had left St Helen's in 1598 or continued to live close to the two Robinson family houses in Little St Helen's until he moved west to Silver Street in 1602/4; see section 4 of the Appendix.
23. See *The Proceedings of the Old Bailey, London's Central Criminal Court, 1674–1913*, <https://www.oldbaileyonline.org/> (last accessed 20 July 2020); section – Trial procedures.
24. *An Act Against Conjurations, Enchantments and Witchcrafts* (5 Eliz. I *c.* 16) stated that those who 'use, practise, or exercise any Witchcraft, Enchantment, Charm, or Sorcery, whereby any person shall happen to be killed or destroyed' were guilty of a felony and should be put to death. Kesselring, '"Murder's Crimson Badge"', records that 228 (20.6 per cent) of 1,158 recorded homicide victims were suspected witchcraft victims. Of the 157 people (148 women; 9 men) accused of killing with witchcraft, roughly half were acquitted.
25. See Anonymous, *The Trial of Maist. Dorrell*, pp. 99–103.
26. When Shakespeare had moved to Silver Street *c.* 1602/4, he would have probably walked through this area to pick up a wherry to cross over to the Globe on Bankside. Did the locals still point out the former home of Anne Kirk, three or four years after these dramatic events had taken place?
27. Glover was educated at Eton College and King's College, Cambridge, gaining his BA in 1538 and MA in 1541. He married Mary, a niece of the Protestant reformer Hugh Latimer (1487–1555). A month later, Latimer, aged sixty-eight, was also burned at the stake in Oxford with Nicholas Ridley, supposedly saying: 'Play the man, Master Ridley; we shall this day light such a candle, by God's grace, in England, as I trust shall never be put out'.
28. It grew from *c.* 1,800 pages with 60 woodcuts to a vast compendium of 2,300 pages and 150 woodcuts.
29. See John Foxe, *Book of Martyrs*, vol. 3, p. 391, available online.
30. The burning of Nicholas Ridley with Latimer in Oxford was particularly horrific. The construction of the pyre resulted in Ridley's lower body being burnt while he was still alive.

31. These accounts present opposing views. See also later accounts, notably Hughes, *Certaine grievances*, p. 12.
32. The two 1603 accounts are reprinted, with an excellent introduction, in Macdonald, *Witchcraft and Hysteria in Elizabethan London*. The *Witches in Early Modern England* site, <http://witching.org/>, also provides a detailed textual analysis of this material, aiming to show the different verbal approaches used by the various participants. This chapter draws heavily on both, which provide the reader with direct access to the key sources for the Glover case.
33. For the Puritan 'networks', see Collinson, *The Elizabethan Puritan Movement*.
34. Republished as Chapter 4 in Greenblatt, *Shakespearean Negotiations*. The essay centred around his search for evidence about creative process: 'I believe that nothing comes of nothing, even in Shakespeare. I wanted to know where he got the matter he was working with and what he did with that matter.'
35. It is thought that Shakespeare may have known Robert Dibdale, one of the exorcists, since he was connected to a family in Stratford-upon-Avon.
36. By an Act of 1585, for a Catholic priest just to be in England counted as high treason, with a gruesome execution if caught.
37. Greenblatt, *Shakespearean Negotiations*, p. 94.
38. Ibid. p. 116.
39. It occupied the former buildings of the Priory of the New Order of our Lady of Bethlehem, which from the fifteenth century had increasingly cared for the mentally ill. The site was just north of St Botolph, Bishopsgate, now occupied by Liverpool Street Station. This eventually became its main function and the City of London took over governance from 1547.
40. It was described as 'itis not fit for anye man to dwell in wch was left by the Keeper for that it is so loathsomely filtheley kept not fit for any man to come into the house'; see 'A view of Bethalem, 4 December 1598', quoted in Allderidge, 'Hospitals, Madhouses and Asylums', p.153. For the original report see *Minutes of the Courts of Governors of Bridewell 1559–1971*, BCB-04, <https://archives.museumofthemind.org.uk/BCB.htm> (last accessed 4 August 2020).
41. In April 1593, two Puritan separatists, Henry Barrowe and John Greenwood (Brownists) were hung for sedition, followed in May by John Penry. Penry had named his four daughters Deliverance, Comfort, Safety and Sure-Hope, giving a clear signal of his beliefs.

# 19

## Mary Glover is Bewitched in All-Hallows-the-Less, Thames Street

*In which Mary Glover's symptoms of bewitchment become one of the sights of London. The medical establishment becomes increasingly polarised about the case – was this really a case of witchcraft in the heart of the City?*

Events started on Friday, 30 April, four weeks after Easter 1602, when Mary's mother, Gawthren Glover, sent her on an errand to the house of Elizabeth Jackson, 'an old Charewoman'. Jackson seems to have been poor, old, bitter and difficult, but she clearly had a powerful way with words. Together with her own daughter, she visited fortune tellers, in itself a suspect activity.[1] The Glovers and Jackson attended the same church, so, given the small size of the parish, both parties must have lived only a few minutes apart.

To an old, poor woman, Mary might easily have come over as a spoiled or pious brat, or possibly both. Maybe there had been words before, but for whatever reason, Jackson had taken against her, specifically 'for discovering [revealing] to one of her Mistresses a certaine fashion [example] of her subtle and importunat begging'. Jackson kept Mary in her house for an hour, berating her and said:

> It had byn better that you had never medled with my daughters apparrell.

This perhaps suggests that she had been begging for old clothes, which she then gave to her family rather than to the parish poor? Jackson then cursed her, wishing 'an evill death to light upon her'. Finally released, Mary fled home, but on the way back she felt ill and stopped at the house of a neighbour called Elizabeth Burges, who could see she looked upset. When Mary left for her own home, Jackson then came by and repeated the threat to Burges:

> I have ratled up one of the Gossips that medled with my daughters apparrell, and I hope an evill death will come unto her.

Things began to escalate and Jackson also threatened Burges, who became ill. Later in court she claimed '[she] had ben therefore threatned by her', and while eating prunes, she was 'not able to swallow one downe, but also fell on vomiting'. Jackson clearly did

not hold back because she expressed the hope later that Burges would, 'cast up her heart, guts and all' and would be bewitched herself: 'Thou shortly, shalt have in thee an evill spirit too.' It is hardly surprising that Burges then has a series of unpleasant dreams over three nights; first a fox, then:

> an ougly black man, with a bounch of keyes in his hand, intysing her to go with him, and those keyes would bring her to gould enough

and on a third night, the

> likenes of a mouse.

Meanwhile, Mary's mother Gawthren had learnt about the cursing of her daughter and went to challenge Jackson. Jackson, despite her earlier belligerence, now denied cursing Mary, but in turn threatened Gawthren:

> You have not crosses ynow, but I hope you shall have as many crosses, as ever fell upon woman and Children.

So inter-generational and inter-household tensions provoked spiralling invective – something which probably happened many times a day among the densely packed houses along London's waterfront.[2] However, this time something was different, and the tensions did not calm down. Three days later, Jackson came by to see Mary's mother. Mary was drinking a posset and again there were cross words. When Jackson left, Mary found that her throat had tightened, 'locked up', and she could not drink. Alarmed, she went to a neighbour's house, where her condition worsened and she seemed struck dumb and blind. Due to her swollen throat, Mary could not eat, and these swellings or fits continued for eighteen days. The contemporary account records:

> She liked to have fingers thrust downe her throate, and could endure how farre so ever downe any could convay their finger without any disturbance by it which all others have. Eighteene dayes togeater she had these fittes three or fower times a day in much extremitie and in all that time never received any manner of sustenance save by way of injection, or forcibl powring downe with a spoone, and that but a little at once, it was so much resisted in passing downe.

In the first week, the fits were so strong and obviously so novel to her parents that they thought Mary was going to die, and they had the church bell tolled for her. Jackson, hearing the bell, triumphantly told her neighbour:

> thanck God he hath heard my prayer, and stopped the mouth and tyed the tongue of one of myne enemies.

Mary Glover, in turn, certainly had a powerful conviction or driving determination, because the fits continued for twelve weeks from May to July. Her parents, who must have been acutely worried and possibly embarrassed by this terrifying affliction, attempted to keep the situation quiet.

> Hitherto the Parents kept Mary Glover's affliction secret, acquainting none therwith but some of their neighboures, like faithfull Christians also disclaiming, to take any benefit by unlawfull remedies.

They invited two members of the College of Physicians, based near St Paul's, to examine Mary, who used:

> their utmost skill uppon her with their phisicall receiptes (yea, with some practises beyond good artt) for the space of 9. or 10. weekes . . .

First, her parents employed the leading doctor Robert Shereman, helped by a surgeon, who treated her for quincy (tonsillitis). After eighteen days, Mary was able to eat again but other physical changes then took over:

> but now her belly was swelled and shewed in it, and in the brest, certaine movings, often in the day, with fits of dumnes, blyndnes and deformed swelling of the throte.

Given the elaborate form that her fits were to eventually become, this early pattern of symptoms was simple at first. The evolution of her fitting suggests that they were her own creation, perhaps started originally to try and get out of some sort of trouble. Perhaps Jackson had good cause to be angry, or possibly Mary wanted to get back at her parents for some reason. However, any attempts to cure Mary 'prooved in vaine', and Dr Shereman concluded that she was afflicted by supernatural beings. The parents of Mary Glover decided to seek the help of a different expert, Dr Thomas Mounford. Dr Mounford was a very distinguished doctor, 'seven times President of the College of Physicians, and an expert on melancholy, which was another natural disease widely believed like hysteria to produce apparently supernatural symptoms'.[3] However, Dr Mounford was also unable to identify the cause of Mary's illness, or to cure it. He concluded that the disease was not hysteria, but another unidentified natural illness. So, from two doctors, two different conclusions, a 'division of medical opinion' that lasted throughout the rest of Mary Glover's case.[4]

## Living with Shakespeare

During this period, Mary and Elizabeth Jackson came into contact several times. One occasion resulted in Mary's 'hand, arme and whole side, deprived of feeling and moving in all her long fitts, and not before'. Another, time they met in church and Mary had a fit, so she had to be taken home. Also, Mary breathed on her sister Anne and a neighbour Mistress Lumas with dramatic results. Mary is described as having:

> 'exceeding wyde gapings, with her mouth, during the which, there did flie out of her mouth a great venemous and stinking blast'. When she 'did smyte her sister Anne upon the face,' with this breath, it caused Anne's face to 'blister and swell. With Mistress Lumas, Mary breathed upon her face, 'and caused it to be very sore.' This left Mistress Lumas sick, and she 'held a noysome impression in her a great while after'.

Furthermore:

> One time [Mary] did hit her mother upon the face, in such a feeling sorte, as she thought her eye had ben stricken out, and made her face to smart and swell very much, for many dayes.

Despite attempts to keep Mary's condition quiet, news not surprisingly spread and the affair moved into a second and 'semi-public' phase. In response, Mary's 'performance', however contrived, increased in intensity. Gawthren had taken Mary on an errand, when they accidentally met Elizabeth Jackson. Upset, they 'retorne speedelie home', where Mary suffered from a much worse fit than normal, 'with many uncouth novelties, and strange Caracters, of a newe stamp'. These severe fits then occured each second day, with Mary becoming ill around three in the afternoon, 'there apeared in her brest a notable hearing or rising', and her body would suddenly thrash about the room. Her neck appeared to be stretched longer than usual, and her eyes were turned 'upward in her head'.

At times, she used her arms:

> 'very nimbly, sometime as though she drew a bow to shoote, and that towards sondry places. So did she, then, play with her fingers; Now as though she had an harpe, then as though she had a payer[pair]of virginals before her.'

Meanwhile her mouth made 'many strange anticke formes' and strange noises such as 'the sound "tesh" in a long accent upon the end' would come out of her. If prayers were said for her during her fits, when reaching the line, 'Deliver us from evill', her body would be thrown across the bed. Often, her body would fit into strange contortions as well. These fits stopped about six in the evening.

Her movements became stranger; sometimes 'she was turned rounde as a whoope, with her head backward to her hippes', sometimes her head was between her legs and she became 'all over colde and stiffe as a frozen thing'. Then:

> suddenly there would arise a swelling in her belly, as great as a football . . . Then the mover seemed, by a visible gliding along the brest, to mount up the channel bone, where making a the stay of halfe a minute, it passed into her throate, whereupon suddenly her head was snatched backward . . . [this happened] above one hundereth severall tymes, ere she attained rest: every of those returns conteyning five, or six, or moe, strong cryings, and violent plungings, with her body.

These 'ordinary' fits could last for five or six hours. If Jackson appeared, Mary would enter into extraordinary fits:

> in this fit, the mouth being fast shut, and her lipps close, there cam a voice through her nostrils, that sounded very like (especially at som time) Hange her, or Honge her.

Increasingly, as it became clear that Mary's condition was non-fatal and for her pious parents a manifestation of some external presence, she was put 'on show'. This third and public stage, with increasingly dramatic effects, took place in August and September. Mary would be put in a room with visitors and then Elizabeth Jackson would be brought into the same room to provoke a response.[5]

Mary had an 'extraordinary' fit at the house of Lady Brunckard, which was witnessed by 'many Divines and Phisitions'. Mary Glover was cast 'with great violence, towardes Elizabeth Jackson, when she touched her'. Elizabeth Jackson seemed terrified with 'gastely lookes, panting breathing, choaking speech, and fearfull tremblinge'. However, the witnesses considered this 'impudent lyinge' and 'nothing els but notes of a ruyned conscience'. When Sir John Harte examined Mary on one of her 'better days', she fell into a fit when Jackson came into the room. Jackson was forced to touch Mary and 'the senseles body was cast (very strangely) upon her', convincing many that Jackson was a 'wicked mediatrice'.

At the house of her close relative, Sheriff Glover, Mary met Elizabeth Jackson on a day when she was not expecting a fit. 'Before she could speak six words', she had a fit far more severe than her previous ones. After this incident, Mary Glover suffered from two kinds of fits: ordinary fits, which came every other day (these were a 'strengthened and lengthened' type of fit compared to what she had experienced before); and extraordinary fits, which occured when she encountered Elizabeth Jackson. MacDonald describes the 'ordinary' fits, which occurred every second day in a fixed pattern, as follows:

> once in the afternoon and once when she goes to sleep; or whenever she tries to eat. These 'ordinary' fits began around noon, and consisted of Mary Glover's eyes rolling up to the top of her head, the clenching of her jaw, and the loss of sense in her left leg. Her body also is prone to thrashing around without order . . . Mary Glover would also often gain large strength, so that several men were required to hold her down . . .

Often, Mary would also utter prayers, including at the end of her fits, when she would say, 'O Lord I geve thee thankes, that thow hast delivered me, this tyme, and many moe; I beseech thee (good Lord) deliver me for ever.' After prayers, she was often seized by a new set of fits, with similar symptoms to the former. Her ordinary fits lasted until 'twelve of the Clocke at midnight', including fits she experienced upon going to sleep, or whenever she 'receaved nourishment, night or day'.

With the claimed bewitchment now out in the open, public opinion became increasingly polarised and other people started to claim that Jackson had brought problems on them. Among them was Mr Lewis Hughes, the minister of St Helen's and a fervent Puritan. He appears to have known the Glovers before 1602, possibly through some Puritan network.[6] He later reported that he visited Elizabeth Jackson to upbraid her for her cursing, but she gave him such a menacing glance that he was unable to speak for a full two hours after his visit.

However, Jackson had local support as well among those who thought Mary Glover was pretending. This support extended to some very influential figures, particularly Richard Bancroft, Bishop of London, who thought that Mary was making up her symptoms. He saw her case as a great opportunity to discredit the Puritans on a public stage. In October, he told Judge Anderson that Mary was a fraud. As a result, Anderson ordered Sir John Cro(o)ke, the Recorder of London, to 'make triall of them in his Chamber at the Temple'. Initially, Croke was also a sceptic and arranged a series of tests for two o'clock on 18 October in front of many witnesses, including the minister of St Helen's, Lewis Hughes.[7] Both parties appeared with their female supporters and Croke put Mary and Jackson in separate rooms. Then he ordered a woman who looked very like Jackson:

> to put on Elizabeth Jacksons hatt and a muffler on her face, and then brought her up into the chamber where Mary Glover was, caused Mary to walke by her, two or three returnes, and to touch the woman once, and again a second time; saying (then when he saw no change happen) I am glad to see this Mary; I hope you will touch her many times hereafter, and never be affrayde: . . .

One can imagine the tension in the room. Then he:

brought up Elizabeth Jackson shortly after; having on the other woman's hat, with a Cloak and muffler; so as none could know who she was.

The result was dramatic. As soon as she had made:

> her first stand . . . but the Maydes Countenance altered: but then she beying brought forward unto the mayd, and the mayd led towards her, there was no more time, nor opportunity lefte, for new maskers to enter. Thus was this senseless image throwen upon a bed, having that voice in her nostrils, spoken of before . . .

Then Sir John Croke sent for a candle and:

> made a pin hot in the flame, and applied it to her Cheeke and after that (with a new heating) neere unto her eye, to see, if she would draw together her eyebrows, or liddes, or make any semblant of feeling, but she did not. Then he tooke paper somewhat writhed, and setting fyre thereon, put the flame to the inside of here right hand, and there held it, till the paper was consumed. In like manner he proceeded with a second, and a third paper, so as her hand (as appeared afterwards) was effectually burned, in five several places.

The detailed records noted that Mary Glover's hand blistered, until the blisters broke, and 'water came out'. However, Mary Glover still lay 'sencelesse' with the voice coming out her nostrils saying, 'hang her, hang her'. Croke then threatened Jackson with the same procedure:

> he proved the fyre upon the Witches hand, who cryed upon him not to burne her: Mr Recorder replied, Why cannot you well beare it as she, Who (ass you say) doth but counterfett? Oh no (quoth the Witch) God knows she doth not Counterfett.

The minister, Mr Lewis Hughes, informed Sir John Croke during the examination of Mary Glover, that he had prayed with Elizabeth Jackson. However, whenever he concluded his prayers with the Lord's Prayer, Elizabeth Jackson was unable to utter the line 'but deliver us from evill'. Upon hearing this, Sir John Croke ordered Elizabeth Jackson to say the Lord's Prayer, which she did, skipping over the line 'but deliver us from evil'. When she recited the Apostle's Creed, Elizabeth Jackson also refused to say 'Jesus Christ is our Lord.' This seemed proof that Elizabeth Jackson might be affiliated with the devil, and a witch. Now convinced, Croke ordered Jackson to be sent to Newgate Prison to await trial, saying: 'Lord have mercy upon thee, woman.'

While she was in prison, Bishop Richard Bancroft continued to support Elizabeth Jackson's case, and on 13 November, presumably with his help, Jackson petitioned the

College of Physicians, naming Dr Bradwell, Dr Mounford and Dr Herring as her accusers. Although Dr Mounford was conveniently away, the other two, in a fourth twist to the story, were then interviewed by a dozen Fellows of the College and several, including Dr John Argent and Dr Edward Jorden, ended up taking Jackson's side. With even the experts split, Londoners waited for the denouement at Jackson's trial.

On 1 December 1602, Elizabeth Jackson was brought to trial, almost exactly three years to the day since Anne Kirk had been hung. There was an impressive panel of four judges: the Chief Justice of the Court of Common Pleas, Sir Edmund Anderson, was flanked by John Croke, the recent Speaker in the House of Commons and Recorder of London, Sir Jerome Bowes, MP, and Sir William Cornwallis. These were men with wide experience of the world: Bowes had led the Queen's pioneering embassy to Ivan the Terrible in Moscow in 1583.[8] A number of men and women served as the jury, although it was usual at the time for their conclusion to be directed by the chief judge. When Mary Glover was first brought in front of the bench to testify against Elizabeth Jackson, even though she could not see her in the prisoners' dock,[9] she cried out, 'Where is she?' Upon hearing this, the jury was initially convinced that Mary Glover was counterfeiting her affliction, and accused her of such, and 'bad her proceede in her evidence'. Mary Glover eventually collapsed in a 'senseles fitt'.

Dr Herring, 'a highly successful' doctor from the College of Physicians, testified with Dr Spencer. He 'explained that he had accompanied Mary during her first test by the Recorder, at her parents' request.' He had been convinced during this trial by stages that Mary Glover was truly bewitched, and that Jackson was the culprit. Dr Herring cited the strange motions of Mary Glover's hands to her mouth, the strict timing of the opening and shutting of her mouth, the voice from her nostrils, and her falling into fits in the presence of Elizabeth Jackson as evidence of the supernatural. He also believed the casting of Mary's body towards Elizabeth Jackson during the reciting of the Lord's Prayer to be further evidence of the involvement of the supernatural.

Dr Spencer then spoke, claiming Mary was afflicted 'of som cause supernaturall', as her symptoms are 'strange effects, then either the mother, or any other naturall disease hath ever ben observed to bring forth'. From antiquity (as discussed in Chapter 15), medical authorities believed that the uterus, or 'mother', could move and exert pressure on other internal organs, causing illnesses in women. Galen considered that the retention of 'female seed' and the build-up of fluids was dangerous and that sexual intercourse was a solution. Unmarried and widowed women were, therefore, particularly at risk. In Mary's case, Dr Spencer argued that it was unlikely that 'so young a mayde' should suffer from the suffocation of the mother, and that the 'disproportioned moving in her belly, which was not so uniformely a rising or bearing upward, but in a rounder and narrower compasse, playing up and downe, as with a kind of easie swiftenes, that certainly it did not truly resemble the mother'. He cited also the variety of fits that Mary

experienced, only in the company of the Elizabeth Jackson, as evidence of the supernatural.

Although not officially summoned, three witnesses then appeared to support Elizabeth. They were two physicians, Dr John Argent and Dr Edward Jorden, along with a Doctor of Divinity, James Meadowes, a 'noted divine' who aimed to 'purge Elizabeth Jackson, of being any cause of Mary Glovers harme'. Dr Argent was a censor and a future eight times president of the College of Physicians in the 1620s and 1630s, so he was a powerful witness.

He was followed by Dr Edward Jorden. We have already met Dr Jorden living from *c.* 1595 in St Helen's, contemporary with Shakespeare's residence and part of a group of doctors who were inclined to progressive 'Paracelsian' medical thinking. It was quite a dramatic step for Dr Jorden to directly oppose the view of his own minister, and this alone would have generated much comment. Jorden's interest in possession went back a long way; he later recalled that while studying at Padua University *c.* 1590, he had seen people who were supposedly bewitched by the devil and who were cured by a Catholic priest making the sign of the cross.[10]

Dr Jorden recognised the illness called the 'mother'. He linked Glover's symptoms to hysteria, originating from the Greek for uterus, *hystera* – rather than witchcraft. For him, all the strange actions of Mary Glover were due to natural causes. The trial became an argument between Dr Jorden, claiming this but being unable to define a specific cause, and Judge Anderson, who firmly believed in the presence and impact of witches:

The Lord Anderson, hearing Doctor Jordaine to often insinuate, some feigning, or dissembling fashions in the maide and withal . . . pressed him to answer directly, whether it were natural or supernaturall.
[Dr Jorden] said, that in his conscience he thought it was altogeather natural. What do you call it quoth the Judge? *Passio Hysterica* said the Doctor. Can you cure it? I cannot tell: I will not undertake it, but I thinck fit tryall should be made thereof.
Lord Anderson, Doe you thinke she Counterfetteth?
D. jordeyn, No, in my Conscience, I thinke she doth not Counterfett:
Lord Anderson, Then in my conscience, it is not natural: for if you tell me neither a Naturall cause, of it, nor a natural remedy, I will tell you, that it is not natural.

One can feel the frustration of Judge Anderson at Dr Jorden's answers and his claim that Mary had a natural illness but he did not know a cure.

With the evidence presented, Chief Justice Anderson summarised the case to the jury, stressing his wide experience of witchcraft and his certainty that:

the Land is full of Witches; they abound in all places: I have hanged five or six and twenty of them; There is no man here, can speake more of them than my self . . . They

have on their bodies divers strange marks, at which (as som of them have confessed) the Devill sucks their bloud: for they have forsaken god, renounced their baptisme, and vowed their service to the Divill . . .

He noted that such marks had been identified on Elizabeth Jackson:

This woman hath the like markes, on sundry places of her body, as you see testified under the hands of the women, that were appointed to search her.[11]

He also noted that, 'you shall hardly finde any direct proofes in such a case', as the 'Devill . . . deales . . . cunningly', and that '[Jackson] is full of Cursings, she threatens and prophesies, and still it takes effect'.

Judge Anderson also pointed out how illogical it was to believe that the cause of Mary Glover's fits was natural, considering their nature. He advised the jury to convict. He was followed by Sir John Croke, who repeated the evidence of the tests he had carried out in his chambers at the Temple, ending, 'The presumptions and probabilities (as we all see) are very great and pregnant.'

The 'minds of the bench were settled', and the jury deliberated briefly, deciding that the prisoner was 'guilty of witchcraft'. Elizabeth Jackson was sentenced to:

a yeeres imprisonment, and fower [four] times therein to stand on the pillory, and confesse this her trespass.

In 1602, a year in prison was the maximum penalty for witchcraft which had not resulted in a death. Incarceration in prison often led to sickness or death due to the poor conditions. It is likely Elizabeth Jackson was quickly released from prison due to her powerful supporters, and she 'probably received a royal pardon; she certainly escaped punishment.'[12] What happened to her afterwards is, frustratingly, unrecorded. There is also no record of Dr Jorden's reaction to his failure to convince the bench and his humiliation in front of a large group of witnesses. However, within ten weeks he had gone into print to justify his views. This may have been less to do with his own feelings and more to do with pressures from the Church of England establishment, who were alarmed at the next stage in the saga.

## Notes

1. Elizabeth Jackson also confessed that she went with an Elizabeth Cook, who 'did at that time geve xl to have her fortune tould her'.
2. The historian John Stow records the abuse he received from his sister-in-law: see 'Introduction: The life of Stow', vii–xxviii, in Kingsford (ed.), *A Survey of London: Reprinted from the text of 1603*.
3. MacDonald, *Witchcraft and Hysteria in Elizabethan London*, p. xxx.
4. A Doctor Bradwell noted Mary 'maie have the semblaunce of natural, touching the outward figure, which is supernaturall, as touching the cause' of her symptoms. He also considered that 'she had not the mother [meaning a problem with the uterus] through menstrual suppression'. Some concluded that Mary's 'afflicttion did exceed both arte and nature' and 'that by the hands of Sathan her bodie was then tormented'. However, 'two other learned and christian, professours likewise of phisicke,' also examined Mary and concluded that her condition was naturally caused and just appeared to be the 'acquittinge of the Witch'.
5. At least three of these sessions were recorded in front of Lady Brunckard; Sir John Harte, Lord Mayor in 1589/90, who had examined Anne Kirk in 1599; and Mary's close relative, Alderman William Glover.
6. Mary's sister was called Anne, and an Anne Glover is recorded as marrying Thomas Rushall in St Helen's on 16 November 1602, e.g. a month before the trial. Presumably the minister Lewis Hughes would have officiated. It is not certain if this is the same Anne Glover, but there are no other Glovers recorded in the parish at this period, so it seems possible.
7. Lewis Hughes wrote his own record much later; see Hughes, *Certaine grievances*.
8. A courtier; his house was at Charing Cross, close to Whitehall Palace. He held the monopoly licence for manufacturing drinking glasses in England from 1592 and took over the manufacturing works of the Italian glassmaker Verzellini (1522–1606), granted a monopoly by Elizabeth I in 1575, in Broad Street, a few minutes walk from St Helen's.
9. At this time, it was normal for trials to be quite brief with several prisoners in the dock together.
10. See Thomas Guidott, 'A Preface to the Reader' (1669), n.p., in the third edition of Jorden, *A Discourse of Natural Bathes*.
11. These women, employed by the court, discovered marks on Elizabeth Jackson 'in divers places of her body.' They attested that the marks were 'not likely to grow of any disease', but rather were 'like the markes which are described to be in Witches bodyes'.
12. MacDonald, *Witchcraft and Hysteria in Elizabethan London*, pp. xviii–xix.

# 20

## An Exorcism in Shoreditch

*In which we travel to a secluded house in Shoreditch to witness the attempted exorcism of Mary Glover by six Puritan ministers – and the dramatic result it had on Mary as well as on Lewis Hughes, minister of St Helen's.*

With the trial finished and Elizabeth Jackson in prison, one might have thought that events would settle down. Mary Glover was now close to her fifteenth birthday, and her family probably hoped to return to some sort of normality. However, it was not to be, and in many ways the fallout from the events in April was just beginning. For the pious Glovers, the year had been traumatic and they must have asked themselves over and over again why their daughter had been bewitched. As importantly, Mary continued to have violent fits every second day of the week, which were 'most strange and fearfull'. Her parents were advised to seek the advice of other doctors. They decided otherwise, perhaps frustrated by the lack of clarity about a course of treatment, and instead asked a group of Puritan ministers to carry out an exorcism on their daughter. This would also demonstrate:

> what a loathsom bondage, to be in the hands of Sathan, and what an arme of unmatcheable power, is on the other side.

Furthermore, perhaps surprisingly, Sir John Croke, one of the judges, argued for an exorcism, since he

> did blame me [Mr Lewis Hughes] and all the Ministers of London [. . .] that we might all be of us be ashamed, to see a child of God in the clawes of Sathan.

The exorcism or dispossession of Mary Glover involved 'fasting and prayer'. John Swan, one of the ministers present, recorded the process.[1] First, on Tuesday, 14 December, six ministers met at the Glovers' house in Thames Street to decide the right procedure. In the evening they prayed with Mary and her parents. Two days later, on Thursday, 16 December, they met together at Mistress Ratclife's house in Shoreditch, a place:

> farr distant, for more quyet and security to performe the good worke of prayer, fasting, and supplication.

There:

> a copany of such as feared god to the number of 24, wherof 6 were Preachers beside the partie afflicted … About 7 of the clocke in the morning before it was full day light, ther were some of us come to the place, where having staide some halfe hower, moe were assembled, and amongst others, the Parents of the afflicted mayden: who having brought her to the house presented her in the chamber.

The ministers then prayed and preached in turn. Mary Glover must have been severely stressed by the whole process:

> the poore creature (being pale and wan coloured) was asked by her mother & others, how it fared with her? She acknowledged that she felt payne in her body, & wept and prayed God to be mercifull unto her …

Minister Lewis Hughes' own account tells what happened:[2]

> Within a few days after, it pleased God to make me an instrument to draw five ministers and other good Christians, to iet a day apart, and to joynewith me in that holy exercise, and continued therein from morning till after candlelighting; then on the suddaine, after a fearfull conflict, which did much amaze some, and caused them to cry with a confused noise, Iesu helpe, Jesus save, the maid did start up out of a little wicker chaire where shee fate, and with her strength did lift me up with her, I kneeling behind her, and holding her in mine armes, and did cast white froth out of her throat round about the chamber, and on a suddaine fell down into the chaire, as one truly dead with her head hanging downe, and her necke and armes limher, which before were stiffe, as a frozen thing;

However, Mary then recovered:

> then suddenly life came into her whole body, and her eyes which were pliickt into her head, and her tongue which was puld into her throat, came into their righ[t] place, then shee looked with a chearfull countenance round abought the chamber, and with a loud voice did speake, saying. *O he is coms, He is come, the comforter is come, the comforter is come, I am delivered, I am delivered.* Her father hearing these words, wept for joy, and with a faultring voice said, O, these were her Grandfathers words (Doctor *Taylor*) when he was at the stake in *Smithfield*, and the fire crackling about him.

Timothy Glover was visibly shaken, crying for his daughter 'with abundance of teares in the disquietnes of his minde, and anguish of his hart' and highlighting her words

'cryed out and saide (as well as his weepinge would give him leave) this was the crye of her grandfather goeinge to be burned'.[3] One of the ministers, John Swan, asked 'whether she did see any thinge departe from her'. Mary Glover denied seeing anything, but said that she did 'feel somewhat depart' and then she 'felt such a freedome of all the powers and faculties of soule and body'.

With their daughter dispossessed, her parents could claim that she had been an innocent party, since it 'pleased God to cleare their innocencie, both by open triall in face of Courte, and stretchinge as it were his owne hand from heaven'.

After her exorcism, it was decided that Mary, her mother and her sister Anne should live for a year at Hughes' house in St Helen's, a move made to protect her from further possession and bewitchment, although she was no longer 'afflicted in this kind'.[4] Hughes later recorded:

> That done, care was had of her, to put her to some minister for one year, least Sathan should assault her againe, and by common consent she was put to me, and I tooke her for my servant, for one yeare, and tooke her and her mother and sister and lodged them at my house in great Saint *Helin*, which then was my living.

However, subsequent dramatic events meant that Hughes did not live with them, at least in the short term. On the 17 December, Lewis Hughes reported back to Sir John Croke on the success of the exorcism the previous day. Croke advised Hughes to inform Bishop Richard Bancroft of the events. It is not clear why Croke recommended this disastrous course of action; perhaps he wanted to cover himself. Bishop Bancroft was furious that an exorcism had taken place in London, and Lewis Hughes found himself in deep trouble.

> The next day I went to Sir *Iohn Crooke*, to shew him what God had done for her, who did advise me to goe to the Bishop before he was misinformed, and to shew him the passages of the day from the beginning to the ending, and not to go of myself, but from him, and tell his Lordship that he did send me; I did so, but could have no audience, and for my paines I was called Rascall and varlot, and sent to the Gatehouse, where he kept mee foure months . . .

Imprisoned for four months, Lewis Hughes was suspended from his parish and soon replaced by Richard Ball in 1603.[5] The fates of the other people who took part in the exorcism are unrecorded, except that one of the other ministers, John Bridger, was also imprisoned. There is also no information about whether the Glovers stayed on in the St Helen's rectory; one assumes that they probably returned home and tried to put the affair behind them. In 1604, Lewis Hughes appears to have signed a petition to James I

alongside twenty-two leading Puritan ministers from London. Thereafter, he disappears from view for a decade, but then reappears as a minor footnote to the early steps of establishing the British Empire (see Chapter 7).

Bishop Richard Bancroft did not see the ejection of Lewis Hughes as the end of the Glover affair, given its widespread impact. As Christmas 1602 passed to the New Year, it was clear that Queen Elizabeth was fading fast. With James VI ready in Edinburgh to take over, it was more important than ever to cement the future king to the Church of England. Bishop Bancroft pushed Samuel Harsnett to produce his pamphlet about Catholic trickery and added a pointed criticism against Puritan ministers, calling them 'credulous frauds'. Lewis Hughes recorded bitterly that Bancroft:

> 'did set forth a booke' wherein he called me and the rest of the ministers, that did joyne with me in that holy action, Devillfinders, Devillpuffers, and Devill prayers, and such as could tare a devill in a lane, as soone as an hare in *Waltham Forrsi*. All the rest, being men and women of good esteeme and credit, he called, a rout, rabie, and swarme of giddy, idle, lunatick, illuminate, holy spectators, of both sexes and, fspecially a sisternitie of nimps, mops, and idle holy women, that did grace the devill with their idle holy presence.

Bishop Bancroft also appears to have lent on Dr Jorden to publish his account of the key issues central to the Mary Glover affair. He probably felt that the views of a respected doctor would sit well alongside the more obviously sectarian views of Harsnett. By the end of February 1603, Jorden had drafted a twenty-six-page extended pamphlet repeating his arguments that apparent and dramatic symptoms of possession could be caused by the individual themselves. The preface, dedicated to the College of Physicians, is dated 2 March, so Dr Jorden must have written at speed and Bishop Bancroft probably personally oversaw its rapid publication. On 24 March 1603, Queen Elizabeth died and James VI of Scotland was proclaimed King James I of England. Two weeks later, on the 5 April, James left Edinburgh, heading south for his new capital. It would take him a month to reach London, progressing at a stately twelve miles a day. This meant he could conveniently avoid attending Elizabeth's funeral on 28 April.

There is a suggestion that these pamphlets were among books presented to James on his journey south.[6] Such pamphleteering tended to produce a response from the other side and, within a few months, Dr Stephen Bradwell, 'a member of the Coll:of physitions in London' wrote *Mary Glovers Late Woeful Case, Together With Her Joyful Deliverance*, attacking Dr Jorden.

> On the occasion of Doctor Jordens discourse of the mother, wherein hee covertly taxeth, first the Phisitions which jidged her sickness a vexation of Sathan And

consequently the sentence of Lawe and proceeding against the Witche', thereby providing 'A defence of the truthe against *D.J.* [Doctor Jorden] his scandalous Impugnations'

Dr Bradwell attacked Dr Jorden's contradictory position, which appeared to embrace the existence of witchcraft as well as natural causes, so that Dr Jorden, 'a fearfull scholler', showed when explaining Mary Glover's symptoms that 'neither all his books, observations, nor friends, were able to drawe out, the just limitts of that dissease'. Bradwell also criticised Jorden for writing directly after the Glover case but not commenting on it, and for stirring up controversy in the College of Physicians about the supernatural, so 'drawing manie of the Colledge, to speake and stirre in it against us'.

It is unlikely that Shakespeare attended the trial of Elizabeth Jackson, as it would have been on a performance day for him. However, if it is correct that Shakespeare and Jorden knew each other in St Helen's, then Shakespeare could have heard a verbatim account. Perhaps Jorden gave him a copy of his pamphlet to sit alongside Samuel Harsnett's pamphlet, to which he certainly had direct access. Perhaps Shakespeare put them in his chest to wait until he needed inspiration for a new play.

Jorden's involvement with witchcraft did not end in 1603. He soon became known to James I, and was even entrusted with the care of Queen Anne of Denmark when she visited Bath. Soon after, in 1605, another case of claimed bewitchment briefly became news. Anne Gunter was born in Hungerford, Berkshire in 1584.[7] Her father, Brian Gunter, became rector of North Moreton, just over the border in south Oxfordshire. There, in 1598, he killed two members of the local Gregory family during what was clearly a violent football match. By 1604, Anne claimed to have been bewitched, as she was apparently vomiting pins from all her orifices. A contemporary account details how Dr Jorden revealed the fraud to James I.

> Whilst he practised in *London* there was one *Anne Gunter*, troubled with such strange and unusual Symptoms, that she was generally thought . . . to be bewitch'd. King *James* hearing of it sent for her to *London* . . . told her, he would take care for her relief, in which thing he employed Doctor *Jorden*, who, upon examination, reported to the King, that he thought it was a Cheat; and tincturing all she took with harmless things, made her believe that she had taken Physick, by the use of which, she said, she had found great benefit. The Doctor acquainting his Majesty that he had given her nothing of a medicinal nature, but only what did so appear to the Maid . . . the King was confirmed in what he had suspected before.
>
> Whereupon the King dealing very plainly with her, and commanding her to discover the Truth unto him, the maid, though at first very unwilling to disclose the juggle, yet, upon the Kings importunity, and promise to her of making up what

damage should accrue from the discovery, confessed all . . . After Which Confession she was very quiet, & the King giving her a Portion, she was afterwards married, being by this subtle artifice perfectly cured of her mimical Witchery.

These three high-profile cases of witchcraft across the seven years 1599–1605 reveal a range of protagonists, processes and outcomes, ranging from hanging to marriage. They presumably provided Londoners with much to discuss, and Dr Edward Jorden was directly involved with two of them; and if he was not involved in the Anne Kirk case, must have heard about it. Is there any connection with the evolution of Shakespeare's *Macbeth*?

Here one needs to consider the different ways in which history is created. It is not known exactly when *Macbeth* was written, but the general assumption is that it was first performed in 1606 and written over the preceding year or two. A date after James I's accession in 1603 is generally assumed, because of the Scottish subject matter, and claimed references to the Gunpowder Plot would put completion after November 1605.[8]

In terms of the sources for the storyline, there is a well-established 'literary' interpretation for the process Shakespeare followed. This argues that he borrowed the core of the historical story from Raphael Holinshed's *The Chronicles of England, Scotland, and Ireland* – first published in 1577, with a revised second edition that was

Figure 20.1  Illustration from *Newes from Scotland – declaring the damnable life and death of Dr Fian, a notable sorcerer* (1591), a pamphlet about the 1590 trials of a large number of people accused of witchcraft in North Berwick, east of Edinburgh. The devil (left) meets the witches.

Figure 20.2  Views on the reality of witchcraft varied widely in the Elizabethan/Jacobean period. John Ford et al.'s *The Witch of Edmonton* (1621) satirised the process of witch-finding and the subsequent trial by water. Title page from a 1658 edition of the play.

probably actually used, in 1587. However, he reworked the story and characters to create in Macbeth a totally compelling tragic character. Alongside this, Shakespeare also appears to have used James I's own study, *Daemonologie* (1597), which summarised his extensive knowledge of the trial of witches in North Berwick in 1590, who were accused of raising a terrible storm to sink the King's ship during his return from Denmark (Figures 20.1 and 20.2).

There is a potential second and parallel process that one might term an 'oral' development route, which might have run in parallel with a book-driven process.[9] The 'oral' route would consider Shakespeare picking up ideas through discussion with friends, neighbours or professionals. Since in the sixteenth century it is rare to find any records of such discussions, and Shakespeare did not list his sources, it is extremely difficult to identify hard evidence for such a route. However, occasionally one picks up odd scraps. As noted above, Shakespeare may have been sufficiently intrigued by the St Helen's resident, Andrew Elbow, to incorporate him as a character into *Measure for Measure*. This oral approach would highlight that Shakespeare and Dr Jorden were probably living within a few yards of each other for three or four years, *c.* 1595–8, and were of the same age. They were also possibly of a similar temperament, which might have created a strong bond around mutual interests, particularly the reasons for

variations in human character. If Shakespeare did discuss such matters with Dr Jorden, he was probably more interested in the development of his thinking during the late 1590s as he left his Italian university training behind and forged his own practice and ideas in London. Critics might argue that *Macbeth* was written six or more years after Shakespeare left St Helen's and after the London witch trials. However, there is no reason why Shakespeare might not have stayed in contact with Dr Jorden. Furthermore, in 1604, Dr Jorden left St Helen's and moved to the parish of St Michael, Wood Street, where he was a only a couple of minutes' walk from Shakespeare's known lodgings in Silver Street from 1602–4 onwards.

Jorden's 1603 study on female health gives some insight into the evolution of his ideas, and the title page sets out his central subject matter (Figure 20.3): *A Briefe Discourse Of A Disease Called the Suffocation of the Mother*.

'The mother', as discussed above, was a contemporary term for the uterus and by 'suffocation' Jorden was referring to the ancient Greek physician Hippocrates' opinion that the womb could move around inside the female body, causing suffocation, choking or problems in swallowing – also termed *Hysterica passio* or *strangulatus uteri*. Dr Jorden explained that the book was:

> Written uppon occasion which have beene of late taken thereby, to suspect possession of an evil spirit, or some such like supernaturall power.

And:

> Wherin is declared that divers strange actions and passions of the body of man, which the common opinion are imputed to the Divell, have their true natural causes, and do accompanie this disease.

Although Dr Jorden does not name Mary Glover, it is obvious he is referring to the case, and 'Chapter 1: Of the Suffocation of the Mother' is prefaced by:

> That this disease doth oftentimes give occasion unto simple and unlearned people, to suspect possession, witchcraft, or some such like supernaturall cause.

Dr Jorden's fifty-six pages are divided into seven short chapters and have been described as the 'first etiology of hysteria'. The introduction is typical of medical thinking of the time (Figure 20.4):

> The passive condition of womankind is subject unto more diseases and other forces and natures then men are: and especially in regarde of that part from whence this

Figure 20.3  Dr Edward Jorden's pamphlet *A Briefe Discourse of a Disease Called the Suffocation of the Mother* (1603), published following his failure in the Mary Glover trial, argued that apparent bewitchment could be self-induced.

Figure 20.4 Male anxieties over female sexuality meant that views on the onset of sexual maturity, procreation and eroticism could become mixed, as in this illustration from an early seventeenth-century pamphlet on pregnancy.

disease we speake of doth arise. For as it hath more varietie of offices belonging unto it than other partes of the bodie have, and accordingly is supplied from other partes with whatsoever it have need of for those uses: so it must needs thereby be subiect unto mo infirmities thaen other partes are.

Jorden then lists symptoms which were typically taken by 'simple and unlearned people' – one wonders if he was also thinking of Judge Anderson – as evidence of bewitchment:

- suffocation in the throate
- croaking of Frogges
- hissing of Snakes
- crowing of Cockes
- barking of Dogges
- garring of Crowes
- frenzies
- convulsions
- hickcockes [hickups]
- laughing
- singing
- weeping
- crying, etc.

It is interesting that five of these thirteen symptoms are making animal noises. Dr Jorden also refers to patients appearing to be dead, like hibernating animals, and mentions doctors who advised allowing three days before burying victims in case they were restored to life.[10] His subsequent chapters explore the following topics:

- Chapter 2: Dr Jorden attempts to explain why the disease causes so many different symptoms; and then in Chapters 3–5, he divides the suffocation of the mother into three kinds
- Chapter 3: 'Of that kinds of this disease, and first of that wherein the vitall facultie is offended' (5 pages; by 'vitall' he meant effects on the blood supply and pulse)
- Chapter 4: 'Of that kind of this disease wherein the animal facultie is offended' (12 pages; by which he meant 'that faculty . . . Whereby we do understand, judge and remember things that are profitable or hurtful unto us . . .'
- Chapter 5: 'Of that kind wherein the natural facultie is offended' (2 pages; by which he meant effects on the digestive system)

For readers today, Chapter 4 is the most interesting. Here one sees Dr Jorden grappling with the influence on the brain and the ability of people to control their own actions:

> This animall facultie hath this peculiar difference from the vitall and naturall faculties, that the functions of it are subject unto our wil, & may be intended remitted, or pervertedat our pleasure, otherwise than in the other faculties. For no man can make his pulse to beate as he list, or alter the naturall functions at his will and pleasure. But these animal functions may be abused both by our own will, and by the violence of some disease . . .

It is this shift of emphasis that has resulted in Dr Jorden being celebrated for his innovation, in that he:

> went beyond classical discussions of the pathology of hysteria and rejected the notion that the malady was primarily a disturbance of the uterus. Jorden's transfer of the seat of all hysterical manifestations from the uterus to the brain constituted a major turning point in the history of hysteria.[11]

Jorden divides the impact on the animal faculty into three types, effecting:

1. 'the internall and principal sense which doth governe and direct all the rest by *Imagination, Reason and Memory*'
2. the five external senses
3. the movement of the body

In each type, normal activity can be 'diminished, depraved, or cleane abolished'. He gives a range of examples for each type and distinguishes between mental suffering, 'when a man doth not *Conceive*, *Judge*, or remember so well . . . where the imagination and reason are hurt' and physical effects, such as convulsions, which are seen as 'milder and more usual'. For example, with movement of the body, he details:

> sometimes the iawes, lips, face, eyelids etc. are contracted, whereby they make many strange faces and mouthes sometimes as though they laughed or wept, sometimes holding their mouthes open or awry, their eyes staring, etc. Sometimes the hands, armes, legges, fingers, toes, etc. are contracted, sometimes particular muscles in the sides, backe, armes, legs, etc. one or more at once, as in cramps . . . & cannot abstaine from motions and gestures, casting their armes and legges to and fro, up and downe, dancing, capring, vawting, fencing and in diverse maners forming their motions.

Jorden adds that these effects are seen through 'too much wakefulnesse through the commotion of animall spirits, also in dreames, where sometimes besides the depravation of the fantasie they wil walke, talke, laugh, crye, etc.' This brings to mind the sleepwalking by Lady Macbeth:

**Doctor**
A great perturbation in nature, to receive at once the benefit of sleep, and do the effects of watching. In this slumbery agitation besides her walking and other actual performances, what at any time . . .
(*Macbeth*, V.i.9–12)

It also recalls other actions such as her repetitive rubbing of her hands, where the line 'I have known her continue in this a quarter of an hour' suggests an observation from a doctor.

This sort of medical detail does not come from Holinshed's *Chronicles* or James I's writings, and here it is tempting to see Shakespeare recalling discussions with doctors who had witnessed such conditions at first hand. Great St Helen's was only 400 yards from the Bethlem Hospital and, as we have seen already, Dr Turner certainly treated one mentally disturbed potential inmate. It seems likely that Dr Jorden could also have been dealing with a variety of mental illnesses in his practice. He was particularly wary of explaining unusual actions as being the result of devils, because he knew that ordinary people could fake such symptoms, especially performers. He noted:

we also do daily see that some can counterfeit madness, some drunkennesse, some the falling sicknesse [epilepsy], some palsies and trembling, some can play the fooles and supply the rooms of innocents, some can make noyses & speake in their bellies or throats . . . as wee see in tumblers, iuglers, and such like companions.

Perhaps here the learning process worked the other way, with Shakespeare explaining to Dr Jorden the tricks that performers could use. If normal people could do these things, Jorden argued, why could not pressure on the brain cause the afflicted to do the same? In an era before psychological analysis, he explained that 'these internal sences are overthrown'. Michael MacDonald, in his major 1991 review of Dr Jorden's book, comments:

Few authors can have won such an enduring reputation for precocious sagacity on the basis of a short and technical pamphlet that was never reprinted and cannot have been widely read, even in its own time, much less in subsequent decades.[12]

While MacDonald may be correct in his argument that Jorden produced his work under heavy pressure from Bishop Richard Bancroft as part of a 'pamphlet war', this does not

undermine the fact that Jorden was wrestling on the frontier of the understanding of psychological factors in human actions, something fundamental to modern thought. The uncertainty of his conclusions does not mean his observations or analysis were crude, but rather that he was pushing into uncharted waters where religious orthodoxy was a powerful control and, indeed, a threat to innovative thinking.

Continuing research will doubtless identify further connections. To cite just one possibility: students of *Macbeth* have often mentioned the visit of James I to Oxford on 27 August 1605. There he and his wife, Queen Anne of Denmark, were greeted at the gate of St John's College by three young men dressed as 'sibyls'. They recounted the story of Banquo and predicted good fortune for his descendant James I. This welcome had been written by Dr Matthew Gwinne, a doctor and playwright. In 1597 he was nominated by the University as the first Gresham Professor of Physic, and he started teaching in autumn 1598. It is quite possible that his period at the newly opened Gresham College in St Helen's overlapped with the end of Shakespeare's residency nearby, just on the other side of Bishopsgate Street.

It has long been recognised that Shakespeare's move in 1599 to the new and larger Globe Theatre, with a fresh audience base, prompted a significant development in his writing. His plots become more complex at this time, the characters more three-dimensional, and there is a much greater emphasis on the psychology of the key figures. These changes result in his great tragedies *Hamlet* (1599), *Othello* (1604), *Macbeth* (?1606) and *King Lear* (1606). While the move to the Globe opened up new opportunities, it may not fully explain this imaginative leap. Shakespeare's residency among a group of radical doctors, close to Bedlam and with Dr Jorden deeply involved in contemporary investigations into bewitchment, is intriguing. While unprovable, it may help provide a key to understanding the intellectual atmosphere he experienced in the late 1590s and the resulting development in his playwriting.

The claimed bewitching of a succession of teenage girls over nine years, Joan Nailor, Mary Glover and Anne Gunter, would have generated a great deal of direct commentary, but could also have produced much questioning of the limits of acting, special effects and human imagination. The possibility should also be considered that Dr Edward Jorden's greatest long-term impact may not have been delivered by his relatively obscure writing, but through helping with the awakening in Shakespeare's imagination of new ideas about understanding, describing and staging the human condition. The debate continues.

## Notes

1. See Swan, 'A True and Breife Report, of Mary Glover's Vexation and Her Deliverance'.
2. See Hughes, *Certaine grievances*.
3. Actually, Robert Glover at Coventry rather than Dr Taylor at Smithfield, London, as stated in the report.
4. The following Wednesday, Mary went to hear a lecture at the Puritan stronghold of St Anne, Blackfriars, a clear indication of her full acceptance back into her community.
5. The churchwardens' accounts for St Helen's in 1602/3 recorded, 'to a preacher when Mr Lewes was in prison 5s[hillings]' and 'to Mr. Morley when he preached Mr Lewes being suspended 3s-6d'. Richard Ball (*c.* 1570–1631), his successor in 1603, was a less controversial and more mainstream figure. In 1597, he was one of two candidates nominated by the University of Oxford as the first professor of rhetoric at the new Gresham College. Although initially unsuccessful, he took over the position in 1598. He would therefore have known St Helen's well, and might have overlapped with Shakespeare's residency. He resigned the professorship in 1614 as he married, but took on the rectorship of the neighbouring parish of St Christopher-le-Stocks, presumably to make up for his loss of income. At some point after 1600, he became chaplain to the 4th Earl of Worcester, whose theatre company Worcester's Men had received a Privy Council licence in March 1602 to perform at the Boar's Head Inn. Richard Ball's family is well researched, as the Balls were ancestors of George Washington; see D. J. French, *The Ancestry of the Balls of Berkshire, Northamptonshire and Virginia* (n.d.), pp. 22–4.
6. See Thomas Webster, *Spiritual Wrestling: The Making of Demonic Possession in Early Modern English Protestantism* (Boydell Press, forthcoming).
7. For a detailed account of this case, see Sharpe, *The Bewitching of Anne Gunter*.
8. *Macbeth* was unpublished until it appeared in the 1623 First Folio.
9. Edmondson and Wells (eds), *The Shakespeare Circle: An Alternative Biography* provides a foundation for such an approach by highlighting a wide range of people known to Shakespeare, including friends and neighbours in Stratford-upon-Avon.
10. This also allowed him to spend a page recounting the story of Dr Vesalius in Spain, who started a dissection on a woman who appeared dead from a fit but who at the second cut 'stirred her limbes'.
11. See MacDonald, *Witchcraft and Hysteria in Elizabethan London*, p. vii.
12. Ibid. p. vii.

# PART VII

Coda: The Advancement of English

Figure 21.1 The development of sugar cane plantations in the Caribbean resulted in the massive expansion of slave labour. This 1681 French illustration shows processing methods dating back centuries. A mill (rear) crushes the cane to release the juice for boiling (front).

Figure 21.2 Honey was the main sweetener of the medieval world. Here the artist of a medieval Arab bestiary depicts bees swarming around a honeycomb. Elizabethans admired the social order of the beehive.

# 21

## Honey or Cane Sugar?

*In which the British Empire and the English language start to spread across the globe. Meanwhile, Caribbean sugar cane begins replacing honey as England's source of sweet energy. In 1629, at the heart of St Helen's, the nuns' cloister garden, where Dr Peter Turner used to walk among his plants, is now dug up for a sugar refinery. Across the Close, Crosby Hall becomes the offices and warehousing of the new East India Company. In 1642, all the playhouses are closed and, over time, Shakespeare's stay in St Helen's is forgotten.*

In August 1614, somewhere under the intense sun of the tropics, enslaved Africans labour over crude brick furnaces to refine boiling raw sugar cane juice in iron vats (Figure 21.1). Out in the surrounding plantations, lines of enslaved people move across the fields, cutting down the towering cane plants with machetes. In the heat and dust, others stack the cane onto bullock carts to be taken to the mill for crushing. This scene is repeated in hundreds of locations along the North African coast, on the islands of Madeira and the Canaries, in Brazil, across the Caribbean and, of course, in Demerara. Sugar, a new human superfuel, is beginning to spread.

From 1740 until 1820, sugar was Britain's most valuable import. Matching its growth came, in parallel, the horrific business of shipping slaves from West Africa to the Americas to cultivate this new luxury. Sometimes the overseers' voices were Spanish, sometimes Portuguese, sometimes Dutch, sometimes French, but the message was always the same: speed at all costs, to get this hugely valuable raw material from out of the plantations to Europe. Particularly in northern Europe, sugar was starting to replace honey as the sweetener of choice. The half-processed sugar was packed into wooden barrels and then loaded onto ships for the reverse Atlantic crossing. In the ports of northern Europe, especially Antwerp, the final stages of sugar refining had been established; cones of purified brownish sugar stood on shelves in grocers' shops for eager customers. An English guide to different trades notes, 'Of the Sugar-Baker':

> sugar is the Juice of a Reed expressed by two great Iron-Rollers, turned by Negroes. The Juice is received into a Boiler, where it is boiled for a considerable Time, and is made to granulate by mixing it with Lime. This dry Powder is put up in Casks, in which there is a Hole left to allow the Molasses to drain from it, and in that shape sent to Market and called Muscovadoes.[1]

As 'mellifluous and hony tongued'[2] Shakespeare, now fifty, sits at table in New Place in Stratford-upon-Avon, does he enjoy the sweetness of a local Warwickshire honeycomb (Figure 21.2), or does he use a sugar hammer or tongs to break off a piece of hard sugar cone (Figure 21.3), enjoying a similar taste but one originating thousands of miles away? If the latter, it was probably of foreign origin, since direct access to 'English' sugar from the Caribbean had to await the occupation of the islands of St Kitts in 1623,[3] Barbados in 1627 and Jamaica in 1655. Although the first recorded sugar refinery in London was established in 1544 by Cornelius Bussine in partnership with Sir William Chester, it remained a small-scale but profitable activity until the end of the century.[4] In 1614, cane sugar would still have been a luxury item akin to an expensive spice rather than a bulk commodity. When Francis Meres wrote in 1598 of Shakespeare's circulation of 'sugred sonnets among his private friends', what was the sugar he had in mind?[5] In his *Palladis Tamia, Wits Treasury*, he writes:

> As a Bee gathereth the sweetest and mildest honie from the bitterest floers and sharpest thornes: so some profit may bee extracted out of obscene and wanton Poems and fables.

but he also mentions:

> As rubarbe and sugarcandie are pleasant and profitable: so in poetry ther is sweetnes and goodness.

Figure 21.3  A replica sugar loaf. The liquid refined sugar was poured into cylindrical moulds and left to harden. At home, the loaves would be broken up with a sugar hammer and small pieces cut off with sugar nips.

The latter might have been made with crushed cane sugar, which had long been imported from North Africa.[6] Although English occupation in the Caribbean came relatively late, traders had been penetrating the region from the 1580s, so barrels of part-refined cane sugar from Brazil and the Caribbean islands would have been unloaded on London's quays by the end of the century.

Shakespeare certainly knew all about honey, describing it in various ways:[7]

> The sweetest honey
> Is loathsome in its own deliciousness,
> And in the taste confounds the appetite.
> Therefore love moderately.
> (*Romeo and Juliet*, II.v.11–14)

Bees in the hive were often portrayed as a metaphor for a well-ordered kingdom, as Shakespeare's Archbishop of Canterbury sets out in *Henry V*:

> For so work the honey-bees,
> Creatures that by a rule in nature teach
> The act of order to a peopled kingdom
> They have a king[8] and officers of sorts;
> Where some, like magistrates, correct at home,
> Others, like merchants, venture trade abroad,
> Others, like soldiers, armed in their stings,
> Make boot upon the summer's velvet buds,
> Which pillage they with merry march bring home
> To the tent-royal of their emperor
> Who, busied in his majesty, surveys
> The singing masons building roofs of gold,
> The civil citizens kneading up the honey,
> The poor mechanic porters crowding in
> Their heavy burdens at his narrow gate,
> The sad-eyed justice, with his surly hum,
> Delivering o'er to executors pale
> The lazy yawning drone
> (*Henry V*, I.ii.183–204)

Despite the loss of his only son in 1596, life in 1614 probably seemed good to Shakespeare. *The Tempest*, written in 1610/11, his last sole authored play, showed he still retained his creative powers; his eldest daughter was married to a respectable doctor, John Hall; and

he had a granddaughter, Elizabeth, aged eight offering the potential of a great grandson. After the turmoil of the 1605 Gunpowder Plot, the reign of James I had settled down to relative stability. The Jacobean era might have seemed very different from the reign of Elizabeth I, but continued peace brought growing prosperity. If Shakespeare had premonitions of his death, he did not seem to show it, as fifteen months earlier he had made his only London property purchase. In some ways, it was a strange choice: one of the large gatehouses of the former Blackfriars. The King's Men (the renamed Lord Chamberlain's Men) had opened their indoor theatre in the former friary hall nearby in 1608, but there would have been more modern properties nearby. Why buy a gatehouse, with all the noise of passing traffic, which must have been well over a hundred years old? Was it a memory of rewarding times in St Helen's with its gatehouse, twenty years earlier, that prompted his interest? If he wandered across the City in 1613 to view his old haunts, what would he have found?

Much would have remained the same and indeed, Great and Little St Helen's, along with the church, would have retained a strong sense of late medieval and early sixteenth-century London. Dr Peter Turner was still living, just, in the Cloister, and although Alderman John Robinson the Elder was long dead, his sons Robert and William were living next door to each other in the two largest houses in Little St Helen's. However, many of Shakespeare's former close neighbours were dead – Israel Jorden (buried 1603), John Hatton (1608), Robert Spring, John Pryn and John Christian (1609) – and others, like Dr Edward Jorden, had moved away. A few people, such as Elizabeth Warren, Joan Hatton and George Axton, still remained. Perhaps most significantly, Cecily Cioll and Sir John Spencer along with his wife had all died early in 1610. Crosby Hall had been inherited by his son-in-law, Lord Compton, later the 1st Earl of Northampton.[9] Before his death, however, Sir John had added a significant feature to his property, the parish and to the City. If Shakespeare had walked around to the back of Crosby Hall, he would

Figure 21.4   As the City of London changed to completely commercial use and lost its residential population, Crosby Hall suffered the final indignity of having a floor inserted for warehouse use. Watercolour by Robert Schnebbelie, 1819.

have discovered a newly built 'large warehouse' on the former gardens (Figure 21.4). Later plans show the site to have been a large courtyard surrounded by buildings on three sides. It was the first sign of a fundamental change, as St Helen's began to decline as a prime residential area and became part of the City's shift to a proto-capitalist business centre.

Shakespeare died in 1616, aged fifty-two; but assuming he was in reasonable health in 1614, he might have expected, like his colleague Ben Jonson, to live to his mid-sixties and to die around 1630. If he had, and revisited St Helen's then, he would have seen this economic process gather pace. In 1629, the Cloister was still the most prestigious address on the Leathersellers' Estate, but it was about to undergo a marked change in use. After Dr Peter Turner's death in 1614, it was briefly occupied by a mercer, John Grove, and from 1616 until 1627 it was taken by Sir William Ayloffe, MP.[10] Following his death, the building was leased by George Leech, a sugar baker or refiner. His lease contained a significant new clause about the use of the presumably once beautiful cloister garden. All new building work was banned, except:[11]

> scaffolde or other such like thing for the only use of the trade of a refiner of Sugers the same being not hinderance or impediment to any the light or licke of the aforesaid [Leathersellers'] hall or any the buildings thereunto belonging.

It seems strange today that the Leathersellers' main concern was losing light to their livery hall, rather than the risk of fire posed by allowing sugar-boiling furnaces next door. However, prior to the Great Fire of 1666, there seems to have been a casual approach to potential sources of fire inside the City. It is not clear if the refinery was built in 1629 since, in the event, domestic tragedy immediately struck the Leech family. When they moved into their impressive new home, George Leech's wife Margaret was heavily pregnant and somehow, one day in August, their young son George, presumably at least a toddler, escaped their attention. The parish burial register for 21 August 1629 records the grim outcome:

> George s[on] of George Leeche of this p[a]rish, Suger Baker, having been drowned in a sin(c)k in his Fathers howse, and the C[o]rowners having passed on him, [buried] in the Xs [ten shilling] grounde in the churche.[12]

Two days later, Margaret Leech gave birth to a daughter, Katherine. However, hardly surprisingly, they did not stay long, and by 1631–2 the house had been taken over by Herriott and Agnes Washbourne. He was also a sugar baker, which strongly suggests that at some point the sugar refinery had started production.[13] Sugar refining, perhaps resulting from the occupation of Barbados in 1627, was symbolic of the much broader expansion of England's international trade and the first steps in overseas colonisation. We have already seen how international merchants from St Helen's and nearby parishes

were key to the voyages of exploration to Russia and Martin Frobisher's three voyages seeking Cathay in 1576–8. Fifty years on, the British Empire was well under way.

On 11 June 1578, Sir Humphrey Gilbert was granted the first Letters Patent to establish English colonies, giving him a six-year exploration licence. Although by 1578 he seems to have left St Helen's, he was still connected to a web of merchants and financiers in the area. Although most of his grandiose projects turned out to be damp squibs, just as the patent was about to run out, he occupied Newfoundland for the English crown on 5 August 1583. This day arguably marked the start of the British Empire. Despite his subsequent drowning, Gilbert's efforts led to his half-brother Walter Raleigh's project to establish the famous 'lost' Roanoke Colony in North Carolina in 1585 – the first English attempt to establish a permanent settlement in America.

The defeat of the Spanish Armada in 1588 gave England and its sailors an enormous boost in confidence and the excuse to take the ongoing conflict against the Spanish/Portuguese anywhere that could reached by ship.[14] Elizabeth I gave permission for English ships to attack settlements and shipping in the Indian Ocean. In 1591, the first force of three ships left England, reaching Zanzibar by February 1592 and the island of Penang, off Malaya, in May. For the next year, they attacked enemy shipping. Only twenty-five of the original crew made it back to England in May 1594, but the raids had demonstrated the ability of England to strike six thousand miles from London.

Meanwhile, in August 1592, Sir Walter Raleigh had seized the huge Portuguese *Madre de Deus* off the Azores. Among the fabulously rich cargo from the East Indies was something almost as valuable: a rutter, or navigation guide, describing the trade connections with India, China and Japan. Sixteen years after Frobisher's first attempt to reach Cathay, direct trade with China was in sight. Following further voyages to the Indies, London merchants lobbied the Queen to support an officially sanctioned monopoly and raised nearly £70,000. On 31 December 1600, as the sixteenth century ended, a Royal Charter established 'The Governor and Company of Merchants of London trading into the East Indies', the organisation which became the East India Company. The company broke the Spanish/Portuguese stranglehold on the spice trade and in 1603 established a factory at Batam on Java. This was followed by the first trading post in India at Surat in 1612,[15] which gave access to the Mughal Empire, and soon after at Machilipatnam on the south-east coast. In 1613, the first English ship, the *Clove*, reached Hirado in Japan, where a trading factory was established (Figures 21.5 and 21.6).[16]

The original charter was awarded to George, Earl of Cumberland, and two hundred and fifteen knights, aldermen, and burgesses. Many of these would have lived in the streets around St Helen's. The first offices of what was to become one of the largest companies in the world were very basic. Indeed, meetings were supposedly first held at the Nag's Head, an inn opposite St Botolph, Bishopsgate. Sir Thomas Smythe, the first governor, then moved operations into a set of rooms in his own house in Philpot Lane,

Figure 21.5  Map of English overseas settlement, c. 1625.

Figure 21.6  Map of British overseas settlement, c. 1713.

Figure 21.7 1790 plan of the buildings at the south end of Great St Helen's by the exit into St Mary Axe (viewed from north). To the left is the Sugar Loaf public house (circled) and to the far right the East India Company warehouse (marked). The Kings Arms Inn and the Ship Tavern lay over the parish boundary.

just south of St Helen's. On his death in July 1621, the East India Company moved its offices to Crosby Hall for the next seventeen years (1621–38).[17] Forty-five years after Martin Frobisher's first voyage, the control centre of England's Asian trade had returned to St Helen's (Figure 21.7).

Comparing the epitaphs of Sir Thomas Smythe and his grandfather, who had died sixty-seven years earlier, neatly highlights the changes in national ambition over this period. It also shows the role of St Helen's, for Sir Thomas's grandfather was none other than Sir Andrew Judd (1492–1558), Lord Mayor in 1551/2 and one of the key instigators of early English exploration. His wall memorial in St Helen's sums up his exploits, highly impressive but limited in geographical scope, in eight lines (Figure 13.3):

> TO RVSSIA AND MVSCOVA
> TO SPAYNE GYNNY [Guinea – West Africa] WITHOVT FAYLE
> TRAVELD HE BY LAND AND SEA
> BOTHE MAYRE OF LONDON AND STAPLE
> THE COMMONWELTHE HE NORISHED
> SO WORTHELIE IN ALL HIS DAIES
> THAT ECH STATE FULL WELL HIM LOVED
> TO HIS PERPETVAL PRAYES

His daughter Alice (d. 1593) married Thomas 'Customer' Smythe (1522–91), who made a fortune from controlling all imports by ship into London. Their son Sir Thomas Smythe (c. 1558–1625) was buried at Sutton-at-Hone, near Dartford in Kent.[18] In another eight lines, Smythe junior's epitaph indicates the global reach and ambitions of his business ventures, now also those of England:

> From those large kingdoms where the sun doth rise,
> From that rich new-found world that westward lies,
> From Volga to the flood of Amazons,
> From under both the Poles and all the zones,
> From all the famous rivers, lands, and seas,
> Betwixt this place and the Antipodes,
> He got intelligence what might be found
> To give contentment through the massy round.

Sir Thomas Smythe really was interested in east and west, since he was not only a founder of the East India Company but also of its equivalent in America, the Virginia

Figure 21.8 A romanticised Victorian illustration (1859) of Sir Walter Raleigh enjoying his first pipe of tobacco. The export of tobacco became a staple of Virginia's economy and supported the increasing colonisation of the eastern seaboard of America.

Company (Figure 21.8). In 1606, James I chartered two organisations to explore and colonise North America (excepting Florida, which was then ruled by Spain). On 14 May 1607, Jamestown was established on the James River in Virginia. Although it only survived by a thread, it was to become the first successful English occupation in North America and the founding settlement of the USA.

News of all these expeditions, with their dramatic successes and tragic disasters, must have thrilled and horrified Londoners in equal measure. It is likely that Shakespeare was as intrigued as everybody else. One indicator of his interest is the plot of *The Tempest* (1611), which was probably inspired by the account of the shipwreck of the *Sea Venture* on Bermuda while trying to relieve Jamestown in 1609.[19] Bermuda subsequently proved a popular destination for English emigrants, particularly since there was no threat from pre-existing inhabitants. It seemed to offer the opportunity of a new start in an attractive climate, perhaps particularly for those who had failed in their ambitions in England. It is, therefore, not totally surprising to find among the new arrivals disembarking in 1614 onto the simple landing stage Minister Lewis Hughes, whom we last saw being expelled from St Helen's in 1603 for carrying out the exorcism of Mary Glover. Nothing is known of what he had been doing during the intervening years, but they clearly had not tamed his Puritan fervour. Quite the contrary: Hughes entered into his Bermuda ministry with unquenched zeal to build a godly community. Precisely what happened there is outside the scope of this book, but one can guess that he continued to use the story of Mary Glover, Elizabeth Jackson, Dr Edward Jorden, Bishop Bancroft and St Helen's as a moral exemplar.[20]

While England's expansion is usually presented in terms of sea captains, ships, battles and settlements, it was also another type of expansion – the spread and growth of English. Slowly and then with gathering speed, fur traders, mineral prospectors, traders, ministers and plantation developers spread out from the tiny rash of initial settlements into the Canadian wilderness, the Appalachians and the vastness of India. In the Caribbean, English voices were no longer heard only from slave traders and merchants but also increasingly from the overseers and owners of the sugar plantations, with the clergy, officials and soldiers alongside to justify God's beneficence to the country. English moved from being a one-country language like Polish, Czech or Japanese to potentially being a world language in less than a hundred years. By 1700, the scatter of English settlements had spread into full colonisation along the Atlantic coast of America. With the push inland towards the Appalachians went the King James Bible and a growing canon of English poetry and plays. Around 1600, it is estimated that there were approximately 1.2 million Irish speakers and 4.3 million English speakers in the British Isles and 10 million French speakers in France.[21] Few people considered that Irish would be overwhelmed by English, and few probably thought at the time that Latin would not be the *lingua franca* of Europe in a hundred years' time. However, nationalism mixed

with empire-building resulted in a very different outcome. Shakespeare became not simply the national playwright of England but a household name around the world. In parallel, English expanded from the islands of the United Kingdom to become a language of global communication.

The 1630s, as England began its slide towards civil war, saw the last of Shakespeare's contemporaries who might have remembered him in St Helen's going to their graves. Actor John Heminges was buried in St Mary's Aldermanbury in 1630; Dr Edward Jorden in Bath Abbey in 1633; mercer William Robinson in St Helen's in 1635; Ben Jonson in Westminster Abbey in 1637; and finally, Joan Hatton in 1638. William Robinson in particular could probably have recalled Shakespeare as a local resident, as he would have been in his twenties or thirties in the 1590s. Perhaps, for a while, a folk memory remained that Shakespeare had once lived in the parish – but even this would have faded away with the turmoil of the English Civil War, the closure of all the theatres from 1642 until 1660, the devastating plague of 1665 and the Great Fire of London in 1666. Local knowledge of Shakespeare's London residencies in St Helen's and later in Silver Street, St Olave's was lost. All that was left to survive were the entries in the Lay Subsidy rolls, reduced by indifference, fire and damp to eventually just the two entries for 1597 and 1598. Without these, we would never know that Shakespeare ever lived in St Helen's and might have once talked, argued and flirted with his neighbours detailed here.

Doubtless there is much more to discover about some of the people who have made their brief entrances and exits in this investigation. Where did John Hatton come from – ditto Israel Jorden? Did John Robinson the Younger ever make peace with his siblings? What was Charles Bostock storing in his warehouse? Can more be found out about Thomas Wrightson and his connections with the Bull Inn and theatre? Did Mary Glover have a happy life after her exorcism? What did Dr Jorden make of William Shakespeare, and vice versa? Did Dr Turner offer Shakespeare any of his apothecary's morphine? Was there a person in St Helen's who had a special hold on the bard's affections? Is it possible ever to prove 'oral' history alongside 'literary' history?

However, our journey now is ended for the present. We will leave William Shakespeare, in October 1598, walking north along Bishopsgate Street towards Shoreditch. He is thinking that negotiations with Giles Allen are pointless, that the Theatre is finished as his workplace, that the certainty he has enjoyed for four and a half years in St Helen's is coming to an end – and that there will need to be a new beginning.

Living with Shakespeare

## Notes

1. See Campbell, *The London Tradesman*, pp. 272–3, which, although much later, records a process essentially unchanged from *c.* 1600.
2. Meres, *Palladis Tamia or Wits Treasury.*
3. Followed by the nearby islands, including Nevis (1628), Antigua (1632) and Monserrat (1632).
4. John Strype's edition of Stow's *Survey of London* provides some background and states that there were only two refineries for twenty years. Sir William Chester (1509–*c.* 1574) was part of London's merchant elite and Lord Mayor in 1560–1. He was also MP for the City of London. One of his apprentices was Lawrence Saunders, the second Marian martyr, whose brother Blaise lived in St Helen's from his return from Marian exile in 1558 until his death in 1581. By the 1580s, English merchants had developed a significant trade in cane sugar from Morocco; see Ungerer, 'Portia and the Prince of Morocco', which provides a fascinating summary of English–Moroccon trading relations at this time. Ungerer argues that this provided the basis for the Prince of Morocco in the *Merchant of Venice.*
5. For the importance of the sugar industry to the income of the Sultans of Morocco and the trade with English merchants via Jewish sugar magnates, see Ungerer, 'Portia and the Prince of Morocco'. Elizabeth I required Moroccan sugar. Ungerer explores the bankruptcy and imprisonment of Isaac Cabeça, a Jewish–Moroccan banker and sugar trader, in 1568/9. A group of English merchants, including Sir William Garrard, Gerard and Thomas Gore along with Henry Colthurst, sorted out his debts. Colthurst's daughter Mary was married to Alderman John Robinson's second son Henry – a typical connection between two leading mercantile families in the City of London.. Ungerer also suggests that the close business and family links between the Gores and the Davenant families may have been the way Shakespeare learnt about Jewish and Moroccan trade relationships, noting: 'it is very plausible that Shakespeare knew John Davenant (1565–1622), who was a theatre enthusiast, before John moved to Oxford in 1601, where he fathered William Davenant, Shakespeare's godson, in 1606'. There may be a closer link: John Suzan, longtime St Helen's resident and witness to Alderman John Robinson's will in 1599, recorded in his own will of 1605 (TNA 11 /106/53) details of his trade with Morocco 'Barbary' and that Edward Davenant was his 'friend', leaving him £10.
6. See, especially, Grinnell, 'Shakespeare's Keeping of Bees', with an extensive bibliography.
7. It was not until 1586 that a Spaniard, Luys Médez de Torres, identified that the 'king' bee was actually a 'queen'; see Grinnell, 'Shakespeare's Keeping of Bees', p. 839. This discovery may not have been known or accepted in England, despite the rule of Elizabeth I.
8. At this time Crosby Hall was probably occupied by Mary Herbert, Countess of Pembroke (1561–1621), the poet and playwright, who is thought to have lived there *c.* 1609–15. Her play *Antonius* is recognised as a source for Shakespeare's *Antony and Cleopatra.*
9. Sir William Ayloffe, 1st Baronet (1563–1627) of Braxtead Magna, Essex, knighted in 1603 and created baronet, along with sixteen others, on 25 November 1612. He was briefly MP for Stockbridge in 1621–2 and spent large sums trying, unsuccessfully, to secure permission to drain the fens.
10. See Leathersellers' Company Archive *Copies of Leases and Deeds*, lease 21, April 1629. Leech/Leache paid an up-front premium or 'fine' of £100.
11. Sink here may mean a large drain, rather than a sink in the modern sense.
12. The Washbournes stayed there until *c.* 1660. During the English Civil War, Herriott was a colonel commanding a troop of cavalry, from 1643 Edmund Harvey's Regiment of London horse; see, 'Surnames beginning "W"', in Roberts, *The Cromwell Association Online Directory of Parliamentarian Army Officers*. In the early 1660s, Alderman Francis Warner rebuilt the Cloister and an adjacent property as five elegantly wood-panelled houses; see Leathersellers' Court Minutes 1662 (Ref Gov/1/4).
13. In 1580, following the War of the Portuguese Succession, Spain and Portugal were united under Philip II in the Iberian Union, which lasted until 1640. The British obsession with the successful defeat of the first Spanish Armada tends to obscure the fact that there were further Armadas in 1596

and 1597. Also, there were English defeats, notably Drake's attack on Iberia in 1589 and his major defeat at Puerto Rico in 1596, which led to his death.

14. In November 1612, four East India Company ships defeated a Portuguese force at the Battle of Swally off the coast of Gujarat. This engagement marked the end of Portuguese dominance of trade with India and opened up opportunities for the English, Dutch and French, who were soon in conflict with each other. One of these English ships was the *Red Dragon*, built as the *Scourge of Malice* at Deptford Dockyard for the Earl of Cumberland in 1595. The ship is famous for being the location of the first recorded performance of *Hamlet*, when anchored off Sierra Leone under the command of William Keeling. His diary recorded in September 1607, 'We had the tragedy of Hamlet: and in the afternoon we went altogether ashore, to see if we could shoot an elephant.' *Richard II* was also performed later, and *Hamlet* was performed again on 3 March 1608 when the ship had reached Yemen.

15. The first Englishman to arrive in Japan was William Adams (1564–1620), who was the navigator on the *Liefde*, a Dutch East India Company ship. From 1613, he worked for the East India Company and is thought to be the first Englishman to visit Thailand (Siam) in 1616 and the third to reach Vietnam, after he went to discover the fate of two Englishmen who had disappeared there in 1615. Adams died in 1620 and his grave still survives at Hirado, about seventy-five miles north of Nagasaki. The East India Company closed the factory as unprofitable in 1623.

16. The Company finally acquired its own site in 1648 in Leadenhall Street, just south of St Helen's. East India House became one of the sights of the City, until the Company was largely wound up in the aftermath of the 1857 Indian Rebellion. The site is now occupied by the Lloyd's Insurance building.

17. For a recent fascinating discussion of his career, see Archer, *Sir Thomas Smythe (c. 1558–1625)*.

18. The *Sea Venture* seems to have been England's first purpose-designed emigrant ship – a significant development in itself. The ship was probably built at Aldeburgh, Suffolk, for the Virginia Company. It left Plymouth on 2 June 1609 as part of the Third Supply mission to Jamestown, but was separated in a huge storm. The admiral of the Virginia company, Sir George Somers, drove the ship onto a reef off Bermuda to save the 150 crew and emigrants, along with a dog. The islands were named the Somers Islands or Virgineola, and were controlled by the Virginia Company until the London Company of the Somers Isles was established in 1615.

19. For an account of what Hughes got up to in Bermuda, see Cole, 'Lewis Hughes' and Craven, 'Lewis Hughes: "A Plaine and True Relation"'. In his 1621 tract, Hughes noted: '4. Consider also of the goodness of God, in reserving and keeping these Ilands, ever since the beginning of the world for the English nation, and in not discovering them to any, to inhabit but the English'; see Craven p. 74. Hughes eventually returned to England, and seems to have ended his days as the minister of a remote Welsh parish.

20. Despite the unified character of the French state, in France many citizens did not speak French, especially in the south.

# Appendix

Where Did Shakespeare Live in Saint Helen's and Who Might Have Been His Landlord?

Figure A.1 Elevation of the south end of Bishopsgate Street showing, lower left, St Martin Outwich with the 'well with two buckets' in the road. Above is Crosby Hall with a minaret tower and multi-storey tenements on either side. Eighteenth-century copy of an earlier drawing, now lost.

Figure A.2 John Ogilby's 1676 map of London records the City rebuilt after the Great Fire in 1666 and is the first accurate map of streets and properties. The scale of the Royal Exchange, Gresham College and Leadenhall Market stand out.

# 1

## Introduction

The information in this Appendix is drawn from many pages of detailed Elizabethan records, particularly the archives of the Worshipful Company of Leathersellers preserved at their Livery Hall, still located on the site of the medieval nunnery of St Helen's. Further information comes from the parish records of St Helen's kept in the London Metropolitan Archive and various wills, tax and legal records preserved at the National Archives, Kew. It can, therefore, only be a summary. References are given to key pieces of information as appropriate. The aim has been to provide enough detail so that readers can follow the line of reasoning and challenge the conclusions, without overwhelming with too much information. However, combined together, it is often the minutiae of these records which help build a clear picture of this corner of the Elizabethan City. Unfortunately, apart from the Lay Subsidy records and the parish registers of St Helen's and other local parishes (St Peter, Cornhill; St Botolph, Bishopsgate; St Leonard, Shoreditch), little of this material is currently published or available online.

To make the evolution of the parish clearer, four maps have been provided for St Helen's in 1476, 1536, 1596 and 1629 (see Figures I.9–I.12). It is important to clarify that these are intended to be diagrammatic rather than 100 per cent accurate. Trying to amalgamate the information from surviving buildings, later maps (especially the 1873 Ordnance Survey map) and actual sixteenth-century measurements in leases may be possible but would require a sophisticated computer mapping exercise. The positions of the west and north wings of the nunnery are accurate since the southern end of the former still survives as 33 Great St Helen's. However, the location and layout of the buildings to the west and north-west of the west wing (Prioress's Lodging/The Cloister) are more speculative. I have followed the suggested layout in this area proposed by George Birch (1842–1904), sometime director of the Sir John Soane Museum, who studied the evidence carefully. However, it is possible that these structures, in the same or a different configuration, were further north and closer to the gateway into Little St Helen's.

# 2

## What Accommodation in Saint Helen's Would Have Appealed to Shakespeare?

Which houses in the parish would have offered accommodation appealing to a socially ambitious player and writer like Shakespeare? Due to the evolution of St Helen's around the nunnery and along Bishopsgate Street, the housing available in the 1590s fell into five broad types/areas totalling about 100–110 individual properties.[1] This number is indicated by both the evidence from the Lay Subsidy rolls in 1598/1600 and parish records, including the 1589 tithe survey.[2]

The first properties to consider are the two large mansions, Crosby Hall and Gresham House, which dominated the area, occupying 10 to 15 per cent of the total parish. They were among the largest private houses in the City, with very rich occupants. It would have been socially unacceptable for either owner to rent accommodation and neither seems likely to have offered Shakespeare lodgings as an act of patronage. Crosby Hall was owned from 1594 by Sir John Spencer, who fiercely opposed theatre. From Sir Thomas Gresham's death in 1579, Gresham House was slated, after his wife's death, for conversion into the new Gresham College, London's first higher education institution. By 1594, his ageing widow Anne Gresham had outlived her husband and his ambitions to preserve his name by fifteen years. Much of Gresham House was probably largely shut up. Indeed, by 1589, Anne had built a second large house, 'her newe dwelling in the streete side', to complement 'her other greate house', perhaps in preparation for moving out.[3] She would then have been in her sixties and there is no evidence of her acting as a patron of the arts. In summary, the likelihood of Shakespeare having rooms in either mansion seems very low.

Running through between the two mansions was the major thoroughfare of Bishopsgate Street (Figure A.1). On the west side, the frontage consisted of up to twenty houses in front of Gresham House. These houses ran south from the extensive premises of the Bull Inn, site of the Bull Theatre, at the northern boundary with the parish of St Ethelburga to the parish and church of St Martin Outwich 'with the well with two buckets' at the south.

The east side of Bishopsgate Street was formed of up to thirty buildings, including the nine houses recorded as running south from the medieval St Helen's 'belfry' gatehouse in front of the mansion of Crosby Hall, with another six to eight houses further south. There were around fifteen to seventeen properties running north from

the gatehouse leading into Great St Helen's up to the parish boundary with St Ethelburga. In this northern stretch of buildings was the new gatehouse entry into Little St Helen's, probably cut through to provide direct access to the Leathersellers' Hall.[4]

Bishopsgate Street was also one of the busiest roads in the City and the cluster of 'carrier' inns, like the Bull, the Green Dragon, the Three Swans and the Vine closer to Bishopsgate itself would have been full of travellers, newly arrived migrants to the City, and the usual scattering of ne'er-do-wells and petty thieves drawn to any transportation hub (Figure A.2). Both sides of the street in St Helen's would have been lined with multi-storey houses.[5] The houses on the east side, where they backed up against the former nunnery precinct, appear to have been quite small, although the properties towards the south were larger. The ground floors were valuable commercial space for shops, workshops and warehousing for goods. Usually, the family would have lived upstairs, 'over the shop' with all the attendant noise and disturbance of young children. Whilst sub-letting was possible,[6] it seems unlikely that Shakespeare would have chosen to live on a main road with all the attendant nuisances of noise, being disturbed by unwelcome visitors and the risk of theft.[7] To illustrate the type of property, there is the example of John Christian, a clothworker, who lived in the building immediately north of the entrance to Little St Helen's in the 1590s. By 1599, he had at least three children under seven. A later lease from July 1622 described the building as a ground floor shop with a cellar underneath with a street frontage of eleven feet and a depth of up to thirteen feet. Above were three floors each with a single room 'of similar bigness', providing around 430ft$^2$ including the stairs with a garret on the fourth floor under the tiles. It is difficult to imagine Shakespeare living and trying to work in such a constrained environment.[8]

In complete contrast to the continuous bustle of Bishopsgate would have been the relative calm of the houses in Great and Little St Helen's, the two side turnings off to the east. Here there were a total of *c.* thirty houses, most of which seem to have been substantial buildings with upmarket owners. Both would have been entered through gateways, which would have provided some degree of control, limited access by carts and enhanced overall security.[9]

Great St Helen's fell into two parts. A row of ten substantial houses with back gardens ran east from Crosby Hall along the south side of the graveyard to where Great St Helen's turned south and narrowed into a twisting alley (Figure A.3). A single photograph, taken in 1885, preserves the only record of the entire frontage of the southern row, prior to its complete demolition.[10] While the nine buildings to the right (west) of No.10 are all seventeenth-century or later rebuildings, the image does convey how impressive the Close must have seemed in the 1590s. It would have provided a secure, quiet and discreet but at the same time distinguished address for Shakespeare. Very much the 'right' location for a lauded writer with two epic poems to his name and possibly seeking future

Living with Shakespeare

Figure A.3  Although these houses had largely been rebuilt in brick in the seventeenth century, this photograph *c.* 1888 shows how impressive Great St Helen's must have been in the sixteenth century as a residential enclave.

rich patrons. Certainly, it was very different from the lifestyle of Marlowe and Kyd's lodging together, half a mile away but significantly outside the City walls, in the Liberty of Norton Folgate. There they were hidden, perhaps deliberately so, in the cheaper, poorer, denser suburban sprawl stretching up to the Theatre in Shoreditch.

These are almost certainly the ten houses with gardens recorded in a 1536 nunnery lease as there seems nowhere else that these properties could be fitted into the Close. They were leased by the nuns in 1536 to John Rollesley, so they must have been constructed sometime in the seventy years from 1466 to 1536. John Schofield considers them unlikely to date from much before 1520,[11] and one possible date for their construction might be *c.* 1524, when the rich Italian merchant Antonio Buonvisi acquired Crosby Hall.[12] In 1540, after the Dissolution, Henry VIII gave them to William Crane, gentleman and then Master of the Chapel Royal from 1523 until his death in 1545.[13] The lease records the families living there, several of whom were clearly of high status .[14] One, Guy Crafford, was recorded at the huge valuation of £300 in the 1541 Lay Subsidy roll, the third highest in the parish.[15] In the decades before the 1590s, this area would have been dominated by Thomas Coleshill, MP and inspector of the Great Customs, who moved in *c.* 1546. His daughter Susan(na) married into the powerful Stanhope family. Sir Thomas died in 1595, but two of the Stanhope brothers acquired the living of St Helen's in 1599.

Remarkably, the easternmost house, on the corner where Great St Helen's turned south and continued

Figure A.4  The rear of the three-storey Tudor house at the corner of Great St Helen's. This house was said to have been occupied by Anne Boleyn's father, perhaps a garbled memory of James Boleyn's role as steward of the nunnery just before the Dissolution. Watercolour by John Crowther, 1883.

Figure A.5  Surviving jettied Tudor house at the east end of the row of ten houses (Crane Estate) facing onto Great St Helen's. In the 1590s, there would have been an impressive row of similar half-timbered houses. Watercolour by John Crowther, 1888.

as an alley connecting with St Mary Axe, survived until 1894, when it was drawn and photographed before demolition.[16] The best watercolours (Figures A.4 and A.5) clearly show a three-storey jettied structure with a garret floor above, dating perhaps to the 1520s or a little earlier.[17] Each property would have been about fifteen feet wide with a main room at the front and a kitchen at the rear opening onto the south-facing yard or garden. Stairs would have led up to the first and second floors, each probably consisting of a main room at the front, overlooking the churchyard, and a bedroom at the back. On the third floor was a garret for servants or storage.

To the south of the graveyard and east of the southward turning of Great St Helen's was a separate group of houses. This area was bounded on its east side by the parish boundary, probably following the line of a major drainage sewer, with a row of ten houses beyond, located on the west side of St Mary Axe in the parish of St Andrew Undershaft.[18]

There were another fifteen or so houses located in Little St Helen's, converted from the former nunnery complex north of St Helen's Church and owned by the Leathersellers' Company from 1543.[19] In the mid-1590s, five of the properties commanded annual rents of over £5 and were probably substantial and prestigious stone buildings.[20] Since Little St Helen's was a cul-de-sac with a gate on to Bishopsgate Street, it would also have been a highly secure neighbourhood. It is not clear precisely how or when this area evolved,

and some parts of the nunnery kitchen garden appear to have survived until at least 1666.[21] The 1542 Thomas Mildmay survey of St Helen's records six houses existing in this area, called the nunnery woodyard, before the Dissolution. Part of the former kitchen garden was also used as the site for Leathersellers' almshouses, of which Stow wrote:[22]

> ... and from thence some small distance is a large court called little S. Helens, because it pertained to the Nuns of Saint Helens, and was their house: there are seuen Almes roomes or houses for the poore, belonging to the companie of Leathersellers.

The leases of the Leathersellers indicate that over the next fifty years there was considerable rebuilding.[23] From the 1590s, the pace of new building grew and rents increased substantially.[24]

Together, the houses in the Close section of Great and Little St Helen's represented *c.* 25–30 per cent of the entire housing stock in the parish. While many of these houses were occupied permanently, a proportion would be the London lodgings for gentry who owned houses in the country and who would have spent much of their time out of town. However, these areas offered more than just space.

Most of the houses around Great St Helen's were probably broadly similar in appearance and layout. Since the area had little passing traffic it would have been of lower retail value than Bishopsgate Street, but rent levels would have been higher due to its social status. The ground floors would have been far more suitable and commercially valuable for professionals, such as the doctors known in St Helen's, or specialist craftsmen and merchants who could rely on their customers to find them and did not need high street premises on Bishopsgate Street. Some may have been entirely residential. In the 1589 tithe survey, there are eleven properties here recorded as paying a tithe of between 11s-0d and £1-2s-0d shillings, equivalent to annual rents of between £4 and £8.[25] The house of Dr Richard Taylor had a tithe of £1-7s-6d, which indicated an exceptional rent of £10. Occupants ranged from a wealthy haberdasher, Clement Kelke, and a musician, Jeronimo Bassano, to Mrs Masters, the widow of a naturalised French immigrant goldsmith. Depending on his mood, purpose or destination, Shakespeare could either have stridden out through the 'belfry' gatehouse, the distinguished, successful player and playwright, into the buzz of Bishopsgate, or alternatively slipped out through the back alleys into St Mary Axe, if he did not wish to be noticed.

Little St Helen's would have had a more varied housing stock, reflecting its piecemeal development. It ranged from grand mansions carved out of the former nunnery to 'mother john [Joan Neville]' who paid 6s-8d a year for a 'shed', probably a one-room structure built against another house or the precinct wall of the priory. When she left, it was taken over by another woman, Mother Ball. The Leathersellers' priority was to

Figure A.6  An 1886 photograph of Great St Helen's, looking north towards the church. At this point the road turned south into a narrow route connecting through to St Mary Axe. The Tudor house on the left was demolished shortly afterwards, in 1894.

maintain an impressive, clean and safe entrance route through to their livery hall. As, in effect, a gated community, the high status environment would also allow them to maximise their rental income, but they also seem to have been happy to allow sub-letting within reason, if it was agreed with them in advance.[26]

The fifth area is the back-alley section of Great St Helen's. This narrow lane connected 'the Close' section of Great St Helen's and the churchyard through to St Mary Axe (Figure A.6). A spur alley gave access to the back gate of Crosby Hall.[27] Little is recorded about this area but it was probably increasingly built up in the later sixteenth century. There were perhaps twenty households here.[28] Most of the houses here would have been smaller than in the main Close around the churchyard, darker because of the narrowness as Great St Helen's reduced to not much more than an alley, and probably noisy, smelly and with poor sanitation. The main 'sink' or sewer of the parish was located in this area. During the 1592–4 plague outbreak, whole households died in St Helen's, and this type of crowded, poorly ventilated alley was strongly associated with a propensity for plague. In the eighteenth century, and possibly much earlier, there was also at least one tavern, the Sugar Loaf, just by the exit into St Mary Axe Street, with others beyond (see Figure 21.7). The likelihood of Shakespeare choosing to live in this part of the parish seems low.

In summary, the thirty or so houses in the Close section of Great St Helen's and Little St Helen's seem to be the most likely to attract Shakespeare, since they offered relative quiet, seclusion, a relatively healthy environment, good security and, as importantly, respectable status due to the upmarket neighbours.

Notes

1. It is difficult to establish to what degree individual properties may have been divided. Successive government proclamations, started by Elizabeth I in 1580, aimed at preventing new building (rather than rebuilding on existing foundations) or sub-dividing properties; see Baer, 'Housing for the Lesser Sort in Stuart London'. The authorities saw such changes as a threat to social stability.
2. The 1589 tithe survey listed seventy-five properties, to which need to be added at least four other properties on the Leathersellers' Estate, two almshouses with thirteen residents and fifteen 'stranger' properties. However, probably a percentage of properties had been sub-divided and, in others, sub-tenants were accommodated. The survey survives, copied from a presumably now lost original into an empty page at the back of the parish annual accounts, held at the London Metropolitan Archive (PS/HEL/B/004/MS 06836). It is in a very clear hand with some spaces left for names to be added.
3. From the 1589 tithe survey; see p. 414, Fig. A.12.
4. This is referred to by various names including, confusingly, in seventeenth-century records of the Leathersellers as 'St Helen's Gate'.
5. Some of these survived long enough to be drawn and photographed in the nineteenth century. Eighteenth-century elevations survive of a row of nine properties owned by the Rochester Bridge Estate around the corner in Leadenhall Street and another row in Shaft Alley, off Leadenhall Street; see Page, *The Guitar in Tudor England*, pp. 69–71, and Gerhold, *London Plotted*, fig. 133.
6. One case brought before the Leathersellers' Court describes how a tenant was renting his ground floor to a cobbler for £1-10s-0d, without telling the Company.

Appendix

7. Also, the threat of plague and other infections. In 1594, Anne Bacon in a letter to her son Anthony Bacon, who had just moved into the street near the Bull, specifically mentions that despite its width, and hence good ventilation, Bishopsgate Street had been hit badly by the 1593 plague.
8. The lease also hints at the need for security referring to, 'all manner of . . . glasse iron barrs . . . locks bolts dores . . .'
9. Little St Helen's was and still is a private road owned by the Leathersellers. Today, there is a barrier and porter, providing the same function.
10. Although rebuilt, many of the original plot boundaries still survived here until the complete replanning of the area in the 1960s for office blocks.
11. Personal communication.
12. The row might, of course, have been built in stages.
13. The boys of the Chapel Royal and St George's Chapel, Windsor provided competition to the boys of St Paul's Cathedral in presenting plays. Crane seems to have acted in and may have written plays; see Duffin, *Some Other Note*.
14. 'On the 7th of April, in the 27th year of Hen. VIII. 1536, the Prioress and Convent granted, demised, and let to John Rolesley ten tenements, with gardens thereunto adjoining, and three chambers, with their appurtenances, situated within the close and tenements aforesaid; the tenements in the holding respectively of 1. Richard Parker, 2. Guy Crayford, 3. Edward Waghan, 4. Edward Bryseley, 5. Margaret Dalton, widow, 6. John Bernard, 7. Richard Harman, 8. John Harrocke, and 9. Andrew Byscombe; and the chambers, one on the ground, in the tenure of Emma Lowe, widow, and the other two up the stairs, over the chambers of the said Emma, in the tenure of William Damerhawle'; and 'On the 3rd of March, 31st Hen. VIII. 1539–40, the King granted to William Crane, Esq. and Margaret his wife, and their heirs, ten tenements, within the close and circuit of the late Priory of S. Helen's', with one exception still being rented to the same people, and in addition 'six chambers in the tenure of 1. Richard Atkyns, 2. Alice Paule, 3. Reginald Deane, 4. Elizabeth Watson, and the aforesaid William, situated in a certain alley within the close', perhaps smaller properties located in the alley south of the church. In 1546, on William's death, these properties passed to his widow Margaret and then successively in 1556 to her son Richard the Elder and in 1584 to Richard the Younger, then aged only eight. The continued ownership in one family for over fifty years reflects the quality of these houses and the status of their occupiers. There are also residents with the surnames of people connected to the royal court such as Parker, Vaughan, Jaskin and Shelton, but for whom no family connections have yet been established.
15. On 3 October 1539, Henry VIII granted Guy Crafford and his wife a house elsewhere in the parish worth £54, which must have been a sizeable property.
16. By the mid seventeenth century these old timber buildings were being replaced by brick houses, which survived until their redevelopment for offices in the nineteenth century. The building immediately to the west of No. 10 had a date of 1646 on its exterior.
17. In 1857, Mr Hugo, an antiquarian, claimed there were still Elizabethan 'relics' at Nos 3 and 4; see Thornbury, *Old and New London*, pp. 152–70.
18. This block of properties seems to have been assembled by the rich Italian surgeon Balthasar Guercy (*c.* 1490–1537). He was granted the houses in St Mary Axe by Henry VIII. In 1557, his post-mortem inquisition listed his properties in St Helen's as, i. his own house, ii. a large garden near Crosby Hall, and iii. four other houses, one formerly 'the howse of preistes of the brotherhed of the Holy Trinite'. The other three houses were in the 'tenures of Hugh Goodolphyn, Richard Edon [Eden] and Thomas Kemysshe'. A William Godolphin, possibly the MP for Cornwall, was recorded in the parish in 1566 in a listing of arrears for the clerk's pay and may have been a relative of Hugh. This holding was probably then acquired by another Italian Doctor, Caesar Adelmare (?–1569), from Guercy's son in 1561. Adelmare was the father of the famous jurist Sir Julius Caesar. While not certain, it is likely that this block of properties, minus the main house, was subsequently acquired by the alderman and leatherseller Hugh Offley (?– 1594), who lived in St Mary Axe. Offley's post-mortem inquisition in 1595 stated that he owned eleven properties in St Mary Axe and it is most likely that these are the same row of houses; see Fry, *Abstracts of Inquisitiones Post Mortem for the*

Living with Shakespeare

*City of London: Part 3.* He is also recorded as owning, 'four messuages ... In St. Helen the Great ... now or late in the several tenures of Levyn van Derstelt [Lewen Vandestilt, a rich Antwerp Merchant, assessed at £50 in the 1598 Lay Subsidy roll], Robert Hubbarde, Hugh Kenrick and Geoffrey Nettleton'. Both Hubbard and Ken(d)rick were recorded as gentlemen/musicians, the latter in his will also as a 'Pronotary in Her Majesty's Court in London' (TNA PROB 11/91/9).

19. Sold by Henry VIII to Richard Williams, Thomas Cromwell's nephew, on 29 March 1542, and sold on by him to Thomas Kendall (before *c.* 1520–52), leatherseller, on 28 April 1543. Kendall then leased it on 22 June 1543 to the Leathersellers for ninety years at a peppercorn rent of one red rose presented at Midsummer. He kept the rental income until his death in 1552, when it was passed to the Leathersellers.

20. The pattern of conversion to secular use was presumably similar to other former religious houses. As a comparison, the new owner of the much larger former Blackfriars complex claimed to have created twenty mansions on his site. Christopher Laoutaris has tracked the specific layout of the Blackfriars – see Laoutaris, *Shakespeare and the Countess*, map after p. xvii, which shows the complex mix of houses alongside a parish church, Richard Field's print shop and the first and second Blackfriars theatres.

21. As shown on maps from immediately after the Great Fire.

22. Kingsford (ed.), *A Survey of London: Reprinted from the text of 1603*, p. 169.

23. The 1542 Thomas Mildmay survey specifically says there were only buildings on the north side of the inner court, so there would have been space for some new building: 'Fyrste, the cheaf entre or cominge in to the same late Priory ys in and by the street gate lyying in the parishe of St Elenes, in Bysshopsgate Streat, which leadeth to a little cowrte next adioyning to the same gate, havinge chambers, howses, and buyldinges, environinge the same, out of which cowrte there is an entre leading to an inner cowrte, which on the North side is also likewise environed with edificyons and buyldings, called the Stewardes lodging, with a Countinge house apperteninge to the same. Item, next to the same cowrte ther ys a faire Kechinge, withe a pastery house, larder houses, and other howses of office, apperteninge to the same; and at the Est ende of the same Kechyn and entre leadige to the same hall ...' The purchase in 1543 included an agreement to build seven almshouses on the site for men and women: 'John Haselwood Esquyre gave £200, appoyntinge that 7 Almsehouse shoulde be therein erected and 7 poore folkes there Receved which to this day are mayntayned accordinglie.' It is not clear if these were a long row or a multi-storey structure. Surveys by Thomas Tresswell of other almshouses in the City show both designs. There are regular bills for repairing them, including locks for the privy doors and reglazing after storms. The almshouse occupants originally received 9d a week (about £2 a year), as well as their housing and a coal allowance.

24. In 1605, what had previously been called 'Huntes garden' is recorded as 'Edward Huntes houses', indicating building on the former nunnery gardens. Little St Helen's can be seen clearly on Ogilby and Morgan's 1676 map of the City of London, as a narrow lane connecting Bishopsgate Street to the Leathersellers' Hall, the latter still with its formal garden in front to the east. The space between the former nunnery kitchen garden and the parish precinct boundary wall has been filled in with an L-shaped row of about twenty tenements, mostly of one room on the ground floor and probably one or two storeys above. Alleys branch off to north and south. Some of these properties may be the original Leathersellers' sixteenth-century almshouses, but much of this building probably took place in the early seventeenth century with the rapid growth in London's population. All this housing was swept away by the construction of St Helen's Place by the Leathersellers in 1799 as part of a major upgrading of their estate. This scheme demolished all the remains of the nunnery buildings, including the converted livery hall.

25. Calculated at the customary level of 2s-9d in the pound(£). Unfortunately, there are no surviving leases from these houses to show the actual rent paid.

26. This is recorded in several leases. For example, in a later lease of 1638, it is recorded that in the case of sub-letting the Leathersellers would receive for each 'tennants to the premises or any part thereof the some of twenty shillings of lawful money ... and to the clarke of the said society for the tymebeing for the wryting & registering of sure bond or admittance the some of tenn shillings of like money'; see Leathersellers' *Copies of Leases and Deeds, 1555–1660*.

27. It also connected to the back-service alley to the Crosby Hall complex, where there would have been deliveries and an ash dump is recorded. The latter became famous locally because on the 1 September 1612, a newly born baby boy was discovered 'in the lane going to Sr John Spencer's back gate and there laide in a heap of Seacole asshes'. He was baptised 'Job rakt out of the Asshes', but sadly died the following day.
28. Some idea of the look of this area may be provided by an elevation of the west side of Shaft's Alley, located just to the south and running north out of Leadenhall Street. It took its name from the storage place of the great maypole erected outside St Andrew Undershaft. The drawing dates to 1797, but probably shows pre-Great Fire buildings. The buildings are about 14' wide and 3½ storeys high; see Gerhold, *London Plotted*, Fig. 133.

# 3

## Identifying the Location of Shakespeare's Residence(s)

Having assessed the general appeal of the five main housing areas within the parish, one can then turn to detailed documentary records to try and identify a more precise location for Shakespeare's residence. This section focuses on Little St Helen's, the adjacent part of Bishopsgate Street and the northern side of Great St Helen's since fortunately, as they formed the Leathersellers' Estate(s), there is detailed relevant information. The information which survives is complicated because evidence from various types of documents needs to be combined. As these were produced originally for different purposes the data is often not directly comparable. For example, the tithe survey recorded the local tax levied on buildings to support the parish church and minister, while, in contrast, the Lay Subsidy was essentially a country-wide wealth tax on individuals, albeit levied locally at ward/parish level. So, potentially, if there was a poor landlord living in a house with a rich sub-tenant, the former might appear in a tithe survey and the latter in a Lay Subsidy tax return. In practice, this situation would be unusual, but it is a possibility in the case of Shakespeare, if he was a lodger in someone else's house.

However, the main problem is the paucity of records of any type which have survived.[1] The order in which the evidence is presented here aims not only to establish the most likely place of residence but to allow readers to come to their own conclusions. The relevant documents fall into the following main categories:

- The Company of Leathersellers' rent rolls and related leases/indentures
- Parish tithe survey
- Surveys of 'strangers'
- Lay Subsidy rolls
- Post-mortem inquisitions of property holdings
- Wills
- Court depositions

For St Helen's, it is fortunate that the Worshipful Company of Leathersellers still owns most of the property it acquired in 1543 with the purchase of the former nunnery of St Helen's.[2] Their archive preserves leases (indentures) and rent records stretching back from today to the 1550s. The conversion of the nuns' dormitory to their livery hall

Figure A.7  Demolition of the remains of the St Helen's nunnery, *c.* 1800. The arches were the remains of the undercroft of the nuns' dormitory, converted by the Leathersellers into their Livery Hall in 1543. Beyond is the former cloister. Engraving by J. P. Malcolm, 1801.

Figure A.8  A detail from the 'Copperplate' map giving an impression of the parish of St Helen's *c.* 1553–9 (outer circle). Shakespeare's residence was probably somewhere in the buildings on the north side of Great St Helen's (inner red outline).

(Figure A.7) and the transfer of the nuns' quire to the parish church necessitated a reorientation of the access routes to the entire property. Until the Dissolution in 1538, entrance to the nunnery was strictly controlled by a single route from the south-west which passed through a series of courtyards that controlled and progressively reduced access until only selected outsiders could reach the nunnery itself.[3]

Passing through the main gatehouse, with its porter, in Bishopsgate Street, visitors would arrive in Great St Helen's in front of the churchyard. This was a semi-public space, as parishioners had to have access to St Helen's church and the parish well next to the south churchyard wall (Figure A.8). Visitors then had to pass through two service areas. An outer courtyard, which included the Steward's Lodgings with its counting house on the north side, would have dealt with business visitors, who were involved with the financial affairs of the nunnery and its extensive property holdings. Food and other suppliers would have passed into an inner area comprising the kitchen and related service buildings, separated from the nunnery itself because of the risk of fire. Here food would be prepared for the nuns' meals and also for charitable distribution to the poor. Nearby may have been the area referred to as 'the well yard', since a good water supply would have been a necessity. The area north of these service buildings was originally a large woodyard with a dovecote. By the 1530s, parts of the woodyard had been developed with private houses which were rented. Thomas Mildmay's 1542 survey records six tenants, including the lodging of the wealthy widow Elizabeth Haute or Hawte, which must have been a very substantial house as it commanded a high rent of £6-8s-4d.[4]

Once the Leathersellers had acquired the property, they needed a direct and impressive access route to their new livery hall on the east side of the nunnery. A new or possibly remodelled entrance, with a gate, was cut through from Bishopsgate Street, just south of St Ethelburga.[5] This new private road, called Little St Helen's, allowed a direct entrance route through to the Leathersellers' Hall. A second gate, 'the hall or middle gate', was constructed at the narrowest point dividing the semi-private Little St Helen's to the west from the Leathersellers' private grounds to the east.[6] Almost immediately, the latter area began to be developed, initially with a set of seven almshouses for the poor, provided in the will of John Haselwood. These seem to have been built in the northern part of the former nuns' kitchen garden.[7]

The remaining former nunnery buildings were then divided up into houses. Combined with the existing dwellings in the former wood yard, there were initially about a dozen properties in all. The larger houses could produce a useful rental income for the Company, while the smaller ones could provide accommodation for employees of the Leathersellers. From c. 1552, there are annual listings of rental payments which record the changing tenants of most of these properties. However, there are no surviving plans of the estate.[8] In addition, over the decades, it is clear from building accounts that the

Figure A.9  Detail of the Leathersellers' 1606 lease to Dr Peter Turner for his large house, the former Prioress's lodging. At the end was this detailed schedule of fixtures and fittings, including 'a double cesterne of lead with a frame' in the kitchen.

existing buildings were upgraded or extended over the gardens with some built new from scratch. However, from surviving leases[9] and other pieces of information, it is possible to establish a broad layout. In terms of the properties to the west of the 'Middle Gate', these have been termed Properties 1 to 11 and their general locations are shown in Figures I.11 and I.12.

The location of Properties 1 and 2 can be precisely located since they were formed from the nunnery itself. The most clearly defined is Property 1, comprising the former Prioress's lodgings in the west wing of the nunnery and later called 'the Cloister'. It was described as 'three fair chambers' on the first floor on the west side of the cloisters, built over the larder and buttery. This was the most expensive and prestigious property with an annual rent of £7-10s-0d, raised with a huge leap to to £20 in 1609.[10] It had a series of upmarket residents, including Sir Thomas Gresham's business partner Richard Clough in the 1560s, Sir Humpfrey Gilbert, Sir John Pollard, Nicholas Gorges and, from autumn 1589, Dr Peter Turner. His leases of 1606 (Figure A.9) and 1611 show that the property benefited from possession of the cloister and its garden as well as its own chapel in the south-east corner of the cloister, presumably created from the former sacristy.[11] Access to the property remained from Great St Helen's and former access routes to the rest of the former nunnery may have been blocked up.[12] The leases for 1606/1611/1629 provide considerable detail, including a fascinating schedule in 1629 of fixtures and fittings owned by the Leathersellers, which might date back to the time of the prioress.[13] The schedule identifies the main rooms and, interestingly, lists a kitchen, larder, pastry house and poultry house. These sound remarkably like the 1542 Thomas Mildmay survey description of the nunnery service buildings, suggesting that this complex was incorporated into the property. In 1606, after living in the house for seventeen years, Dr Turner paid the Leathersellers the huge sum of £200, and there seems to have been much new building, with references to glazed windows protected with iron bars.[14]

Property 2 was the former nuns' frater (dining hall) in the north wing. An engraving (Figure A.10) of its demolition in 1799 shows how impressive this property must have been, with three great lancet windows at the west end of the main first floor, with storage below on the ground floor. This had the second highest rent of £6-13s-4d along with 'one good bucke of season towarde their [the Leathersellers] saide yearly feaste or dinner', worth another £1 or more (Figure A.11).[15] There was a sequence of important occupants, including Sir Francis Walsingham in the 1560s and, from 1574, John Robinson the Elder, Merchant of the Staple, who lived there with his large family until his death in 1600. This house was accessed from Little St Helen's.[16] The surviving lease of 1578 required Robinson to 'repave, pave, maintain the pavement the same as if in the Queen's High Street'. The house was occupied by John's son Robert from 1600 until 1613 and then passed out of the family after forty years.[17]

Figure A.10 Demolition of the remains of the St Helen's nunnery, *c.* 1800. The lancet windows were the remains of the nuns' dining hall, converted by the Leathersellers into a large house, occupied from 1584–1613 by Alderman John Robinson the Elder and then by his son. Engraving, 1819.

Figure A.11 Annual accounts of the Leathersellers' Company for 1598. This section shows the list of rents for their Little St Helen's estate, including Dr Peter Turner, Alderman John Robinson the Elder, Robert Spring, John Prynne and their clerk John Hatton.

The identification of the locations of the other houses (Properties 5 to 11) is more challenging. The location of Properties 3 and 4 can be identified because they are referred to as 'adjoining' Properties 1 and 2 respectively. Property 3, with a rent of £4 and a deer or £5,[18] must also have been a prestigious residence, since it was rented to Sir Giles Capel (1485–1556) for £5 in the late 1540s.[19] It was then sub-leased by Sir George Barne II from 1551, who considered it sufficiently impressive to use it for his mayoralty in 1552–3.[20] A lease of 1580 carefully records its fully glazed bay windows. A later lease[21] records it as adjoining Property 2 and it seems to have been accessed from Little St Helen's. It is possible that this is the adaptation of the pre-Dissolution 'Elizabeth Haute's lodging'.[22] In the 1550s, it was rented by Jasper Upton, almost certainly the uncle of the diplomat Sir Henry Unton, whose famous multi-scene portrait is in the National Portrait Gallery. From 1579, it was leased by Robert Spring, a wealthy skinner, although he may have sub-let it. By 1597, it was occupied by John Robinson the Younger, living next door to his ageing father, now in his sixties.[23] The house was later occupied by his brother William, and a lease of 1633 provides a detailed room by room survey, which probably reflects the earlier layout of the house.[24]

Property 4 must have been south of Property 3 and west of Property 1, as it was recorded as 'beinge within the Gate of St Hellens [the Leathersellers' gate, not the nunnery gatehouse] leadinge to the Lethersellers hall' and in a lease of 1586 it was specifically recorded as adjoining Property 1. It was rented from 1564 by the wealthy skinner Robert Spring, who consolidated a house, previously with a rent of £3, with a warehouse with a cellar underneath into one property rented for £5-13s-4d. In a lease of 1574, he paid a fine of £45 and agreed to spend £20 on repairs over the next three years in return for a twenty-one-year lease. From 1579 until 1593, he paid the rent on both Property 3 and 4, which must have been close to each other.[25] From 1594, he paid rent just on Property 4, until he gave up the lease in 1606, when he must have been well into his sixties.[26] The house was then taken from 1614 by Charles Bostock, a warden of the Scriveners Company in 1619–21, who was paying the rent until his death in December 1633 and is discussed further below.[27]

Leases from the 1620s and 30s show that these four major properties continued until the English Civil War. However, these also indicate rebuilding and infilling building using brick and some limited subdivision of properties. A lease of 18 January 1631/2 referred to in a lease of 1638 suggests a newish property or possibly a rebuilding between Properties 1 and 3. This was occupied by Robert Honeywood III (?), mercer, from 1635–7.[28] It was taken over by Edmund and Katherine Markes on a new twenty-two-year lease from 1638. Frustratingly unspecific, a detailed lease of Property 1, dating to 1629, states that 'on the south parte, the said church yard[,] the common passage, the messuage of the said Dr Patrick Saunders with a greate warehouse now in the occupacon of Charles Bostocke on the west part [Property 3 ?], other Tenements belonging to the said Society [Leathersellers] and in the several tenures or occupacons of the said Charles Bostock,

and William Meller . . .', without giving details of the location of these houses.[29] By this time, the character of the area was beginning to change. The East India Company had been established in 1600, with offices in Philpot Lane. In 1621, the Company took over Crosby Hall, where it stayed until 1638. By 1624, the vaults of the Leatherseller's Hall were generating £26 a year as storage space for the East India Company.[30] Slowly, the surrounding buildings began to shift from residential to commercial use as the Leathersellers looked for ways to augment the value of their estate.[31]

In summary, it would have been unnecessary and socially unacceptable for the wealthy owners of these four properties to rent accommodation. It might have been possible for one of them to offer Shakespeare lodgings as an act of patronage. However, as we will see, there are neighbouring properties which seem more likely to have been Shakespeare's residence.

Leases and rent listings record another seven properties in this area, here termed Properties 5 to 11. Before examining these, it is important to note that the Leathersellers appear to have also owned a strip of properties forming the northern end of the east frontage of Bishopsgate Street. These properties seem to have been operated as a separate estate, perhaps because the Leathersellers inherited pre-existing leases dating back before 1543.[32] There is little clear evidence for these properties, especially as the property immediately north of the Leathersellers' gate was subject to an ongoing dispute over title in the 1590s.[33] The main document is a short ten-year lease dated 16 January 1598/9 signed by Edward Hall, leatherseller, paying £12 rent for nine properties occupied by a rather mixed group of individuals, ranging from a well-established cordwainer to, unusually, a probably unmarried woman and an immigrant silk weaver. It seems likely that these were a row of properties, although they might not have been continuous. The occupants are listed as follows and information from the parish registers shows that at least five of the heads of households died over the next decade.

- George Tedder, merchant taylor, who had at least eleven children of whom nine died young. From 1585/6–1589/90, he was living across Bishopsgate Strcct, just north of the entrance to the Bull Inn, in the parish of St Ethelburga.[34] A son was christened in St Helen's in December 1590, so the family must have moved into the parish by then. Three servants died in the 1592 plague. Buried in St Helen's on 5 October 1601.
- William Staveley, cordwainer, who seems to have moved into the parish c. 1585 and was churchwarden 1604/5. The only Englishman in this group to pay the 1598 Lay Subsidy, at the minimum assessment of £3. At least seven children, four of whom died aged four or under. Buried in St Helen's on 15 March 1606.
- Bevis Tod, occupation uncertain. His unusual literary Christian name and the fact that Thomas Hales, gent., was buried from his house in 1598 suggests he was well

# Living with Shakespeare

connected. From 1585/6–1589/90, he was living towards the northern end of Bishopsgate Street in the parish of St Ethelburga. His son Henry was christened in St Helen's in July 1597, so he must have moved into the parish by then.

- Matthew Ledill, labourer, two children. Buried in St Helen's on 17 September 1609.
- Abraham Gramer, immigrant silk weaver, at least two children. Four of his servants died in just four weeks in June/July 1603 at the start of the plague outbreak.[35] Buried, as a 'pensioner', in St Helen's on 17 August 1643, when he was probably in his seventies.
- Robert Hilliar, otherwise unknown.
- Robert Warde, haberdasher and perfumer with four children. Son Henry baptised June 1597, so in the parish by then. Died, probably a victim of the 1603 plague, along with his son. Buried in St Helen's on 25 July 1603.
- Alice Mitten, unmarried daughter of John Mitten, a joiner. Two of her sisters married in St Helen's in 1596 and 1602.
- Robert Merkwell, haberdasher with three children. Son baptised in March 1593, so in parish by then. Daughter died in 1603 plague. Buried in St Helen's on 28 October 1601.

Apart from Staveley, these people do not otherwise appear in the Leathersellers' records and it is difficult to identify precisely where these properties were located. In the 1589 tithe survey, William Staveley appears to be occupying the second house south of St Ethelburga church on the east side of Bishopsgate Street.[36] If he was still living there in 1599, the spacing of houses would suggest that Bevis Tod lived immediately south of the Leathersellers' gate, with the rest occupying the houses stretching southwards. The relatively low tithes here, which suggest annual rents of £1–£2, would equate to an annual rental of around £12. These properties would have backed onto the precinct wall of the nunnery, which would have provided a clear divide between this estate and the 'inner' and more upmarket houses in the 'gated' Little St Helen's.

Returning to Properties 5 to 11, there are five useful pieces of evidence in trying to locate these seven properties.

- The 1542 Thomas Mildmay survey of the nunnery records, 'out of whicb cowrte [Great St Helen's] there is an entre leadinge to an inner cowrte which on the North side is also likewise environed with edificyons and buyldings, called the Stewardes lodging, with a Countinge house apperteninge to the same'.[37] There is no evidence that this area of the nunnery did not pass to the Leathersellers, although the Skinners' Almshouses were constructed in this area, which might have required the transfer of a small area of land. From the Leathersellers' perspective, there was no point in demolishing buildings if they could be repurposed, as with the main

# Appendix

nunnery buildings. Logic would suggest, therefore, that the Steward's Lodging and counting house was converted into housing. Unfortunately, it is not possible to determine if this was one or several houses.

- In a legal dispute in 1599, the Steward's Lodging is referred to in a way which suggests it was still a recognised location, even if by then the building had probably been divided, extended or rebuilt.[38] Properties 3 and 4 are not recorded in relation to the Steward's Lodging, which suggests there was some empty space between the properties.
- In the Leathersellers' first rent record for 1552, five properties were identified as 'on the street side', presumably as viewed from the Leathersellers' livery hall, indicating that they lay in this area, beyond Properties 1–4. It is not clear, however, if this meant that they were on Bishopsgate Street itself, the normal meaning, or were behind those houses, which probably backed up against the precinct wall of the nunnery. The Leathersellers' accounts record the sequence of rent payers, presumably in most cases also the occupants. 'Street side' could potentially also refer to Great St Helen's.
- In 1575, the original nunnery well was converted to a pump and the five neighbouring properties had to contribute towards the cost. The two largest, Properties 1 and 4, contributed 10 shillings each. Three other smaller properties occupied by John Pryme, Richard Clarke and an unrecorded resident paid 1s-6d each. If, as seems likely, the well/pump was close to the former nunnery kitchen, probably now incorporated into Property 1, the three smaller properties may also have been located nearby to the west and could be Properties 7, 8 and 9.

It is significant that Properties 2 and 3, which now faced north onto Little St Helen's, did not contribute to this pump, suggesting they had an alternative source of water.[39] Property 1 clearly was entered from Great St Helen's to the south. While Property 4's main entrance was from Little St Helen's by the 1580s it appears to have retained access to the well yard. The three smaller properties, lying to the west, had also retained access to the well/pump, and it seems most likely that these were houses running east to west in a band between Great and Little St Helen's, either built next to the former Steward's Lodging and counting house or, perhaps most likely, created by dividing it up.[40] While it should not be considered as an accurate representation, the Copperplate Map of 1553–9 shows buildings in just such a relationship to the churchyard:[41]

- There are surviving leases from the 1590s/1630s for five of these seven properties[42] and it is possible to follow the successive occupants through the annual rent payments. Unfortunately, locations are only indicated in three cases:
- Property 5 was immediately north of the Leathersellers' outer gate onto Bishopsgate Street.[43]

Figure A.12  Page one of a survey of actual and potential tithe payments for St Helen's drawn up in May 1589. The four most prestigious residents head the list, but the following names appear to be in house-by-house order as the survey moves around the parish.

Figure A.13  Page two of the May 1589 tithe survey for St Helen's. The nineteenth name on page one is Alderman John Robinson (the Elder), followed by Robert Spring(e) and John Pryn. The twentieth name on page two is Nicholas Bond, then owner of Crosby Hall, paying 31s 8d.

- Property 9 was recorded in one lease as being 'in Bishopsgate Street'. While this seems probable, this turn of phrase is also used for the area as well as the street itself in other documents.
- Property 6 was recorded as 'neare adjoininge to the comon hall of the saide mystery', i.e. near the Leathersellers' Hall.[44]

This is the limit of information provided by the Leathersellers' leases, so there is uncertainty over four of the seven properties. To discover more about the layout in the 1590s, one must turn to other types of record, particularly the 1589 tithe survey. Tithes were a property tax levied to pay for the parish minister and the chancel of the church. They were subject to widespread manipulation as owners and head leases tried to minimise payments.

Although other surveys are recorded for St Helen's, only one complete tithe survey survives for the parish, undertaken in May 1589 (Figures A.12 and A.13) before the national tithe survey undertaken in 1638.[45] This is not a straightforward listing of tithes, since annotations show that it was part of an effort to get the residents, particularly the richer ones, to contribute more money.[46] Below the list, a note states that the parishioners, 'yet they are taxed farr under their several rente'. The minister of St Helen's received a stipend of £20 a year, which would have been low for maintaining an appropriate lifestyle in London at a time of major inflation. £30 was considered a more appropriate level and from the 1580s, the minister of St Helen's also held the parish lectureship, which provided another £10 to £12 a year. This latter income had to be raised from donations by rich parishioners. In the 1589 tithe survey, the seven individuals responsible for payment in this area are recorded as:

- Leathersellers' Property 5 (rent, one part of £1-6s-4d)[47] – George Warren, leatherseller or Mr Baker, leatherseller (who had just died in January 1589 and was buried in St Helen's)
- Leathersellers' Property 6 (rent, second part of £1-6s-4d) – like Property 5 – George Warren, leatherseller or Mr Baker, leatherseller
- Leathersellers' Property 7 (rent £1-15s-0d plus a 'fine' equivalent to an additional £1-18s-8d pa; total £3-13s-8d pa) – John Pryn, grocer. Buried St Helen's, 2 March 1609.
- Leathersellers' Property 8 (rent £3-6s-8d) – Richard Bootes, tailor (but the rent was paid by John Hatton – clerk to the Leathersellers – until his death in 1608). The previous occupant, Richard Clarke, a barber surgeon, who had lived there for twenty-six years, was evicted in 1587.
- Leathersellers' Property 9 (rent £3-0s-0d) – William Stone, draper, later St Helen's parish clerk (but leased by Richard Hay/Hey, leatherseller – from 1587).

- Leathersellers' Property 10 (rent £1-0s-0d) – William Warren, tallow chandler – buried St Helen's in October 1590 (then Widow Elizabeth Warren). Probably George Warren's brother.
- Leathersellers' Property 11 (rent £2-10s-0d) – John Curtis, leatherseller and parish sexton, buried St Helen's April 1600 – then leased by his widow.

The rental payments (without 'fines' in most cases) ranged from £1-0s-0d to £3-13s-8d, suggesting small to medium-sized houses, certainly nothing exceptional.

St Ethelburga, the small adjacent parish to the north of St Helen's, consisted just of houses along Bishopsgate Street and the adjacent inn yards. David Kathman has demonstrated that the annual collectors for the parish clerk's wages started at the southern end of the west side, anchored by the Bull Inn, then walked north up the street, crossed the street and then came back down along the east side.[48] It is clear, from other evidence, that the people conducting the tithe survey in St Helen's followed a similar methodology, working up from houses at the south end of the west side of Bishopsgate Street to the north, then crossed over the road and worked south taking in Little St Helen's, then down along Bishopsgate Street and then moving around Great St Helen's. The surveyors then passed back to Bishopsgate Street, past the houses in front of Crosby Hall and down to the south end of the houses on the east side of Bishopsgate Street.[49]

This can be demonstrated by the position of houses in the tithe listing, whose locations are known from other sources.[50] For example, Cecily Cioll lived in the northern section of the row of houses fronting Crosby Hall, while Nicholas Bond lived in the Hall itself. There are five names between Cioll and Bond and these match five properties known here from earlier depositions.[51] While evidence from other sources demonstrates the broad route of the tithe survey, it is not possible yet to locate many of the properties, particularly the layout around Great St Helen's.[52]

The properties which appear to lie between the south side of Little St Helen's and the churchyard/Great St Helen's (Nos 7, 8, 9, 10 and 11?) are important because they probably occupy the area where Shakespeare may have lived.[53] However, to explore the detail of this area, it is necessary to turn to a third form of record, the Lay Subsidy rolls. In contrast to the parish tithe, the Lay Subsidy was not a local property-related tax but a national wealth tax, administered locally by each ward. Also, unfortunately, the dates do not overlap, so there are nine years of potential change between the 1589 tithe survey and the 1598 listing for the Lay Subsidy. The background to the 1598 Lay Subsidy has already been discussed in Chapter 3. Interpretation of Lay Subsidy listings is complicated by three factors. First, the tax needed to raise money rapidly for immediate expenditure by the government. In practice, most of the money would come from a small number of rich individuals in each parish. As a result, the listing in each parish was divided into two surveys, a rich 'high' list and a general 'petty' list. So, if one is looking at an overall

Figure A.14 Detail of the 1598 Lay Subsidy roll for St Helen's. Willam Shakespeare (underlined blue), rated at £5, is listed nineteenth out of forty English households. He was twenty-first in order of the value of the assessment. The 'Affid' in the margin records that no payment was received. The names appear to be in topographical order, as the assessors walked up and down Bishopsgate (red lines indicate different areas). The dashed red line indicates the likely division between the original 'rich' and 'petty' listings.

Figure A.15 Detail of the 1598 Lay Subsidy roll for St Helen's showing Willam Shakespeare's name (underlined). Above are Walter Briggen, John Robinson the Younger and John Prymme. John Robinson the Elder and Robert Spring have been removed to the rich 'high' list.

parish listing, it will not be a house by house record, as most of the richer residents will have been removed and placed separately, usually at the top. The second factor is that the listing only included people whose wealth in goods was assessed at £3 or above. In some poor parishes this would exclude most of the residents. St Helen's was a relatively rich parish, but it is likely that just over half the houses, and possibly more in terms of families, fell below the £3 level. Finally, foreigners or 'strangers' were also removed from the main listing and put separately at the end of each parish list.[54] Although St Helen's may have had 10 to 15 per cent foreign residents, this does not impact on the Leathersellers' estate, as in general, they do not seem to have leased to foreigners.[55]

Examining the 1598 Lay Subsidy listing (Figures A.14 and A.15) at the point corresponding to Little St Helen's/the Leathersellers estate provides the following sequence of names:

- James Rowking (presumably the same person as James Rowkyll, as both listed as cooks)
- Walter Briggen[56]
- John Robinson the Younger
- John Pryme
- William Shakespeare
- George Axton, whose property was possibly on Bishopsgate Street.[57]

But John Robinson the Elder and Robert Spring, who are known to have lived here from their leases, have been placed on the 'high' rich list. If they are added back in the locations known from the Leathersellers' records (names in underlined italics), the list runs:

- James Rowking (presumably the same person as James Rowkyll, as both listed as cooks)
- Walter Briggen[58]
- *John Robinson the Elder* (from rich list)
- John Robinson the Younger
- *Robert Spring* (from rich list)
- John Pryme
- William Shakespeare
- George Axton, whose property was possibly on Bishopsgate Street.

And finally, if the people who did not pay the lay subsidy but who are known to have lived here from their Leathersellers' leases (names bold underlined) are added, the sequence probably runs:

# Appendix

|  | Leathersellers' property location known | Leathersellers' property location uncertain | Non-Leathersellers' property |
|---|---|---|---|
| (George Warren in 1589) |  | Property 5 and 6 |  |
| James Rowking |  | ?? |  |
| Walter Briggen |  | ?? |  |
| *John Robinson the Elder* | Property 2 |  |  |
| John Robinson the Younger | Property 3 |  |  |
| *Robert Spring* | Property 4 |  |  |
| John Pryme |  | Property 7 |  |
| William Shakespeare |  | ?? |  |
| **John Hatton** |  | Property 8 |  |
| **Widow Warren (widow of William Warren)** |  | Property 10 |  |
| **Israel Jorden**, whose property was probably on Bishopsgate Street |  | Property 9 |  |
| George Axton, whose property was probably on Bishopsgate Street |  |  | Yes |

This is the order which a surveyor would have made by turning into Little St Helen's, walking to the east end and then coming back along the south side. If this is the case, then William Shakespeare could have either occupied a whole house, where the main tenant had moved elsewhere, or, probably more likely, been a lodger of a resident tenant of the Leathersellers' Company or possibly another adjacent landlord. The most likely six options are that he:

- lived in Leathersellers' Property 7 as a sub-tenant of John Pryn/Pryme, grocer, who was resident. Pryme's rent, with the addition of his fine, was £3-13s-8d pa, suggesting a quality medium-sized house. Its status was reflected in its wainscoted interior, recorded in 1609. By the mid-1590s, John and his wife would have been in their early sixties and, with no family, were later recorded as having lodgers in 1599 (see section 5 of the Appendix). The Prymes had lived in St Helen's for forty years and John was part of the parish 'establishment', so he would have been a useful person to have as a landlord. His reappointment as an 'emergency' churchwarden for 1599/1600 suggests someone with Puritan sympathies.
- lived in Leathersellers' Property 8 – as a sub-tenant of John Hatton, Clerk of the Leathersellers, who might have been resident.[59] The rent of £3-6s-8d again suggests a quality medium-sized house, although unlike the Prymes, Hatton had a family of two teenage daughters and three younger children. It seems highly likely that Hatton was sub-letting the property in some way, as his lease of 1604 refers to the

Living with Shakespeare

property being 'sev(er)ed and divided' (Figure A.16). In addition, it is difficult to see how Hatton could have afforded a rent at this level given his salary (see section 6 of the Appendix). As Clerk of the Leathersellers, Hatton would also have been a very useful and responsible person to have as a landlord. Furthermore, with his training as a professional scrivener and clear script, Hatton could have been perfect for writing up fair copies of Shakespeare's writing.

- lived in Leathersellers' Property 8 – but as a sub-tenant of John Hatton, who was living in his other property next to the Leathersellers' Hall, which he rented from 1597.
- lived in Leathersellers' Property 9 – as a sub-tenant in the property previously leased to widow Agnes Stone and then her son, William Stone.[60] From 1590, the rent on this property was paid first by Thomas Wrightson, scrivener, and then, following his death in early 1594, to Israel Jorden, another scrivener. Both Wrightson and particularly Israel Jorden had strong connections to the theatre world (see section 7 of the Appendix). However, this house may have been on Bishopsgate Street.

Figure A.16 Detail of the copy of the lease issued by the Leathersellers' Company to their clerk John Hatton in 1604. It describes the property 'as it is now sev(er)ed & divided ... and now in the tenure & occupacon of the saide John Hatton'.

Figure A.17  Four initial letters from the Leathersellers' Company annual accounts in the late 1580s–1590s decorated by their clerk John Hatton with fabulous figures. His name is hidden in the 1589 initial (lower right).

Living with Shakespeare

- lived in Leathersellers' property 10 – as a sub-tenant of widow Elizabeth Warren, who was resident and was a Leathersellers tenant, latterly as an almswoman until her death in 1625, after thirty-five years of widowhood. The Warrens' rent of £1, later raised to £2, then reduced to £1-10s-0d, suggests a small house. She would have been in her forties and sufficiently strong-willed for the Leathersellers to grant her own lease.
- lived in the property of George Axton, merchant taylor, who was not a tenant of the Leathersellers. Shakespeare might have been a tenant or sub-tenant. In the late 1580s, George Axton had acquired the properties of Richard Kirk the Elder and William Barber, who had both died in 1586.[61]

This is as far as the current evidence appears to go. Choosing one specific property over another cannot be more than an educated guess. The most likely is probably Property 9, leased by John Hatton, clerk of the Leathersellers. The annual rent of £3-6s-8d would have been a major burden without sub-letting, as it was nearly 40 per cent of Hatton's fixed salary from the Leathersellers, and he clearly took on other work, as in some years he wrote up the parish accounts.[62] Moreover, in 1597 he took over the lease of a second property next to the Leathersellers' Hall with a rent of only 13s-4d, which he could have either leased out or used as his home while sub-letting the larger house. Each year, he drew a different design for the initial letter at the start of the annual Leathersellers' accounts (Figure A.17). These suggest an educated, creative and imaginative personality who might have chimed with Shakespeare.

It may seem strange today that such a famous individual as Shakespeare was not recorded in the Leathersellers' accounts, even if he was a sub-tenant, particularly if his landlord was the clerk. However, this is to misunderstand the nature and purpose of these accounts. Furthermore, we know from the frontispiece of his books that the composer and music publisher Thomas Morley had his press in Little St Helen's and may have lived there c. 1598–1601. Like Shakespeare, he was assessed at £5 in the 1598 Lay Subsidy roll, but he is not recorded in the Leathersellers' archives, so presumably again, he was a sub-tenant.

One final possible landlord worth mentioning is John Jeffrey, who is listed four names down from Shakespeare in the 1598 Lay Subsidy roll (Figure A.14). John Jeffrey is interesting because his profile is similar to that of Christopher Mountjoy, who was Shakespeare's landlord in 1602/4. Further information is provided in section 8 of the Appendix. Unfortunately, there is no certain evidence about the location of his house, although his position on the 1598 Lay Subsidy roll immediately after Dr Edward Jorden might suggest he was living on the south side of Great St Helen's, close to the churchyard.

In conclusion, it is certain that Shakespeare lived in the affluent parish of St Helen's, Bishopsgate Street in the 1590s. All the surviving evidence points to him occupying a

Appendix

house located between the west wing of the former nunnery (Property 1) and the houses, to the west, fronting onto the east side of Bishopsgate Street. The most likely location is that the house formed part of a group of buildings between Great St Helen's and the churchyard to the south and Little St Helen's to the north. This area, pre-Dissolution, was occupied by the Steward's Lodging and the counting house of the nunnery. All the other pre-1538 nunnery buildings seem to have been adapted to new uses, and it seems probable that the Steward's Lodging was either divided, extended or rebuilt to form a row of three or four houses. Most of this area is currently occupied by a four-storey office building, 35 Great St Helen's, built in the early 1970s.

Notes

1. These losses are recorded for the parish accounts, e.g. 'The xx daye of Marche 1568. It is agreed. That Willim Kynell the Clarke shall have daie and tyme until the sixth daie of March next comynge to enquire and search for the Reister of the parish which as he sayth he lost neckligently'; and 22 May 1702, 'This Vestry being convened to consider of the condition of this Parish With respect to the books, deeds, and writings belonging to the same, and as to several gifts, devizes, and bequests to this Parish and the poor thereof, and as to the number, condition, and charge of the poor. And the three keys belonging to the Parish Chest being lost, it was thereupon Ordered, That the said Chest now remaining in the Vestry be forthwith broken open, which was accordingly done. And in the said chest are found several deeds and writings belonging to the Parish, but upon strict search and enquiry, some of the Books relating to Vestry proceedings in this parish for many years past are wanting.'
2. The Company still owns the majority of the site but the south-west boundary has probably altered due to the building of the Skinners' Company almshouses (now the site of the St Helen's Hotel). The property line of the former nunnery service buildings also appears to have shifted south (now 35 Great St Helen's, closer to the north wall of the churchyard).
3. This situation is recorded in Thomas Mildmay's survey, made in 1542, prior to the Leathersellers acquisition. For the full text, see Cox, *The Annals of St Helen's Bishopsgate, London*. The north and east sides of the nunnery estate consisted of gardens surrounded by a continuous precinct wall, which also formed the parish boundary.
4. The first reference to this is a lease of 1535 by the nuns to a property between 'the tenements of Sir John Russell, knt. [presumably the 1st Earl of Bedford] and Alen Haw(u)te'; see Cox, *The Annals of St Helen's Bishopsgate, London*, p. 17. Elizabeth Hau(w)te's husband, Alen Hawte, probably connected to the Hautes of Igtham Mote, was clerk to Sir Brian Tuke, 5th Treasurer of the Chamber, 1528–45. He died in 1537. In the 1541 Lay Subsidy roll he is listed at a valuation of £133-6s-8d, so he was clearly wealthy. There is no definitive evidence for the position of these buildings, other than back-projecting from the layout recorded in the Ogilby and Morgan map of 1676, by which time there had been significant rebuilding.
5. Probably approximately where the modern entrance is. By 1636, the entrance had a building over it, as a lease of Michael Alexander refers to a 'tenement lately built of bricke sittuate lying and being over the passage or way leading from Bishopsgatesteete into Little St Hellens'.
6. In 1592, the Leathersellers' accounts record 'paving 112 yardes of pavement before the hall gate into the streett at 2d-23s-4d'.
7. They were certainly there in the nineteenth century.
8. In 1603–4, the well-known surveyor 'Master Tresswell' was paid £1 for a survey, but it has not survived.

425

Living with Shakespeare

9. The leases are copies preserved in the Leathersellers' *Copies of Leases and Deeds, 1555–1660* – EST/8/1, which was started in 1609 by the new Company clerk who replaced John Hatton. They run to July 1638, but include earlier leases from the St Helen's estate dating back to 1574. All references are from this copy book. Since the leases are in chronological order and there are various page numberings of different dates, individual references have not been given.

10. A copy of Dr Turner's first lease from 1589 does not survive, and it is not clear if he paid a 'fine' when he first took over the property, in effect making the annual cost of the house higher than this. He paid £200 when he renewed the lease in June 1606.

11. Detailed in Dr Turner's lease of July 1611.

12. A lease of 1629, however, refers to a room 'over the passage and entry comming into the said messuage hereby demised from little St. Hellens', indicating there was also access from the north side.

13. See Leathersellers' *Copies of Leases and Deeds, 1555–1660*, for example, 'in the Hall' was 'a standing cupboard with a half . . .' worth '6 shillings', 'In the Palour within ye Hall', was 'the wainscot [panelling] about the same . . . about the windows over the east side' valued at '£2-10s-0d' and 'in the kitchen' was 'a double cistern of lead with a frame' worth £2.

14. Perhaps some of this money came in 1606 from his fee for treating Sir Walter Raleigh, then imprisoned in the Tower of London. A lease to George Leache for this property, dated 21 April 1629, contains a detailed description of the property. By this time the property had been split in some way, so Dr Patrick Saunders was living in the south part, which had possibly been extended. The description suggests that there was a separate entrance to the main property, possibly from Little St Helen's. The Leathersellers still own 33 Great St Helen's, the only part of their current estate which faces onto the churchyard. This would have been the southern part occupied by Dr Patrick Saunders.

15. Lease of 1578.

16. The scale of the property is indicated by John Robinson's wish in his will for the property to be divided in half for two of his sons; see TNA PROB 11/98/472.

17. In 1613, a survey by the Leathersellers stated the building was in 'great decay' and sought repairs. This seems to have prompted Robert Robinson to leave. However, the house survived for another 180 years: first rented for five years to a prosperous mercer, Robert Hungate, and then with a higher rent of £10 to William Meller, a leatherseller.

18. Almost feudal traditions are reflected in the tenant having to provide a 'bucke of season good sweete venison to be eaten or 20 shillings' in addition to the main rent.

19. His magnificent foot combat helmet, originally hung with his sword over his tomb at Rayne church in Essex, is now on display in the Metropolitan Museum, New York.

20. Barne (d. 1558) was a leading figure in the City's mercantile elite. His daughter Anne married Sir Francis Walsingham. His son married the daughter of Sir William Garrard (1507–71), Lord Mayor in 1555–6.

21. Lease of 1586 when Hugh Offley took over the head lease from Robert Spring. There seems to have been a small garden to the south.

22. Unlike the other five, cheaper properties recorded in 1542, Elizabeth Haute does not appear in a list of tenants made by Thomas Kendal in 1543. However, it is not clear if she vacated the property when the Leathersellers took over, as she may be mentioned again in 1547.

23. The lease was taken over by his brother William, probably in 1600, who was still living there in the 1630s with his son William. They were paying a rent of £4, unchanged since the 1560s, although they also provided 'half a bucke', worth 20 shillings.

24. The survey starts on the ground floor, 'All with several particulars hereafter mentioned that is to say, a Gallery or Walke an enytrey and several staires and staircases A Warehouse a Kitchen a Buttery a parlor a hall or little parlor a yard a Garden or grasse plott and a little warehouse at the southwest corner of the said yard . . .' and then describes the floors above.

25. Before 1564, the house had been occupied for twelve years by a grocer, George Marian, or his mother, Katherine Wolbred. In 1575, a rich widow, Mistress Winifred Garraway/Garway, paid rent on both Properties 3 and 4, the first time they were held jointly, but the following year John Gresham, Sir Thomas Gresham's cousin, had taken over payment on Property 3. By 1582, she had moved to the

neighbouring parish of St Peter-le-Poore, where she was assessed at the high valuation of £120 for the Lay Subsidy. Spring seems to have been an astute businessman, steadily building up his wealth and fathering six children, who all seemed to have survived to adulthood – no mean achievement. He dealt in property leases as in 1586, the wealthy Alderman and leatherseller Hugh Offley took over the head leases of both properties. From 1575–8, the rent on both properties was paid by others and Spring seems to have left St Helen's, as he is absent from the 1576 Lay Subsidy roll for the parish. Given the dates, one wonders if he was somehow mixed up in the three Frobisher expeditions to Cathay 1576–8, but there is no hard evidence. He then returned to St Helen's in 1579 and paid the rent on his old house, Property 4 and now on Property 3 as well, totalling £9-13s-4d. Robert Spring was a parish auditor in 1580, was assessed in the 1582 Lay Subsidy roll at £20, and the first of his five children christened in St Helen's was born in 1581. He was churchwarden in 1582 and 1583 and seems to have been good with money, as he was listed as an auditor virtually every year from 1584–97, for which there are records. He appears to have been very much part of the parish establishment. He probably married his wife Denise while out of the parish, and he had an older son, John, perhaps born *c*. 1577, either by her or possibly from an earlier wife. Denise died in April 1598, when the five younger children would have been aged between seven and fifteen. She was buried in the north-west corner of the church alongside the Robinson/Garrard family graves. Her death may have prompted Spring's subsequent dramatic action. Sometime in the 1580s, perhaps in 1586/7 after he had sold, or possibly exchanged, his two Leathersellers leases with Hugh Offley, Spring had acquired a property at the north end of the west side of Bishopsgate Street, between the properties of the locally important Skeggs and Hagar families. Joan Skegges, the matriarch of that family, died two weeks after Denise Spring in May 1598. These properties were immediately to the south of the entrance to the Bull Inn and its former theatre. It must have been a substantial property (two parts?), since in the 1589 tithe listing, the occupants David Hollyland (baptised St Lawrence Jewry 24 November 1546), a mercer, and his second wife, Judith, were paying a tithe of 11s-0d, equivalent to an annual rent of £4, and had offered another 2s-9d, equivalent to a further £1 of rent. Hollyland's first wife, Elizabeth, had died in October 1585 giving birth to their daughter. In 1587 and 1588, Hollyland was churchwarden and must have known Spring well, as the latter was an auditor for his first year. It was perhaps at this time, *c*. 1587, that the newly remarried Hollyland leased Spring's recently acquired Bishopsgate property. A decade later, in 1598, the Hollylands launched a legal case against Robert Spring and his son John, claiming that they had forcibly broken into the Hollylands' house; see TNA C3/275/55. The outcome is unknown, but David Hollyland does not appear in the 1598 Lay Subsidy roll, which suggests he may have lost out.

26. Robert Spring acquired 'Three Tenement with Three gardens' for £143-10s-0d in 1601, located outside the walls in the parish of St Botolph Bishopsgate, just at the time Sir Paul Pinder was building his new mansion there. A sale document of 1602 records his purchase, which was witnessed by Edward, his eldest son, and a Robert Hollyland. A second document of 1614 records him as 'deceased' and the sale of the site by his second son, Thomas, to Ralph Pindar, brother of Sir Paul; see LMA, MS 1419 and 1420, following his death at his country house at Dagenham in 1609.

27. He was buried in St Bartholomew by the Exchange on 19 December 1633. Although married in St Helen's, his nine children were baptised in St Bartholomew.

28. Given the date, this is likely to have been Robert Honeywood III, since Robert Honeywood II died in 1629.

29. Charles Bostock was clearly trading on a significant scale at this time. His will of 1633 (TNA PROB 11/164/758) refers to £800 invested in trade with the 'East Indies' and £300 with 'Persia'.

30. The East India Company complained about the lack of ventilation in the vaults, and the Leathersellers paid for the creation of air ducts.

31. The Leathersellers' Court records show that, in 1662, Alderman Francis Warner took a long lease on three properties, previously leased by George Leach (Property 1), Colonel Herriot Washbourne (Property 1/other?) and Edmund Markes, and developed houses. Ogilby and Morgan's map of 1676 shows an L-shaped row of eight houses to the west of these properties. All the properties were demolished in 1798 for the construction of St Helen's Place.

32. They are described as being 'within the Siyte Sircuite and pr[ec]incte of the late priory of St. helen'; see Leathersellers' Archive SHE/1/2/7.
33. At this period, the Leathersellers' accounts record legal disputes about this area. In 1598/9, they mention 'when the leases were sealed of the houses now in Controversie'. In 1599, they record: 'talked to William Staveley about the houses in question at the Kings Head – 4 s[hillings]' and 'Payd for a dynner at the meremayd the 4th day of February when the company perused the wrytings conserninge the houses in question 12s-1d'. Part of the problem seems to have been that the original lease was not for a fixed term, but for a lifetime plus a number of years.
34. A court case of 1586 records him as a tenant in a building which formed part of the Green Dragon Inn; see TNA C24/190/W.
35. Five other people from three other houses in this group were buried in July/August 1603, suggesting these houses were a primary infection area for the plague.
36. It is worth noting that, in 1593 and 1599, there are references to a 'Stavel(e)y's Alley'. This could have been an alley cut through by the side of his house, perhaps accessing some tenements built over the back yard.
37. See Cox, *The Annals of St Helen's Bishopsgate, London*, p. 29.
38. See LS E 1/41, which copies the 1542 Mildmay survey word for word and then adds, ' To pre[sent?] that the Stewarde Lodginge of the priorie was where the house in question is, one Berd then being Steward That Berd was Steward See a coppie of an Account of his', with William Prior's name alongside, as if it was his statement. William Prior was a pewterer living in Bishopsgate Street who died in March 1608, so he could conceivably have remembered events in the 1540s.
39. A Leathersellers' lease with James Harlow from 1634 refers to a pump under a jettied first floor supported on columns, which must have been accessible from Little St Helen's. This property was probably to the north of Property 1 and west of Property 4, so there were other sources of water in later decades.
40. The Steward's Lodging was presumably part of the site acquired by the Leathersellers in 1543. Clearly, this corner of the site passed to other owners over the years, starting with the construction of the Skinners' almshouses. However, there are no records of leases from this part of the site, unless it is these houses.
41. At the Vestry on 29 March 1682, it was agreed that 'twenty shillings be paid to mr Houghton the Registrar of st Pauls, for the draughts of the leases that were formerly made for two parcels of ground in the Church Yard, to build upon. That the inhabitants on the north side of the Churchyard have liberty at their own charges (that vail [wall?] being to be pulled down) to build a wall and pallisadoes, provided they come no further with the foundation wall than the first row of trees upon the Churchyard.'
42. These two properties lack surviving leases. The tallow chandler William Warren and then his widow, Elizabeth, occupied their house from 1561 for over fifty years. Their lease does not survive but there is a reference to a forty-year lease in 1576 saying it had sixteen years to run, indicating it must have started *c.* 1547. It is termed the 'Baker alias Warren lease' and a William Baker was renting a house in the woodyard for the same rent of £1-0s-0d in 1541 before the sale to the Leathersellers. It is probably the same property. Its earlier occupants were of some status, since the skinner Francis Nottingham, who lived there in the early 1560s, warranted a brass when he was buried in St Helen's in January 1564. There also seems to be no lease for John Curtis, leatherseller and later parish sexton, who took on a new or perhaps substantially rebuilt house in 1583. There is detailed breakdown of the building costs in the Leathersellers' accounts: 'what the newe house cost the company the buildinge that standeth in the uteermoste yarde now in the tenour of John Curtes leatherseller begonne the 5th marche anno 1583 – £25-3s-10d'.
43. One of the two properties rented by George Warren or 'Mr Baker' (Properties 5 and 6) can be located with certainty. Later leases allow the identification of subsequent owners of Property 5, paying the higher rent of £6: first John Christian, clothworker, from *c.* 1593 to 1609, then Thomas Aldridge, sadler, to 1636. His rent was raised by £1 to £7 when he gained two rooms over the gate previously rented to Widow Warren. This amalgamation had been planned since 1615, when the Court stated,

'And it is allsoe agreed that after the decease of Elizabeth Warren widowe and in consideration of xxx li to be bestowed in buildinge wthin twoe yeares after her decease or removall, that he shall have added to the said tenement those two roomes over the gate now in the occupason of the saide widowe Warren for the tearme above sayd he then paienge xxs per annum more wich is seven pounds by the year', demonstrating the Leathersellers' power, if necessary, for the 'removall' of widows who were in the way, hopefully to their almshouses. Elizabeth Warren was indeed removed, *c.* 1617, and died as a Leathersellers' almswoman in June 1625 after thirty-five years as a widow. It seems unlikely that the gatehouse property would have been the home of a tallow chandler and it may be that she moved into it from her original dwelling, perhaps in 1602–3 when she was probably around fifty and her rent dropped from £2 to £1. Scarborough's lease of 1636 locates the building on the north side of the entrance to Little St Helen's. This is confirmed by a second lease, that of Michael Alexander for 1636, which relates to a new brick building 'over the passage lately built'; see Leathersellers' *Copies of Leases and Deeds, 1555–1660.* It is presumably the issue of the access rights in John Baker's leases which caused so much trouble in the late 1590s; see p. 453.

44. The location of Property 6 is less clear. Leases show that following John Baker's death in 1589, it was taken over by a cook, James Rowkyll, *c.* 1595, who occupied it until at least 1598, paying an increased rent of £4 a year. In February 1597/8, the head lease was taken on by Humfrey Orme, a mercer of Cheapside and Peterborough. His house in Peterborough is now the city museum and exhibits a painting of Orme by the Dutch artist Jakob Killig. The lease then passed to Anne Turke, a widow, and eventually to James Chatfield, a fishmonger. These leases show the property was probably located close to the middle gate or may have been just east of it.

45. By the 1630s, inflation meant that tithe payments had fallen way behind the income needed to support a similar standard of living to the sixteenth century. The 1638 survey was an attempt to get a comprehensive national analysis of the problem.

46. As a result, 'William Kerwyn and Clement Kelke nowe her Maje[sty's] farmers of the saide parishe at a vestrye holden by them have emproved all the better sort of persons of the said p[ar]ishe, whe are marked w[it]h the l[et]tre f so much as their increase doth amount to yearely value of lxxi s vi d' [£3 -11s-6d). Kerwyn and Kelke were pillars of the local establishment, the former giving donations to the church. They paid the Queen for the right to the tithes and the note makes it clear that they accepted that, after paying for minister's stipend, repairs to the chancel (a tithe responsibility) and bread and wine for communions, they might not receive anything for the effort involved in collecting the tithe.

47. In the Leathersellers' accounts, John Baker paid this amount for two properties. This was clearly a very low rent level, possibly dating back to the 1540s. When the properties were relet in the 1590s, the rents were £6 and £4.

48. See Kathman, 'Hobson the Carrier and Playing at the Bull Inn'.

49. The Hagar property is known from a post-mortem deposition to have been the northernmost property on the west side of Bishopsgate Street, immediately south of the entry into the Bull Inn, which was located in St Ethelburga parish. There were then three houses on the east side of Bishopsgate Street, south of St Ethelburga church, occupied by [Edward] Dudley, William Staveley, a cordwainer (shoemaker) and [?] Higge. The next ten properties listed, of which eight were definitely Leathersellers' properties, indicates the survey then followed around Little St Helen's. It is worth noting that the properties to the east side of the 'middle [Leathersellers'] gate' do not appear in the 1589 tithe survey – presumably because the tithe payments were the direct responsibility of the Leathersellers' Company. The rent listings show there were at least four houses here and the almshouses for seven single people. Two of the properties were occupied by employees of the Leathersellers, while two were private houses occupied by Edward Duncombe and Mistress Heathe, both enjoying parts of the former nuns' garden.

50. These include post-mortem inquisitions, wills and other sources.

51. Occupied by Giles Farnabee, musician/composer; John Parke, pewterer; William Axton, merchant taylor; Thomas Wrightson, scrivener; and Richard Risby, merchant taylor.

52. In the section of the 1589 tithe survey, which logic would suggest corresponds with Great St Helen's, there are twelve properties assessed at a high tithe of 11s-0d to 27s-6d, corresponding to a nominal

annual rent of £4 to £10 and indicating larger and more prestigious houses. Of these occupants, three are rich widows, two are gentlemen, along with a professional musician and a wealthy Dutch 'Antwerp' merchant. The nominal £10 rent relates to Dr Richard Taylor and is probably the highest rent level in the parish. Logic would suggest these expensive properties relate to the ten properties on the south of the churchyard and possibly a couple of other large houses to the east. However, these properties are not listed consecutively but are interspersed with cheaper/smaller properties rented by people such as a merchant taylor, musicians and a bricklayer. At present, there is no obvious explanation for what accounted for this order. The longest sequence is seven expensive properties divided by two cheaper properties next to each other, occupied by Mistress Newman (otherwise unknown), who was probably a widow and paying 5s-6d (equivalent to a £2 rent), and an unnamed person paying 10s-0d. In this case, it is possible that a large house had been divided in two. It may also be that there were alleys between some of the houses with cheaper properties on the back lands. However, when the survey returns to the southern part of Bishopsgate Street, the houses are clearly listed in their topographical sequence.

53. The only evidence that would argue against this relates to John Pryme's house (Property 7). After his death in 1609, the property was taken over by his executor, Edward Jackson, who rapidly got into a dispute with the Leathersellers and was evicted; see p. 448. The lease was then taken on in 1611 by a leatherseller, John Gannett, who was later Master of the Leathersellers in 1621–2. He died in 1629 and his wife continued to pay the rent of £6 until 1634. In 1636 the lease of Michael Alexander stated that widow Joan Gannett was living immediately to the south of his property on the south side of the entrance to Little St Helen's. My view is that Joan Gannett had probably moved following the death of her husband and the end of his lease, since there is no record of its renewal. Apart from anything else, if John Pryme's property had been next to the entrance gate, one would have expected this to be mentioned in his lease and the later ones (1611/1614, when he was third warden of the Leathersellers) for the property, but they just state it was in the parish of St Helen's. Furthermore, Gannett in 1611 paid a large fine of £100 for a twenty-one-year lease, meaning he was actually paying the equivalent of £11 a year, a far higher level than was typical for properties in Bishopsgate Street. Similarly, another widow, Elizabeth Whitterance, appears to have moved from a property close to the Leathersellers' Hall to a house fronting Bishopsgate Street, *c.* 1634.

54. Foreigners paid double, and everybody had to pay. For those below the £3 limit, there was a poll tax of 4d. In practice, this means that the records of foreigners are comprehensive, compared to their English co-residents.

55. Although the names of some of the sub-tenants suggest they were foreigners. In the case of Abraham Gramer in 1599, he is specifically recorded as an immigrant silk weaver. He had several servants, all with French/Dutch-sounding names.

56. Walter Briggen married John Pryn(me)'s daughter Anne in 1582. His position on the 1589 tithe survey suggests the family was then living on the west side of Bishopsgate Street. Following Anne's death in 1590, he remarried and appears to have moved with his new family across the street.

57. George Axton, a merchant taylor, is not recorded anywhere as a Leathersellers' tenant. As described in Chapter 3, his probable older brother William had married the widow Katherine Kirke in 1579 following the death of her husband Richard Kirke the Younger. Richard's sister Joan lived in St Helen's, where she had married Thomas Cheston, a wiredrawer, and subsequently had four children. Thomas died in June 1587 and was buried in St Helen's. Three months later, on 28 September 1587, George Axton married Joan in St Leonard, Shoreditch. He acquired two stepchildren, since Joan had also lost two children in the previous two years. Even so, the marriage seems to have been done in what even in the Elizabethan period might have been considered unseemly haste and it is interesting that it took place, by archbishop's licence, a mile away in the village of Shoreditch. Joan would have been a 'good catch' if she brought her former husband's or father's houses with her. However, if so, the Axtons did not immediately return to St Helen's. In 1588–9, the new Axton family was living on the west side of Bishopsgate Street, two doors along from George Tedder and the entrance to the Bull Inn, in the parish of St Ethelburga. A Peter Axton is recorded in the parish of St Ethelburga, and one wonders if this was the father of William and George. In the meantime, Katherine Axton had died

in August, leaving William with five children. Here, George and Joan would have only been a few minutes' walk from their respective brother and brother-in-law. They were soon on the move again and their first child, also George, was baptised in St Helen's on 11 July 1588, so they must have moved into the parish by then. Over the next few years they had four more children, so there must have been five or six children in the house. Thereafter, they remained in the parish, with George Axton senior being buried in June 1615 but Joan surviving until October 1637, when she must have been well into her seventies. In the May 1589 St Helen's tithe survey, George senior is listed as paying for two houses previously occupied by John Kirk the Elder (his new wife's father) and William Barber, until they both died in 1586. The two houses were adjacent, except that Willliam Warren was listed between them, and he was a long-time tenant of the Leathersellers with a lease running back to 1561. Professor Peter McCullough has written on the wider activities of the Kirke family, particularly Joan and Richard's other siblings, Frances and Edward. The latter is traditionally identified as the 'E. K.' who was responsible for the 'Epistle' and 'Argument' to Edmund Spenser's *The Shepheardes Calender* (1579). I am very grateful for advice from Professor Peter McCullough in advance of his forthcoming publication reviewing this attribution and related matters. He notes that Robert Kirk, a sadler, Richard Kirk the Elder's brother, owned three properties in Bishopsgate Street in St Helen's which he potentially left to Richard in his 1567 will (TNA PROB 11/49/176), although they eventually passed in 1589 to 'John Ellis, gent of Greys Inn'.

58. Walter Briggen and Robert Spring clearly knew each other well. In Spring's will of May 1609 (TNA PROB 11/113/387) he bequeathed a house to his younger son currently rented to Briggen. In 1608, Briggen, now probably close to fifty, had a daughter, seventeen years after his second marriage. This suggests he had married again and possibly moved. If so, it could have been to the house Spring owned on the west side of Bishopsgate Street, which was occupied by the Hollylands up to 1598; see p. 428, footnote 25.

59. The lease states 'as it is now sev(er)ed & divided late in the tenure of or occupacon of one Richard Clarke Barber Surgion and now in the tenure & occupacon of the saide John Hatton', which suggests the house had been physically split up in some way, rather than just having tenants. There is only one other lease which records a property as 'divided', which suggests this was a rare occurrence and needed to be recorded.

60. The history of the property at this point is complicated. Agnes Stone, widow of Edmund Stone, sadler, who was buried on 7 September 1577, continued the lease until her own death a decade later in July 1587. That year, 1586–7, the rent was paid by her son William Stone, a draper with a family of five children. They may have been living there since his marriage in 1582. In the following year, John Hatton covered the rent for six months as the record says, 'Areredge of Rent of the house wherein William Stone now dwelleth in to be paid by our clarke – 30s'. Perhaps Hatton was thinking of moving in and had come to some agreement with William Stone that he would move elsewhere. However, in spring 1588 Richard Hey/Hay, a leatherseller, took over the head lease for the next three years with a significant fine of £20. In 1590, the record is 'Receayd of Rychard Heye at thensealing of his Lease of the house wherein Thomas Wrytson now dwelleth in full payment for his fynne – £10.' Hey then disappears. William Stone moved locally, as he became parish clerk *c*. 1595, but he died soon after and was buried in St Helen's in November 1597.

61. Noted in the 1589 tithe survey, where in the listing they are separated by the house of William Warren. It is not clear whether he was living in one of these properties in 1598 or an entirely different house, nor is it clear where these houses were located. They are most likely to have been in Bishopsgate Street, close to the gateway to Little St Helen's.

62. This is clear from his distinctive hand and his elaborate first letters. For example, in 1586, when William Warren, tallow chandler and a Leathersellers' tenant, was senior churchwarden.

# 4

## When did Shakespeare Leave Saint Helen's?

The 'Wooden O', the Globe Theatre in Southwark, has so dominated Shakespearean studies over the years that the image of our national poet as the 'Bard of Bankside', striding the surrounding streets, has become a feature of the British collective memory. A corollary of this has been a widespread assumption that Shakespeare lived in Southwark, as did his brother Edmund and other members of the Lord Chamberlain's men. If so, the most obvious time would be in 1599 onwards, during the building and early operation of the Globe. As previously noted, Shakespeare was definitely living in Silver Street in St Olave's parish in 1604 and quite possibly from 1602. Given that Shakespeare was recorded in St Helen's in 1598, albeit with an 'Affid' status, did his sequence of residences run St Helen's – Bankside – Silver Street?

Suprisingly, there is no conclusive evidence that Shakespeare lived, as opposed to worked, in Southwark. There is some evidence to support a Bankside home but there is nothing as clear as the legal deposition about Silver Street for 1602/4. The argument that Shakespeare lived in Southwark is based on three pieces of evidence: the so-called 'Langley Writ'; the records of the efforts to recover his unpaid 1597 Lay Subsidy demand of 5s-0d and 1598 demand of 13s-4d; and the fact that Shakespeare's name does not appear in the 1600 Lay Subsidy roll for St Helen's.[1] Each needs to be considered separately.

The 'Langley writ' is a legal 'security of the peace' document from October 1596/ January 1597 which records a dispute between Francis Langley, builder of the Swan playhouse in 1595,[2] and an unsavoury Bankside character named William Wayte. Shakespeare and two women seem to have got involved, as they are named in the documents. This has been taken to mean that Shakespeare was living in Southwark at the time. While there is no disputing the naming of Shakespeare, and that he may have had a connection with Langley, a difficult character, this legal case does not prove Shakespeare was living in Southwark. Moreover, at this time, Shakespeare was working with the Lord Chamberlain's Men at the Theatre in Shoreditch, and there is no obvious reason why he would want to live in Southwark at this point. Indeed, everything would suggest that accommodation north of the Thames made much more sense. True, by this time, the future of the Theatre was uncertain, but James Burbage's efforts, until his death in February 1597, were going towards acquiring a site in Blackfriars.[3] There is no evidence in 1596/7 that the Lord Chamberlain's Men were yet planning to decamp to

Southwark, as they did in 1599. Indeed, with the opening of Langley's Swan playhouse in 1595, a move to Southwark would have meant competing with two other theatres.[4]

More convincing is the second piece of evidence, the three follow-up documents, dated from 1598 to 1600, recording the efforts of the crown to recover Shakespeare's unpaid Lay Subsidy demand in St Helen's for 1 October 1598 of 13s-4d. These indicate that the authorities thought that Shakespeare was living in Southwark, and the last one, with a marginal note – 'London R': domini Episcopo Wintonensi' – means Shakespeare was thought to be under the jurisdiction of the Bishop of Winchester, whose diocese included the liberty of the Clink, where the Globe was located. While these documents and their dates clearly indicate that the authorities thought Shakespeare was in Southwark, do they prove he was living rather than working there? It is worth noting that at the time of the 1 October 1598 Lay Subsidy roll, the decision to take down the Theatre and rebuild it in Southwark may not have been made and certainly was not implemented for another three months. The only reason for Shakespeare moving to Southwark was to be close to the Globe, where construction only started in spring 1599 at the earliest.

For many, the most compelling argument is the third piece of evidence: that Shakespeare is not listed in the St Helen's 1600 Lay Subsidy return.[5] Since the Globe opened in 1599, it would seem to make perfect sense for Shakespeare to have left St Helen's at this point and to have migrated across the River Thames to be near the new venue in which he was heavily invested – both financially and artistically. Certainly Shakespeare, now having changed from being a 'sharer' to being a 'housekeeper' of the Globe, might have wished to be physically close to the source of his financial future, particularly in the early years when there was a new location, an enlarged theatre and possibly a largely new audience. Two other sharers, Augustine Phillips and William Sly, are recorded in Southwark from 1593.[6] However, others, notably John Heminges and Henry Condell, remained living north of the river in the City.

However, a detailed study of the 1598, 1599 (incomplete) and 1600 Lay Subsidy returns for St Helen's demonstrates that, as often is the case with Elizabethan documents, matters are no so clear-cut. Tables A.1, A.2 and A.3 compare the English residents who were taxed in 1598 with the situation in 1600 and subsequently 1611. It is immediately apparent that something unusual is going on. In 1598 there are forty people listed. Two years later, twenty of these – 50 per cent, including Shakespeare – have disappeared. The Lay Subsidy rolls were clearly kept up to date,[7] but it would seem unlikely that half the richest people in a desirable parish would move out over a twenty-four-month period without some good reason.[8] What was going on? Leaving Shakespeare aside for the moment, of the nineteen others, three are easily explained, as the individuals had died.[9] Of the remaining sixteen, for eight there is no other documentation that they were living in St Helen's at a later date.[10] Of these eight, four have 'Affid' against their name in 1598,

# TABLE A.1: SAINT HELEN'S: LAYOUT OF PROPERTIES ON THE LEATHERSELLERS' ESTATE c. 1598 COMPARED TO THE 1589 TITHE SURVEY

| Property number in text | Property | Tithe payer in 1589 | Trade/background | Tithe payment in 1589 | Annual rent in 1589 to Leathersellers | 'Theoretical' rent calculated from tithe valuation at 2s-9d/£ | Individuals valued at less than £3, so not listed in 1598 subsidy roll | Annual rent in 1598 to Leathersellers |
|---|---|---|---|---|---|---|---|---|
| 5 and 6 | two properties | George Warren | leatherseller, buried 5 June 1596 | two properties together at 8s-3d – suggests adjacent | £1-13s-4d | £3-0s-0d | ?John Christian, clothworker – arrives c. late 1591 | £6-0s-0d |
| | | or Mr Baker' | leatherseller, buried 4 January 1589 | | | | | |
| | | | "or Mr Baker" – Leatherseller buried 04.01.1589 | | | | | |
| 1 | by Leathersellers' Hall (outside?) | John Curtis | leatherseller | 17d | £2-10s-0d | 10s-0d | John Curtis – sexton | £2-10s-0d |
| n/a | probably a small property given tithe (outside) | Ralphe Yarrow | ? | 17d | none recorded | 10s-0d | ? | none recorded |
| n/a | location unclear | | | | | | | |
| 2 | former nunnery dining hall (frater) | John Robinson the Elder | alderman and Merchant of the Staple | 16s-0d | £6-8s-4d | £5-16s-4d | | |
| 3 | property @1 to north-west of main nunnery buildings (property 2) | Robert Springe | skinner | 16s-0d | £4-0s-0d | | | |
| | | | | | [£9-13s-4d] | £5-16s-4d | | |
| 4 | property @2 to north-west of main nunnery buildings (property 1) | Robert Springe | skinner | | £5-13s-4d | | | |
| 7 | property recorded as 'Streetside' @1 | John Pryn[ne] | grocer and mortgage broker | 4s-1d | £1-15s-0d | £1-10s-0d was £1-10s-0d originally | | |
| | | | | | with fine equivalent to £1-18s-8d pa totals £3-13s-8d pa | | | |
| 8 | property recorded as 'Streetside' @2 | Richard Bootes | buried 12 May 1593 – but Richard Clarke to 1587 paid off . . . buried 1591 – Where Hatton + family in May 1589? – Richard Boot in E. Drome house in 1592 | 4s-1d | £3-6s-4d | £1-10s-0d was £1-6s-8d originally | John Hatton – Leathersellers' Clerk | £3-6s-4d |
| | | | | | | | controls property and pays rent but does not occupy? or subdivided | |
| 9 | property recorded as 'Streetside' @3 | William Stone | His mother? Agnes Stone, widow – bur. 21 July 1587 – father Edmund, sadler, bur. 7 September 1577 – is he Clerk of Parish, bur. 6 November 1597. Hugh Anslowe, tailor, bur. from Widow Stone's house – 25 July 1598 | 5s-6d | £2-0s-0d | £2-0s-0d – was £2-0s-0d originally | Israel Jorden – scrivener | £3-0s-0d |
| | later 1609 lease of John Wardner suggests in Bishopsgate Street | | | | | | | |
| n/a | location? on Bishopsgate Street | George Ax[t]on | for Richard Kickes [Kirk the Elder] house' | 5s-6d | ?? | £2-0s-0d | | |
| | | | His brother William Axton married daughter-in-law Katherine in 1579 | | | | | |
| 10 | property recorded as 'Streetside' @4 | William Warren | tallow chandler – buried 4 October 1590 | 2s-9d | £2-0s-0d | £1-0s-0d | Widow Warren | £2-0s-0d |
| | | | Jane, his widow, continued the Leathersellers' lease | | | | | |
| n/a | location? on Bishopsgate Street | George Ax[t]on | for William Barbour's house' | 5s-6d | ?? | £2-0s-0d | ??? | not a Leathersellers' tenant if Barber's |
| **Properties definitely not part of Leathersellers' Estate** | | | | | | | | |
| n/a | location? on Bishopsgate Street | | | | | | | |
| n/a | The Close end of Great St Helen's? – Crane Estate on south side? | | | | | | | |
| n/a | The Close end of Great St Helen's? | | | | | | | |

| Individuals valued at £3 or above, so listed in general 'petty' section of 1598 subsidy roll | Annual rent in 1598 to Leathersellers | 1598 – subsidy valuation | Individuals valued at wealthiest level, so listed in rich 'high' section of 1598 subsidy roll | Annual rent in 1598 to Leathersellers | 1598 – subsidy valuation | Possible locations for William Shakespeare | 1598 – subsidy valuation | Type of accommodation |
|---|---|---|---|---|---|---|---|---|
| ...te of Lay Subsidy assessors in 1598 | | | | | | | | |
| | route with rich 'high' individuals added | | | | | | | |
| ...hn Roking/Rowkyll – cook – c. 1596 | £4-0s-0d | £3 | | | | | | |
| ...9 Humfrey Orme from ...nes Rowkill – cooke . . . and ...t adjoining the Common Hall' – ...ned access route/times | | | | | | | | |
| ...ter Briggen | not a Leathersellers' head leasee | £5 | | | | | | |
| | | | John Robinson the Elder | £6-8s-4d | £100 | | | |
| ...Robinson the Younger | £4-0s-0d | £10 | | | | | | |
| | | | Robert Spring | £5-13s-4d | £30 | | | |
| ...Pryn[ne] | £6-0s-0d | £3 | | | | William Shakespeare possible location@1? | £5 | a lodger with John Pryn[ne] and wife, 2 grandaughters? |
| | | | | | | William Shakespeare | £5 | a lodger with John Hatton and wife, 5 children |
| | | | | | | possible location@2? William Shakespeare | £5 | or, occupier if John Hatton living elsewhere |
| | | | | | | possible location@3? | | A lodger with Israel Jorden |
| ...ge Ax[t]on | not a Leathersellers' tenant if Kirk's | £3 | | | | William Shakespeare possible location@4? | £5 | a lodger with George Ax[t]on |
| | | | | | | William Shakespeare possible location@5? | £5 | a lodger with Widow Warren |
| ...rd Jackson – arrived 1596? | | £3 | | | | | | |
| ...dward Jorden – arrived c. 1595/6 | | £8 | | | | | | |
| ...Jeffrey – returned to St Helen's c. 1592–8 | | £3 | | | | | | |

TABLE A.2: PARISH OF SAINT HELEN'S: COMPARISON OF INDIVIDUALS LISTED IN LAY SUBSIDY ROLLS FOR 1598, 1599 (INCOMPLETE) and 1600

There were forty tax payers in 1598, eighteen of whom had left by 1600, leaving twenty-two. The addition of twelve new tax payers resulted in a total of thirty-four tax payers in 1600. Names from Professor Alan H. Nelson's transcriptions (spellings mostly standardised).

| | | 1598 Subsidy | | | 1599 Subsidy (incomplete) | | 1600 Subsidy | | |
|---|---|---|---|---|---|---|---|---|---|
| 1 | Sir John Spencer | Commissioner of Subsidy | £200 | | entry missing | | Sir John Spencer | Commissioner of Subsidy | £200 |
| 2 | Sir William Reade | 'in landes' | £150 | | entry missing | | Sir William Reade | 'in landes' | £200 |
| | | | | | | | Thomas Marsh | 'in landes' | £20 |
| | | | | | | | Salomon Hewett | | £80 |
| 3 | Alderman John Robinson the Elder | Merchant of the Staple | £100 | | entry missing | | | buried 28 February 1600 in St Helen's | |
| 4 | Dr Richard Taylor | Doctor in Physic | £10 | | entry missing | | | still in St Helen's until 1607? but taxed elsewhere | |
| 5 | Dr Peter Turner MP | Doctor in Physic | £10 | | entry missing | | Dr Peter Turner MP | Doctor in Physic – 'in landes and fees' | £10 |
| 6 | Peter Lallyla (?) | | £30 | | entry missing | | | date of leaving St Helen's ? | |
| 7 | Robert Honeywood II | gent – 'in landes' | £40 | Affid' | moved to St Leonard, Hoxton June/July 1598 | | | | |
| 8 | John Alsoppe | | £50 | | entry missing | | | date of leaving St Helen's ? | |
| 9 | John Morrys | | £30 | | entry missing | | John Morrys | | £30 |
| 10 | Roberte Spring | skinner | £30 | | entry missing | | | still leasing from Leathersellers until 1606 but taxed on country property at Dagenham? | |
| 11 | Edward Swayne | 'in land[es] & fees' | £10 | | entry missing | | Edward Swayne | 'in land[es] & fees' | £10 |
| | | | | | | | John Hewett | 'in landes' | £40 |
| 12 | Jeames Scoles | | £20 | | entry missing | | | date of leaving St Helen's ? | |
| 13 | Joane Lomley | widow | £3 | | entry missing | | Joane Lomay | widow | £3 |
| 14 | Anthony Snoade | grocer | £10 | | entry missing | | Anthony Snoade | grocer | £10 |
| 15 | Jeames Roking | cook | £3 | | entry missing | | Jeames Rokeinge | cook | £3 |
| 16 | Walter Briggen | merchant taylor | £5 | | entry missing | | Walter Briggen | merchant taylor | £5 |
| 17 | John Robinson the Younger | mercer | £10 | | entry missing | | John Robinson the Younger | Mercer | £20 |
| 18 | John Pryn[ne] | grocer | £3 | | entry missing | | John Pryn[ne] | definitely in St Helen's but not taxed | |
| 19 | William Shakespeare | playwright and player | £5 | Affid' | entry missing | | | date of leaving St Helen's ? | |
| 20 | George Ax[t]on | merchant taylor | £3 | | entry missing | | George Ax[t]on | merchant taylor | £3 |
| 21 | Edward Jackson | merchant taylor | £3 | | entry missing | | Edward Jackson | merchant taylor | £3 |
| | | | | | entry missing | | Dr Edward Jorden | Doctor of Physic | £5 |

| # | Name | Occupation | Amount | Notes | Name | Occupation | Amount | Notes |
|---|---|---|---|---|---|---|---|---|
| 23 | John Jeffrey | milliner/embroiderer | £3 | | John Jeffrey | | | definitely in St Helen's but not taxed |
| 24 | Christopher Eland | grocer | £3 | | | | | entry missing; date of leaving St Helen's ? |
| 25 | Oswald Fetche [Fitch] | | £20 | Affid' | | | | possibly moved to Bocking, Essex. Died 1613 |
| 26 | John Stockett Jeckett [Stoker Jekyll] | gentleman | £3 | Affid' | John [...]' | | | moved to Bocking, Essex. Died 1598 |
| 27 | John Suzan | haberdasher | £20 | | John Suzan | haberdasher | £20 | |
| 28 | Sisley Cioll | widow | £3 | | Ciceley [...]' | | £3 | Cecily Cioll, widow |
| 29 | William Winckefielde | | £3 | | William Wyn [...]' | | £15 | Capteine Pryst; definitely in St Helen's but not taxed |
| 30 | Thomas Childe | | £3 | | Thomas Childe | | £3 | buried St Helen's 1625 |
| 31 | Richard Rysley | merchant taylor | £3 | | Richard Rosbye | merchant taylor | | Richard Risby buried St Helen's 24 October 1599 |
| 32 | Tymothie Bathurst | grocer | £20 | | Tymothie Batthurste | grocer | £20 | Timothie Basthurst, grocer |
| 33 | Jeames Olwicke [Elwick] | | £20 | | [......] Downer | ? | £3 | date of leaving St Helen's ? |
| 34 | William Cherle | | £3 | Affid' | destination from St Helen's ? | | | |
| 35 | Francis Wells | | £3 | | destination from St Helen's ? | | £3 | |
| 36 | Henry Mawnder | Queen's messenger | £3 | | Francis Wells | | | |
| 37 | Mrs Pooley | | £10 | Affid' | Henrie Mawnder | Queen's messenger | (blank) | not listed; definitely in St Helen's but not taxed |
| 38 | William Staffely | cordwainer | £3 | | destination from St Helen's ? | | | |
| 39 | Thomas Morley | composer and music publisher | £5 | | William Stavely | cordwainer | £3 | William Stanley, cordwainer |
| 40 | Henry Hetherland [Litherland] | plumber | £3 | | Thomas Morley | composer and music publisher | £5 | Thomas Morley, composer and music publisher |
| | definitely in St Helen's but not taxed – married 1595; son baptised 1597 | | | | | | | definitely in St Helen's but not taxed |
| | | | | | George Mergettes | gentleman and mercer | £5 | George Mergettes, gentleman and mercer; buried St Helen's 1603 (plague) |
| | | | | | Ralphe Hernne | ? | £3 | destination from St Helen's ? |
| | | | | | Edward Brandon | ? | £10 | Edward Brandon, ? |
| | | | | | Thomas Sturgeon | Yeoman of the Guard | £5 | Thomas Sturgeon, Yeoman of the Guard |
| | | | | | William Oliver | | £3 | freemason |
| | | | | | John Symondes | | £3 | arrived St Helen's late 1599; ? |
| | | | | | Blase Carrell | gentleman | £5 | |

TABLE A.3: SAINT HELEN'S: COMPARISON OF INDIVIDUALS LISTED IN LAY SUBSIDY ROLLS FOR 1600 AND 1611

By 1611, only eight St Helen's residents – Sir Thomas Reade, Dr Peter Turner, Walter Briggen, William Oliver, Joan(e) Lomeley, George Axton, Robert Robinson and his brother William Robinson – were still listed of the richer (subsidy paying) parishioners in 1600.

| Listing in 1600 subsidy roll | | 1601 | 1602 | 1603 | 1604 | 1605 | 1606 | 1607 | 1608 | 1609 | 1610 | 1611 subsidy | | | Notes |
|---|---|---|---|---|---|---|---|---|---|---|---|---|---|---|---|
| William Shakespeare writer, player and part theatre owner | not recorded in 1600. Possibly left St Helen's in 1598? or later | ? | living at Silver Street? | 1603 plague Elizabeth I dies | definitely living at Mountjoys' house, St Olave, Silver Street | | | | | | | | | | buried Holy Trinity, Stratford-upon-Avon, April 1614 |
| Sir John Spencer | Commissioner of Subsidy | | | | | | | | | | buried St Helen's 1610 | | | | |
| Sir William Reade | 'in landes' | | | | continued to occupy Crosby Hall 1594–1610 | | | | | | | 1. Sir William Read | 'in lande' | £? | date and location of burial uncertain |
| Thomas Marshe | 'in landes' | | | | | | | | | | | | | | |
| Salomon Hewett | £80 | buried St Helen's 1601 | | | | | | | | | | | | | |
| John Robinson the Elder | died February 1600 | | | son Robert Robinson took over Leathersellers' lease c. 1602/3–13, previously his father's lease 1589–1600 | | | | | | | | 6. Robert Robinson | merchant | £50 50 shillings | date and location of burial uncertain |
| Dr Richard Taylor | taxed elsewhere | | | | | son buried St Helen's | | | date of leaving St Helen's? | | | | | | buried St Gabriel, Fenchurch Street, 1615 |
| John Allsop(e) | churchwarden 1600 | | | date of leaving St Helen's ? | | | | | | | | | | | |
| John Morris | haberdasher | | | | | | | | | | | | | | buried Dagenham, 1609 |
| Robert Spring | skinner – taxed elsewhere | | | continued lease from Leathersellers' Company 1564–1606 | | | Abraham Jacob took over Leathersellers' lease in 1606 | | | | | | | | |
| Edward Swayne | 'in land(es) and fees' | | | date of leaving St Helen's? | | | | | | | | | | | |
| Dr Peter Turner | Doctor of Physic – 'in landes and fees' | | continued lease from Leathersellers' Company 1589–1614 | | | | | | | | | 3. Dr Peter Turner | Doctor of Physic – 'in fees' | £20 | buried St Olave, Hart Street, 1614 |
| John Hewett | 'in landes' | buried St Helen's, 1602 | | | | | | | | | | | | | |
| Andrew Ellem | grocer | | | | | | | | | | | 21. Andrew Ellem | grocer | £5 3 shillings | buried St Helen's, 1613 |
| Joane Lomay (Lomeley) | widow | | | | | | | | | | | Joane Lomeley | widow | not taxed | buried St Helen's, 1635 |
| Andrew Snoade | grocer | | | | | buried St Helen's, 1606 | | | | | | | | | |
| Jeames Rokeinge (Roking) | cook | | | left St Helen's c. 1600 – Humfrey Orme of Peterborough, mercer, took over lease from Leathersellers' Company 1599–1603, then Anne Turke, widow from 1606 | | | | | | | | | | | |
| Walter Briggen | merchant taylor | | | | | | | | | | | 17. Walter Briggen | merchant taylor | [?] | buried St Helen's, 1625 |
| John Robinson the Younger | mercer | | | moved from St Helen's 1602? – William Robinson took over Leathersellers' lease in 1602/3 from John, who was his older brother | | | | | buried St Helen's, 1609 | | | 19. William Robinson | merchant – 'in lande' | £10 10 shillings | buried St Helen's, 1633 |
| John Pryn(ne) | grocer | not taxed | | | | | | | | | | | | | |
| George Ax(t)on | merchant taylor | | | | | | | | | | | George Ax(t)on | merchant taylor | not taxed | buried St Helen's, 1615 |
| Edward Jackson | merchant taylor | | | | | | | | took over John Pryn(ne)'s lease but evicted | | | 22. Edward Jackson | merchant taylor | [?] | buried St Helen's, 1611 |
| Dr Edward Jorden | Doctor of Physic | | | | | | | | | | | | | | buried Bath Abbey, 1633 |
| Francis Calton | gentleman | | cate of leaving St Helen's ? | moved to St Michael, Wood Street, by 1604 | | | | | | | | | | | date and location of burial uncertain |
| John Jeffery | milliner/embroiderer | buried St Helen's, 1601 | | | | | | | | | | | | | |
| John Suzan | haberdasher/Barbary (Morocco) merchant | | | | buried St Helen's, 1605 | | | | | | | | | | |
| Cicely Cioll | widow | | | | | | | | buried St Michael, Bassishaw, 1610 | | | | | | |
| Captain Pryst | ? | | date of leaving St Helen's ? | | | | | | | | | | | | date and location of burial uncertain |
| | | | | | | | | | | | | | | | date and location of burial |



| # | Name | Occupation | Tax | Notes | Date/location of burial |
|---|------|------------|-----|-------|------------------------|
| | Timothy Bathurst | grocer | £20 | court case v. Charles Bostock 1609; date of leaving St Helen's ? | date and location of burial uncertain |
| | Francis Wells | ? | £3 | date of leaving St Helen's ? | date and location of burial uncertain |
| | Henry Maunder | Queen's messenger | not taxed | servant buried St Helen's, 1603; dead by 1607 at latest | |
| | William Staveley | cordwainer | £3 | buried St Helen's, 1606 | buried St Andrew, Holborn, 1602? |
| | Thomas Morley | composer and publisher | £5 | left St Helen's; died 1602 | |
| | Henry Litherland | plumber | not listed | buried St Helen's, 1603 (plague) | |
| | George Marget(es) | gentleman and mercer | £5 | date of leaving St Helen's ? | date and location of burial uncertain |
| | Edward Brandon | ? | £10 | date of leaving St Helen's ? | date and location of burial uncertain |
| | Thomas Sturgeon | Yeoman of the Guard | £5 | daughter buried St Helen's; date of leaving St Helen's ? | died 1613, buried Kent |
| 29 | William Oliver | freemason | £3 | | died 1613, buried Kent |
| | John Symonds | ? | £3 | date of leaving St Helen's ? | date and location of burial uncertain |
| | Blase Carrell | gentleman | £5 | churchwarden 1607–9 | died 1631? |
| | | | | married and lived St Gabriel, Fenchurch Street, 1589–1605 | |
| 2 | Humfrey Basse | girdler/Virginia Company | £10 | son baptised St Helen's, 1605 | buried St Helen's, 1616 |
| 4 | Edmund Peshall | merchant/grocer – 'in lande' | £20 | date of arrival in St Helen's ?; witness to Cecily Croll's will; son baptised St Helen's | 13s-4d; (26 shillings?); died Cheshire 1637? defendant with Charles Bostock C2/JasI/S28/24 |
| 5 | Maises (Moses) Tryon | merchant – 'in lande' | (£20?) | baptised, 1572 and married, 1600 at Dutch church, Austin Friars. His father, a wealthy dutch refugee, lived in St Christopher-le-Stocks | (26 shillings?); buried Harringworth, Northants, 1652 |
| 7 | Abraham Jacob | customs/gentleman – 'in lande' | £20 | married All Hallows-the-Less, 1592 (parish of Mary Glover) – lived there? not in 1598/99/1600 subsidy lists; took over Leathersellers' lease from Robert Spring for 1606–13; son baptised St Helen's? | 26 shillings; buried St Leonard, Bromley-by-Bow, 1629 son was John Jacob MP |
| 8 | Thomas Emerson | gent 'in lande' | £35 | date of arrival in St Helen's?; close friend of Dr Peter Turner; son baptised St Helen's? | (?); date and location of burial uncertain |
| 9 | Abraham Chamberlaine | merchant | £35 | date of arrival in St Helen's | (?); 1638 St Helen's tithe survey. Buried St Helen's 1640 |
| 10 | William Hales(?) | gent 'in lande' | £30 | | 40 shillings; date and location of burial uncertain |
| 11 | George Dorrington | agent Aleppo/clothworker – 'in lande' | £10 | date of arrival in St Helen's? | 13s-4d; date and location of burial uncertain |
| 12 | John Alens[..] ? | 'in lande' | £15 | date of arrival in St Helen's? | 20 shillings; date and location of burial uncertain |
| 13 | Thomas [.....]ett | gent 'in lande' | £10 | date of arrival in St Helen's? | 13s-4d; date and location of burial uncertain |
| 14 | John Mal[....]ett | 'in lande' | £20 | date of arrival in St Helen's? | 26 shillings; date and location of burial uncertain |
| 15 | Thomas Parl[........]en 'in lande' | | £20 | date of arrival in St Helen's? | 26 shillings; date and location of burial uncertain |
| 16 | Thomas [........]ley | 'in lande' | £10 | | 13s-4d; date and location of burial uncertain |
| 18 | Robert Coppin | merchant taylor | (£5?) | wife (2) buried St Helen's 1605; wife buried St Helen's 1605 churchwarden | 5 shillings; 1638 St Helen's tithe survey. Buried St Helen's 1640 |
| 20 | Sir Henrie Baker of Sissinghurst 'in lande' | | £40 | married St Gabriel, Fenchurch Street, 1606; date of arrival in St Helen's? | 53s-4d; died Cranbrook, Kent, 1623 |
| 23 | James Fawcet | | £3 | date of arrival in St Helen's ? | 3 shillings; date and location of burial uncertain |
| 24 | John Phillips | tallow chandler | £3 | Leathersellers' lease 1604 daughter baptised | 3 shillings; buried St Helen's, 1617 |
| 25 | Edmund Francis | mercer | £3 | date of arrival in St Helen's ? | 3 shillings; buried St Helen's, 1620 |
| 26 | Caley Clarke | | £3 | date of arrival in St Helen's ?; daughter baptised | 3 shillings; date and location of burial uncertain |
| 27 | Francis Benbowe | merchant | £3 | son xeptised St Helen's 1602 | 3 shillings |
| 28 | Cornelius Godfrey | | £3 | date of arrival in St Helen's ? | 3 shillings; date and location of burial uncertain |

Timeline columns: 1600 | 1601 | 1602 | 1603 | 1604 | 1605 | 1606 | 1607 | 1608 | 1609 | 1610 | 1611

indicating payment had not been secured for whatever reason. These losses seem to be balanced by ten new arrivals, mostly well-to-do given their assessment levels in 1599/1600.[11]

However, with the remaining eight, there is some evidence that they were living in St Helen's later. They are an interesting group:

1. Henry Maunder (£3 in 1598 LSR), a queen's messenger and government agent?; his 1599 LSR entry has no valuation filled in. Was he away on 'official' business? He was definitely in the parish in 1603, as his servant was buried then in St Helen's, followed in July 1608 by his 'widow' Isabel, so he must have died 1603–08.
2. John Allsop(pe) (£50 in 1598 LSR), gentleman?, was churchwarden in 1598–9 and 1599–1600, so arguably he could have left the parish or died in the short period between the end of his churchwardenship and October 1600 subsidy payment, but it seems odd.
3. Christopher Eland (£3 in 1598 LSR), merchant, was churchwarden in 1599–1600 and 1600–1, so he must have been senior churchwarden during the October 1600 subsidy payment.

But the next three must have been alive in October 1600, since they are all recorded in St Helen's after 1 October 1600:

4. William Wingfield (£3 in 1598 LSR), brown baker, was a churchwarden in 1605 and 1606 and, recorded as a 'pensioner', was buried in St Helen's on 25 December 1628.
5. Henry Litherland (£3 in 1598 LSR), plumber, recorded as a plague victim, was buried in St Helen's on 11 September 1603.
6. John Jeffrey (£3 in 1598 LSR), embroiderer (also 'milliner') was buried in St Helen's on 29 October 1601.

The only reason for their absence would have been if all three had fallen below the £3 assessment limit.

In the context of Shakespeare, the last two names are the most interesting since they are John Pryme and Robert Spring, the two people who were probably living next door to Shakespeare and, in the former case, was immediately above his name in the 1598 Lay Subsidy roll.[12] John Robinson the Younger, the name above John Pryme in the 1598 LSR, had also disappeared from the 1600 LSR general list, since he had been moved to the 'rich' list to replace his dead father, John Robinson the Elder.

There are several reasons why these two individuals might have disappeared from the 1600 Lay Subsidy roll:

- John Pryme was in his late sixties and could have dropped below the £3 assessment level. However, this seems unlikely, as he had agreed in September 1598 for his rent to rise to £6 a year and paid this to the Leathersellers until his death in February 1609. There was no up-front 'fine', but it was a short lease for only thirteen years.
- Robert Spring, in contrast, was far too rich to drop below the £3 level. However, his wife had died in 1598 and he must have been sixty or older. His youngest child, if still living, would have been about seventeen. He had been a regular figure in parish affairs but there is no record of him serving as an auditor after 1597. However, he regularly paid his rent of £5-13s-4d to the Leathersellers until 1606, just before his death in 1609. Then his lease was taken over by Abraham Jacob for seven years, followed by the scrivener Charles Bostock in 1614.[13] Spring had a country property in Dagenham, and it seems likely that he moved there and perhaps sub-let his house on the Leathersellers' estate to his son.
- In the case of William Shakespeare: He has 'Affid' against his name, and five of the seven people with this designation in 1598 may have left the parish (four) or died (one). However, the composer Thomas Morley was recorded as 'Affid' as a royal official, and was clearly living in St Helen's at this time.

In summary, it is curious that these three very different people, two listed next to each other in the 1598 roll and the third a neighbour, have all disappeared by October 1600. In addition, George Axton, the next name in the 1598 Lay Subsidy listing, has also gone from his position, but has been placed at the end of the 1600 list. A possibility is that, when John Robinson the Younger's name was moved to the 'rich' list and his father's name removed, there was an error by the scribe and Pryme and Shakespeare got removed by accident.[14] An alternative reason, noted by Professor Alan H. Nelson, was that Shakespeare, having purchased New Place in May 1597, had convinced the authorities that he should pay his lay subsidy contribution in Stratford-upon-Avon.[15] This can be demonstrated with other residents in St Helen's.[16]

In conclusion, there is some evidence that Shakespeare moved his accommodation to Southwark *c.* 1598/9, but it is not as clear-cut as it is often presented. While he was working there with the opening of the Globe, there is a possibility that Shakespeare did not shift his home across the river. A larger question, in either case, is why Shakespeare would want to live in Southwark anyway. Compared to the upmarket, respectable and familiar St Helen's, it was a densely occupied, sprawling suburb with largely poor inhabitants. It was advantageous for providing a theatre audience, but it would have been very much a social step down, particularly for a man who had just acquired an impressive house in his home town. Also, much of Bankside was low-lying and damp, so a general health risk even before the threat of plague, which was recognised to hit the poor and crowded suburbs hardest. When Shakespeare's trail can definitely be picked

up again in Silver Street in 1602/4, he is living in a very similar sort of affluent environment to St Helen's. St Olave's parish was located inside a bend in the City wall, meaning that there was little passing traffic. He was also close to two of his partners in the Globe, John Heminges and William Condell, both respectable members of the adjacent parish of St Mary Aldermanbury. They clearly saw no need to move to Southwark in 1599 to be near their new investment.

My own view, unprovable at present, is that Shakespeare never moved his accommodation to Southwark, or if he did, it was for a very short period around the opening of the Globe in 1599/1600. It is interesting that the entries referring to 'Surrey' and then 'the Diocese of Winchester' are dated to October 1599 and 1600, by which time the Globe would have been fully operational and associated with Shakespeare. More probable is that he remained within the City walls, in areas he knew well. He could have either moved directly from St Helen's to Silver Street in 1602/4 or, possibly, via an as-yet-unidentified third location. The logical reason for choosing Silver Street was that it was close to his colleagues Heminges and Condell and provided easy access to watch the Lord Admiral's Men at their new theatre, the Fortune, which opened just north of Cripplegate in 1600. In this context, it is interesting to note that Dr Edward Jorden is recorded in 1604 as having moved from St Helen's to St Michael Wood Street, a few minutes' walk from Silver Street.[17]

## Notes

1. See Professor Alan Nelson's notes for all these documents in Folger Library's *Shakespeare Documented* website, <https://shakespearedocumented.folger.edu/> (last accessed 20 July 2020). Bearman, *Shakespeare's Money*, pp. 64–6 provides a recent summary of the detailed arguments.
2. He was later involved in the Boar's Head Theatre at Aldgate.
3. The Blackfriars project had been brought to a halt by local opposition in November 1596 but given Burbage's large financial investment in the site and his character, he probably continued to plot how to realise his indoor theatre until his death.
4. The fact that Shakespeare did not pay his October 1597 lay subsidy demand of five shillings does not prove he had left St Helen's. Given that the St Helen's subsidy rolls was kept up to date, the inclusion of his name on the 1 October 1598 roll indicates the assessors thought that he was living in the parish prior to October.
5. Unfortunately, the 1599 Lay Subsidy roll is incomplete at the crucial point.
6. For a detailed review of this period, see Bearman, *Shakespeare's Money*, pp. 63–6.
7. For example, Richard Risby, who was buried on 24 October 1599, was listed in the 1599 Lay Subsidy roll only a few weeks before his death, but was removed from the 1600 Lay Subsidy listing.
8. In 1598, John Crane (in 1584 aged eight), freeholder of the houses on the south side of Great St Helen's, if still living, would have turned twenty-one and come into his majority. A possibility, unproven, is that his estate was sold at this point, resulting in a significant upheaval amongst the upmarket tenants.
9. John Stocker Jekyll died in December 1598, Richard Risby in 1599 and John Robinson the Elder in 1600.

Appendix

10. William Cherle and Mrs Poole – both in 1598 LSR as 'Affid', gone by 1599 LSR; Oswald Fetche and Robert Honeywood II – both in 1598 LSR as 'Affid', gone by 1600, the latter by July 1598 to St Leonard, Shoreditch; James Elwick, in 1598 LSR, gone by 1599 LSR; Dr Richard Taylor, Peter Lallyla and James Scoles, in 1598 LSR, gone by 1600 LSR – relevant section of 1599 LSR missing.
11. Salomon and John Hewitt (£80 and £40), Thomas Marsh (£20), Capteine Pryst (£15), Francis Colten (£10), Andrew Ellem (£10), Edward Branson (£10), Thomas Sturgeon (£5), George Margettes (£5), John Symondes (£3). The Francis Colten is Francis Calton, knighted in 1605, who is of interest as he sold the manor of Dulwich to Edward Alleyne for £5,000 in 1605. Two of his children were buried in St Helen's in March 1600 and July 1601, although neither is recorded as being baptised there. A third child, Thomas, was baptised in August 1601. The relevant part of the 1599 Lay subsidy roll is missing, so Calton and his family could have arrived anytime between autumn 1598 and spring 1600.
12. Robert Spring was absent from the general 'petty' list because he was placed in the 'high' rich list.
13. It is difficult to know the significance of these payments, since Hugh Offley had taken over the head lease in 1586 but had died in 1594.
14. There are scribal errors in the Lay Subsidy rolls, notably in the 1582 records for St Helen's and St Ethelburga, when the lists have been conflated.
15. Unfortunately, there are no surviving subsidy records for Stratford-upon-Avon during this period. Clearly, ownership of the freehold of one of the largest houses in Stratford would be more convincing to the authorities as his 'home residence' than a leased house or lodging in London.
16. For example, in the 1589 tithe survey, James Elwick, a successful mercer, is recorded in Bishopsgate Street in a substantial house immediately south of Timothy Bathurst. A James Elwyck is listed in the 1582 Lay Subsidy roll at St Michael Bassishaw, near the Guildhall, with an assessment of £50. His first child was christened in St Helen's in October 1585, so he may have married and moved into the parish in 1583–5. He was clearly respected, as in 1593, the plague year, he was chosen as under-churchwarden, and he progressed to senior churchwarden the following year when parish affairs must still have been in some disarray. He may therefore well have been a churchwarden when Shakespeare moved into the parish, and was certainly in charge when Sir John Spencer moved in as Lord Mayor. Yet his Lay Subsidy payment for August 1593 was certified as in 'Stratforde of the Bowe' with a valuation of £15, which was stated to be 'in w[hi]ch place the saide James was moste resident w[i]th his familie at the tyme of the taxaion . . . and for the moste part of the yeare before [1592]'. This may have been true but it seems hard to square with him being churchwarden in a large and busy parish, unless he had simply moved out with his family because of the plague. By 1598, he was being taxed in St Helen's at a valuation of £20, his position immediately below Timothy Bathurst, suggesting he was still living in his old house. He was a parish auditor in 1595, 1597 and 1598, but is not in the 1600 Lay Subsidy roll listing and seems to have left the parish. See residency certificate TNA E115/137/34, dated 20 January 1594/5. Although this certificate survives, the Lay Subsidy rolls for St Helen's for these years are lost.
17. I am indebted to Peter Elmer for pointing this out. There is no obvious reason why Dr Jorden should have moved here. The richer central parishes to the east of St Paul's were less affected by the 1603 plague than those closer to the suburbs and he may have felt it was a healthier environment to bring up his young family; see Slack, *The Impact of Plague in Tudor and Stuart England*, figure 6.4 (1603 plague) and figure 6.5 (1625 plague), compared to the much more mixed distribution of victims in the 1563 plague (figure 6.3).

443

# 5

## Who Was John Pryn, Pryne, Prynne, Pryme, Prymme?

John Harvey's detailed analysis distinguishing William Byrd, the music composer, from William Burd(e), the wealthy merchant and St Helen's resident (*c.* 1570–91), is a stark warning of the dangers of conflating two people with the same name.[1] However, it seems highly likely that the John Pryme who appears above Shakespeare's name in the 1598 Lay Subsidy roll (Figure A.15) is the same person as the shadowy money-broker who arranged the mortgage of the lease of the Theatre by James Burbage and John Brayne to the grocer John Hyde, for £125-8s-11d on 26 September 1579, only three years after it had opened. A legal deposition from 1592 states:

> Jo.[hn] Hide of London grocer of thage of lviij [58] yeres or therabotes sworn &c i. Interrogatory That true it ys one Jo[hn] Brayne late husband of the Comp.[lainant] and one Jo.[hn] Prynne a Broker did take up, borrow and owe unto hym this d[e]p[onen]t about the xxvj day of Sept 1579. The some of 125li 8s 11d . . . furthermore,
>     Joyntlie they and the said Pryne . . . did entre into bonde . . . for the Redempcion thereof.[2]

This bond was for £200, which would be forfeited if Burbage and Brayne, along with Pryne, did not repay the £125 after a year and a day. Thereafter, John Pryn(n)e appears to disappear off the scene. Who was this person? Was this just one of many financial deals for him, or did he have a deeper interest in this new entertainment enterprise?

The St Helen's John Pryn appears in the first line of the first page of the earliest surviving book of churchwardens' accounts for the parish dating to 1564/5. It reads: 'Accompte of John Howe and John Prynne churchwardens of the Parish of St. Helen within Bishopsgate'.[3]

Each churchwarden served two years to ensure financial and administrative continuity. In 1564/5, John Prynne was in his first year as under-churchwarden to John Howe and in 1565/6, now recorded as John Pryn, he was upper [senior] churchwarden. That year he was certainly mixing with the money, as he was joined as under-churchwarden by German Cioll, who was married to Sir Thomas Gresham's cousin Cecily and who owned Crosby Hall.[4] Three degrees of separation from the super-rich financier who was planning the [Gresham] Exchange. The churchwardens held a highly

responsible position. To be chosen by the parish Vestry, an individual needed to have lived long enough locally to know the community thoroughly, to demonstrate mainstream religious convictions, to be responsible with money and to be trusted by the richer parishioners who controlled local affairs.[5] During the Sunday service, they would sit in the churchwardens' pews at the back of the church, where they could keep a watchful eye on attendance and general behaviour.

The records of the Grocers' Company show that the apprentice John Prynne became a freeman in 1557, suggesting he was born *c*. 1533.[6] He would, therefore, have been able to remember the death of Henry VIII, the iconoclasm of Edward VI's reign and the return to Catholicism with rule of Queen Mary. By 1558, he was living in St Helen's as he took over the lease of a house on the Leathersellers' Estate from Elizabeth Stretton/Stratton, whose husband, Master Stretton, also a grocer, had died *c*. 1551.[7] Could this be the same John Pryn(ne) arranging the refinancing of the Theatre twenty-one years later, in 1579?[8]

Our Mr Pryn was certainly a stable fixture in the parish of St Helen's, as he lived there for over half a century, until his death in February 1609, well into his seventies. His life paralleled that of the historian John Stow (1525–1605) and Pryn must have been able to remember much of the evolution of London recorded in Stow's *Survey of London*, published in 1598. Pryn was one of the inner coterie of about a dozen men who, at any one time, controlled the Vestry and therefore managed the affairs of the parish and ensured social and religious conformity. He rented the same house on the Leathersellers Estate for at least fifty years until his death. The annual rent of £1-10s-0d, raised to £1-15s-0d in 1574 (actually £3-13s-8d per year with its premium or 'fine'), suggests a medium-sized house. Evidence indicates that it was one of the properties carved out of the buildings to the west of the nunnery service wing, and that he possibly lived for thirty years next door to Richard Clarke, a barber surgeon, with the Skinners' almshouses beyond to the west. Pryn's house would probably have looked out south-east over St Helen's graveyard to the west front of the church.[9]

Sometime between 1558 and the early 1560s, John Pryn married Margery (surname unrecorded) and they had one daughter, Anne. She, in turn, in her early twenties, married Walter Briggen, a merchant taylor, on Sunday, 7 October 1582 in St Helen's.[10] Over the next seven years she provided John with four granddaughters, Mary, Elizabeth, one whose name was unrecorded, and finally Margery in 1589. However, seven months later Anne was dead, leaving her husband with two motherless babies, eighteen and six months old.[11] Walter Briggen immediately remarried in 1590/1, as by July 1592 he had a new daughter.[12] In 1597, there was further upheaval when John's wife Margery died and was buried in St Helen's on 12 April 1597. Left a widower and now in his early sixties, with no surviving children, John signed a new thirteen-year lease for his property on the Leathersellers' Estate on 15 September 1598, this time at a rent of £6 a

# Living with Shakespeare

year – nearly double the previous level. What was the reason? Had he remarried? Unfortunately, the records are silent. One possibility is that he was planning to share the property with Walter Briggen, his son-in-law. Did Walter, his new wife and their three children ever move in with John in 1598? Walter Briggen is listed above John Pryn in the 1598 Lay Subsidy roll, but significantly, not immediately above.[13]

What else can we find out about the St Helen's Mr Pryn/Prymme? He seems to have been good with money and also responsible. He was churchwarden again in 1600 during an emergency,[14] but probably more significantly, starting in 1567, he frequently signed off the churchwardens' accounts at the end of the year as one of the auditors.[15] This provides many versions of his signature, which is usually a clear 'by me John Pryme'. Only his last signatures in 1605 and 1606, towards his death in February 1609, are shaky. John Pryme was clearly also a man who could act decisively in the fluctuating religious environment in the years following Elizabeth I's succession from Queen Mary in November 1588. When in January 1565 'by the whole consent of the parishioners that the residue of our rood loft' was to be removed, it was John Pryme, as under-churchwarden, who was responsible for overseeing the demolition.

So, the St Helen's John Pryn(e)/Pryme was a married grocer, born around 1533/4, who had at least one daughter, and who by 1565 had established himself as a respected member of the local community. This sounds a very good fit for the John Pryn(n)e who in 1579 persuaded a rich grocer, John Hyde, to lend £125 to the financially straitened owners of the Theatre, a decision Hyde probably regretted.[16] However, to demonstrate that the two Pryns were the same person would require stronger evidence that the St Helen's Pryn was more than just a grocer but was involved in financial and property negotiations as well.[17] Such evidence exists in a legal deposition from 1582, preserved in the National Archives, when John Pryne took Robert and Matthew Pigott to court.

To put this dispute in its broader context, Pryn(e) had regularly paid his annual two-shilling annual levy to the Grocers' Company, where his name is spelt various ways. However, in 1570, he paid only 12d and then did not pay his Grocers' fee again until 1576, when he reappears as John Pryn. This was also the longest period, 1568–75, when he did not audit the parish accounts. Now in his late thirties, with a single daughter and probably no likelihood of more children, perhaps he decided to embark on other business activities – could this be the start of his mortgage broking? Perhaps the opening of the Royal Exchange a few hundred yards away tempted him into 'financial services' and then into the early years of the commercial entertainment world. Around 1578, Pryne acquired three adjoining properties at Bishopsgate, 'in the yeard called or known by the signe of The Wrestlers' for £42 from Robert Piggott, a carpenter, and his wife, Let(t)ice, in the next parish of St Ethelburga.[18] In 1582, a court complaint records a dispute over these properties. Let(t)ice had died and Matthew, the Piggotts' son, claimed that Pryne's ownership was invalid. Instead, Matthew attempted to sell the properties to someone else.[19]

Certainly, in the 1590–2 depositions about the Theatre, Pryn is specifically referred to as a 'broker' twice, not a grocer.[20] The second deposition was by John Hyde, who, as the lender, presumably could remember with whom he had dealt. Also, £125-8s-11d was a significant sum to loan, which suggests that Pryn(e)/Pryme had developed some reputation and connections in this area of work. He certainly had no intention of moving out of St Helen's, as he signed a new and more expensive twenty-one-year lease with the Leathersellers in 1574, which included a fine (premium) of £40 equivalent to an additional £1-18s-0d a year. In 1579, John Pryn(e)/Pryme would have been in his early forties.[21] Thus, while there is no absolute certainty, it seems that William Shakespeare was living in very close proximity to someone who had been involved in the early years of the Theatre. It is also possible – see above, pp. 421–4 – that John Pryn was Shakespeare's landlord.

Pryn(e)/Pryme is an uncommon name and there are no other Pryn(ne)s or Prymes in any of the 1582 Lay Subsidy rolls for London, apart from one 'Widdowe Pryme'. There are two interesting things about the record of this woman. First, she was living in the section of the parish of St Peter Cornhill that fell into the ward of Bishopsgate, which was the southern end of the east side of Bishopsgate Street, adjoining St Helen's. Could this be John's widowed mother living around the corner? Second, she is the last name in the parish and recorded as a 'stranger', paying the standard poll tax of 4d that all foreigners had to pay regardless of their wealth. Mrs Pryme was almost certainly from northern France or some part of the Low Countries.[22] Might his mother have come to England in the 1530s?[23] Unfortunately, the records do not seem to offer any further details.

John could not have been an immigrant himself, since he was apprenticed to the Grocers' Company. However, he could have been born in England to a French mother and English father. In any event, there are two other pieces of intriguing evidence suggesting foreign connections. In 1589, two 'strangers', Roberte Budram and John Course, probably French, are recorded as living 'in Proynes house'.[24] On 19 May 1596, the St Helen's burial register records 'Peter Deroyne, a frenchman out of Mr. Pryns house, [buried] in the middest neere unto Mr. Saunders Stone'.[25] So, Mr Deroyne got a respectable, and at a cost of 6s-8d, proper burial inside the church. This would suggest that at the time Shakespeare was living in St Helen's, John Pryn, now aged around sixty, was living with his wife in a house large enough to take in a lodger of some standing. His need for a lodger's income is perhaps indicated by his assessment in the 1598 Lay Subsidy roll, now as a widower, at £3, while his former son-in-law Walter Briggen and Shakespeare were both assessed at £5.

There is one other tantalising piece of evidence which may connect John Pryn with the world of theatre. At Christmas/New Year 1573/4, the Office of the Revels was particularly busy, preparing plays and masques for Whitehall Palace. Among the list of

seventeen 'imbroderers & habberdashers' is a payment of 12d for one day's work by Anne Prynne.[26] If this, as seems likely, is John's daughter, she would have been aged about fourteen. Professor Natasha Korda, who kindly pointed out this reference, considers that it would have been perfectly normal for a girl of this age to be doing such work.

John Pryn, aged about seventy-five, was buried in St Helen's on 3 February 1609 on top of his wife, who had died twelve years earlier, and next to his only daughter. Pryn had appointed Edward Jackson, a neighbouring merchant taylor and friend, as executor, and he appears to have taken over Pryn's property. Jackson's wife had just died, leaving him with four children under eleven, and serious trouble followed. The Leathersellers' Court for 6 April 1611 noted:

> Edward Jacksons lease of a T[enem]ente att St Helen's gate was expired att . . . Ladie daie last, since w[hi]ch tyme he hath done wronge to the company in taking down the wainscot [probably wooden panelling] and other thinge there. . . . It is ordered by this Court that upon condition that the said Edward Jackson w[i]th his whole familie doe departe thence peaceablie before the fifteenth daie of June next ensuing . . . is pleased to give him five pounde out of their good will . . . [agreed] That John Gannett. Letherseller, for and in consideration of £100 . . . shall have a lease of the same ten[emen]te.

Four months later, Jackson was dead, leaving four young orphans. He was buried in St Helen's, between his wife and John Prynne.[27]

## Notes

1. See Harley, *The World of William Byrd*. The only other John Prym was a merchant taylor who makes a deposition in a court case about a property in Mayfield, Sussex in 1594, when he is recorded as aged fifty-six. He was living in the parish of St Giles without Cripplegate and had a different signature; see TNA C 24/240 B.
2. TNA C 24/218/93, ex parte Burbage; Wallace, *The First London Theatre*, p. 53; and TNA C24/228/10, ex parte Burbage; Wallace, *The First London Theatre*, p. 111.
3. See St Helen's churchwardens' accounts for 1564/5.
4. Or, perhaps more accurately, the 'shortly to be ex-money', since the once wealthy Ciolls were in serious financial trouble at this point and had to sell Crosby Hall to Alderman William Bond, international trader, backer of Martin Frobisher's 1576 voyage to Cathay and older brother of George Bond, Lord Mayor in 1587/8. As a result, the Ciolls retained just four houses fronting onto Bishopsgate Street and a part of the hall complex for their own use. German Cioll died in the 1580s but his widow, Cicely, lived on until 1610, outlasting in turn the occupancy of the Bonds, who sold up in 1594.
5. For example, Timothy Bathurst, a wealthy and successful grocer, was appointed churchwarden in 1595, probably about eight years after he moved into the parish.

Appendix

6. He was apprenticed to a grocer called Ryder and there seems no connection with the Strettons/ Strattons. One had to be at least twenty-four to become a freeman of the Grocers' Company; see Ingram, *The Business of Playing*.
7. Elizabeth signed a new lease, in her own name, in 1552 for twenty-one years at a rent of £1-10s-0d, suggesting she planned to continue the grocery business. Although John Pryn(ne) was not apprenticed to her husband, it is possible that he had been helping her for some years as he started paying his levy to the Grocers Company c. 1556. At the St Helen's Vestry meeting on 20 December 1562, he was chosen as parish 'Scavenger' for 1563. He then moved up the hierarchy of parish responsibilities, being appointed 'Collector of the Poor' on 27 September 1563 and lower churchwarden on 1 October 1564. Following his two years as churchwarden he was chosen as an auditor of the churchwardens' accounts. In 1563, he was recorded as 'John Pryme groc[er]'.
8. Variable spelling is always a problem with researching names in this period. In the Theatre depositions (see Wallace, *The First London Theatre*) his name, which appears six times in the 1590–2 depositions, is written differently in the same document as 'Jo. Prynne a broker' (p.53)/ 'the said . . . and Pryne' and 'Pryne' (p. 54)/ 'said Pryne' (p. 55)/ 'Js. Prynne' (p. 57)/ 'one Prvne A Broker' (p. 111), while his signature in the St Helen's churchwarden records is usually Pryme. However, in the record of the September 1576 vestry, it is clearly written John Pryn and also at the start of the 1566 churchwardens' accounts.
9. Although it should not be taken as a literal representation, the 'Copperplate' map of 1553–9 shows a row of houses running across this location. The draughtsman of the map typically shows about 50–60 per cent of the actual properties.
10. Three days after Pope Gregory XIII introduced the Gregorian Calendar to Catholic Europe. This change cut out ten days, so Italy and Spain went straight from 4 to the 15 October, meaning there was no 7 October 1582 in much of Europe.
11. Pryn's first two granddaughters died in infancy. Anne was buried in St Helen's on 8 January 1590, 'righte against the ende of the Skynners Almes Pewes, 3 stones bredth from the Corner of the Pewe and 9 in length towards the greate dore'. When Margery died eight years later, the burial record reads 'Margery wife of John Prynne, Grocer, close to her daughter Mrs Briggin'.
12. One wonders what his father-in-law thought of this rapid remarriage, which was not unusual in a period when young children were often suddenly left without a mother or father. Certainly, both worked together later as parish officials. Walter married his new wife away from St Helen's, presumably in her own parish. In 1608, Walter is recorded as having another child when he must have been around fifty. He was buried in St Helen's in 1625.
13. John Pryn and John Robinson the Younger were both renting their houses on the Leathersellers' Estate, but as far as is known, Walter Briggen never took on a head lease. If he had moved into part of his former father-in-law's house as a sub-tenant, he would not have been listed as a tenant, but he would have attracted a valuation by the subsidy assessors. However, his name is separated from John Pryn's in the listing. If John Robinson the Younger was living in part of his father's large house in the 1590s and moved out next door in 1597, it is conceivable that Briggen took over his accommodation. In 1600, Walter Briggen is listed in the Lay Subsidy roll but his relationship with John Pryn is unclear because the latter is no longer listed; see above, pp. 440–1.
14. This was a time of major upheaval in the parish, when the Stanhope brothers had acquired the rectory rights and must have been involved in the appointment of Lewis Hughes, a radical Puritan, as minister in late 1600. Lewis was to get into a lot of hot water in 1602/3. This suggests that John Pryn was broadly attached to the Puritan tendency, in religious matters at least.
15. John Pryme, as an auditor, signed off the churchwardens' accounts for twenty separate years. With four years as a churchwarden, he was therefore intimately involved in the financial affairs of the parish for over half the period 1565 to 1609, when he died, presumably well into his seventies (churchwarden 1565–6), 1567, 1576, 1578–9, 1581–4, 1586, 1592–6, 1598–9, (churchwarden again as an emergency in 1600), 1602, 1604–6. The longest period he did not sign is the seven years 1569–75. Also, the surviving accounts were not signed in five years: 1577, 1588–91. For the forty-five years 1565–1610, only one other person served more than two stints as churchwarden. This was Thomas

Coleshill (1517/18–1595) in 1546, 1567–8, and 1574–5, and he was also an auditor in five years. However, he became the farmer (tithe collector) with Blaise Saunders of the rectory lease in 1564, so he had a vested interest in efficient parish administration. On 20 March 1565, the Vestry agreed 'that the curate to forthwith make a perfect book of all names of the householders of this parish with their wife children and servants of age 16 or above, and the same book or a true copy to be delivered to Mr Colshill and Mr Sanders'. Unfortunately, this survey does not survive, but it is interesting that the new churchwardens' account book starts in 1565. Coleshill's second period as churchwarden coincided with the alterations to the pulpit and the lead up to appointing a parish lecturer, when he may have wished to keep a tight rein on church activities and parish expenditure.

16. In 1579, James Burbage would have been aged about forty-eight, as he is thought to have been born *c.* 1531. John Brayne was born *c.* 1541, so would have been about thirty-eight. John Hyde in the 1582 Lay Subsidy roll is recorded as living in the parish of St Dunstan in the East, located to the south of St Helen's.

17. In the 1570s and 80s, there were around 250 members of the Grocers' Company, on average 2.5 per parish, so they would have been present in every significant street.

18. See TNA C3/215/73. The fifty-six-line document is in very poor condition, with sections missing. It could be argued that the Pryn in this document is just the Theatre mortgage broker, but the fact that the property was in the next parish and less than a hundred yards from Pryn's house in St Helen's strongly suggests that these are the same person. The Wrestlers was once an inn and the property contained stables and hay lofts. Stow recorded the Wrestlers as: 'The first of these houses towards the North, and against the wall of the Citie, was sometime a large Inn or Court called the Wrastlers', and it was the building marking the north-west corner of his own parish of St Andrew Undershaft. By the 1570s, the building seems to have been divided into tenements, suitable for poultry sellers, watercarriers and widows. The purchase price of £42 for three premises suggests that Pryn was looking for an annual rental income of around £4-10s-0d a year. These were not high-end properties, but neither were they at the bottom of the housing ladder. Pryn's own rent on the Leathersellers' estate was £1-15s-0d, but in 1574 he paid a fine of £40 on sealing a new lease, more than doubling his effective annual rate. His ownership at the Wrestlers was not clear-cut, as the three properties were mixed up amongst other buildings still owned by the Piggotts, and there were specific access rights to use facilities such as a well. This purchase might be seen as simply an ageing grocer looking to build up a property portfolio to provide a steady income stream for his old age. However, Pryn's activity here clearly suggests that the St Helen's John Pryn was involved in property dealing around the time of the Theatre mortgage and that the two Pryns are almost certainly the same person. He was in a position to spend £40 in 1574 on a lease and then £42 on the purchase in 1578, suggesting he was generating an income of at least £10 a year above his basic spending needs.

19. The case is a good example of the arguments over Elizabethan property rights with ongoing claim and counter-claim. Unfortunately, as with so many depositions from this period, there is no matching record to show the outcome of this fascinating vignette of Elizabethan London life. Matthew Piggott certainly held on to his own properties at least, since the post-mortem inquisition on William Horne, grocer (d. 1592) on 16 August 1594 refers to his widow Isabel inheriting 'my messuages, tenements, stables, hay-lofts and yards set within Wrestlers ... which I bought of Matthew Piggott'; see Fry, *Abstracts of Inquisitiones Post Mortem for the City of London: Part 3*, pp. 171–219. During the period 1588–1610, surviving legal evidence records at least four St Helen's residents – John Pryn, Robert Spring, Timothy Bathurst and George Tedder – as well as the Company of Leathersellers, involved in local property litigation in the courts, giving some indication of the quantum of disputes across the City of London at this time.

20. It is noticeable that, if he is the same person as the mortgage broker, he was not called as a witness in 1590–2 during the protracted court case about the money owed on the Theatre.

21. John Pryme is not listed in the 1564, 1576 or 1582 Lay Subsidy rolls for St Helen's, despite being clearly resident since he signed the churchwardens' accounts in the latter years. Presumably he was below the £3 assessment limit. He is listed in the 1589 tithe listing at an unimpressive 4s-1d, 57th equal out of seventy-three households. In the 1598 Lay Subsidy roll, he is assessed at £3, the lower limit. By

1589, he would have been *c.* fifty-three years old, so the tithe payment may reflect his age, but he never appears very prosperous. In 1576, he is recorded as paying 12d for a second-hand ladder from the church, perhaps the steps up to the pulpit, which was being remodelled. This mirrors the status of another grocer, Peter Dod(d), who was involved in the Vestry from at least as early as 1568, was churchwarden in 1570 and 1571 and often signed off the accounts up to 1593. In 1577, Pryme and Dod are recorded buying stone off the church valued at 13s-4d.

22. The French-speaking church had split from the Dutch church in the former Austin Friars to the former St Anthony's Hospital Chapel in Threadneedle Street, just a few minutes walk from Widow Pryme's home.
23. If John's birth was around 1533–5, it is likely that Mrs Pryme would have been born *c.* 1505–15.
24. Both rated per poll at 4d; see Kirk and Kirk, *Returns of Aliens*, p. 419.
25. Blaise Saunders, a Marian exile, was also a grocer and was churchwarden in 1568 and 1569. He was joint auditor with John Pryme in 1579 and was buried in St Helen's on 12 October 1581.
26. See Feuillerat, *Extracts from the Accounts of the Revels at Court*, p. 196, account line 20. Four or five of the seventeen were female. Three lines above is Davy Axson, paid for six days' work, and below is Thomas Levert, 'the wiredrawer and his servuentes'. One wonders if Davy Axson was connected to the St Helen's Axsons/Axtons; see Appendix section 8, note 13.
27. The lease on the house was taken over by John Gannett, a reliable leatherseller, who had been living on the other side of Bishopsgate Street in a property of Edward Walker adjoining the Green Dragon Inn. Walker's will described Gannett as his good friend and appointed him as an overseer; see TNA PROB 11/99/336.

# 6

## Who Was John Hatton?

John Hatton is a strong possibility to have been Shakespeare's landlord in the 1590s, and it is therefore worth summarising what is known about him. He is one of the thousands of Elizabethan Londoners upon whom the economy of the City depended, but who largely remain in the shadows of more famous figures. Hatton was born in about 1550, as a deposition of 1590 records him as aged forty.[1] Nothing has yet been clearly established about his place of birth or family. In the late 1560s, he was apprenticed in London to John Walker, a scrivener. Many scriveners were drawn from the younger sons of minor gentry and yeomen, who could read and write and were looking for a profession with some social status. His use of Latin maxims in his official work suggests that he had enjoyed a good grammar school education (Figure A.17).

On 15 July 1577, he became a freeman of the Company of Scriveners on the same day as Israel Jorden (see Section 7) and George Samwell.[2] Before this, he had married his first wife, Mary, who rapidly had two sons, William and John. The family appears to have been living in the riverside parish of St Mary Somerset, where William was baptised on 14 October 1574 and John on 22 May 1576. Sometime in 1578, the family moved to St Helen's, where John had secured a job as 'under officer' to Bartholomew Drum(e), clerk to the Company of Leathersellers. He was paid £3-6s-8d a year or 1s-4d a week – the amount a skilled craftsman earned in a day, but it was a beginning with a prestigious City organisation. He moved into a house close to the Leathersellers' Hall for which the rent was £2-0s-0d, more than half his pay from the Leathersellers, so presumably he used his writing skills to generate other sources of income.[3] Within a few months, tragedy struck. 1578 saw the recurrence of plague in London, and in October and November, his wife Mary and their two boys were all buried in St Helen's. John was clearly not a man to hesitate, and within four months he had married his second wife, Joan, who gave birth to a daughter, Mary, in December 1579, followed by Anne in 1581 and William in 1582.

With this new growing family, John needed a good income. Fortunately, in 1584 Drum(e) retired, with a £4 a year pension, and Hatton became clerk of the Leathersellers at a wage of £8-13s-8d, with the Company contributing £2 towards his livery gown.[4] After ten years' service, in 1594, his wage was increased to £10, but the records specifically state that this included 'and for wrytinge our bookes of accoumptes – £10'. The following decade seems to have been a good time for Hatton. He had three more children in 1586,

1588 and 1592, although the last died almost immediately. He appears to have moved from house to house across the Leathersellers' estate and in 1587 took over the house of Richard Clarke, a barber surgeon, who had been evicted.[5] The rent on this property was £3-6s-8d, and it is puzzling that with three children and more on the way Hatton was prepared to spend nearly 40 per cent of his income on rent. Perhaps he always planned to let it or sub-let a part. He seems to have moved again by 1589, when this house was listed in the tithe survey under Richard Bootes, a (merchant?) taylor, who had married Elizabeth Dromine in 1582, but probably had no family. However, within three years, Bootes himself had moved on. Bartholomew Drum(e) had died in November 1591, and the Bootes moved into his former house, paying the £2-2s-0d rent. This is an interesting example of the rapid movements which could take place in renting and which often go unrecorded in documents. Within seventeen months Bootes was dead, possibly of plague, and was buried in St Helen's on 12 April 1593. Ten months later, his widow married Giles Mollett, a merchant taylor, in St Helen's on 25 February 1594.

In a 1604 lease for Hatton's main house, it is specifically stated 'as it is now sev(er)ed & divided late in the tenure of or occupacon of one Richard Clarke Barber Surgion and now in the tenure & occupacon of the saide John Hatton'[6] (Figure A.16). This is the only example of 'severed and divided' being used in a Leathersellers' lease at this time and suggests he had split the property up in some way, so that rent from sub-tenants could cover his costs. Presumably, the Leathersellers were happy to allow this as Hatton was their employee.

Meanwhile, Hatton would have much to occupy him, as from 1589–93 the Leathersellers were involved in a bitter legal dispute with Clement Finch and his wife Grace over their entire ownership of their St Helen's estate.[7] Then there were the constant ongoing building works and repairs on the estate. In 1587, the Leathersellers spent a large sum to 'built a garnade/garnett for provisions £189-3s-10d' and, more prosaically, in 1589 there was a bill for repairing 'the wyndowes about the halle and parler and almsehouses which was Spoyled in the Greatt wynde – 6s-8d'. From 1595, there are several references to disputes about two properties which had been leased by a leatherseller, John Baker, from the 1560s until his death in January 1589. These were next to the gate into Bishopsgate Street and there seems to have been a lack of evidence about what property the Leathersellers owned in this area. Thus in 1594,[8] 'Cousaile Master Bakers lease – 10s[hillings]', in 1595, 'John Hatton trying out tytell for the houses in st. Hellyns' – 40s[hillings]' and 'Paid to John Christian for that he layd owte in charges of Lawe about the houses that were Master Bakers per the companies apoyntment – £12', and in 1596, 'Tryall of Elexione Fiume' brought by Hatton 'for the houses that are in Bishopsgate Street – £7-7s-4d', and 'At Augmentation Court search' 'what landes dyd belonge to the priory of St. Hellyns' and 'for a copie – 40s'; 'copy of grant to Richard Williams – £3-10s[hillings]'. It is not clear how this case ended, but it is noticeable that

from 1597 there are a stream of carefully worded leases, suggesting the Leathersellers were making efforts to ensure stricter control over their properties.[9]

Hatton was responsible for maintaining the Leathersellers' accounts. Each year he would start the first page with an elaborate capital letter (Figure A.17). One has his own name in tiny letters hidden within the design. As well as dragons and other fabulous beasts, there are human faces, and a hunter with bow and arrow and a dog on a lead. Several contain Latin maxims: 'Veritas vincit omnia' [Truth conquers everything]; 'Deus videt' [God sees]; and 'Concordia nutrit Amorem' [Harmony nourishes love]. Probably the most dramatic and certainly the most gruesome is 'Veritas Temporis filia' [Truth is the daughter of time], written by a human head, apparently with a dragon biting off its nose and its tongue pulled out and tied in a knot. This phrase was claimed by both Protestants and Catholics in England, and it was Queen Mary's official motto.[10] These maxims are the sort of classical expressions that grammar school boys would typically have learnt. The drawings suggest an educated, imaginative and thoughtful man, just the sort of person who might have got on well with Shakespeare. Clearly, he felt confident enough in his abilities and status to decorate the accounts in this idiosyncratic manner.[11]

All through this period, Hatton continued to pay the £3-6s-8d rent for his main house. However, in 1597, he took on the lease of a second property next to the Leathersellers' Hall, presumably much smaller, since the rent was only 13s-4d. It would seem that Hatton was trying to augment his income. In the 1589 parish tithe survey, Hatton's main house is listed immediately after John Pryme's house and was presumably next door. Given that Shakespeare's name follows Pryme's in the 1598 Lay Subsidy roll listing, there must be a good chance that he was a lodger in either Pryme's or Hatton's house. In 1593, Hatton would have had five children – two under nine, but the two older girls would have been a couple of years older than Shakespeare's own daughters.

Hatton seems to have acted responsibly for the Leathersellers. He occasionally owed small sums of money, but nothing significant. It is intriguing that he seems adept at financial manipulation, as in his 1604 lease he converted 60 per cent of his rent into an annual fine of £2, meaning that his official rent was £1-6s-8d, which it had been up to 1569. This may, however, have been more an attempt to stop his tithe payment being increased than getting it cut, since the 1589 tithe payment was 4s-1d, equivalent to a nominal rent of £1-10s-0d. The only negative information about Hatton is in 1599, when the Leathersellers' accounts record, 'Payd in charges for our clarke beinge commytted to the coumpter [prison] – 2s[hillings]', unfortunately without any further explanation.

In the early 1600s, tragedy struck Hatton again. Both his elder daughters married; first Mary, aged twenty-one, to Richard Collins, a (merchant?) taylor, then Anne, aged twenty, to Thomas Swarson, another merchant taylor, with the Leathersellers helping out: 'Payd to John Hatton our clarke towards his two daughters maryages by order of

courte 40s[hillings]'.[12] Both rapidly had two children each, but all four grandchildren died in just over two years. Mary's second child, a boy, was stillborn three days before Anne gave birth to Alice, who only survived six months. The curse of high infant mortality was interwoven with the devastation of the 1603 plague. Furthermore, in 1602 William, Hatton's only son, died aged twenty. Hatton, like Shakespeare, now had no male heir.

Hatton was now in his early fifties, but he was considered active enough to be chosen as churchwarden from Easter 1605 until Easter 1607. On 5 September 1607, his servant Anthony Darlley was buried in St Helen's and recorded as a plague victim. Hatton, who had survived three major plague outbreaks, probably had some level of immunity, but on 5 April 1608 he in turn was buried, the register simply recording 'dead palsy' – perhaps the result of a stroke.[13] Hatton's widow, Joan, received an annual £5 pension from the Leathersellers and on one occasion their accounts also record them buying her a gown. In 1613, by which time her youngest daughter would probably have been married, she was provided with one of the Leathersellers' almshouses. There she lived out her long widowhood of thirty years, eventually being buried in St Helen's on 16 May 1638, aged close to eighty. She was possibly the last surviving person with direct experience of Shakespeare's residency in the parish.

Notes

1. Leathersellers' Archive, MS 145, examination of John Hatton, 24 June 1590.
2. John Warren, the son of William Warren, tallow chandler, a neighbour of John Hatton, was apprenticed to George Samwell c. 1590 and became a Freeman of the Scriveners in 1599. In a deposition of 1601, Israel Jorden is a witness in a case where a George Samuel the Elder is the defendant and one wonders if it is the same person; see TNA C 24/288.
3. In 1581, the Leathersellers were letting 'the stall under john hatton's shoppe in the use of (H)umfre lucy – 2s[hillings]'.
4. His wife also received a useful £1-6s-8d a year for washing the Leathersellers' table linen and cleaning the utensils.
5. 'Paid to Richard Clarke barbour to departe owte his house granted by courte, and the Rent that he did owe was forgiven him – £3-6s-8d'. Evictions were very rare on the Leathersellers' estate. Clarke had two wives die within sixteen months in 1584–6 and was behind with his rent. He died shortly afterwards in 1591 and was buried in St Helen's.
6. Leathersellers' *Copies of Leases and Deeds, 1555–1660*.
7. The Finches were descendants of Thomas Kendall the Elder. Through him, they claimed the St Helen's Estate; see Leathersellers' Company Archives M1433–1462.
8. This and the following references are from the Leathersellers' Company Archives, *The Liber Curtes* (Wardens' Accounts).
9. In the 1560s and 1570s, the Leathersellers' *The Liber Curtes* contains lists of leases but, unfortunately, only three from the 1570s appear to have survived in the *Copies of Leases and Deeds 1555–1660*, which seems to have been started in 1609 following John Hatton's death. The book starts with copies of older leases surviving in 1609 followed by new leases.

## Living with Shakespeare

10. See Iwasaki, 'Veritas Filia Temporis and Shakespeare', for a detailed history of this maxim in the late Elizabethan period.
11. William Averell (1556–1605), parish clerk at St Peter's Cornhill, added poems, comments and drawings to the parish burial registers, including a memorial inscription to his own wife in 1595. There are six elaborate capital letters which are very similar in style to those by Hatton. Although they are at the start of entries dated 1538 and 1558, they must have been done much later when Averell copied up the original register, which has not survived. This was probably *c.* 1580 or slightly later, and the designs are so similar that it seems possible that Hatton and Averell knew each other, likely given their similar professions; see Leveson Gower, *A Register of all the Christninges Burialles & Weddinges*, p. 126.
12. They had offered Elizabeth Spencer just ten shillings in 1599; see p. 197, note 10.
13. From 1603, Hatton's writing in the Leathersellers' accounts becomes simpler, suggesting he had some significant illness at this time, possibly a side-effect of the plague.

# 7

## Who Were Thomas Wrightson, John Harvey and Israel Jorden, Jordan, Jordaine, Jordayne, Jurden?

Regardless of whether he was a tenant in Pryn's house, Shakespeare probably knew him during his stay in St Helen's during the 1590s. However, the likelihood of John Pryn being the mortgage broker for the Theatre in 1579 is strengthened by the fact that there was another moneylender, Israel Jorden, living in St Helen's in the 1590s, who was definitely involved in financing theatre.

This connection began twenty years earlier, in the 1570s, with the career of Thomas Wrightson. He was a freeman of the Scriveners' Company, trained specialists who could not only read and write but could also produce, witness, record and enrol clearly written documents for legal and other purposes. Given their profession, it is not surprising that many scriveners became involved in the financial side of commercial contracts. Soon after he became a freeman, Wrightson is recorded in 1574/5 living in Peahen Alley, a side turning out of the north end of Bishopsgate Street in the parish of St Ethelburga.[1] He disappears in 1576–7 but reappears six years later, this time living around the corner in Bishopsgate Street itself.[2] He was listed as occupying the eighth house north on the west side of Bishopsgate Street, just a few doors up from entrance to the Bull Inn with its theatre performances, just beyond the entrances to the Green Dragon and Three Swans Inns. He was a deponent in a court case of 1576/7, where William Hagar, a salter, was the defendant.[3] The Hagars lived immediately south of the entrance to the Bull Inn, just across the parish boundary in St Helen's. In 1580, he was a witness for and probably drew up the will of Thomas Skynner of Paris Garden, St Saviour, Bankside, a successful river operator who owned ten properties and a barge.[4]

Wrightson seems to have moved again in 1587/8 to live on the other side of Bishopsgate Street in St Helen's, where he is recorded in the May 1589 tithe survey at the southern end of the parish.[5] During the early 1580s he became friends with Matthew and Joan Harrison, who ran the Bull, one of the four City inns which staged theatre and fencing displays. When Matthew died in the autumn of 1584, he helped his widow, Joan, to sort out her husband's significant debts.[6] When she, in turn, died in autumn 1589, Wrightson her 'neere frynde' and William Webb the Elder, 'farrior to the queens maiestie' were named as her executors, with an equal division of her estate described as 'goodes chattels plate Jewells readye money credits and debts'.[7] By 1593, Wrightson was taking on work north-east of the City, as he drew up a will listing properties in the parishes of St Botolph

and St Leonard, Shoreditch outside Bishopsgate, including the Half Moon, an important inn close to the Bedlam Hospital.[8]

It is not clear whether Wrightson became interested in theatre matters because he lived near the Bull, or if he moved to be near the Bull, then at the physical centre of London's theatre world before the 1594 'duopoly', because he was interested in theatre. Due to its location, the Bull probably acted as the main information exchange and an equivalent of an Elizabethan *poste restante* for theatre companies.[9] By early in 1589, Wrightson was also known to the wider theatre community, as he drew up the Deed of Sale by Richard Jones to Edward Alleyne, for theatre costumes, play texts and instruments worth £37-10s-0d:[10]

> That I Richarde Jones of London yoman for and in consideracon of the Some of Thirtie Seaven poundes and Tenne shillings of lawfull mony of Englande to me by Edwarde Allen of London gentleman well and trulie paid ... have delyured to the same Edwarde Allen All and singuler suche Share parte and porcion of playinge apparrelles playe Bookes, Instrumentes, and other commodities ... with the same Edwarde Allen, John Allen Citizen and Inholder London and Roberte Browne yeoman ...
> By me Richard Jones
> [witnessed] ...
> Johannis Harvey apprentice
> Thomas Wrightson Scrivener

It is interesting to note the reference to Roberte Browne, who later in 1599 bought into the Boar's Head Theatre, Aldgate, established in 1598. By 1590/1, Wrightson had moved again within St Helen's as he was leasing a house on the Leathersellers' Estate, where he died in January 1594.[11] His rent was £3-0s-0d, similar to John Pryn's £3-13s-0d, suggesting a medium-scale property. It was almost certainly (like Pryn's) in the area to the west of the main nunnery buildings and close to the main gateway into Bishopsgate.[12] Another Leathersellers' property, probably in this area, was leased in 1584 for the same rent of £3-0s-0d to Master Luke Lane, a solicitor.

At this point, it is worth following the career of John Harvey, who is recorded as Wrightson's apprentice in Richard Jones' January 1589 sale document.[13] His career path is unclear at this point, as he does not seem to have become a freeman of the Scriveners' Company. He is later recorded as a grocer, but unfortunately the relevant Grocers' account books are missing for 1593–1601, and Harvey does not appear in the lists paying 'brotherhood' money from 1601. A twentieth-century index states that he became a freeman of the Grocers in 1593, but it has not been possible to trace the source for this information. Perhaps, when Wrightson died in 1594, Harvey carried on a working

association with the scrivener Israel Jorden, who took over the property. John Harvey married his first wife, Mary, probably in 1597, and they settled in St Helen's as their first son, John, was baptised in the church on 18 December 1597, when he was described as a scrivener. Eleven days earlier, he had drawn up the will of John Stanton, a girdler who owned the Vine, the inn closest to Bishopsgate on the west side of Bishopsgate Street.[14] He was also doing commercial work for Alderman John Robinson the Elder, and wrote his will in July 1599. However, when his second child arrived in December 1599, he was described as a grocer. In April 1602 he witnessed the will of Edward Walker,[15] who owned the Green Dragon, the inn immediately north of the Bull. Walker owned several properties, including the Bull Inn itself, which he had recently purchased from George Maese.[16] Interestingly, there is also a reference to Walker leaving to 'my saide sonne John Walker all that longe barne called the Gunpowder house and the ground there unto belonging and the littell cottage . . . at the ende, thereof situate and being nere unto the Curtain in hollywell', where his 'brother' John Skerrie lived. This indicates the Curtain playhouse was not only still in operation, but was a recognised landmark.

The following year, Harvey's wife, Mary, two of his three young sons and his two servants died within a few days in September as the 1603 plague tore through the parish. At this terrible time, on 20 September, Harvey drew up the will of Edward Fenner,[17] a carpenter probably in his thirties, who lived in Bishopsgate Street and left his house to the parish. Fenner, who was 'sicke and weake in body but of good and perfect remembrance (praised be god)', had already contracted the plague, but survived for another eleven days. He may have contracted it from his son, who was buried on 3 September. Harvey's wife must have already been stricken, as she was buried on 22 September, her name marked as a victim. Somehow, two days earlier, she had given birth to a son, Thomas, while in the throes of dying from plague herself. Thomas only survived for a few days, and was also marked as a plague victim in the parish burial register. Perhaps Harvey felt that writing out wills was a way to help his doomed neighbours as they endured the agonising pain of the plague and the enforced isolation from their friends. On 29 September, five days after burying his baby boy, Harvey drew up the will of Rowland Blackbourne, a vintner of St Ethelburga, who left him forty shillings.[18] This assumes that John Harvey the scrivener is John Harvey the grocer. This seems highly likely, as in his own will Harvey stated that it was 'written with my owne hand'[19] and he also left forty shillings to the Company of Parish Clerks.

Like many people who lost a partner to plague, John remarried swiftly. In his case it was within six months, as his new wife, Emme, gave birth to a girl, An[ne], in January 1605. Harvey thus acquired a stepmother for his six-year-old son John. John Harvey junior was clearly bright, as when he grew up he gained a MA Arts. Emme produced four sons between 1607 and 1615, all of whom were still alive when Harvey made his will in 1623. She then had twin girls, Mary and Martha, in November 1617, but unfortunately

they died immediately and were buried in St Helen's – as was another baby, Humpfrey, the following year. Three years later, in January 1621, John must have been devastated when his clever twenty-three-year-old-son and his second wife died within a few days of each other. However, despite having now buried eight relatives in St Helen's, John Harvey seems to have been positive about the future, as he married his third wife, Elizabeth Adams, a fellow St Helen's resident, in the church in September 1622. Eight months later, he joined his previous two wives with a grave 'in the church porch' on 8 May 1623.

On Wrightson's death in February 1594,[20] his lease was taken over by another scrivener, Israel Jorden.[21] The record states: 'House of Israel Jorden wherin while he lived dwelled Thomas Wrightson'.[22]

Israel Jorden lived on in the same property for nine years, and was buried in St Helen's on 29 May 1603.[23] However, Jorden, in addition to being a member of the Scriveners' Company, was a moneylender, as Wrightson may have been, and he was lending money to a theatre entrepreneur. After the first wave of four theatres in 1576–87, there was a gap of seven or eight years. However, in the mid-1590s, the establishment of the two major acting companies in May 1594 at the Theatre and the Rose seems to have encouraged others. In 1594/5, Francis Langley built the Swan on Bankside despite opposition from the Mayor, Sir John Spencer. At the same time, north of the River Thames, Oliver and Susan Woodcliffe decided to convert the yard of the Boar's Head Inn, just outside the City boundary at Aldgate, into a play yard.[24] It was this latter project that Israel Jorden was involved with. On 28 November 1594, the inn owners signed a lease with the Woodcliffes. The agreement stated that from 25 March 1595, over the next seven years, they would spend at least £100 building a stage and a tiring house. £100 would not have bought a large structure, and a basic stage was constructed in 1598. Evidently, the site was felt to have potential, as the facilities were rebuilt in 1599. By that time, the Theatre had migrated to Bankside, leaving a major commercial opportunity to cater for the audience in the north-east of the City and the adjacent densely populated suburbs. Oliver Woodcliffe was a man who came with a track record of using real or threatened force to get what he considered his own property. There is insufficient space to detail here the resulting legal and other shenanigans at the Boar's Head. As Theodore Leinward has written: 'An extraordinary tangle of obligations, indebtedness, leases, and bonds underwrote The Boar's Head playhouse as well . . .'[25]

In 1599, Francis Langley got involved, and violence soon followed. He was accused of coming with armed men to the Boar's Head to assault the owners.[26] Looking back over the tumultuous events of the previous five years, Oliver Woodcliffe stated on 20 May 1603:

> Israiell Jordane of London Scrivener belonging unto ye said Broune & his fellow stage players . . . by whome the said Broune is directed and advised in all his indirect dealeings & unlawefull Courses.[27]

Documents show that Israel Jordan had been involved in financial dealings with Robert Browne since at least May 1600. A deposition of 27 May 1601 records a court case between William Woodward, gentleman,[28] and Robert Browne, where Jordan, Richard Samwell the Elder, Roland Rose (a servant of Samwell), Francis Kente and William Jeroe(?) were called as witnesses. The core of the case was 'whther a yeare paste or thereabouts did Richard Samuell the Elder make a bonde of Twentie markes [£6-6s-8d] to paye the pl[aintiff – William Woodward] Twenty nobles in October Last yea or noe.' At this point, Browne owed Samwell (the Elder) £60.

Maybe Israel Jorden was just a local scrivener in Bishopsgate Street, who only got involved in the theatre world in 1599 when Robert Browne took the opportunity to acquire Richard Samwell the Elder's share of the Boar's Head.[29] However, it is intriguing that he was living in a house where the previous occupant, Thomas Wrightson, had dealings with Robert Browne and Edward Alleyn as far back as 1590 and a strong connection to the Bull Inn with its theatre. What seems more likely is that Israel Jorden continued Wrightson's services to a network of merchants, inn holders and theatre practitioners. This raises the thought about where Shakespeare felt his loyalties lay in 1598. With the failure of Burbage's Blackfriars project in 1596 and the uncertainty of the Lord Chamberlain's Men, he may have felt that some investment in the Boar's Head was a sensible insurance policy. In 1599, the 6th Earl of Derby was described as 'busye in penning comedyes for the common players' and the company had the honour of first performing at court at Shrovetide 1599/1600. Shakespeare, ever the pragmatist, would surely have kept a sharp eye on the emergence of this new venue.

The Boar's Head playhouse may also account for the two actors recorded as living in the parish of St Helen's, probably after Shakespeare had left. Suzanna, daughter of John Harrison, 'player', and his wife, Anne, was baptised in St Helen's on 10th January 1602. There are no further records of this family, so they may have stayed only briefly. In contrast, Robert, son of William Shepherd, 'player', and his wife, Johane, was baptised almost a year later on 26 December 1602. However, the 1603 plague was to bring an abrupt and tragic turn of events. With the closure of the theatres, William seems to have taken up tailoring to feed his young family as his wife was pregnant again. In the summer heat, the death toll from the plague mounted, with the first two burials specifically recorded as such at the end of June.[30] In July, there were five burials; in August, twenty-three and in September fifty-six, mostly from the plague. Among them, on 18 July, was the Shepherds' six-month-old son, Robert, buried in the churchyard. The shock may have made Joane give birth prematurely, since on 30 August John, 'son of William Shephard, Tayler and Johane his wife', was baptised and then buried.[31] The following day, Johane was buried. William then disappears – perhaps he moved east to the parishes of St Botolph, Aldgate or St Mary, Whitechapel, where there was a cluster of actors associated with the Boar's Head playhouse.

Meanwhile, Francis Langley had died in January 1602,[32] and Robert Browne in October 1603 during the plague. Joan Alleyne, wife of Edward Alleyne, informed him in a letter that 'Browne died very poor', leaving a young family of five including the future actor William Browne, born in April 1602, and a daughter, Anne, born posthumously in 1604.[33] Thereafter, the conflicts at the Boar's Head playhouse seem to have died down. Browne was not the only theatre victim of the 1603 plague year. On 30 July 1603, Oliver Woodliffe, who had been the original mover behind the Boar's Head Theatre, was buried in Whitechapel along with twenty-seven other dead. Two months earlier, on 29 May, the St Helen's register recorded the burial of Israel Jorden. He remains an intriguing and enigmatic figure whose role in London theatre around the time of the crucial changes in 1599 remains unclear. It is unfortunate that no records have been traced, apart from his rental payments to the Leathersellers, which would reveal his activities in the crucial years from 1594–9. Hopefully, more records of Wrightson, Harvey and Jorden will be identified, allowing a better understanding of their relationships at this time.

## Notes

1. Listings preserved in the records of payments for the parish clerk, which begin in 1569; see LMA GL MS 4241/1. David Kathman has demonstrated that the collectors started at the south end on the west side of Bishopsgate Street with William Harrison who leased the Bull Inn and then worked up the street then crossed over and came back down the east side; see Kathman, 'Hobson the Carrier and Playing at the Bull Inn'.
2. A deposition of 1576/77 (TNA C24/126A) states he was then thirty-two, and others of 1582 and 1587 that he was thirty-six and forty-one, indicating he was born 1545/6. He was apprenticed to Thomas Bradforth and became a freeman of the Scriveners' Company on 9 March 1573, when he would have been about twenty-seven. He then took on an apprentice, John Stacey, who became a freeman on 6 August 1590; see Steer, 'The Common Paper'.
3. The case concerns twenty-five tons of malt (a hundred quarters) acquired by William Hagar from Ashwell in Hertfordshire; see TNA C 24/126A. Wrightson's earlier association with the area is borne out by another deposition from 1585, relating to a property in St Peter Cornhill, where he states he has known both the parties for seven years, i.e. from around 1578; see TNA C24/177R. If this is the case, he would have been in the area when James Burbage mortgaged the Theatre in 1579.
4. TNA PROB 11/62, ff.148v-150r (register copy). Each scrivener had to do a test piece of work in the book, and Wrightson's is flanked by a flowery TW logo.
5. Given Wrightson's residence in front of Crosby Hall, it is hardly surprising that Margaret Bond's will (TNA PROB 11/73/94), drawn up on 1 May 1588, was done in 'the presence of me John Harvie apprentice to Thomas Wrightson Scr'.
6. For his pains Wrightson was sued in 1591 and 1592; see Kathman, 'Hobson the Carrier and Playing at the Bull Inn'. He also was a deponent in cases involving Edward Walker, who owned the Green Dragon Inn, so he seems to have been a respected local figure. The fact that he lived in at least five different properties (four known) in two adjacent parishes over twenty years, shows the difficulty of tracking the residences of individuals, particularly if they were unmarried, as may have been the case with Wrightson.
7. Detailed in Kathman, 'Hobson the Carrier and Playing at the Bull Inn'.

8. Will of John Wood, brewer, TNA PROB 11/82/277. Robert, John's father, is recorded as living at 'le Signe de le hulfe Mone' in 1543. John left the Half Moon brewhouse with eight houses to his mother, Joanne, in 1593 and she then sold the site to Ralph Pindar in 1597 (recorded in the 1599 LSR for St Botolph). It was Sir Paul Pindar a rich Turkey merchant and Ralph's brother, who then erected his mansion on the site *c*. 1599, the front of which is preserved in the V&A Museum. Wrightson appears as a witness in various cases at this time: see TNA C 24/126 A in 1576/77; C 24/177 R in 1585; C 24/190 W in 1586 and C 24/217 P in 1590. It is conceivable that Wrightson drew up the agreement for John Hyde's loan in 1579, but since it only survives as a report from 1592 there is no original signed document.
9. One is reminded of Denmark Street in London's West End, until its recent redevelopment, which played a similar role for the music business. In the late 1960s, David Bowie, Mark Bolan, Elton John and many others hung out for hours in the Giaconda Café because it offered cheap tea and the luxury of a telephone.
10. See Item 6, dated 3 January 1588/9, in Rutter, *Documents of the Rose Playhouse*, pp. 42–3. Richard Jones was moving to work on the Continent but returned to England in the mid-1590s.
11. Such local movements are seen with other residents, such as Bla(i)se Saunders, who lived in St Helen's before taking up a lease in 1576 on the Leathersellers' estate.
12. Wrightson's property was described as being in Bishopsgate Street and would have been almost opposite the entrance to the Bull Inn. The property was occupied previously, from at least the 1550s, by Edmund Stone, a sadler. In 1552, this property was recorded as being 'on the street side', which was the term for the properties to the west of the main nunnery closer to Bishopsgate Street.
13. This assumes that it means he was Wrightson's apprentice, rather than saying he was an apprentice, which would be odd in a legal document.
14. TNA PROB 11/94/167.
15. TNA PROB 11/99/336.
16. Probably a relative of a grocer, Robert Mase, who lived in Bishopsgate Street in St Helen's in the 1570s.
17. A copy of Fenner's will was written out at a later date on an empty page at the end of St Helen's parish accounts (1565–74; PS/HEL/B/004/MS 06836), along with records of other donations to the parish.
18. See TNA PROB 11/102/255. At this time, Blackbourne rented the cellars of the Leathersellers' Livery Hall as a store.
19. TNA PROB 11/141/745.
20. Wrightson is not recorded as a victim of the 1593 plague but this is a possibility since he was only in his late forties when he died early in 1594. No evidence of a family or will has been traced so far. He was buried at the feet of Mrs Christian Robinson, wife of John Robinson the Elder, wool merchant. The Robinson family graves occupied the north-west corner of the former nuns' quire, below a large wall monument. This suggests Wrightson may have had close links with the sprawling Robinson family. His ex-apprentice, John Harvey, certainly did, as he drew up an indenture in a Star Chamber case about a troubled property purchase in Yorkshire for John Robinson the Elder on 9 May 1597. This related to a group of properties south of York owned by John Aske, MP (*c*. 1564 – *c*. 1605) for Yorkshire in 1593, who had tried to defraud Robinson; see John Aske in *The History of Parliament* online. These included the former Benedictine nunnery of Thirkhead Priory. Robinson had paid Aske £2,550 but had not received the legal title. On the back of the document (LMA ACC/176/F/04/23) it reads: 'sealed and delivered in the presence of us John Harvey of London Scr[ivener]'. This document is important as it may show John Harvey's writing for comparison with other unattributed documents, at a time when Shakespeare was living in St Helen's. The Aske papers, including a copy of John Aske's will, are held at the University of Hull.
21. Despite the unusual surname, there is no evidence that he was related to Dr Edward Jorden. A legal deposition, TNA C 24/288, indicates that Jorden was fifty in 1601, so he would have been born *c*. 1551. The Bishop of London issued Israel Jorden, then of St Bride's, Fleet Street, and Elizabeth Parpointe, a widow of St Bartholomew near the Stocks, with a general marriage licence on 30 March 1577; see Chester, *Allegations for Marriage Licences*, vol. 1, p. 74. It is not clear if the marriage took place, as a 'Wydowe Perpoynte' was recorded nearby in St Peter Cornhill/St Andrew Undershaft in the 1582 Lay

Subsidy roll (£3) and Jorden's wife in 1603 seems to have been called Anne. Jorden received his freedom of the Scriveners' Company on 15 July 1577, the same day as John Hatton, who was to become the future clerk of the Leathersellers, and George Samwell, notary public, who apprenticed John Warren, son of Elizabeth Warren, in the 1590s, rising to be warden in 1599 and eventually master. Either might have tipped off Israel Jorden about the vacant premises, particularly if Wrightson had no family and had left his tools and materials.

22. The Leathersellers' Company Archive, *The Liber Curtes.*
23. He is not listed in either the 1598 or 1600 Lay Subsidy rolls for St Helen's, which would usually indicate that he was below the £3 limit. Scriveners clustered around the Chancery Lane area, where some were assessed at £3 or £4, but rarely more. Jorden was buried in the church 'betweene Thomas Wrightson and M[ist]ris Garrard', suggesting a connection with Wrightson that was more than just professional. His name is miswritten in the burial register as Israel Fareen. Thereafter, the property was recorded by the Leathersellers as 'the House of Widowe Jorden alias Dod', since on 20 February 1604, Anne Jorden married the recently widowed Peter Dod(d). Dod(d), a grocer, had lived in the St Helen's area for over thirty-nine years, since he is recorded in the Grocers' Company accounts from at least as early as 1564. He is not listed in 1559, and the records for 1560–5, when he would have become a freeman, are lost. His first wife, Joane, had died five months earlier and was buried in St Helen's on 10 September 1603. However, it was a very brief second marriage as Peter, in turn, was buried nine months later on 15 November 1604. Peter Dodd was an associate of John Pryn as they bought materials together; see section 5 of the Appendix, n. 21. Intriguingly, the Thomas Wrightson/Israel Jorden house leased by them successively from the Leathersellers in 1590–1603 was eventually re-let in 1609 to a third scrivener with theatrical connections. John Warner/Wardnar (c. 1584–1649/56: will TNA PROB 11/207/331) was variously described as a woodmonger, scrivener and public notary and became the parish clerk of St Helen's in 1629. In 1615, he wrote the will of Robert Armin the comedy actor who replaced Will Kempe in the Lord Chamberlain's Men c. 1600. Armin lived in the parish of St Botolph, Aldgate which stretched around to Bishopsgate. There is also a recommendation letter, dated January 1618, in the Dulwich Henslowe-Alleyn Archive (MSS 3 - 079) from John Warner to Edward Alleyn. In 1616, he wrote the will of Mary Basse, wife of the East India Company member Humphrey Basse and mother of Captain Nathaniel Basse, who founded Basse's Choice on the James River in Virginia in 1621.
24. For the general history of the Boar's Head playhouse, see Berry, *The Boar's Head Playhouse.*
25. Leinwand, *Theatre, Finance and Society in Early Modern England*, pp. 68–9. For a detailed evaluation, see Berry, *The Boar's Head Playhouse*, pp. 21–71.
26. On 16 December 1599, Francis Langley and some thugs arrived in the dark at the Boar's Head to arrest the part owner Richard Samwell. He later stated that the gang came with 'Weapns drawen' and 'very sore beate and hurte' Samwell and his son 'in theyre Armes and legges and div*erse* p*a*rtes of theyre bodyes . . . intending to murder and klyll' and that they 'did in the darke throwe div*erse* daggers and other Wepons . . . w^ch weapons hardly myssinge . . . did stycke in the wales of the said house'. While there was doubtless some dramatic licence here for the benefit of the court, the fracas illustrates the violent underbelly of the theatre world in which Shakespeare worked and thrived.
27. For the broader role of scriveners in the theatrical profession, see Woudhuysen, *Sir Philip Sidney and the Circulation of Manuscripts*. Sisson considered that this 'certainly suggests that he was the scribe and book-keeper of Worcester's Men'; see Sisson, *The Boar's Head Theatre*, p. 73. The Earl of Worcester's men had a long history, including in 1583 employing the sixteen-year-old Edward Alleyn, but it was at the end of the century that Edward Somerset, 4th Earl of Worcester, obtained a licence from the Privy Council on 31st May 1602, making it the third officially recognised company in London. They played at the Boar's Head at various times, 1598–1602. However, Berry, *The Boar's Head Playhouse*, pp. 191–7, clearly unpicks that there were two Robert Brownes, and this one managed the Earl of Derby's Men rather the Earl of Worcester's Men. Berry considers that Robert Browne's wife, Susan, may have had a connection with Worcester's Men.
28. The William Woodward, gentleman, here has not been traced further. It is possible that he was related to the large Woodward family based at Upton in Buckinghamshire. George Woodward, MP,

who died in January 1598, married Lucy Honeywood in St Helen's in 1579. Her brother, Robert Honeywood II, lived in the parish to be recorded as 'Affid' in the 1598 Lay Subsidy roll.
29. Berry, *The Boar's Head Playhouse*, p. 36, suggests that Browne paid £260 for his share in the Boar's Head; see also Appendix 6, pp. 177–8, and Appendix 9, pp. 191–7, for more about Browne. He appears to have married his wife Susan early in 1599 and moved into the local parish of St Mary Matfellon, Whitechapel before December 1600, when his second child, Susan, was baptised there.
30. One of these was Thomas Long, 's[e]rv[an]t to Abraham Gramer, Silkweaver'. Over the next four weeks, three more of his servants died, suggesting his house may have been where the infection started in St Helen's. The 1603 plague probably killed *c.* 20 per cent of the parishioners, twice as many as in 1593. By December, victims were recorded from about fifty-five houses, or about half the households in the parish. It is noticeable that the richest English residents seemed to be largely unaffected, possibly because they left London. Although some of the most affected households were immigrants – Mathias Stilt, Levan vander Stilt's 'servant' (5 died – his wife, 3 sons, 1 servant), Abraham Gramer (4 died – all servants), Peter Vanderscuer (3 died) – there were also badly affected English families, such as John Harvey, scrivener and grocer (6 died – wife, 2 sons, 3 servants), Jane Tedder, widow (4 died – 1 son, 1 daughter, 2 lodgers) and Robert Ward, haberdasher (3 died).
31. However, this would have required Johane to conceive almost immediately after birth and to have had a premature baby. John was marked as a plague victim. If it is the same William Shepherd/Shephard, then he could have taken up tailoring as a result of the closure of the theatres due to severe plague in 1603.
32. For the later activities of Langley and Browne at the Boar's Head, see Berry, *The Boar's Head Playhouse*, pp. 51–4 and pp. 195–7, where he distinguishes their involvement from the use by Worcester's Men.
33. See Rutter, *Documents of the Rose Playhouse*, pp. 214–15, Document 113, letter of 21 October 1603: 'All the Companyes be Come hoame & well for ought we knowe, but that Browne of the Boares Head is dead and dyed very pore'. Susan, left with five children under five, married the clown Thomas Greene. He moved to Whitechapel *c.* 1604, suggesting Susan remarried within a year. Following his death in August 1612, aged about thirty-nine, Susan married the bigamist James Baskerville a year later.

# 8

## Who Were John, Antonia and Katherine Jeffrey?

There were a few households in St Helen's that consisted of older couples who either did not have children, or whose children had left home. As a result, they might have taken in lodgers. These included John Jeffrey, an embroiderer, and his probable second wife, Katherine, assessed at £3 in the 1598 Lay Subsidy roll.

Quite a lot can be discovered about John Jeffrey (probably born before *c.*1545 – buried in St Helen's on 29 October 1601), since he was a foreigner and, as such, attracted the attention of the authorities. He was originally an immigrant from Valenciennes, which is now just inside the north French border, near Lille, but was then on the southern edge of the Spanish Netherlands. In 1568, he is recorded as living in St Helen's as a tenant of a Mr Holinshead, otherwise unrecorded in the parish, and heading a household of seven Dutch adults.[1] These were his wife, 'Anthony' (presumably Antonia), brother James and four 'dutch maids': Julian Delacroes, Mary Seliar, Isobell Molkeman and Katherine Warme.[2] He is described as a merchant, but in later documents as a milliner and an embroiderer. The maids were perhaps specialist embroiderers/lace makers or, possibly given later events, had another function. It would have been an organisational challenge to bring this group of refugees to England and one would assume that John Jeffrey had not only completed his apprenticeship but must have been old enough to have built up some financial resources. His home town of Valenciennes had been one of the first to rebel against its Spanish masters in 1566, but control was soon wrested back. Philip II's general, the Duke of Alba, unleashed a campaign of brutal repression against the Dutch through his 'Council of Troubles'. On 4 January 1578, eighty-four Protestant protesters were executed in the main square of the town; and this was just one incident among many.[3]

Through all these months, the frightful cruelties of the blood-judges were continued. Every day the executions took a wider sweep. 'I would have every man feel that any day his house may fall about his ears,' wrote Alva to Philip II. 'The fury of the persecution spreads such horror throughout the nation,' said William of Orange at the time, 'that thousands, and among them some of the principal papists, have fled the country where tyranny is direct against all.' The Jeffreys may have been forced to leave in 1566/7, as John is recorded as 'came five years past to England for religion and is of the French Church'.[4] This suggests that John Jeffrey was either French-speaking or quite possibly bilingual.

In 1571, the three Jeffreys were still in St Helen's, but their servants were now Elizabeth Peters and Anthony Caviliar, both 'born in Flanders'. Five years later, in 1576, there is no record of the Jeffreys in the St Helen's Lay Subsidy roll, and it appears that John Jeffrey moved to Lambeth Hill.[5] At some point between 1571 and 1576, his wife Antonia must have died or disappeared, as it was probably his second wife, Katherine, who was brought before the Bridewell Court in July 1576 for an affair two years earlier with Robert Bradley at the 'house of Wallis' in Elbow Lane.[6] Thereafter, there are several references in the Bridewell records for 1576–7 to John and Katherine Jeffrey being involved in illicit sexual activities.[7] These seem to have gone beyond just casual affairs to certainly the fringes of organised prostitution, since they were mixed up with Thomas Boyer, a well-known 'bawde' (pimp). Just before Christmas 1577, Jefferies 'of Lambeth hill [had] to bringe in a harlott by his bonnde'. Sometime afterwards, the Jeffreys moved again to the densely populated area outside Bishopsgate in the parish of St Botolph, where he ('John Jefferye', assessed at £3) is recorded in the 1582 Lay Subsidy roll. He is listed under the 'Englishmen', so he must have been naturalised by then. This change in nationality status would have allowed him to buy property. A document detailing where John, described as a 'myllener', paid his Lay Subsidy payment in 1589 (on a valuation of £3) indicates that they were then still in the parish of St Botolph.[8] He does not appear in the May 1589 St Helen's tithe survey, but is listed in the 1598 Lay Subsidy roll. By then, he would have been in his fifties or sixties.[9] While it is speculation, one could envisage Shakespeare renting a floor from such an elderly couple. They would have the benefit of a steady income to help support them in old age and a quiet, hard-working tenant in his thirties. Shakespeare would have a landlord who was probably not too inquisitive and who could probably afford a servant or two to undertake the domestic chores.[10]

One says speculation and there is no conclusive proof that the Jeffreys specifically lived in the Close, rather than elsewhere in the parish.[11] However, if one looks at where Shakespeare was living five or six years later, when he moved to Silver Street near Aldersgate *c.*1602–4, the potential parallels are intriguing. In Silver Street, Shakespeare was living with a French immigrant from Crecy in northern France, who was probably in his forties. Christopher Mountjoy, Shakespeare's landlord, was also an upmarket craftsman, and indeed his elaborate and fashionable head-tires sometimes would have included specialist embroidery or lacework.[12] It is interesting that in 1575/6 and later in 1589, John Jeffrey is described as a milliner, with its strong association of making female headwear, which might have included head-tires.[13] Charles Nicholl notes Shakespeare's various references to head-tires, starting with the *Two Gentleman of Verona*, *c.* 1590, which was more than a decade before he started living with the Mountjoys. By 1602/4, John Jeffrey was dead, but one wonders if some link within the Huguenot craft community provides the connection between Shakespeare's various

homes in London. It is worth noting that Christopher Mountjoy appears to have had a possible relative, John Mountjoy (Mountoye). In the 1582 Lay Subsidy return for St Botolph, Bishopsgate, his assessment at £10, meaning that he was well off, appears ten lines above John Jeffrey's name.[14] It is, of course, possible that Shakespeare knew the Jeffreys from living in St Botolph when he arrived in London, and later moved in with them when they relocated back to St Helen's.

But even supposing there is a connection, it does not explain why Shakespeare, born in a Warwickshire town where he may never have seen a foreigner while growing up, became enmeshed in the French Huguenot community in London. As we have seen, the early 1590s was a period of rising tension with London's immigrants, so something or somebody must have been a strong draw to a community where his knowledge of the language, whether French or Dutch, was probably initially slight. There were none of the exotic links to the Mediterranean world which would have come from a connection with the much smaller group of Italians in London. What was the appeal – the anonymity of a no-questions-asked group with no great love of the civic authorities? A desire to explore other languages apart from English and Latin? Sexual attractiveness? Good food? Or perhaps a combination of all four?[15] It has long been recognised that Shakespeare had a knowledge of French, which he later used in the Princess Catherine/Alice scene in *Henry V*, Act III, Scene 4.

Notes

1. The 1568 Survey of Strangers records housing being rented to at least fifteen immigrant families by nine named English landlords, who all seem to be wealthy locals. These included future MP Thomas Coleshill, one of whose tenants was Richard Masters (?–1587), a goldsmith, who was an earlier immigrant *c.* 1547 now naturalised (?). Masters, in turn, was also sub-letting accommodation to two other immigrant families. Who was Mr Holinshead?
2. See 1568 Return of Strangers.
3. See *Executed Today*, 1568: 'Eighty Four Valenciennes Iconoclasts', 4 January 2015, <http://www.executedtoday.com/?s=Eighty+Four+Valenciennes+Iconoclasts> (last accessed 20 July 2020).
4. See Kirk and Kirk, *Returns of Aliens Dwelling in the City*, 1571; Return of Strangers, p. 57.
5. It is not absolutely certain that this is the same John Jeffrey but it seems highly probable.
6. See *Minutes of the Courts of Governors of Bridewell 1559–1971*, BCB-03, <https://archives.museumofthemind.org.uk/BCB.htm> (last accessed 4 August 2020) for 7 July 1576. She had confessed in front of Mr Kelke of St Helen's the previous day.
7. See *Minutes of the Courts of Governors of Bridewell 1559–1971*, BCB-03, <https://archives.museumofthemind.org.uk/BCB.htm> (last accessed 4 August 2020) for 27 September 1576, 19 and 21 December 1576, 10 and 11 May 1577 and 20 December 1577.
8. See his certificate recording his residency for paying the lay subsidy, 1589.
9. 'Katheren Jeffery, widdow', presumably his second wife, was buried in St Helen's on 21 January 1606 /7, with a note describing her as 'Aged'.
10. An indication that the Jeffreys were renting out rooms in the 1590s is suggested by a reference in the parish burial register on 8 March 1599 to 'a crysome childe of Willm Collins and Anne his wife being a man childe, out of Mr Jeffryes Howse', although possibly Mrs Jeffrey could have been acting as a

midwife. There is no other record of these Collins in the parish. The fact that William is given no trade and they are listed as a couple suggests they might be tenants rather than servants.
11. However, the fact that John Jeffrey's name is four below Shakespeare's in the 1598 Lay Subsidy roll and immediately below the wealthy Dr Edward Jorden suggests he lived in the Close area.
12. See Nicholl, *The Lodger*, pp. 139–71 for a description of the origin and spread of fashionable head-tires and the supply by 'Mary Mountjoy, tyrewoman' of head-tires to Queen Anne of Denmark in 1604–5.
13. Thomas Cheston (?–1587), the first husband of Joan Axton, was described as a wiredrawer, a skill necessary for producing the support framework of head-tires and the decorative metal thread. Stephen Belott, Christopher Mountjoy's apprentice and one of the central figures in Shakespeare's appearance in court in 1612, had his wiredrawing equipment stolen in 1619 by 'heavies' working for the people who had been given a monopoly over silver and gold thread; see Nicholl, *The Lodger*, pp. 275 and 305. His daughter Anne married William Haier or Hayer, a wiredrawer.
14. The possible Mountjoy connections are explored in Nicholl, *The Lodger*, pp. 99–101.
15. Crecy is 100 miles from Valenciennes, with the major textile centre of Arras lying midway between them.

# 9

## Some Other Residents of Saint Helen's in the 1580s and 1590s

There are a few other St Helen's residents who are worth mentioning because they link the parish to the murkier edges of the Elizabethan underworld and espionage. This, in itself, is not surprising, since Sir Francis Walsingham (*c.* 1532–1590), Elizabeth's spymaster, lived about five hundred yards away in Seething Lane, strategically positioned close to the Tower of London.[1]

When Shakespeare arrived in London in the late 1580s, the London stage was dominated by the new plays of Christopher Marlowe and Thomas Kyd. Shakespeare must have been horrified by the news, probably on Thursday, 31 May 1593, that Marlowe had been killed the previous day in a brawl over a bill – the 'reckoning' – following a supper at Mrs Bull's house in Deptford.[2] It should be remembered that the playwright Robert Greene had died in poverty nine months earlier aged only thirty-four, and Shakespeare would presumably have known of the arrest of Thomas Kyd, who shared lodgings with Marlowe, on the 12 May and his torture, which perhaps led to his early death aged thirty-five on 15 August 1594. Three premature deaths in twenty-four months, torture and the fear of denunciation by informers must have made anyone writing for the theatre concerned for their own well-being.

It is, therefore, curious, to say the least, that amongst the names recorded five years later in St Helen's in the 1598 Lay Subsidy roll is one 'Henry Mawnder', a Queen's messenger, assessed at the minimum £3.[3] It was Henry Maunder who, on the 18 May 1593, was ordered by the Privy Council to bring Marlowe to the authorities, issuing a:

> warrant to Henry Maunder one of the Messengers of her Majesty's Chamber to repair to the house of Mr. Thomas Walsingham in Kent, or to any other place where he shall understand Christofer Marlow to be remaining, and by virtue hereof to apprehend and bring him to the Court in his Company. And in case of need to require aid.

Given Marlowe's violent history, the last line is hardly surprising – but it was Marlowe who was dead twelve days later, aged just twenty-nine. Mawnder/Maunder is an unusual name. That the Henry Mawnder is the same person is suggested from two further references in the St Helen's records, on 1 September 1603 to the burial, from plague of 'Christian Cannion, servant of Henry Maunder' and the burial on 30 July 1608 of 'Issabell Maunder, Widowe'. Isabel is not recorded as dying of plague but there were

several victims buried around this time. These records show that Henry Maunder must have died around 1603–8 and away from the parish, perhaps outside London.[4] He was not buried in St Helen's, and presumably was living there throughout the entire period that Shakespeare was in the parish.

It seems likely that, given the reputations of those involved in the death of Marlowe and the brutal interrogation and consequent death of Kyd in 1594, Shakespeare would have sought information from someone so closely involved in the events and living close by. A well-off 'stranger' merchant, Godfrey Canion, with his wife and two servants, are recorded as living in St Helen's, possibly in the Close itself, in the 1576 and 1582 Lay Subsidy rolls (in the latter record referred to as 'alias Anthony Jorrey'). There is no record of a Christian Can(n)ion at that time, or in later surveys, but even if she was not related the name suggests an immigrant or English-born person of Huguenot stock. In itself, the fact that Henry Maunder lived in St Helen's is not surprising, given his job. Bishopsgate was the main gate for the road to the intellectual and religious centre of Cambridge, the Archbishopric of York and the Court of James VI of Scotland in Edinburgh. The area was full of inns where he would be able to hire a horse for his journeys.[5]

However, further examination shows some possible strange connections. On the line below Henry Mawnder on the 1598 Lay Subsidy roll is a name which is difficult to interpret. Professor Alan H. Nelson has examined it in the National Archives and thinks it may read, 'Affid Mrs Poole – £10 [her assessment] – 26s 8d [1st payment in 1598]', double Shakespeare's assessment. Fifteen years earlier, after his marriage in 1572, the parish register records on 22 April 1583 the baptism of 'Anne d[aughter] of Roberte Pollye'. It is generally accepted that this is the Robert 'Sweet Robyn' Po(o)ley who was an English double agent, messenger and agent provocateur employed by the government; he was described as 'the very genius of the Elizabethan underworld'. He is now best remembered for his central role in the Babington Plot in 1586, which led to the execution of Mary Queen of Scots in 1587, and for his presence in Deptford on 30 May 1593, when Marlowe was killed or probably murdered. In summer 1584, Robert Poley appears as 'poolie' in the anonymous satirical pamphlet smuggled into England from France titled *Leicester's Commonwealth*, which viciously attacked Queen Elizabeth's favourite, Robert Dudley (1533–88).[6] It calls Pooley one of Leicester's henchmen [17, pp. 96–7]. Pooley was also interrogated for possessing a copy.[7] Mrs Poole then disappears from the records.[8]

If the possible presence of Maunder and Pooley together in St Helen's was not curious enough, there is another interesting record. A document in the British Library, Lansdowne MS 33/No. 59,[9] provides a list of people in St Helen's in 1581 who were 'Strangers who go not to church'. The first four are a bricklayer and a labourer with their wives. However, the remaining six are of higher status – Nicholas Gastrell, yeoman; Robert Harvie, yeoman; Georgius Pooley, yeoman; Thomas Watson, yeoman;

Oswaldus Fetche, yeoman; and John Gyfforde, Esq. The most likely reason they were not at church was because they were Catholics, or potentially Protestant separatists. Several names leap out of the page. George Pooley is probably the cousin of Robert, who was caught trying to smuggle him into the country – much to the anger of the authorities. Seventeen years later, Oswald Fetche is still in the parish, as he was listed in the 1598 Lay Subsidy roll.[10]

The much bigger fish in the list is 'John Gyfforde'. This is almost certainly John Giffard (1534–1613) of Chillington in Staffordshire, MP and a leader of Roman Catholic recusancy.[11] He had fourteen children, of whom the most famous today is his fourth son, Gilbert (1560–90) – of whom Sir Edward Stafford, the English ambassador in Paris, noted: 'He had showed himself to be the most notable double, treble villain that ever lived.'[12] Gilbert had a key role in the 1586 Babington Plot, but was 'turned' by Sir Francis Walsingham, who, naming him 'No. 4', used him to gain Mary's confidence at the moated Chartley Castle, where she was kept under close watch.[13] Gilbert helped set up the system by which letters were smuggled out of the castle to, so Mary thought, her allies – but in reality they went straight to Walsingham, who read them before sending them on. It was these letters that provided the evidence of Mary's treason, leading to her subsequent trial and beheading in February 1587.[14]

It seems likely that Gilbert would have stayed in his father's house when he was in London. So, in early 1586, there is Gilbert probably living in St Helen's, possibly alongside Robert Pooley's family. Robert, who was central to the government's handling of Anthony Babington as his 'servant and companion', was based in Walsingham's house nearby in Seething Lane. On 2 June 1586, the conspirators had met and dined 'in Poley's garden' – the house having actually been requisitioned by the government from another Queen's messenger, Anthony Hall.[15] All the plotters were then arrested, and to preserve Pooley's cover he was also imprisoned in the Tower of London for a period. After his release he continued to work for the government until at least 1601.

Notes

1. Francis Walsingham lived briefly in St Helen's in the early 1560s after his return from Marian exile. He probably moved in with his first wife, Anne Barne, after their marriage in 1562 and they were living in the former frater of the nunnery in 1564, later the home of Alderman John Robinson. His assessment in the 1564 Lay Subsidy roll was at the huge sum of £400. Their immediate neighbour was Richard Clough, the business partner of Sir Thomas Gresham, who had taken over the lease of his property from Sir Nicholas Throckmorton (the house later occupied by Dr Peter Turner from 1589). Anne was the daughter of Sir George Barne II (d. 1558), Lord Mayor of London in 1552–3 and international merchant/financier. He lived in another property next door c. 1551–6, so she presumably knew the parish well. Anne died in 1564 and Walsingham, probably in some distress after their brief life together, moved away from St Helen's.

2. For detailed discussions of Marlowe's death, see Nicholl, *The Reckoning*.
3. At this time there were at least half a dozen queen's messengers, as delivery duties might take them away on long journeys to York, Chester or beyond.
4. Isabel had a cheap burial in the churchyard.
5. It is worth noting that in the 1559 Lay Subsidy roll, 'Ralph Skeyrs' and in the 1564 Lay Subsidy roll, 'William and Ralfe Skyrs' were living in St Helen's in Bishopsgate Street in the houses fronting Crosby Hall. William must have died before 1576; however, his widow (?) and 'Raulf Skyres' are recorded in the 1576 Lay Subsidy roll (both at £5), but not the 1582 assessment. Could this Ralph be the father of Raffe Skerer junior, the cousin of the nefarious Nicholas Skeres (1563–1601?), the confidence trickster and government informer who was present at Marlowe's murder in 1593? Intriguingly, Charles Nicholl relates that a man called 'Skeggs' was in the company of Sir Francis Walsingham's young relative Thomas Walsingham in France in 1581, and suggests this was Nicholas Skeres; see Nichol, *The Reckoning*. Edward Skegges, the Queen's Poulterer, lived in Bishopsgate Street and had recently died in 1578. Had Skeres borrowed his name from his gravestone in St Helen's? Alternatively, Henry Skegg(e)s, possibly Edward's son, was married on 10 September 1576 to Suzan Barnardiston, and represented the next generation. Nicholas Skeres was involved in Sir Francis's disclosure of the 1586 Babington plot with Thomas Walsingham and Robert Poley, Nicholl noting that '[T]wo of Babington's "crew" . . . had been seen there: "Dunn" and "Skyeres". Dunn is Henry Dunne, who was among those executed the following month. "Skyeres" – a spelling he uses in his signature – is almost certainly Nicholas Skeres. It looks like he was there as a government plant. He was recognised by [Sir Francis] Walsingham's watchers, and was named without further comment in [the] report. His name does not figure among those later arrested. He quietly drops from the story, almost certainly because he was Walsingham's man all along.' In 1564, Francis Walsingham would have been living less than a hundred yards from Ralfe Skyrs' house in St Helen's.
6. See Peck, 'Government Suppression of Elizabethan Catholic Books'.
7. TNA, State Papers, 78/17/26. Robert Pooley to Leicester, early 1585.
8. Pooley spent considerable periods in London prisons being placed by the authorities amongst Catholic prisoners to try and gain their confidence and garner information about colleagues, networks and plots – a 'stool pigeon' in modern parlance. He clearly had an unusual relationship with his wife, 'Watson's daughter', since in 1583 when he was imprisoned in the Marshalsea prison, he refused to see his wife presumably with news of their young baby, but regularly entertained a married woman called Joan Yeomans to 'many fine banquets' there; see Riggs, *The World of Christopher Marlowe*, pp. 257–8 – a reminder that Elizabethan prisons operated at different levels according to your status, crime and wealth. He was back in the Marshalsea Prison in the summer of 1597, where he may have been placed to spy on the playwright Ben Jonson, who was there because of the outrage caused by *The Isle of Dogs*, which he wrote with Thomas Nashe. Jonson attacked Poley and a second informer, named Parrot, as 'damned villains' and later wrote an epigram, 'Inviting a Friend to Supper', including the line 'we shall have no Poley or Parrot by'. This may account for Mrs Poley not being recorded in the Lay Subsidy roll as a widow and being registered with an 'Affid', which could mean she was excluded from paying because her husband was involved in government service. After 1600, the government seems to have lost interest in Robert Pooley's skills and he disappears from the records.
9. Kirk and Kirk, *Returns of Aliens Dwelling in the City*.
10. See Chapter 17, n. 29 for his possible connection to John Stoker Jekyll.
11. This identification is demonstrated by his overall wealth in the 1582 Lay Subsidy roll at £100, the second-highest assessment, and that it records his taxation of £2 in Staffordshire. Notwithstanding their Catholicism, the family lived at Chillington in a mansion built on the site of Black Ladies, a former nunnery, and also acquired the nearby White Ladies convent. It would be ironic if he lived in St Helen's in one of the houses carved out of the former nunnery buildings. The fine alabaster tomb of John, his wife Joyce Leveson and some of their children still survives in the church of St Mary and St Chad in Brewood, Staffordshire. He is not listed in the 1589 St Helen's tithe survey, so he had probably moved away by then, perhaps following the unmasking of the Babington plot and his son's flight to Paris.

12. Letter of Sir Edward Stafford to Walsingham, January 1588, *Calendar of State papers, Foreign Series*, (London: HMSO), vol. 21, part 1, pp. 661–2.
13. In December 1585, he returned to England and was arrested when he landed at Rye. Gilbert's home, at Chillington, was only about twenty miles from Chartley Castle.
14. Thomas Watson's connection with the events of 1585–7 is unknown. Watson, who saved Marlowe's life in 1589, was born *c.* 1556 close to St Helen's, probably in St Olave's parish, Hart Street. He was eight years older than Shakespeare, and enjoyed a privileged upbringing that included time at Oxford University. By the early 1580s, he was well established as one of England's leading poets. He was a significant playwright, described by Francis Meres in 1598 as amongst 'our best for Tragedie'. By 1587, Watson had moved to the Liberty of Norton Folgate but he is recorded as being 'late of St Helen's' (BL, Lansdowne MS 53/79, 162–3), possibly living there from 1581. A John Watson (relationship unknown) lived in St Helen's from at least 1561, when he was recorded as Under-Churchwarden, and was buried in the church in 1589. However, Watson's reputation has suffered because none of his plays survive, although his employer (Sir) William Cornwallis recorded that 'twenty fictions and knaveryes in a play' was his 'daily practyse and his living'. Cornwallis employed Thomas Watson as a 'reader' in his household at Fisher's Folly, a grand mansion just outside Bishopsgate that he had bought from Edward de Vere, 17th Earl of Oxford in 1588. Their daughter Anne was a poet in her own right and Watson continued as her tutor until he died in 1592. David Riggs suggests that Poley and Watson were brothers-in-law. Since Shakespeare must have met Marlowe on his arrival in London, it is highly likely that he knew Watson personally, and so possibly Pooley and others in the web of connections that led back to Walsingham's spy operation based in his house in Seething Lane.
15. Hall recalled, in a letter of 12 February 1593 seeking advancement for his son: 'Also my house was possessed, at your honour's commandment, certain days and nights, whereby Ballard the priest, and Babington, and with others of that traitorous crew were apprehended in a garden near my house.'

# Bibliography

Archival Material

*National Archives, London*
PROB 11/27/552
PROB 11/31/103
PROB 11/61/23
PROB 11/62/136
PROB 11/63/486
PROB 11/70/86
PROB 11/73/215
PROB 11/75/265
PROB 11/82/73
PROB 11/82/221
PROB 11/82/277
PROB 11/82/387
PROB 11/82/561
PROB 11/83/389
PROB 11/85/243
PROB 11/91/9
PROB 11/91/387
PRO 11/94/167
PROB 11/97/22
PROB 11/98/348
PROB 11/98/460
PROB/11/98/472
PROB 11/99/336
PROB 11/102/255
PROB 11/103/421
PROB 11/103/522
PROB 11/106/53
PROB 11/112/269
PROB 11/113/387
PROB 11/114/169

PROB 11/115/130
PROB 11/121/512
PROB 11/125/116
PROB 11/126/609
PROB 11/135/530
PROB 11/137/600
PROB 11/139/119
PROB 11/152/199
PROB 11/164/758
PROB 11/178/372
PROB 30/34/14

C 2/Eliz/H13/13
C 2/Eliz/R6/62
C 2/JasI/LandJ6/2
C 2/ChasI/E9/64
C 3/275/55
C 3/362/46
C 8/10/11
C 8/29/108
C 24/126 A
C 24/153 D
C 24/176 E
C 24/177 R
C 24/190 W
C 24/217 P
C 24/218/93
C 24/228/10
C 24/240 B
C 24/288
C 24/297/W
C 24/507
C 54/1682

E 115/137/34
E 115/225/10
E 115/394/45
E 115/394/74
E 115/394/107

Bibliography

E 163/14/7
E 164/35
E 179/146/354
E 179/146/369
E 214/930
E 355/16
E 359/56
E 372/444

REQ 4/1/4/1

SP 78/17/26

STAC/A57/3

*Bodleian Library, Oxford*
MS Aubrey 6
MS Don. D.152
MS Ashmole 4041

*Worshipful Company of Leathersellers' Archives, London*
The Liber Curtes (Wardens' annual accounts):
ACC/1/1 for 1471–1584
ACC/1/2 for 1584–1647
Volume 1 was transcribed by Katherine S. Martin in 1908 and Volume 2 by Helena M. Chew in 1930, but neither is published.
Copies of Leases and Deeds, 1555–1660 – EST/8/1
This was compiled from 1609 with copies of earlier leases from 1555 from the London Wall Estate and 1574 from the St Helen's Estate.

Leathersellers' Court minutes
E 1/41
MS 145
M 1433–1462
GOV 1/4
SHE/1/2/70 – 1598 lease on individual separated sheet

*Guildhall Library, City of London*
MS 4241/1

*London Metropolitan Archive London*

ACC/176/F/04/23

ACC/1876/F/04/23

CLA/024/02/012

CLC/521/MS01419

CLC/521/MS01420

HB/B/016

MJ/SR/0225/4

MS 6836

P69/BENI/A/001/MS04097

P69/ETH/B/006/MS04241/001

PS/HEL/B/004/MS 06836

*British Library*

Harley MS 1927

*Folger Shakespeare Library, Washington, DC*

X.d.428

## Books and Articles
*Primary*

Anonymous, *A Warning for Fair Women* (London, 1599).

Anonymous, *Gammer Gurton's Needle* (London, 1553).

Anonymous, *The Trial of Maist. Dorrell* (London, 1599).

Author unconfirmed (Robert Langham/William Patten), *A letter: whearin, part of the entertainment vntoo the Queenz Maiesty, at Killingwoorth Castl, in Warwik Sheer in this soomerz progress 1575. iz signified: from a freend officer attendant in the coourt, vntoo hiz freend a citizen, and merchaunt of London* (London, 1575).

Ascham, Roger, *The Scholemaster* (London, 1570).

Averell, William, *A Mervalious Combat of Contrarieties* (London, 1588).

Averell, William, *Four Notable Histories* (London, 1590).

Best, George, *A True Discourse of the Late Voyages of Discoverie, for the Finding of a Passage to Cathaya, by the Northwest, under the conduct of Martin Frobisher Generall . . .* (London: by Henry Bynnyman for Sir Christopher Hatton, 1578).

Camden, William, trans. Philemon Holland, *Britain: Or a Chorographicall Description of the Most Flourishing Kingdomes, England, Scotland, and Ireland . . .* (London: for George Bishop and John Norton, 1610).

Campbell, Robert, *The London Tradesman* (London, 1747).

Crooke, Helkiah, *Microcosmographia* (London, 1615).

Gascoigne, George, *The Spoyle of Antwerpe, Faithfully reported, by a true Englishman, who was present at the time* (London, 1576).

Gilbert, Humphrey, *A Discourse of a Discoverie for a New Passage to Cataia* (London: For Richard Jones, 1576).

Gough, Richard, *The History of Myddle*, ed. David Hey (London: Penguin, 1981).

Gosson, Stephen, *Schoole of Abuse, Containing a Pleasant Invective against Poets, Pipers, Plaiers, Jestters and such like Caterpillars of the Commonwealth* (London, 1579).

Hakluyt, Richard, *The Principal Navigations, Voyages, Traffiques, and Discoveries of the English Nation* (London, 1599).

Hoby, Thomas (trans.), *Il Cortigiano or The Book of the Courtier* (London, 1561).

Hughes, Lewes, *Certaine grievances, or the errours of the service-booke; plainely layd open* (London, 1641).

Jorden, Edward, 'A Brief Discourse of a Disease Called the Suffocation of the Mother' [1603], in Michael MacDonald (ed.), *Witchcraft and Hysteria in Elizabethan London: Edward Jorden and the Mary Glover Case* (London: Routledge, 1991).

Jorden, Edward, *A Discourse of Natural Bathes, and Mineral Waters wherein the Original of Fountains in General is Declared . . .* (London, 1631).

Maunsell, Andrew, *The Seconde Parte of the Catalogue of English Printed Bookes* (London, 1595).

Mercurialis, Hieronymus, *De Pestilentia* (Venice: for P. Meietus, 1577).

Meres, Francis, *Palladis Tamia or Wits Treasury* (London, 1598).

Milton, John, *Poems of Mr John Milton, both English and Latin, Compos'd at Several Times* (London, 1646).

Morley, Thomas, *A Plaine and Easie Introduction to Practicall Music* (London, 1597).

Morley, Thomas, *The First Book of Ayres* (London, 1600).

Plowden, Edmund, *Les Commentaries ou les reports de Edmunde Plowden* [1571], abr. Thomas Ashe (London, 1597).

Stow, John, *Survey of London* (London, 1598).

Swan, John, 'A True and Breife Report, of Mary Glover's Vexation and her Deliverance', in Michael MacDonald (ed.), *Witchcraft and Hysteria in Elizabethan London: Edward Jorden and the Mary Glover Case* (London: Routledge, 1991).

Turner, Peter, *The Opinion of Peter Turner Doct. in Phisicke, Concerning Amulets or Plague Cakes, Whereof Perhaps some Holde too Much, and Some too Little* (London: For Edward Blount, 1603).

Turner, William, *A Booke of the Natures and Properties as well as the Bathes in England as of Other Bathes in Germany and Italye* (Collen, 1562).

## Secondary

Addyman, Mary, *William Turner: Father of English Botany* (Castle Morpeth: Castle Morpeth Borough Council, 2008).

Alford, Stephen, *London's Triumph: Merchant Adventurers and the Tudor City* (London: Allen Lane, 2017).

Allderidge, Patricia, 'Hospitals, Madhouses and Asylums: Cycles in the Care of the Insane', *British Journal of Psychiatry*, 134.4 (April 1979), pp. 321–33.

Archer, Ian, *The Pursuit of Stability: Social Relations in Elizabethan London* (Cambridge: Cambridge University Press, 2003).

Archer, Ian, *Sir Thomas Smythe (c. 1558–1625): A Lecture Delivered at Skinners' Hall*, London, 26 November 2007, via *Oxford University Research Archive*, <https://ora.ox.ac.uk> (last accessed 27 June 2020).

Astington, John H., 'His Theatre Friends: The Burbages', in Paul Edmondson and Stanley Wells (eds), *The Shakespeare Circle: An Alternative Biography* (Cambridge: Cambridge University Press, 2015), pp. 248–60.

Axton, Marie, 'Robert Dudley and the Inner Temple Revels', *The Historical Journal*, 13.3 (1970), pp. 365–78.

Baer, William, 'Housing for the Lesser Sort in Stuart London: Findings from Certificates, and Returns of Divided Houses', *The London Journal*, 33.1 (2013), pp. 61–88.

Ball, Philip, *The Devil's Doctor: Paracelsus and the World of Renaissance Magic and Science* (London: Arrow Books, 2006).

Bannerman, W. Bruce (ed.), *The Registers of St Helen's Bishopsgate* (London: Harleian Society, 1904), <https://archive.org/details/registersofsthel31sthe> (last accessed 27 June 2020).

Bearman, Robert, *Shakespeare's Money: How Much Did He Make and What Does This Mean?* (Oxford: Oxford University Press, 2016).

Beaven, Alfred P., 'Chronological List of Aldermen: 1601–1650', in Alfred P. Beaven (ed.), *The Aldermen of the City of London, Temp. Henry III – 1912* (London: City of London, 1908), pp. 47–75, via *British History Online*, <http://www.british-history.ac.uk/no-series/london-aldermen/hen3-1912/pp47-75> (last accessed 27 June 2020).

Berry, Herbert, *The Boar's Head Playhouse* (Washington, DC: Folger Books, 1986).

Berry, Herbert, *The First Public Playhouse: The Theatre in Shoreditch 1576–1598* (Montreal: McGill University Press, 1979).

Berry, Herbert, *The Noble Science: A Study and Transcription of Sloane MS. 2530, Papers of the Masters of Defence of London, Temp. Henry VIII – 1590* (Cranbury: Delaware University Press, 1991).

Blanchard, Ian, 'Sir Thomas and the House of Gresham: Activities of a Merchant Adventurer', in F. Ames-Lewis (ed.), *Sir Thomas Gresham and Gresham College: Studies in the Intellectual History of London in the Sixteenth and Seventeenth Centuries* (London: Taylor & Francis, 1999), pp. 13–23.

Bolton, Paul, 'Education: Historical Statistics', *House of Commons Library*, SN/SG/4252 (2012).

Bowsher, Julian, *Shakespeare's London Theatreland: Archaeology, History and Drama* (London: Museum of London Archaeology, 2012).

Bradwell, Stephen, 'Mary Glover's Late Woeful Case' [1603], in Michael MacDonald (ed.), *Witchcraft and Hysteria in Elizabethan London: Edward Jorden and the Mary Glover Case* (London: Routledge, 1991).

Bremer, Francis J. and Tom Webster, *Puritans and Puritanism in Europe and America: A Comprehensive Biography*, vol. 1 (Santa Barbara: ABC-CLIO, 2006).

Bruce, John, *Diary of John Manningham of the Middle Temple and of Bradbourne, Kent, Barrister-at-Law, 1602–1603* (London: Camden Society, 1868).

Burrow, Colin, *Shakespeare and Classical Antiquity* (Oxford: Oxford University Press, 2013).

Butman, John and Simon Targett, *New World, Inc: How England's Merchants Founded America and Launched the British Empire* (London: Atlantic Books, 2018).

Campbell, James Stuart, *The Alchemical Patronage of Sir William Cecil, Lord Burghley*, PhD thesis (Victoria University of Wellington, 2009).

Carlton, Charles, '"The Widow's Tale": Male Myths and Female Reality in 16th- and 17th-Century England', *Albion*, 10.2 (1978), p. 120.

Chambers, E. K., *The Elizabethan Stage* (Oxford: Clarendon Press, 1923).

Chapman, George T. L., Frank McCombie and Anne Wesencraft, *William Turner: A New Herball*, 2 vols (Cambridge: Cambridge University Press, 1996).

Chester, Joseph Lemuel (ed.), *Allegations for Marriage Licences Issued by the Bishop of London, 1520–1610* (London, 1887), <https://archive.org/details/allegationsform01londgoog> (last accessed 27 June 2020).

Cole, George Watson, 'Lewis Hughes; The Militant Minister of the Bermudas and his Printed Works', *Transactions of the American Antiquarian Society* (Oct. 1927), pp. 247–311.

Coley, Noel G., '"Cures Without Care": "Chymical Physicians" and Mineral Waters in Seventeenth-Century English Medicine', *Medical History*, 23 (1979), pp. 191–214.

Collinson, Patrick, *The Elizabethan Puritan Movement* (Oxford: Oxford University Press, 1990).

Collinson, Patrick, John Craig and Brett Usher, *Conferences and Combination Lectures in the Elizabethan Church: Dedham and Bury-St-Edmunds* (Woodbridge: Boydell Press, 2003).

Colthorpe, Marion E., 'The Elizabethan Court Day by Day', *Folgerpedia*, <https://folgerpedia.folger.edu/The_Elizabethan_Court_Day_by_Day> (last accessed 20 July 2020).

Cook, Judith, *Dr Simon Forman: A Most Notorious Physician* (London: Vintage, 2002).

Cox, John, *The Annals of St Helen's Bishopsgate, London* (London: Tinsley Brothers, 1876), <https://archive.org/details/annalsofthelens00coxjuoft> (last accessed 27 June 2020).

Craven, Wesley Frank (ed.), 'Lewis Hughes, "A Plaine and True Relation of the Goodness of God towards the Sommers Ilands"', *William & Mary Quarterly*, 2nd Ser. 17 (1937), pp. 56–89.

Dasent, John Roche (ed.), *Acts of the Privy Council of England Volume 23, 1592* (London, 1901), pp. 183–4, via *British History Online*, <http://www.british-history.ac.uk/acts-privy-council/vol23> (last accessed 2 August 2020).

De Schepper, Susanna L. B., *Foreign Books for English Readers: Published Translations of Navigation Manuals and their Audience in the English Renaissance, 1500–1640*, PhD thesis (Warwick University, 2012).

Debus, Allen G., *The English Paracelsians* (New York: Franklin Watts, 1965).

Duffin, Ross W., *Some Other Note: The Lost Songs of English Renaissance Comedy* (Oxford: Oxford University Press, 2018).

Duncan-Jones, Katherine, 'Afterword: Stow's Remains', in Ian Gadd and Alexandra Gillespie (eds), *John Stow (1525–1605) and the Making of the English Past* (London: British Library, 2004), pp. 157–63.

Evans, Lloyd, 'Review: *Gorboduc*', *The Inner Temple Yearbook*, 2013–14, pp. 38–9.

Evelyn, John, *The Diary of John Evelyn*, ed. Guy de la Bédoyère (Woodbridge: Boydell and Brewer, 2004).

Fagel, Raymond, 'Gascoigne's *The Spoile of Antwerpe* (1576) as an Anglo-Dutch text', *Dutch Crossing*, 41.2 (July 2017), pp. 101–10.

Feuillerat, Albert, *Extracts from the Accounts of the Revels at Court, in the Reigns of Queen Elizabeth and King James I: from the Original Office Books of the Masters and Yeomen* (Louvain: A. Uystpruyst et al., 1908).

Flood, Alison, 'William Shakespeare: Father's Legal Skirmishes Shed Light on Bard's Early Years', *The Guardian*, 13 September 2018.

Freeman, Arthur, 'Marlowe, Kyd, and the Dutch Church Libel', *English Literary Renaissance*, 3 (1973), pp. 44–52.

Fry, G. S. (ed.), *Abstracts of Inquisitiones Post Mortem for the City of London: Part I* (London: British Record Society, 1896).

Fry, G. S. (ed.), *Abstracts of Inquisitiones Post Mortem for the City of London: Part 3* (London: British Record Society, 1908), via *British History Online*, <https://www.british-history.ac.uk/inquis-post-mortem/abstract/no1> (last accessed 27 June 2020).

Gerhold, Dorian, *London Plotted: Plans of London Buildings c.1450–1720* (London: London Topographical Society, 2016).

Godfrey, Walter H., 'Crosby Hall (re-erected)', in Walter H. Godfrey, *Survey of London: Volume 4, Chelsea, Part II* (London, 1913), pp. 15–17, via *British History Online*, <https://www.british-history.ac.uk/survey-london/vol4/pt2> (last accessed 27 June 2020).

Gosling, William G., *The Life of Sir Humphrey Gilbert: England's First Empire Builder* (London: Constable & Co., 1911).

Green, Dominic, *The Double Life of Dr Lopez: Spies, Shakespeare, and the Plot to Poison Elizabeth I* (London: Century, 2003).

Greenblatt, Stephen, *Shakespearean Negotiations: The Circulation of Social Energy in Renaissance England* (Oxford: Clarendon, 1988).

Greer, Germaine, *Shakespeare's Wife* (London: Bloomsbury, 2008).

Grinnell, Richard, 'Shakespeare's Keeping of Bees', *Interdisciplinary Studies in Literature and Environment*, 23.4 (2016), pp. 835–54.

Guariento, Luca, *Life, Friends, and Associations of Robert Fludd: A Revised Account*, <https://www.academia.edu/38279617/Life_Friends_and_Associations_of_Robert_Fludd_A_Revised_Account> (last accessed 27 June 2020).

Gurr, Andrew, 'Henry Carey's Peculiar Letter', *Shakespeare Quarterly*, 56.1 (2005), pp. 51–75.

Gurr, Andrew, *The Shakespeare Company: 1594–1642* (Cambridge: Cambridge University Press, 2004).

Guy, John, *Gresham's Law: The Life and World of Queen Elizabeth's Banker* (London: Profile Books, 2019).

Hamlin, Hannibal, *The Bible in Shakespeare* (Oxford: Oxford University Press, 2013).

Harkness, Deborah, *The Jewel House: Elizabethan London and the Scientific Revolution* (New Haven: Yale University Press, 2006).

Harkness, Deborah, *John Dee's Conversations with Angels: Cabala, Alchemy, and the End of Nature* (Cambridge: Cambridge University Press, 1999).

Harley, David, 'Rychard Bostok of Tandridge, Surrey (*c.* 1530–1605), MP, Paracelsian Propagandist and Friend of John Dee', *Ambix*, 47.1 (2000), pp. 29–36.

Harley, John, *The World of William Byrd: Musicians, Merchants and Magnates* (London: Routledge, 2010).

Harrison, George, *England in Shakespeare's Day* (London: [Methuen, 1928] Routledge, 2005).

Hasler, P. W., *The History of Parliament: The House of Commons, 1558–1603* (London: The Stationery Office, 1981).

Haynes, Samuel (ed.), 'The Bishop of London's Certificate', in *A Collection of State Papers Relating to Affairs of the Reigns of King Henry VIII, King Edward VI, Queen Mary and Queen Elizabeth*, 2 vols (London: William Bowyer, 1740), vol. 1.

Hey, David, *An English Rural Community: Myddle under the Tudors and Stuarts* (Leicester: Leicester University Press, 1974).

Hughes, Paul L. and James F. Larkin, *Stuart Royal Proclamations*, 2 vols (Oxford: Oxford University Press, 1973).

Hughes, Paul L. and James F. Larkin, *Tudor Royal Proclamations*, 3 vols (New Haven: Yale University Press, 1964–9).

Hunter, Joseph, *New Illustrations of the Life, Studies, and Writings of Shakespeare*, 2 vols (London: J. B. Nichols, 1845).

Ingram, William, *The Business of Playing: The Beginnings of the Adult Professional Theatre in Elizabethan London* (Ithaca: Cornell University Press, 1992).

Ingram, William, 'Laurence Dutton, Stage Player: Missing and Presumed Lost', *Medieval and Renaissance Drama in England*, 14 (2001), pp. 122–43.

Iwasaki, Soji, '*Veritas Filia Temporis* and Shakespeare', *English Literary Renaissance*, 3.2 (Spring 1973), pp. 249–63.

Iyengar, Sujata, *Shakespeare's Medical Language: A Dictionary* (London: Bloomsbury, 2011).

Jeaffreson, J. C., *Middlesex County Records*, 4 vols (London: Middlesex County Record Society, 1886–92, repr. 1972).

Junot, Yves, *Les Bourgeois de Valenciennes: Anatomie d'une élite dans la ville (1500–1630)* (Villeneuve: Presses Universitaires du Septentrion, 2009).

Kassell, Lauren, *Medicine and Magic in Elizabethan London: Simon Forman: Astrologer, Alchemist, and Physician* (Oxford: Clarendon Press, 2005).

Kassell, Lauren, Michael Hawkins, Robert Ralley, John Young, Joanne Edge, Janet Yvonne Martin-Portugues, Boyd Brogan and Natalie Kaoukji (eds), *The Casebooks of Simon Forman and Richard Napier, 1556–1634: A Digital Edition*, <http://casebooks.lib.cam.ac.uk/> (last accessed 27 June 2020), covering Bodleian Library MS Ashmole 234.

Kathman, David, 'Hobson the Carrier and Playing at the Bull Inn', lecture at the Shakespeare Association of America Annual Conference (2009).

Keeling, William, 'Dragon: Fragment of Journal' [1607], ed. Zoe Wilcox, *Shakespeare Documented*, 28 February 2017, <https://shakespearedocumented.folger.edu/exhibition/document/fragment-captain-william-keelings-journal-hamlet-and-richard-ii-possibly> (last accessed 27 June 2020).

Keeson, Andy, 'His Fellow Dramatists and Early Collaborators', in Paul Edmondson and Stanley Wells (eds), *The Shakespeare Circle: An Alternative Biography* (Cambridge: Cambridge University Press, 2015), pp. 235–47.

Kesselring, Krista J., '"Murder's Crimson Badge": Homicide in the Age of Shakespeare', in Malcom Smuts (ed.), *The Oxford Handbook of the Age of Shakespeare* (Oxford: Oxford University Press, 2016), pp. 543–58.

King, Donald, 'The Earliest Dated Sampler (1598): Jane Bostocke's Gift to Alice Lee', *Connoisseur*, 149.234 (1962).

Kingsford, Charles L., 'Introduction: Letters to Stow', in Kingsford (ed.), *A Survey of London: Reprinted from the text of 1603* (Oxford: Clarendon, 1908), via *British History Online*, <http://www.british-history.ac.uk/no-series/survey-of-london-stow/1603/lxviii-lxxiv> (last accessed 27 June 2020).

Kingsford, Charles L. (ed.), *A Survey of London: Reprinted from the text of 1603* (Oxford: Clarendon, 1908), via *British History Online*, <http://www.british-history.ac.uk/no-series/survey-of-london-stow/1603/lxviii-lxxiv> (last accessed 27 June 2020).

Kirk, Richard Edward Gent and Ernest Kirk (eds), *Returns of Aliens Dwelling in the City and Suburbs of London from the Reign of Henry VIII to that of James I* (London: Huguenot Society, 1907), Quarto series of Huguenot Society.

Kitching, C., 'Introduction', in C. Kitching, *London and Middlesex Chantry Certificates, 1548*, pp. ix–xxxiv, via *British History Online*, <https://www.british-history.ac.uk/london-record-soc/vol16> (last accessed 27 June 2020).

Lang, R. G., 'Introduction', in R. G. Lang (ed.), *Two Tudor Subsidy Rolls for the City of London, 1541 and 1582* (London: British History Online, 1993), pp. xv–lxxvii, via *British History Online*, <http://www.british-history.ac.uk/london-record-soc/vol29/xv-lxxvii> (last accessed 27 June 2020).

Laoutaris, Chris, *Shakespeare and the Countess: The Battle that Gave Birth to the Globe* (New York: Pegasus, 2014).

Larmuseau, Maarten, et al., 'The black legend on the Spanish presence in the low countries: Verifying shared beliefs on genetic ancestry', *American Journal of Physical Anthropology*, 166.1 (May 2018), pp. 219–227.

Lasocki, David, 'The Bassano Family, the Recorder, and the Writer Known as Shakespeare', *American Recorder*, Winter 2015, pp. 11–25.

Lasocki, David and Roger Prior, *The Bassanos: Venetian Musicians and Instrument Makers in England, 1531–1665* (Aldershot: Scolar Press, 1995).

Leinwand, Theodore B., *Theatre, Finance and Society in Early Modern England* (Cambridge: Cambridge University Press, 1999).

Leveson Gower, Granville, *A Register of all the Christninges Burialles & Weddinges within the Parish of Saint Peters upon Cornhill* (London: Harleian Society, 1877), <https://archive.org/details/registerofallchr01stpe> (last accessed 27 June 2020).

Levin, Joanna, 'Lady Macbeth and the Daemonologie of Hysteria', *English Literary History*, 69.1 (2002), pp. 21–55.

MacDonald, Michael, *Witchcraft and Hysteria in Elizabethan London: Edward Jorden and the Mary Glover Case* (London: Routledge, 1991).

MacMillan, Ken, *Sovereignty and Possession in the English New World: The Legal Foundations of Empire 1576–1640* (Cambridge: Cambridge University Press, 2006).

Madge, Sidney (ed.), *Abstracts of Inquisitions Post Mortem Relating to the City of London Returned into the Court of Chancery during the Tudor Period* (London: British Record Society, 1901), <http://www.archive.org/details/abstractsofinqui2627grea> (last accessed 27 June 2020).

Manley, Lawrence and Sally-Beth MacLean, *Lord Strange's Men and Their Plays* (New Haven: Yale University Press, 2014).

Marsh, Christopher, 'Order and Place in England, 1580–1640: The View from the Pew', *Journal of British Studies*, 44.1 (2005), pp. 3–26.

McClure, Norman, *The Letters of John Chamberlain* (Philadelphia: The American Philosophy Society, 1939).

Morrissey, Mary, 'Episcopal Chaplains and Control of the Media, 1586–1642', in Hugh Adlington, Tom Lockwood and Gillian Wright (eds), *Chaplains in Early Modern England: Patronage, Literature and Religion* (Manchester: Manchester University Press, 2013), pp. 64–82.

Murray, Tessa, *Thomas Morley: Elizabethan Music Publisher* (Oxford: Oxford University Press, 2014).

Nelson, Alan, 'His Literary Patrons', in Paul Edmondson and Stanley Wells (eds), *The Shakespeare Circle: An Alternative Biography* (Cambridge: Cambridge University Press, 2015), pp. 275–88.

Nelson, Alan, 'Neighbours' Petition against the Blackfriars Playhouse, November 1596', in Hannah Leah Crummé (ed.), *Shakespeare on the Record: Researching an Early Modern Life* (London: Bloomsbury, 2019).

Nicholl, Charles, *The Lodger: Shakespeare on Silver Street* (London: Penguin, 2007).

Nicholl, Charles, *The Reckoning: The Murder of Christopher Marlowe* (London: Vintage, 2002).

Nichols, J. G. (ed.), *The Diary of Henry Machyn, Citizen and Merchant-Taylor of London, 1550–1563* (London: Camden Society, 1848), via *British History Online*, <https://www.british-history.ac.uk/camden-record-soc/vol42> (last accessed 27 June 2020).

Nicolas, Nicholas H., *The Privy Purse Expences of King Henry the Eighth* (London: William Pickering, 1827).

Norman, Philip and W. D. Caroe, *Survey of London: Monograph 9 Crosby Place* (London, 1908), via *British History Online*, <https://british-history.ac.uk/survey-london/bk9> (last accessed 27 June 2020).

Orwell, George, *Coming Up for Air* (London: Victor Gollancz, 1939).

Owen, H. Gareth, *The London Parish Clergy in the Reign of Elizabeth I*, PhD thesis (University of London, 1957).

Page, Christopher, *The Guitar in Tudor England: A Social and Musical History* (Cambridge: Cambridge University Press, 2015).

Peck, D. C., 'Government Suppression of Elizabethan Catholic Books: The Case of *Leicester's Commonwealth*', *The Library Quarterly*, 47.2 (1977), pp. 163–77.

Pelling, Margaret, 'Failed Transmission: Sir Thomas Gresham, Reproduction, and the Background to Gresham's Professorship of Physic', in F. Ames-Lewis (ed.), *Sir Thomas Gresham and Gresham College: Studies in the Intellectual History of London in the Sixteenth and Seventeenth Centuries* (London: Taylor and Francis, 1999), pp. 38–61.

Pelling, Margaret, *Medical Conflicts in Early Modern London; Patronage, Physicians, and Irregular Practitioners 1550–1640* (Oxford: Clarendon Press, 2003).

Pelling, Margaret and Frances White, *Physicians and Irregular Medical Practitioners in London 1550–1640 Database* (London, 2004), via *British History Online*, <https://www.british-history.ac.uk/no-series/london-physicians/1550-1640> (last accessed 30 June 2020). In particular: 'CHETLEY, John'; 'SAUL, James or Jacob?'; 'SAUNDERS, Patrick'; 'TAYLIOR, Richard'; 'TURNER, Peter'.

'Petition Against the Return of George Gascoigne, the Poet, to Parliament', *The Gentleman's Magazine*, 2.36 (1851), pp. 241–4.

Pogue, Kate E., *Shakespeare's Friends* (Westport, CT: Praeger, 2006).

Porter, Roy, *The Greatest Benefit to Mankind: A Medical History of Humanity from Antiquity to the Present* (London: W. W. Norton, 1997).

Rappaport, Steve, *Worlds within Worlds: Structures of Life in Sixteenth-Century London* (Cambridge: Cambridge University Press, 1989).

Reddan, Minnie and Alfred W. Clapham, *Survey of London: Volume 9, the Parish of St Helen, Bishopsgate, Part I* (London, 1924), via *British History Online*, <http://www.british-history.ac.uk/survey-london/vol9/pt1> (last accessed 27 June 2020).

Richardson, Catherine and Martin Wiggins (ed.), *British Drama 1533–1642: A Catalogue*, 10 vols (Oxford: Oxford University Press, 2011–18).

Riggs, David, *The World of Christopher Marlowe* (London: Faber & Faber, 2004).

Roberts, Stephen K. (ed.), *The Cromwell Association Online Directory of Parliamentarian Army Officers* (London: British History Online, 2017), <https://british-history.ac.uk/no-series/cromwell-army-officers> (last accessed 27 June 2020).

Ross, Catherine, and John Clark, *London: The Illustrated History* (London: Allen Lane, 2008).

Rowland, Richard, *Thomas Heywood's Theatre, 1599–1639: Locations, Translations, and Conflict* (Cambridge: Cambridge University Press, 2010).

Rowse, A. L., *Shakespeare's Sonnets: The Problem Solved* (London: Macmillan, 1973).

Rutter, Carol Chillington (ed.), *Documents of the Rose Playhouse* (Manchester: Manchester University Press, 1984).

Rutter, Carol Chillington, 'Schoolfriend, Publisher and Printer: Richard Field', in Paul Edmondson and Stanley Wells (eds), *The Shakespeare Circle: An Alternative Biography* (Cambridge: Cambridge University Press, 2015), pp. 161–73.

Schofield, John and Richard Lea, *Holy Trinity Priory, Aldgate, City of London: An Archaeological Reconstruction and History* (London: MOLA Monographs, 2005).

Schuessler, Jennifer, 'Actor, Playwright, Social Climber', *New York Times*, 29 June 2016.

Schupbach, W. M., 'A Venetian "plague miracle" in 1464 and 1576', *Medieval History*, 20 July 1976, pp. 312–16.

Scott, Edward J. L. (ed.), *Letter-Book of Gabriel Harvey ad 1573–1580* (London, 1884), <https://archive.org/stream/letterbookgabe00camduoft/letterbookgabe00camduoft_djvu.txt> (last accessed 27 June 2020).

Scouloudi, Irene, 'Returns of Strangers in the Metropolis, 1593, 1627, 1635, 1639: A Study of an Active Minority', *Quarto Series of the Huguenot Society of London 57.473* (1985).

Shackelford, Jole, *A Philosophical Path for Paracelsian Medicine: The Ideas, Intellectual Context, and Influence of Petrus Severinus, 1540–1602* (Chicago: Chicago University Press, 2004).

Shapiro, James, *1599: A Year in the Life of William Shakespeare* (London: Faber & Faber, 2006).

Sharpe, James, *The Bewitching of Anne Gunter: A Horrible and True Story of Deception, Witchcraft, Murder, and the King of England* (London: Routledge, 2001).

Sherman, William, *John Dee: The Politics of Reading and Writing in the English Renaissance* (Amherst: Massachusetts University Press, 1995).

Sisson, Charles J., *The Boar's Head Theatre* (London: Routledge, 1972).

Slack, Paul, *The Impact of Plague in Tudor and Stuart England* (London: Routledge & Kegan Paul, 1985).

Smith, Frederick, 'A "fownde patrone and second father" of the Marian Church: Antonio Buonvisi, religious exile and mid-Tudor Catholicism', *British Catholic History*, 34.2 (2018), pp. 222–46.

Smith, Irwin, *Shakespeare's Blackfriars Playhouse: Its History and Its Design* (New York University Press, 1964).

Stamper, Kory, *Word by Word: The Secret Life of Dictionaries* (New York: Pantheon, 2017).

'The Stanley Papers: Part I', *Remains, Historical and Literary, Connected with the Palatine Counties of Lancaster and Chester*, vol. 29 (London: The Chetham Society, 1853).

Steer, Francis W., 'The Common Paper: Subscriptions to the Oath, 1417–1613', in Francis W. Steer (ed.), *Scriveners' Company Common Paper 1357–1628, with a Continuation to 1678* (London: London Record Society, 1968), via *British History Online*, <https://www.british-history.ac.uk/london-record-soc/vol4> (last accessed 27 June 2020).

Stensgaard, Richard K., '*All's Well that Ends Well* and the Galenico-Paracelsian Controversy', *Renaissance Quarterly*, 25.2 (1972), pp. 173–88.

Stone, Lawrence, 'Elizabethan Overseas Trade', *The Economic History Review*, new series, 2.1 (1949), pp. 30–58.

Sutton, Anne F., 'Lady Joan Bradley', in Caroline Barron and Anne F. Sutton (eds), *Medieval London Widows 1300–1500* (London: Hambledon Press, 1994), pp. 209–38.

Suzuki, Mihoko, 'The London Apprentice Riots of the 1590s and the Fiction of Thomas Deloney', *Criticism*, 38.2 (Spring 1996), pp. 181–217.

Swan, John, *A True and Briefe Report of Mary Glovers Vexation, and of Her Deliverance by Fastings and Prayer* [1603], in Michael MacDonald (ed.), *Witchcraft and Hysteria in Elizabethan London: Edward Jorden and the Mary Glover Case* (London: Routledge, 1991).

Syme, Holger Schott, 'The New *Norton Shakespeare* and Theatre History', *Dispositio*, 28 July 2015, <http://www.dispositio.net/archives/2197> (last accessed 27 June 2020).

Taylor, Gary, John Jowett, Terri Bourus and Gabriel Egan (eds), *The New Oxford Shakespeare* (Oxford: Oxford University Press, 2016).

Thornbury, Walter, *Old and New London: Volume 2* (London: Cassell, Petter & Galpin, 1878), pp. 152–70, via *British History Online*, <http://www.british-history.ac.uk/old-new-london/vol2/> (last accessed 27 June 2020).

Todd, Barbara J., 'The remarrying widow: a stereotype reconsidered', in Mary Prior (ed.), *Women in English Society, 1500–1800* (London: Taylor & Francis, [1985] 2005).

Ungerer, Gustav, 'Portia and the Prince of Morocco', *Shakespeare Studies*, 31 (2003), pp. 89–126.

Vaughan, Alden T., *Transatlantic Encounters: American Indians in Britain, 1500–1776* (Cambridge: Cambridge University Press, 2006).

Venables, Edmund, 'Honywood, Mary', *Dictionary of National Biography 1885–1900*, vol. 27 (London: Smith, Elder & Co., 1900).

Wallace, Charles William, *The First London Theatre: Materials for a History* (London: Benjamin Bloom, 1913).

Webster, Charles, *The Great Instauration: Science, Medicine and Reform 1626–1660* (London: Peter Lang, 1975).

Weiner, G. M., 'The Demographic Effects of the Venetian Plagues of 1575–77 and 1630–31', *Genus*, 26.1/2 (1970), pp. 41–57.

Whitney, Charles. 'The Devil his Due: Mayor John Spencer, Elizabethan Civic Antitheatricalism and *The Shoemaker's Holiday*', *Medieval and Renaissance Drama in England*, 14 (2001), pp. 168–85.

Wickham, Glynn, Herbert Berry and William Ingram (eds), *English Professional Theatre, 1530–1600* (Cambridge: Cambridge University Press, 2000).

Wolfe, Heather, 'Pew-Hopping in St Margaret's Church', *Folger Library Online*, 14 June 2012.

Wolfe, Heather, 'Shakespeare's Coat of Arms: The Surviving Manuscripts in Context', in Hannah Leah Crumme (ed.), *Shakespeare on the Record: Researching an Early Modern Life* (London: Arden, 2019), pp. 33–76.

Woudhuysen, Henry K., *Sir Philip Sidney and the Circulation of Manuscripts, 1558–1640* (Oxford: Oxford University Press, 1999).

# Index

*Italic* denotes illustrations, **bold** tables and n indicates notes.

*A Groats-worth of Witte*, 181
*A Midsummer Night's Dream*, 133, 141, 187–9, *187*, 300
*A Warning for Fair Women*, 213n
Accession Day tilts, Whitehall Palace, 198n
Act of Uniformity 1549, 205
Act of Uniformity 1552, 207
Act of Uniformity 1559, 207
Adelmare, Doctor Caesar and family, *17*, 60n, 69, 77n, 179n, 236, 240, 250n, 261, 272n, 401n
Adelmare, Margaret (Lok), 68–9, 78n, 236, 251n, 303n
Adelmare, Sir Julius Caesar MP and family, 69, 78n, 161n, 236, 246, 250n, 251n, *254*, 292, 302n, 303n, 304n, 347n
'Agas' map, 321, 329n
Agnello, Giovanni Baptista, 70, 77n, 78n, 251n
alchemy, 70, 274n, *283*, 285–6, 289n
Aldgate, London, 89, 157, 224, 276–7
Aleppo and Tripoli, Syria, 185, 259
Alfrey, Johane and Ledys, William, 224, 228n
All Hallows-by-the-Wall, parish, *14–17*, 60n, 111, 177n
All Hallows-the-Less, parish, *334*, 336, 346n, 346n, 349
Allen, Giles, 46, 87–8, 95, 106, 135–41, 142n, 387
Alleyn, Edward, *82*, 83, 98n, 129n, 211n, 308, 443n, 458, 461
Allsop(pe), John, *144*, **166**, **168**, 170, 311, 314
Almshouses, 55
    Leathersellers', *18–19*, 171, 178n, 219, 311, 326n, 397, 402n, 428n, 455
    Skinners', 18–19, 171, 177, 178n, 219, 231, 250n, 310, 320, 326n, 425n
Amsterdam, 12, *30*
Anderson, Sir Edmund, *335*, 336–7, 354, 356–8, 370
Anne, Queen of Denmark, 364, 373
*Anthony and Cleopatra*, 388
anti-immigrant protests 1593, 191
anti-theatre protests, 191–4, 198n
Antwerp and 'Spanish Fury', 12, 29–34, *30*, *32*, 35, 43n, 172, 212n, 227, 313

Antwerp Bourse, *32*, 43n, *56*, 243
Apothecaries, Society of, 288n
apprentice riots 1595, 190–1, *191*, 198n
*Arden of Faversham*, 125–6, 129n
*As You Like It*, 296, 300
Aske, John MP, 197n, 249n, 463n
astrology, 249n, 251n, *266*, *283*, *339*
Augustinian 'Austin' Friary, 162n
Averell, William, 8, 24n, 456n
Axton, George and Joan (Cheston), family, 112, 114n, 326n, 380, 420–1, 424, 430n, 441, 469n
Axton, William and Katherine (Kirk), family, 112, 114n, *415*, 429n, 430n
Axton family, 114n

Babington plot, *127*, 471–2, 473n, 474n
Bacon, Anne, 155–6, 401n
Bacon, Anthony and Francis, 155, 302n, 355
Bancroft, Bishop Richard, 344, 354–5, 362–3, 367, 386
Barbados, 378, 381
Barne II, Sir George Lord Mayor and family, 426n, 472n
*Bassanio, Merchant of Venice*, 238–9, 250n
Bassano family, 250n, 294
Bassano, Emilia (Lanier), 250n
Bassano, Edward, 326n
Bassano, Mark Anthony, 250n, 294, *414*
Bassano, Jeronimo, 250n, 294, 326n, 398, *415*
Bath Spa, 10, 67, *284*, 285, 290n, 364
Bathurst, Timothy and Mary, 8–9, 24n, 25n, **166**, **168**, 274n, 326n, 443n, 448n
Battle of Alcácer Quibir (*Battle of Alcazar*), 78n, 126
Battle of Swally, India, 389n
bearbaiting, 84, 98n
Bearman, Robert, 14, 49n, 79n
'*Beeldenstorm*' in Spanish Netherlands, 212n
bees and honey, 388n
Bel Savage Inn and theatre, Ludgate, 118, 129n, 155
Bell Inn and theatre, Gracechurch Street, 118, *154*
Benolt, Thomas, Clarenceux Herald, 226, 229n, 270n, 303n

Bermuda (Somers Islands), 12, 231, 386, 389n
Bethlem Hospital 'Bedlam', Bishopsgate, 60n, 100n, 176, 276, 291n, 305n, 344, 348n, 372–3, 458
Bible, 10, 11
Bishopsgate, London (city gate), 89, 100n, 146, 176, 224, 395
Bishopsgate (street), *16–19*, 91, 131, *154*, 155–7, 174–5, 191, 199n, 241, 249n, 250n, 274n, 282, 288n, 308, 310–11, 326n, 329n, 345, 373, 387, 394, 398, 401, 406, 411, 416–17, 471
Bishopsgate (ward of), 47, 161n, 177 n, 196, 244
Blackfriars and former friary, 275n, 300, 302, 380, 402n
Blackfriars Hall and theatre II, 130, 134–5, 141, 162n, 196n, 228n, 308, 432, 442n, 461
Blackfriars theatre I, 119, *154*
blood-letting, 278, 339–40
Boar's Head theatre, Aldgate, 132, *154*, 308, 315, 374n, 442n, 460–1, 464n
Bologna University, 262, 273 n, 282
Bond, Daniel (son), **48**, **240**
Bond, Lord Mayor Sir George (brother), 196n, 239–40
Bond, Martin MP (son), 196n, *237*, 239–40, 251n
Bond, Nicholas (son), *237*, *415*, 417
Bond, Alderman William and family, **48**, 50, **52**, 53, 60n, 65–6, 71, 78n, 84, 114n, 181, 184–5, 228n, 236–7, *237*, 238, 240, 251n, 246, 259, 293, 324, 448n
Bond, William junior (son), **48**, 61n, 78n, 184, *237*, 272n
Book of Common Prayer 1549, 207
Book of Common Prayer 1559, 204
Booksellers, Saint Paul's Churchyard, 174
Bostock(e), Charles and family, *19*, 24n, 274n, 387, 410, 427n
Bostock(e), Jane, *266*, 274n
Bostock, Richard MP, 274n
Boys of Chapel Royal, performers, 119, 401n
Boys of St Paul's, performers, 119, *154*, 227, 401n
Bradwell, Stephen, 343, 346n, 363
Brayne, John, 46, 92, 98, 101, 104–8, 113n, 118, 134, 293, 444
Brayne, Margaret (wife), 101, 113n
Bridewell and Court, 60n, 61n, 113n, 288n, 305n, 326n, 348n, 467, 468n
Briggen, Walter, *144*, **166**, **168**, 170, 326n, *418*, *419*, 420–1, 430n, 431n, **438**, 445–7, 449n
British Empire, 12, 13, 53, 63, 71, 231, 363, 377, 381, 382, *383*

Brooke, Henry 11th Baron Cobham, 268, 275n
Browne, Robert and Susan, family, 308, 315, 458, 460, 462, 464n, 465n
Brussels, Ommergang, 1615, *116–17*
Bull Inn and theatre, Bishopsgate, 114n, 118, 121, 129n, 153, *154*, 155–6, 162n, 163n, 176, 191, 195–6, 308, 387, 394–5, 417, 429n, 457–8, 459
Buonvisi, Anthony/Antonio and family, *17*, *183*, 270n, 271n, 272, 293, 303n, 325, 396
Burbage, Cuthbert (son), 83, 102, 108, 130, 134–40, 142n
Burbage, Ellen (wife), 102
Burbage, James and family, 46, 83, 87–9, 91, 98, 99n, 100n, 101–2, 104–8, 113n, 115, 118, 121, 124, 130, 134–5, 137, 142n, 162n, 293, 308, 432, 444, 461
Burbage, Richard (son), 50, 60n, 65, 77n, 251n, 444
Burd(e), William, **48**, 50, 60n, 65, 77n, 251n, 444
Burghley, Sir William Cecil Lord, 61n, 70, 113n, 131, 270n
Burma, 259

Calais, 12, 224, 229n, 230
Ca(o)lton, Sir Francis, 443n
Cambridge University, 38, 243, 260, 262, 274n, 347n
Camden, William, 78n
Canonbury House, Islington, 197n, 246
Canterbury, *30*, 38–9, *38*, 302,
Capel, Sir Giles, 132, 142n, 250n
Carey, Henry 1st Baron Hunsdon, 132, 142n, 250n
Carey, George 2nd Baron Hunsdon, 296, 305n
Castle Alley, Broken Wharf, Thames Street, 336
Catherine of Aragon, 261, 271n
Chamberlain, John, 189–90, 198n
Chancellor, Richard, 63, 250n
Chapel Royal, 270n, 294, 296, 396, 401n
Charles V, 42n
Cheston, Thomas and Joan, family, 430n, 469n
Chettle, Henry, 181, 196n
Chigwell, Essex, 89, *90*, 328n
China (Cathay), 63, 66, 76n, 110, 128, 241, *273*, 382
Christian, John, *18*, **169**, 380, 395, 428n, 453
Cioll, Cecily and German (husband), 23n, **48**, 114n, 236, 244–5, 293, 310, 325, 326n, 380, 417, 444, 448n

'The Cloister' (former Prioress's Lodgings), *6*, *16–19*, 48, 54, 55, *151*, 262, 268, 380–1, 388n, 393, 407, 408
Clough, Richard, 54, 62n, 408, 472n
Clowes, Doctor William, 273n
Col(e)shill, Thomas MP, 47, **48**, 60n, 69, 89, *90*, *270n*, 293, *319*, 328n, 396, 449n, 468n
Coleshill, Susan(na), daughter, (Stanhope), 47, *90*, 270n, 328n, 396
College of Physicians, 172, 264, 267–8, 271n, 272n, 273n, 282, 288n, 289n, 290n, 351, 356–7, 363–4
*Comedy of Errors*, 300
Compton, William 2nd Baron Compton, 187–90, 197n, 198n, 252n, 380
Condell, Henry, 257, 294, 433, 442
'Copperplate' map, 89, 99n, 329n, 413, 449n
Cornwallis, Sir William the Elder, 91, 100n, 356, 473n
Court of Wards and Liveries, 62n
Coventry, 207, 342
Crafford, Guy and family, **48**, 270n, 303n, 396, 401n
Crane, John junior, 442n
Crane, William and Margaret, family, *17*, *209*, 270n, 294, 328n, 396, 401n
Crayford, Kent, 276
Cromwell, Sir Thomas, 224
Crooke, Doctor Helkiah, *19*, 291n, 302
Crooke, Sir John MP, 318, 328n, 354–6, 358, 360, 362
Crosby, Sir John and family, *222*, 223–4, 228n, 236, 324–5
Crosby Hall, 11, *14–17*, 110, 114n, 181, *182–3*, 184–5, 190–1, 194, 196n, 197n, *222*, 223–4, *237*, 240–1, *247–8*, 251n, 259, 261, 272n, 293, 303n, 308, 311, *322*, 325, 380, *380*, 384, 388n, *392*, 394–6, 401n, 411, 462n
Cross Keys Inn and theatre, Gracechurch Street, 118, 142n, *154*
Cullymore, Doctor, **167**, **168**, 179n, 314, 326n
Curtain playhouse, Shoreditch, *5*, 46, 102–3, 107, 114n, 115, 121, 132, 136–7, 141, 142n, *154*, 174, 195, 297, 304n, 320, 459

Dagenham, Essex, 8, *256*, 427n
Dartford furnace, Kent, 70–1
Davenant, John, 388n
de Beaulieu, Augustine and family, *144*, **167**, **168**, 313
de Vere, Edward, 17th Earl of Oxford, 91, 328n, 474n
Dee, Doctor John, 274n, 282, 290n

Dee, Doctor John, disposal of library, 282, *283*, 289n
Dekker, Thomas, 190, 329n
Dereham, Baldwin, 62n
Dethick, William, 179n, 299, 329n
Devereux, Robert 2nd Earl of Essex, 89, *323*, 343
Disney, Walt, 83
Dod(d), Peter and family, **48**, **51**, **169**, 450n, 464n
Drake, Sir Francis MP, 71, *72*, 134, 213n, 388n
Dudley, Robert 1st Earl of Leicester, 86, 98n, 119–20, 128n, 471
Dulwich College, London, 129n
'Duopoly', 132, 142n, 198n
Dutch Church (ex-Augustinian Friary), 210–11, 227
'Dutch Church Libels', *18*, 22n, 25n, 191
Dutch Protestants, 91, 313
Dyers' Company, 346n

Earl of Derby, William Stanley 6th, 461
Earl of Derby's Men, 315
Earl of Leicester's Men, 46, 75, 86, 92, 101, 115, 118, 129n
Earl of Oxford's Men, 105
Earl of Warwick's Men, 75, 118
Earl of Worcester, 198n, 374n, 464n
Earl of Worcester's Men, 374n, 464n
earthquake, London, 1580, 113n
East India Company, *19*, *183*, 231, 241, 243, 250n, 347n, 377, 382–5, 389n, 411, 427n
Eden, Richard, 213n, 401n
*Edward III*, 300
Edward VI, 44, 206, 215n, 221, 272n, 303n
Eightshilling, Baldwin, 1, 22n
Eland, Christopher and Elizabeth, **166**, **168**, 170, 213n, 326n, 440
Elbow, Andrew (Constable), 194–5, 199n, 366
Eliot, T. S., 15
Elizabeth I, *10*, 20, *21*, 39–41, 53–4, 61n, 66, *66*, 67, 71, 75, *76*, 99n, 119–20, 128, 131, 132, 134, 141n, 142n, 170, 179n, 207, 213n, 241, 243, 246, 249n, 250n, 257, 261–2, 268, 270n, 276, 282, 285, 293–4, 299, 302n, 308, *316*, 324, 328n, 333, 343, 359n, 363, *380*, 382, 429n, 470–1
  excommunication, 86
  Lopez affair, Doctor Roderigo, 122, *123*, 273n, 285, 291n
  Parliaments, 44n
*Elizabethan Court Day by Day* (Folgerpedia), 22n, 44n, 45n, 141n, 142n, 198n

Elwick, James and family, 24, *144*, **167**, **168**, 326n, *415*, *418*, 443n
English Civil War, 240, 387, 410
English language, 12, 377, 386–7
*Epicœne, or The Silent Woman*, 173–4
Epping Forest, Essex, 89
Erasmus, Desiderius, 221
Essex (County of), 89
exorcism, 344–5, 348n, 360–3

Farnaby(ee), Giles and family, 294, 303n, *415*, 429n
Felton, Doctor Nicholas, 260, 271n
fencing displays, 121, 457
Ferrara University, 262, 282
Fetch (Fitch), Oswald, *144*, **166**, **168**, 311, 314, 326n, 327n, 329n, 443n, 472
Field, Richard, 75, 79, 203, 255, 304n, 402n
Fisher's Folly, Bishopsgate, 91, 100n, 474n
Fitch, Ralph, 259, 270n
Fleet Prison, 190, 198n
Florio, John, 163n
Flushing, Holland, 39
Fontaine, Margaret, 31, 43n, **49**, 60n, 204, 212n, 313, *415*
Forman, Simon, 23n, 110, 249n, 251n, 272n, 275n, 338–40, *339*, 347
Fortune theatre, Clerkenwell, 95, 99n, 137, 141, *154*, 302, 305n, 442
Foxe, John, 270n, 327n, 328n, *341*, 342–3
French Church, Threadneedle Street, 210–11, 227, 451n
Frobisher, Martin, 53, *64*, 77n, 78n, 251n
    First voyage 1576, 65, *66*, 67–8, 95, 110, *237*, 241, 244, 382–4
    Second and Third voyages 1577 and 1578, 68, 70, *71*, 244

Galen of Pergamon, 274n, 290n, 290n, 356
Galenists, 264, 274n
Gannett, John and Joan, 430n, 448, 451n
Garrard, Sir Anthony and family, 230, 426n
Gascoigne, George, 33–4, 40, 43n, 62n, 129n
Gentili, Alberico (lawyer) and Matthew (doctor), 291n, 292, 303n
Gerard, John, 271n
Geneva, 281
Germany, 262, 289
Gessner, Doctor Conrad, 267, 328n
Giffard, John MP and Gilbert (son), 472, 473n
Gilbert, Sir Humphrey, 13, 55–7, *58*, 59, 62n, 63, 65, 71, 73, 76n, 134, 251n, 268, 382, 408

The Globe theatre, 4, 7, 137, *138*, 139–41, *154*, 293, 300, 302, 303n, 320, 325, 333, 373, 432
Glover, Anne (sister), 346n, 352, 359n, 362
Glover, Gawthren (mother), 349–52, 362
Glover, Mary, 207, 328n, 333, *334*, *335*, 342–64, 373, 386–7
Glover, Robert (grandfather), 207, *341*, 342–3, 347n, 374n
Glover, Timothy and family (father), 336, 346n, 360–1
Glover, Sheriff William (close relation), 336, 346n, 353, 359n
gloves and glove making, 36, *37*, 62n, 99, 149
gold and gold fever, 43n, 63, 69–71, 77n, 78n, 226, 238, 241, 250n, 379, 469n
Golden Fleece, 237–8
Gorges, Sir Nicholas MP, 262, 273n, 408, *414*
Gosson, Stephen, 61n, 84, 98n, 115, 118, 128n, 155
Gramer, Abraham, **167**, **169**, 199n, 412, 430n, 465n
gravediggers and Hamlet, 317–19, *317*
Great Barn, Shoreditch, 87, 99n
Green Dragon Inn, Bishopsgate, 16–19, 176, 395, 428n, 451n, 457, 459, 462n
green sickness, 340
Greenblatt, Stephen, 344
Greene, Robert, 124–6, 181, 196n, 470
Greenwich Palace, 66–7, *66*
Gregory XIII, Pope, 449n
Gresham College, *19*, *57*, 59, 174, 179n, *242*, 243–4, 251n, 272n, 282, 302, 373, 374n, *392*, 394
Gresham House, *18*, 55, *57*, 62n, 114n, 157, 163n, 174, 243, 251n, 259, 261–2, 325, 326n, 394
Gresham, John, **48**, 114n
Gresham, Lady Anne (Ferneley/Reade), 59, 157, 174, 228n, *242*, 243–4, 246, 251n, 261, 279, 325n, 326n, 394, **414**
Gresham, Sir Thomas, 43n, **48**, 50, 53–4, 60n, 62n, 65, 114n, 157, 163n, 174, 219, 236, *242*, 243–4, 259, 261, 293, 310–11, *322*, 324, 394, 444
Grocers' Company, 213n, 288n, 347n, 445, 449n, 450n
Guercy, Doctor Balthasar and family, *17*, 77n, 179n, 261, 270n, 271n, 272n, 401n
Guidott, Thomas, 285, 289n, 291n, 359n
Guilpin, Everard, 136, 173
Guinea (West Africa), 231, 250n
Gunpowder Plot, 365
Gunter, Anne affair, 364–5, 373

Gwinne, Professor Matthew, 251n, 262, 272n, 273n, 373

Hagar, William, Edith/Elizabeth and family, 23n, **48**, *414*, 429n, 457
Hales, Sir James, 317, *318–19*, 320
Halcs family (Warwickshire), 274n
*Hales v Petit* court case, 317–20, 329n
Half Moon Inn, Bishopsgate, 457, 460n
Hall, Doctor John, 261
*Hamlet*, 7, 13, 121, 300, 317–20, *317*, 373, 389n
Hampton Court Palace, 40–1, 44n, 75, 86, 131
Harrington, William, 78n, 272n
Harrison, John and Anne, family, 461
Harrison, Matthew and Joan, 114n, 457
Harrison, William, 20, 196, 214n
Harsnett, Samuel, 279, 344, 363–4
Harte, Lord Mayor Sir John MP, 340, 347n, 353, 359n
Harvey, Gabriel, 118
Harvey, John, 457–65
Hastings, Reed, 83
Hathaway, Anne, 75
Hatton, Sir Christopher, 274n
Hatton, John and Joan, family, *18*, 111–12, *150*, **165**, 195, 196, 199n, 307, 310, 380, 387, *409*, 416, 421–2, *422*, *423*, 424, 426n, 431n, **438**, 452–5, 455n, 456n, 464n
Hawkins, Sir John, 250n
Haw(u)te, Elizabeth and Alen, 425n
Hayles, Sir Charles Christopher, 315, 317, *318–19*
Hayles, Cheyney, 315, *318–19*
Hayles, Sir James junior, *318–19*, 328n
Ha(y)les, Humpfrey, 315, *318–19*
head-tires, 467, 469n
Heidelberg, 264, 268, 271n, 274n
Heminges, John, 257, 270n, 294, 387, 433, 442
Heneage, Michael, MP, 315, 326n, 328n
Heneage, Sir Thomas, *235*, 315, *316*, 328n
*Henry IV, I & II*, 281, 300
*Henry V*, 195, 300, 379, 468
*Henry VI* trilogy, 128, 180–1, 224
Henry VIII, 179n, 205, 226, 229n, 298, 396, 401n, 402n, 445
Henslowe, Philip and family, *82*, 87, 98n, 99n, 100n, 121, *122*, 123–4, 129n, 130, 145, 161n, 180, 196, 199n, 305n
Herbert, Mary Countess of Pembroke, 388n
Heywood, Thomas, 243
Hilliard, Nicholas, 44n, 302n, *316*, *323*
Hippocrates of Kos, 367
Hitchin, Hertfordshire, 99n

Hobson, Thomas the University Carrier, 129n, 156–7, 163n
Holden, Sir Edward and family, 249n
Holinshead, Mr, 466
*Holinshed's Chronicles*, 20, 328n, 365, 372
Hollis, Lord Mayor Sir Willam and Lady Elizabeth, *17*, 178n, 213n, 226, 228n, 250n, 303n
Hollyland, David and family, *414*, 426n, 431n
Holy Trinity, Aldgate, 162n, 228n, 270n
Holywell Lane, Shoreditch, 46, 100n
Holywell Priory and Hollywell, 46, 106, 459
Honeywood, Anna (sister), 315, *318–19*
Honeywood, Elizabeth (sister), 315, *318–19*
Honeywood, Lucy (sister), *318–19*, 464n
Honeywood, Mary Atwater (mother), 315, *318–19*, 326n, 328n
Honeywood, Robert II and family, 144, **166**, **168**, 170, 178n, 311, 314–17, *318–19*, 320, 326n, 328n, *418*, 443n
Honeywood, Robert III (son), *318–19*, 410, 427n
Horse Head Inn, Whitechapel, 276–8
Houndsditch, 25n, 162n, 176
Howard, Charles Lord Effingham, 131
Hubbard, Robert and Katherine, family, 7, 23n, **168**, 294, 303n, 312, 326n, 402n, *414*
Hyde, John, 106–8, 112, 134, 293, 444, 446–7
hysteria, 285, 367–71
*Hysterica passio*, 287, 357, 367

*If You Know Not Me, You Know Nobody*, 243
India, 241, 243, 382, 389n
Indian Ocean, 382
Indonesia, 241
inheritance and 'transmission failure', *222*, *242*, 246, 251n, *322*, 324–5
Inner Temple, 22n, 119–20, 129n
Inns of Court, 2, 22n, 29, 105, 119–20, 129n, 134, 137, 292, 300
Inuks, 67–8, *68*, *71*, 78n, 251n
*It was a lover and his lass*, 296
Italy, 9, 25n, 98n, *225*, 226, 262, 271n, 282, *284*, 285–7, 289n, 291n, 449

Jackson, Elizabeth, *334*, 336, 349–58, 359n, 360, 386
Jamaica, 378
James 1st (6th of Scotland), 77n, *127*, 128, *186*, 198n, 214n, 251n, 302, 345, *345*, 363–4, 366, 373
Jamestown, Virginia, 386, 389n
Japan, 243, 382, 389n
*Jason and the Golden Fleece*, *237*, 238–9

493

Java, Batam, 382
Jefferies, Thomas, 189, 197n
Jeffrey, John, Antonia & Katherine, 60n, **166**, **168**, 312, 314, 424, 466–9
Jekyll, John Stoker, **48**, *144*, **166**, **168**, 312, 314, 326, 327n, 328n, 329n, 442n
*The Jew of Malta*, *122*, 123, 288n, 291n
Jones, Richard, 457, 463n
Jonson, Ben, 189, 276, 282–7, 289n, 290n, 291n, 312, 314, 334, 373, 380, 386, 424, 463n, 469n
Jorden, Doctor Edward and Lucy, *18*, *144*, **166**, **168**, 189, 276, 282–3, *284*, 285–7, 289n, 290n, 291n, 312, 314, 334, *368*, 373, 380, 386, 424, 463n, 469n
    1598 Lay Subsidy, 172, 289n, 290
    *A Brief Discourse Of A Disease*, 363, 367, *368*, 369–73
    character, 291n
    College of Physicians, 289n, 290n
    death and burial at Bath Abbey, 10, 289n, 312, 387
    family, 9
    father in law, Sir William Jordan MP, 25n, 289n
    Mary Glover affair, 356–65
    Anne Gunter affair, 364–5
    medical training in Basel and north Italy, 282, 289n
    move to Saint Michael, Wood Street, 367, 443n
Jorde(a)n, Israel and Anne, 176, **169**, 196, 308, 311, 315, 326n, 328n, 380, 387, 421–2, 452, 455n, 460–5
Judd, Lord Mayor Sir Andrew, *17*, *158*, 178n, 229n, *234*, 250n, 293, 384
Judd, Alice (daughter), *234*, 250n, 384
*Julius Caesar*, 300

Kelke, Clement, **48**, 50, 60n, 113n, 228n, 229n, 251n, 270n, 305n, 398, *414*, 429n, 468n
Kemp, Will, 255
Kendall, Thomas, 162n, 402n, 426n
Kendrick, Hugh family and brothers, **48**, **168**, 294, 303n, 401n
Kenilworth Castle celebrations 1575, 86, 98n, 99n, 129n
Kerwyn, William, **48**, 60n, *245*, 246, 251n, 270n, *414*, 429n
Ketel, Cornelius, *18*, 51, **51**, 78n, 250n, 251n
*King John*, 300
*King Lear*, 246, 279, 344, 373
King's Men, 134, 380

Kirk(e), Anne, *335*, 336, *336*, *339*, 346n
Kirk, Edward (E.K.?), 430n
Kirk the Elder, Richard and Julia, 110, 112
Kirk the Younger, Richard and Katherine (Axton), 51, **51**, 110–12, 114n, *182*, 430n
Kyd, Thomas, 22n, 126, 129n, 180, 299, 396, 470–1

Langley, Francis, 192, 432–3, 460, 462, 463n
Lanier, Alfonso, 250n
Lanman, Henry, 121
laudanum, 280, 291n
Lay Subsidy, 146, 178n
    1541, 162n
    1576, 47–50
    1582, 272n, 273n, 299
    1593, 347n
    1597/98, 47, 50, 111, 114n, 146, 165, 177n, 178n, 179n, 326n
Lay Subsidy residency certificates, 162n, 273n, 467, 468n
Lay Subsidy rolls, 146, 162n
Leadenhall Street, *16–19*, *152*, 261, 294, 389n, 400n
leather, 145, 149
Leathersellers, Worshipful Company of, 8, 54, 197n, 212n, 219, 255, 393, 404, 425n
    accounts, *423*, 454
    clerks, 452
    Finch, Clement, dispute with, 453
    garnett (store) built, 453
    Little St Helen's estate, *18–19*, 47, 111, 149, *151*, 162n, 171, 195, 205, 248n, 273n, 275n, 295, 310, 326n, 381, 379, 400n, 402n, 404–31, *407*, *409*, *422*, 445–6
    livery gown, *150*, 452
    Livery Hall and garden, *18–19*, 54, 98n, 149, *150*–1, 162n, 175, 179n, 195, 259, 324, 325n, 381, 400, 402n, 404, *405*, 406, 411, 416, 425n, 427n
    property disputes, 453
Lee(a)ch, George and family, *19*, 274n, 381, 388n, 426n, 427n
Levant Company, 275n, 380, 408, 426n
Leveson, William and family, 293–4, 303n
Libavius, Doctor Andreas, 285
'Lime Street naturalists', 260–1
L'Obel, Mattias, 260, 271n
Lodge, Thomas and family, 61n, 125–6, 213n, 236, 250n
Lok, Michael, 66, 69–70, 71, 76n, 77n, 78n, 185, 240, 251n, 303n

Lomeley, Dominic (father), 155, 225–6, 228n, 270n, 271n
Lomeley, James and Joan, **48**, *144*, **166**, **168**, 225–6, *225*, 228n, 229n, *414*
London
  alleys, 91
  anti-immigrant agitation, 191
  apprentice riots 1595, *191*, 194, 309
  citizen of London, 257
  city wall and moat, *10*, *92*, 162n, 176
  cockpits, *85*
  dissolution of monasteries, 224
  doctors of law, 272n
  doctors of physick, 177n, 272n
  domestic servants, 204
  economic hardship in 1590s, 190, 258
  Elizabethan population growth, 84, 91
  Great Fire 1666, 381, 387
  Guilds/Livery Companies, 91, 162n, 179n
  immigration from rest of England, 224
  immigration from Low Countries, 30, 91,
  map, 'Agas', *85*, 321
  map, Braun & Hogenberg, 1572, x
  map, 'Copperplate', 89, *92*, 99n, *152*, 329n, *405*, 413, 449n
  map, Ogilby, 1676, 392
  noise, 164n, 173–5
  plague 1665, *109*
  poll tax, 430n
  River Thames, *x*, *138*, *154*
  sympathetic magic, 337
  Tower of London, *x*, *154*, 198n, 272n, 275n, 288n, 328n, 426n, 472
  ward administration, 162n
Lopez, Doctor Roderigo, *122*, 123, 268, 273n, 285, 291n
Lord Admiral's Men, 99n, 123, 132, 145, *154*, 270n, 302, 308, 442
Lord Chamberlain's Men, 4, 124, 132, 136–7, 142n, 162n, 173, 175, 194–5, 203, 205, 213n, 250n, 255, 270n, 293–4, 296, 299, 305n, 308, 314, 325n, 328n, 380, 432, 461
Lord Mayor of London, 104, 134, 149, 184, 198n, 223, 275n, 350
Lord Strange's Men, 78n, 142n, 328n
*Love's Labour's Found*, 300
*Love's Labour's Lost*, 300
Lumley (Lomeley?), Sir Martin and family, 228n
Lyly, John, 124–6

*Macbeth*, 160, 259, 278–9, 281, 333, *334*, *345*, 365–7, 372–3, 374n

*Madre de Deus* (ship), 282
Malay Peninsula, 241, 382
mandrake, 280, 288n
Manningham, John, 279, 288n
Marian exiles, 207, 262, 388n, 472n
Marian martyrs, 207, 242, *341*
Marks Hall, Coggeshall, Essex, 311, 326n
Marlowe, Christopher, 38–9, *38*, 75, *82*, 89, 123–4, 126, 128, 129n, 132, 180, 274n, 288n, 291n, 299, 305n, 396, 470–1
Marprelate Controversy, 274n, 344
Marshalsea prison, 61n, 105, 473n
Martin, Lord Mayor Sir Richard, 340, 347n
Mary I, 179n, 207, 261–2, 271n, 293, 303n, 342, 445,
Masters of Defence, 121, 129n
Master of the Revels, 86, 99n, 118
Maunder, Henry and Isabel, *144*, **167**, **168**, 257, 326n, 440, 470–1
*Measure for Measure*, 195, 366
Medieval English drama, 83, *116–17*, 118
Meeres, Francis, 100n, 189, 299, 378, 474n
melancholy, 277–8, 289
Melanchthon, Professor Sigismund, 264
mental illness, 276–9, 289
Mercers' Company, 244
Merchant Taylors' Company, 250n
Middlesex, County of, *x*, 5, 53, 59n, 89, 99n, 104, 106, 108, 193, 299, 305n
Miles, Robert, 91, 113n
Milton, John, 156, 163n
Moffet/Muffet, Doctor Thomas, 268, 274n
Montaigne, Michel de, 15, 20, 156
Moor Fields, 15, 87, *92*, *93*, 99n, 282
More, Sir Thomas and family, *183*, 224, 271n, 328n
Morley, Thomas, *18*, *144*, 165, **167**, **168**, 176, 257, 294, *295*, 296–7, 304n, 325, 326n, 424, 441
Morocco (Barbary), 314, 388n
'Mother' (uterus), 287, 356–7, 359n, 363, 367, *368*
Mother Gillams, 337
Mountjoy, Christopher and Mary, family, 63, 65, *154*, 171, 179n, 288n, 300, 424, 467–8
*Much Ado about Nothing*, 300
Muscovy Company, 87, 89, 99n, 213n
musical instruments, *152*, 294, 303n

Nai(y)ler, Anne (sister), 337, 347n
Nai(y)ler, Christian (sister), 338–40, 347n
Nai(y)ler, George (brother), 337
Nai(y)ler, George (father), 346n
Nai(y)ler, Joan (sister), 337–40, 347n, 373

Napier, Richard, 197n, 249n, 347n
Napier, Sir Robert 'Sandy', 197n, 249n
Nashe, Thomas, 473n
natural history, 260
New Place, Stratford-upon-Avon, 147, 171, 172, 30, 305n, 309, 378, 441
Newfoundland, 13, 71, 134, 381
Newgate prison, 341
Newington Butts playhouse, 59n, 123n, 129n
North, Roger 2nd Baron North, 268, 274n
North, Sir Thomas, 274n
Northbrooke, John, 59n, 123, 129n
North-East Passage, 63, 65
North-West Passage, 53, *64*, 65–6, 68, 70, 231, *237*
Norton Folgate, liberty of, 60n, 91, 99n, 299, 396

Office of the Revels, 447–8
Offley, Alderman Hugh, 259, 303n, 401n, 426n, 443n
Oldcastle, Sir John, 275n
*Ommergang*, Brussels 1615, *116–17*
*On the University Carrier*, 156–7
Opium, 288n
Osterley House and park, 53–4, 163n, 244
*Othello*, 280, 373
Oxbridge, 42n, 78n, 179n, 210, 244
Oxford University, 251n, 272n, 273n, 288n, 292, 373, 374n

Padua University, Italy, 10, 25n, 262, 282, 286, 289n, 357
Palladio, Andrea, 98n
*Palladis Tamia, Wits Treasury*, 100n, 189, 299, 378
Paracelsians, 261, 264, 268, 274n, 275n, 286, 289n
Paracelsus, Theophrastus von Hohenheim, 264, *265*, *266*, 267–9, 273n, 274n, 280, 285
Parish Clerks' Company, 459
Parry, Henry and family, 268, 279–80, 288n
Peele, George, 78n, 125, 198n
Penn(e)y, Doctor Thomas, 268, 271n, 274n
Pepys, Samuel, 98n
Philip II of Spain, 31, 41, 42n, 61, 78n, *117*, 126, 212n, 388, 466
Pickering, Sir William, 231–2, *235*, 243, 250n, *316*, 328n
Pindar, Sir Paul and mansion, 23n, 91, 100n, 346n, 427n, 463n
Pistorius, Doctor Johannis, 269

Plague, 24n, 74, 78n
 1563 plague, 108
 1578 plague, 51–2, 108, 110–12
 1592–93 plague, 110, 112, 130–2, 269
 1603 plague, 275n
 1665 plague, 108, 387
 immunity from, 108
Plato, 4
Pollard, Sir John MP and family, **48**, 59, 62n, 228n, 268, 408
Polsted, Thomas and family, 271n
Pontois, John, 282, 289n
Pooley, Mrs, Robert and Anne, 144, **167**, **168**, 312, 326n, 443n, 471–2, 473n, 474n
Privy Council, 41, 65, 108, 131, 141n, 191
prostitution, 99n, 103–4, 113n, 467
proto-capitalism, 325, *380*, 381
Pryme, widow, 447, 451n
Pryn(ne)/Prymme, John and Margery, *18*, 112, 144, **166**, **168**, 176, 177n, 241, 293, 308, 310, 326n, 380, 413, *414*, *418*, *419*, 420–1, 430n, 440–1, 444–51, 457
Purgatory, 223
Puritans and Puritanism, 11, 50, 103, 203, 210, 213n, 214n, 252n, 274n, 281, 289n, 302, 327, 336, 342, 343, 344–5, 346n, 347n, 349n, 354, 360, 363, 374n, 386, 421, 449n

Queen's Men, 115

Raleigh, Sir Walter, 13, *73*, 302n, 382, *385*, 426
Rate, Melchior, 1, 229n
Reade, Anne, 279
Reade, Sir Thomas, 163n, 243, 290n, 311, 314, *415*
Reade, Sir William, **51**, *144*, 157, **166**, **168**, 170, 243–4, 246, 326n
Red Bull theatre, Clerkenwell, 141
*Red Dragon*, former *Scourge of Malice* (ship), 389n
Red Lion Inn and theatre, Mile End, Whitechapel, 46, 59n, 92, 100n
Reformation in England, 205
Return of Strangers 1571, 212n, 272n
*Richard II*, 133, 246, 300, 321, 329n, 389n
*Richard III*, 181, 185, 224, 240–1, 305n
Richard III, Duke of Gloucester, *183*, 224, 226, 240–1, 325
Risby, Richard and family, 51–2, **51**, 111–12, 114n, 131, *144*, 165, **167**, **168**, 228n, 326n, *418*, 429n, 442n
Roanoke Colony, Virginia, *73*, 382
Robinson, Anne (daughter, married Thomas Walthall), 197n, *232*

Robinson, Sir Arthur (son), 198n
Robinson, Christian (wife), 230, *232*, 248n, 463n
Robinson, Elizabeth (wife of John Robinson the Younger), 197n, 230, 249n
Robinson, Elizabeth (daughter), 188–90, *232*
Robinson, Henry (son), 198n, *232*, 275n, 388n
Robinson, Humpfrey (son), 197n, *232*
Robinson, John (witness to Shakespeare's will), 249n
Robinson, John (others), 288n
Robinson, Katherine (daughter), 197n, *232*
Robinson, Mary (daughter), 197n, 249n, 347n
Robinson, Robert (son), *232*, 275n, 380, 408, 426n
Robinson, William (son), *19*, 232, 249n, 380, 387, 410, 426n
Robinson the Elder, Alderman John, *18*, **48**, 60n, 62n, *144*, **166**, **168**, 170, 188–9, 197n, 205, 230–1, 241, 246, 248n, 249n, 250n, 251n, 259, 270n, 275n, 314, 325, 326n, 347n, 380, 408, *414*, 420–1, 426n, 440, 442n, 459, 463n
Robinson the Younger, John (son), *18*, *144*, **166**, **168**, 197n, 230–1, *232*, 249n, 275n48, 326n6, 387, 410, *418*, *419*, 420–1, 440–1, 449n
*Romeo and Juliet*, 4, 11, *11*, 133, 141, 142n, 176, 198n, 281, 300, 308, 321, 329n, 379
Rose playhouse, Southwark, 46, 87, 99n, 100n, 115, 121, *122*, 126, 129n, 130, 136, 145, *154*, 174, 180, 195, 198n, 199n, 305n, 308, 460
Rowkyll/Roking, James, *144*, **166**, **168**, 326n, *418*, *419*, 420–1, 429n
Royal (Gresham) Exchange, 54, *56*, 62n, 189, 243, *392*, 444
Royal Mint, Tower of London, 70, 157, 163n
Russell, John 1st Earl of Bedford, 270n, 425n
Russia, 63, 231, 250n
Ruttings, John and family, 1

Saint Alban, Wood Street, parish, 212n
Saint Andrew Undershaft, church and parish, *16–19*, 161, 163n, 214n, 228n, 260, 271n, *298*, 304n, 396, 403n
Saint Anne, Blackfriars, church and parish, 214n, 294, 344
Saint Antholin, Budge Row, church, 214n, 260
Saint Bartholomew by the Exchange, church, 274n
Saint Bartholomew Day's Massacre 1572, 39, *40*, 91, 227

Saint Bartholomew's Hospital, Smithfield, London, 264, 268, 273n, 285
Saint Benet Fink, church, 189
Saint Botolph, Aldgate, parish, 70, 461
Saint Botolph, Bishopsgate
  church, 176, 348n, 382
  parish, *16–19*, 47, 60n, *82*, 89, 98n, 128n, 178n, 213n, 313, 393, 427n, 457, 467
Saint Ethelburga, church and parish, *16–19*, 60n, 176, 177n, 215n, 288n, 394–5, 406, 412, 417, 429n, 443n
Saint Gabriel, Fenchurch Street, church and parish, 273n, 312
Saint George the Martyr, Alie Street, church, 227n
Saint Helen Hotel, *158*, *159*, 177, 178n, 425n
Saint Helen's, Bishopsgate, *5*, *16–19*, 148, 152, *218*, 310–14, *405*, *409*
  'Affid' records, 326n, 327n, *418*, 433–41
  Ball, Minister Professor Richard, 251n, 271n, 272n, 362, 374n
  baptisms, weddings and burials 1576, 51–3
  'bare ruined choirs', *218*, 225, 324
  bell tower, lack of, 329n
  benches in church, 219, *220*
  bombing 1992, *218*, 250n
  burial areas inside church, 219
  burials, 1575–1613, *109*
  character, 147
  church bells, 163n, 329n
  church box pews, *202*, 216–19, 227n, 228n
  church clock, 163n, 204, 213n, 329n
  church communion table, 208, 216–19, 236, *236*
  church font, 221, 228n
  church new communion cup 1570, 208, *209*, 214n
  church poor chest, 223
  church pulpit, 216–17, 221, 229n, 236
  church rood screen and removal, 205, 208, 210, 217, 446
  church, tombs and memorials, 196n, 205, 214n, *220*, *222*, 223–6, 228n, 230–48, 384
  church, tombs and memorials moved from St Martin Outwich, 216, 228n
  church, west frontage and two entrance doors, *6*, 320–1, *322*, 329n
  churchwardens, 114n, 290n, 444–5
  churchwardens' accounts, 219, 374n
  churchyard and uses, *6*, *16–19*, 149, *158*, *159*, 160, 162n, 163n, 195, 203–4, 211n, 212n, 216, 219, 227n, 308, 320–1, *322*, 325, 425n, 428n

churchyard (new), 325n
Clapham, Minister Lucas, 214n
'The Cloister' (former Prioress's Lodging), 6, *16–19*, 48, 54, 55, *151*, 262, 268, 380–1, 388n, 393, 407, 408
'The 'Close', 6, *16–19*, *158*, *159*, 161, 163n, 164n, 174–5, 194–5, 204, 258, 262, 268, 308, 309, 320
coffins required inside church, 211n
communion service, 210
dissolution of two chantries, 207, 213n
doctors, cluster of, 261, 289n, 291n, 292, 314, 325
Fenner, Edward, gift of, 459, 463n
gatehouse 'belfry' on Bishopsgate, *16–19*, 153, *158*, *159*, 160, 163n, 199n, 212n, 216, 320, 329n, 394–5, 398
gender segregation in church, 219–21
Great St Helen's (street), *16–19*, *158*, *159*, 161, 163n, 164n, 175–6, 212n, 231, 290n, 305n, 310–11, 380, 393, *396*, *397*, 398, *399*, 400, 404, 429n
29 Great St Helen's, 272n
33 Great St Helen's, *5*, 426n
35 Great St Helen's, *159*, 177, 425
high altar, Catholic, 223, *235*
Hughes, Minister Lewis, 210, 214n, 302, 336, 346n, 348n, 354, 359n, 360–3, 386, 449
iconoclasm, 206–8, 445
Italians, 226, 270n
'Job rakt out of the Asshes', *19*, 402n
'Large warehouse', *18–19*, 380–1, *384*
1593–1597 Lay subsidies, 165
1541 Lay Subsidy roll, 226, 229n, 261, 396
1576 Lay Subsidy roll, 42, **48**, 50, **51**, 61, 77n, 114n, 236, 427n, 473n
1582 Lay Subsidy roll, 178n, 196n, 328n, 443n
1597 Lay subsidy roll, 387
1598 Lay Subsidy roll, *144*, 165: listing, 167–9, 170, 174, 177n, 180, 196n, 262, 299, 309–10, 326n, 327n, 387, 394, 417, *418*, *419*, 420–4, **433–9**
1599 Lay Subsidy roll, 165, 196n, 394, **433–9**
1600 Lay Subsidy roll, 165, 180, 262, 394, **433–9**
1611 Lay Subsidy roll, 178n, 433
lectureships, Protestant, 114n, 210, 214n, 416
Lewis, Minister Richard, 210, 214n, 270n
Little St Helen's (street and gatehouse), 8, *16–19*, 176, 195, 305n, 326n, 380, 393, 395–6, 398–400, 400n, 402n, 404, 428n
'Little St Helen's Publications', *18*, 294

1542 Thomas Mildmay survey of nunnery, 157–60, 398, 402n, 406, 408, 412, 428n
minister/rector, 260, 270n
nunnery, demolition, 402n, *405*, 408, *409*
nunnery, dissolution, 205, 259, 261, 326n, 406
nunnery of St Helen, *16–19*, 54, 149, 153, 162n, 164n, 171, 175, 205, 213, *218*, 224, 226, 230, 324, 397–8, 406
nuns' choir seats, *218*, 219
nuns' dining hall (frater), *16–19*, 62n, 408, *409*
nuns' dormitory (dortor), *16–19*, 54, 149, *150*, *151*, 205, 213n, 404, *405*
nuns' quire, *16–19*, *220*, 406
nuns' well/pump, *16–19*, 413
Oliver, Minister John, 156, 204–5, 213n, 260, 346n
organs in church, removal, 210, 214n
paraphrase desk in church, 221, 228n
*Paraphrases of Erasmus*, 221, 297
'pardon door', entrance into nuns' quire, 6, *16–19*, 219
parish, *16–19*, 4, 50, 60n
parish accounts, 400n, 425n
parish church, *16–19*, 153, 159–60, 163n, 175, 177, 195–6, 205, 216, 406
parish clerk, 221
parish registers, 161n, 393
parish sexton, 204–5, 210, 212n, 417, 428
parish well/pump, *16–19*, 162n, 321, 329n
plan of church 1808, 217–19, *220*, 228n
planning of burials in church, 221
population movement in parish, 175
private gardens, *16–19*, 325
1578 plague, *109*, 110–11
1592–93 plague, *109*, 131, 205, 325n
1603 plague, *109*, 213n
property litigation, 450n
rectory rights and farmers, 60n, 69, *90*, *245*, 252n, *254*, 260, 270n, 279, 299, 346n, 429n, 449n, 450n
rents for houses, 100n, 309, 429n
re-glazing windows in church, 227n
re-plastering interior of church, 227n
row of ten houses in The Close (Crane estate), *17–19*, 259, 270n, 320, 328n, *396*, *397*, 398, *399*, 401n, 429n
Saint Helen's Place, 402n, 427n
Skinners' almshouses, *18–19*, *158*, *159*, 171, 177, 178n, 219, 231, 250n, 310, 320, 326n, 425n
steeple, proposal for, 251n

Steward's Lodging, *16–19*, 199, 402n, 406, 412–3, 425, 428n
'Strangers'/immigrants, 165–6, 171–2, 179n, 203, 205, 212n, 226–7, 229n, 259, 272n, 288n, 291, 313–14, 420, 430n, 447
sub-division of properties, 400n, *422*, 425, 431n, 453
sub-letting properties, 400n, 402n
sugar refining, *19*, 377, *378*, 381
Sugarloaf Public House, *19*, *384*, 400
survey of parishioners 1565, 449n
survey of Strangers 1568, 468n
survey of Strangers 1593, 229n
survives Great Fire 1666, 147, *148*
tithe survey 1589, 114n, 171, 180, 212n, 270n, 326n, 394, 400n, *414–15*, 416–17, 429n
tithe survey 1638, 178n, 429n
topography, *16–19*, 148, 153–4, *154*, 175, *392*, 394–400
transfer of Lay Subsidy payment elsewhere, 262, 443n
vestry records, 214n
Saint Katherine Coleman, church and parish, 190, 315
Saint Katherine Cree, parish, 196n
Saint Kitts (island), 377
Saint Leonard, Shoreditch, church and parish, 135, 250n, 311, 315, 326n, 393, 430n, 458
Saint Martin-le-Grand, liberty of, 212n
Saint Martin Outwich 'by the well with two buckets', parish, *16–19*, 60n, 77n, 177n, 181, 216, 227n, 249n, 271n, 282, 310, 329n, *392*, 394
Saint Mary, Bocking, Essex, 312, 327n
Saint Mary Aldermanbury, parish, 257, 294, 442
Saint Mary Axe, church and parish, *16–17*, 163n, 271n
Saint Mary Axe, street, *16–19*, 157, 161, 163n, 164n, 397–8, 401n
Saint Mary Matfelon, Whitechapel, 214n, 276, 461, 464n
Saint Mary Somerset, church and parish, 338, *338*, 346n, 452
Saint Mary Woolchurch Haw, church, 249n
Saint Michael Bassishaw, church, 198n, 310, 443n
Saint Michael, Wood Street, parish, 312, 443n
Saint Olave, Hart Street, church, *263*, 311
Saint Olave, Silver Street, church and parish, 305n, 442
Saint Paul's Cathedral and bookshops, 6, 102, *138*, *154*, 228n

Saint Paul's Cross, 6, 23n, 102, 211, 215n
Saint Peter, Cornhill, parish, *16–19*, 114n, 25, 28, 179n, 197n, 299, 329n, 393, 447
Saint Peter-le-Poore, parish, *16–19*, 60n, 177n, 426n
Saul, Jacob and family, **49**, 172, 179n, 227, 261, 290n
Sa(u)nders, Bla(i)se and family, **48**, 207, 213n, 214n, 388n, 449n, 451n
Saunders, Doctor Patrick and family, *19*, 282, 289n, 290n, 410, 426n
Saunders, Thomas and family, 274n
scaffolds, 84
*School of Abuse*, 84, 115, 155
scriveners and Scriveners' Company, 175, 179n, 195–6, 199n, 274n, 311, 410, 452, 457, 460, 463n
*Sea Venture* (ship), 386, 389n
Sebastian, King of Portugal, 78n
Serjeant Poulterer and poultry, 50, 160, 163n, 223, 236, 250n
Severinus, Doctor Petrus (Peder Soerensen), 268, 274n, 286, 291n
sex industry, 102–4
Shakespeare, John (father), *28*, 36, *37*, 38, 44n, 112, 149, 162n, 195, 207
Shakespeare, William, 5, 44n, 75–6, 112, 115, 118, 124–5, 128, 129n, 132, 135–6, 141, 179n
 access to books and manuscripts, 297
 arrival in London, 162n, 180, 196
 arrival in St Helen's, 181, 194
 association with Marlowe, 196n
 attendance at St Helen's church, 205, 211
 bees and honey, 378–9
 Blackfriars gatehouse, purchase, 380
 brothers Gilbert and Edmund, 255, 270n
 career choices in 1594, 204
 character, 145
 childhood, *28*, 149, 195, 207
 coat of arms, grant of, 172, 179n, 226, 258, 299
 'Dark Lady' of sonnets, 250n
 Dibdale, Robert, contact with, 348n
 Doctor Edward Jorden, 366–7, 372, 387
 family, 309
 finances, personal, 258
 *First Folio* 1623, 5
 French, knowledge of, 195, 258, 468
 global reputation, 386–7
 Hall, Elizabeth (granddaughter), 380
 Hall, Dr John (son-in-law), 380
 Hamnet Shakespeare (son), 9, 181, 279, 309, 314, 379

Hathaway, Anne (wife), 309
health threats, 179n, 441
'housekeeper' at Globe theatre, 433
Judith Shakespeare (daughter), 9, 279
'Langley' writ, 432
Lay subsidy payment 1597, 147, 177n, 180, 432
Lay Subsidy roll 1598, *144*, 146, 161n, 165, **166**, **168**, 174, 177n, 180, 249n, *418*, *419*
Lay Subsidy roll 1599, 196n
Lay Subsidy roll 1600, 180, **432–3**
landlords, possible, 447, 454
leaving St Helen's, 432–43
length of residency in St Helen's, 181, 195
living in Silver Street 1602/04 onwards, *154*, 180, 194, 196, 212n, 257, 288n, 300, 302, 305n, 347n, 367, 432, 442, 467
local connections in St Helen's, 257, 269, 276, 179, 286–7
location in the city, *18*, *154*, 173–4, *301*
location of lodgings, *18*, *159*, 268, 274n, 394–400
lodgings, 172–3, 175, 177
Mary Glover affair, 364
medicine, knowledge of, 261
microcosmos at St Helen's, 320–1
Mountjoy deposition 1612, 43n
move to Southwark, 432–43
New Place, Stratford-upon-Avon, 171–2, 279, 302, 305n, 309, 378
payment of Lay Subsidy in Stratford, 147, 273n
portrait in *First Folio*, 5
St Helen's tithe survey 1589, 180
'sharer' in the Theatre, 212n
sonnets, 308
*Sonnet 55*, 324–5
*Sonnet 73*, 224–5
status, 174–5, 300
'Strangers'/immigrants, association with, 258
'sugred sonnets', 378
Susanna Shakespeare (daughter), 9, 181, 279
trips to Stratford-upon-Avon, 205
twins, 286
'upstart crow', called, 180
walking to work, *154*
wall memorial, Stratford-upon-Avon church, 297, *298*, 304n
wealth, 170–2
will, 249n
work load, 172–3
Shepherd, William and Johane, family, 199n, 461, 464n
Sheriffs, City of London, 99n

Shoreditch, village of, *5*, 46, 83, 89, 95, 98, 99n, 100n, 103, 118, 136, 140–1, 174, 176, 195, 289n, 308, 326n, 360, 387, 432
Sierra Leone, 389n
silk-weavers, 199n, 430n
de Silva, Spanish Ambassador Diego, 61n
Skegges, Edward and Joan, family, **48**, 50, **52**, 60n, 61n, 163n, 223, 236, 250n, *414*, 426n
Skelton, John, 271n
Skeres, Nicholas, Ralph, Ralph junior and William, **48**, 473n
*Skialetheia*, 136–7, 173
Skinners' Company, 219, 257
Slaney, Lord Mayor Sir Stephen, 340
slave trade, 231, 250n, *376*, 377, 386
sleep, lack of, 279–9
sleepwalking, 372
Sleford, Roland, 276, 288n
Smythe, Sir Thomas and Lady Alice (father), 250n, 385
Smythe, Sir Thomas (son), 231, 250n, 385, 389n
Sno(a)de, Anthony and family, 170, 326n
Somers, Sir George, 389n
Southbank/Southwark, 23n, 84, 137, 162n, 180, 199n, 304, 432
Spanish Armada, 1st 1588, 115, 126, 128, 134, 180, 241, 344, 382
Spanish Armada, 2nd & 3rd, 1596 & 1597, 388n
Spanish Netherlands, 12, *30*, 212n, 226–7, 466
spas and medicinal baths, 10, 67, 267, *284*, 285–7
Spencer, Edmund, 189, 430n
Spencer, Lord Mayor Sir John and Lady Alice, 11, *18*, 133, 134, *144*, **166**, **168**, 170, 181–2, *183*, 184–94, 197n, 198n, 214n, 228n, 246, *247*, 248, *248*, 252n, 259, 269, 309–10, 320, 325n, 326n, 329n, 380, 394, *418*, 460
Spencer, Elizabeth (daughter), *18*, 187–90, 197n, 198 n, 246, *247*, *248*, 252n, 456n
Spice Islands, 241
Spring, Robert and Denise, family, 8, *18*, 23n, 60n, *144*, **166**, **168**, 241, *256*, 257, 274n, 326n, 380, 410, *414*, *418*, *419*, 420–1, 426, 427n, 426n, 427n, 431n, 440–1, 443n
Stanhope, Edward I (brother), 47, **51**, 270n, 328n
Stanhope, Edward II (brother), 279, 299
Stanhope family, 270n, 279, 305n, 346n, 396, 449n
Stanhope, Michael (brother), 279, 288n, 299
Stationers' Register, 124, 189, 196n, 211n

Staveley, William, 141n, *144*, **167**, **168**, 176, 326n, 411, *412*, *414*, *428n*, *429n*
Staveley's Alley, 131, 199n, 428n
Stewart, James 1st Earl of Moray, 44n
Stewart, Mary Queen of Scots, 67, *127*, 128, 281–2, 344, 471–2
Stockwood, John, 102–4
Stow, John, *18*, 163n, 181, 184, 297, *298*, 304n, 359n, 398, 445
'Strangers', 12, 25n, *30*, 43n, 47, 53, 61n, 160, 165, 170–2, 177n, 178n, 194, 196, 199n, 212n, 226–7
Stratford-upon-Avon, 2, *37*, 181, 205, 255
   birthplace, Henley Street, *28*, 302
   Charlecote House, 274n
   fires in 1594 and 1595, 309
   Holy Trinity Church and communion cup, *28*, 29, 181, *209*, 297, *298*
   Lay Subsidy records, 443n
   New Place, 171, *256*, 279, 303, 305n, 309
   Shakespeare's family, 257
   Shakespeare's friends, 374n
   Shakespeare's wall memorial in church, 297, *298*, 304n
   town council, 255
Street, Peter, 95, 99n, 137–40
street performance and parades, *116–17*
Stringer, Anthony, 62n
sub-division of London houses, 91, 99n, 400n
sugar and sugar refining, *376*, 377–81, *378*, 388n
Survey of Strangers 1567/68, 61n
Suzan, John, *144*, **166**, **168**, 314, 326n, 388n, *415*
Swan, Minister John, 343, 360–2
Swan theatre, Bankside, 132, 191, 460

Tallis, Thomas, 304n
*Tamburlaine the Great*, 126, 180
Taylor, Doctor Richard and family, *144*, 162n, **166**, **168**, 172, 228n, 262, 273n, 282, 285, 290n, 291n, 312, 314, 398, *414*, *418*, 429n, 433n
Tedder, George, family and household, 131, 141n, 411, 430n, 450n, 465n
Teerlinc, Lavinia, 40, 44n
Thailand, 259, 389n
Thames Street, London, 336, 342, 360
Thanington, Canterbury, Kent, 315, 317
*The Isle of Dogs*, 473n
*The Merchant of Venice*, 4, 133, 238–9, 246, 291n, 300, 308, 388n
*The Merry Wives of Windsor*, 300
*The Rape of Lucrece*, 2, 3, 203–4, 211n, 308, 315
*The Shoemaker's Holiday*, 190

*The Spanish Tragedy*, 22n, 126–8, 180
*The Taming of the Shrew*, 100
*The Tempest*, 282, 379, 386
The Theatre, Shoreditch, 4, *5*, 46, 67, 103, 114n, 115, 130, 132, 149, *154*, 174, 195, 198n, 297, 308, 432, 460
   closure due to plague, 108, 132
   construction, 1576, 92–3, *94*, 95–7, 100n
   cost overruns, 101, 113n
   end and removal, 136–40, 142n, 300, 304n, 305n, 314, 328n, 387
   financial operation, 97–8, 106–7, 112–13, 145
   1576 lease and attempts to renew, 87–8, 95, 106–8, 135–9
   1579 mortgage, 106–7, 112, 444–7
   opening, 101
   performances at, 142n
   stage doors, 320, *322*
   trouble at, 104–5
*The Tragedy of of Gorboduc*, 119, 129n
*The Tyger* (ship), 259
theatre closure due to plague, 131, 203
Theatro Olympico, Vicenza, Italy, 98n
Thirty-nine Articles 1563, 208–9
Three Swans Inn, Bishopsgate, *16–19*, 176, 395, 457
Treswell, Master (probably Ralph senior), 425n
Throckmorton, Nicholas and family, 270n, 302n
Throckmorton House, 196n, 240
*Titus Andronicus*, 181, 305n
tobacco, *385*
Torbay, 241
Turner, Doctor Peter and Pascha (Parry), *18*, *73*, *144*, *151*, **166**, **168**, 172, 221, 230, 248n, 262, *263*, 264–9, 271n, 273n, 274n, 275n, 276–87, 288n, 288n, 289n, 291n, 310, 315, 325n, 326n, 372, 380–1, 387, *407*, 408, *418*, 426n
Turner, Professor Peter (son), 273n, 279, 282
Turner, William (father), 262, *263*, 273n, 275n, 279–80, 285, 289n, 310
twins, 286–7, 291n
*Two Gentlemen of Verona*, 180, 305n, 467

Upton, Jasper and Sir Henry (uncle), 410
'Utrecht Panorama' of Shoreditch, London, 5

'Vagabond' Act 1572, 86
Vanderstilt, Leven and family, *144*, **167**, **168**, 259, 313, 401n, 465n
Venice, 12, 22n, 262
*Venus and Adonis*, 2, 203, 211n, 304n, 308, 315
Vietnam, 389n

Virginia Company, 250n, 289n, 385–6, 385
Walker, Edmund, 459, 462n
Walsingham, Sir Francis, *x*, 248n, 408, 426n, 470, 472, 472n
Walsingham, Thomas, 473n
Walthall, Anne (Robinson), 197ns
Walthall, Alderman Thomas, 197n
Walthall, William, 197n
War of the Roses, *222*, 224
Warner, Alderman Francis, 427n
Warren, Elizabeth and William, family, *18*, **169**, 311, 380, *414*, 417, 421–4, 428n, 430n, 431n, 455n
Warren, George, 416, 428n
Watson, Thomas, 91, 100n, 299, 304n, 305n, 474n
West Africa, 250n
West Ham (Plaistow), Essex, 262, 273n, 312
wherries, 85, *154*, 333, *335*, *336*, 337, 347n
Whitechapel, 269, 276
Whitefriars, *154*, 174
Whitehall Palace, 23n, 105, 359n, 447
Whitgift, Archbishop John, 271n, 344
Williams, Richard (nephew of Thomas Cromwell), 402n

Wilson, Robert, 124–5
Windsor, Lady Katherine, **40**, 114n, *414*
Windsor Castle, 2, 131, 302n
witchcraft, *332*, 333–67, *339*, *365*, *366*
    *The Witch of Edmonton*, 366
    trials, 10, *345*
    Witchcraft Act 1563, 342, 347n, 358
witches in *Macbeth*, 259, *334*
Wittingham, Richard, 276–8
Wolsey, Cardinal, 271n
Woodward, George MP, 315, 328n
wool staple, 224, 230–1, 250n, 288n, 408
Wotton, Thomas and family, 155
Wrestlers Inn, Bishopsgate, *16–19*, 176, 450ns
Wrightson, Thomas, 175, 196, 199n, 230, 308, 326n, 387, *415*, 422, 429, 431n, 457–65, 462n
Wriothesley, Henry 3rd Earl of Southampton, 203–4, 255, 315, *318–19*

Yemen, 389n

Zanzibar, 382